DRAWING THE HUMAN FORM

METHODS / SOURCES / CONCEPTS

A GUIDE TO DRAWING FROM LIFE

WILLIAM A. BERRY

FOR ESTHER L. BERRY

Copyright © 1977 by William A. Berry Library of Congress Catalog Card Number 76-48736 ISBN 0-442-20718-2 (cloth) ISBN 0-442-20717-4 (paper)

All rights reserved. No part of this work covered by the copyright hereon may be reproduced or used in any form or by any means—graphic, electronic, or mechanical, including photocopying, recording, taping, or information storage and retrieval systems—without written permission of the publisher.

Printed in the United States of America Designed by Loudan Enterprises

Published in 1977 by Van Nostrand Reinhold Company A Division of Litton Educational Publishing, Inc. 450 West 33rd Street New York, NY 10001, U.S.A.

Van Nostrand Reinhold Limited 1410 Birchmount Road Scarborough, Ontario M1P 2E7, Canada

Van Nostrand Reinhold Australia Pty. Ltd. 17 Queen Street Mitcham, Victoria 3132, Australia

Van Nostrand Reinhold Company Ltd. Molly Millars Lane Wokingham, Berkshire, England

16 15 14 13 12 11 10 9 8 7 6 5 4 3 2 1

Library of Congress Cataloging in Publication Data

Berry, William A.

Drawing the human form.

Includes bibliographical references and index.
1. Human figure in art. 2. Drawing—Instruction.
1. Title.
NC765.B39 1977 743'.4 76-48736
ISBN 0-442-20718-2
ISBN 0-442-20717-4 pbk.

Acknowledgments

Thanks must be given to my friend Sterling McIlhany. who originally proposed that I write a book on drawing and, more importantly, offered invaluable critical advice throughout the years spent in completing this project. Under the spell of my drawing students' enthusiasm the book metamorphosed from a short work on drawing media to its present form. Regrettably, space does not permit listing them individually, though some of their drawings are reproduced herein. In the early stages of writing I learned much from the sympathetic insights of Professor Harold Larrabee, who kindly consented to read the feeble first draft. I also benefited enormously from the advice of Professor lanet Rollins Berry, my wife, whose wide-ranging knowledge of art history was a constant resource and whose objective criticism is a wonderful antidote to murky writing. Without her encouragement and assistance the book might have remained yet another unfinished project. Thanks are also due to Nancy Witting, who provided professional editorial assistance, and to Maria Rainho, whose typing skills are matched by her editorial acumen. I am grateful for the generosity of the studio models in allowing their images to be reproduced in these pages. It was a thrilling experience to receive the cooperation of great art museums and private collectors around the world who diligently filled my many orders for photographs. Many other people have contributed time, effort, and valuable advice. Special thanks to my colleagues, Professors Donald Weismann, Mort Baranoff of the University of Texas at Austin. Jack Kramer of Boston University, John Frazer of Wesleyan University, and Jerrold Simon of City College of New York. I am grateful to Robert Tyndall and Paul Russell for their assistance with computer graphics. Richard J. Wolfe, Rare Books Librarian at the Francis A. Countway Library of Medicine, deserves thanks for personally introducing me to the treasured anatomical publications for which the library is justly famed. Special thanks to Wendy Lochner, whose editing helped clarify this manuscript, and to Van Nostrand Reinhold, for patiently awaiting its completion and generously enlarging the book's dimensions as the project developed.

Contents

_		•	-
D	MA	face	1
		ace	4

- 1. Drawing a Simple Form: Prelude to the Human Form 7
- 2. Seeing Large Forms: Outline and Silhouette 14
- 3. Drawing in Line: Contour, Constructs, Visual Measurement, and Movement 22
- 4. Line: the Classic Drawing Method, Proportion, and Symmetry 66
- 5. Modeling: Relief, Shadow, Tone, and Contour 76
- 6. The Skeleton: the Structural Framework of Body Forms 140
- 7. The Muscles: the Dynamics of the Human Form 178
- 8. Drawing as Preparation: the Development of Visual Concepts 222

Footnotes 244

Bibliography 250

Index 252

Preface

Many years ago when I was a student, a professor noticed that I was carrying a book written in German, a language that he knew I could not read. Chiding me, he asked what on earth I intended to do with it. I replied that I was going to look at the pictures. Undaunted, I have since continued to look at pictures in books that I can't (or don't) read. Drawing the Human Form offers information about drawing to those who, like myself, enjoy looking at pictures. It is organized around visual material so that a student can learn directly from it—visually, technically, and creatively—without detailed reference to the text.

Illustrations include student drawings and masterworks, grouped to focus on one specific drawing principle at a time. The text follows a simple pattern, giving materials lists and procedures for each study as well as a short theoretical-historical explanation of the principle involved. The studies are based upon my years of experience teaching freshman classes in drawing. The sequence permits the student to master individually the concepts that become components of the drawing methods, often more complex, that follow. The discussion is limited to drawing methods: stylistic preferences are avoided. The studies are designed to be repeated, with the understanding that only through practice can drawing concepts, however well described, become meaningful and useful to the artist. In this connection the illustrations can be helpful, especially for those who, like most established artists, are visually oriented.

Many people have commented on the pleasure and satisfaction that they derive from drawing. There is an undeniable sense of accomplishment in making something with your own hands, a feeling of particular value in this machine-oriented civilization. This is especially true if the object produced is a work of quality that has personal meaning for the artist. Satisfaction of this kind generally comes after the work has been completed.

I believe that there is an even deeper satisfaction in drawing from life, which is felt before the drawing is completed. During the intense period of concentration required by drawing, thoughts unrelated to the activity of drawing temporarily disappear. I have noticed, for instance, that as I become more aware of the model and of my drawing, I become less aware of myself. And the contemplation of the form of the model, a fellow human being, may be compared to an act of humility in which the artist temporarily forgets his or her physical frailties and imperfections and marvels at the diversity possible within the human form. While transferring your total attention to another human being in an attempt to seize upon the uniqueness of the living

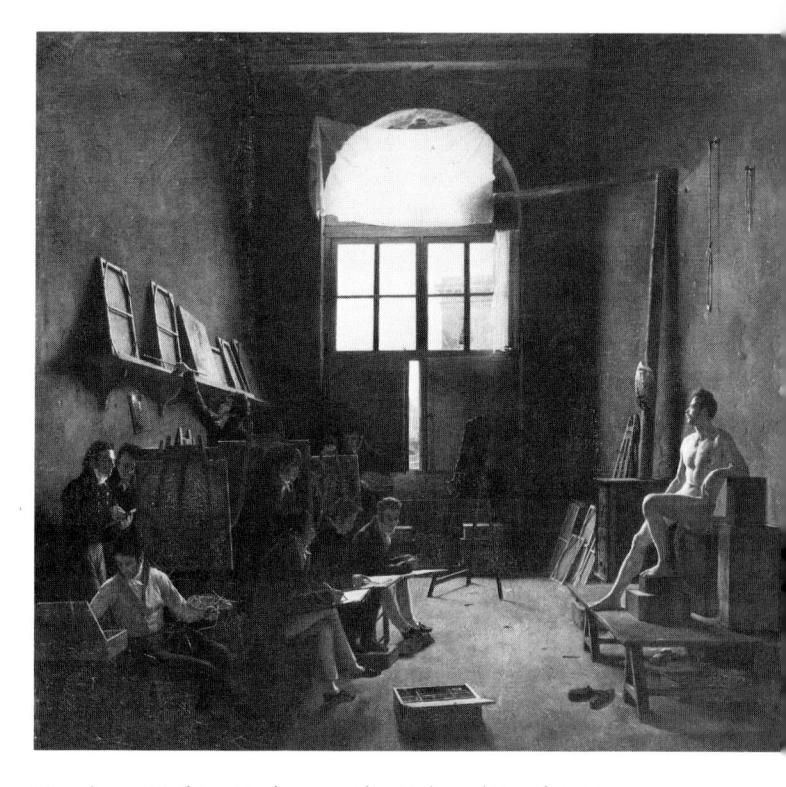

I-1. Above. Mathieu Cochereau, The Atelier of David, 1814. Oil on canvas. Paris, the Louvre. Similar drawing sessions are still conducted in Paris. In the 19th century (and earlier) admittance to such an atelier required an arduous preliminary study of engravings and casts, a course that is no longer followed in many art schools. The use of a thin cloth to diffuse the light falling on the model is in accordance with Leonardo da Vinci's instructions for lighting a studio: "A broad light high up and not too strong will render the details of objects very agreeable. The light for drawing from nature should come from the North in order that it may not vary. And if you have it from the South, keep the window screened with cloth, so that with the sun shining the whole day the light may not vary" (Leonardo da Vinci, The Notebooks of Leonardo da Vinci, vol. 1, ed. Jean Paul Richter [New York: Dover Publications, Inc., 1970], p. 257). Leonardo was concerned primarily with variations in the direction rather than in the intensity of the light. In direct sunlight the effects of light and shadow on the model vary according to the time of day. Diffusion of the sunlight prevents such variation, making the draftsman's task easier. Above right. Drawing class, 1976. The large windows and north light in this modern studio provide these students with the natural, even illumination advocated by Leonardo. It is generally advisable to avoid drawing studios that have only artificial light: "The illumination provided at eye level in artificially lighted rooms is commonly . . . less than 10 percent of the light normally available outdoors in the shade of a tree on a sunny day" (Richard J. Wurtman, "The Effects of Light on the Human Body," Scientific American, vol. 233 [July 1975], p. 70).

form, you can experience a pleasurable release from self. This kind of satisfaction comes not so much from the completed drawing as from the process of drawing itself.

It is a pity that the completed drawing often gives no hint of the excitement of discovery that takes place in the studio while the artist draws. And, more important, it is unfortunate for the student that the finished drawing often obscures the method that the artist employed in developing it. For this

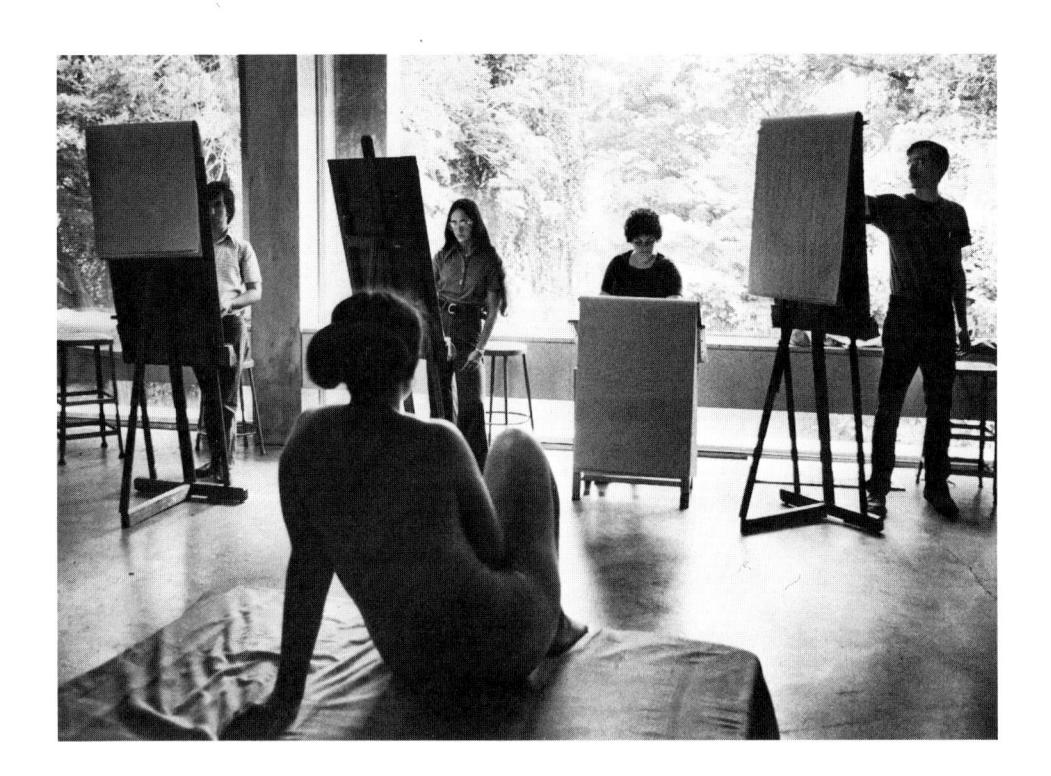

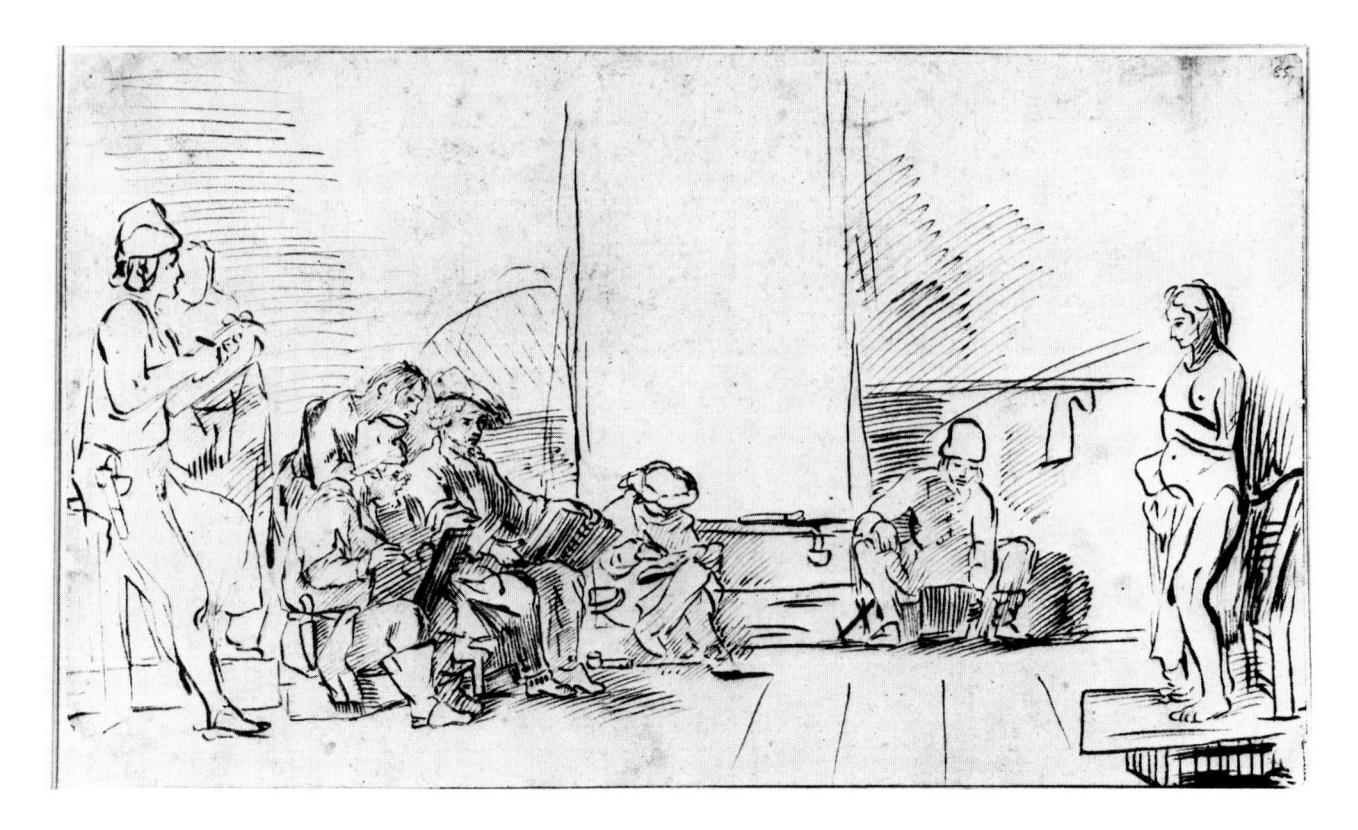

I-2. Rembrandt (school of), Rembrandt with His Students in the Workshop Drawing from the Live Model. Quill and ink. 178 × 317 mm. Weimar, Schlossmuseum. The quality of teaching in a drawing class is as important as the physical aspect of the studio. In Rembrandt's time students applied to the studio of a recognized master and often worked as apprentices. The apprentice system made possible a long period of continuous training with one teacher. Students unable to apprentice with an artist of stature did not benefit from this system, but for those fortunate enough to study with a Rembrandt there was an enviable

advantage. Even so it is doubtful whether Rembrandt would be tenured by most present-day art schools, for "We know that Rembrandt used to teach his pupils by getting them to copy, stroke for stroke, his own drawings" (Philip Rawson, *Drawing* [London: Oxford University Press, 1969], p. 292). The teacher remains an important factor in any drawing class. Today's schools, though they generally do not provide prolonged instruction with a single teacher, do offer the student a variety of artistic viewpoints unavailable to the apprentice in Rembrandt's day.

reason I have used a camera to record drawings at various stages of development, paralleling projects described in the text.

The student drawings, with their freshness and flaws, indicate what you might reasonably expect to achieve in your first year of study in art school. I have also included some drawings by students who later became recognized masters, drawings that reveal how exceptional art students resolved problems similar to those described. Picasso's student work is of special interest in this connection. Mature graphic works of well-known artists are presented both as examples of the creative use of various drawing concepts and as sources of inspiration.

Photographs are also employed to document something of the delicate relationship that exists between the drawing and the model, a relationship that vanishes as soon as the model ceases to pose. The reader can judge visually the successes and shortcomings of the student's draftsmanship. Since watching others draw is sometimes a strong inducement for you yourself to try, it is hoped further that the photographs of art students at work will encourage you to explore drawing, whether independently or in the classroom environment.

I should add here that, while I do not wish to discourage the independent study of drawing—many of the studies call for independent work—my experience as a teacher has convinced me that the subject is most easily mastered in a studio environment with other students. This view is shared by artists of great authority, among them Leonardo da Vinci, who put it this way: "I say and insist that drawing in company is much better than alone, for many reasons. The first is that you would be ashamed to be seen lagging behind the other students, and such shame will lead you to careful study. Secondly, a wholesome emulation will stimulate you to be among those who are more praised than yourself, and this praise of others will spur you on. An-

other is that you can learn from the drawings of others who do better than yourself...."

This book attempts to bring the reader, whether instructor, student, or interested layman, into the drawing studio to share the problems and experiences of a group of serious young art students who are concerned with acquiring a basic mastery of drawing.

Drawing from the model is one of the traditional ways of attaining such mastery (Figures I-1 and I-2). Many art schools require it. In an age in which art is largely nonfigurative, however, you might well question the relevance of drawing the human figure. Is the study of drawing from real life relevant only to figurative art? I think not. As Kenneth Clark has pointed out, "... our admiration of an abstract form, a pot or an architectural molding, has some analogy with satisfying human proportions."²

Human proportions are naturally best seen in the nude body. Your first experience in drawing from the nude model, however, may seem quite unnatural. Yet for centuries the social taboo of viewing another human being without clothes has been lifted in the artist's studio. Michelangelo once implored, "... who is so barbarous as not to understand that the foot of a man is nobler than his shoe, and his skin nobler than that of the sheep which with he is clothed. ... "3 Such reasoning holds true as long as the model appears noble. With many models, however, this is simply not the case, and yet they too are fascinating to draw. Noble or not, the nude figure has compelled the attention of artists through the ages. Even to the revolutionary artist the canons of form learned through the traditional study of life drawing are useful. Many of the most innovative artists of the past, including Picasso, studied drawing from the model with instruction that can only be termed academic. In order to break the rules, it is helpful to know what they are.

1. DRAWING A SIMPLE FORM:

Prelude to the Human Form

Drawing is not form; it is your understanding of form.—Edgar Degas

So central is the human form to the history of western art that it inevitably became an accepted standard against which draftsmen tested and sharpened essential drawing skills. Some artists have maintained that a person who can draw the human figure can draw any subject under the sun. There is some truth in this claim, for methods used to draw the human form can readily be applied to other forms, yet it is likely that the reverse is also valid: namely, that a person who can draw any subject can also draw the human figure. Drawing the human figure raises many of the same problems that are encountered in drawing any observed form. It is useful, therefore, to begin by considering some of the principles that life drawing has in common with all drawing.

CONCEPTS OF FORM: THE BASIS FOR THE DRAWING CONSTRUCT

Seeing a form is the first step in the drawing process, but perception alone is not sufficient to enable you to draw. In order to draw an observed form, the artist must learn to conceive of form in terms that can be translated into the visual constructs that the artist actually draws as marks on paper. The formal concept provides an intellectual means of translating the raw data of visual observation into coherent constructs, in somewhat the same way that a computer program offers a means of processing numerical data. The German Renaissance artist Albrecht Dürer (1471-1528), for example, may have conceived of the neck of his model Catherine in terms of a cylinder in space (Figure 1-1). Such a concept of form appears to underlie the curvingline constructs in that area of the drawing. Each curved mark of the pen conveys some information about the form of the neck: straight-line constructs might have marred the structural consistency of the drawing.

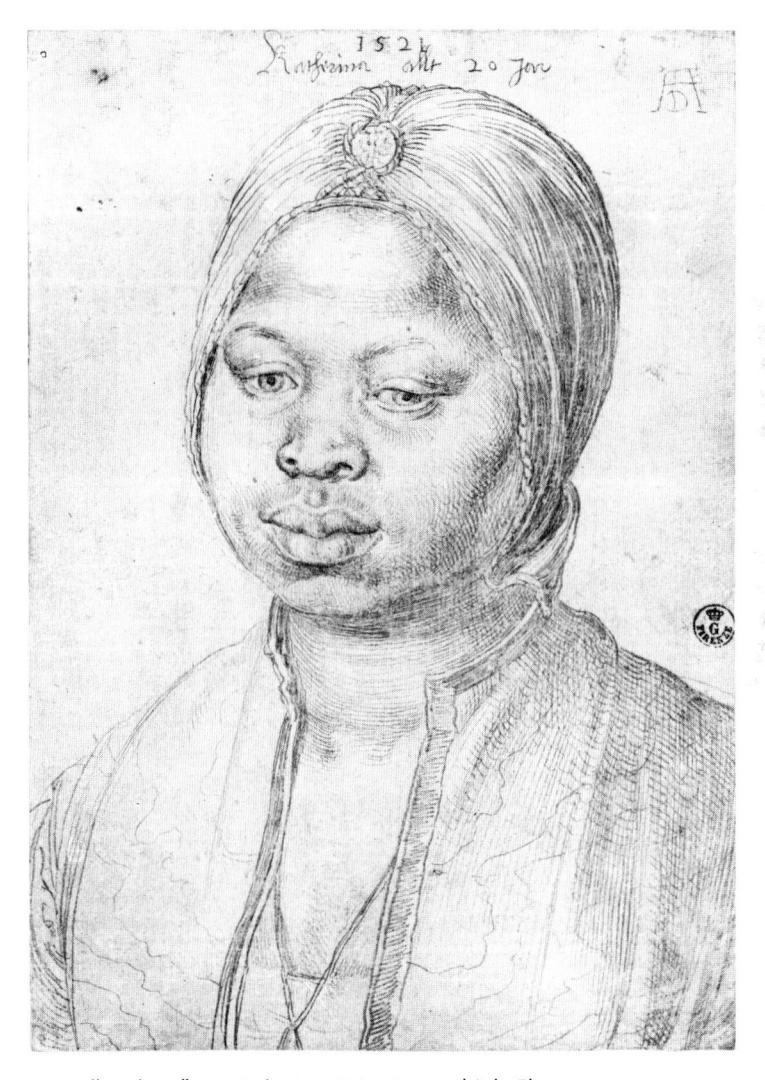

1-1. Albrecht Dürer, Catherine, 1521. Pen-and-ink. Florence, Galleria degli Uffizi. The complex structure of Dürer's drawings is often built with simple, curving-line motifs that suggest rounded forms.

The richly complex construction of Dürer's drawing seems perfectly in keeping with the subtle perceptions that it records. Such technical virtuosity, dazzling though it may be, is not the critical factor in

determining the quality of a drawing. Artistic quality depends rather on the appropriateness of the drawing's constructs to the artist's perceptions. This partly explains the special charm of children's drawings, in which technical virtuosity plays no part. The boldly schematic constructs often seem admirably suited to the directness characteristic of a child's perceptions (Figure 1-2). The constructs in both drawings are similar in that they do not initially attract the viewer's attention: they seem to exist only in order to communicate the forms that they embody.

What are the origins of the constructs that enable a drawing to convey form so effectively? From early times artists have looked to geometry as one way of constructing form. This is not to say that artists necessarily employed rulers and compasses, as mentioned in Isaiah,1 though such instruments were used to rough out sculptured form, but simply that many artists have used geometry as a source of ideas for the structural units with which to build a drawing. Some artists, such as Villard de Honnecourt in the Middle Ages (Figure 1-3) and Albrecht Dürer in the Renaissance (Figure 1-4), used triangles or circles as the framework for drawing a figure. In the more complex portrait drawing by Dürer (Figure 1-1) geometry is less obvious, yet the parallel lines in the neck-hatching-that seem to curve around form are nothing more than segments of a circle visualized in space (see chapter 5).

The importance of geometric constructs in art is illustrated by a curious account from the life of the early Renaissance painter Giotto (c. 1266-1337), as recorded by the sixteenth-century artist-chronicler Giorgio Vasari. The story began in Rome, where Pope Benedict was trying to select an artist to decorate Saint Peter's Cathedral. Having heard much of Giotto's fame, the Pope sent a courtier to Florence to request a sample drawing of the artist's work. Upon receipt of the request, Vasari tells us: "Giotto, who was a man of courteous manners, immediately took a sheet of paper, and with a pen dipped in red, fixing his arm firmly against his side to make a compass of it, with a turn of his hand he made a circle so perfect that it was a marvel to see it. Having done it, he turned smiling to the courtier and said, 'Here is the drawing.' But he, thinking he was being laughed at, asked, 'Am I to have no other drawing than this?'

'This is enough and too much,' replied Giotto. 'Send it with the others and see if it will be understood.'"²

Was this simply Giotto's way of saying that he felt no need to give proof of his ability as an artist? Or was he serious in submitting his drawing? The paradoxical nature of Giotto's response undoubtedly left the courtier puzzled, and no further explanation of its meaning has come to light. Although Giotto's purpose can only be guessed at, this anecdote suggests the artist's awareness of the fundamental role that geometric constructs such as the circle play in drawing.³

Today the geometric approach to form is found in many popular books on drawing technique, but the concepts embodied in the geometric form itself are seldom discussed. There are at least three formal concepts underlying Giotto's circle: (1) You might think of the circle as a single line described by a point that changes its direction consistently and uniformly as it moves across a plane. (2) You can also regard a circle as the path of a moving point that maintains a constant distance from another point. (3) Or you can think of a circle as a shape composed entirely of points surrounding and equidistant from a central point on a plane. The three concepts, although they describe the same form, are not merely superficially different: they differ to such an extent that each of them dictates a different drawing method.

1-2. A five-year-old's drawing of the human body. Crayon. A simple, schematic construction of a circle and lines represents the figure.

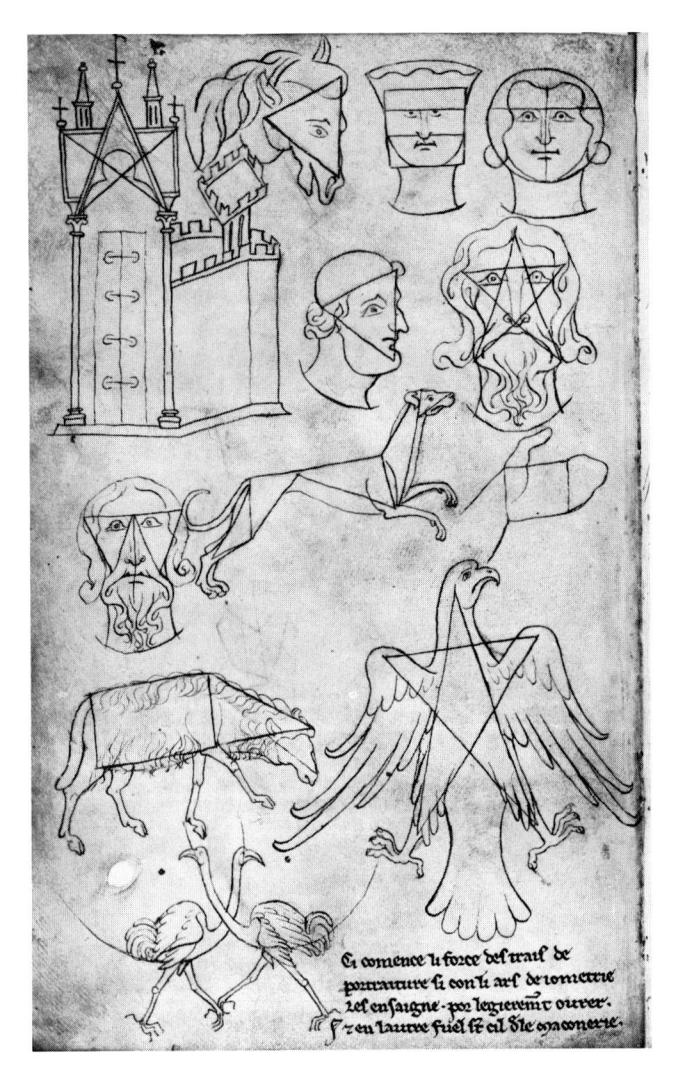

1-3. Villard de Honnecourt, *Gateway*, *heads*, *animals*, *and heraldic eagle*, c. 1240. Page from a notebook. Pen-and-ink over lead point on parchment. 9 11/16" × 5 15/16". Paris, Bibliothèque Nationale. Since early times artists have explored the use of geometric forms as the framework for drawing. Villard de Honnecourt, an artist in charge of building cathedrals, employed a compass and a ruler to construct his sketches. In the inscription at lower right he wrote that drawing is "easy to practice . . . as it is taught by the discipline of geometry."

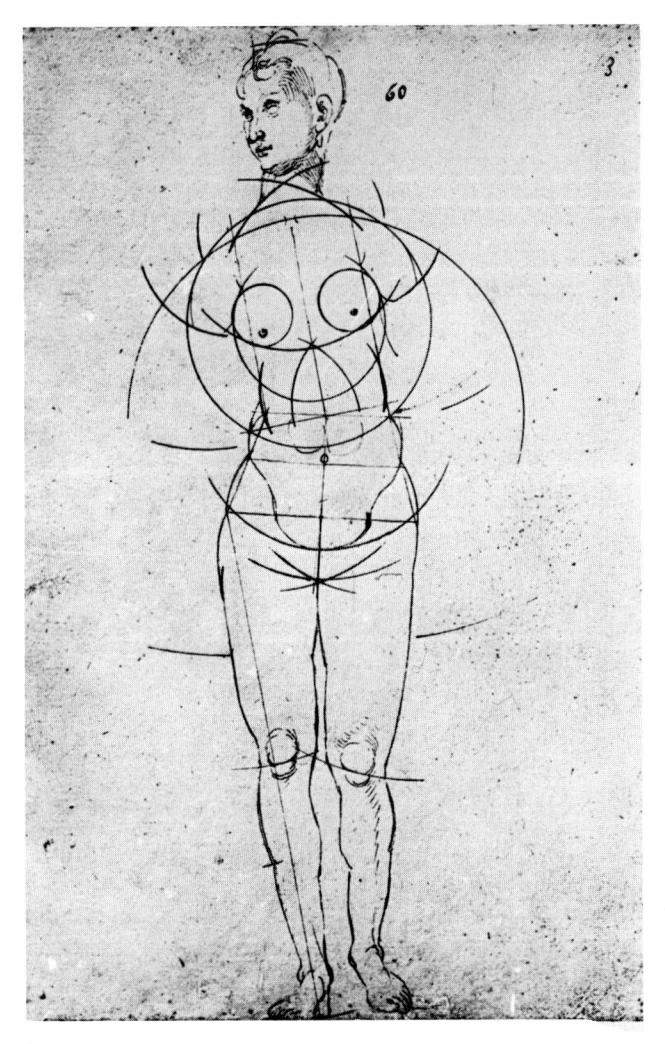

1-4. Albrecht Dürer, Nude woman, constructed, c. 1500. Page from the Dresden Sketchbook. Pen-and-ink with compass. 290 \times 188 mm (11 $_3$ /8" \times 7 $_3$ /8"). Dresden, Sächsische Landesbibliothek. Dürer used a compass in his search for a system of circular constructs in the figure. Even the parts of the figure drawn without the compass appear to have been constructed with arcs.

STUDY 1. THE CIRCLE

Materials:

36"-x-24" newsprint drawing pad 37"-x-25" piece of Masonite or 1/4"-thick plywood (to back

the drawing pad)

drawing-board clamps (preferably the ball-bearing type) to hold drawing pad and drawing

board together

easel (if none is available, rest the lower edge of the pad on the seat of a straight chair with the chair back supporting

the back of the pad)

dark brown or black drawing crayon (Nupastel or soft Conté

brands)

Suggested time:

3-5 minutes

Keeping in mind the first concept of the circle, try moving the point of the crayon across the page in such a way that the direction of movement changes evenly and constantly, forming a uniform, even arc (Figure 1-5a). This arc, if it is uniform, will form a circle. Control of the hand and its swinging motion are very important in this exercise.

This first method is a natural way to draw a circle. Even scribbles by very young children often reveal rounded-contour patterns drawn with a swinging motion, because: "The lever construction of the human body favors curved motion. The arm pivots around the shoulder joint, and subtler rotation is provided by the elbow, the wrist, the fingers. Thus, the first rotations indicate organization of motor behavior according to the principle of simplicity. The same principle also favors the priority of the circular shape visually."4 This method of drawing the circle exploits the body's inclination to favor circular motion and may explain in part the tendency of certain artists such as Dürer (Figure 1-4) and Leonardo (Figure 4-5) to relate the human figure to the abstract form of the circle.

The second concept of the circle provides a more measured way to draw it. If you first establish a center for the circle by making a dot in the center of the paper, you can draw around the point while concentrating on maintaining an equal distance between the crayon and the central dot (Figure 1-5b). In this instance visual judgment is as important as muscular control. Errors caused by accidental movement of the arm are easily corrected by reevaluating the distance between the central point and the circumference (Figure 1-6).

The third concept leaves no doubt about how to draw the circle: one dot must be drawn at a time, with each dot the same distance from the central dot. A sufficient number of dots will appear to form a line describing a circle (Figure 1-5c). A perceptual

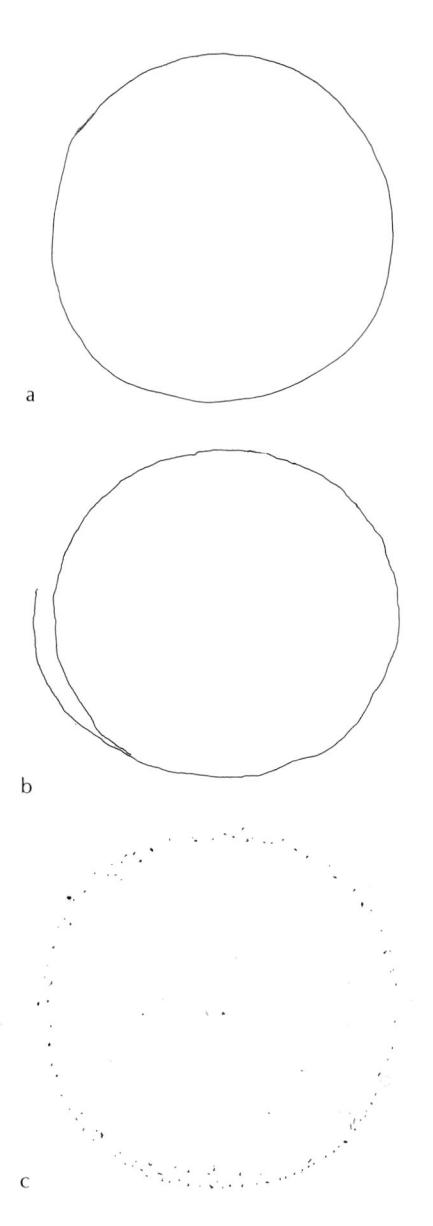

1-5. Three ways of drawing a circle: (a) as an evenly turning arc, (b) as a line drawn equidistant from a central point, (c) as a series of points equidistant from the center.

phenomenon called *closure* explains the tendency of the mind's eye to fill the spaces between the outer dots with an illusory line, sometimes referred to as a *virtual line* or an *implied line*. This method of drawing a circle permits the artist to focus on the problem of visual distance and the principle of visual measurement. It is useful not only in estimating physical distance, as in the case of the circle, but also in drawing from life, since it is important to establish relative and apparent distance between points observed on the model and marks made by the artist on the paper in order to translate the solid form into a two-dimensional drawing.

Regardless of which method you use to draw a circle, this simple, abstract, geometric shape so breezily drawn by Giotto illustrates two other important spatial principles of drawing: overlapping forms and figure-ground relationships.

OVERLAPPING FORMS

If a drawing of a circle intersects another circle (Figure 1-7a), the result is an ambiguous visual effect. Either of the circles may be seen as a transparent form on top of the other: it is not clear which form is on top. If the intersected arc of one circle is erased (Figure 1-7b), however, the apparent spatial relationship of the two forms is clarified: the complete circle appears to be an opaque disk that covers part of another complete disk. Even though part of the latter circle has been erased, you continue to perceive it as a complete closed form rather than as a crescent shape next to a circle. The mind's eye tends to complete the regular shape of the incomplete circle. A slight separation of the two elements suffices to destroy the illusion of completeness (Figure 1-7c). The manner in which the two elements are joined is essential to the integrity of the overlapped form. This is of special importance in contour-line drawing (see chapter 3), which relies almost exclusively on the overlap principle to convey a sequence of forms in depth. Some artists in the past drew overlapping circles as constructs to represent the overlapping contours of forms observed in life (Figures 1-8 and 1-9), but the principle is not limited to rounded figures: rectangles, triangles, and many other regular and irregular shapes can be repeated and overlapped to suggest spatial order.

1-6. Drawing the circle. The student on the left has drawn a circle by the method illustrated in Figure 1-5a. On the right another student completes a circle as shown in Figure 1-5b. Note the Masonite panels supporting the drawing pads.

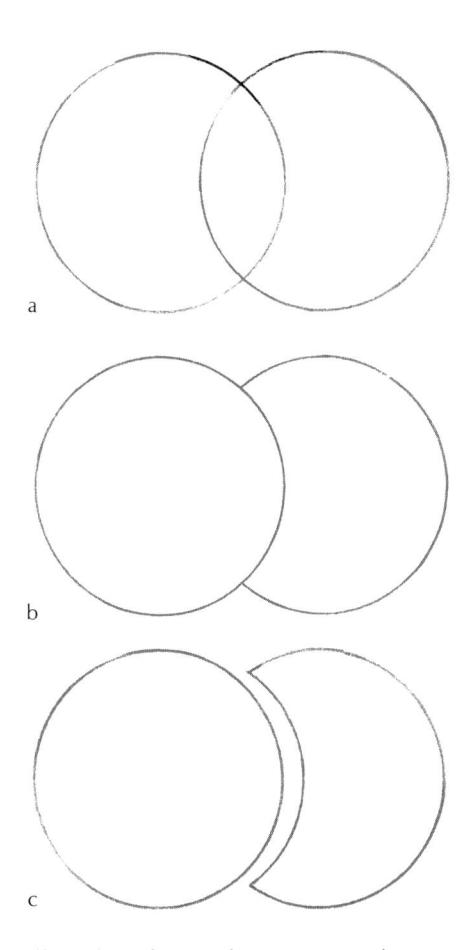

1-7. The effect of overlapping forms: (a) an ambiguous, transparent effect results if two circles overlap; (b) if the overlapped portion of one circle is removed, the remaining circle appears to lie on top of and to partially hide the broken one; (c) the effect of overlapping form is destroyed if the two shapes are separated. The predominant visual interpretation of (b) is of overlapping circles, not of the independent shapes in (c).

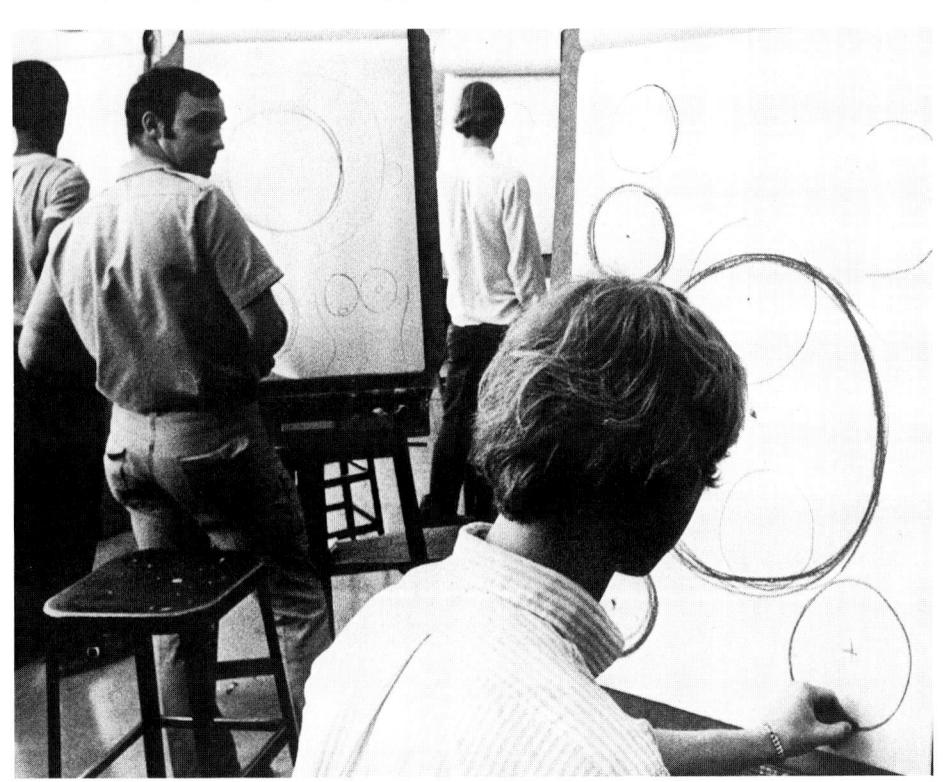

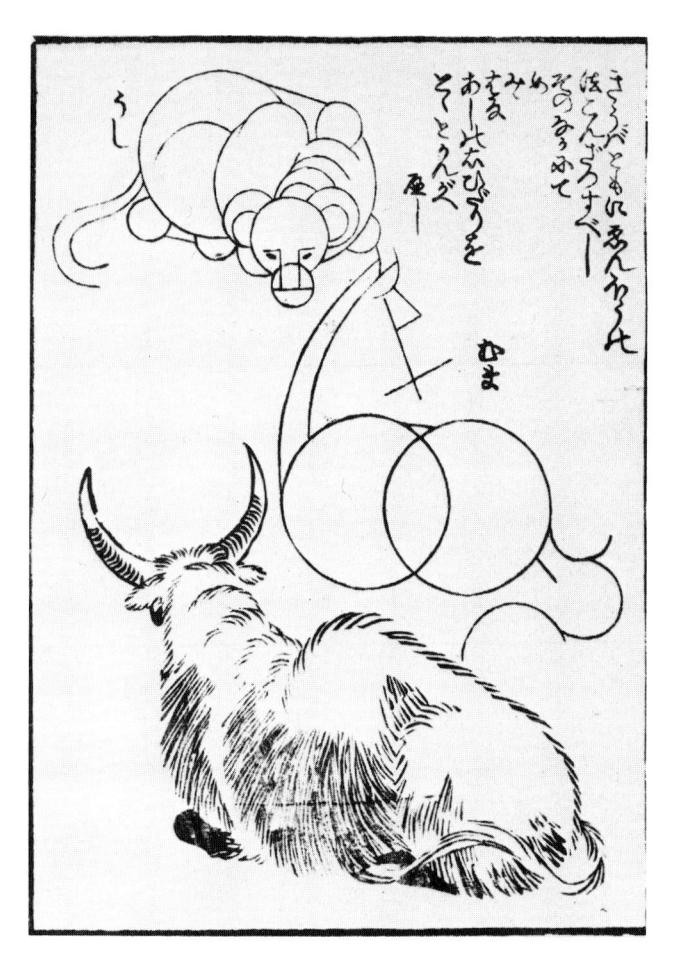

1-8. Hokusai (1760–1849), Stereometric elaboration of various animals. Double-page illustration from Rayakuga Haya Oshie, vol. 3. Wood engraving from a brush drawing. 16 × 11.25 cm. London, British Museum. An important painter and graphic artist, Hokusai is also the author of a book explaining his drawing methods. Here he illustrates how to draw animal figures by means of overlapped circles that suggest hidden or "foreshortened" forms. In the upper-right corner of the left-hand illustration two arcs with commalike hatch marks demonstrate Hokusai's construction technique.

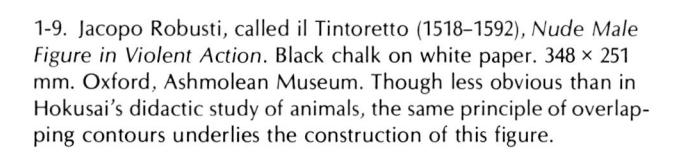

1-10. Both the circle and the square are usually seen as positive forms. If a circle is superimposed on a square, however, the former can be interpreted either as a positive shape surrounded by empty space or as a hole (i.e., negative space) in the square. This phenomenon, known as figure-ground reversal, has numerous applications in drawing.

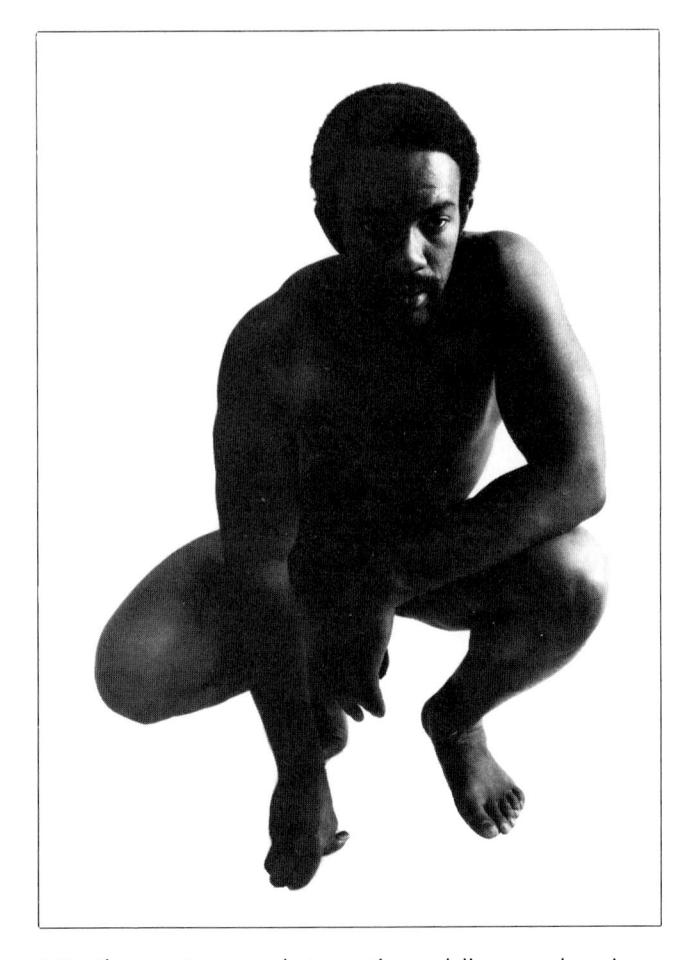

1-11. The negative space between the model's arm and trunk can be viewed as a positive shape. A voluntary figure-ground reversal of this type provides the artist with a useful means of interpreting form in a drawing. A similar negative space, not completely enclosed, is apparent between the model's left leg and thigh.

FIGURE-GROUND RELATIONSHIP

Psychologists state that a closed figure such as a circle establishes a special relationship between the figure and the background. This *figure-ground relationship* was first described by Kurt Koffka in 1922.⁵ He noted that any closed figure (such as a circle) appears more distinct in structure than the area that surrounds it, which is called the ground or background. Due to the assertive quality of the figure, artists often refer to it as the *positive shape*, while the ground is called the *negative space*. Under certain conditions the elements are reversible: that is, the figure can be seen as the ground, and vice versa (Figure 1-10).

The notion of "empty" or "negative" space applies not only to the ground surrounding a drawn enclosure, as in the case of the circle, but also to observations of the human form. An empty space such as that between a model's arm and the rest of the body can be perceived as a positive shape (Figures 1-11 and 2-6). Seeing a negative space as a positive shape involves the recognition of the empty space as an entity and therefore implies a figure-ground reversal similar to that seen in Figure 1-10. Once the "empty" space is perceived as a shape, the artist can compare it with the corresponding negative shape in a drawing of a model for the purpose of checking draftsmanship (i.e., accuracy).

Beyond their immediate use in the drawing process negative shapes determine to a considerable extent the character and quality of a work of art. This cannot be overstressed. The beginning art student tends to be sensitive only to positive forms, both in drawing and in objective reality. A conscious effort to see negative shapes while drawing will overcome this difficulty and improve the quality of your work. It is useful to examine masterworks to see how artists of the past enhanced their compositions by means of negative shapes (Figure 3-34).

SUMMARY

The drawing exercises with the circle, simple though they may seem, can assist you in understanding several fundamental drawing principles, including positive and negative shape, overlapping form, and visual measurement. Only by actually drawing is it possible to comprehend the enormous range of application such abstract principles have in the drawing process. The circle, which requires a minimal degree of manual control to draw, demonstrates the principles without the complication of a figurative subject. In the following chapter these and other principles are applied to the process of drawing from life.

2. SEEING LARGE FORMS:

Outline and Silhouette

You must have the whole figure you want to draw in your eye and mind. —Ingres

On a clear day you can see a natural phenomenon that has much in common with the process of drawing (Figure 2-1). It is your shadow. Like most drawings, a shadow, or silhouette, is a two-dimensional transformation of three-dimensional form. In the silhouette, however, the transformation is far more severe than in most drawings, for it contains practically no visual information about the forms that may lie inside its dark, even tone (Figure 2-2). The silhouette provides a singular example of a large configuration of the human form without most of the complex detail that sometimes lures the unwary art student into overworking a drawing. In fact, the only specific detail in a silhouette is its sharply defined edge. The linear effect of that edge is called an outline (Figure 2-3).

Drawing the human silhouette involves at least one important departure from the previous exercise: it requires a model. The circle, a simple, unchanging shape, is easily remembered, whereas the silhouette, an irregular form that changes with every movement of the model, is difficult to reconstruct from memory alone. Using a model resolves some of the difficulty. In drawing the circle you saw that the concept of form affects the way you draw. Before drawing the silhouette, consider these two concepts. (1) Viewed as an outline, the silhouette may be thought of as a pure line separating the figure from the ground. (2) The silhouette may also be regarded as a shape like a shadow, in which the edge is defined by tonal contrast rather than by an actual line. The first concept requires considerable concentration on a single aspect of the model, the apparent outside edge of the large shape of the body. Of course, you see much more than that. Your visual perception includes many patches of color and many value combinations in both figure and ground areas. Only the patches that establish the boundary of the figure are relevant to the outline: the rest must be temporarily ignored. Drawing the outline

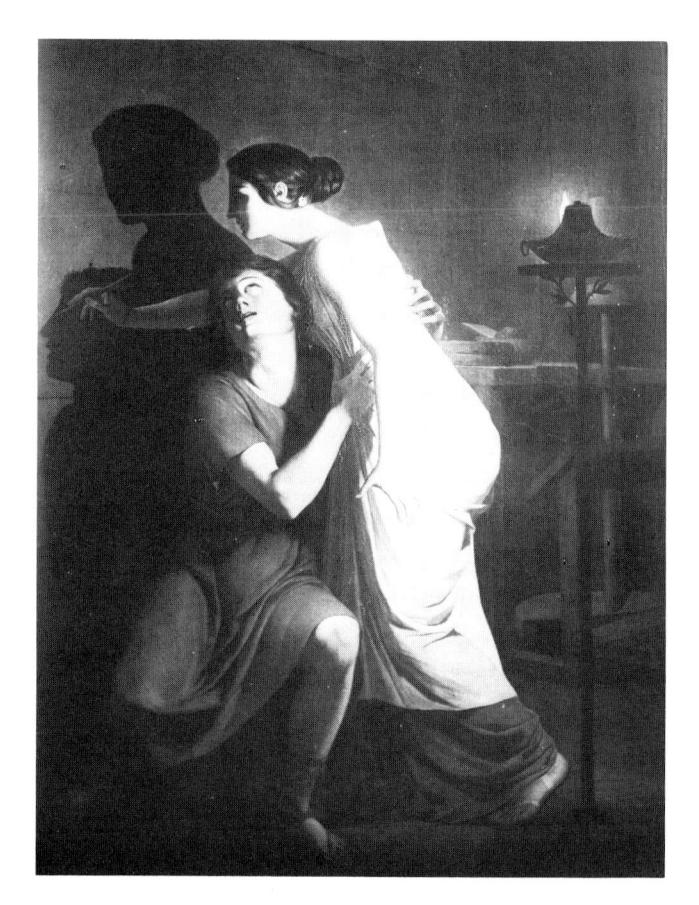

2-1. Joseph Benoît Suvée, *The Daughter of Butades Drawing the Shadow of her Lover*, 1799. Oil on canvas. Bruges, Groeningemuseum. The close relationship between the cast shadow and the representation of form in two-dimensional art is recognized in the folklore of art. "All agree," wrote the Roman author Pliny, "that it [painting] began with tracing an outline round a man's shadow. . . ." He recounts the tale of Butades's daughter, ". . . who was in love with a young man; and she, when he was going abroad, drew in outline on the wall the shadow of his face thrown by a lamp" (Pliny, *Natural History*, trans. H Rackham [Cambridge, Mass.: Harvard University Press, 1968], Book XXXV, 65-68, pp. 271, 373.

is an extreme example of Max Lieberman's belief that "drawing is leaving out."

If this is your first experience in drawing from a model, you will need a studio arrangement, includ-

ing a platform for the model and an easel for your-self. The platform should be about two feet in height in order to eliminate unintentional visual distortion (Figure 2-4). Similarly, the easel should be adjusted so that the center of the drawing paper is at your eye level. This helps to avoid scale distortions in your drawing and at the same time permits easy movement of the arm to all parts of the drawing surface.

Although a platform for the model and an easel for yourself are standard professional equipment, many fine drawings have been produced without them. A straight chair can serve as an easel (see study 1), and the necessity of a platform, used primarily to minimize distortion, can be eliminated if you draw from a seated position.

2-3. Outline drawing in chalk by a police detective. The close relationship between the outline and objective reality makes this form of drawing useful in establishing the factual situation in an accident. (Photo by Lee Romero courtesy of the New York Times.)

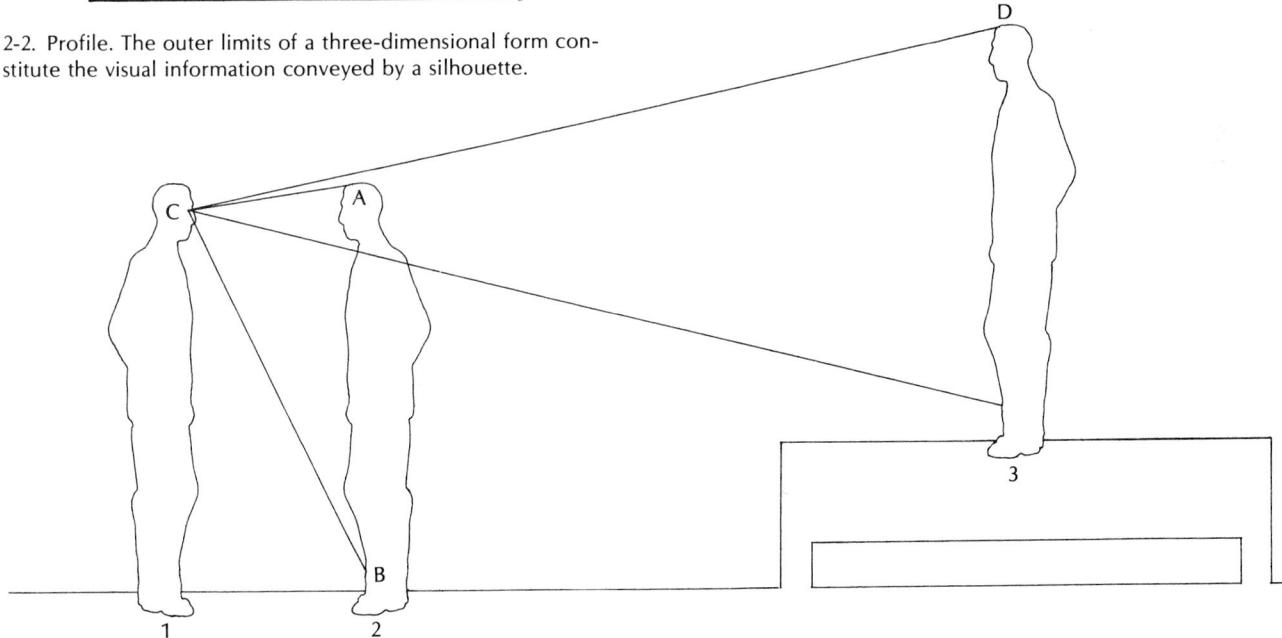

2-4. Unintended distortions in a drawing sometimes result from the relative location of the artist and the model in the studio. This is due to the nature of the visual field. Objects close at hand occupy a larger part of one's field of vision than those at a greater distance. For this reason the closer forms may appear disproportionately large. This phenomenon would occur if figure (1) were observing figure (2). (CA) is a shorter distance than (CB), with the result that the head of figure (2) would appear disproportion-

ately large compared with, say, the feet. Such distortion would not occur, however, if figure (1) were looking at figure (3). The greater distance separating (1) and (3) and the elevation provided by the model stand help to equalize the distances (CD) and (CE), eliminating the cause of the distortion. If, on the other hand, distortion effects are desirable in a particular drawing, you may wish to situate the model nearby.

STUDY 2. THE OUTLINE

Materials: 36"-x-24" newsprint drawing pad

easel or straight-back chair Masonite or plywood board and

clamps

dark brown or black drawing crayon (Nupastel or soft Conté

brands)

felt-tip pen with broad point

(optional) model

Reference: Suggested time:

10-15 minutes

Look at the entire shape of the model and select a point on the apparent edge of his or her form. If the point you choose is relatively high on the body, place the crayon at a relatively high point on the paper. Imagine that the crayon point is resting on the model instead of on the page. Follow the edge of the model's form, moving your eye and the crayon in unison while looking *only* at the model

(Figure 2-5). You will be able to register the slightest bumps in the outline by drawing slowly and carefully. The proverb that art, like nature, cannot be rushed is especially true of the outline drawing. It may require ten to fifteen minutes to complete.

It is possible to draw the outline in one continuous line except for negative spaces, such as between the arm and the trunk or between the legs of the model. These will appear as islands of closed (negative) forms within the larger shape. To draw them, you have to repeat the first step by selecting a new point of contact. Make sure to situate your crayon on the drawing at the same relative position as the point observed on the model: otherwise the drawn negative shape may not appear to be a part of the silhouette. After you initially place the crayon on the paper, avoid looking at the paper as you draw. The beginning art student is often more aware of the reality of the paper than of the model. By stressing observation of the model this exercise may help the student come to an equal awareness of the model and the drawing page.

2-5. Drawing the outline with a felt marker on a newsprint pad. The student on the left is effectively transcribing the outline of the model. She is also committing the common error of drawing over her shoulder, making the drawing procedure unnecessarily tiring and at the same time somewhat restricting her view of the model. The problem is easily solved by shifting the easel to the left so that the model appears to the right of the drawing pad.

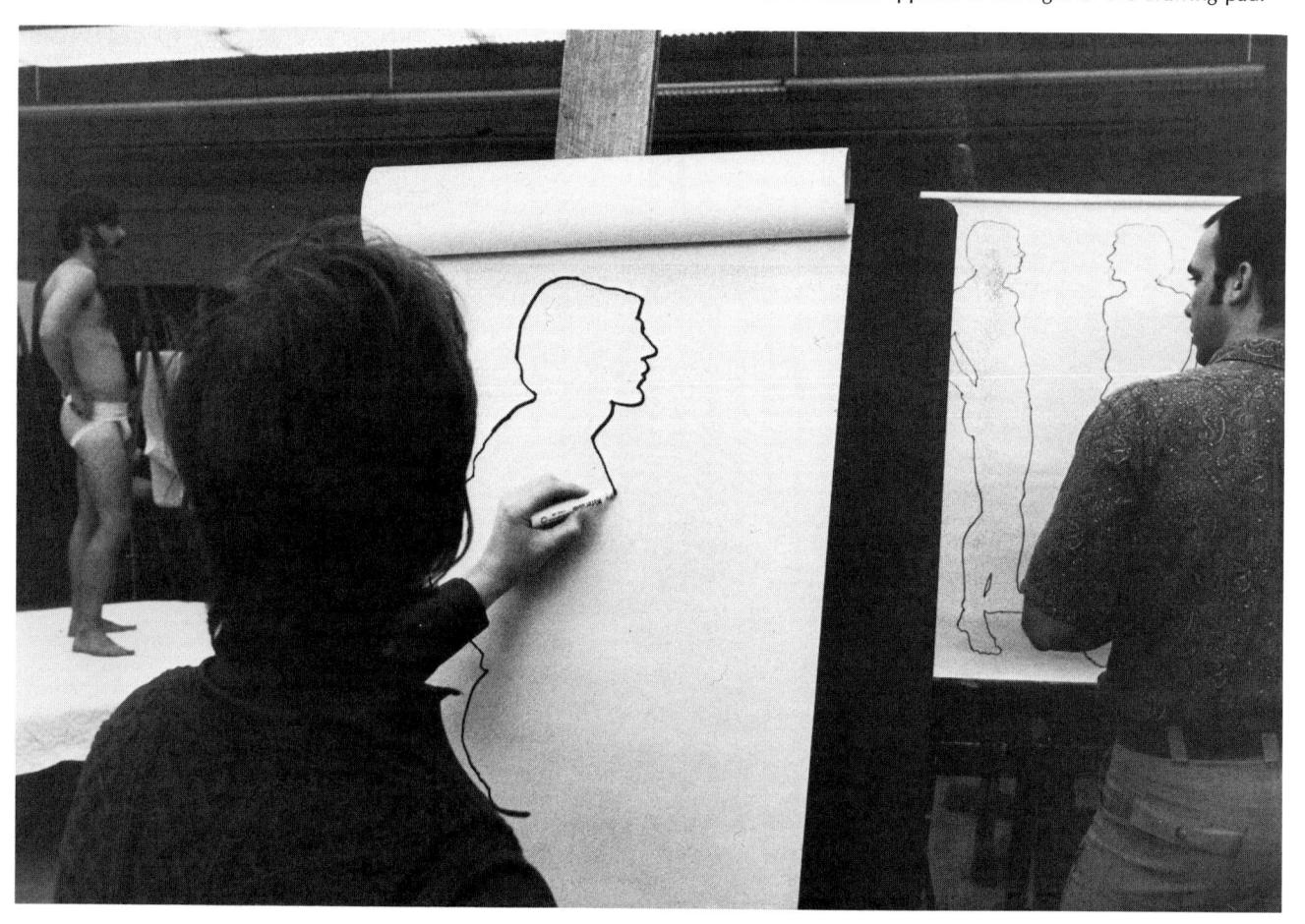

The primary aim of this exercise is to develop a sensitive, animated line based on observed form (Figures 2-6 and 2-7). Accuracy of proportion, while desirable in some drawings, is not a universal standard, nor is it the objective here. You should not feel discouraged with the results, however disproportionate, of your first outline drawing.

In drawing the outline you should concentrate on the edge of the silhouette, just as you did with the drawing of the circle. Continuing the analogy with the circle, draw the silhouette again, this time with the center of the form as the area of focus. In accordance with the second concept of form draw a dark inner form, which, by its contrast with the white page, will generate an exterior linear effect.

2-6. Student drawing, two outline studies of the same model. Felt pen on newsprint pad. $36'' \times 24''$. Negative spaces in an outline drawing tend to appear as isolated shapes.

2-7. Student drawing, superimposed outline studies. Crayon on newsprint pad. $36^{\prime\prime} \times 24^{\prime\prime}$.

STUDY 3. THE SILHOUETTE

Materials: 36"-x-24" newsprint drawing pad

easel or straight-back chair Masonite or plywood board and

clamps

drawing crayon

Reference: mo

model

Suggested time: 10–15 minutes

In nature the silhouette is essentially a flat shape, determined by the three-dimensional form of the body. In drawing the silhouette it is helpful to consider the underlaying formal structure that gives rise to the sharp edge, or outline. One way of approaching body structure is to imagine central cores that lie roughly midway between the outer edges of the model's body forms. Such imaginary cores can be estimated visually and drawn as median lines running through the longitudinal centers (axes) of body forms. The median lines bend in accordance with the general turn of the form rather than with the specific curves of the outer edge, temporarily freeing the artist from the detailed visual information conveyed by the outline.

2-8. Student building up the form of the figure from the center out. Crayon on newsprint pad. $36'' \times 24''$.

Once they are visualized, median lines provide an excellent means of beginning the silhouette drawing, which can then be developed outward from the core. Since a median line is only a rough estimate of the form's core, it can be rendered broadly with the flat side of the crayon. The dark tone of the silhouette itself can be built up by moving the crayon sideways right and left over the paper. If the crayon is new, it should be rounded off at the end to avoid drawing a sharp linear edge along with the tone.

You can establish a suitable size for the drawing in its early stages by allowing the crayon to wander rapidly and freely over the entire length of the form, using large, swinging strokes of the arm and keeping the crayon on the paper. Freedom of arm movement can give your drawing a quality of breadth and spontaneity. By keeping your eyes on the model rather than on the paper freer arm movement and a more spontaneous drawing quality may result (Figure 2-8).

Free arm movements can also assist you in controlling the scale of the figure. Some beginning art students tend to draw the figure very small in relation to the format of the paper. This would be of no concern if it were done intentionally, but frequently it is not. It seems to be caused by a lack of control over the scale of the drawing. Sometimes the reason for

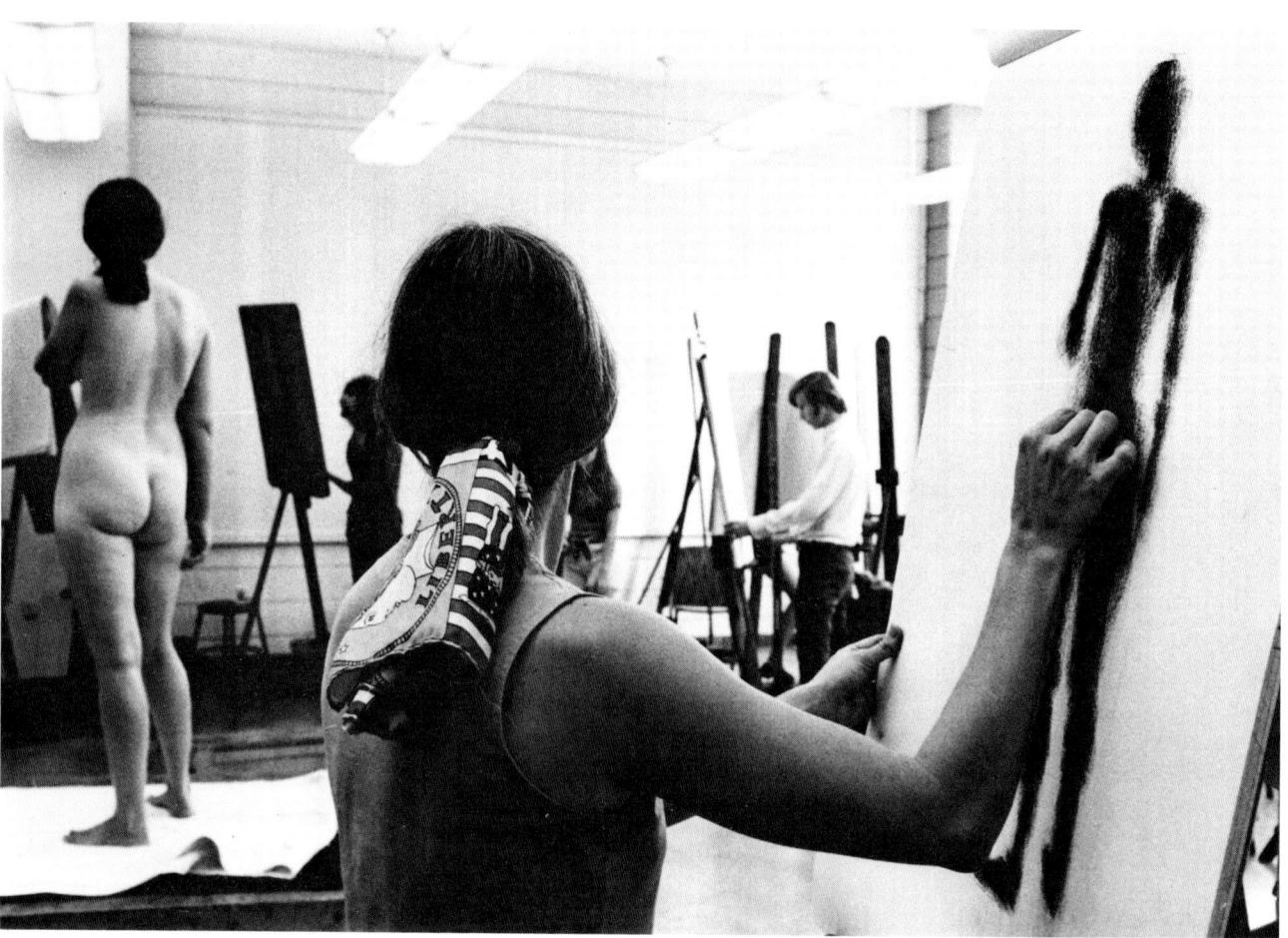

this problem is found in the way the student holds the crayon. If it is grasped like a pencil, the hand tends to move it in small, push-pull strokes similar to those used for handwriting. Such restricted movements can give rise to small, stiff drawings, as the drawing is a direct result of the motion of the crayon. By holding the crayon with the thumb and fingers so that the side of the crayon touches the paper (Figure 2-9) you are forced to move it with the arm in characteristically larger movements. As a further aid in controlling the scale of the figure you can try to estimate the desired size of the drawing at an early stage of development. One way of doing this is to make light marks at the top and bottom of the paper to indicate the intended size of the figure. While you are drawing, use the marks to gauge your success in controlling the scale of the figure.

Moving the crayon constantly back and forth, continue the drawing by building outward from the median or core lines (Figure 2-9). With this method the form develops in somewhat the same manner as sculpture modeled in clay. Like a clay sculpture, the silhouette will appear to grow as dark mass is added to the general shape of the figure, until at last the full silhouette appears (Figure 2-10).

It is essential in this study to see the bodily form in terms of the imaginary axes mentioned earlier. This draws your attention away from the visual edges of the figure toward the form as a whole so that contour edges are not isolated linear features but part of the boundary of the perceived form. If a shape is drawn in this way, the linear edge per se becomes less important than the unit of perceived form that it helps define. In this study it is significant that the linear edge of the drawn silhouette develops last.

At first the student's capacity to perceive forms as a whole may be limited to the smaller, more familiar units of body structure, such as the thigh, the lower leg, the forearm, and the upper arm. This is quite natural. Most people are conditioned through such activities as reading to see only very small units as complete shapes and to exclude larger visual forms from consciousness, even though they are within the visual field. For example, it is virtually impossible to read this page if you perceive the entire block of type as a unit of form. All but a few words are usually excluded in the visual process of reading. To be sure, smaller formal units are visually important in themselves, but unless they are perceived as parts of the larger context of the body, the resulting drawing may likewise be conceived in terms of unrelated, segmented forms, giving the figure an unintended puppetlike appearance.

2-9. Student's drawing page with the silhouette figure at various stages of development. The darker central passages represent general median lines in the figure.

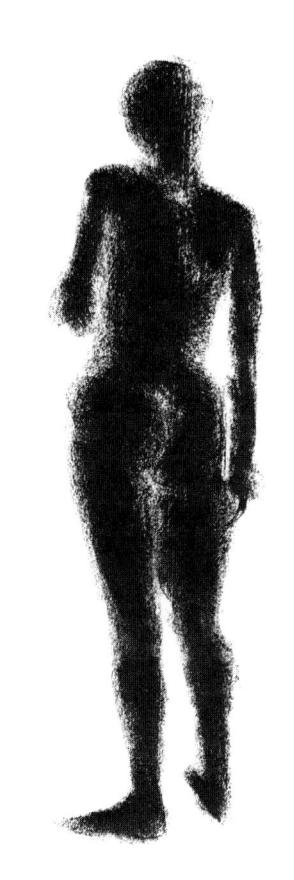

2-10. Student drawing, silhouette. Crayon on newsprint pad. 36" × 24". The somewhat tentative quality of the silhouette edge results from a careful buildup of tone corresponding to the overall configuration of the model.

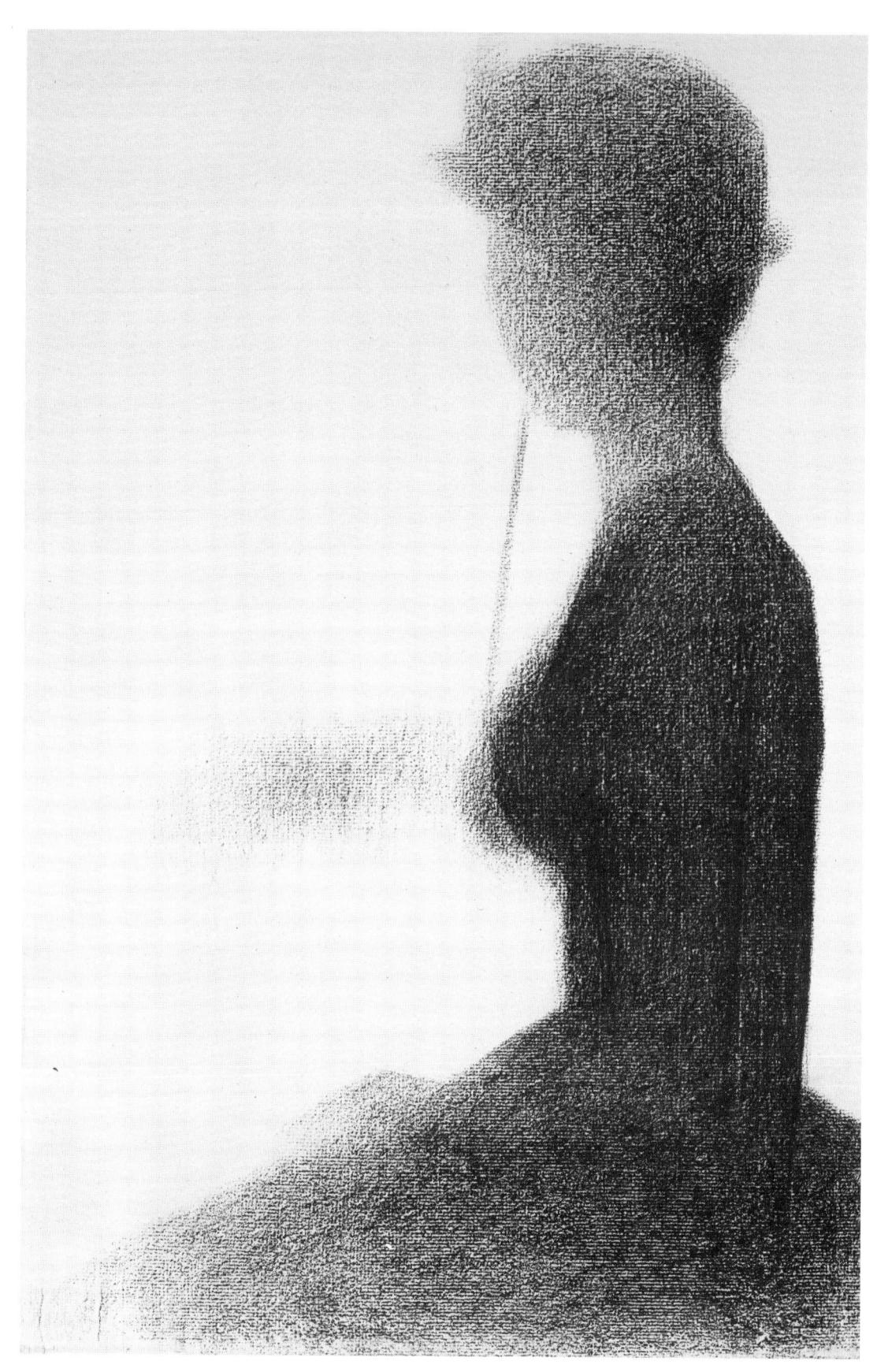

2-11. Georges Seurat, Seated Woman, c. 1884. Conté crayon. 1876" × 1236". New York, Museum of Modern Art. Abby Aldrich Rockefeller Bequest. The subtle changes of value in this drawing convey far more visual information than is seen in a simple silhouette. Such subtleties are subordinate, however, to Seurat's overriding concern with the large form of the figure.

The main purpose of this study is to help overcome any difficulty you may have in relating the smaller, more easily perceived units of form to the totality of the figure. By intentionally looking for the largest units of form while drawing, you will experience a gradual expansion of your perceptual scope so that ultimately you can "have the whole figure you want to draw in your eye and mind." 1

SUMMARY

To a certain extent drawing is a circular process. The experienced artist has a clear idea of form in mind and knows in advance what to look for in the model. As an aid to the less experienced artist specific concepts of form are incorporated into the exercises in this chapter and in the chapters that follow. By practicing the exercises you will internalize the underlying concepts and thereby enlarge the circle of your drawing experience. It is important to remember, however, that different drawing concepts are often combined in one drawing: they are rarely found in the "pure" state presented in the preceding two exercises.

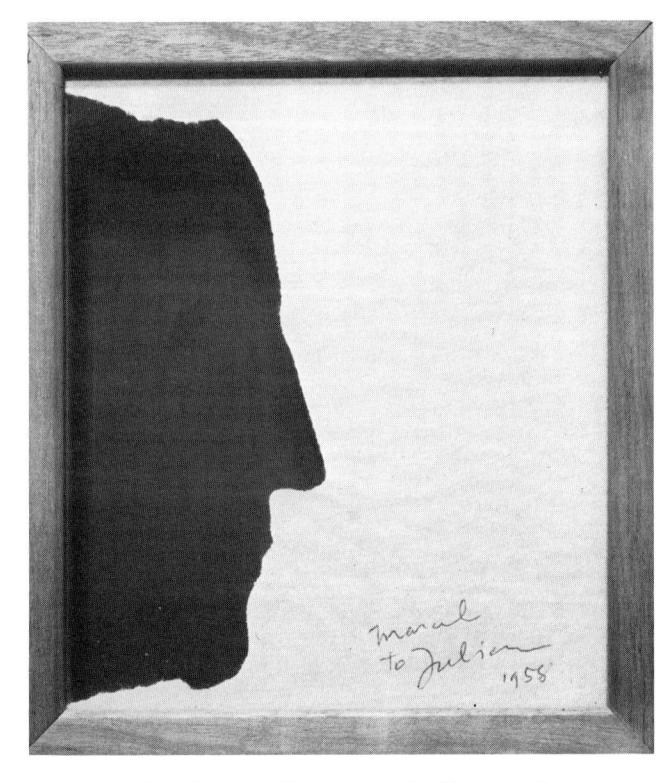

2-12. Marcel Duchamp, Self-portrait in Profile, 1958. Torn paper. 55%" × 47%". Julien Levy collection. (Photograph by Nathan Rabin.) Duchamp simply tore away part of a piece of white paper to create the shape of the profile. A darker surface beneath the paper creates the silhouette effect. Although an empty space is normally seen as a negative shape, here it is perceived as the positive shape of the head. The figure-ground reversal, also common in 19th-century silhouettes, is enhanced by the unusual physical separation of the white paper from the dark surface.

Even though pure silhouettes and outlines are rare in art, they are appealing to the contemporary sensibility, as evidenced in certain drawings of modern masters (Figures 2-11 and 2-12). Paul Klee, the twentieth-century Swiss artist, once wrote, "Graphic imagery being confined to outlines has a fairy-like quality and at the same time can achieve great precision."² This special quality may be due in part to the very low information yield of the silhouette or outline. The visual edge of the human form tells us little about the round three-dimensionality of the body: it is little more than a cross section of the figure. The deliberately incomplete description of form conveved by the silhouette or outline calls upon the imagination of the viewer to complete it, thus inducing a higher level of personal participation than that experienced with many drawings that are formally more developed.

Though they are based on the same large shape of the figure, silhouette and outline drawings present conceptually opposite constructs. With the outline the artist draws the edge of the form first. The quality of the line used to define the edge tends to dominate the drawing, which is essentially a linear enclosure. With the silhouette, however, the artist works from the inside core of the form outward. Linear edge, if it appears at all, appears last. The silhouette is associated with form in terms of mass and interior structure, while the outline is related to the exterior edge of form, the boundary separating the figure from the ground. The two concepts represent basically different ways of looking at form and as such underlie a number of drawing methods that are considered later in this book.

3. DRAWING IN LINE:

Contour, Constructs, Visual Measurement, and Movement

. . . the contour ought to round itself off and so terminate as to suggest the presence of other parts behind it also, and disclose even what it hides.—Pliny

CONTOUR

Many artists make a distinction between contour and outline. The distinction is a subtle one often glossed over in dictionary definitions, but it is nevertheless implied in the derivations of the words. The word "contour" is derived from the Latin con ("with") and tornare ("to turn"), hence its meaning: a line that appears to turn with the form to which it pertains. A naturally occurring contour such as a fold or crease of the skin pertains to the form of the body and is therefore three-dimensional in character. A line drawn on a flat surface can convey a powerful sense of the three-dimensional contour, and it is this type of line that artists commonly designate as contour (Figure 3-1). The drawn contour, as Pliny accurately observed, can also effectively suggest the continuity of volumetric form beyond the visible edge of the object observed. This is not the case with an outline, which is literally an outer line that limits the shape of the silhouette (Figure 3-2). An outline tells us almost nothing of the volumes that lie within its edges: it is essentially flat.

The distinction between outline and contour is clarified in the familiar globe model of the earth. The outline of the globe is simply the circular outer shape, which is clearly visible when the globe is seen in silhouette (for example, in front of a window). Contours of the globe are represented by the lines of latitude, which appear to curve and turn around

the spherical surface before disappearing at the edge (or outline). By spinning the globe you can visualize many additional contours. The motion of any point on the globe's surface describes one contour, which results from the actual turning. Moreover, such contour lines turn around an axis, the North-South axis.

Contours of the human body also appear to turn around the form, and, although body forms are more complex than the spherical form of the globe, body contours can usually be visualized around imaginary axes, or cores, as discussed in chapter 2. Just as a point on the spinning globe describes a contour in space, so can the point of a drawing instrument describe a contour of the body, although it is somewhat altered by the dictates of the flat surface.

The artist's contour drawings are generally less schematic than those of the globe but no less interesting, for they are related to the sensuous experience of touch. To an even greater degree than the outline drawing the contour drawing evokes the tactile sense. This may be due to the close affinity of the contour to the tactile experiences of childhood: "Since the child begins to learn how to identify objects by handling them and running his fingers round their edges, it is natural that this pattern of touch should become associated with the contour of the object perceived visually." The child associates the contour with touch and vision in a natural, un-self-conscious way. The application of this principle to your first contour drawing must necessarily be more deliberate. With practice, however, the coordination of your vision with your sense of touch will become second nature.

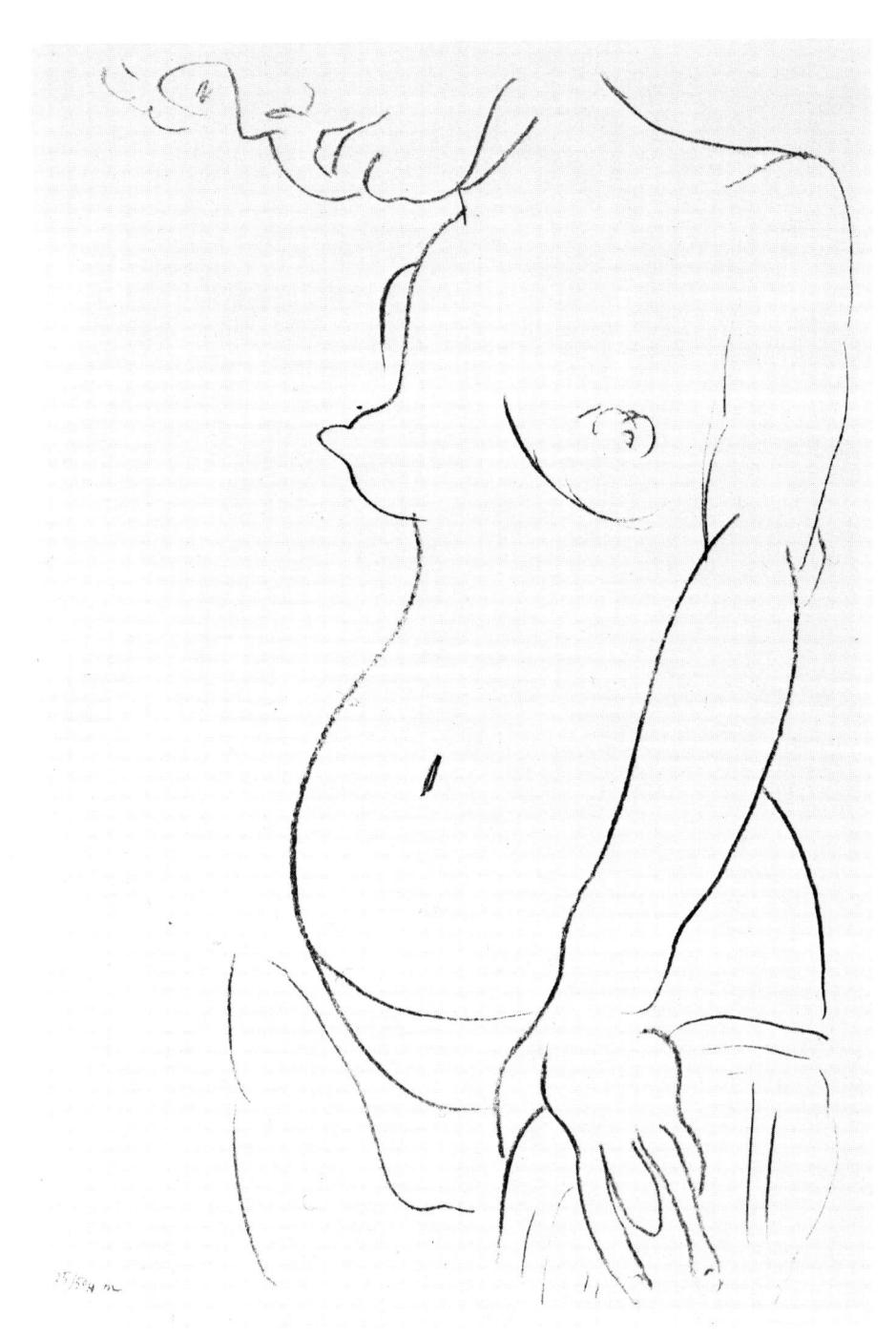

3-1. Henri Matisse, *Nude*, *Face Partly Showing*, 1914. Lithograph. 1934" × 12". New York, Museum of Modern Art. Frank Crowninshield Fund. Contour line endows this work with a suggestion of roundness and implies a complex sequence of forms with a remarkable economy of means.

3-2. Outline reduction of figure 3-1. Outline, by eliminating overlapping contours, deprives the viewer of a means of interpreting the sequence of forms in space.

STUDY 4. CONTOUR DRAWING

Materials: 36"-x-24" newsprint drawing pad

easel or straight-back chair Masonite or plywood board with

clamps

drawing crayon or felt-tip pen

Reference:

model

30 minutes Suggested time:

You should observe the entire form of the model carefully before beginning a contour drawing. Actually walk around the model to gain an idea of the disposition of the form in space. After you return to your easel, select a point somewhere on the outer edge of the model's form. Place your crayon on the drawing paper, imagining as you do so that the point your crayon touches is the same point that you see on the model. It is important to imagine that you are actually touching the model, for in this way you can benefit from simulating the child's learning process. Instead of actually touching the model, as a child might do, you are using your eye as an extension of your sense of touch. Keeping this in mind, slowly draw the crayon across the paper while you simultaneously follow the model's contour, with your eye and hand in close coordination. When the contour on the model changes direction, your hand should also change direction. As you extend the contour line, you may notice that, though it originates from the edge (or outline) of the form, it does not necessarily remain along the edge. The contour line probably turns inward on the form, at the same time curving around the volume of the figure. As with drawing the outline, you should not break your concentration by glancing back at the page while you are drawing (Figure 3-3).

When you can no longer see the progression of the contour on the model, stop for a moment to regain your bearings. Lift the crayon and go back to the point on the drawing at which the contour departs from the outline. With the crayon placed on that point, relocate the corresponding point on the form of the model before drawing the next contour. The second contour will probably also turn inward from the outline. When you are unable to see this contour clearly enough to follow it further, stop again and repeat the process. With practice you will soon be able to follow contours far inside the outline shape of the figure.

Wrinkles or creases in the skin may offer the clearest visible clues to the contours of the body. They are often noticeable in those portions of the body that bend, such as the waist or the joints of the limbs. If a crease line lies near the apparent outline of the figure, the contour may appear to turn sharply as it nears the outer limit of the silhouette. Contours of

this type should be observed and drawn carefully, as they convey a great deal of visual information about the rounded volume of the form. Contour drawing need not be limited to representing such obvious linear features of the human form as wrinkles. Less clearly linear forms, such as muscle and bone patterns, can also be represented by means of the contour line.

The nature of contour drawing makes it advantageous to work from a standing position, for the slight shifts of viewpoint that occur quite naturally as a result of standing enable you to see slightly beyond each side of the model and to follow contours further around the figure, both in life and in the drawing. This flexibility is inhibited in the sitting position. The standing position also facilitates free arm movement, which is essential to a spontaneous line quality, since line itself is in a sense a trace of movement.

If the model is illuminated by a strongly directional light (i.e., a floodlamp), the boundaries between illuminated and shadowed surfaces on the model may appear as linear contours. For the purposes of this study such shadow contours should not be drawn. Shadow contours, though useful in certain drawing techniques, are more related to the quality of light than to the *character* of the form, which is the primary concern in this exercise.

Since this method of contour drawing depends heavily on careful observation, it is better to proceed slowly and carefully by deliberately restricting your gaze to the contours of the body that you are drawing. In this way the lines you draw will have a quality of visual unity, no matter how erratic they may appear. A figure composed of contour lines will gradually emerge (Figures 3-4 and 3-5), which will convey a sense not only of turning form but also of formal sequence, for the way in which each contour joins the next suggests overlapping (compare Figure 1-4 with Figure 3-1). Another method of contour drawing involves rapid eye movements and results in a greater sense of the unity of the body as a whole.

VISION AND EYE MOVEMENT

Before attempting a contour drawing utilizing rapid eye movement it is worth examining briefly how such movement is related to the process of visual perception. Under normal circumstances the eye moves constantly, even when you look at a single object. The movement is not smooth, however: the eye scans in neat jumps from one point to another two or three times per second.² Each movement, called a saccade by physiologists, terminates with a fixation, during which the eye remains stationary for a short time while it records detailed visual information by means of the fovea.3

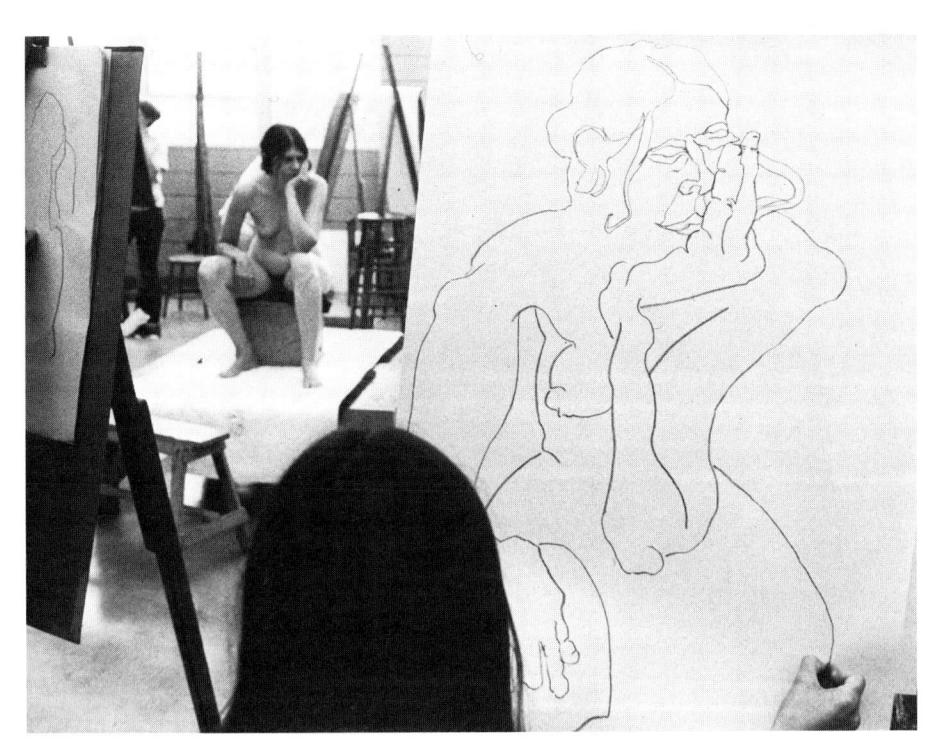

3-3. Student drawing. Crayon on newsprint pad. 36" × 24". The sensitive and bold contour treatment of the figure is somewhat marred by the relatively fussy drawing of the head. It is evident that the student looked at the paper while drawing that part of the model. Consistency of method ensures consistency of style.

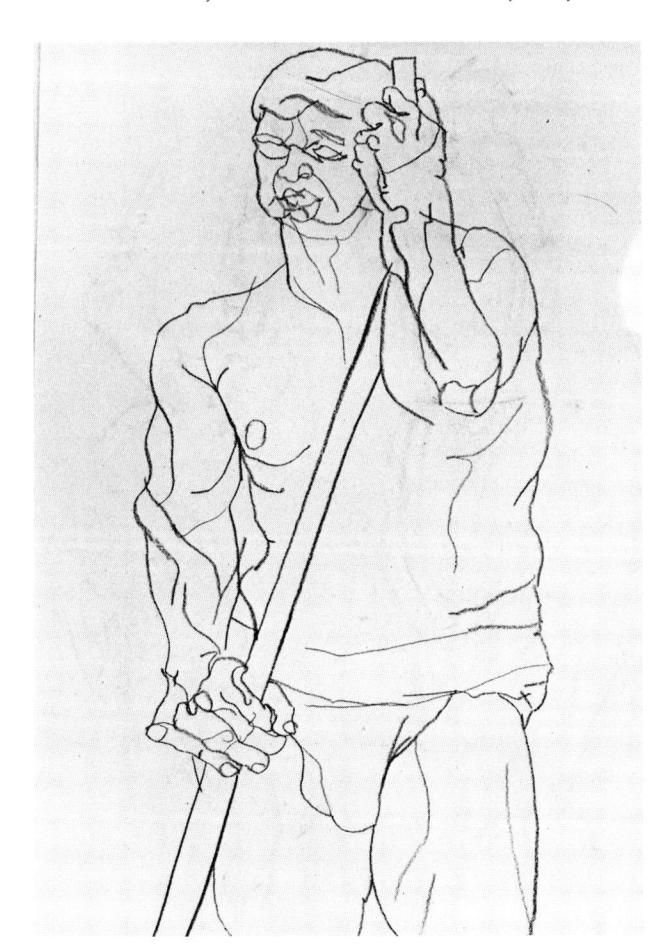

3-4. Student drawing, contour study of the figure. Crayon on newsprint pad. $36^{\prime\prime}\times24^{\prime\prime}.$

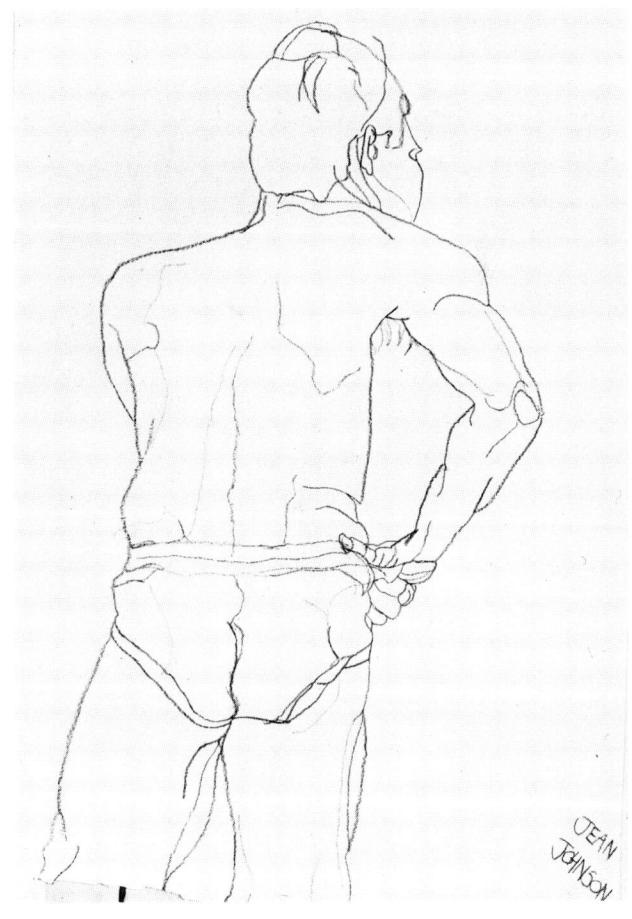

3-5. Student drawing, contour study of the figure seen from the back. Crayon on newsprint pad. $36'' \times 24''$.

It is of particular relevance to drawing that the eye, as it moves and gathers information, seems at times to fix on points along the contours of forms (Figures 3-6 and 3-7). From this visual information the brain constructs a mental model of the object. Exactly how the brain constructs this model and perceives it is one of the mysteries of science: to understand it fully would require an explanation of consciousness. Yet it is believed that what is consciously perceived is the model, not the retinal image: that is, the continuously moving eye supplies the brain with visual information, but the eye itself does not see—the brain does. This modern concept of vision suggests a contourdrawing exercise designed to take full advantage of natural rapid eye movement.

3-6. Unknown Egyptian artist, Head of a Queen from El Amarna, Egypt, c. 1370 B.C. Sandstone. 85% high. Berlin, Staatliche Museen.

3-7. Dr. Alfred L. Yarbus, Record of eye movements during free examination of a photograph of the sculptured Head of a Queen [Figure 3-6] for 2 minutes. The photographic recording was made by means of a small mirror attached to the eyeball. Darker spots on the trails indicate fixations, or short pauses in the eye movement during which visual information is gathered. Although the trails of eye movement do not follow the contours of the head (Figure 3-6) precisely, nevertheless they suggest an as yet unexplained relationship between eye movement and drawing. (Photographs courtesy of Dr. Alfred L. Yarbus, Institute for Problems of Information Transmission, Academy of Sciences of the USSR.)

STUDY 5. RAPID CONTOUR DRAWING

Materials: 36"-x-24" newsprint drawing pad

easel or straight-back chair Masonite or plywood board and

clamps

drawing crayon

Reference: model
Suggested time: 1–3 minutes

The starting position of the crayon on the drawing paper does not matter in this exercise, but it is vitally important to allow your eye to freely scan the entire length and breadth of the model as you draw and to avoid concentrating on small body features. The crayon should move continuously and in unison with the eye as much as possible. This does not permit you to look back at the drawing pad, for it would spoil the continuity of your eye movement, forcing an interruption not only in the movement of your hand but also in the unified development of the drawing. The crayon, keeping pace with the eye, will leave many trails that eventually will develop into a wiry structure clearly related to the general contours and attitude of the model (Figures 3-8, 3-9, 3-10, and 3-11). Remember that, as in the slow contour drawing (study 4), a great many contours do not lie on the edge of the form. They may rather wrap around the volumes located between the outside edges of the

With the same basic drawing concept in mind, you can also create contour drawings with a brush. The technique of the brush as a drawing instrument, is so different, however, that it is advisable to employ it in a separate study.

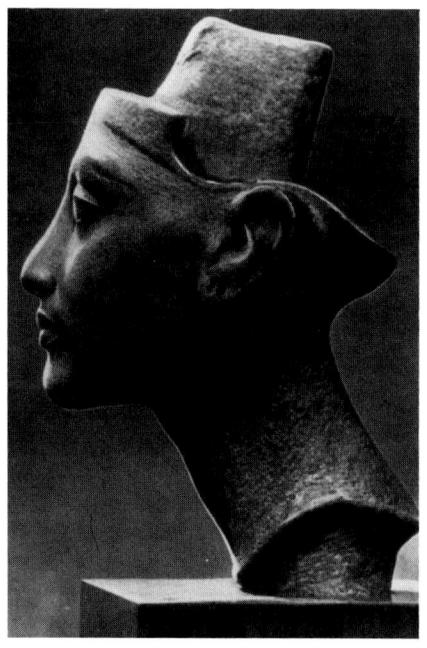

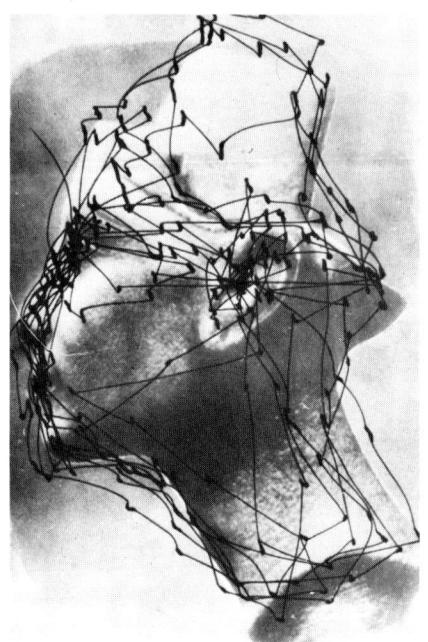

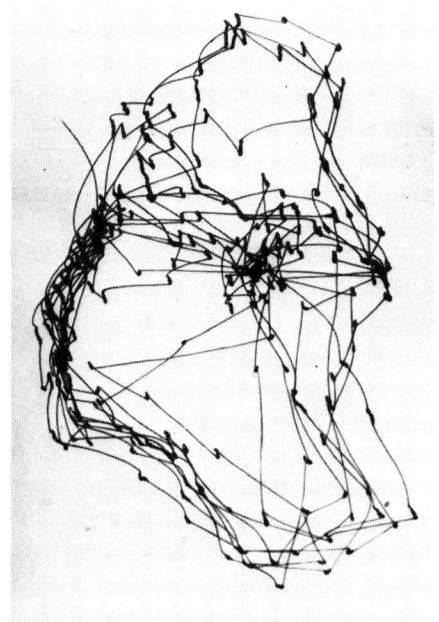

3-6.

3-7.

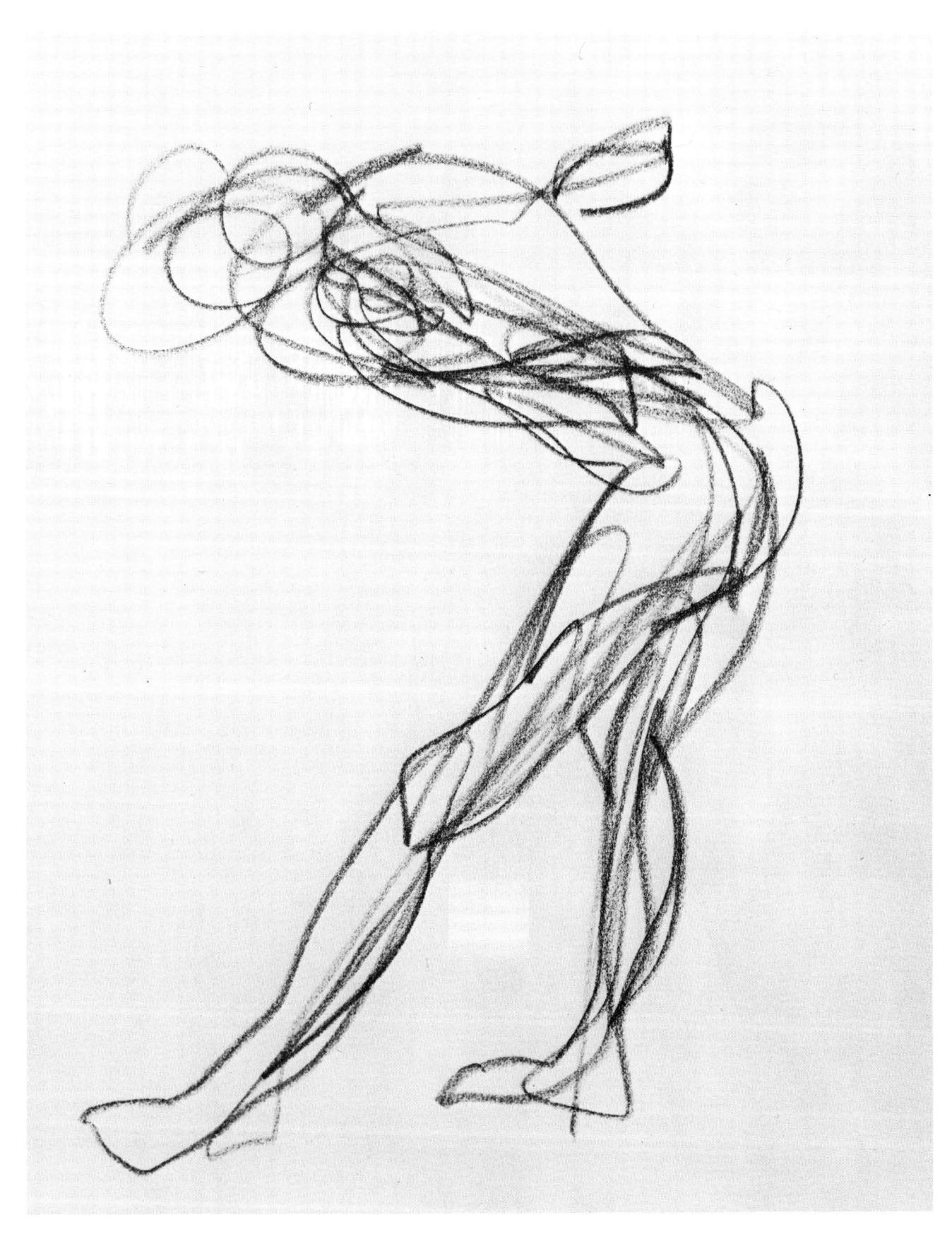

3-8. Student drawing, rapid contour study. Crayon on newsprint pad. $36'' \times 24''$.

3-9. Student drawing, rapid contour study. Crayon on newsprint pad. $36'' \times 24''$.

3-10. Student drawing, rapid contour study. Crayon on newsprint pad. $36^{\prime\prime} \times 24^{\prime\prime}$. Holding the crayon on its side results in a greater tonal effect with contour line.

3-11. Jacopo Robusti, called il Tintoretto (1518–1594), San Giovannino. Crayon. Florence, Galleria degli Uffizi. (Courtesy of Fratelli Alinari.)

STUDY 6. RAPID CONTOUR DRAWING WITH THE BRUSH

36"-x-24" newsprint pad (or **Materials:**

watercolor paper in a large size if expense is no problem)

table or desk

Japanese bamboo-handled brush, size 6 or larger

mason jar half filled with water small jar of india ink or tube of

watercolor black

saucer to hold black washes

model

Reference: Suggested time: 1-3 minutes

Squeeze out a small amount of black pigment into the saucer and dip the brush in the water. Use the wet brush to dilute some of the pigment until a black wash appears in the saucer. Load the brush moderately with the wash and you are ready to draw. The drawing procedure is essentially the same as in the preceding rapid contour study. If this is your first attempt to draw with a brush, however, you may need to learn how to hold it.

In order to experience the unique freedom of movement possible with the brush, try holding it in the oriental manner, near the top of the shaft between the thumb and the middle joint of the first finger (Figure 3-12). It should be held almost vertically, with the drawing pad flat on a table. This arrangement enables you to draw both with the large, swinging motions of the arm and wrist and with the finer movements of the fingers. Under no circumstances should your hand or arm rest on the paper or table: this would limit your motion.

Held high on the shaft, the brush registers even the slightest movements of the fingers. In fact, it seems to magnify such movements. So assertive of movement is the line quality of brush drawings that it tends to dominate other aspects of the drawing. This allows great spontaneity of effect, but you may find that control of form is rendered more difficult. This may be due to the fact that the sensation of touch and contact with the drawing surface is minimal. Considerable practice may be necessary to get the feel of the brush (Figure 3-13). The special qualities of brush drawing, however, make the effort worthwhile. These qualities are often apparent in the calligraphy of the Far East, where brush drawing and writing are closely related expressions (Figures 3-14 and 3-15), as well as in the more familiar master drawings (Figures 3-16 and 3-17).

Some art students may feel that the results produced by the contour method lack finish of execution. Such a reaction is understandable. You are accustomed to seeing drawings that are designed to communicate information in an instantly comprehensible way. Often the information to be conveyed has little to do with art but requires a detailed rendering—a highly finished drawing—to make it clear. Such finish is wholly inappropriate for many types of drawing, particularly rapid contour drawing or preparatory drawing for works of art in other media. What matters here is the quality rather than the quantity of visual information. Even for purposes of exhibition a drawing that communicates the intended effect is "complete," regardless of its degree of finish. Moreover, lack of finish in a work of art has long been appreciated as an expressive quality in its own right. Pliny informs us that certain "unfinished" paintings by Aristides and Apelles, important painters of ancient Greece, "are more admired than those which they finished, because in them are seen the preliminary drawings left visible and the artist's actual thoughts...."5

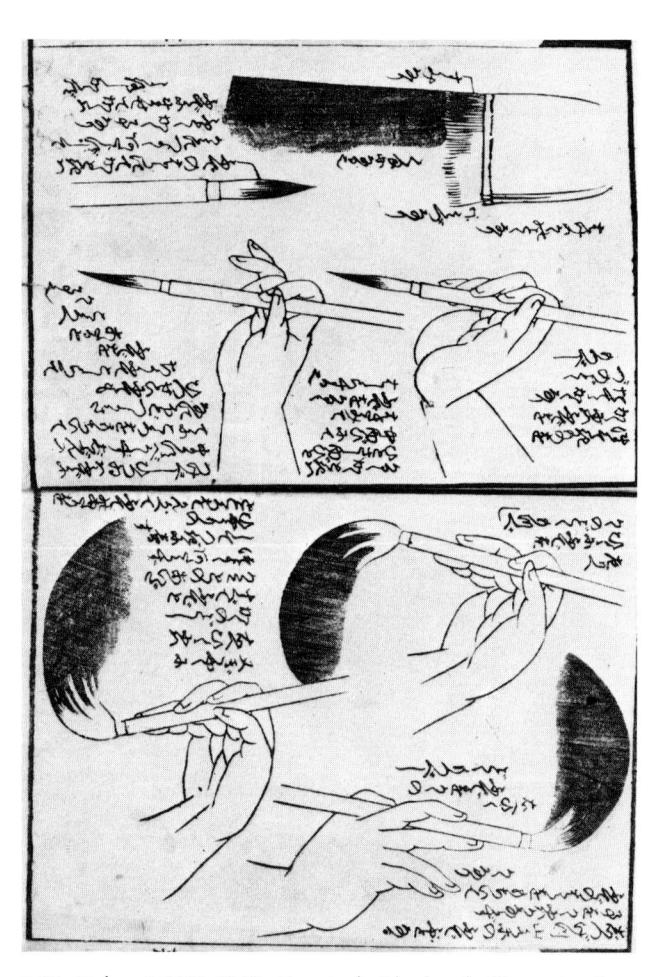

3-12. Hokusai (1760-1849), How to hold a brush. Illustration from Rajakuga Haya Oshie, vol. 2. Woodblock print. Boston, Museum of Fine Arts. Gift of William Sturgis Bigelow. Holding the brush at mid-length or above is helpful in creating free movement of

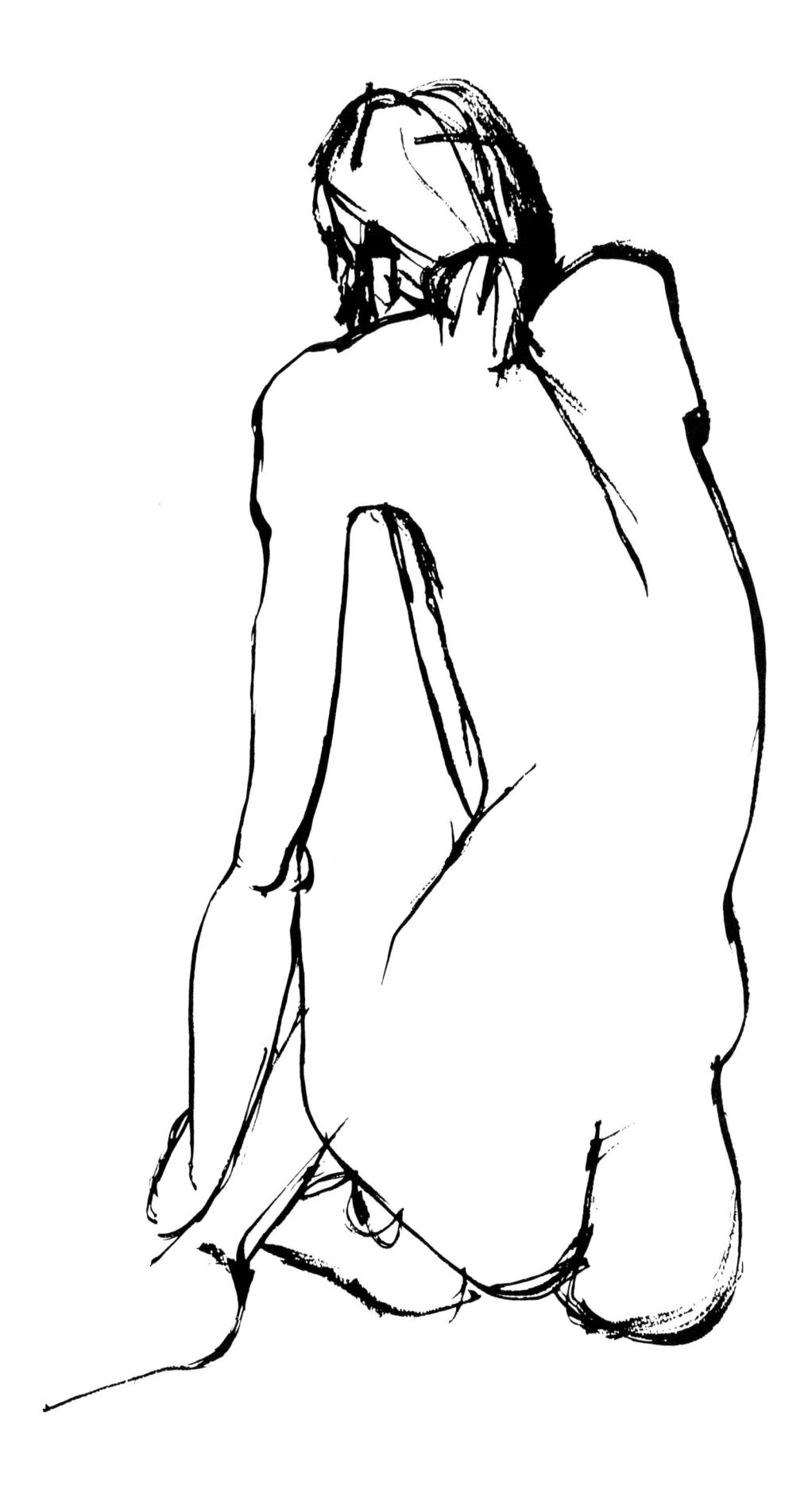

3-13. Student drawing, contour study. Brush and ink on newsprint pad. $36^{\prime\prime}\times24^{\prime\prime}.$

DUNWOODY

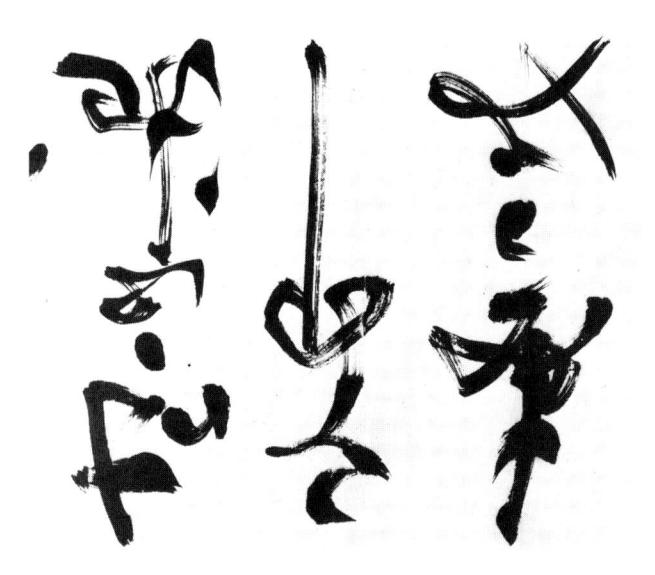

3-14. Calligraphy. Section of a poem by Chu Yun-ming (1460–1526), Ming Dynasty. Hand scroll, ink on paper. $18'' \times 624\%''$. Princeton University Art Museum.

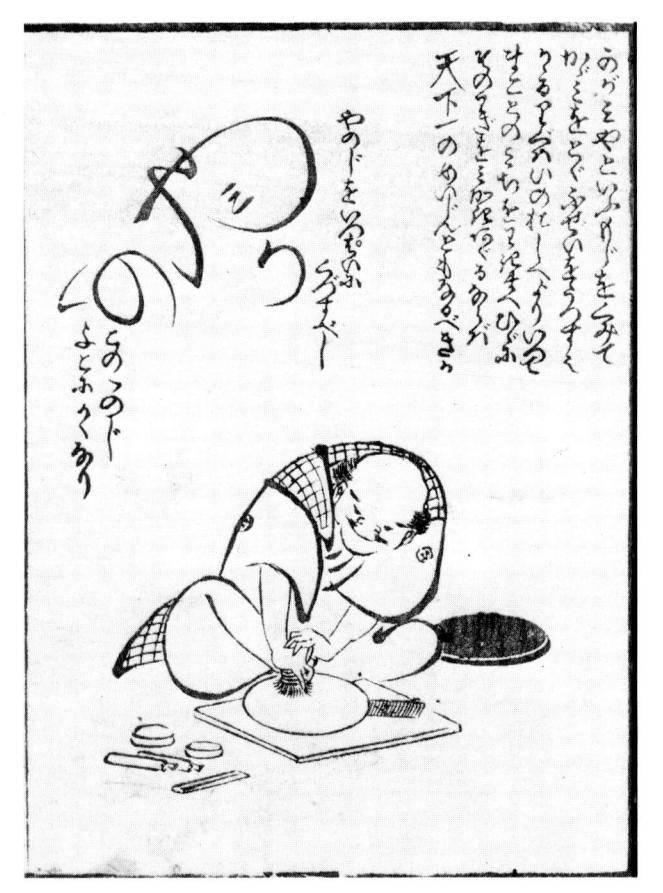

3-15. Hokusai, *The Mirror Polisher*. Illustration from *Rajakuga Haya Oshie*, vol. 2. Woodblock engraving from a brush drawing. 16 × 11.25 cm. Boston, Museum of Fine Arts. The abstract cursive forms in the upper left are a calligraphic reduction of the figure of the mirror polisher, illustrating the affinity between writing and drawing in the oriental tradition.

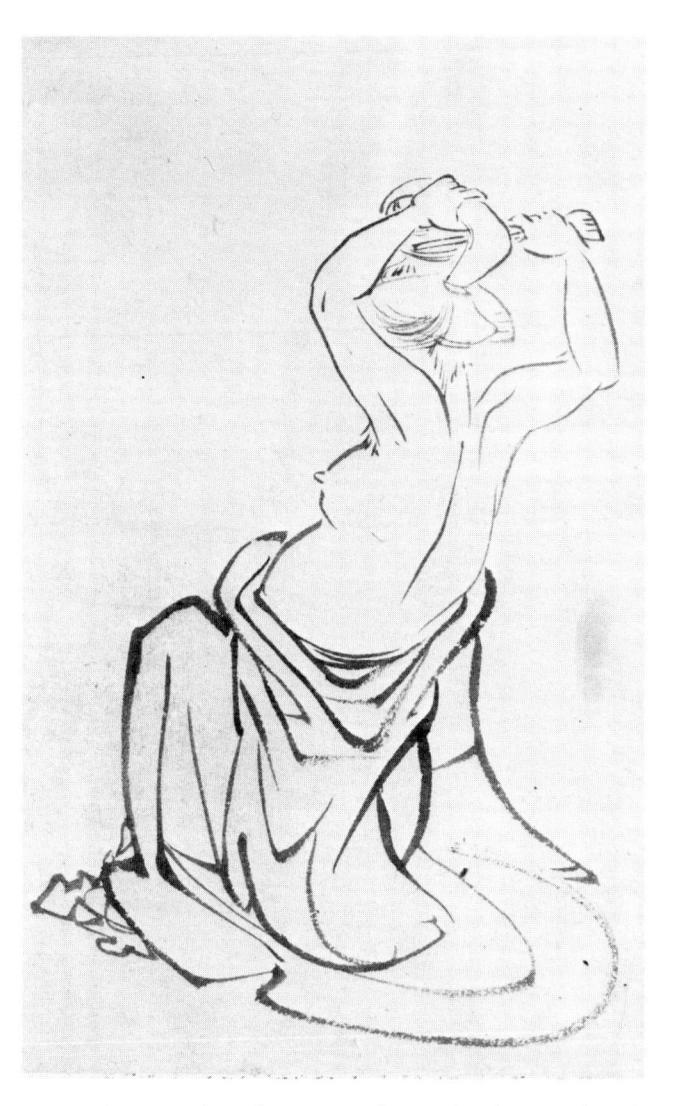

3-16. Hokusai, Studies of a woman adjusting her hair. Brush and ink. $10\%'' \times 6\%''$. New York, Metropolitan Museum of Art. Gift in memory of Charles Stewart Smith, 1914.

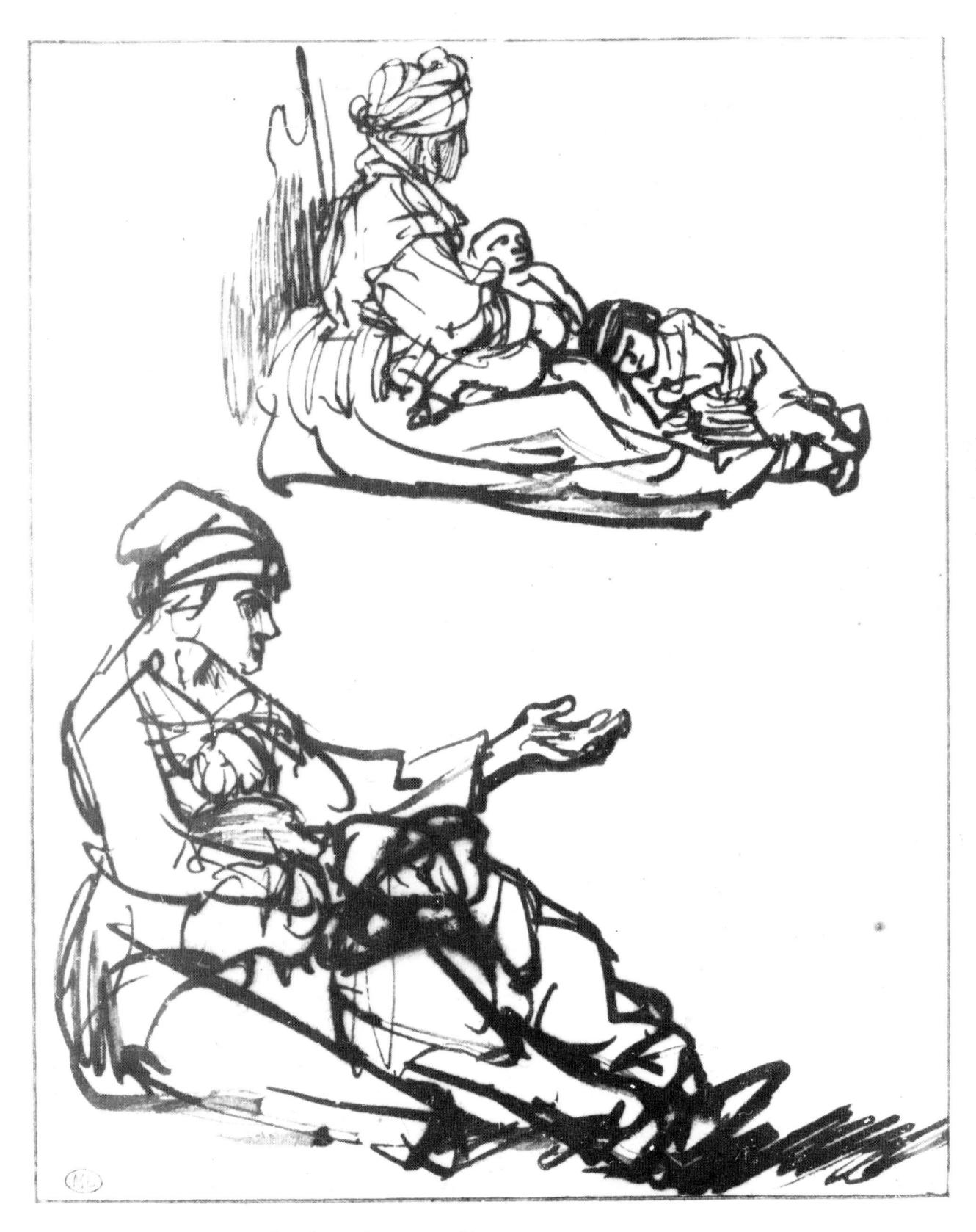

3-17. Rembrandt van Rijn, Two studies of a begging woman with two children, c. 1632–33. Pen and gallnut ink. $6.9'' \times 5.5''$. Paris, the Louvre.

BODY FORMS

Up to this point line has been considered as it relates to edge (outline) and to the turning surface of an observed form (contour). It can also be considered as a means of visualizing a form. Extensive knowledge of anatomy is not necessary in order to visualize the parts of the body as structural units of form—units that are also familiar as common words, such as the thigh, the calf, the hip. The following study suggests a way of drawing the figure in terms of such visual units by means of a single formal construct—the oval.

STUDY 7. THE FIGURE AS A CONSTRUCT OF SMALLER UNITS

Materials: 36"-×-24" newsprint drawing pad

easel or straight-back chair Masonite or plywood board and

clamps

drawing crayon

Reference: Suggested time: model

3-5 minutes

No more than five minutes are needed to complete this study, so you may choose to set the model in a pose of action or movement. Once the pose is set, observe body contours that appear as parts of rounded form. The calf, for example, can be interpreted as a continuous ovoid (egg) form and drawn as an oval. The same is true of the other segments of the limbs, such as the thigh. The trunk, by virtue of its skeletal construction, is most readily conceived as two general ovoid masses, one corresponding to the egg shape of the rib cage and the other enclosing the more irregular pelvic mass of the lower abdomen. Both can be further broken down into smaller components, but it is helpful to keep the two essential masses in mind. Between the two masses are the spine and abdominal muscles, which bend and change shape with the body's gesture.

Begin with a lightly drawn, rapid contour sketch of the entire figure to establish a frame of reference for placing the oval constructs. It is best to draw rapidly with this method, as it lends itself to the most generalized aspects of the figure. Even the head, with all of its subtle complexities of form, can be reduced to an oval construction. As far as possible, however, you should strive for a correspondence between the oval shape and the observed form. The oval discussed here is not the perfect and fixed form of geometry but a plastic form adaptable to the character of the formal unit observed. The character of the formal unitrather than the character of any line or individual contour—is the aim of this study (Figure 3-18). The oval is merely a convenient graphic symbol, suggested by the rounded form of many shapes of the body.

Although it is relatively easy to interpret the body forms as ovals, it may require practice to relate those forms to the whole configuration of the drawing. The oval method may at first tend to produce drawings of a somewhat doll-like, segmented character. To overcome this difficulty, begin by making a rapid contour drawing with faint crayon lines, establishing the general form of the figure, before drawing the oval constructs.

It is also possible to utilize other shapes as constructs. Artists such as Lucas Cambiaso and Dürer produced many drawings based on rectangle and box constructs. Likewise, some instructional anatomy books use the block as the basic construct of the figure.⁶ Arcimboldo, an Italian painter of the Renaissance, conceived each construct as a separate object in itself, creating what amounts to a well-told visual joke (Figure 3-19). The twentieth-century artist Conrad Marca-Relli stresses unit constructs of form in his work by adopting the medium of collage, which seems to require them (Figure 3-20). In collage the units of form are often separate pieces of paper or canvas pasted in place on the picture surface. Large

3-18. Student drawing. Crayon on newsprint paper. $36'' \times 24''$. Familiar body forms can be drawn as overlapping oval constructs that suggest spatial sequence. A similar concept of form was expressed by Hokusai (Figure 1-8).
forms tend to take on a constructed look, and overlapping form results not from an illusion, as in drawing, but from a physical overlapping of the mounted pieces. Although practically all artists use constructs to define form, Marca-Relli and Arcimboldo stress them as the main vehicle of expression.

Drawing with constructs, particularly with oval constructs, not only simplifies certain aspects of drawing from life but also makes it possible even for the beginner to draw the human figure without a model. In doing so the student is in a sense drawing from memory.

3-19. Giuseppe Arcimboldo (1527–1593), Allegorical Figure of a Cook. Pen-and-ink. Paris, L'Ecole Nationale Supérieure des Beaux-Arts. Acknowledged as a precursor of surrealism, the Italian painter Arcimboldo developed figural constructs of larger forms to represent objects symbolic of the allegorical subject. Here the constructs represent the pots, pans, and other objects associated with the subject of the allegory—the cook.

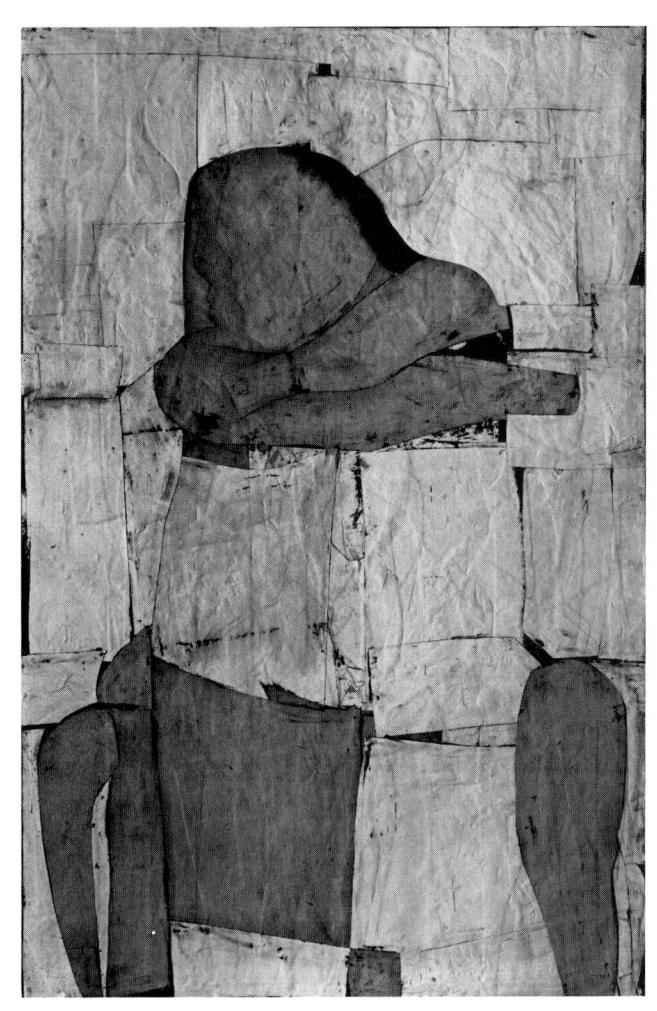

3-20. Conrad Marca-Relli, Collage, 1953–54. Paint and canvas. Art Institute of Chicago.

STUDY 8. DRAWING THE MODEL FROM MEMORY

Materials: 36"-x-24" newsprint drawing pad

easel or straight-back chair Masonite or plywood board and

clamps

drawing crayon

Reference: model

Suggested time: 5 minutes for each drawing

Once you are familiar with the method described in the preceding study, you can apply it to drawing the model from memory. Drawing from memory is much easier to do than you may imagine. In a sense you are already experienced at memory drawing, for every time that you look at the paper while you draw, you are utilizing your short-term memory to recall forms that you have just seen. This exercise makes use of short-term memory in the same way but to a greater degree.

The model should be set in a simple pose, preferably with an ordinary gesture such as bending over to tie a shoe. When the pose has been decided upon, be sure to mark the position of the feet with chalk or pieces of tape. The reason for the marks will become clear in the second phase of the study. When the pose is set, observe the model for about three minutes without drawing at all. During that time it may be helpful to walk around the model to gain a clearer sense of the disposition of body form. There are also two simple mental exercises that many students have found helpful: (1) imagine yourself performing the same gesture as the model; (2) pretend that you are drawing while you observe the model. Both exercises rely on your natural ability to recall actions. By reinforcing your visual memory they can assist you in remembering body forms as you draw them later.

As soon as the time is up, have the model step down from the stand, and you are ready to commence drawing. The drawing procedure is almost the same as that in study 7. A light indication of the gesture with a rapid contour sketch can help set up the figure, but the oval constructs constitute the final drawing. Drawing time should be limited. For best results allow a maximum time of five minutes. One advantage of the oval-construct method is that changes can be easily made while the drawing is in progress, particularly in the early stages when the constructs are still very general in nature.

When you have completed the memory study, it is instructive to make a second drawing of the same pose from life. Since the position of the feet is marked on the model stand, the model can resume the same pose for another five-minute drawing session. It is vital that the second drawing be made immediately after the first in order to resolve any problems while they are still fresh in your mind.

The importance of memory studies cannot be overstressed. Not only do they exercise the student's short-term memory, but they also develop the long-term memory of body forms and their relative sizes—knowledge that can also be used in making studies from life. One memory study per drawing session is recommended. The significance of memory in drawing is illustrated by the often overlooked fact that the great majority of all drawings are done from memory (or, if you prefer, from imagination). Constructs such as the oval serve as the basis for many of them, even though such constructs may not be visible in the finished drawings. This is as valid for Walt Disney's Mickey Mouse drawings as for classical figures on Greek vases.

Despite the importance of memory to many drawing methods, memory-drawing exercises are often omitted in art-instruction courses. This may be partly due to the western emphasis on what is considered to be empirical observation of objective reality. Whatever the reason, the omission reflects a misunderstanding of the role that memory can play in figurative art: "Visual memory differs from [visual] perception because it is based primarily on stored rather than on current information, but it involves the same kind of synthesis. Although the eyes have been called the windows of the soul, they are not so much peepholes as entry ports, supplying raw material for the constructive activity of the visual system."7 In some ways human visual memory is similar to the "memory" of the modern digital computer, which also consists of stored information, though it is exclusively numerical. A "large" computer memory is necessary to produce drawings (projections) of a complex three-dimensional form such as the human figure (Figure 3-21).

Remembering the general forms of the body can be helpful in evaluating observations of a particular form. Rodin credited his facility as a draftsman to the memory training he received as a young art student in the classes of Lecoq de Boisbaudran: "... at home in the evening, before going to bed, it was his custom to practice what Lecoq de Boisbaudran had recommended, reproducing from memory what he had studied during the day."8 Degas, though a master of drawing from life, believed that memory played a special role in the drawing process. Commenting on this role, he wrote: "It is all very well to copy what you see; it is much better to draw what you see only in memory. There is a transformation during which the imagination works in conjunction with the memory. You put down only what made an impression on you, that is to say the essential. Then your memory and your invention are freed from the dominating influence of nature. That is why pictures made by a man with a trained memory who knows thoroughly both the masters and his own craft are almost always remarkable works. . . . "9

3-21. Anthropometrically correct numerical model of a 50-percentile human male. Drawing produced on the CDC6600 computer. (Courtesy of Boeing Computer Services, Inc.) This figure was extracted from a film produced to evaluate computer-animated human movement. Composed of three-dimensional linear constructs, the figure features articulated joints (i.e., the arm and forearm) that simulate natural movements of the body.

3-22. A curve reduced to an angle. The broken lines represent a visual reduction of a curve into straight lines that intersect to form an angle.

FORM AND VISUAL MEASUREMENT

Study 8 takes advantage of your ability to perceive body forms as rounded ovoid units in space. This drawing method might be called stereometric. In order to learn how to make the fine adjustments of drawing associated with draftsmanship, however, it is necessary to practice a method of drawing that is planimetric—based on measuring the appearance of form in the optical image rather than on threedimensional form. A visual measurement of an image is the apparent distance between two features, not the actual distance in space. For example, the actual distance between a model's eyes is constant, but when the head is turned, the eyes may appear much closer. It is this apparent distance that is involved in planimetric drawing. For purposes of planimetric measurement the straight line is a more effective tool than the curved (contour) line, with its infinite variations.

The natural configurations of the human body, however, present few instances of truly straight lines. What you see instead is a complex array of curves with varying degrees of shallowness or sharpness. The guestion then arises as to how the complexities of bodily form can be reduced to shapes defined by the more easily controlled straight lines on a flat surface. One key to such visual generalization lies in the construction of the curves themselves, which as a rule are irregular in shape. The curves of the body bend more sharply in some places than they do in others. The irregularity of their curvature gives many of them an angular quality. By interpreting a contour as an angle it is possible to draw it in terms of two straight lines that intersect at the sharpest point of the contour (Figure 3-22). A method of observing and drawing such intersections is the subject of the following exercise, which is designed to focus on the problems of measurement in planimetric drawing.

STUDY 9. VISUAL MEASUREMENT OF ANGLES

Materials: 36"-x-24" newsprint drawing pad

easel or straight-back chair Masonite or plywood board and

clamps

drawing crayon (pen or pencil should not be used for this study)

Reference: model

Suggested time: 2 minutes for part 1 and 30

minutes for part 2

In this study two preliminary steps are advisable: (1) a rapid (two-minute) contour drawing of the figure to establish the placement and size of the intended drawing; (2) a vertical and a horizontal line drawn through the center of the figure as a useful reference point for your first visual measurements. These lines should be drawn as lightly as possible, since dark tones might interfere with further development of form. Very light indications can be achieved by holding the crayon on its side (Figure 3-23) and sliding it sideways across the paper. The two reference lines can be drawn by holding the crayon on its side and pulling it lengthwise across the pad. Use the edges of your drawing pad as a guide for proper vertical and horizontal alignment. You should check the alignment of your drawing pad on the easel: make sure that it is not tilting or wobbly. A clamp may help hold the drawing pad in place.

Begin the study by examining the form of the model for large contours that can also be interpreted as angles. At this point it is best to ignore smaller indentations or angles contained within the larger contours. Concentrate on visualizing the larger angles only. Isolate one angular feature and draw it by holding the crayon sideways on the paper so that it parallels the line observed on the model (Figure 3-23). Since your first visual measurement serves as a reference line for the rest of the drawing, take time and care with it. Consider carefully the direction of the line that you observe in the model. Is it vertical or horizontal? If neither, how much does it depart from the vertical or horizontal?¹⁰ After you have answered these questions, use the vertical and horizontal reference lines in your preliminary drawing as a guide for drawing the line. The crayon itself can be a useful instrument of angular measure. Hold it on its side as before so that its length parallels the line that you wish to draw.¹¹ Move it across the paper on its side to produce a line with the same direction. The second line of the angle can be drawn in the same way. The sharp, angular intersection of the two lines should represent your estimate of the contour of the model. Its accuracy (or inaccuracy) depends upon how closely the drawn lines parallel the imagined lines in the contours.

After you have drawn the first angular intersection, you can shift to another part of the figure in which

an angular effect is apparent. The light preliminary drawing should prove useful in locating the angle. Once you have placed it, repeat the process described above, taking equal care to make the lines parallel to those perceived in life. To place the second angle and all those that follow it, you can refer to the first to determine a more precise relationship among shapes of the body form. Observe their respective positions carefully in the model. Ask yourself the following questions: Does the first angle rest directly under or above the second? Does it lie on a horizontal with the second? If so, the horizontal and vertical reference lines can help you place the second angle accurately. If not, ask yourself how far the second angle departs from the horizontal or vertical standard. It may be helpful to imagine a clockface with the intersection of the first angle as its center. You can estimate the directional position of the second angle by means of the numbers on the clock. By repeating the steps described above to construct additional angular intersections, you can build up linear structures that accurately reflect body forms.

When you have completed the broad angular construction of the figure, you may wish to develop the form further by searching out the smaller angular indentations within the large shapes (Figures 3-23 and 3-24). You can use the same method to place these smaller shapes within the framework of the larger ones. The task is somewhat simplified by the presence of the larger framework: it requires visual measurement only within the local area, since the problem of the larger relationship has already been solved by

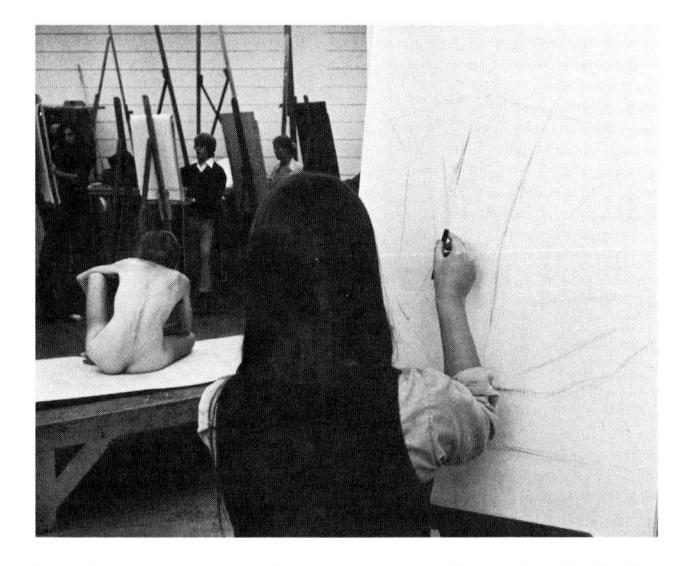

3-23. Student using angular measurement. The student holds the crayon on its side and examines the model for contours that can be interpreted as straight lines. Parallel alignment of the crayon with the observed line facilitates visual correspondence between the model and the drawing. Note the relationship of the crayon to the line drawn just above it. The first line indicates the spinal column. It was used as the reference line for determining the general placement of all additional lines. Vertical and horizontal guidelines, not shown in this drawing, can be helpful in gauging the alignment of the initial reference line.

the more generalized shapes. This kind of visual measure can often be seen in terms of fractions—for example, one-half the length of the larger shape. Such smaller measurements can be critical in areas with more complex features, however, such as those of the face and extremities, and should be drawn with care. The first stages provide the foundation for the detailed development of form. It follows that the better the foundation, the better your drawing will sustain the burden of detailed rendering.

Although there is no fixed time period for this type of drawing, you will find that 15 minutes should be allowed to complete the most general forms of the body. The additional time depends on the extent to which you wish to develop the drawing. For your first experience with this technique an additional 15 minutes is sufficient.

One of the advantages of this method of drawing is its flexibility: it permits constant reevaluation of visual measurement, since you can simply draw another angular intersection to conform to your new estimate of the original's location. In most cases the original angular intersection need not be erased, as it will not affect the quality of the drawing. Several instances of such reevaluation are visible in Figure 3-25, a drawing in which no erasures were made. The extra lines do not mar the quality of the drawing. On the

3-24. Developing the drawing. The student blocks in the shape, holding the crayon parallel to the contour observed on the lower-left side of the model. At this point in the drawing the head should have been developed to the same degree as the rest of the figure.

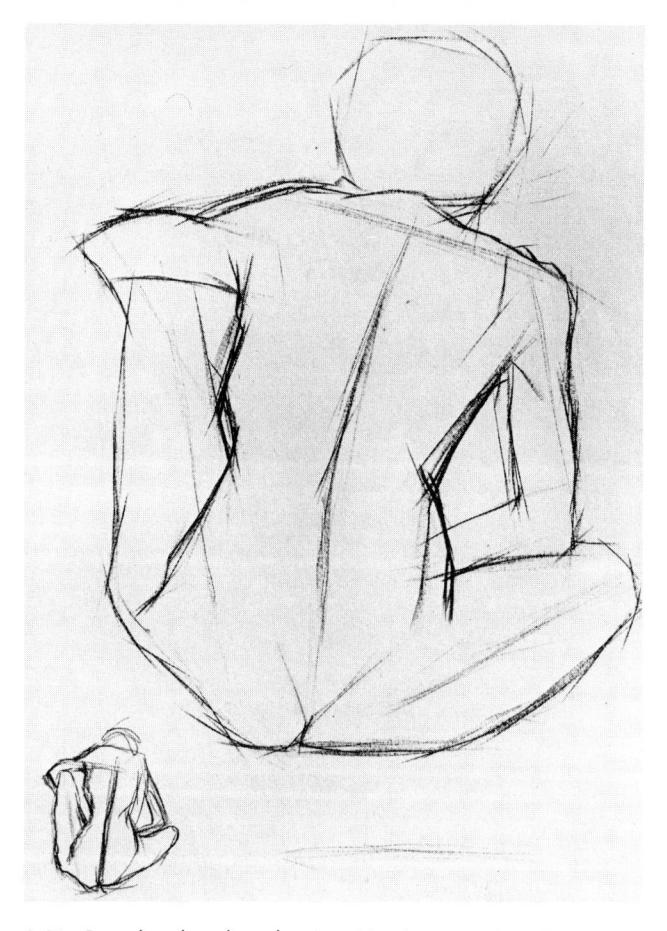

3-25. Completed student drawing, 30-minute session. Crayon on newsprint pad. 36" × 24". Mistakes left unerased do not impair the quality of the drawing. An important correction was made in the angular intersection on the right-hand side of the figure's trunk at waist level. Drawing the shape of the head after that of the body contributed to the visual inconsistency in the two portions of the drawing. Certain other parts, such as the lower lines of the right leg, also need the reassessment of placement seen in the trunk.

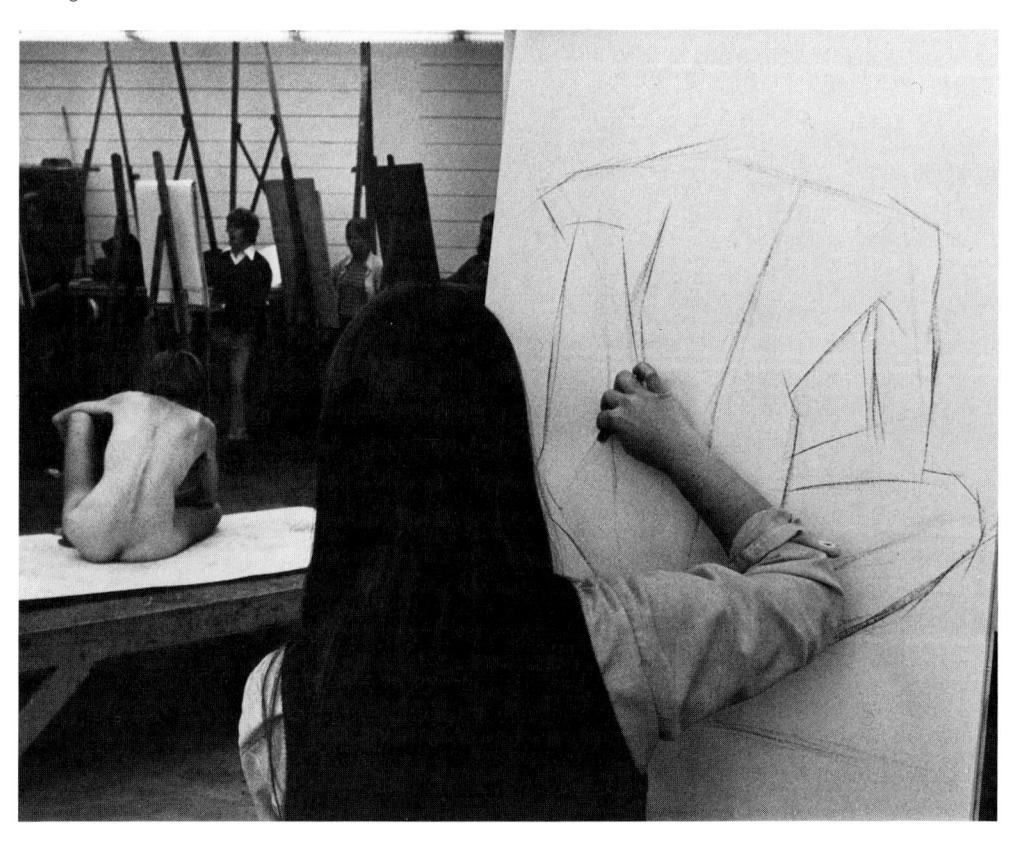

contrary, they seem to add a kind of graphic excitement by revealing the artist's search for shape and form. Graphic effects of this sort, it should be remembered, are a by-product rather than the goal of the method. Negative spaces offer an effective means of reevaluating your drawing. If parts of the figure seem to enclose a negative space, you can check your angular measurements by redrawing the negative space as a positive shape. A voluntary figure-ground reversal offers a different point of view, which can help you to be more self-critical.

The examples of student work seen in Figures 3-25, 3-26, and 3-27 demonstrate the use of angular construction to describe and enclose shapes. Figure 3-27, however, illustrates a more selective use of this drawing method: by restricting the angular construction to areas of intersection the artist leaves the spaces between those areas open. This method brings into play the closure principle described in chapter 1 in connection with the circle. The figure is completed, or closed, in the viewer's mind, yet the draftsmanship is as accurate as that in any student drawing reproduced in this book. Limiting the drawing to "essential" angular intersections is a way of sharpen-

ing the accuracy of the drawing. Moreover, the selectivity involved can enhance its personal quality. Whether the shapes are "open" or "closed," all three examples of student work demonstrate that the angular method produces drawings with a clear structural quality. The clarity of structure, however, does not result so much from a reduction of the complexity of observed forms as from the elimination of patterns of shadow and color, often complex in themselves and frequently irrelevant to the form of the object on which they appear. The angular method, like line drawing in general, gives birth to drawings "in which the general appearance of the world is not altered by the light, which modifies forms as it changes color." ¹³

This drawing technique is conceptually related to Cézanne's view that "art is a harmony parallel to that of Nature." For Cézanne parallel harmony did not merely refer to a method, such as that described here, of drawing lines parallel to those observed in nature. His view encompassed all components of art, including color, value, composition, and form. Nevertheless, his own drawings reveal that he too practiced drawing according to a similar method (Figure 3-28).

3-26. Observing and drawing angular intersections of the figure. Careful visual measurement is necessary in drawing the model's form in terms of angular intersections.

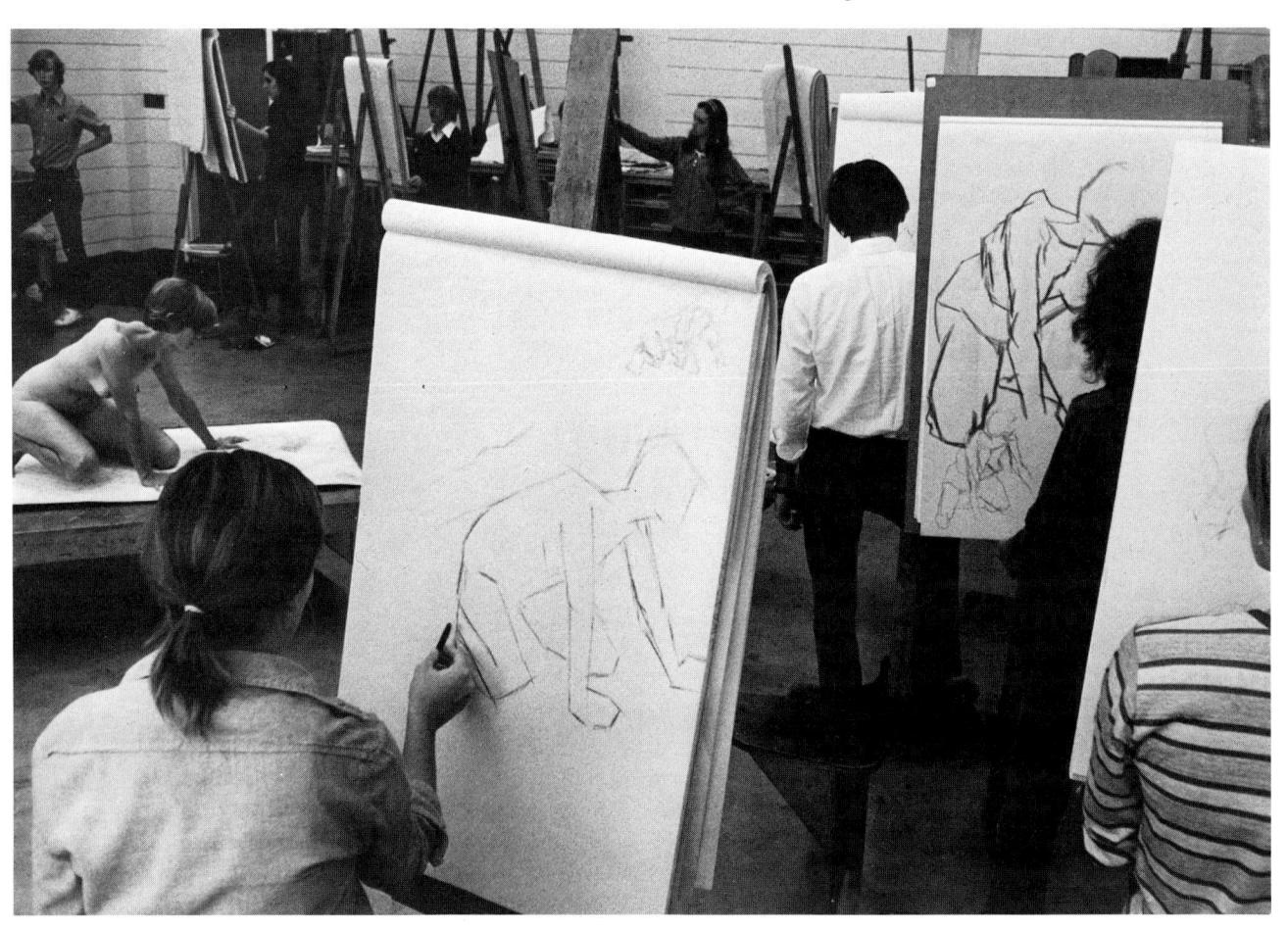

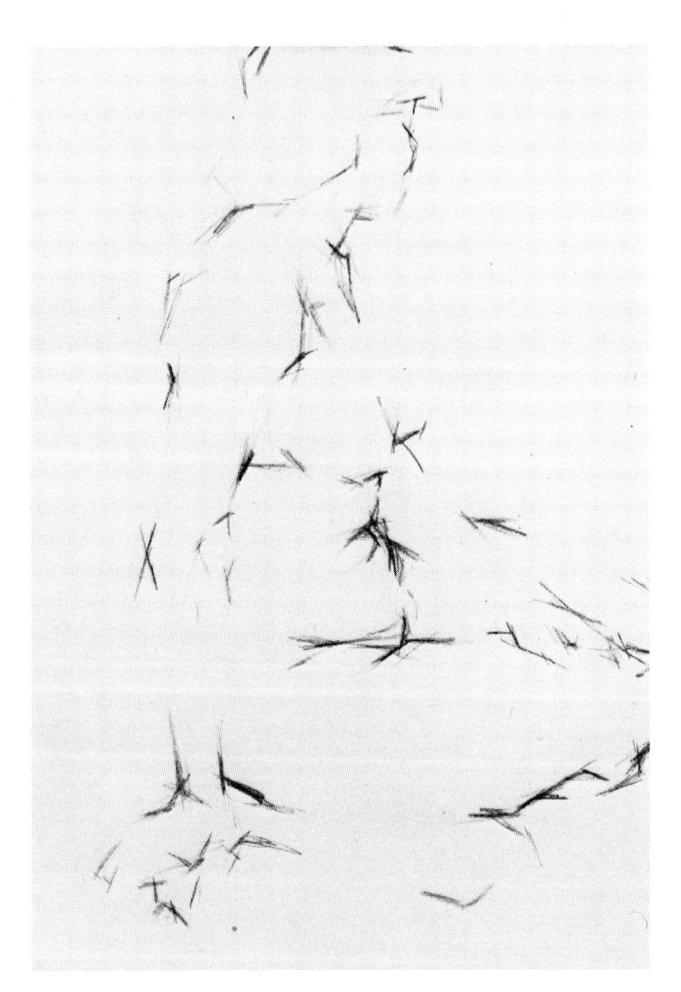

3-27. Student drawing. Crayon on newsprint pad. $36'' \times 24''$. Angular intersections are registered only in areas where visual information is concentrated, allowing the forms to appear open, or unenclosed by line. Such forms are completed by the viewer.

3-28. Paul Cézanne (1839–1906), Sketchbook study of the écorché. Pencil on white paper. 12.4" × 21.7". Art Institute of Chicago. The method used by Cézanne to construct form with line is similar to that described in study 8 except that it stresses vertical elements. The lines designating planes are also reinforced with parallel hatch marks.

The drawings of many major artists show affinities with this method. It is especially apparent in the work of artists such as Cézanne, Lautrec, and Picasso, who received their training in the nineteenth century when parallelism and angular measurement were a part of art-school training. Picasso, who learned to draw in the late nineteenth century, was taught drawing by a method much like the one described here (Figures 3-29 and 3-30). The method is not limited to the nineteenth century, however. The same general approach to drawing can be found in contemporary works. Figure 3-31 shows that the Swiss artist Giacometti used an angular method to build up an almost abstract linear framework of the figure. He took advantage of the "transparency" of line in order to describe both the interior and the exterior structure of the body in the same drawing.

With the angular method you can achieve a fairly high degree of visual correspondence between the drawing and the model. Such correspondence, often called *draftsmanship*, demonstrates control over the artistic process, which is the goal of many beginning artists. The suitability of the angular method for attaining this goal seems to have a basis in the structure of human vision. Scientists now believe that the brain is specially equipped for the detection of angles. Your awareness of your own body gestures is also due in part to a sense of the angles formed by the skeletal bones at their joints. Angles are thus important in the perception of your own body gestures as well as those of other people.

3-30. Pablo Picasso, *Study*, 1892–93. Conté crayon. 20.4" × 14.4". Barcelona, Museo Picasso (Courtesy of S.P.A.D.E.M.) Picasso's astonishingly early grasp of drawing principles is apparent in the above study, created when he was approximately 11 years old.

3-29. Pablo Picasso, Study of a profile, 1892–93. Conté crayon. 9.3" × 12.2". Barcelona, Museo Picasso. (Courtesy of S.P.A.D.E.M.) Drawn when Picasso was only about 10 years old, this study features vertical and horizontal reference lines (intersecting at the eye) as the basis for constructing the other lines. Note the lightly drawn lines that indicate the general angle of the profile: they serve as the reference for smaller angular intersections of the lines composing the features.

3-31. Alberto Giacometti, *Trois Femmes Nues*, 1923–24. Drawing. 44.5×28 cm. Kunsthaus Zürich. The three versions of the same figure can be seen as a progression from the more generalized forms of the figure on the right to the richly complex construction in the two other figures. The artist's drawing method, though highly personal, includes careful angular measurement in line.

LINE, SHAPE, AND COLOR

In this chapter line has been considered primarily as a means of representing form (structure)—that is, the three-dimensional aspect of objects. Line is also ideally suited to the representation of another aspect of objective reality-shape. To people not familiar with the problems of drawing form and shape may seem to mean the same thing—indeed, they do overlap in meaning to a certain extent, for a shape generally contains some visual information about the three-dimensional form on which it is based. But a shape is essentially a two-dimensional reduction of a form, a reduction that eliminates almost all suggestion of depth or space. Certain works of art, such as Japanese prints, seem to be based almost exclusively on the shapes of things rather than on volumetric forms or structures. In Utamaro's Girl combing her hair (Figure 3-32) you tend to see the shapes of the arm and the robe instead of their forms in space. Similarly, despite the white lines in the dark area of the hair, the shape of the hair is sensed first and foremost.

For eastern artists this mode of representation was a part of their artistic tradition, but for the European artists of the nineteenth century, trained to model form in light and shade, it was a novel and fascinating idea. The Japanese print exerted a strong influence on a number of important western artists of the time, including Toulouse-Lautrec (Figure 3-33 and 3-34) and Aubrey Beardsley (Figure 3-35). Lautrec in particular adapted Japanese techniques in creating his poster designs, an artistic debt he acknowledged by signing his initials in the manner of a Japanese seal. Comparing a preparatory drawing (Figure 3-33) with the final printed poster (Figure 3-34), you can examine his method of working. In the drawing he defined the shapes of the figure and the lettering and their relationship to each other. He also recorded the gesture of the nude figure beneath the gown, using a freely developed, angular construction of line. Although the nude figure is not visible in the poster, the preparatory study may account for the authoritative sense of the body suggested in the poster. As in the Japanese print, line in the poster largely serves to define shapes as bold areas of color.

The high cost of color printing often limits the number of colors in a graphic work such as a poster. For May Milton (Figure 3-34) Lautrec used only three colors: red, yellow, and black. Color restrictions of this kind do not apply to drawing media, of course, but you would be well advised to limit the number of hues in a colored drawing. Try for maximal effect with a minimal number of colors. You will find that you can obtain a rich effect with two or three colors, an economy of technique that can be interesting in itself. Most important, keep in mind that the white of the page can be used as a color. Among the color media for drawing, transparent watercolor and

colored pencils are perhaps the most versatile. Some colored pencils produce marks that dissolve like watercolor if a wash of clear water is applied. If they are used without water, such pencils have the advantage of not causing the paper to buckle. Pastel crayons offer another medium for drawing in color, but, due to their powdery quality and the special paper required, they are not recommended for beginning artists.

The same method of visualizing forms as "colorshapes"17 can also yield brilliant effects in pure black and white. Aubrey Beardsley, the English graphic artist, used this technique as a way of energizing shapes in his black-and-white illustrations (Figure 3-35). By filling in outlined areas that represent dark colors with solid black he gave the remaining white areas a positive quality much like the figure-ground reversal described in chapter 1. This is especially noticeable in the aprons and shirtfronts, which emerge as luminous abstract patterns locked in tension with the black shapes. Since the black areas also register as positive shapes, the figure-ground reversal is incomplete, causing a formal ambivalence that may be the source of the visual excitement generated by this work.

3-32. Utamaro, *Girl combing her hair*, c. 1802. Illustration from the series *Ten Forms of Feminine Physiognomy*. Colored woodblock print. 36.3 × 24.5 cm. London, British Museum.

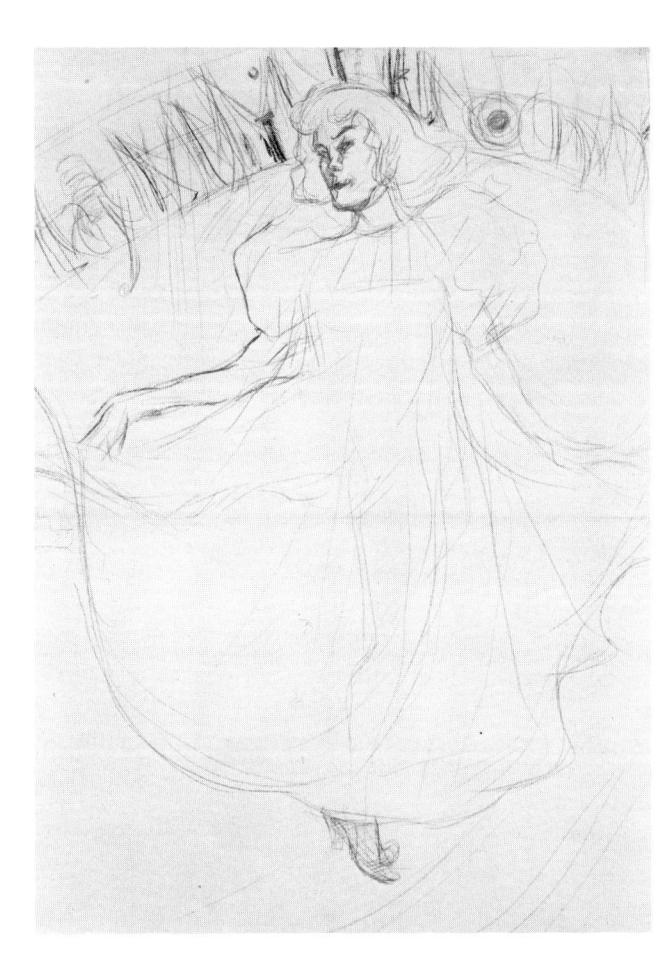

3-33. Henri de Toulouse-Lautrec, May Milton, 1895. Blue and black crayon on light brown paper. 291/8" × 23 3/16". New Haven, Connecticut, Yale University Art Gallery. Gift of Walter Bareiss, B.S. 1940.

3-34. Henri de Toulouse-Lautrec, May Milton, 1895. Colored lithographic poster. $31'' \times 231_2'''$. Paris, Bibliothèque Nationale.

3-35. Aubrey Beardsley, *Garcons de Café*, 1894–95. Illustration for *The Yellow Book*. London, Victoria and Albert Museum.

A similar approach is seen in a self-portrait by the Swiss artist Paul Klee (Figure 3-36). Although the line in this work is somewhat hidden by the black tone that extends over much of the surface, the drawing is nonetheless an essentially linear description of shapes, to which tone was added. Significantly, the black tone does not serve to model effects of rounded form but rather translates color areas (shapes) into dramatic patterns of black and white within the framework of the flat-line construct. Color-shapes are filled in with the same directness as in a child's coloring book. Darker colors are lumped together as black; lighter tones are conceived as white areas enclosed by line. This represents a considerable simplification of the multicolored Japanese print, but the reduction of form to shape is the same in both. Since the Klee self-portrait and the Beardsley drawing were conceived with printing processes in mind—the selfportrait for a woodcut and the drawing for letterpress—their similarity of approach may be partly attributable to the dictates of the printing methods.

Your own preference in art media will determine to some extent which concept of form to adopt in your work. The reverse is also true, for the medium and the concept of form go hand in hand. If you prefer to work in the three-dimensional medium of sculpture, considerations of color may not be as meaningful to you as they are to an artist working exclusively in the two-dimensional media of painting and graphic art.

3-36. Paul Klee, *Self-portrait*, 1909. Study for a woodcut, india ink on linen. 13 × 14.5 cm. (Courtesy of Felix Klee and S.P.A.D.E.M.)

This may result in a conceptual carry-over from your primary expressive medium to your drawing. There is no need to strive consciously for such a transfer: it will happen automatically as you explore the art form and medium best suited to expressing your ideas.

Conceptual carry-over from one art form or medium to another is not uncommon in the history of art: it accounts for the formal contradictions in various works of art, notably sculpturesque painting and pictorial sculpture. Such contradictions are generally hazardous, but there are brilliant exceptions (e.g., the sculpturesque frescoes of Michelangelo). One of the redeeming features of drawing is that, despite the fact that it is a physically flat art form, it is capable of encompassing almost all formal concepts, volumetric or coloristic, without producing a sense of visual paradox. The general acceptance of this latitude in drawing illustrates the primacy of ideas in the drawing process. An interesting example of the flexible nature of drawing is seen in drawings that represent movement, a phenomenon that would seem at odds with such a stationary art form.

MOTION AND CHANGING POINTS OF VIEW

In drawing the human form most people tend to think of the body as it is seen from a specific point of view in time and space. This is a traditional concept of visual representation that is apparent in many works of art, particularly those based on Renaissance single-point perspective. It is an idea, moreover, that has been reinforced by much (though not all) still photography. Yet when you observe a person in life, it is usually not in the context of a stationary situation. You may be walking; the other person may be moving as well. With each change of relative position you can see the person from a different point of view, often with accompanying changes of light and background. So closely is such motion associated with visual perception that it warrants special attention in drawing. Studies 10, 11, and 12 can assist you in exploring the graphic possibilities of motion.

STUDY 10. THE ROTATING MODEL

Materials: 36"-x-24" newsprint drawing pad

easel or straight-back chair Masonite or plywood board and

clamps

felt-tip pen or drawing crayon

Reference: model **Suggested time:** 10 minutes

The contour line is an appropriate vehicle for drawing a form in motion, for it suggests the continuity of surface beyond the visible side of the figure, even if the drawing presents the figure from a single viewpoint. By logical extension the contour can be useful in representing the figure from several points of view simultaneously. The "transparency" peculiar to line drawing makes it especially effective in representing overlapping and superimposed forms, which are characteristic of simultaneous vision.

The drawing procedure recommended for this study is essentially the same as the rapid contour method (study 5). It is helpful to observe the model continuously, checking the location of your crayon only when necessary. It is advisable, however, to draw more rapidly here, due to the special nature of the pose. The model should hold a simple standing pose that can be turned 45 degrees approximately every two minutes (Figure 3-37). This can be accomplished by actually rotating the model stand or by having the model change position and resume the same pose with each change. After ten minutes the model will have rotated 180 degrees. The drawing executed during this interval should consist of a partial or complete contour description of the five different views of the model. As a consequence, the drawing may exhibit a considerable amount of superimposed form as well as dislocated shapes (Figure 3-38). It may also convey an overall symmetry of form that results from the model's rotation, a symmetry similar to that of lathe-turned wood.

Rotation implies an axis—a stationary line around which the form turns. In this case the figure turns around a line (axis) that runs vertically through the center of the body. Axis more commonly refers to the longitudinal centers of three-dimensional forms, including the forms of the body. Since the contour line often appears to turn around a drawn form, the idea of rotation of form around an axis is closely associated with the concept of contour. In a sense rotation simulates the way you see things in daily life, for it enables you to see forms from different points of view. This changing viewpoint is especially noticeable when you move rapidly. As you may have observed from the side window of a moving automobile, people and objects appear to turn, or rotate, as you travel past them. The same apparent rotation occurs when you walk, though it is less obvious. Motion of this kind is an important aid in

comprehending three-dimensional form.

Another special quality frequently emerges in drawings of the rotating model: *simultaneity*. Instead of a sense of motion the drawing may seem to present a figure composed of forms that, while belonging to the same body, are seen from different points of view at the same time. A drawing of this kind is comparable to a map of the globe: it is an inclusive visualization on a flat surface of a three-dimensional form. Such a drawing includes a description of both sides of the figure. If you wish to aim for this effect, it is advisable to request the model to rotate slowly and continuously without sudden shifts of position.

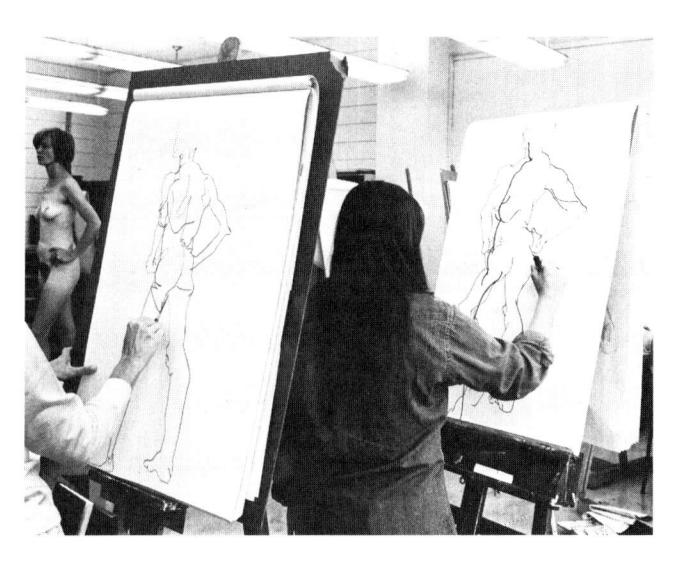

3-37. Drawing the rotating model, early stages. With the model facing a different direction every 2 minutes the draftsman's attention tends to focus more on the model than on the drawing page.

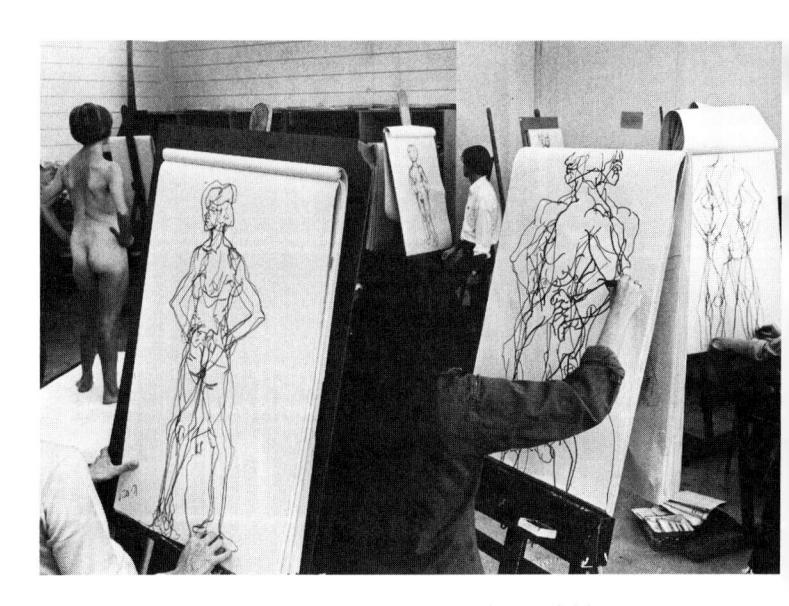

3-38. Drawing the rotating model, final stage. The model has turned 180 degrees after 10 minutes. The resulting drawings reflect not only that movement but also a multiplicity of views of the figure.

Like a map of the globe, a simultaneous drawing manifests unavoidable dislocations and distortions of the rounded form. Shapes may seem to join or extend in ways that do not correspond to the conventional idea of the figure seen from one point of view. Such a concept of form violates the canons of European art as they were conceived from the fifteenth through the nineteenth century. Yet it is an idea that flourished in the art of India and of ancient Egypt, where different views of form appear even in the description of the face. Simultaneity was also important in the development of cubism in the early part of this century. A key member of this movement was Pablo Picasso, who created many drawings based on the principle of simultaneity (Figure 3-39). Cubism brought with it a revolutionary change of attitude toward many basic values of traditional art. Simultaneity challenged artistic presumptions of time and space in much the same way that the theory of relativity challenged scientific opinion on matters of time and space.

Studies of the rotating model are one means of achieving effects of simultaneity and movement, but rotation is not the only way to represent movement in drawing. The movement of the model in the rotating pose is limited to motion as revolution around an axis: the pose remains the same. Human movement in space is not normally so limited. It is more like a linear pathway in space—i.e., it advances from one point to another. In the next study a way of drawing this type of linear movement is considered.

3-39. Picasso, Seated Nude, 1956. Page from a sketchbook, penand-ink. 42 × 33 cm. (Courtesy of S.P.A.D.E.M.)

STUDY 11. SIMPLE MOVEMENT: A DOUBLE POSE

36"-×-24" newsprint drawing pad **Materials:**

> easel or straight-back chair Masonite or plywood board and

clamps

drawing crayon

model Reference: Suggested time:

20 minutes

A simple shift of weight from one foot to the other while standing in the same place can cause a remarkable change in body posture and position: it is a movement of gesture. The standing model can perform the movement with relative ease if you explain clearly that the feet are to remain in place. To move the feet would change the focus of the study and make it difficult to see the movement specifically involved in the gesture. It is recommended that the model shift weight at regular one- to two-minute intervals for a period of twenty minutes. If an additional gesture, such as lifting the arm, is included in the movement (Figure 3-40), the one-minute interval is preferable for the model's sake.

The double pose has certain special advantages for the first-year art student. Knowing that the pose will change momentarily, you are encouraged to observe keenly and to draw rapidly, even in a relatively long session. Since the pose is continually changing, it is best to work only on the drawing that corresponds to the pose then being held. In this way you can return to the other drawing with renewed interest, as each drawing enhances your understanding of the forms drawn in the other.

The aim of the study is to suggest movement by representing the figure at two stages of the gesture. The rapid-contour-line method is well suited to this aim. You can begin with a rapid contour drawing of the first position. It is especially important even in the early stages of the drawing to indicate the general forms of the lower portion of the figure. Before you can complete the drawing of the first position, the model will move to the second position. This is no cause for concern, however, as the model will later resume the first position, and you can continue the original drawing. The motion is one of shifting weight, not of walking, so it is appropriate to draw the figure's feet in the same location in both positions. For this reason you may wish to begin the second drawing by indicating the forms of the lower limbs, which will necessarily overlap those in the first drawing.

3-40. Student drawing, double pose. Crayon on newsprint paper.

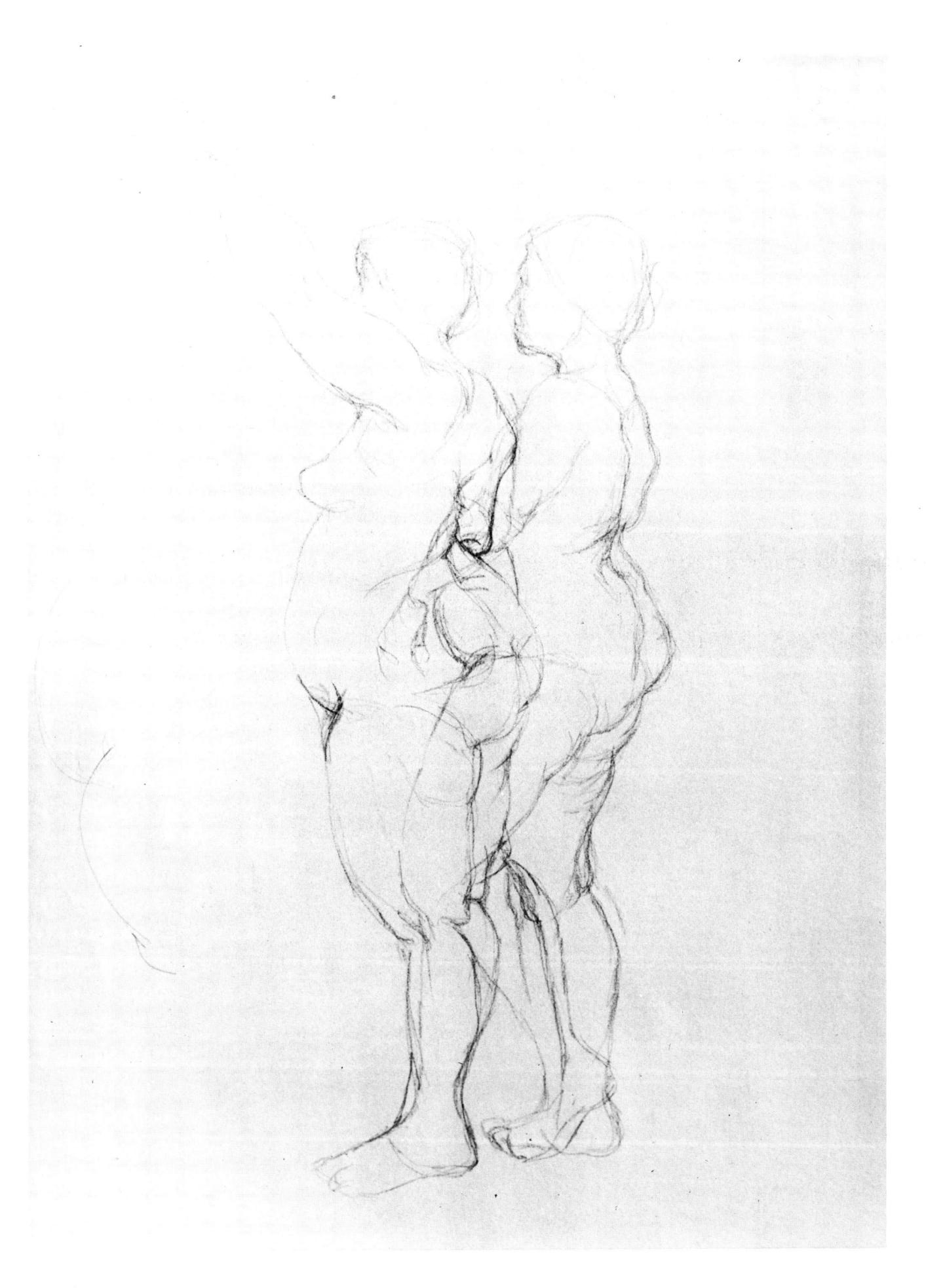

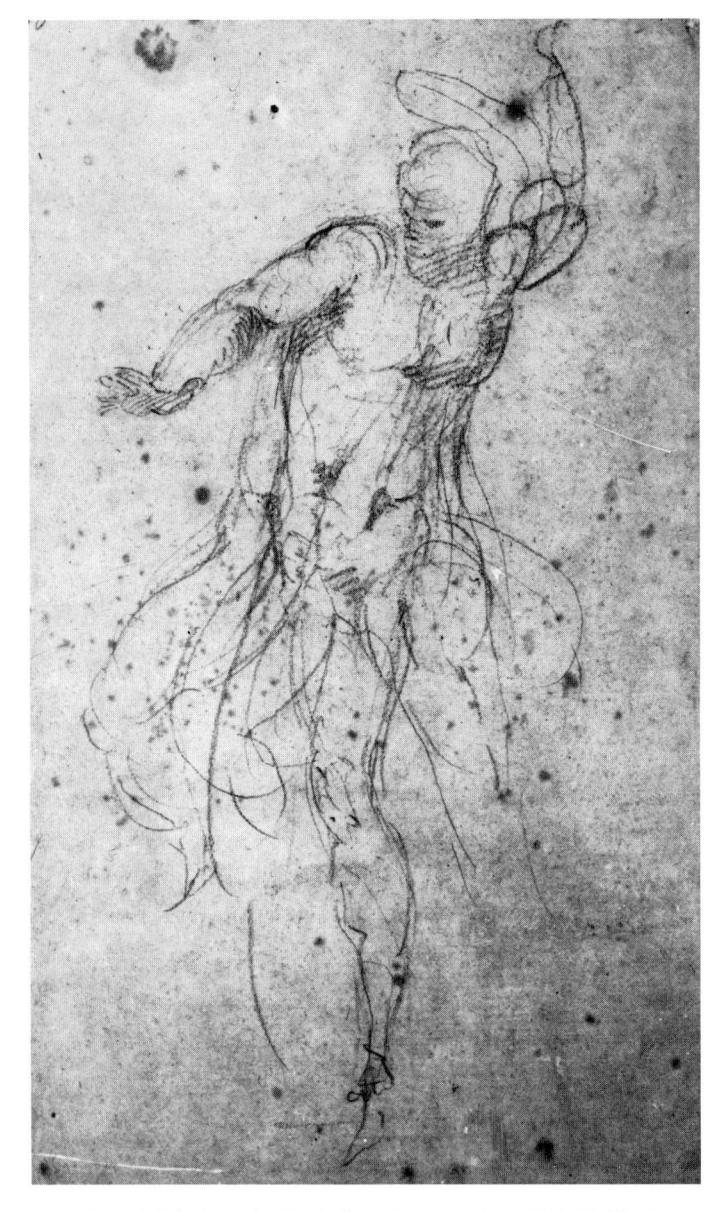

3-41. Michelangelo, Study for a Resurrection, 1523–33. Black chalk. 16.2×12 cm. Florence, Casa Buonarroti. (Courtesy of G.F.S.G.)

Beginners often experience difficulty in drawing the model in a standing pose, especially if the model's weight is shifted to one side. The drawn figures often appear to be unbalanced and about to fall over. This problem may result from a faulty understanding of equilibrium. In nature a state of equilibrium exists when the center of gravity divides the masses of the body equally. If the body's weight rests on one foot, the center of gravity can be traced from the middle of the weight-bearing foot to the base of the skull (or just behind the ears). If the weight rests on both feet, the center of gravity lies somewhere between them.

An understanding of how body features are displaced in standing poses can be useful in conveying the effect of equilibrium in your drawing. For example, if the weight rests mostly on one leg, the lower abdomen (pelvic region) tends to tilt upward on the weight-bearing side and downward on the other side, as in the classical contrapposto position (Figure 4-4). The weight-bearing leg is almost always straight, while the other leg may be bent as a consequence of the pelvic tilt. In the shoulder region you are likely to see the opposite effect: the shoulder on the weight-bearing side may be lowered, while the other shoulder is raised. If the model is relaxed, the body displacements are more pronounced.

After you have completed study 11, you may find it instructive to test the equilibrium of the figures by drawing a vertical line from the center of the weight-bearing foot. The edge of the drawing paper makes a convenient guide for such a line. If the drawn figure is balanced (assuming that none of the limbs is raised), the line should pass through the middle of the head. If it does not do so, the line itself will suggest a better placement for the head, which can easily be redefined. Degas, in drawing his well-known studies of ballet dancers, sometimes employed a vertical plumb line for this purpose. An understanding of body equilibrium is essential for the next study—the walking model, or cinematic motion.

STUDY 12. THE WALKING MODEL

Materials: 36"-x-24" newsprint drawing pad

easel or straight-back chair Masonite or plywood board and

clamps

drawing crayon

Reference: model
Suggested time: 20 minutes

As a drawing subject the walking model is similar to the previous study, but it is carried several steps further—figuratively and literally. Instead of a simple shift in weight the model takes two carefully planned steps on the model stand. The model should first walk across the stand a few times to decide upon the most natural way in which the movement can be performed in the limited space. The steps can be marked with crayon so that they can easily be repeated and held to allow time for drawing. The walking movement, which consists of moving the body weight in equilibrium from one foot to the other, can be frozen midway when the weight is distributed evenly on both feet as well as when the weight rests on one foot alone. The two steps, broken down into component parts, amount to five different poses. No more than one minute should be allowed for each position and each position should be repeated during the drawing session, allowing you to develop the figures continuously as a single drawing (Figure 3-42). As in the previous study, the feet act as pivots for the figure, so their positions can serve as reference points for the placement of the individual figures of the drawing. The lower limbs should be a primary objective in your study (Figure 3-43). Observation of the model remains a vital factor in determining the quality of your drawing, making it imperative that you work only on the part of the drawing representing the position then held by the model.

The premise of this study is cinematic motion: motion interpreted as a sequence of images of the same subject seen at different points in time. Historical precedents can be found in some ancient works of art, notably in certain Egyptian reliefs and Greek vase paintings (Figure 3-44), as well as in representations of the god Shiva in Indian art, in which a multiplicity of similar figural elements suggest the motion of one form. In the nineteenth century photographic techniques accurately recorded sequential motion for the first time. The English photographer Eadweard Muybridge, an innovator in this technique, taught his method to the American painter Thomas Eakins (Figure 3-45). Although sequential photographs eventually led to the invention of motion pictures, the stills remain interesting in their own right. The unexpected patterns and visual rhythms produced in such photographs were of interest to painters as well as to photographers. Since that time sequential imagery has been utilized by a number of artists, in-

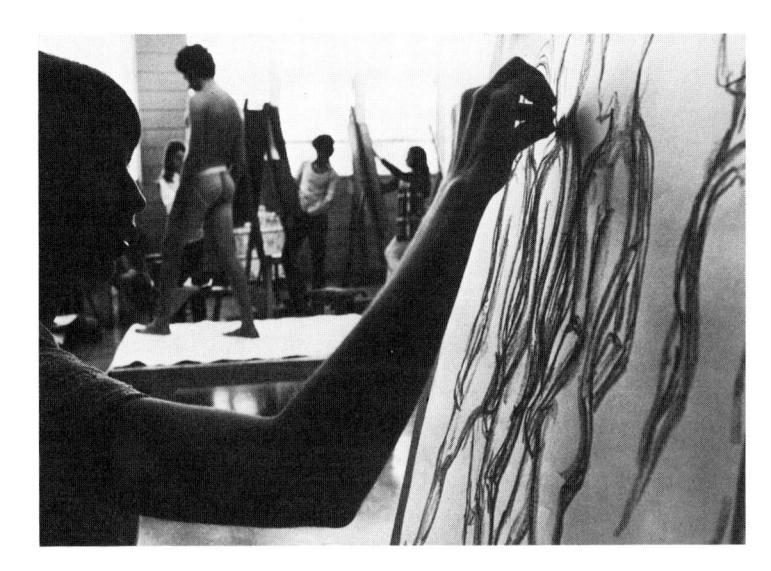

3-42. Drawing the walking model. The walking motion can be halted at convenient intervals for purposes of study.

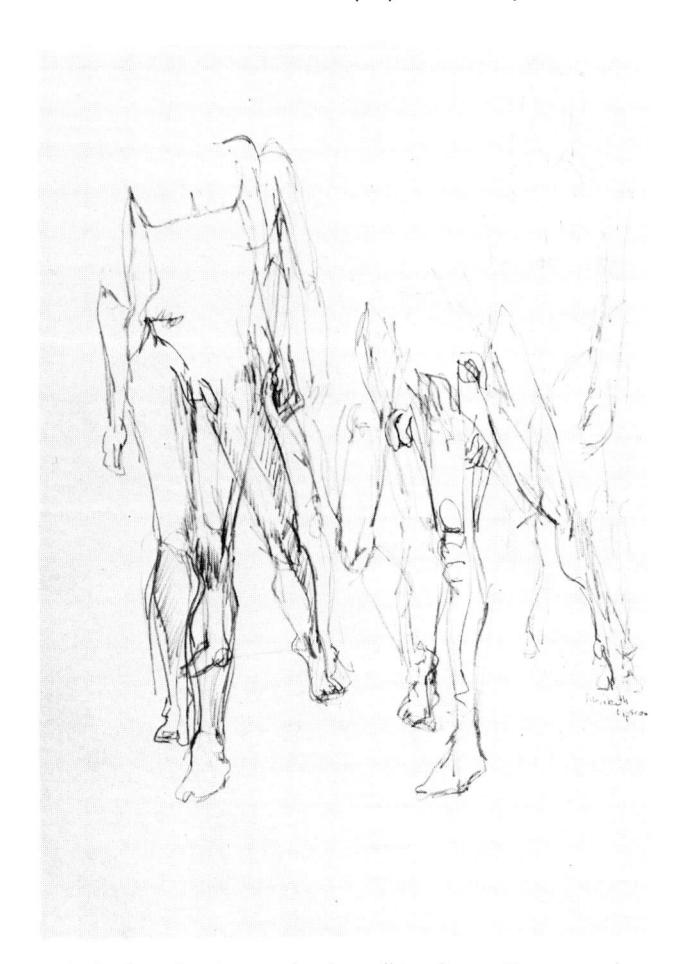

3-43. Student drawing, study of a walking figure. Compressed charcoal pencil on newsprint paper. 36" × 24".

cluding the twentieth-century French painter Marcel Duchamp, whose painting *Nude Descending a Stair-case* is clearly based on such techniques. It is worth noting, however, that Duchamp did not merely copy the photographic effect of cinematic motion but rather expressed the principle in his own pictorial language.

3-44. Unknown Greek artist, *Painted figures of athletes*. Panathenaic vase, late 6th century B.C. London, British Museum. The repetition of similar figural elements sets a visual rhythm that can also be interpreted as motion if the elements are aligned at regular intervals. *Rhythmos*, the word from which "rhythm" derives, was a term used in ancient Greece to designate "compositional patterns, especially of figures in movement" (J. J. Pollitt, *The Art of Ancient Greece 1400–31 B.C. Sources and Documents* [Englewood Cliffs, N.J.: Prentice-Hall, Inc., 1965], p. 57.

The idea of *rhythm* is inherent in many forms of motion and is a visible aspect of cinematic motion. Visual rhythm is apparent in Eakins' photograph (Figure 3-45) in the regular repetition of a similar but changing pattern, a repetition in which the space between each figure corresponds to a precise interval of time. A secondary rhythm is apparent in the arching pattern created by the movement of the legs. In most works of art rhythm is not as regular as in Eakins' photograph, but rhythmic patterns are often apparent. The recurring but varied figural elements of Rubens' *Dancing Peasants and Peasant Dance* (Figures 3-46 and 3-47), for example, create visual rhythms that are analogous to the rhythmic beat of dance music.

3-46. Peter Paul Rubens, *Dancing Peasants*, 1629–32. Black chalk with traces of red, reworked in pen-and-ink. 502×582 cm. London, British Museum.

3-45. Thomas Eakins, Marey wheel photographs of Jesse Godley Running, 1884. New York, Metropolitan Museum of Art. Gift of Charles Bregler, 1941. A noted exponent of realism in painting, Eakins also took great interest in photography. The Marey wheel (named after its inventor, Jules Marey) was a revolving-disk shutter that permitted multiple exposures on a single plate.

3-47. Peter Paul Rubens, Peasant Dance, 1636–40. Oil on wood. $2834'' \times 3934''$. Madrid, the Prado.

LINE, MOTION, AND ART

Just as rhythm and motion are inseparable concepts in dance, so motion and line are closely related in the visual arts. In some compositions the movement implicit in line is restricted and serves primarily to isolate and clarify figural elements. In such compositions any effect of linear movement is usually contained within and does not extend beyond the individual figural element. This is analogous to three separate circles: the rotation implied in one circle does not extend to or connect with the other circles. with the result that the effect is static. The same motionless effect frequently occurs in figurative art even when the subject ostensibly represents motion. The opposite effect occurs, however, in compositions in which lines link sequential figural elements in an unbroken rhythmic pattern, such as a wave or an ellipse. Oddly enough, motion of this type is often implied in works of art that represent stationary subjects. Folds of cloth or anatomical shapes of the figure often produce such effects. The principle is perhaps clearest, however, in works that present subjects involved in physical movement, such as dance (Figure 3-47).19

Rubens' drawing of dancing figures (Figure 3-46) reveals how he worked out problems of movement and gesture in a dancing couple, perhaps drawn from life, before using the figures as part of the composition of a painting. In the painting the couples are linked together as part of a larger pattern, like a visual chain forming an ellipse. The drawing, though more directly related to Rubens' Kermesse, also seems to have been the basis for the two figures in the foreground of Peasant Dance (Figure 3-47). The effect of swirling dance movement is enhanced by the similarity of types, giving rise to an implied cinematic movement that, in combination with the almost unbroken flow of line around the ellipse, makes the painting somewhat of a centrifugal tour de force. A masterwork of this quality can itself serve as a subject of a motion study.

There are many ways of studying a masterwork, and you will discover the approach that suits you best. If you have never drawn from another work of art, however, the following procedure can prove helpful.

STUDY 13. MOVEMENT IN A MASTERWORK

Materials: $8\frac{1}{2}$ "-×-12" or larger bound

sketchbook of smooth bond

paper

india-ink drawing pen (2.5 Castell TG, 0.5 mm Mars Staedtler, or Rapidograph) art museum or library

Reference: Suggested time:

10–30 minutes (depending on the complexity of the work)

For studying works of art there is a practical advantage to using a pen and sketchbook for studying artworks: they are portable. You can carry them with you into the art museum or library, and generally you are allowed to use them on the spot. As a matter of form, however, it is proper to request permission from the museum attendant or librarian. In many European museums a written permit is required for this purpose. A mechanical pen is also recommended for another reason: it forces you to translate the visual ideas of the work you are studying into simple line constructs and prevents you from falling into the trap of mimicking (copying) the appearance of the original. This is a very important point to keep in mind, for the aim of studying—as opposed to copying—a masterwork is to uncover the concepts that produce the quality that interests youin this case the quality of movement. This means that you need draw only those features of the masterwork that are essential to that quality. If you decide to study Rubens' Peasant Dance, for example, the undulating ellipse formed by the dancing figures and the smaller, interlocking units of form (i.e., the arms of the figures) will be of special interest. In a student study based on a drawing by the sixteenth-century Italian artist Cambiaso a different means was used to express motion—an explosive pattern of diagonal figure gestures (Figure 3-48). In place of the flowing contours of Rubens' dancers a curious block construction of form was favored by Cambiaso, yet the suggestion of movement is apparent.

Movement is but one lesson to be learned from the study of masterworks. You may wish, for instance, to record in your sketchbook the composition of masterworks in terms of abstract design. By studying the art of the past with a clear purpose in mind you can discover specific information that is useful for your own artistic efforts. "The past," wrote Italo Svevo, "is always new; it changes continuously as life goes on. Parts of it, seemingly forgotten, emerge again, while others, being less important, plunge into oblivion. The present directs the past as the members of an orchestra."20 In drawing from the art of the past the artist has the extraordinary privilege of personifying "the present," to use Svevo's simile. An intelligent study of earlier works usually involves selecting from them the ideas that are most useful for creating new

works of art. This perhaps accounts for the fact that many artists—painters and sculptors alike—have made drawings of earlier works throughout their careers. Their drawings were not limited to the study of motion, of course, and yours need not be either.

Around the same time that Columbus discovered America, Michelangelo drew from a fresco wall painting by Giotto, a work already 200 years old. His drawing (Figure 3-49), which has survived in somewhat better shape than the fresco, shows his interest in the compositional relationship of two of the five figures depicted in the fresco (Figure 3-50). Leaving out the stylistic details peculiar to Giotto's work, Michelangelo invested the figures with his own sculptural sense of form and roundness while preserving the gestures and compositional relationships of the originals. Another example of an artist learn-

3-48. Student drawing, study from Cambiaso's *The Return of Ulysses* (drawing in line and wash). Mechanical pen and ink on sketchbook page. 9" × 11". The 16th-century artist Cambiaso is of special interest for his use of the geometric block as a construct in drawing.

3-49. Michelangelo, Copy after two figures from The Ascension of St. John the Evangelist by Giotto, c. 1488. Pen-and-ink. 31.7 \times 20.4 cm. Paris, the Louvre.

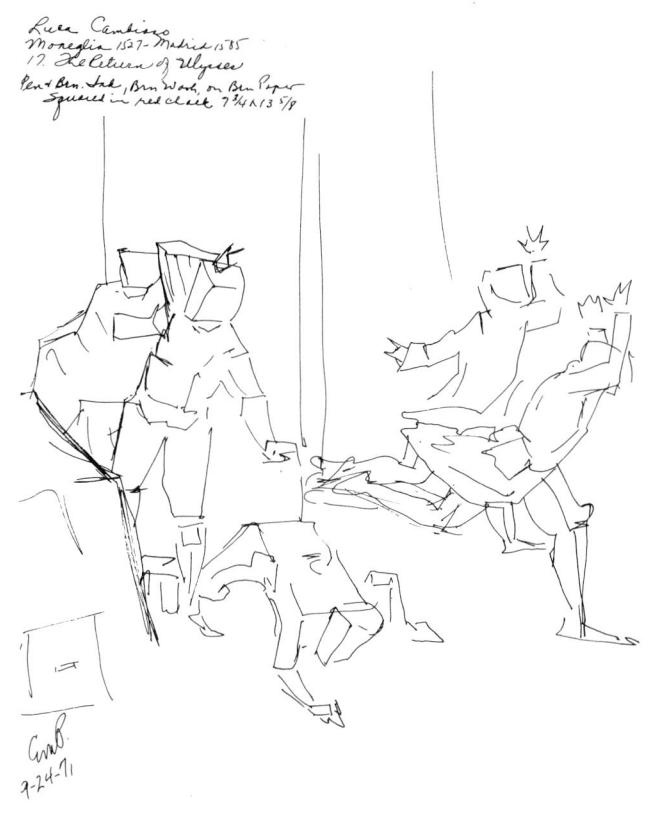

3-50. Giotto, detail from *The Ascension of St. John the Evangelist*, c. 1318. Fresco. Florence, Santa Croce, Cappella Peruzzi. (Courtesy of G.F.S.G.)

ing from previous art comes from seventeenth-century Holland. A quick study by the young Rembrandt of Raphael's *Portrait of Baldassare Castiglione*, made while the painting was on the auction block in Amsterdam, led to a subsequent self-portrait that incorporated some of the compositional features of the Raphael work (Figures 3-51, 3-52, and 3-53). Together the works cited represent a model of how drawing can be used to reinterpret earlier art for the purpose of furthering new creative efforts.

The history of art provides numerous instances of nineteenth- and twentieth-century artists using sources remote from their own time and culture. Ingres, a French painter of the nineteenth century and an excellent draftsman, continued throughout

3-51. Rembrandt, *Sketch after Raphael's* Baldassare Castiglione, 1639. Pen and bister with some white body color. 163 × 207 mm. Vienna, Albertina. Art museums did not exist in Rembrandt's time, but public auctions, such as the one at which Rembrandt made his sketch of Raphael's painting, afforded an opportunity to see and possibly purchase artworks from other countries and periods. Rembrandt's writing at upper right records the price that the Raphael painting brought (3,500 guilders) and the date.

3-52. Raphael, *Baldassare Castiglione*, c. 1510. Oil on canvas. 32%" × 26½". Paris, the Louvre.

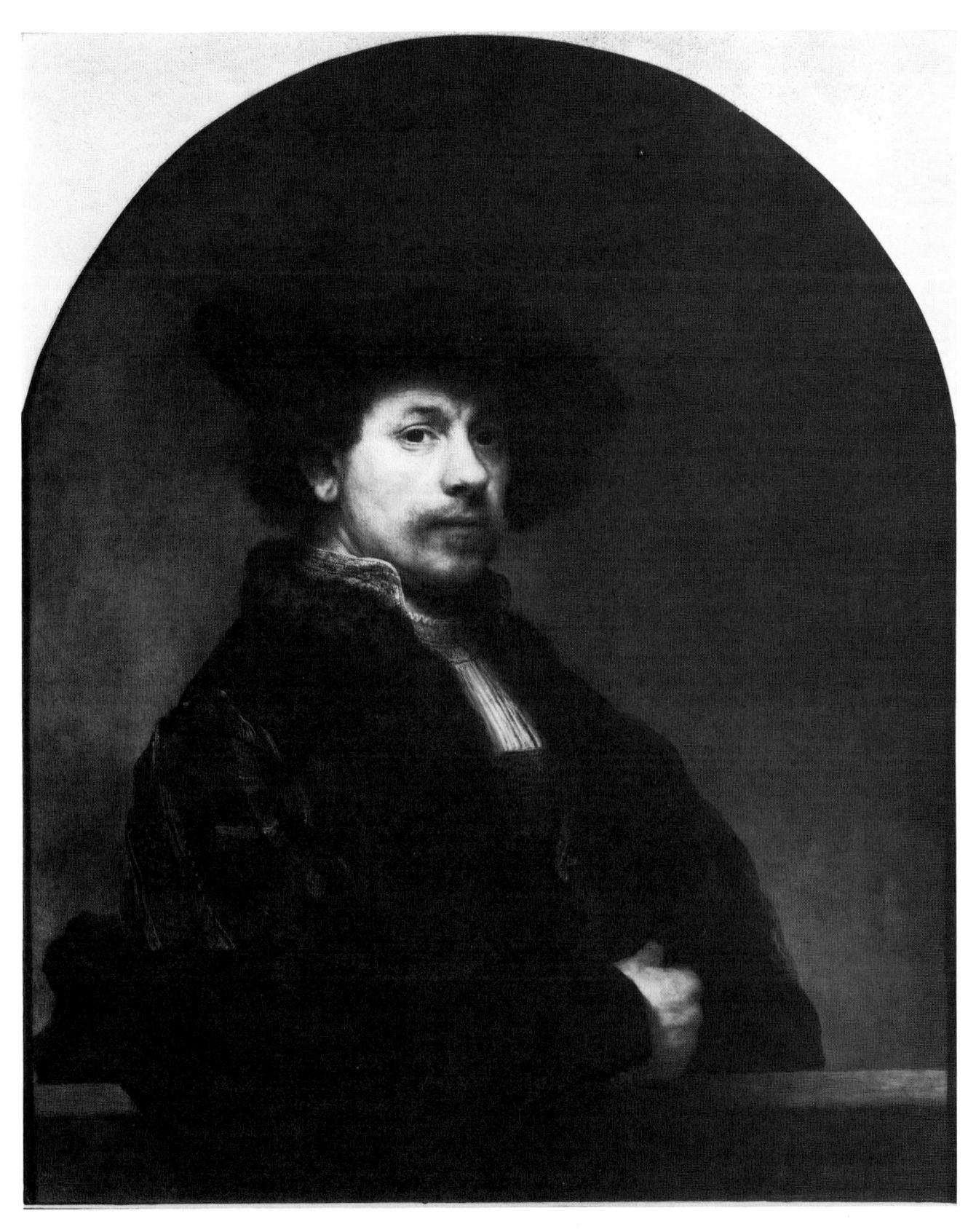

3-53. Rembrandt, Self-portrait, 1640. Oil on canvas. $40\%'' \times 31\%''$. London, National Gallery.

his lifetime to study the art of ancient Rome and Greece. He developed a way of constructing form with line that owes much to these sources, even though it is unmistakably individual. In some cases it is possible to trace the origin of a gesture in his drawing to an ancient prototype (Figures 3-54 and 3-55). The art of other cultures was also studied by such twentieth-century artists as Modigliani, who drew studies of African sculptures in order to learn their visual language—i.e., the rhythmic constructs and proportional relationships that they embody. Similar constructs became the basis for some of his most original paintings and sculptures (Figures 3-56, 3-57, and 3-58).

It is misleading, however, to discuss the sketchbook only as a means of recording studies of artworks, for it is also a repository of the most informal type of art: the sketch. The sketchbook fulfills an important need of the artist and student—it helps to maintain a continuing sense of pleasure in drawing. This need is sometimes overlooked due to the pressure to produce "serious," finished work, a pressure that is felt not only in professional life but also in art schools. While many of the drawings in sketchbooks may appear trivial or inconsequential, their true significance may lie in the sense of unbridled personal pleasure and interest that they convey. The conglomeration of sketches and smears characteristic of many sketchbook pages seems to radiate a iov and spontaneity that many finished works do not possess (Figure 3-59). You will naturally find your own way of using the sketchbook for fun. If you have never kept one, however, you may profit from a suggestion from Leonardo, who had definite ideas on its use: "When you are out for a walk, see to it that you watch and consider men's postures and actions as they talk, argue, laugh, or scuffle together; their own actions, and those of their supporters and onlookers: and make a note of these with a few strokes in your little book which you must always carry with you."21

3-54. Jean Auguste Dominique Ingres, Study for the Portrait of Madame Moitessier, c. 1851. Charcoal over graphite on thin white wove paper squared with graphite. 73/8" × 77/8". Cambridge, Massachusetts, Fogg Art Museum, Harvard University. Bequest of Charles A. Loeser.

3-55. Unknown Herculanean artist, *Hercules and Telephus*, c. 70 A.D. Wall painting, Naples, National Museum.

3-56. Amedeo Modigliani, *Caryatid with African Sculpture*, c. 1913. Pencil. 10¾" × 8½". Mr. and Mrs. James W. Alsdorf collection.

3-57. Unknown Baoule (Ivory Coast) artist, Horned dance mask. Wood. 15" high. Private collection.

3-58. Unknown Congolese artist, *Standing sculptured figures*. Washington, D.C., Smithsonian Institution.

3-59. Picasso, *Page from a sketchbook*, 1897. Pen and ink. 30.8 × 21 cm. Barcelona, Museo Picasso. (Courtesy of S.P.A.D.E.M.)

VARIATIONS AND COMBINATIONS OF LINE

The studies outlined in this chapter are intended to facilitate the study of line drawing by focusing on one concept at a time. The studies offer an effective way to begin drawing seriously, but they are so basic that the accomplished artist will also benefit from them. Practice is the key ingredient in the study of drawing: each study must be repeated many times before the principle it embodies becomes a useful tool for the artist. Repetition of the exercises, however, need not follow this specific order of presentation, and the student should feel free to invent variations or combinations of the different exercises. You may wish, for example, to execute a more controlled contour drawing than is possible by concentrating exclusively on the model, as recommended in study 1. This can be accomplished by glancing back at your drawing page while you work in order to check the relative location of the crayon. Even though your primary concern continues to be observation of the model, greater attention to the placement of the crayon on the paper will produce a less spontaneous drawing. You are likely, however, to gain in control (Figures 3-60 and 3-61).

There are also ways of combining the concept of silhouette (chapter 2) with the rapid-contour method. The drawings of Rodin illustrate one way of doing this: he used a combination of contour line drawn in pencil with silhouette painted in watercolor wash (Figure 3-62). It is significant that Rodin gave each component a slightly different role. The silhouette does not merely reinforce the contour drawing, as it would if it merely filled in the space between the lines. Instead it flows in and around the contours, representing a fresh reevaluation of the general shape. The resulting interaction of the two simple drawing modes creates a surprisingly rich visual effect, strongly suggestive of motion. Technically Rodin's drawings are disarmingly simple. He drew rapidly in pencil on small sheets of paper, generally about ten by twelve inches, looking all the while at the model. Later he added a watercolor wash. The wash silhouette, though it follows the general shape defined by the pencil contours, is often a free reevaluation of the form, adding a unifying sense of the body as a whole and at the same time creating a visual counterpoint between the two media similar to that seen in reflected lights on bronze (Figure 3-63). Rodin himself supplies a rare insight into

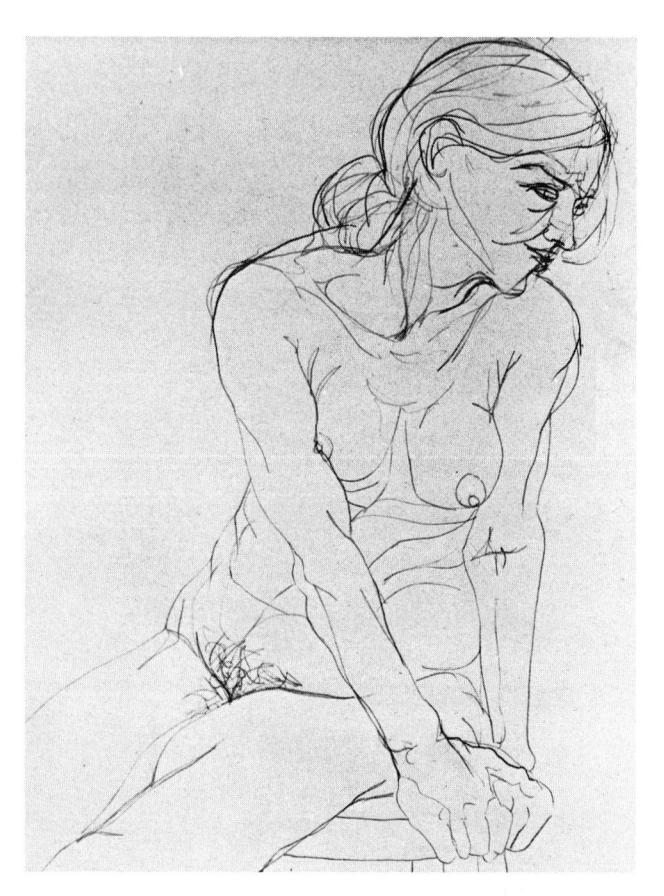

3-60. Student drawing, contour line. Compressed charcoal pencil on newsprint paper. $36'' \times 24''$. Unlike the technique of study 4, here the student looked at both the model and the paper, which resulted in a more controlled drawing.

3-61. Student drawing, contour line. Crayon on newsprint paper. $36'' \times 24''$.

3-62. Rodin, Dancing Figure, pre-1908. Lead pencil and watercolor wash. 12 $3/16'' \times 93/4''$. Washington, D.C., National Gallery of Art.

his method of drawing: "I must become permeated with the secrets of all its [the body's] contours, all the masses that it presents to the eve. I must feel them at the end of my fingers. All this must flow naturally from my eye to my hand. . . . Not once in describing the shape of that mass did I shift my eyes from the model. Why? Because I wanted to be sure that nothing evaded my grasp of it. Not a thought about the technical problem of representing it on paper could be allowed to arrest the flow of my feelings about it, from my eye to my hand. The moment I drop my eyes that flow stops. . . . I try to see the figure as a mass, as volume. It is this voluminousness that I try to understand. This is why . . . I sometimes wash a tint over my drawings. This completes the impression of massiveness, and helps me to ascertain how far I have succeeded in grasping the movement as a mass. . . . My object is to test to what extent my hands already feel what my eyes see."22

Three-dimensional counterparts of Rodin's drawings are his clay "sketches," which were created for much the same purpose as the drawings: namely, as

preparations for larger works of sculpture. Rodin's concern with sculptural form influenced his drawing procedure: only after making the contour drawing from life did he paint the silhouette wash from memory as a way of consolidating the mass of the figure. You may prefer to create the silhouette wash first, establishing the large form of the figure directly from life. The wash, when it has dried, can then function as an armature around which to construct the form in contour line.

The analogy of line drawing to sculpture is carried one step further in the wire figures of Alexander Calder, in which the line is actually three-dimensional (Figure 3-64). Such an unconventional use of line calls for unconventional drawing tools. If you wish to experiment with this medium, you may find a pair of round-nosed pliers helpful in bending the wire into shape, a process that requires time and forethought. The line produced is not likely to be as spontaneous as that resulting from a crayon on paper. Nevertheless it is an exciting means of realizing form, especially if you are ready for challenging new materials.

3-63. Rodin, $Dance\ Movement\ A$, 1911. Bronze. $12^{1/4}''$ high. Philadelphia, Rodin Musuem.

3-64. Alexander Calder, Acrobats, c. 1928. Wire sculpture. (Courtesy of Fernand Hazan éditeur, Paris.) Line is not the exclusive property of the flat surface. Whether it is viewed as a sculpture or as a three-dimensional line drawing, Calder's work suggests a creative and amusing use of an unconventional medium.

OUTLINE, CONTOUR, AND CONSTRUCT

The outline and contour methods of drawing, until this point considered separately, can be and often are combined in a single drawing. There are many advantages to this. The union of the two concepts allows the artist to be more selective in describing form. In drawing the figure, for example, you may wish to use the contour method only to delineate forms that need more spatial explanation in order to be understood. An overlapping contour, as you have seen, can clarify the sequence of forms in terms of spatial depth. In places that do not require such explanation the more economical outline method can be used. The interplay of the two methods can extend the expressive range of a line drawing. Your intuition is the best guide in deciding which passages of the drawing require contour, and which outline, but you may find, as I have, that it is helpful to practice restraint in combining the two.

Combining outline and contour in a line drawing is not difficult, and after you have become accustomed to it, you may be ready to add yet a third factor: the oval constructs described in study 7. In that study, you will recall, form was drawn in terms of body shapes that were interpreted as ovoid units. Instead of actually drawing the complete oval constructs of the figure, as you did in study 7, try drawing only those portions that are part of an outline or contour of the form you wish to represent (Figure 3-65). As you draw, it is helpful to visualize the complete construct, even though your drawing will show only portions of that construct. This technique is simply a more economical version of the procedure followed in study 7; much that was drawn in that study can be left out. Nevertheless, a certain amount of practice is usually necessary in order to bring these three concepts together in a free, spontaneous drawing (Figure 3-66). Despite the simple appearance of such a drawing, the method involves the visualization and reduction of constructs that can be quite complex in the human form. Concentration is necessary in order to see body structure in terms of ovoid units and at the same time to draw only enough of them to communicate the forms that they encompass. Economy of means is of the essence. It is the method's ability to suggest rather than to completely describe form that engenders the elegance of similar effects seen in some classical drawings (Figure 3-67).

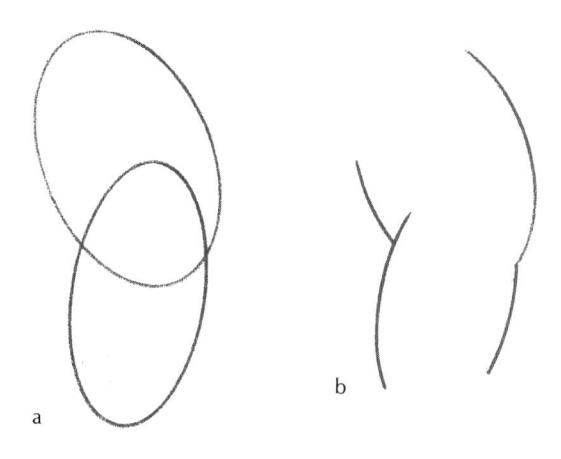

3-65. Oval drawing constructs. (a) Intersection of two oval constructs. (b) Two oval constructs, similar to (a) but with most of the intersecting portions eliminated. The spatial order of the two constructs is suggested by overlapping on the left side, while the right side shows only outline.

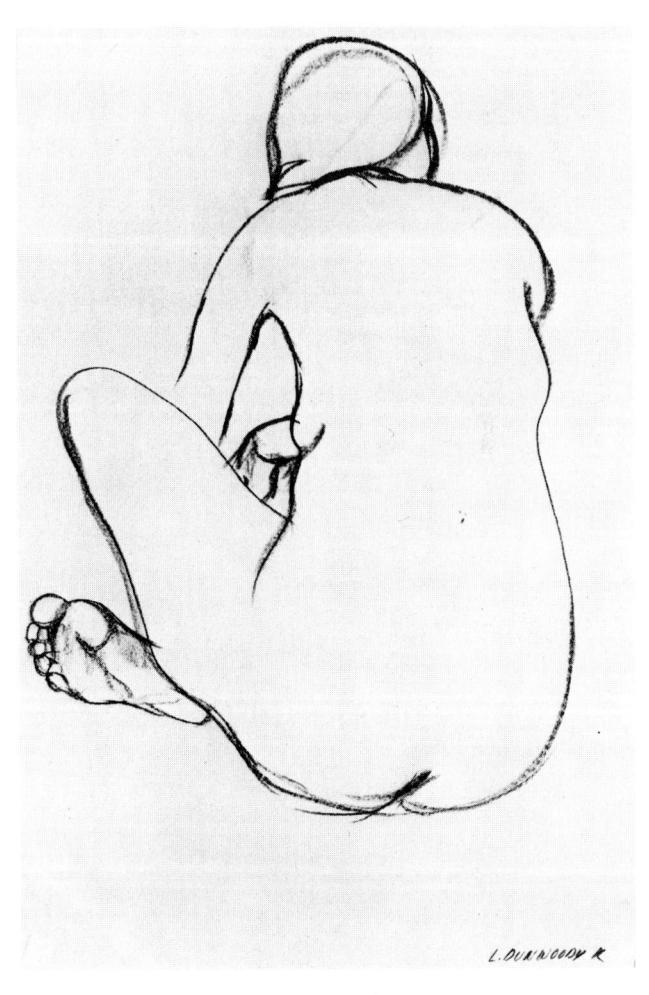

3-66. Student drawing, oval constructs with contour and outline. Crayon on newsprint paper. $36'' \times 24''$.

3-67. Greek, Phiale painter, Hermes Waiting for a Woman [partially visible on the right] Departing for the Underworld, c. 440–430 B.C. White-ground lekythos (pottery oil flask) Munich, Glyptothek.

SUMMARY

Both the beginner and the more advanced student may appreciate the way in which contour drawing frees the eye and the hand from preconceived notions of proportion and scale. Emphasis on "correct" proportions, while not intrinsically undesirable, can inhibit the drawing process, causing tightness and excessive control. The deliberately slow movement of the eye and hand in the first contour exercise (study 4) should result in an extremely sensitive line, which, like a seismograph, records the small changes of form, often at the expense of the organic unity of the whole. A sense of the unity of the large form is more readily grasped through more rapid eye and hand movement.

Like the slow contour drawing, rapid studies are recommended for both beginners and advanced students. For the beginner they provide a way of grasping the essential unity of the large components of the human form. The brevity of such exercises makes them an excellent warmup for the advanced student. The sense of breadth and movement generated by rapid drawing makes it a useful method for almost any artist. Since the hand must move at a much greater speed than in study 4, the drawing produced does not have the delicacy of line characteristic of the slow contour drawing. The heightened sense of movement and gesture in the rapid drawing, however, more than compensates for the lack of linear detail. Some artists call this approach gesture drawing. The gesture inherent in rapid drawing, however, is as much the gesture of eye movement as it is that of the model.

Although the contour method can produce drawings of remarkable spontaneity and freshness, it tends to limit the degree of formal development within a drawing. Different methods, such as modeling (chapter 5), allow greater description of form, but it is well to consider the need for such description before switching one's drawing method. How much formal training development (i.e., visual information) is needed in a drawing? It is tempting to answer that "less is more," the dictum of the modern architect Miës van der Rohe. For the beginning draftsman this answer is often proper, yet it fails to take into account the expressive power of

highly developed master drawings. A partial answer to the question, however, may be suggested by the concept or idea underlying a drawing. In your drawing of the double pose (study 11), for example, the visual idea of movement seems to suggest the contour method: the visual movement inherent in line makes this method appropriate. A more complete description of the two figures—the ostensible subject of the drawing-would be of doubtful value in portraving the idea of motion. Surprisingly, motion is also fundamental to the perception of form, for movement, "far from obscuring the shapes and spatial relations of things . . . generally clarifies them."23 Artists in the past were not unaware of this principle.²⁴ Michelangelo sometimes drew figures in motion by superimposing contours of the body in different positions as a way of resolving a single ideal representation of the moving body (Figure 3-41).

Motion is associated with the idea of line itself. The Greek geometer Euclid defined line as the path of a moving point in space. This definition takes on special meaning when you consider that in Euclid's view a point signifies a place (locus) in space but does not occupy it. Pure geometric line is a completely abstract concept. It follows that the draftsman's lines, all of which have physical width, are merely marks that represent lines in the geometric sense. The drawn line symbolizes the "true" (geometric) line. A line drawing, therefore, is an especially abstract transformation of the visible world, involving two levels of abstraction: the abstraction of the line itself and the abstraction of the observed form into line. Understanding the geometric meaning of line is of particular importance if art is, as many believe, essentially a process of transforming reality, for it may explain the abstract quality apparent in even the most naturalistic line drawings. To some students the simple but profound transformation that is effected through a line drawing may seem too abstract. The techniques of modeling described in chapter 5 may provide a degree of realism that is better suited to their artistic purposes. Other students, however, may prefer the linear mode because of its abstractness. This preference is implicit in Picasso's declaration that "Only line drawing escapes imitation."25

4. LINE:

The Classic Drawing Method, Proportion, and Symmetry

4-1. Achilles painter (active c. 460–430 B.C.). A Woman Holding a Warrior's Helmet. Attic. Brush drawing on a pottery oil flask (lekythos). London, British Museum.

Ideal form consists . . . in the harmonious proportion of the parts, the proportion of one finger to the other, of all the fingers to the rest of the hand, of the rest of the hand to the wrist, of these to the forearm, of the forearm to the whole arm, in fine, of all parts to all others as it is written in the canon of Polyclitus.—Galen

THE CLASSIC DRAWING METHOD

The linear drawing method described in chapter 3 is similar to the method employed by Greek artists in the fifth to fourth century B.C., the classical period (Figures 4-1 and 4-2), and for this reason it is called *classic*. The conventions of classic drawing, however, were not limited to Greek art: they appear in a variety of cultures as remote in time and place as the Mayan art of Mexico, the Japanese print (Figure 3-32), and the Ajanta paintings of India. Western ideas of classic methods, however, are derived largely from the classical art of Greece.

The linear method of classical art was revived in fifteenth-century Italy when artists began to reject the flat, schematic constructs of medieval art (Figure 1-3) in favor of the rounded constructs of ancient art. An especially clear instance of the classic outline-contour method is seen in Pollaiuolo's fresco, Dancing Nudes (Figure 4-3). Not only are the rounded constructs and the sharp separation of figure and ground classical in quality, but the gestures of the figures themselves seem to be derived from ancient art. Despite the obvious derivation the frescoes are unmistakably Renaissance in feeling, partly because of the description of anatomical structure and detail, which goes beyond the more general rhythmic forms of classical art and results in a slight awkwardness of the figures. The close attention paid to anatomical form reflects the empirical spirit of scientific inquiry in the Renaissance.

The vitality of the classic drawing method has been demonstrated in periodic revivals not only in Renaissance Italy but also in nineteenth-century France. Leading artists such as Ingres found inspiration in the linear mode of ancient art (Figure 3-54). In the twentieth century, which has been largely dominated by abstract art, classic methods have enjoyed a more limited revival, yet paradoxically the modern movement has sometimes produced art that is closer in spirit and technique to ancient Greece than to works of the preceding century. Picasso, for example, returning to the severe outline-contour method seen in ancient mirror drawings (Figure 4-2) and vases, created line drawings that closely parallel classical art (Figure 4-10). As in classical art many of Picasso's figures are drawn with constructs that reflect a rational ideal form rather than the appearance of a specific individual.

CLASSICAL PROPORTIONS

The outline-contour method noted in classic drawings, such as those by Picasso, is often accompanied by another feature, also derived from classical antiquity—a system of *ideal proportions*. In the broadest sense proportion in drawing simply refers to the relative size (ratio) of one part to another. The classical system (canon) of proportion proposes a set of ratios that makes possible an integrated, harmonious figure construction. Though based on the natural forms of the human body, the system presupposes the existence of "ideal" norms and hence an ideal figure. This concept has much in common with Greek idealism, a philosophy that interprets existing things as imperfect reflections of transcendent "perfect" ideas.

4-2. Anonymous Greek artist, *Aphrodite and Pan Playing at Dice*, 4th century B.C. Engraved underside of a mirror cover. London, British Museum.

According to the Roman architect Vitruvius, the Greeks preferred the word analogia (analogy) to describe the proportional relationship of forms.² The remarkable similarity of proportions observed in nearly all works of classical Greek art suggests that the formal "analogies" were functions of fixed rules, or canons. However, aside from a passing reference to the canon of Polyclitus in the work of the later Roman author Galen, no ancient canons have been preserved in a complete written form, although they are assuredly embodied in some works of classical sculpture. By drawing from classical sculpture (as Picasso did as a young student) it is possible to gain a sense of such formal relationships (Figure 5-43).

The canons themselves were the result of a long process of artistic evolution. The earlier, more schematic representations of the figure seen in archaic Greek art (sixth century B.C.) show similarities to Egyptian sculpture. It was not until the fifth century B.C. that figural representations reflected a closer correspondence to human proportions. The classical canons, however, were not the result of measured translations of the body forms of live models (as in the drawings of some Renaissance artists centuries later). They were a system of proportional norms of an ideal human figure, gradually refined by artists through their work.³

The Greek artist of the classical period did not use visual measurement merely to translate appearance into art, though *mimesis* (mimicry of nature) was a vital factor in Greek art. His primary aim was to

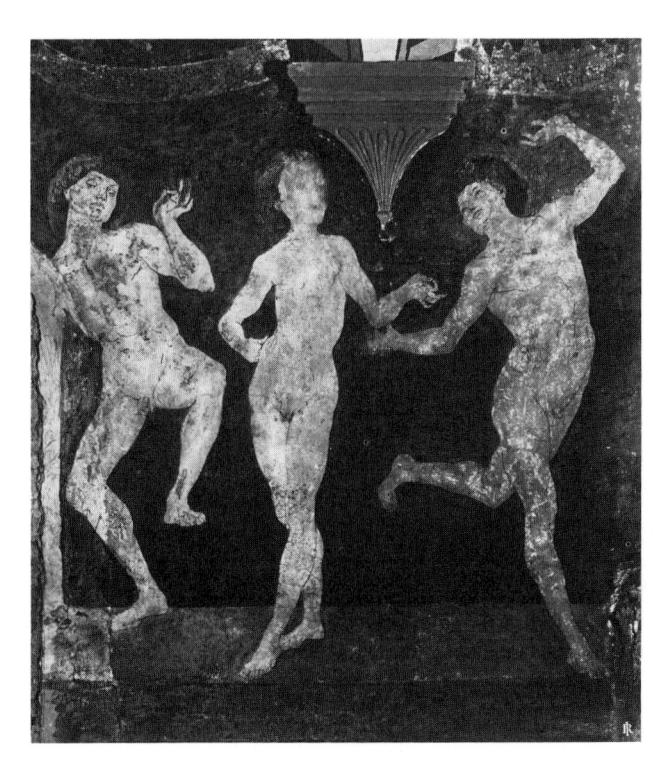

4-3. Antonio Pollaiuolo (1431-1498). *Dancing Nudes*. Fresco. Florence, Torre del Gallo. (Courtesy of Alinari.)

create ideal form—hence the need for a canon of proportion to refine his raw observations from life into ideal representations that accorded with the religious and philosophical beliefs of his culture. Polyclitus himself is believed to have said that ". . . the beautiful comes about, little by little, through many numbers." The Greek idea of a canon based on numerical fractions was adopted by the Romans, as described in a text by Vitruvius, around 25 B.C. He used proportional relationships of body forms to justify the geometrical forms employed in designing temples. In addition to using a system based on numerical fractions, he also found "perfect" geometrical forms (i.e., the circle and the square) in the body.

Although the writings of Vitruvius were not unknown in the Middle Ages, medieval artists largely ignored the classical canons and resorted to schematic representations of the human figure (Figure 1-3). The geometrical system of proportions was revived in the fifteenth century when Italian artists began to rediscover the monuments and writings of the classical past. Some of the most important artists of the day, including Leonardo and Dürer, drew studies of the figure according to the instructions of Vitruvius (Figures 4-4 and 4-5), not only to learn how to draw the figure in classical proportions but also as a form of speculative research aimed, it seems, at establishing a correlation between visual art and philosophy. (Such a link was established with music in ancient Greece when the philosopher Pythagoras divided a vibrating string into fractional parts, thereby demonstrating the mathematical basis of harmony.) For the Renaissance artist, Vitruvius' writings conferred the perfection of ideal geometric forms on the forms of the body and consequently conferred a new intellectual status on Renaissance art. Such status was one way of justifying the Renaissance artist's claim to superiority over the "craftsmen" of the Middle Ages.

Despite many careful proportional studies by Renaissance artists no conclusive mathematical relationships among "harmonious" forms of the body were established, as with musical harmony.5 Yet such studies were an influential factor that contributed to the harmonious appearance of the figures and compositions of many works by Renaissance artists. Leonardo, for example, expressed a deep interest in proportional relationships both in his art and in his writing and gave practical advice on how to achieve them: "All parts of any animal exist in relationship to the whole; that is, those short and stocky ought to have each part short and stocky, and those long and thin should have parts that are long and thin, and the medium-sized should also have medium-sized parts."6

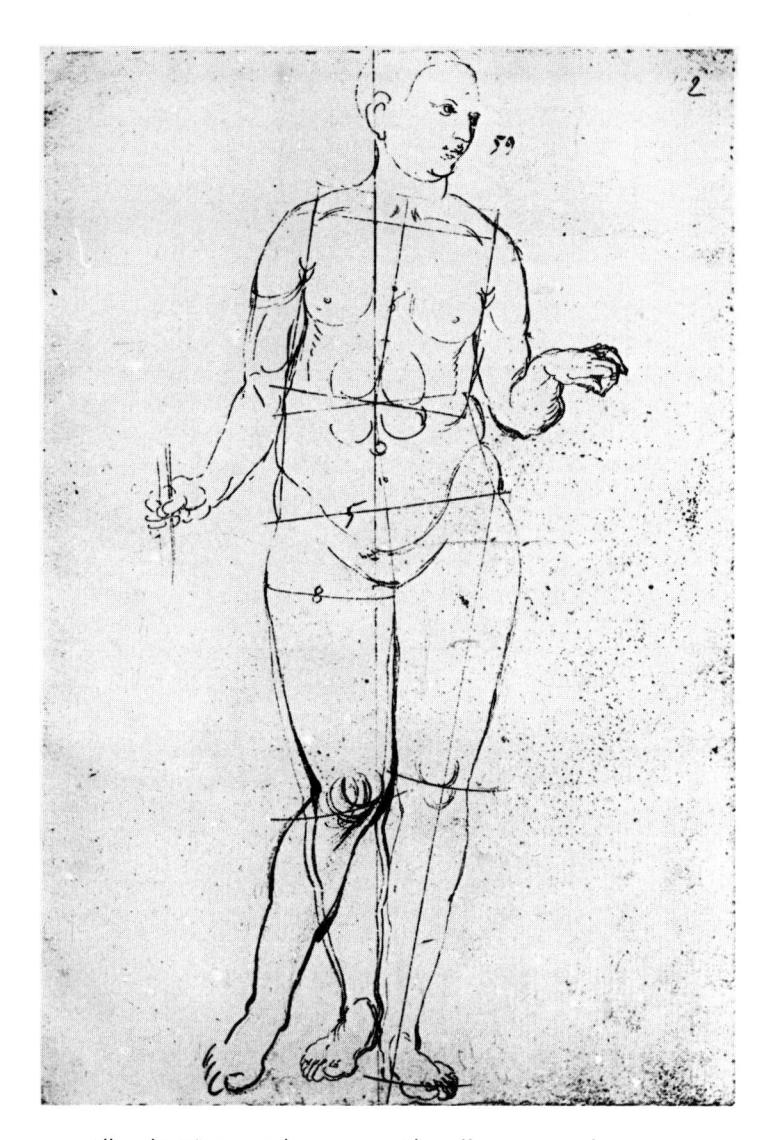

4-4. Albrecht Dürer, Nude woman with staff, constructed, c. 1500. Pen-and-ink with ruler. 290 \times 194 mm (11 $_{3/8}'' \times 7$ $_{5/8}''$). Dresden, Sächsische Landesbibliothek. Based on a proportional canon of the Roman author Vitruvius, the figure shows cross axes that relate the forms of the shoulders with those of the lower abdomen. These axes are helpful in constructing a figure from life.

4-5. Leonardo da Vinci, *A study of proportions after Vitruvius*, 1485–90. Pen-and-ink. 34.3 × 24.5 cm. Venice, Accademia. In this drawing Leonardo interpreted a statement on proportions by Vitruvius: "... the navel is naturally the exact centre of the body. For if a man lies on his back with hands and feet outspread, and the centre of a circle is placed on his navel, his figure and toes will be touched by the circumference. Also a square will be found described within the figure, in the same way as a round figure is produced (*On Architecture*, Book III, c. 1).

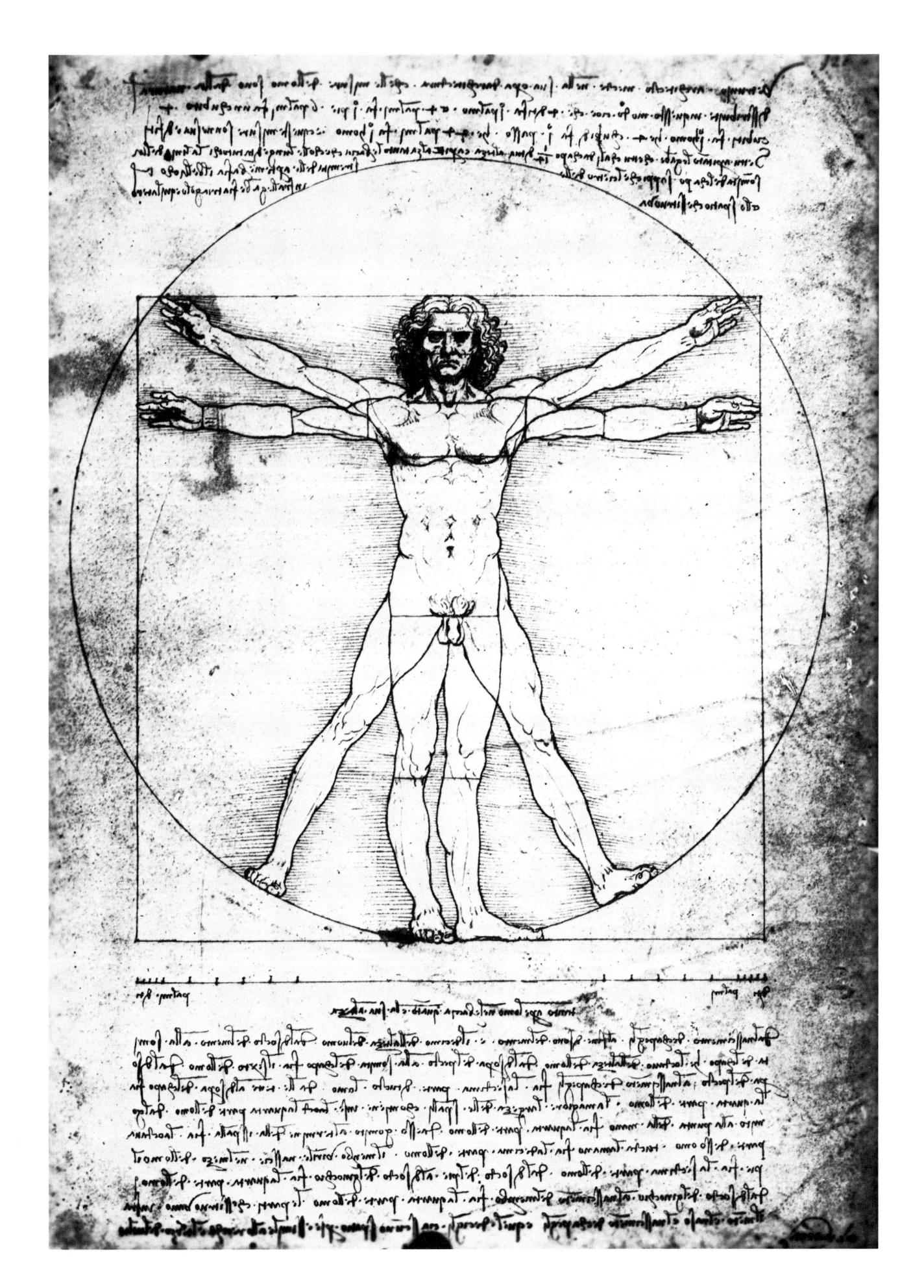

Long after the Renaissance period artists continued to be haunted by the concept of ideal human proportions and the symmetry that such proportions imply. Bernini, the seventeenth-century sculptor and architect, drew an idealized figure representing God the Father in order to explain his design for the loggia of the Vatican—even though it was necessary to bend the figure's arms out of shape to fit the design (Figure 4-6).

It is natural that human proportions should be relevant to the architectural structures designed for human habitation, and it is for this reason that the concept of ideal proportions has survived to a greater extent in the field of architecture than in the pictorial arts. The architectural studies of the twentieth-century architect Le Corbusier provide an outstanding example. In a manner not unlike that of Vitruvius, Le Corbusier derived geometric shapes and ratios from a schematic drawing of the human figure—the Modulor—representing proportional norms (Figure 4-7). Instead of deriving the Vitruvian circle and square from the figure, however, Le Corbusier derived the *golden section*, 7 a rectangular proportion of ancient Greek origin.

The study of ideal proportion was part of the curriculum in most European art academies. In the French Academy, for example, a drawing instructor would not hesitate to "correct" a student by imposing classical proportions on a figure that by academic standards was drawn too naturalistically. Although such academic instruction produced draftsmen of great expressive power in the seventeenth and eighteenth centuries, by the late nineteenth century classical proportion was no longer a vital art concept. It had come to be the hallmark of many lifeless paintings and sculptures produced by members of the academic art establishment, a circumstance to which is owed the modern pejorative term "academic." The study of human proportions has continued as a vital discipline in medical morphology, however, where it is used as a diagnostic tool (Figure 4-8). Although the medical study of human porportions is not concerned with idealized form, it does represent a continuation of the investigation of actual body forms begun by Renaissance artists as the basis for theories of ideal form.8

The concept of ideal human proportions has not recently aroused interest as a vehicle of expression in the visual arts. Yet the ideal figure retains a unique potential for visual communication, a potential that has not been overlooked in the commercial arts. The clothing-store mannikin, for example, usually represents an idealized figure. Two ideal-figure representations were recently sent into outer space by the National Aeronautics and Space Administration as a means of communicating with intelligent beings of other worlds (Figure 4-9). The figures are rendered in a linear style vaguely resembling that of classical art, though

sadly lacking in the high degree of quality generally associated with such art. Perhaps the intelligent beings in outer space will recognize this work for what it is—the product of a scientific rather than an artistic effort.

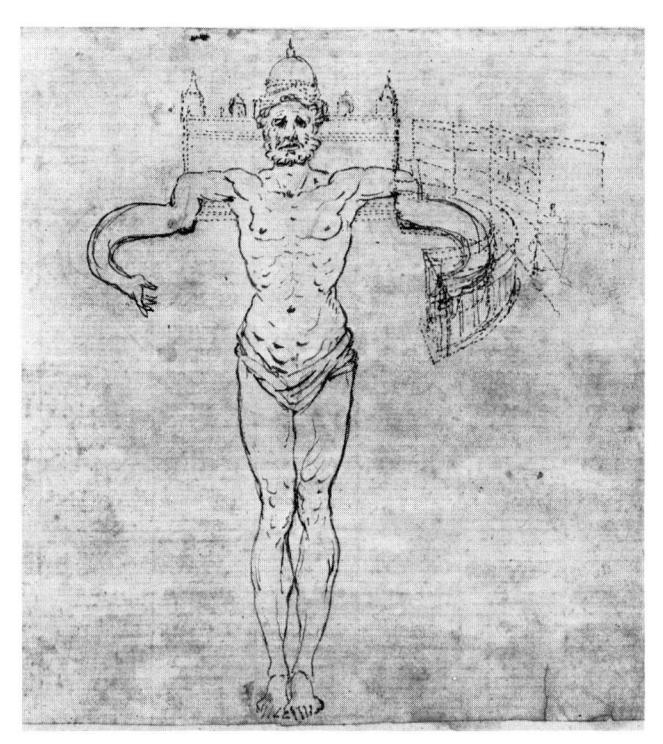

4-6. Bernini, Allegorical drawing of the plan of Saint Peter's Square, c. 1656. Rome, Library of the Vatiçan.

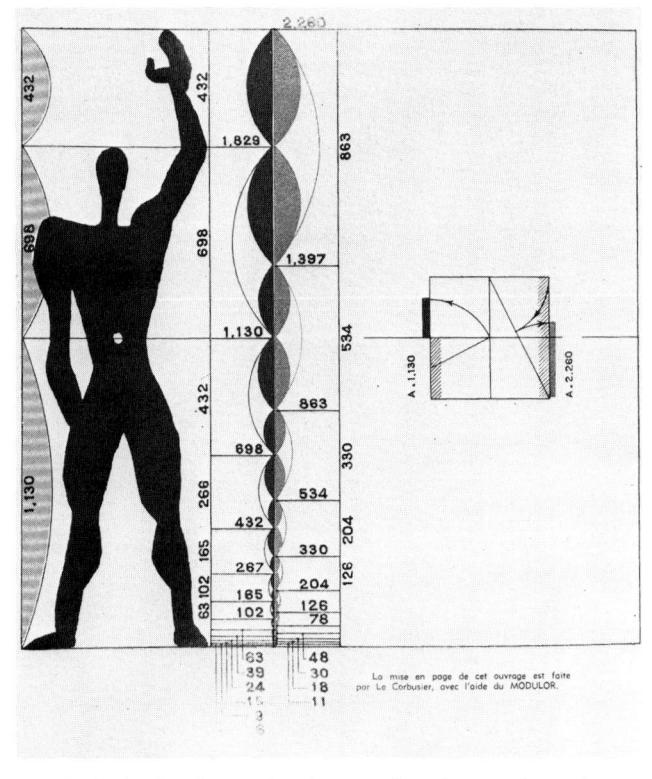

4-7. Le Corbusier, Proportional system based on a schematic figure, le Modulor, 1949. Illustration from the book Le Modulor by Le Corbusier.
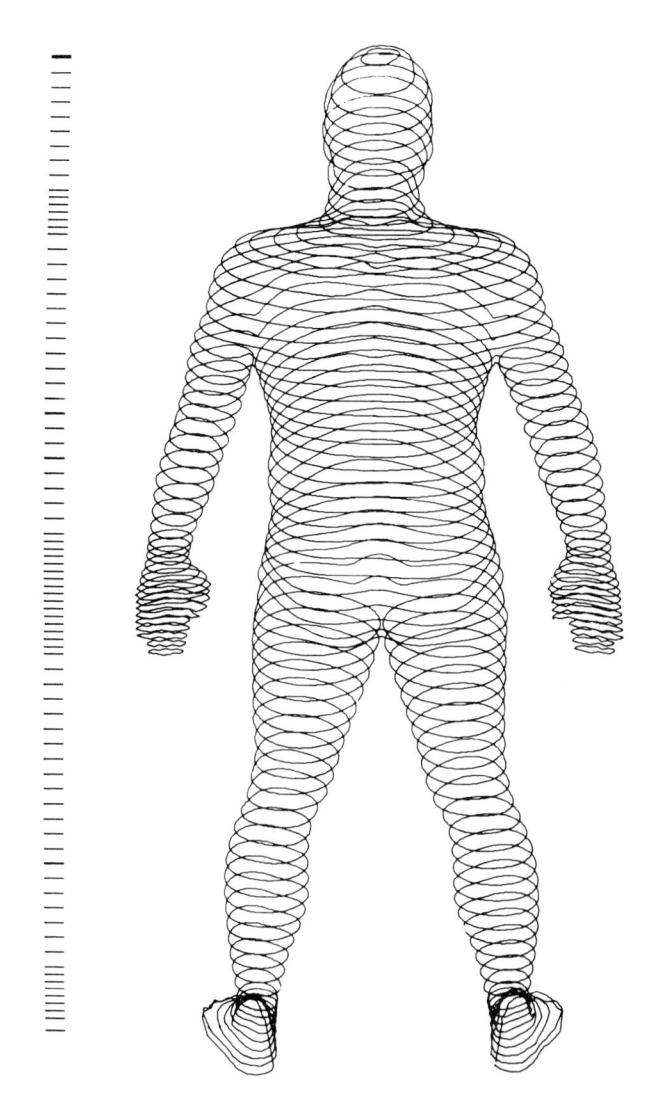

4-8. Dr. R. E. Herron, Computer drawing (plot) of the proportional volumes of a human subject. (Courtesy of Biostereometrics Laboratory, Baylor College of Medicine, Houston.) The cross-sectional figure (left) is translated into a bar graph that illustrates relative and absolute volumes of the body.

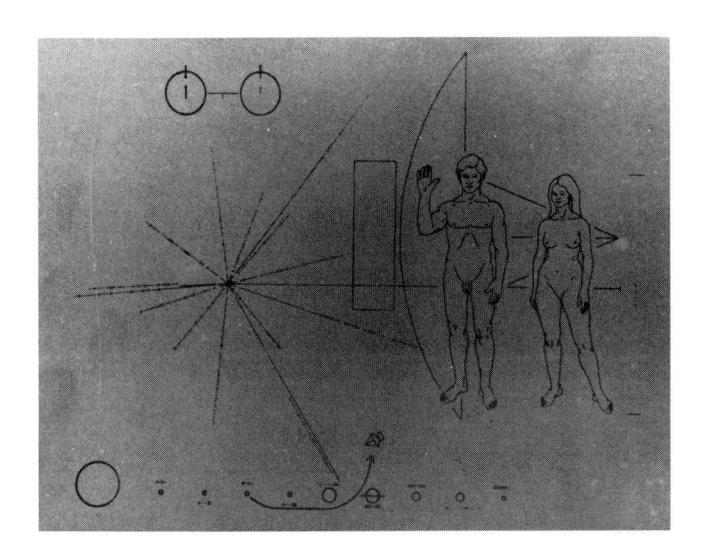

4-9. National Aeronautics and Space Administration, *Pioneer F plaque*, 1972. Etched gold-anodized aluminum plate. 152 × 229 mm. (Photograph courtesy of NASA.) "The Pioneer F spacecraft, destined to be the first man-made object to escape from the solar system into interstellar space," NASA states, "carries this pictorial plaque. It is designed to show scientifically educated inhabitants of some other star system—who might intercept it millions of years from now—when Pioneer was launched, from where, and by what kind of beings."

PROPORTIONAL CANONS

Rules of proportion are not and never have been a guarantee of quality in a drawing. In practice proportions (i.e., the analogous relationships of forms) develop largely as a side effect of the artist's drawing method and purpose rather than from a conscious effort to use proportional rules and measures. A systematic drawing method is the most reliable way of creating harmonious forms in a figure. For this reason the actual method of constructing drawn forms and the concept implicit in the method are stressed in this book: visual measurement of angles, rather than proportional norms, is presented as a specific method of achieving correspondence with objective reality. A number of popular texts optimistically present proportional guides as the answer to "how-to-do-it," but in reality applying such memorized rules can impede and restrict rather than help you in drawing from life because of the preconceptions that they impose between you and objective observation. Although the proportions given in such books are usually derived from an ideal figure, their origin is often left unexplained, implying that the rules are in some way absolute. This has the effect not only of masking the unintended cultural bias present in the rules but also of ignoring the existence of other canons of proportion, which, although not classical, are nevertheless equally valid—such as those admired and studied by Modigliani in African art (Figures 3-56 and 3-57).

Although strict rules of proportion have little application in life drawing today, there remain one or two uses for proportional guides. If you tend to draw the top of the figure too large in proportion to the lower portion or vice versa, for example, it can be helpful to know that the midpoint of the body generally lies just above the genitals (the top of the genital triangle), as seen in Leonardo's Vitruvian Man (Figure 4-5). By marking light lines at this point and under the heel of the figure you can estimate the proper measure from the top of the genital triangle to the top of the head in the standing figure, which should be the same as the lower interval. Note, however, that this measurement is valid only for the standing figure—and the average (ideal) standing figure at that. In drawing from life the rule is useful primarily as a way of checking or reevaluating what you have done.

A second type of guide, more anatomical than proportional, is seen in a Vitruvian study by Dürer (Figure 4-4). In this study the cross axes of the body are shown as straight lines that traverse the figure at the hip (pelvic) level and at the shoulder level. Their respective tilt reflects a natural shift of forms that is due to the underlying skeletal structure. Known as the shoulder and pelvic axes, these lines can be very helpful in constructing convincing and

consistent connections (articulations) of the arm with the shoulder and the leg with the abdomen—problems that often baffle the beginning draftsman. They can also be useful in drawing rapidly for gesture.

Today the artist exercises practically unlimited freedom in drawing proportions of the human form-which has its disadvantages as well as advantages. In ancient times the same proportional canons were accepted within the classical world, since artists shared a common standard and training.9 Modifications were slight and came gradually. Our more pluralistic society seems to lack the cultural consensus necessary to codify rules of this kind, which leaves the artist with what can be an exciting but sometimes bewildering variety of choices. The choices, however, are narrowed greatly by the artist's purpose. In drawing from life your purpose may be to create a two-dimensional analogy of the proportions perceived in the live model rather than an analogy with a preconceived canon of classical proportion. Such a decision on your part need not be final, of course, but it will strongly influence the character of your drawing.

PROPORTION AND SYMMETRY

The special qualities and importance of classical canons of proportion are immediately apparent when you consider two drawings that are technically similar but differ greatly in figure proportions. Such a contrast is apparent in Picasso's ink drawing Little Girl Playing Ball (Figure 4-10) and the lithograph Bourgeois Society by the modern German artist George Grosz (Figure 4-11). In the ink drawing Picasso maintains the consistent and harmonious relationship of "all parts to the others" that is traditionally associated with classical proportions. In the lithograph by Grosz, however, the relative size of figural components (i.e., head, arm, and hand) is altered with the unbridled freedom of a child. The oval construct of the head, for example. is proportionally a different size in almost every figure. Such proportional variation enables the artist to include an astonishing amount of narrative detail, much of which is anything but childish. The deliberate violation of ideal proportions is emphasized all the more by Grosz's use of the classic outline-contour method, adding to the sense of outrage and social criticism that the drawing communicates. The word "deliberate" bears repeating in connection with this drawing, for Grosz was an accomplished draftsman, well known for his masterly studies from the live model (Figure 7-20).

^{4-10.} Picasso, Little Girl Playing Ball, 1902. India ink. 28.8×19 cm. Baltimore Museum of Art. Cone Collection.

What accounts for the immediacy with which one comprehends the figures of the Grosz drawing despite their lack of correspondence with objective or ideal proportions? And why do so many works of "primitive" art exhibit figures with a similar set of proportions? At present there is no satisfactory answer to such questions, but the answer must include cultural, psychological, and physiological factors.

Reactions to such figures may spring from an intuitive inner sense of individual body form. If you close your eyes for a few moments and try to imagine the form of your body, you may find it difficult to retain an objective sense of your body proportions. Your head and particularly your face may seem very large in relation to the rest of your body. Yet you will probably retain a sense of equal proportion between the right and left sides of your body—in other words, a sense of your body's symmetry. For example, no matter how small your arms

may seem, your right and left arms will seem to be the same size. The Grosz drawing shows a similar phenomenon: the head is drawn disproportionately large in some of the figures, but the symmetry of the forms is maintained.

Symmetry, though traditionally associated with ideal proportions and classical art (Figure 4-12), can be developed as an independent concept, as in "primitive" or anticlassical figure representation. This suggests that symmetry is a more fundamental feature in art than ideal proportion. Psychologists have discovered a general human tendency to perceive any shape with the maximum degree of simplicity, regularity, and symmetry. This may account in part for the frequently strong and disturbing emotional impact of seeing a markedly asymmetrical representation of the human face, a form whose features are basically symmetrical (Figure 4-13).

4-11. George Grosz, *Bourgeois Society*, 1920. Illustration from *Ecce Homo*. Lithograph. $8\,1/4'' \times 10\,3/8''$. New York, Museum of Modern Art.

4-12. Unknown Greek Cypriote artist, *Stone carving*, 5th century B.C. Rome, Museo Barracco. Formal elements of the head appear to have been conceived along a vertical line of bilateral symmetry, which is analogous to the natural symmetry of the human body.

4-13. Picasso, Man's head, 1937. Study for Guernica. Pencil and wash on paper. $9\,_{1/4}$ " × $11\,_{1/2}$ ". On extended loan to the Museum of Modern Art, New York, from the estate of the artist.

Symmetry in art parallels the bilateral symmetry of the body, which is seen not only in its exterior forms but also in its structural makeup, notably in the skeleton, the muscles, and the nervous system.¹¹ The eyes themselves partake of the body's bilateral structure. It seems reasonable that our sense of symmetrical structure in visual form has its basis in the symmetrical structure of the body. Attempts to represent proportionate areas of the brain as devoted to parts of the body have resulted in figures that appear to correspond more with primitive proportions than with those of classical art (Figure 4-14). Such figures suggest a possible physiological basis for the potent immediacy of primitive art. Conversely, a sense of ideal proportions as an artistic phenomenon may be a product of observation and reflection, not solely of intuition or instinct.

SUMMARY

The system of classical proportion as first formulated by the ancient Greek artists was indissolubly linked to ideas of symmetry. In addition to the word analogia the Greeks used the word symmetria to signify proportion—the commensurability of all parts of a statue. 12 Although the ancient Greek artist classical concepts of proportion and symmetry were primarily expressed in a linear mode, but a classical system of proportion need not be limited to a linear style. Proportion as a system of visual analogy is a fundamental concept in figurative art that has wideranging applications in a variety of drawing techniques, including those of a nonlinear nature such as modeling.

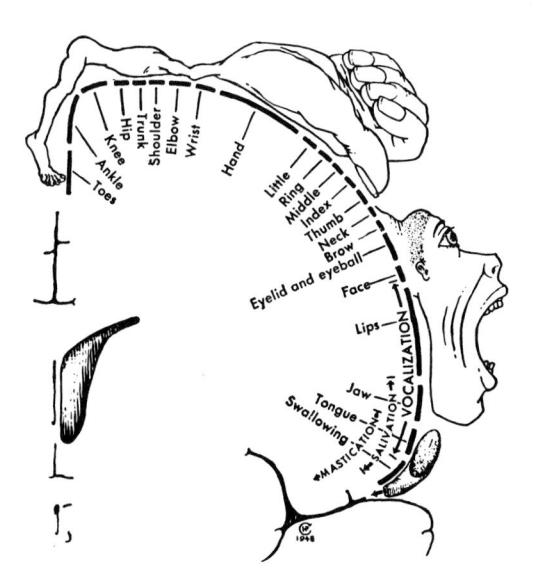

4-14. Homunculus. (Wilder Penfield and H. Rasmussen, *The Cerebral Cortex of Man* [New York: Macmillan Co., 1950], figure 22.) The homunculus, a disjointed human figure, illustrates how much of the human cortex (represented in cross section) is devoted to motor control of various regions of the body; compare figures 1-1 and 3-58.

5. MODELING:

Relief, Shadow, Tone, and Contour

There are no lines in nature, only lighted forms and forms which are in shadow, planes which project and planes which recede.—Francisco Goya

The view of nature espoused by the Spanish artist Francisco Goya is not merely a rationale concocted to explain why so few contour lines appear in his work: it expresses an attitude that has been held by many artists of many different persuasions and that is shared by contemporary psychologists concerned with visual perception. Recent studies in this field draw attention to the fact that "... the world we ordinarily look at consists mostly of surfaces, at various angles and in various relations to one another." 1

What you may interpret as the lines of an object often prove on closer inspection to be sharply turning areas on its surface, as the corners of a cube (Figure 5-1). Such surface discontinuities are commonly reinforced by the effects of light, resulting in comparable discontinuities of tone on the surface. A line drawing of a cube defines the form strictly in terms of discontinuities, suppressing the essential surface continuity of the object (Figure 5-2). It is understandable, therefore, that some artists prefer a mode of drawing that takes into account the physical surface continuity of forms in nature—its "planes which project and planes which recede" and their attendant effects of tonality. This alternative approach to drawing is generally called modeling.

5-1. The effect of light on a white cube.

5-2. Line representation suppresses the surface continuity of a cube.

Modeling is more, however, than a mere graphic representation of the surface of an object. A lithograph by the American artist Jasper Johns (Figure 5-3) helps to clarify this point. It is an impression made from the actual surface of the human head. The resulting image of human topology, though derived from a solid form, lacks any suggestion of the surface's orientation in three-dimensional space. Moreover, the limitations of human vision are ignored in the lithograph, which shows more of the surface of the head than is normally possible at one time from any single point of view. (A comparable representation of a box would show it unfolded as a flat piece of cardboard.) Johns has documented a facet of objective reality divorced from its spatial context; modeling techniques, by contrast, enable the artist to describe surfaces of forms within the context of three-dimensional space. A modeled drawing by the modern French sculptor Aristide Maillol (Figure 5-4) uses tone to suggest the body surfaces turning around volumetric form as seen from a specific point of view.

5-3. Jasper Johns (b. 1930), *Study for* Skin I, 1962. Lithograph. 22" × 34". Artist's collection. Adopting a technique borrowed from police fingerprinting, the artist recorded the surfaces of his face, palms, and fingers, producing an image of the head's surfaces without a sense of its volumes.

5-4. Aristide Maillol (1861–1944), Female Nude Seen from the Back. Red chalk. 12 $1/4'' \times 4 1/2''$. Philadelphia Museum of Art. McIlhenny Fund.

RELIEF MODELING

Maillol's drawing employs a beautifully simple modeling principle. Dark tones are used to signify surfaces that are turned away from the viewer; light tones, surfaces that front (face) the viewer. The dark tones in the Maillol drawing are imposed arbitrarily without reference to natural lighting effects in order to give a sense of sculptural relief to the form. For this reason the method is called *relief modeling*.

Relief modeling has much in common with the modeling of clay: the term itself is borrowed from sculpture (Figure 5-5). In making a clay relief the sculptor works and shapes the clay, pushing back forms that are meant to recede in space. The fingers often serve directly as modeling instruments. By an extension of the sculptor's technique you can use your hand as an instrument in modeling a drawing.

5-5. Matteo de' Pasti, Isotta da Rimini (1446–1467). Bronze medal (enlarged). Florence, Museo Nazionale. (Ludwig Goldscheider, Unknown Renaissance Portraits [New York: Phaidon, Praeger]. Photo courtesy of Phaidon Photo Archive.)

STUDY 14. RELIEF MODELING WITH PRINTING INK

Materials:

36"-x-24" newsprint drawing pad easel or straight-back chair Masonite or plywood board and

clamps

stand or small table

black or brown oil-base wood-

block-printing ink 5" ink roller

pane of glass (minimum size

 $10'' \times 12'' \times 1/8''$

small roll of masking tape (to cover the sharp edges of the

glass)

turpentine and rag (to clean the

plate and hands)

Reference: Suggested time:

model 15 minutes

For your first experience in modeling the figure it is helpful though not necessary to arrange your easel and drawing pad so that you can draw while you observe the model from the same side and direction as the source of light. With this arrangement the visual effect of relief modeling appears ready-made on the model (Figure 5-5): "the greater density of shadows are created on the sides where the parts of the body are most curved [turned from you], and the least dark shades will be found on the flattest sides [facing you]."2 In a studio situation this may require a drawing position between the window and the model stand. If this arrangement is not possible, you will have to disregard the appearance of light and dark values on the model and apply tone to the drawing strictly in terms of sculptural form, with dark shading signifying surfaces that turn away. The highest value, the white of the paper, will remain in areas of the figure representing the surfaces that are flat with respect to your field of vision.

You may wish to arrange your drawing materials on a stand by your easel so that the pane of glass may be laid flat and is within easy reach when you begin to draw. Squeeze a small amount of printing ink on the glass pane and spread it with the roller until it has the consistency of a thin film. Before you start to draw, it is wise to clarify your mental picture of the model. From a single viewpoint the three-dimensionality of the model's form may not be apparent. By walking slowly around the model, however, and observing the disposition of the form in space it becomes somewhat easier to interpret the specific view from your position at the easel. When you are ready to begin to draw, press the fingertips of your drawing hand into the film of ink on the glass pane. The ink that your hands pick up will mark the paper wherever you touch it.

Observe the model carefully, asking yourself which surfaces of the figure are most turned from your line of sight and which face you. Your recollections of form gained by walking around the model will help you determine the answers to such questions. With a general notion of the form in mind press your inked fingers against the drawing paper, imagining as you do so that you are pushing back the surfaces that are most recessive, as you might if you were modeling a clay relief. Work rapidly, concentrating on the most generalized forms of the figure. Within a period of 15 minutes the figure should take shape in your drawing. The illusion of volume and relief (sometimes referred to as *mass*) may be quite strong even on your first try (Figures 5-6 and 5-7).

Throughout the drawing process it is vital to employ your tactile sense of form. You may find it helpful to imagine that you are reaching for and touching the model. Search out the ways in which forms recede and turn (Figure 5-8). Using your fingerprints to draw may seem so natural that it scarcely needs explanation, but a few hints can make it easier. With your fingers lightly inked you can lay in the general

shape of the figure with light tones, saving the deeper values until you are more certain of their position. In modeling the more subtle passages of form you may wish to use scarcely any ink at all.

As always, it is best to avoid overworking the drawing. In a longer drawing session you can sustain a unity and spontaneity of effect by modeling the subtler changes of form within the large forms of the figure. In modeling the head, for example, first establish the general large, ovoid form before attempting the finer modulations of the facial features. This procedure helps avoid fragmentation of the drawing into isolated dark patterns. Although such disconnected tonal passages are sometimes necessary, they tend to break up the sculptural unity of the drawing and to produce an unintended flatness of effect, a common problem in beginners' work. In some instances turned surfaces may be relatively near to you and therefore pose a special problem in modeling. Although these surfaces may be nearer than others, it may be desirable to make them darker than the more distant surfaces (Figure 5-9).

5-6. Student drawing, figure seen from the front. Woodblock-printing ink applied with the fingertips on newsprint paper. 36" × 24".

5-7. Student drawing, figure seen from the back. Woodblock-printing ink applied with the fingertips on newsprint paper. $36'' \times 24''$.

Modeling with the fingers employs the sense of touch in a way that is uniquely direct but has the disadvantage of requiring special materials. A simpler though not quite so direct approach to modeling is offered by the medium of the felt-tip pen, an instrument ideally suited to producing the dots associated with the *stippling* technique.

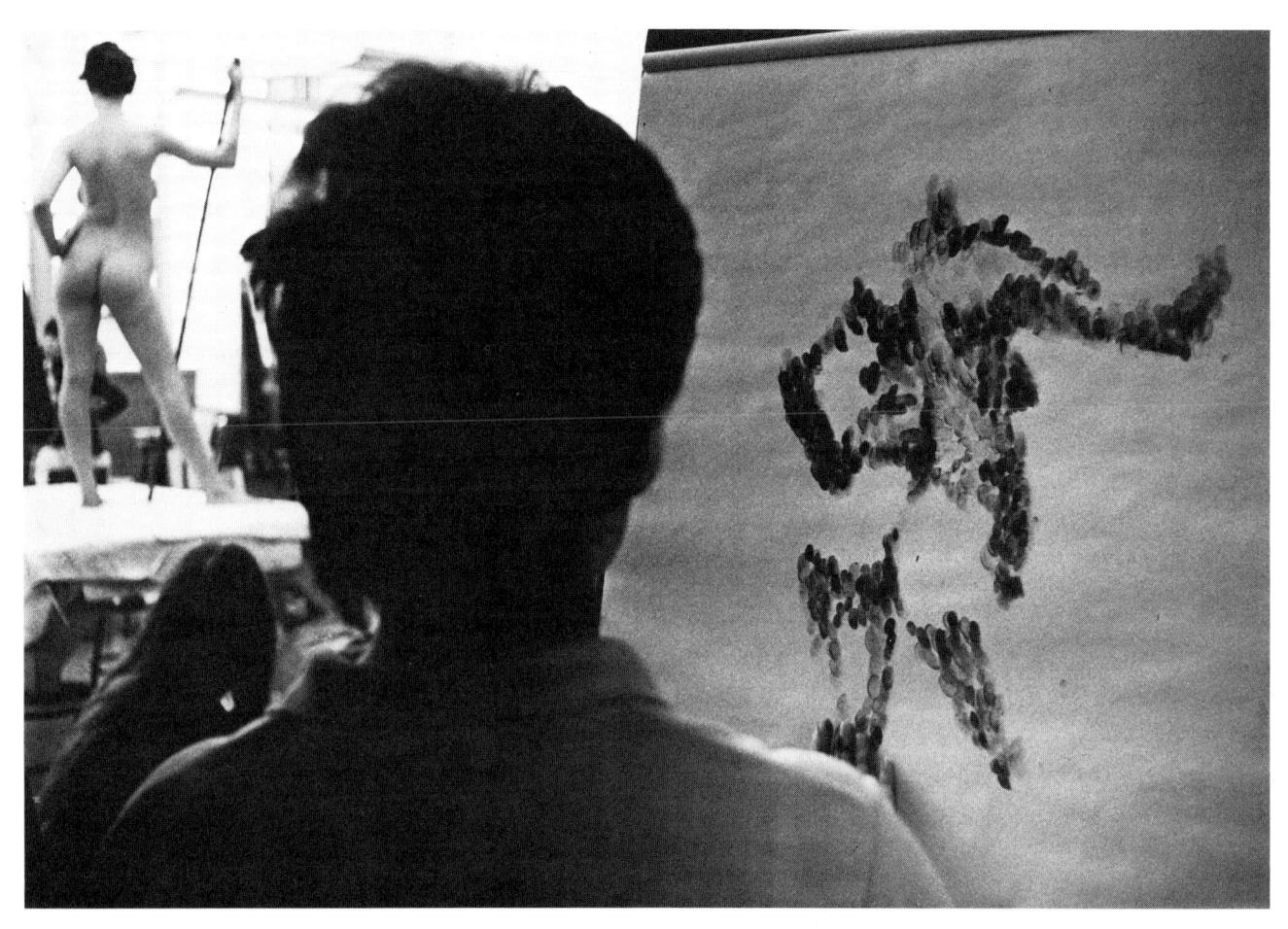

5-8. Drawing the model with fingerprinting. The tactile sensation of modeling is made vivid by using the fingers as drawing instruments. The problem becomes somewhat more difficult if the model is viewed against the background of an open window.

5-9. Octagonal shapes with turned surfaces. Though facet (B1) appears nearer to the viewer than facet (A2), the latter is represented as lighter because of its spatial orientation. At first glance this use of lighter value may seem to be a contradiction in terms of modeling but is actually a common occurrence in complex passages of the human form.

STUDY 15. RELIEF MODELING WITH STIPPLING

Materials: 36"-x-24" newsprint drawing pad

easel or straight-back chair Masonite or plywood board and

clamps

warm black³ or dark brown kerosene-base, blunt-point felt-

tip pen

medium yellow, process blue,

magenta (optional colors)

Reference: Suggested time:

model 15 minutes

The principles of modeling discussed in study 14 apply equally to this study. Surfaces that appear to turn away from your line of sight are translated into deeper tones than surfaces that face you; deepest tones are reserved for surfaces that turn the most. Instead of making fingerprints to create modeling effects you can use the dots that result from pressing the tip of the pen to the paper. The necessary variation of tone is achieved by varying the number (density) of dots in different areas of the drawing: if you wish to deepen the tonal values in one area, simply add more dots until the desired effect is achieved (Figures 5-10 and 5-11). By tapping the pen rapidly against the paper you can produce many dots with little effort. Rapid application enables you to think of the dots as tonal areas of a modeled surface rather than as individual points. Since the eye tends to perceive areas of dots as tone and texture rather than as independent dark units, it is doubly important to use the pen in this way.

If this is your first experience in modeling with dots, a few suggestions may be helpful. Before initiating a study of the model experiment with the pen by making simple areas of tone with dots to get an idea of the tonal range possible with this technique. In drawing from life you should develop the drawing by working from the large forms of the body to the small. Begin by placing dots randomly on the page at a considerable distance from one another in order to establish the general breadth and height of the figure. As the drawing evolves, a more unified effect of form can be created by developing the figure as an integral whole rather than modeling one small area at a time. You can lay in a nebulous general form by tapping continuously with the pen. With further modeling the figure will seem to emerge as if through a fog. A gradual development of form in the drawing permits you to exploit the special advantage of dots in making visual estimates of form.

It is important to avoid stringing dots together into virtual lines in this exercise. Modeling primarily treats surfaces, not contours: although qualities of edge and contour may be apparent in a highly modeled drawing, such linear effects are a by-product, not the aim, of the technique. As with study

5-10. Student drawing, modeling by stippling. Felt-tip marker on newsprint paper. $36'' \times 24''$. Dots are concentrated in areas where the form appears to turn and/or recede. The changing density of dots corresponds to changing distances and orientations of the body surface.

14 on the silhouette, linear detail is generally more convincing if it appears last in the modeling process. Such graphic detail is meaningful only in the context of larger forms. An advantage of the dot technique is that the variation in tonal value is automatically accompanied by a corresponding variation in texture, with the recessive areas richest in both elements. Such textural effects greatly enhance the power of tone to suggest form.

The dot can be considered as a visual module—a small, irreducible unit of standard size used to construct imagery. Interest in the technique began with the development of the graphic process called *aquatint* in the eighteenth century: a process that Goya exploited to create speckled tonal areas in many of his prints (Figure 5-102). In the nineteenth century the dot module became the basis for a new painting

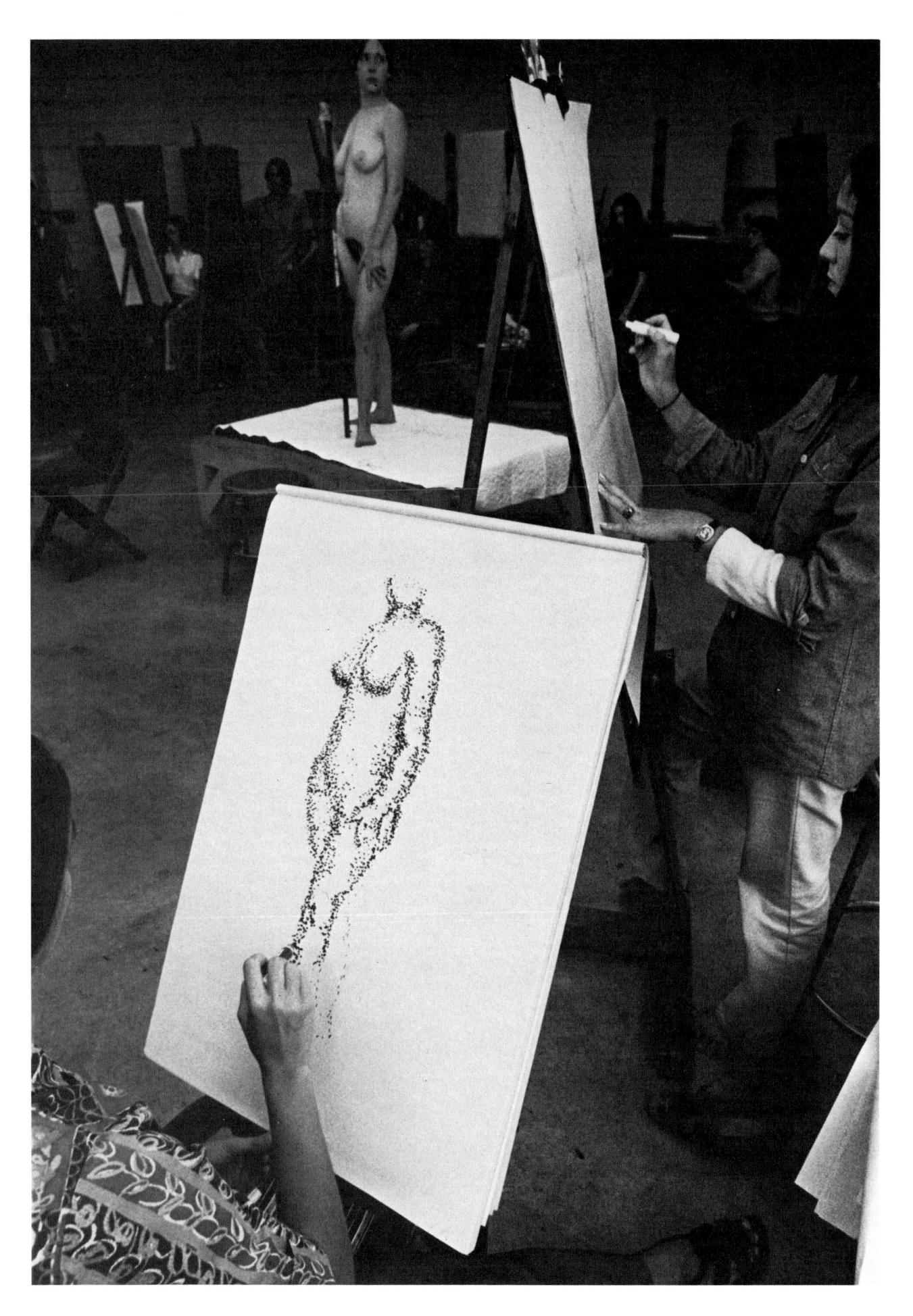

technique, called *pointillism*, which is associated most closely with the French artist Georges Seurat (1859–1891). In his paintings dots of pigment produce effects of color and tonal modulation while creating a unifying texture (Figure 5-12). Through Seurat's careful juxtaposition of dots of different colors the figure appears to emerge as if through a screen. Since the "screen" seems to lie on the painting surface, the viewer is constantly made aware of the two-dimensional nature of painting despite the opposing three-dimensional relief effects of the modeling.

Seurat was condemned by critics and fellow artists alike for his new technique—Gauguin, a contemporary painter, called pointillists "young chemists who accumulate some small points." Few, however, would agree with such a negative assessment today. The initial unfavorable reception to Seurat's work may have been due to the prevailing romanticism of his time, with its nostalgia for art of the past and its corresponding bias against modern technology. Seurat was a radical innovator, one of the first artists to see the pictorial possibilities inherent in commercial mass-media printing processes.

The deliberate breaking up of pictorial form into small particles of pure pigment, characteristic of pointillist theory, is related to concurrent developments in science and technology. For example, the newly invented photographic plate recorded for the first time images composed of dotlike particles of light-sensitive silver bromide (i.e., grain). The nineteenth century also witnessed renewed interest in atomic theory, which postulated a world composed of irreducible particles of matter so small that they were comparable to points in space. Language itself was reduced to dots by means of the new telegraphic code. The most direct link to Seurat's art. however, remains the color-printing process,⁵ in particular the nineteenth-century chromotypogravure,6 which utilized unevenly spaced dots to suggest imagery. Present-day printing techniques feature evenly spaced dots of varying thicknesses, produced by means of a screen. These photomechanical dots tend to have an even texture that distinguishes current printed pictures from chromotypogravure. The varying density of dots of chromotypogravure is also characteristic of the paintings of Seurat and of stipple drawings.

5-11. Modeling the figure by stippling. A rapid, random tapping motion with the marker can give a free approach without resorting to linear effects.

The affinity of stippling with early color printing suggests another application of the technique to drawing. The variety of colors seen in "full-color" reproductions are produced with small dots of only four colors of ink. By using a medium-yellow marker, a process-blue marker, and a magenta marker along with your original black marker you can create full-color stippling effects. A more practical application of stippling is found in scientific illustration, in which the technique is often employed because of its unusual capacity for modeling form accurately in a manner that is well suited to modern reproduction methods.

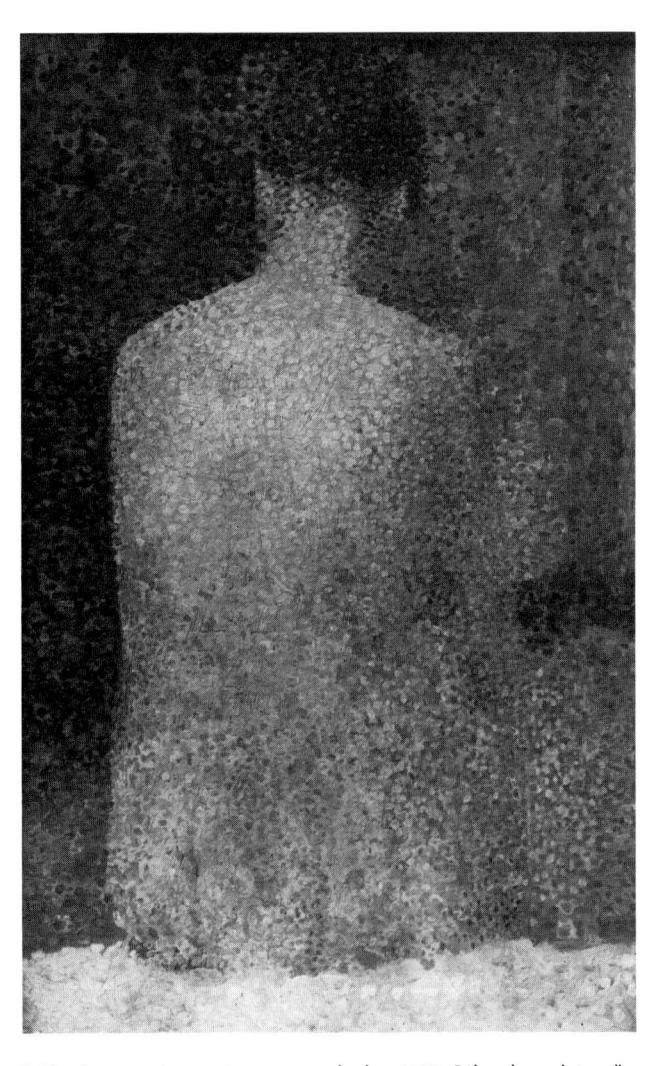

5-12. Georges Seurat, *La poseuse de dos*, 1887. Oil on board. 9 5/8"× 6 1/4". Paris, the Louvre. This is a preparatory sketch for a figure in the painting *Les Poseuses*, "the first of Seurat's pictures to be conceived and executed from the start in small separately applied dots" (Norma Brouse, "New Light on Seurat's 'Dot': Its Relation to Photo-Mechanical Color Printing in France in the 1880's," *The Art Bulletin*, LVI [December 1974], p. 581).

STUDY 16. RELIEF MODELING WITH CONTINUOUS TONE

Materials: 36"-x-24" newsprint pad

easel or straight-back chair Masonite or plywood board and

clamps

black or brown medium-soft or

soft drawing crayon

Reference: Suggested time:

model 15 minutes

The traditional drawing crayon is an effective medium for modeling. If it is held with the broad side against the paper and moved sideways back and forth, it produces a grainy but unbroken (i.e., continuous) dark tone. A slight pressure of the hand produces a light tone; a stronger pressure, a darker tone. The relationship between the tone and the pressure makes crayon especially useful in pushing back the receding forms in a drawing. Too much pressure can break the crayon, so it is advisable to make several strokes with moderate pressure to obtain the darkest tones.

A drawing period of 15 minutes is suitable for your first attempt at crayon modeling. Holding the crayon on its broad side, establish the general shape of the figure first with a light tone without attempting to model it. Within the tone of this shape begin to search out the receding surfaces of the massive forms of the body—trunk, head, and limbs—as distinct from smaller parts or details of the forms (Figure 5-13). At this stage it is advisable to work continuously over the whole figure as much as possible. Drawing with the broad side of the crayon provides a beneficial feedback for the artist. Since it registers a wide tonal mark, it tends to make you observe and conceive forms in terms of broad shapes and volume.

Like the surface of the cylinder, the large body forms appear to turn in space. To represent such effects, simply apply pressure to the crayon on the drawing page as if you were pushing back the clay in a relief, making sure to apply more pressure to represent forms that turn more sharply (Figure 5-14). Although these principles are simple enough for the beginner, tonal modeling presents a challenge to the sensibilities of the most experienced draftsman.

After a few 15-minute studies you may wish to increase the drawing period to 30 minutes or more to develop a modeled figure more completely (Figure 5-15). In an extended drawing period you may wish to vary the treatment by modeling one side of the figure more heavily than the other to avoid unwanted repetition of tonal effects. For the strongest sculptural effect, however, consistent tonal modeling is desirable (Figure 5-4).

5-13. Student drawing (early stage), study in relief modeling. Crayon on newsprint paper. $36'' \times 24''$. Even in the beginning stages the drawing should encompass the general forms to be modeled. Holding the crayon with the flat side against the paper permits the draftsman to model general form without linear effects.

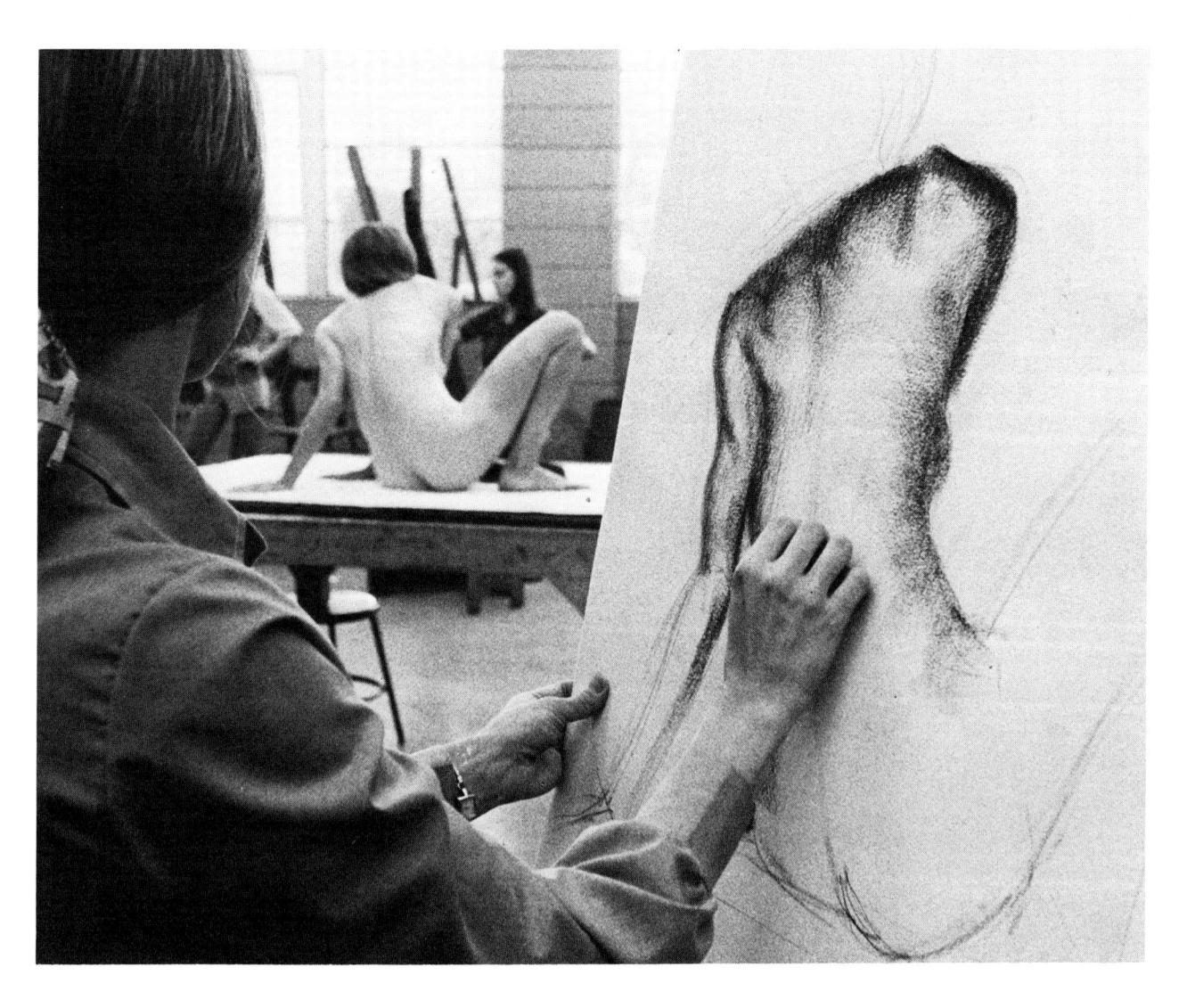

5-14. Modeling the figure from life with crayon. Forms that recede or turn in space can be pushed back in the drawing by pressing on the crayon, which results in a correspondingly darker tone.

5-15. Student drawing, figure viewed from the back. Crayon on newsprint paper. $36'' \times 24''$. Relief modeling creates a sense of volumes only suggested by the preliminary contour-line drawing, still visible in the lower portion of this study.

5-16. Honoré Daumier, (1808–1879), *Ganneron*. Bronze cast from the artist's unfired painted-clay sculpture. 179 mm high. Washington, National Gallery of Art. Lessing J. Rosenwald Collection.

The work of Honoré Daumier (1808-1879) demonstrates the close relationship between relief modeling in drawing and in sculpture. As a political caricaturist whose work appeared in Charivari, a French periodical, Daumier often employed the somewhat unusual procedure of modeling in clay before drawing his lithographic illustration of the same subject. This method enabled the artist to experiment with different viewpoints of the clay portrait and to select the angle from which the subject's most salient features are visible. Daumier further heightened the facial expression by painting the clay bust before drawing it. It would be interesting to know whether Daumier used the clay bust to make drawings on paper prior to drawing on the lithographic stone or whether he drew directly from the clay model onto the stone. No such intermediary drawings appear to have survived.

In creating the sculpture and lithograph of the French deputy Ganneron (Figures 5-16 and 5-17) Daumier exaggerated the larger forms of the head rather than the smaller, more linear facial features (i.e., lips, eyebrows, etc.), an approach ideally suited to relief modeling. Daumier "concentrated on warping the structure of the head itself. Ganneron, with his huge lumpy brow hiding his tiny eyes, his crooked potato nose, and his big broad chin, is . . . one of Daumier's most extraordinary conceptions. . . . The translation of the [sculptured] bust with its large, smooth, irregular areas into broad areas of lights and darks is especially successful in this lithograph. The bronze, one of the first cast, also reproduces these largely-modelled areas particularly well." Despite the comic intent of Daumier's caricatures, they attest to an underlying humanism and a high artistic quality that continues to set a standard for the serious draftsman who wishes to employ relief modeling in drawing the human form.

5-17. Honoré Daumier, *Gan....L.D.* Illustration from *Charivari*, September 6, 1833. Lithograph on white paper. 142 × 132 mm. Boston Public Library. A wealthy manufacturer of candles and president of the French Chamber of Commerce, Ganneron became a subject of political caricature as a result of his strong support of the July Monarchy. During Daumier's long career as a journalist-illustrator he produced over four thousand lithographs, many of which satirized the restored French monarchy. Daumier himself was a Republican.

STUDY 17. ONE-TO-ONE-SCALE MODELING

Materials: 36"-x-24" newsprint pad

easel or straight-back chair Masonite or plywood board and

clamps

drawing crayon

Reference: model **Suggested time:** 30 minutes

The broad area of tone produced by the side of the crayon is well suited to drawing on a large scale. Drawing life-size (i.e., one-to-one) affords an opportunity to make a large-scale drawing. Moreover, since one-to-one is the human scale, you can use your own body as a rough measure to check the accuracy of the drawing (Figure 5-18). It would be impossible to make a one-to-one drawing of the entire human figure on a newsprint pad, so this study concentrates on isolated portions of the figure.

Drawing only a portion of the figure can cause you to lose sight of its relationship to the whole, which in turn can affect the quality of the drawing. For this reason it is useful to begin with a small contour study of the entire figure on the margin of the page (Figure 5-19). No more than one minute is needed for this thumbnail sketch. As you work on the preliminary sketch, you are likely to notice from your position in the studio one region of the figure that has particular visual interest, either in terms of form or as a challenge to your drawing skills. Let it be the subject of your one-to-one study.

Begin by developing the selected region or part lightly in contour, taking care to draw it as large as it appears. If you decide to draw an arm, for example, use your own arm to gauge the approximate size. Your drawing may include more than the area of interest: if so, simply model the portion you wish to study, leaving the rest in line. The modeling procedure is the same as for study 16, but the larger scale enables you to model more boldly, taking advantage of broad tonal effects. Thirty minutes is sufficient for a study of this kind, not counting the time for the preliminary sketch.

Two suggestions may prove helpful in completing this exercise. (1) Avoid drawing the head. Unless it is part of an unfamiliar gesture, it may lack the freshness of formal or visual interest that you may sense in other parts of the figure. As an isolated form the head tends to result in stale, tight drawings with little compositional value. (2) Use your design sense. Drawing and design are often closely linked, especially in a drawing of this type. You may find it helpful to select the area for your study by sketching a rectangle around that part of the figure in the preliminary sketch. In the following study compositional design is a primary consideration.

5-18. Drawing a life-size study in relief modeling of one portion of the figure. Darkly modeled surfaces correspond to the volumes seen in the model, not to the effect of observed light and shadow.

5-19. Student drawing, life-size study of the arm. Crayon on newsprint paper. $36'' \times 24''$. Above the life-size study is a small preliminary sketch of the entire figure.

STUDY 18. MODELING NONSEQUENTIAL FORMS

Materials: 36"-x-24" newsprint pad

easel or straight-back chair Masonite or plywood board and

clamps

drawing crayon

Reference: model

Suggested time: 20–30 minutes

Within a single gesture certain passages of bodily form, as you can see in study 17, appear more interesting than others as subjects for modeling. Although such passages are usually drawn as sequences of form within the context of a unified, figural structure, they can be divorced from it and modeled as abstract form, which is the aim of this study. Instead of observing the model in terms of overall shape look for regions with special visual qualities (as in study 17), such as transitions of intersecting planes, recessive turns of form, or forms around a negative space—in short, forms that are interesting to model.

Draw first the passage of form that interests you most.

After you finish that portion to your satisfaction, begin another without regard to its location in the context of the figure. You may, for example, complete a drawing of an upper region of the body and then model a lower portion above or beside the first (Figure 5-20). The two portions may overlap as they develop: the form drawn first can overlap the second and so on. If you exhaust the possibilities of the figure from one viewpoint, move to another location in the studio and continue the same procedure from the new point of view.

Nonsequential drawing enables you to compose more freely. Utilizing the nonsequential method permits you to select parts of the body for study and to draw them in innovative compositional arrangements without the constraints imposed by the natural organic structure that normally governs relationships between parts of the figure and the whole (Figure

5-20. Modeling body forms as separate figural elements independently of their structural sequence.

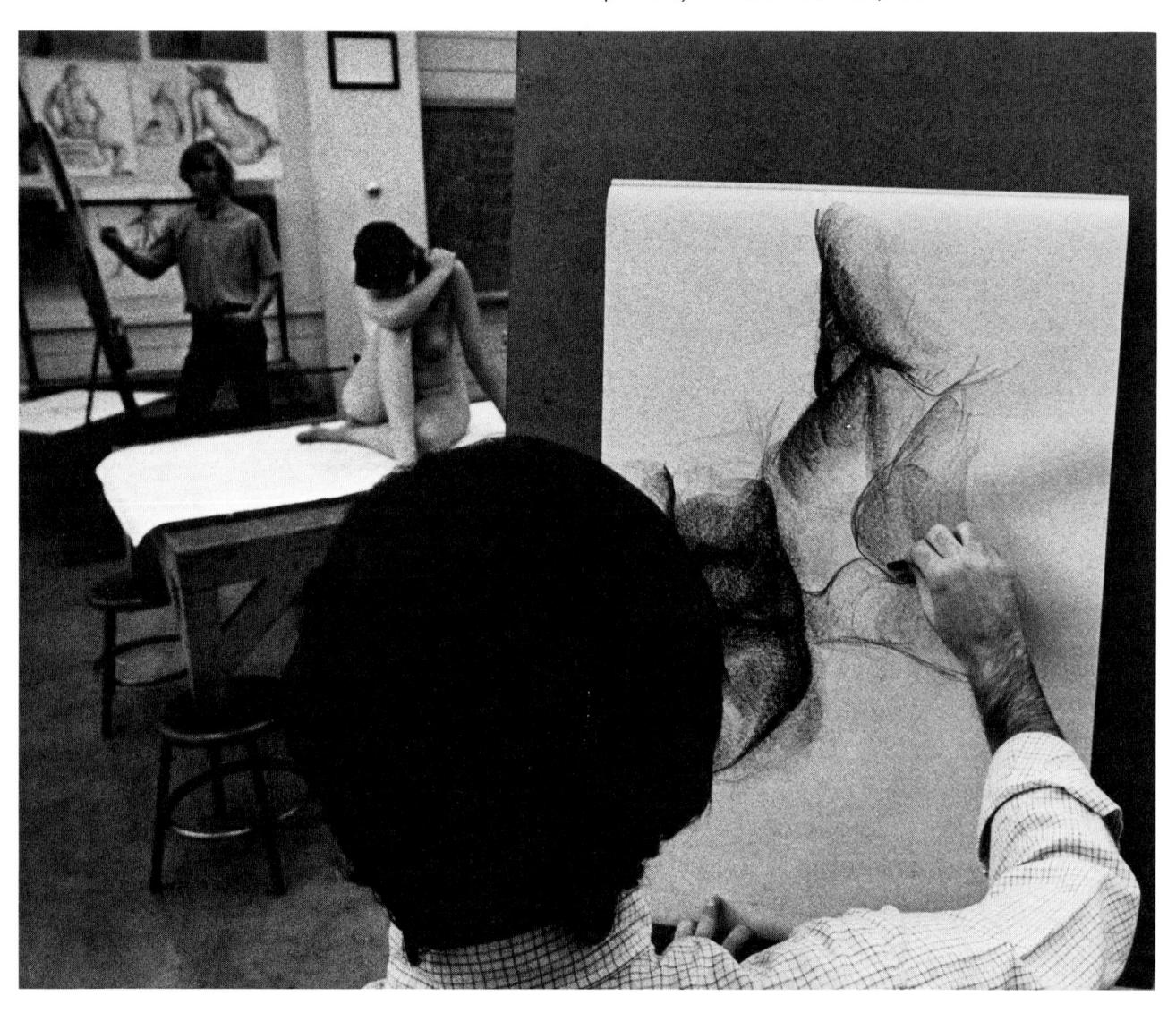

5-21). This is an enjoyable study. With the problem of body structure set aside temporarily, you can indulge in the more sensuous aspect of modeling—searching out surfaces that lend themselves to tonal treatment as pure volumes. This is an experimental approach to tonal relief modeling and a fresh way of seeing the human form that is especially interesting to the artist concerned with the abstract element in art. Utilizing relief modeling as a drawing technique provides a good introduction to visual perception of form through shadow and texture.

5-21. Student drawing, nonsequential forms of the human body. Crayon on newsprint paper. $36'' \times 24''$.

PERCEPTION OF FORM: THE THEORETICAL BASIS FOR RELIEF MODELING

In its broadest aspect modeling is an approach to drawing that utilizes textural and tonal values to describe form. Both texture and tone play key roles in the perception of form.

Although people often perceive tone (shadow) and texture of an object simultaneously, each has distinguishing qualities. Shadows are determined by such variable factors as the type of illumination (i.e., directional or diffused) on the object and the position of the viewer with respect to the light source and the object. Consequently, shadows in nature tend to be ephemeral, changing with the time of day. Under harsh direct-lighting conditions the side of an object that faces the sun shields the back side from the light, casting a shadow over it. Unlit parts of the object may appear to vanish into a uniformly dark pattern of cast shadow. Photographs often record this type of image simplification. Such cast shadows do not necessarily clarify the form of the object: they sometimes have quite the opposite effect by creating misleading visual patterns, though these can also be of interest to the artist.

Unlike shadow, textural elements, such as a small, repetitive motif, are often a permanent feature of the object's surface. Not entirely dependent on lighting conditions, texture can be perceived not only visually but also through the sense of touch, the sense that is associated with the perception of solid form. Studies by the psychologist James J. Gibson confirm that uniform surface-texture patterns provide important visual cues that assist human perception of three-dimensional forms and their orientation in space.⁹

The key roles that texture and tone play in the perception of form can be demonstrated by examining their appearance on a simple object, the faceted column (Figure 5-22). If the viewer is situated in the same location as the source of light (S), facet (A) appears lighter in value than the other facets (B and C) of the column (Figure 5-23). In this arrangement facet (A) reflects more light to the viewer for two reasons. (1) It is the plane nearest the light source and is illuminated before the light weakens as a result of diffusion by distance, thus it reflects more light than the more distant planes beside it. (2) Facing both the light source and the viewer, it tends to reflect more light in that direction than in other directions—in other words, it acts somewhat like a dull mirror. 10 Facets (B) and (C), on the other hand, are turned away from the light source and the viewer. For this reason they not only present less reflective surface to the light source but also reflect less light in the direction of the viewer, who as a result perceives them as darker in tone. If a column with more facets is illuminated in a similar way (Figure 5-24), the gradation from light to dark is more gradual. In a fully rounded column the gradation of tone may be imperceptibly smooth, but the principle seen in the faceted column prevails: that is, surfaces of an object appear darker if they are turned away or more distant from the viewer.

A surprisingly similar result occurs if a column is drawn merely as a textured (i.e., faceted) surface without regard to the effects of light (Figure 5-25). This is demonstrated by subdividing the facets of the column so that it becomes successively a 16-sided polygon (Figure 5-26), a 32-sided polygon (Figure 5-27), and a 64-sided polygon (Figure 5-28). As with the illuminated column, surfaces that turn away from the viewer appear darker, and the column looks as if it were modeled in relief. A comparable effect of roundness can be observed in a photograph of a cylinder (Figure 5-74) with a surface pattern of equally spaced vertical lines. The principal difference between the drawing and the photograph is the apparent progressive thinning of line width near the edge of the cylinder. In both figures the apparent modulation of surface is suggested primarily by the changing interval of the lines. In order to account for this, it is necessary to consider how the eye gathers visual information.

5-22. Leonardo da Vinci, diagram from his *Treatise* on *Painting*. (S) represents the source of light and the position of the viewer observing facets (A, B, C) of an octagonal column from above.

5-23. Octagonal column. Seen from (S), the position of the viewer, the surfaces of the column appear to have different values. Facet (A), a plane that faces the viewer and the source of light, reflects a greater amount of light toward (S) than do the planes (A, B), which are turned at an angle from the viewer.

5-24. Sixteen-sided column. A greater differentiation of tonal values occurs if the octagonal column becomes a 16-sided column. The degree to which each facet is turned from the viewer affects its apparent value.

5-25. The octagonal column represented without tonal values.

5-26. The 16-faceted column shown without tonal values.

5-27. A 32-sided column.

5-28. A 64-sided column. The apparent contraction of facet width near the sides of the column produces a gradual change of texture and tone that suggests recession and roundness of form. Compare with the tonal and textural changes in Picasso's *Self-portrait* (Figure 5-33).

In viewing an object the eye focuses a projected image (or *array*) on the retina, the inner, back surface of the eyeball. Like the image inside a camera view-finder, the size of the retinal image varies with distance (Figure 5-29): the more distant the object, the smaller the absolute size of its retinal image.¹¹ Another factor that affects the size of the retinal image is the orientation of the object in space with respect to the eye (Figure 5-30). If the bar (A'B') is turned to position (AB), the size of the corresponding retinal image contracts.

Just as with a single element, the retinal image of a group of elements exhibits size variations (Figure 5-31). Elements of identical size form a plane, causing the eye to project a retinal image (array) in which the elements appear graduated from large to small, with the most distant represented by the smallest component. The optical contraction of the elements in the retinal image produces a relationship among them (visible as a geometric ratio in Fig-

ure 5-31) that is specific to a flat surface turned away from the eye at the angle shown. The relationship of such visual components, known as the *gradient of texture density*, is believed to be an important source of information about the orientation and form of an object's surface.¹²

If the equal-size elements are arranged so as to turn at equal angles with one another (Figure 5-32), a sharper gradient of texture density results, which is particularly noticeable in the projected retinal images of element (CD). It occurs primarily because of the different orientation of the elements. Although (CD) is the same size in both diagrams, the retinal image (cd) is much smaller in Figure 5-32 than in Figure 5-31. As the actual elements turn away from the viewer, they appear closer together on the retina than they would if they were extended in a flat plane. The resulting difference of gradient assists the viewer in perceiving the rounded surface.

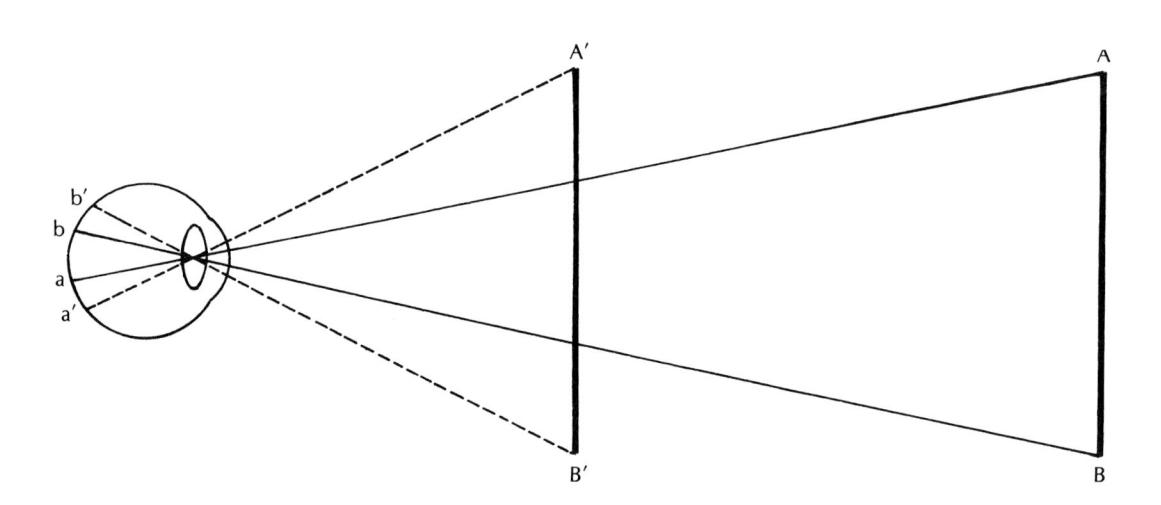

5-29. The retinal image. An object's image on the retina of the eye varies according to the object's distance from the eye. Bars (AB) and (A'B') are identical in size, but (A'B'), which is nearer to the eye, produces a larger retinal image (a'b') than image (ab) projected by (AB).

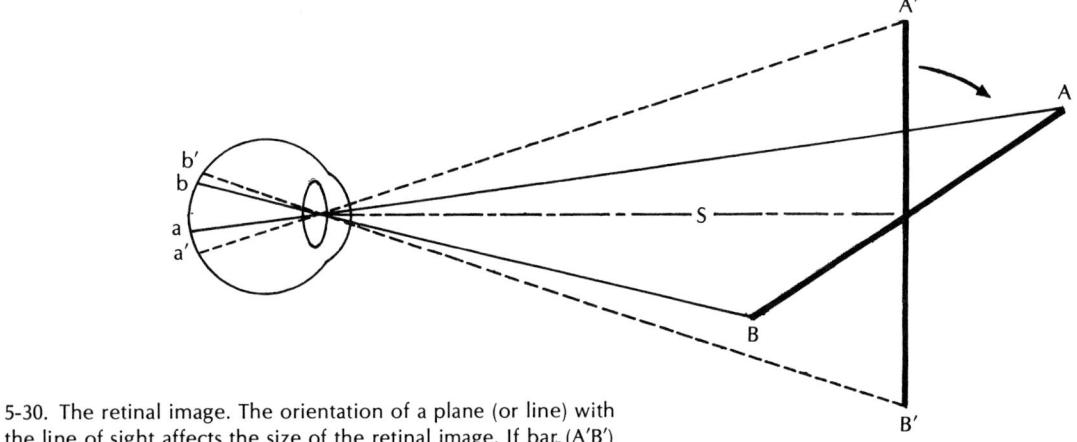

the line of sight affects the size of the retinal image. If bar. (A'B') turns from a position of 90° alignment with the line of sight (\$\docume{S}\$) to a new position (AB), the retinal image contracts from (a'b') to (ab).

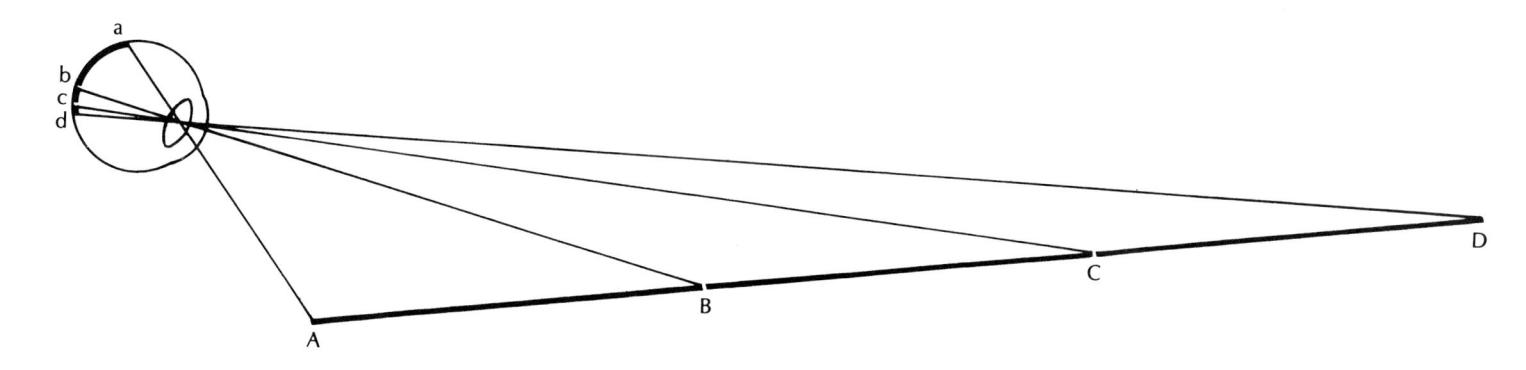

5-31. The retinal image. (Illustration after Ulric Neisser, "The Processes of Vision," *Scientific American*, vol. 219, no. 3, September 1968, pp. 206–207.) Elements of equal length result in a retinal image in which their projected lengths diminish in a specific proportion. This proportional reduction in image size, the gradient of texture density, informs the observer of the orientation and character of the surface. A common instance is observed in railroad-track slats, which gradually appear to become more closely spaced with distance but are perceived as evenly spaced. The same phenomenon occurs on a smaller scale with such textures as cloth, hair, and skin.

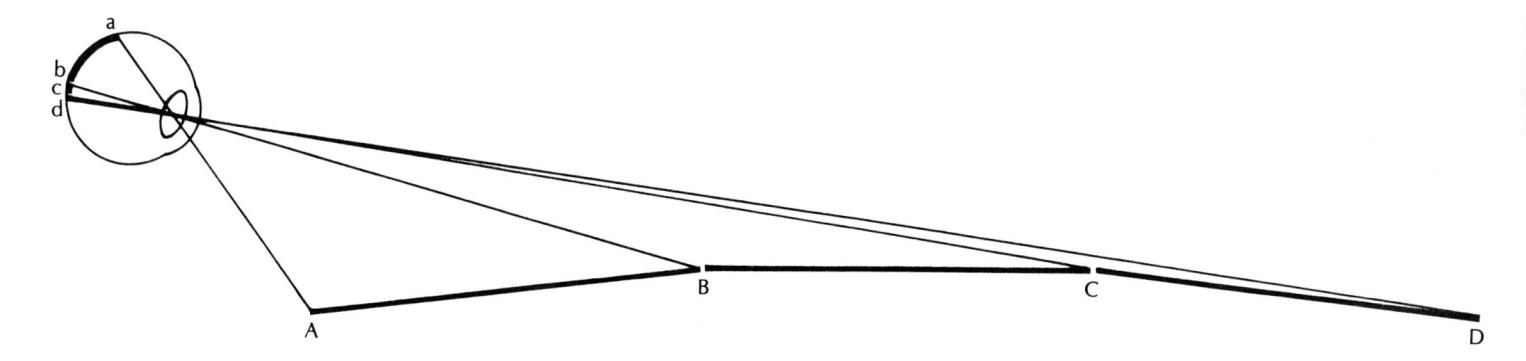

5-32. The retinal image. If equal elements are turned, as on the surface of a column, the proportional contraction of the retinal image is greater than that seen if the elements form a flat surface (as in Figure 5-31). The contraction of retinal image caused by distance is enhanced by the changing orientation of the elements. Compare with Figure 5-28.

Gradients of texture density are so much a part of the natural process of perception that one is seldom conscious of them, even though a sense of form depends heavily on this type of visual information. In drawing, however, the gradient concept can be used consciously as a principle for representing the relief and volume of observed forms. A simple application is represented in Figure 5-28. The vertical lines of the drawing represent edges of equal elements (facets of the surface). The graduated diminution of the widths of the facets (intervals) corresponds to the gradient of texture density as it might occur on the retina while viewing an actual threedimensional column, producing an illusion of roundness. The illusion is enhanced by tonal darkening on the sides of the column, which results from drawing with a line of equal width. In an actual column such lines appear thinner on the sides, as seen in Figure 5-74.

If the retinal image registers the apparent diminution of form (i.e., the gradient of texture density), why do children and primitive artists seldom depict such image contraction in their paintings? Why, for instance, do primitive artists almost universally define a road in a landscape by two parallel borders rather than by the converging borders associated with image contraction? The answer may lie in the fact that "one does not see the retinal image; one sees with the aid of the retinal image."13 People tend to compensate unconsciously for the contraction of retinal image caused by distance and orientation of surfaces. In drawing a road with parallel lines a primitive artist remains faithful to the constancy of the perception (i.e., the road is of uniform width) rather than to the retinal image with its converging linear pattern. Continued exposure to the photographic image, which is similar to that of the retina, conditions one to accept the latter's accompanying optical distortions (i.e., contractions of image components) so that they seem entirely natural in works of art. (It should be remembered, however, that the "primitive" interpretation of the visual world is as valid as the retinal interpretation, in some respects more so.) Prior conditioning to the retinal image predisposes most people to recognize Figure 5-27 as a "correct" representation of an equal-sided form, even though the facets are unequal in width.

It might be objected that the faceted column has little relevance to the problem of drawing in ordinary circumstances, since few objects are as simple as a cylinder and fewer still have equally spaced, geometric elements. Yet the surfaces of many objects display textures that, though nongeometric in pattern, are nevertheless composed of regularly repetitive elements. Such a pattern is often apparent in the bark of a tree, the sand on the beach, or the texture of cloth. The texture of animal and human hair likewise supplies information about the character of these forms. Careful observation of

textural phenomena while drawing can greatly assist you in understanding the form.

Texture can also be utilized in modeling form independently of the actual texture of the subject. This principle, noted earlier in connection with stippling, is especially important in drawing the figure, which offers little texture to the eye from a distance. The artist is thus free to create "artificial" textures that correspond to the density gradients of smooth, textureless surfaces. Often misunderstood by nonartists, such artificial textures are apparent in Picasso's Self-portrait (Figure 5-33), in which accumulated line strokes model the form in relief rather than describing the actual texture of the skin. The appearance of texture created by the lines in this portrait is much more irregular than that seen in the cylinder (Figure 5-28). The lines are freely drawn; they describe a complex and irregular form; yet the effect of modeling occurs. Receding planes of the head are drawn with closely packed lines, while flatter planes are represented with more widely spaced lines. The resulting "artificial" texture is comparable to a gradient of texture density that varies in accordance with the orientation of the surface. The accumulation of lines in the denser areas of the drawing also produces a darker tone, which heightens the relief effect.

Tonal variation as an isolated form of modeling does not employ textural effects to represent form but instead translates the observed form strictly in terms of tonal contrasts. In a drawing of the figure by Maillol (Figure 5-4) texture functions quite differently than in the Picasso drawing. In the former the drawn texture largely results from the grain of the paper, which produces a screenlike horizontal textural pattern, as though Maillol, like Seurat, wished to remind the viewer of the objective reality of the flat drawing surface as opposed to the modeled illusion of the figure's roundness.

The Maillol drawing is a fairly straightforward application of relief modeling to the human form. The surface of the figure appears to darken in relation to the degree that it turns from the viewer, as in Figure 5-28. (A slight inconsistency, however, is apparent in the groove of the back, which darkens on the right side only, probably a concession to the convention of shadow.) Part of the effectiveness of the modeling derives from Maillol's careful construction of large, generalized forms in the figure. This does not mean that he perceived simple forms only, but rather that he preferred to ignore what he felt to be trivial visual information and to record instead the large, massive forms of the body. He shared this concern with an earlier artist, Ingres, who, although not a sculptor, warned that "One must not dwell too much on the details of the human body; the members must be, so to speak, like shafts of columns; such they are in the greatest masters."14

It is significant that Maillol was a sculptor, since re-

lief modeling is most effective in representing the sculptural qualities of form so evident in Maillol's drawing—namely, roundness and volume. It also tends to produce forms that function on the drawing page in somewhat the same way that sculpture does in open space, for relief-modeled figures are often self-contained constructions of positive form with little compositional relation to the surrounding negative space.

Relief modeling can also be useful to the artist concerned with effects of color and volume. The French artist Pierre Auguste Renoir (1841–1919), whose work includes both paintings and sculpture, made effective use of relief modeling in his drawings (Figure 5-34). His highly personal technique conveys not only a sense of rounded, human volumes but also a luminous effect that is suggestive of the impressionist colors of his paintings.

5-33. Pablo Picasso, *Self-portrait*, August 11, 1940. Pencil. $6.3'' \times 4.3''$. Geneva, Walters. (Photo courtesy of Gallerie Jan Krugier.) Differences of texture and tone within this work correspond to observed differences in orientation of the surfaces of the head and provide the basis for the effect of relief modeling.

5-34. Pierre Auguste Renoir (1841–1919), Crouching Nude. Charcoal. $21\,9/16''\times19\,1/16''$ (54.8 × 48.4 cm). Ottawa, National Gallery of Canada.

SHADOW MODELING

Natural effects of light and shade have little bearing on relief modeling, which is essentially an artificial system used to interpret the human form. Yet the natural effects of light and shadow on the model are of considerable visual interest and provide the basis for another system of modeling—shadow modeling.

STUDY 19. SHADOW MODELING

Materials: 36"-x-24" newsprint pad

soft or medium-soft black or brown drawing crayon

india ink and watercolor brush

(optional)

Reference: model **Suggested time:** 20 minutes

The direction of the light and the relative positions of the artist and model are important in shadow modeling. For this study you should be situated so that you can see part of both the illuminated and the dark sides of the model. If the illuminated side only is visible, the visual effect is the same as in the previous exercise; if the dark side only is visible, a silhouette results. The quality of the light is also important in shadow modeling. An ordinary studio window provides sufficiently directional illumination, but you may prefer to use an artificial light source such as a floodlamp, as it creates a clearer division between light and shadow. The advantages of such an arrangement will become apparent as you work.

The procedure essentially involves drawing form purely in terms of the patterns of light and shadow observed in the subject. Although this is simple in principle, the tonal values that comprise such patterns are often complex: gradations of value in nature are in fact infinite. It is useful to limit the number of tones in your first studies to four, including the white of the paper (Figures 5-35 and 5-36). These four tones, though arbitrary in number, are analogous to four fairly distinct tonal steps that are usually discernible on the model: (1) the white areas of the form that reflect the most light, (2) the intermediate tone of surfaces that reflect less light but are not themselves in shadow, (3) the darkest areas of cast shadow, and (4) the portions of form in cast shadow that receive some reflected light.

Begin with a carefully constructed line drawing of the model, then examine the model for tonal patterns. Look first for the division between intermediate tones (2) and darkest tones (3), a division that is usually a distinct shadow contour. Draw this contour lightly in line, then look for similar divisions between the other tones. If a separation between light (1) and intermediate (2) values is not distinct, you may have to estimate it. You may also have to estimate the shadow contour separating the lighter darks (4) within the cast shadow (Figures 5-37 and 5-38). For greater precision the angular method (study 9 in chapter 3) can be employed to construct the figure's contours and shadow patterns (Figure 5-39).

When the shadow contours are complete, you can use the broad side of the crayon to apply even tones within them in accordance with the four

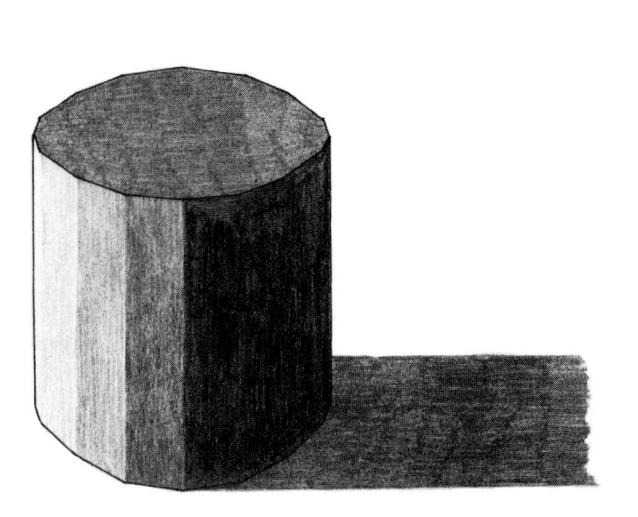

5-35. Light and shadow effects. A 16-sided column as it might appear with the light source on the left side, interpreted with four tones.

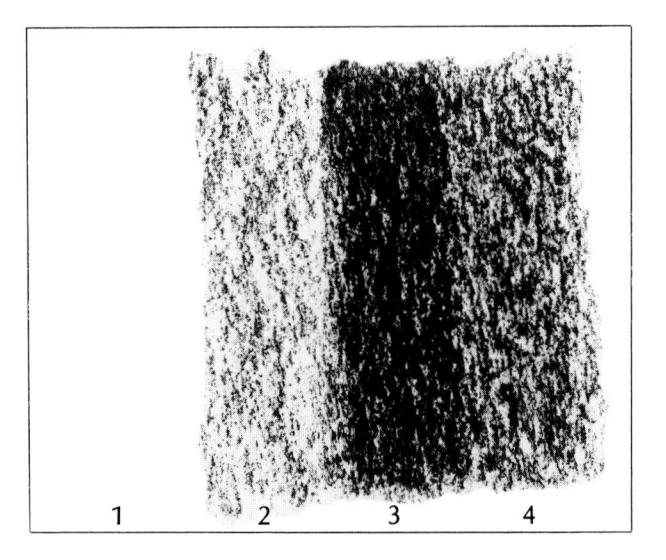

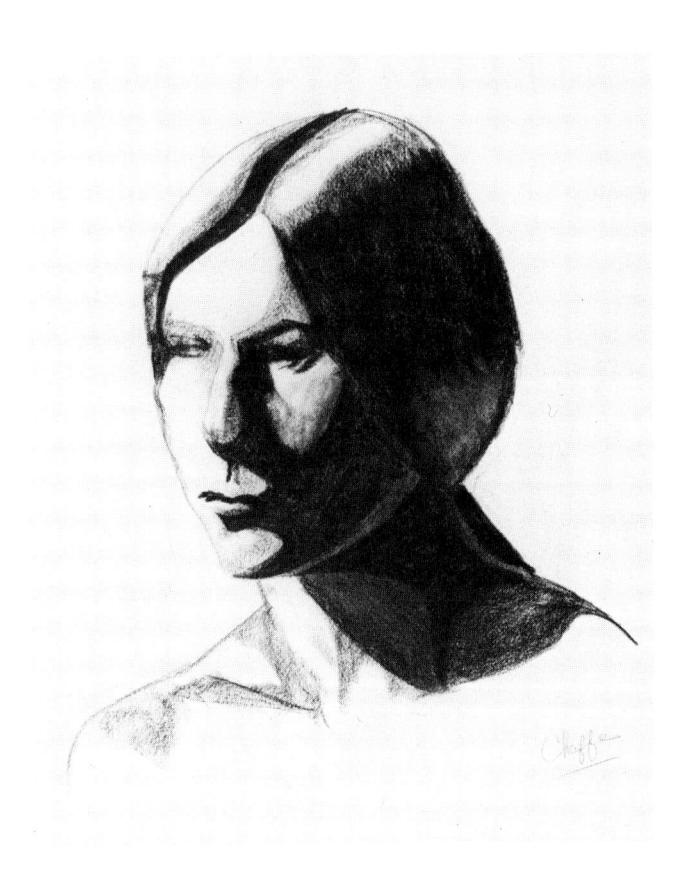

5-37. Student drawing, life-size portrait. Crayon on newsprint pad. $36'' \times 24''$. It is useful to limit the number of tones in shadow modeling. Here there are four tonal values, counting the white of the paper.

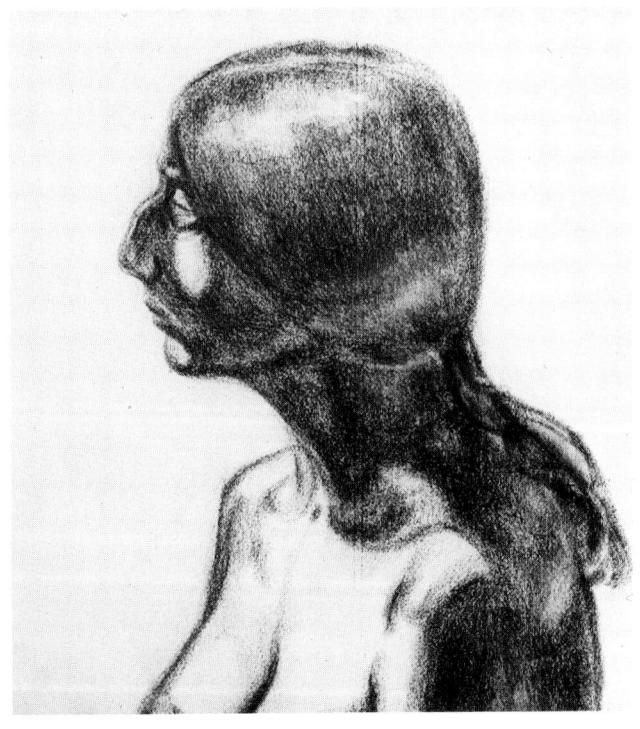

5-38. Student drawing, portrait. Crayon on newsprint pad. $36'' \times 24''$. The cast shadow of the head, represented on the shoulder of the figure, is intended to convey not only the shape of the head but also the form of the shoulder. By maintaining the integrity of both elements in the drawing the effect of shadow transparency is attained.

shades shown in Figure 5-36. In your first studies it is advisable to resist the temptation to rub and blend the tonal gradations of the drawing. The unblended tones reflect the texture of the paper and create a unifying effect that rubbing tends to destroy. The crisp contours also permit easy corrections.

By limiting the tones in number you may find it easier to develop and control the value relationships within the drawing, which is especially helpful with a complex compositional study (Figure 5-40).

5-39. Henri de Toulouse-Lautrec (1864–1901), *The Model Niz- zavona*. Charcoal. Art Institute of Chicago. In modeling the figure the artist made a careful estimate of the shadow contours, blocking them with the same precise, angular measurements seen in the rest of the drawing. The flexibility of the charcoal medium is seen in the redrawing of the head and neck.

5-40. Andrea Boscoli (c. 1560–1607), *The Annunciation*. Crayon. 14 $_{1/4}'' \times 11$ $_{3/8}''$. Cambridge, Fogg Art Museum, Harvard University. The shadow modeling in this drawing remains clearly visible as an orderly progression of value steps from light to dark.

Some shadow contours may enclose a tonal area that extends the entire length of the figure; others may form separate islands of tone. The larger patterns generally lend a quality of cohesion and unity to the drawing.

Restricting the number of tones in a crayon drawing may seem arbitrary, given the ease with which the tones blend into smooth gradations. In a medium such as watercolor, however, a limited number of tones is advisable for practical reasons. A watercolor tone is usually applied with a brush loaded with wash (pigment highly diluted in water). In order to model with some degree of control, it is advisable to wait for the first wash to dry before applying another. This process takes time, and it is best to keep the number of washes to a minimum if you wish to complete the drawing in one sitting. A superb example of wash modeling is seen in a drawing (Figure 5-41) by the French painter Théodore Géricault (1794-1824). His technique is especially evident in the head area, where, incidentally, the tones appear to correspond in number with those recommended in the preceding crayon study (Figure 5-42).

5-41. Théodore Géricault (1791–1824), Soldier Holding a Lance. Brush with brown and gray wash. 13 3/16" × 9 13/16". Cambridge, Fogg Art Museum, Harvard University. Bequest of Meta and Paul J. Sachs.

5-42. Théodore Géricault, Soldier Holding a Lance (detail). The figure's head reveals a series of discrete tonal steps from light to dark, applied as watercolor washes.

If a strong directional light is trained on the model, some parts of the body may cast shadows on other parts. This problem attracted the attention of Leonardo da Vinci, who advised the artist to "Take care that the shadows cast upon the surface of [a] body by different objects must undulate according to the various curves of the limbs which cast the shadows and of the objects on which they are cast." Cast shadows of this sort are seen in student drawings (Figures 5-37 and 5-38), in both of

which the head casts a shadow on the shoulder. The same cast-shadow effect is carried much further in the *Self-portrait* (Figure 5-43) by the Swiss artist Fuseli (1741–1825). The cast-shadow patterns in this drawing create contours that describe not only the volumes of the arm and the head but also those of the much smaller forms, including the eyeball. The calculated consistency of Fuseli's shadow modeling is responsible for the luminous, transparent quality of the work.

5-43. Henry Fuseli (1741–1825), Self-portrait. Black chalk with white. London, National Portrait Gallery.

5-44. Value constancy: folded paper and a cylinder. Despite the apparent differences of tone caused by light and shadow both the folded paper and the cylinder are perceived as uniform (constant) in value—white. The cylinder displays a more graduated value change, which enhances the effect of value constancy. The cast shadow at the base of the folded paper reinforces the effect of value constancy.

TRANSPARENCY

The transparency of shadows represented in drawings touches on a curious phenomenon of everyday human perception known in psychology as value constancy. 16 It is best explained by a visual example of a folded piece of paper (Figure 5-44). If it is illuminated from one side, it seems lighter in value on that side than on the other, yet one tends to perceive it as uniform (constant) in value. The memory of past visual experiences is believed to be an important factor in this effect. One is conditioned by experience to recognize that a strong light source causes an object of uniform color to appear darker on the shadow side. Since a shadow cast by the object often extends to neighboring surfaces or nearby objects, the continuity of the shadow is a visual cue to the color constancy perceived in the object. This can be demonstrated by covering the cast shadow at the base of the folded paper in Figure 5-44. With the cast shadow covered, the folded paper appears to consist of two pieces, a gray and a white, instead of a single sheet of folded white paper.

In shadow modeling the transparency effect of shadow patterns (i.e., lightness constancy) depends on the consistency and continuity of those patterns in relation to the forms drawn. It is therefore important to draw shadows as continuous patterns in order that they be perceived as transparencies on integral forms rather than as multicolored shapes. Without a sense of value constancy the naturalistic appearance of the form may be lost.

THE ARTIST'S POINT OF VIEW

Naturalism is associated with shadow modeling even more than with relief modeling, because in shadow modeling the artist functions primarily as an observer—attempting to capture tonal relationships as they appear at specific times and under specific lighting conditions. The momentary and ephemeral aspect of light is of paramount importance. In relief modeling, on the other hand, the values of light and dark are based on an imaginary, timeless light source. Such a close association with an imaginary, unchanging source of light suggests a profound philosophical difference between the two drawing methods.

The artist who adopts the shadow-modeling technique shares some of the same concerns as the photographer who takes pictures in available natural light, yet few people would mistake a photograph for a drawing! The difference between the drawing medium and the chemical-bromide surface of the photograph is usually apparent even in drawings reproduced photographically, such as those in this book. Unless the drawing is derived from a photograph, another factor distinguishes the photographic process from the drawing process—human binocular vision. The human visual system, unlike most cameras, normally gathers visual information from at least two points in space. The slight shift of position that usually accompanies the drawing process permits many more points of view. Drawings made by direct observation of a subject are thus the result of a process that permits more spatial information about form than is possible with the standard camera, and this difference is usually reflected in the drawings even if shadow modeling is restricted to only a few tonal steps.

In a lithograph (Figure 5-45) by the German artist Käthe Kollwitz (1867-1945) shadow modeling yields an almost sculptural sense of form with the same four tonal steps used in the preceding exercise. The artist's masterful draftsmanship emphasizes the general structure of the head as illuminated by a low source of light, suggestive of a hearth. Intended as a poster for a homecraft exhibition, the shadow modeling in the lithograph becomes part of the expressive content of the work. The special importance of the role of lighting in shadow modeling had attracted the attention of Leonardo centuries before: "Above all," he warned, "see that the figures you paint are broadly lighted and from above, that is to say all living persons that you paint; for you will see that all the people you meet out in the street are lighted from above, and you must know that if you saw your most intimate friend with a light (on his face) from below you would find it difficult to recognize him."17

Deutide Heimarbeit-Ausstellung 1906.

Kathe Kollwitz's aims were obviously guite different from those of Leonardo. Her work reflects a deep concern with the social conditions of the working class. For this reason it was not important that her subjects be seen as if under an ideal light, nor was it necessary that the individual be easily recognized as a unique person. Of greater concern was the general humanity of an entire class of people. Her philosophical and political views are thus inseparably connected with the formal means that she adopted in her work, just as Renaissance attitudes about individualism are related to the works of Leonardo.¹⁸ Such a range of expressive meanings demonstrates that shadow modeling is a vital modality of drawing, undeserving of the commonly appied label "academic."

The tonal simplification apparent in the Kollwitz work is carried further in a Self-portrait (Figure 5-46) by the German artist Emil Nolde (1867–1956), who was not only a compatriot of Kollwitz but was born in the same year. A master of the woodcut, a medium that dictates a bold black-and-white effect, Nolde's lithographic Self-portrait is highly graphic. He apparently used a flat-tipped brush dipped in undiluted tusche (lithographic drawing ink), thus ensuring the intensely high contrast apparent in this work. His choice of instrument and medium necessarily reduced the amount of visual information contained in the drawn image, yet, as in the Kollwitz lithograph, a remarkable sense of form and structure remain. For example, although one side of the hat represented in the Self-portrait is not delineated, the portion drawn suggests the entire form. Nolde's technique is not merely a simplification but a reduction of form in which each brushstroke indicates the area drawn and also suggests others that are not. The economy of means inherent in this method makes it well worth exploring.

5-46. Emil Nolde, *Self-portrait*, 1907. Lithograph. Cambridge, Fogg Art Museum, Harvard University.

^{5-45.} Käthe Kollwitz, *Poster for the German Homecrafts Exhibition*, 1905. Lithograph. Berlin Kupferstichkabinett und Sammlung der Zeichnungen.

STUDY 20. BLACK-AND-WHITE SHADOW MODELING

Materials: 36"-x-24" newsprint pad

easel or straight-back chair Masonite or plywood panel and

clamps

stand or small table

india ink

Japanese brush or flat-tipped, long bristle brush (#6 or #7) 200-watt floodlamp (optional)

Reference: model **Suggested time:** 10 minutes

Several drawing media can be used for this study, including crayon, but liquid media seem ready-made for it. Like the liquid tusche used in lithographs, india ink can be brushed on undiluted. A flat-tipped bristle brush or a Japanese brush is a good carrier of the ink. It will last longer if you dip it in clear water before loading with the ink. Excess ink can be wiped off on a scrap of paper before you begin to draw.

The drawing procedure is basically the same as for the previous study: draw for shadow pattern. The black ink makes it possible to compress your description of shadow into a single tone, a reduction that may require several attempts before you are satisfied with the results. This study requires only 10 minutes, however, so you should be able to complete several drawings in an hour.

A strong, directional light, such as that provided by a single large window or a 200-watt floodlight, is useful in creating clear shadow patterns on the model. These shadow patterns should be drawn as directly as possible, translating observed dark values into black and white. As you draw, the brush will require replenishing from time to time; before dipping it in the ink again, however, you may wish to explore the possibilities of drybrush drawing. The stroke produced by the dry brush tends to be broken and often registers the texture of the paper. The generally ragged quality of this technique is often responsible for the halftone effects that occur in drawings with undiluted ink or lithographic tusche, some of which are present in Nolde's Self-portrait. If you are not familiar with the brush as a drawing instrument, you may wish to begin your drawing with a dry brush, as it is handled similarly to the more familiar crayon.

SUBTLE TONAL VALUES

You may eventually wish to model the figure by using fine degrees of intermediary tones. Very subtle effects are possible with crayon by rubbing the paper to smear the marks. You can also use a small, cylindrically shaped roll of paper (called a stump) that is made especially for this purpose. For the subtlest gradations of tone another drawing medium is suggested, stick charcoal. With this medium the stump is best used in combination with a chamois skin (a piece of soft leather) and a kneaded rubber eraser. The chamois is used to rub in broad areas of smooth tone; the kneaded eraser, to create lighter tone by lifting crayon granules from the paper. It is necessary to spray a completed charcoal drawing with a thin varnish fixative in order to fix the particles of charcoal permanently to the surface. Fixative is also useful for preserving the quality of crayon and pencil drawings, even though these media tend to be less subject to smearing than charcoal.

The art academy of the nineteenth century emphasized naturalism of effect and taught shadow modeling as a technique for drawing the nude. Such studies, known as académies d'après nature, required a drawing medium capable of rendering delicate nuances of tone in order to create the desired effect of light and shade. Charcoal, inexpensive, flexible, and capable of rendering subtle values of tone, was most frequently used, but its very flexibility, which permitted easy erasure and correction, not infrequently led to overworked drawings that were derisively labeled "academic."

Charcoal shadow modeling was and is not suited to every artist's purpose. For the young American artist Thomas Eakins, however, it seemed tailor-made. A drawing by Thomas Eakins (1844-1916) provides a fine example of shadow modeling with charcoal (Figure 5-47). The artist has carefully translated his formal observations into shadow patterns that are drawn in distinct tonal steps. The tones range from pure black, used discretely within areas of dark gray, to the highest values of demitint, created by means of the stump. All patterns were apparently constructed with line and integrated into the tonal configuration. Highlights appear to have been created by erasing within a light tone. Eakins' use of line is instructive though not immediately apparent. Patterns of tone in the figure's right leg reveal fine broken lines that mark the boundary of the shadow area. The sharp angularity of the broken line suggests that careful angular analysis and measurement formed the basis for the remarkable accuracy of this life study, drawn while Eakins was a student in a French art academy. Although such structured accuracy is a quality sometimes identified more with academic discipline than with art, for Eakins it formed the basis of the intensely personal idiom of his mature work.¹⁹

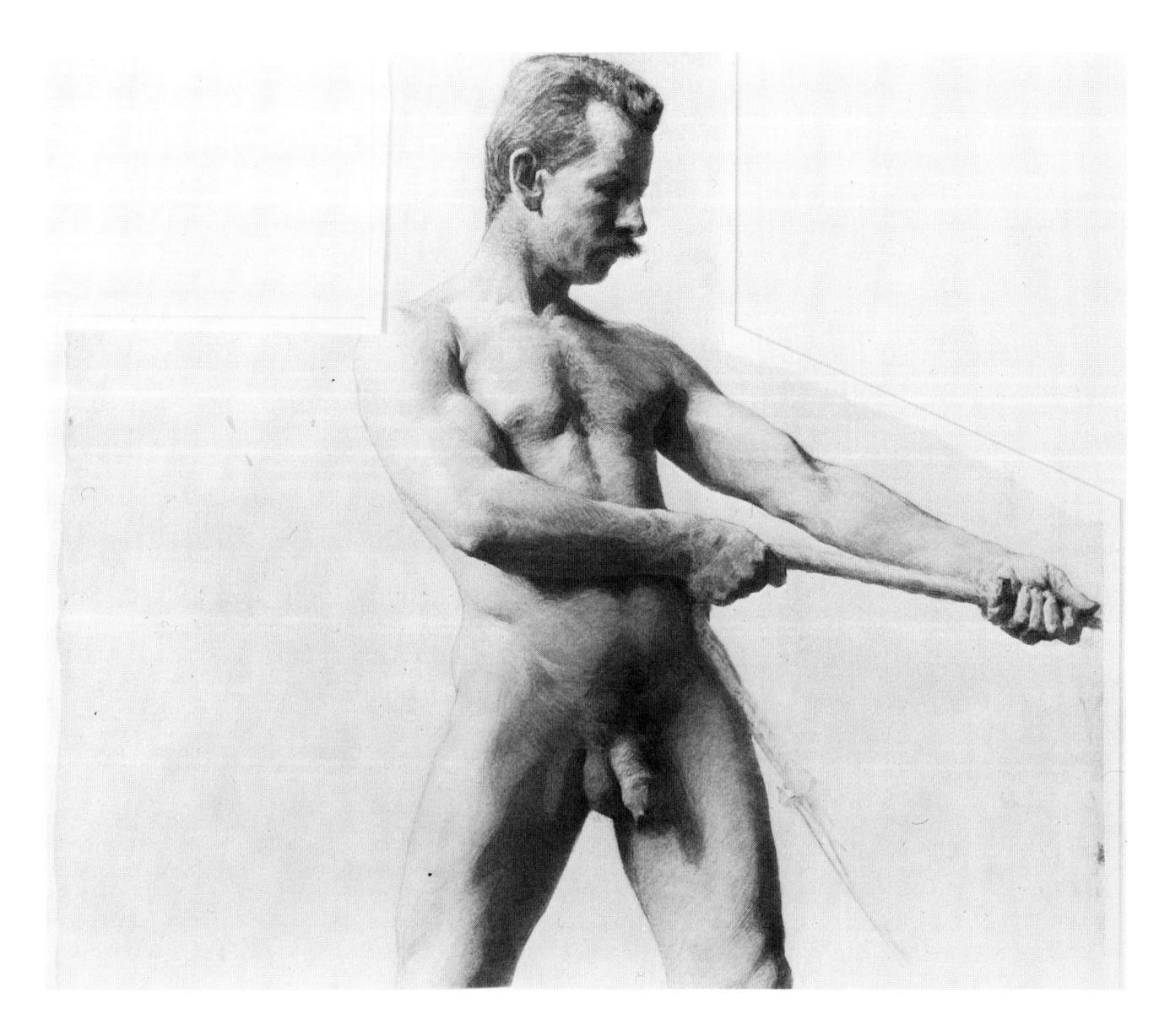

5-47. Thomas Eakins (1844–1916), *Academic study*. Charcoal on paper. Seiden and deCuevas, Inc.

COLORISTIC AND FORMAL VALUES IN DRAWING

Up to this point modeling has been considered only in terms of describing form and its shadows, yet the draftsman often finds it necessary to deal with problems of color in a subject. Kollwitz, in her lithograph for a poster (Figure 5-45), chose to stress form in one area and color values in another. The dress and hair of the figure, for example, are treated as flat shapes distinguishable only in terms of color areas, while the region of the face is modeled in almost sculptural form. If the same inconsistency occurred in the work of a lesser draftsman, it might appear as a glaring error, but here the contrast that it provides seems to dramatize the subject. A greater integration of color effects with modeled form was achieved by Eakins in his Academic study (Figure 5-47), in which he modeled the figure's hair within a generally darker tone. The same solution was arrived at by a present-day student (Figure 5-37). There are no fixed rules for combining modeling techniques with tones representing color areas: their appropriateness depends upon the purpose of the artist.

Although drawing is usually thought of as an art form in which color is absent or subordinate, many artists in the past felt no such limitation and neither should the draftsman of today. Colored drawing media permit a more direct way of transcribing colors from life, and if color is your primary interest, you may wish to extend your media to include colored crayons, chalks (pastels), colored pencils, and/or watercolors. Even tempera and oil paints can be considered as drawing media in this sense.

Some modern artists have preferred to mix media while drawing in color. Picasso, for example, used tempera, watercolor, and pencil in a single drawing (Figure 5-93). Such mixtures are possible with nearly all media that share the same solvent, in this case water. If you have not previously used colored media in drawing, however, a more cautious approach may be helpful. By restricting the number of colors in a drawing it is possible to obtain a surprisingly rich coloristic effect with a single medium. Sanguine (rusty-red), black, and white crayons, for example, used on a bluish-gray ground, are especially effective in modeling form. These colors, limited though they are, provide contrasts of warm and cool effects (i.e., reddish and bluish tones), which can be used to model form just as contrasts of value are used in monochromatic drawing. Toned drawing papers are made in a variety of colors for this purpose and are available in sketchbook form. It is also possible to prepare a toned drawing ground on white paper by means of a watercolor or acrylicpaint wash.

Regardless of the means used to represent it, form rather than color is the element most commonly

identified with drawing. If form is more interesting to you, you may wish to pursue it as an isolated factor by drawing from monochromatic sculptures or casts, in which color as a form-defining element is virtually absent. Relief sculptures or, if they are not available, casts of relief sculptures are of special interest to the draftsman who is also concerned with pictoral form, for sculptured reliefs share many of the qualities of painting. Both painting and relief sculpture usually function within a rectangular, planar format. Although relief sculpture physically modulates the pictorial surface, the surface modulations, like those represented in painting, are in part illusionistic, for the relief represents volumes in a relative rather than an absolute way. In a relief by the Italian sculptor Jacopo della Quercia (1374/5-1438) entitled The Creation of Adam (Figure 5-48) the figure of Adam does not physically rise from the surface to form fully rounded features of the body, as in freestanding sculpture, but rather protrudes only to the degree necessary to give the effect of rounded forms.

Another illusionistic spatial device common to both relief sculpture and painting is that of overlapping form (see chapter 1). A clear example of overlapping form is seen in the della Quercia panel, in which the head of the figure of God, by interrupting the triangular form of a halo, appears to be in front of it. Such spatial relationships as overlapping form and the relative representation of volumes are most apparent if the reliefs are illuminated, as they often are, by a directional light source. Under such lighting conditions the tonal values observed on the relief are a remarkably clear function of form (Figures 5-48 and 5-49). The highest values occur on the leading edges of planes that face the direction of the light source. Here a clear separation of values occurs between the darker tones of the adjoining plane. Like a line, the separation corresponds to a discontinuity of surface in the sculpture. The darkest values occur in shadow areas in which the surface turns sharply away from the light, resulting in a value contrast of dark and middle tones. Tonal steps of this kind help to establish a pictorial figure-ground relationship and lend themselves to straightforward translation into shadow modeling.

The French artist Nicolas Poussin (1593–1665) accomplished such a translation in his drawing of an ancient relief found on the Arch of Titus (Figures 5-49 and 5-50). Using line to establish the contours of the relief, he laid in transparent washes to model shadow tones. In some later drawings such as *The Triumph* of *Galatea* (Figure 5-51) he reduced the number of tones to obtain a bolder effect. Many leading edges represented in this drawing are not separated from the background by tones but rather by faint contour lines drawn with chalk. Despite this tonal abbreviation the drawing retains the qualities of values and form that are peculiar to relief sculpture.

5-48. Jacopo della Quercia, *The Creation of Adam*, c. 1430. Marble relief. $34\,1/2'' \times 27\,1/2''$. Bologna, main portal, San Petronio.

5-49. Unknown Roman artist, *The Triumph of Titus*, 81 A.D. Stone relief. Arch of Titus, Roman Forum.

5-50. Nicolas Poussin, *Study after* The Triumph of Titus, 1640–45. Pen, brown ink, and wash. 15.1×27.7 cm. Stockholm, National-museum.

Relief sculpture as well as sculpture in-the-round were commonly available in art schools of the past in the form of plaster casts, which, like the original sculptures, enabled students to study the human form without the sometimes confusing elements of color and movement (Figure 5-52). Casts also provided a means of acquainting young art students with the classical-sculpture tradition of Rome and Greece. For both reasons drawing from the cast was an important feature of art instruction in western Europe from the seventeenth through the nineteenth century, es-

pecially in France. Only after considerable study with casts, often of different parts of the body (such as the casts of heads in Figure 5-52), was the student admitted to life classes in the art academy.²⁰ The unbroken tradition of such instruction is seen in the student work of Picasso (Figure 5-53). Today, however, casts have fallen into disuse as a means of study, though many can still be found in art schools. This is perhaps to be regretted, for the cast can ease the transition for the beginning student from basic drawing problems to the complexities of the human form.

5-51. Nicolas Poussin, *The Triumph of Galatea*, c. 1635. Black chalk and brown wash. 14.2×20.2 cm. Stockholm, National-museum.

5-52. Wallerant Vaillant (1623–1677), Young Artist Drawing from a Cast. Oil on canvas. London, National Gallery.

5-53. Pablo Picasso, Study of a torso after a plaster cast, 1893—1894. Conté crayon. 19 $_{3/8}'' \times 12 _{1/2}''$. La Coruña. (Courtesy of Museo Picasso, Barcelona.) While still in his early teens Picasso produced this study of a cast from an ancient Roman sculpture of a satyr. The knowledge of classical form acquired as a student emerged later in his mature work (see Figure 5-106).

LINE AND MODELING

A plaster cast can be used to demonstrate yet another instrument of modeling—line. Although line is perhaps better known for its capacity to represent form in terms of edges and discontinuities, it is also capable of defining the continuous aspect of form and can therefore be used for modeling. By projecting a thin beam of light on the model or on a cast (Figure 5-54) it is possible to see contour lines over the entire surface of the form instead of the more familiar contours normally perceived along edges and other surface discontinuities.²¹ Ordinarily, of course, surface contours are not visible on the human form, and it would be difficult to draw them with such a projected light on the model. A similar effect can be achieved, however, with the draped model.

5-54. Cross-section contours. A time exposure of a cast of the head of the Aphrodite of Melos, recording many cross-section contours projected by means of a specially prepared slide (see footnote 21; Chapter 5).

STUDY 21. DRAWING CONTOURS OF FABRIC PATTERNS

Materials: 8 1

8 1/2"-x-12" or larger bound sketchbook of smooth bond

paper

india-ink drawing pen (2.5 Castell TG or 0.5mm Mars Staedler or Rapidograph)

nodel draped in striped m

Reference:

model draped in striped material

Suggested time: 20–30 minutes

A striped pair of overalls or a bathrobe (Figure 5-55) will provide the necessary visual pattern for this study. Because the pattern is in the cloth and changes as the cloth shifts, the study is best completed in one session, with the model holding a sitting pose. The drawing session need not exceed 20 or 30 minutes.

With the model posing in the striped clothing, you may begin by making a preliminary contour drawing in pen-and-ink. When the contour drawing is established to your satisfaction, draw one by one the undulating contours that appear on the cloth. Many such contours reflect the form of the body beneath; others result from folds in the cloth. Together they can communicate a sense of surface relief similar to modeling. The optical excitement of the striped pattern and its ability to describe volume seem to have intrigued the French artist Jean-Antoine Watteau (1684–1721), who exploited the pattern's special qualities in a brilliant series of drawings of women in striped gowns (Figure 5-56).

Drawing forms covered by striped material is a helpful introduction to the construction of surface relief with line. The next step is to draw imaginary lines of the same character—a true form of modeling. A figure clothed in unpatterned material can be modeled with line strokes that follow the form in a fashion similar to the stripes in Figure 5-55. An instance of this use of line is observed in Netherlandish drawing (Figure 5-57), in which short strokes describe boldly simplified cloth-fold structures reminiscent of Gothic woodcarving. The artist created the effect of receding form by increasing the density of the line strokes, causing correspondingly deeper values and richer textures in the valleys of folds and along the sides of the upper figure. Modeling technique aside, the drawing represents a superb achievement in linking two figures together in a single composition by means of the rhythmic patterns of the folds.

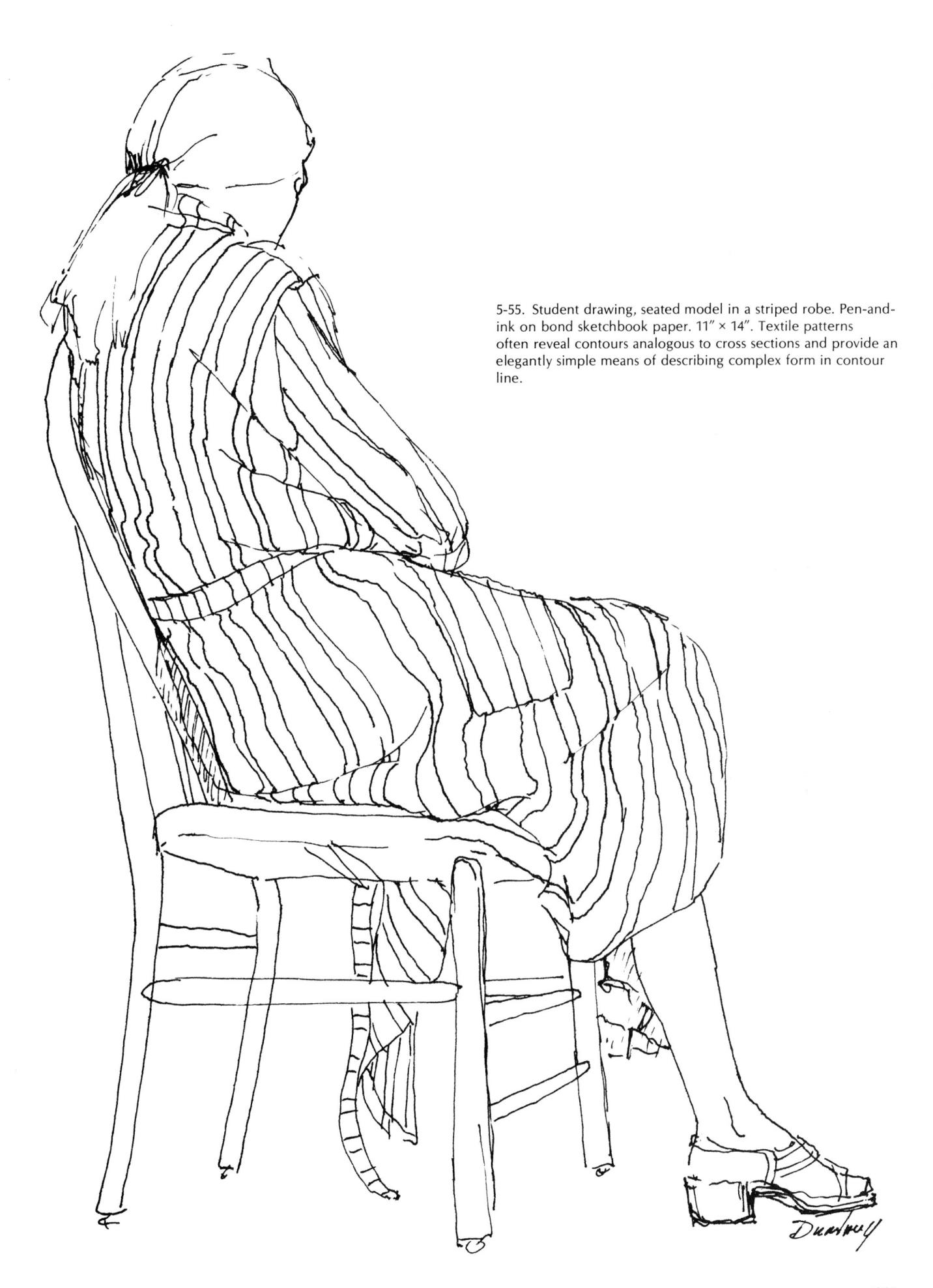

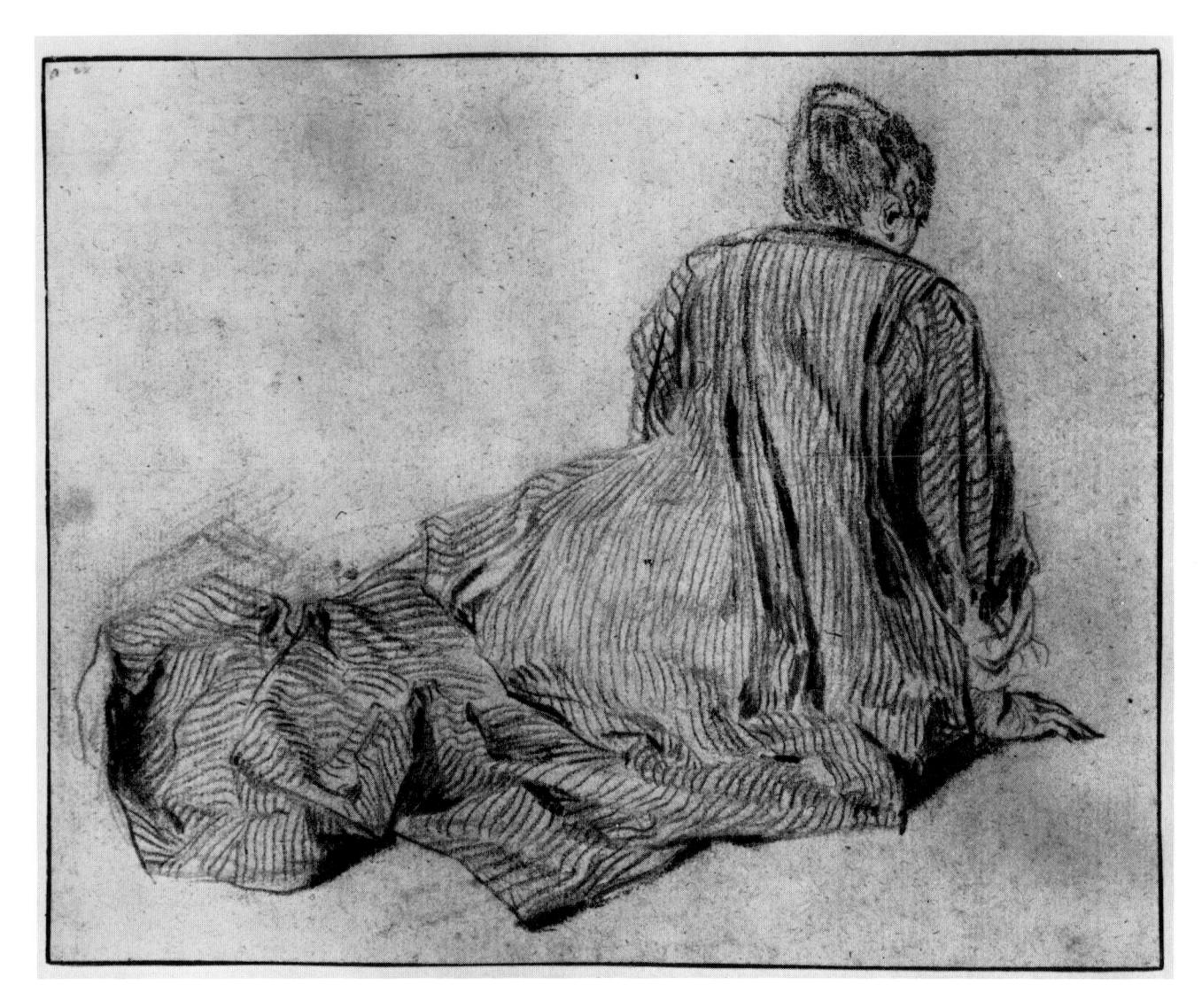

5-56. Jean Antoine Watteau (1684–1721), Woman Seated on the Ground, Seen from the Back. Crayon. London, British Museum. The pattern of the material worn by the model informs the artist not only of the nature of cloth folds but also of the form of the body. Both functions can be observed in this drawing, in which the richly undulating contours suggested by the model's dress are echoed in the linear patterns of the model's hair.

5-57. Anonymous Netherlandish master, Mary and Saint John, 1425. Pen, brush, and brown ink. 302×772 mm. Dresden, Staatliche Kunstsammlungen.

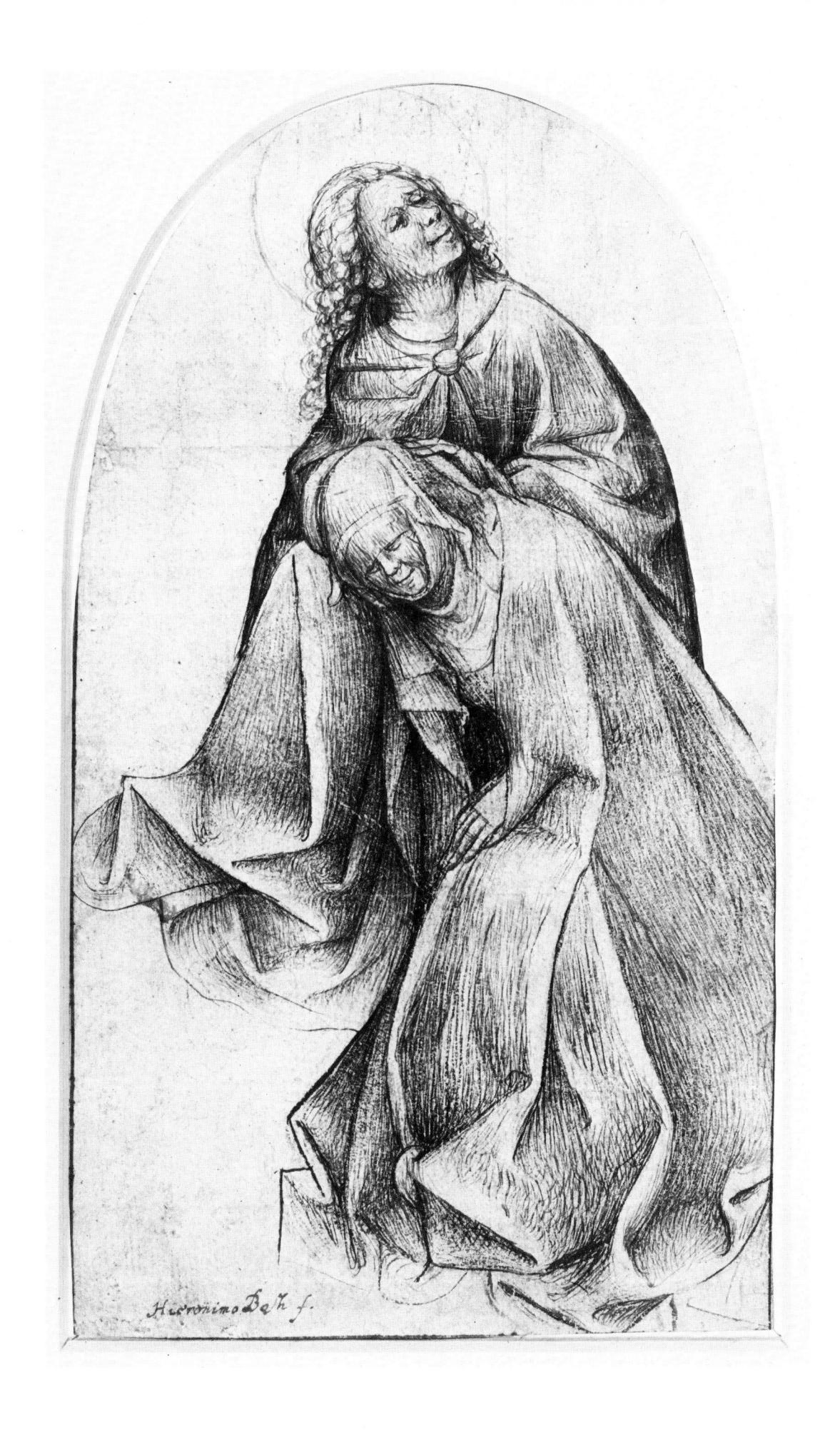

5-58. Model of a cylinder intersected by a plane.

5-59. A cylinder marked to show intersections by parallel planes.

5-60. Leonardo da Vinci, Anatomical study: cross-sectional rendering of a man's right leg. Windsor Castle, Royal Library. The horizontal lines on the right represent planes that visually cut through the form, producing the separate sections seen from a different angle on the left. Compare with Magritte's Studies for Sculpture: Delusions of Grandeur (Figures 8-30, 8-31, 8-32, and 8-34).

CROSS-SECTION CONTOURS

The surface contours projected on the plaster cast shown in Figure 5-54, though similar in some ways to those in the Watteau and the Netherlandish drawings (Figures 5-56 and 5-57), are far more systematic and therefore more revealing of the way in which such contours function. The projected contours represent true cross sections (slices) resulting from the intersection of the solid form of the cast by parallel vertical planes of light. If the cast in Figure 5-54 were viewed from the same angle as the direction of the light, the projected lines would appear straight and vertical without any suggestion of the relief form of the head. Seen from the view in the photograph, however, they convey a strong sense of the cast's form. Other angles of intersection are equally effective in communicating form (Figures 5-58 and 5-59). Leonardo experimented with this principle in an anatomical study of the legs (Figure 5-60). He drew imaginary segments of two legs, revealing total cross sections, represented as ovals, that give a graphic idea of the rounded form of the leg at various heights. The same cross sections in the leg drawn on the right remain flat and devoid of relief, however, as they are based on planes parallel to the line of sight. The power of the cross-section contour to suggest relief and volume in a drawing or in any twodimensional representation thus depends on the apparent angle (orientation) of the cross-section plane with respect to the surface plane of the drawing. By experimenting with imaginary cross sections you can discover which orientation best describes form in your drawings.

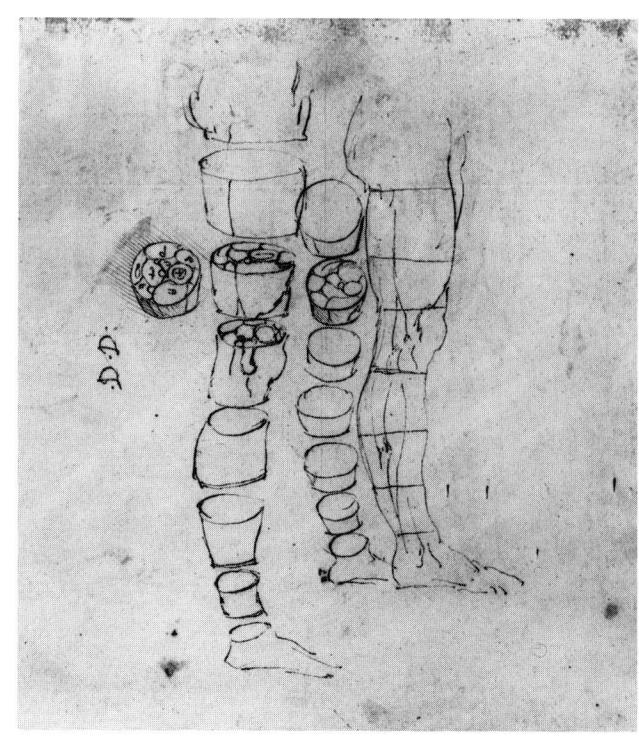

STUDY 22. DRAWING CROSS-SECTION CONTOURS OF THE HUMAN FORM

Materials: 36"-x-24" newsprint drawing pad

easel or straight-back chair Masonite or plywood panel and

clamps

drawing crayon

Reference: model **Suggested time:** 20 minutes

To begin this study, lightly indicate the figure in contour, paying special attention to the general gesture of the body. Try to draw a contour that would appear if the body were intersected (sliced) by an imaginary plane. Any region of the figure can be used for this purpose, but you may find it easier to use the more cylindrical forms of the leg or arm. Draw slowly, allowing the crayon to follow the apparent contour of the imagined intersection (Figure 5-61). Observe the model carefully as you draw: the contour. though generally rounded like an oval, must follow the undulations of the body's irregular volumes if it is to be accurate. (Only in the Michelin rubber-tire figure are contours truly regular!) If you find it difficult to construct a cross-section contour in a particular passage of the body, it is helpful to draw a rectangle representing the plane that intersects the form, as shown in Figure 5-59. This makes it easier to visualize the contour produced by the plane. Particular care is necessary as the contours approach the apparent edge of body forms, for they may appear to turn sharply. Quality is easily detected in a crosssection drawing. If the cross sections are drawn sensitively, curving in accordance with observed form, they seem to have a light, transparent quality (Figure 5-62); if they are drawn inconsistently and do not correspond with the turning of form, they tend to appear as opaque stripes painted on the figure.

The geometrical nature of the cross-section contour may account for the fascination that it held for some artists of the Renaissance. Leonardo employed the cross section, as in Figure 5-60, for anatomical study: Piero della Francesca used it to represent three-dimensional volumes of the human form on a flat surface (Figures 5-63 and 5-64); Dürer, the German contemporary of Leonardo, adopted the crosssection contour as a measuring device in his search for ideal human proportions (Figure 5-65). The crosssection contour is now utilized in medical studies to measure body volume (Figure 5-66). In these medical studies Piero della Francesca's painstaking measurements are replaced with modern mapmaking and computer techniques, resulting in unique cross-sectional "portraits" of human subjects.²²

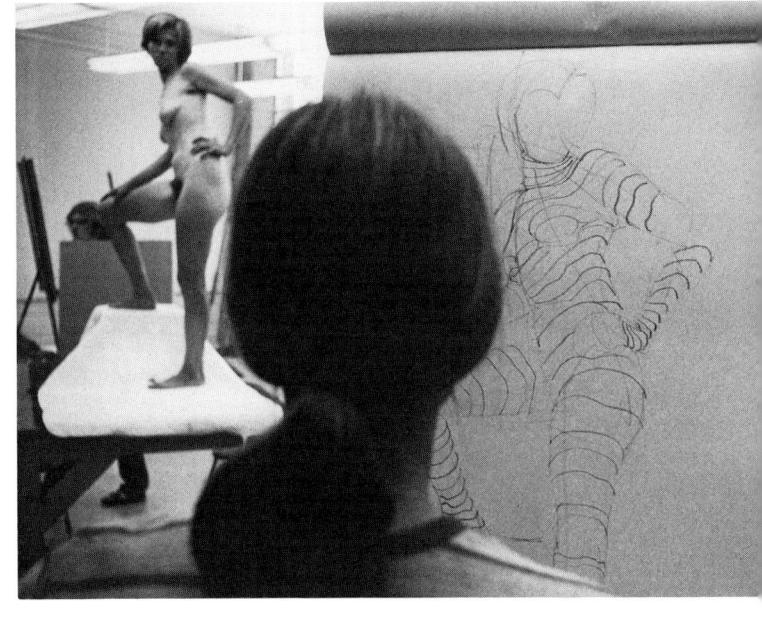

5-61. Drawing cross sections. The preliminary contour drawing provides a visual armature for a study of cross-section contours.

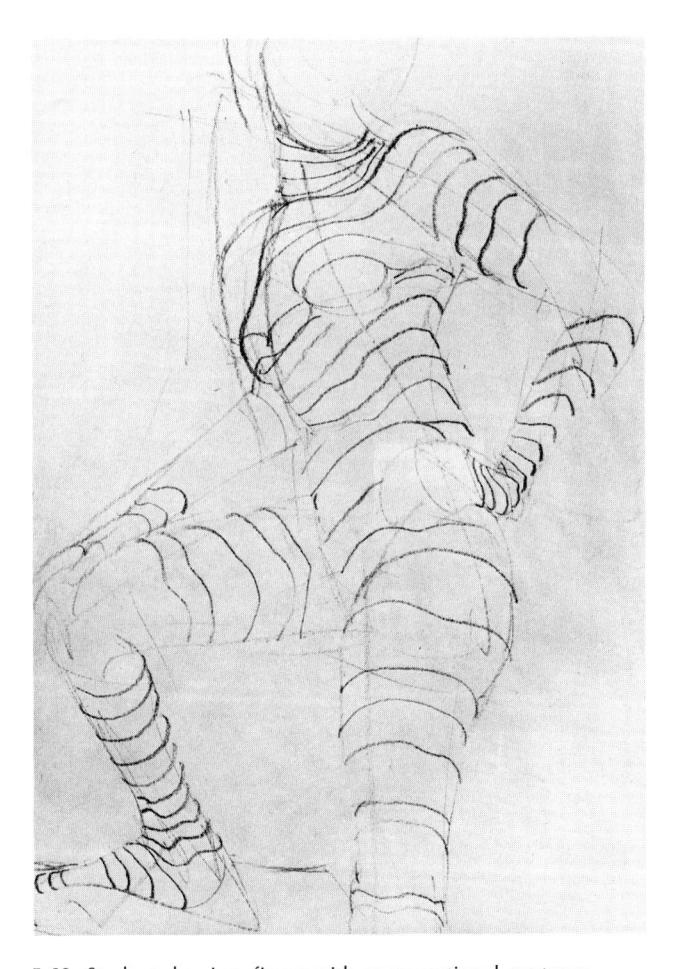

5-62. Student drawing, figure with cross-sectional contours. Crayon on newsprint paper. 36" × 24". Apparent irregularities of contour result from careful observation of external form. A relatively slow drawing speed is suggsted for such studies.

5-63. Piero della Francesca (c. 1420–1492), Study of the proportions of the head. Milan, Biblioteca Ambrosiana. An artistic innovator with linear (geometric) perspective, Piero also experimented with cross-section constructions of the head. The horizontal lines cross the profile and frontal views of the head in the upper portion of the drawing at specific points. From those points the artist dropped vertical lines, which measure the corresponding points on the cross-sectional representation below.

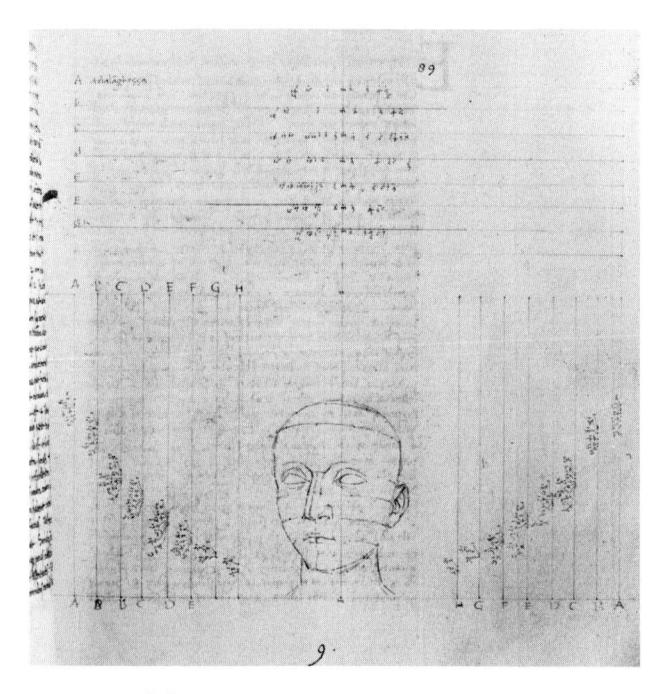

5-64. Piero della Francesca, Study of the proportions of the head. Milan, Biblioteca Ambrosiana. By showing the cross-sectional contours inclined with respect to the drawing surface the artist illustrates a systematic way of representing the volumes of the head.

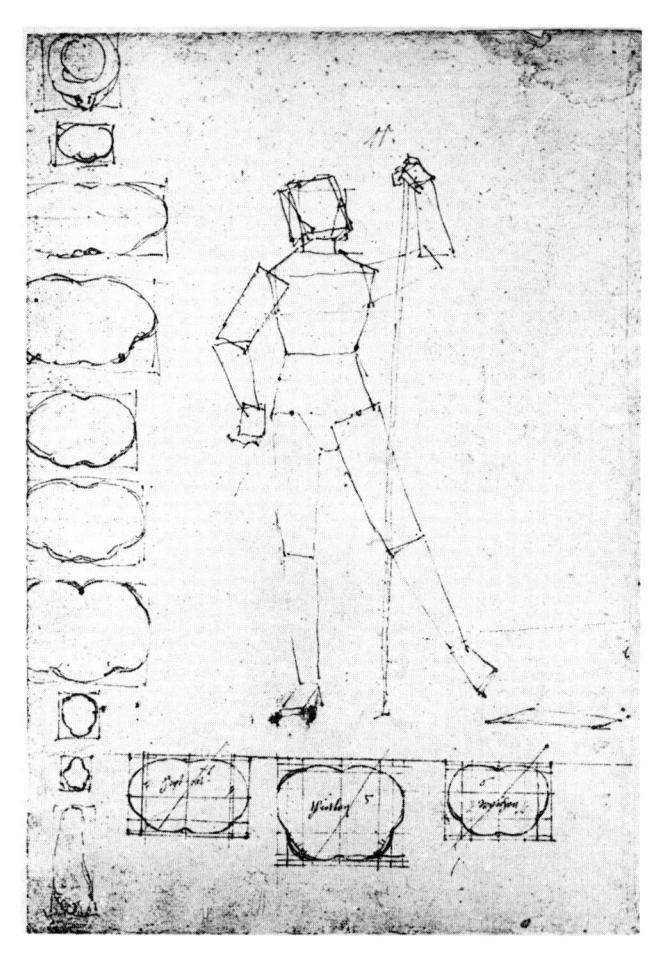

5-65. Albrecht Dürer, Stereometric man: thirteen cross sections of the body, c. 1527. Page from The Dresden Sketchbook. Penand-ink. 11 3/8" × 8". Dresden, Sächsische Landesbibliothek. This is one of a large number of studies that Dürer made in preparation for the last of his Four Books on Human Proportion.

5-66. Dr. R. E. Herron, Cross-sectional representation of an individual, drawn (plotted) by computer. Pen-and-ink. Houston, Biostereometrics Laboratory, Texas Institute for Rehabilitation and Research, Baylor College of Medicine. This is essentially the same construction as that improvised by Piero della Francesca (Figure 5-64) but drawn with the accuracy possible only with computer and map-making techniques. The drawing process of the computer is suggested by the slightly jerky line quality, produced as the pen moves in a straight line from one calculated point to another. Upon command the computer can generate a different view of the same figure. The angle of cross-section inclination can be gauged by the apparent angle of the figure's feet.

The cross-section contour lends itself to scientific studies because it is capable of describing form with unequalled accuracy and completeness. Paradoxically, these very qualities may explain why it is seldom employed in realist art: the cross-section contour records more information about forms than the human eye normally takes in. The superrealistic, or, more precisely, surrealistic, aspect of the cross-section contour is apparent in some computer studies of the human body. Moreover, several twentieth-century artists who have employed it have in fact been closely associated with the surrealist movement (Figures 5-67 and 5-70).²³

The cross-section contour also appears in some works by artists concerned primarily with formal analysis. The modern French artist Jacques Villon (1875–1963), for example, used such contours to interpret the volumes of a bust of Baudelaire by the artist's brother, Raymond Duchamp Villon (Figure 5-68). He analyzed the form of the sculptured head freely in terms of cross-section contours, which, however, are not drawn as they might appear around the sculptured form but are rather laid out like a deck of cards. Treated as objects in themselves, the contour-planes seem to cast shadows. Pursuing this direction in subsequent works with the same theme, Villon created compositions so abstract that they are easily mistaken for nonobjective art.

5-67. Paul Klee, The Angry Kaiser Wilhelm, 1920. Pen-and-ink. $7\,1/4''\times 8''$. Bern, Fr. Felix Klee collection.

5-69. Geobattista Pisani, Figure from a calligraphic scroll, 1640. Pen-and-ink. Genoa. The pen produces calligraphic effects that often carry over into pen drawings, though seldom in so decorative a manner. The systematic thicks and thins of cursive writing apparent throughout the drawing are characteristic effects of the broad-point pen, which produces a line that varies in width according to the direction in which it is pulled (and not according to the pressure of the tip against the surface, as is the case with the oriental brush). As in Figure 5-70, the form of the figure is perceived as though it were constructed with cross-section contours.

5-70. Pavel Tchelitchew, Head, 1950. Colored pencil on black paper. 18 $_{7/8}'' \times 12''$. New York, Museum of Modern Art. Purchase. Only the form of the neck is modeled in regular cross-section contours, for Tchelitchew conceived the head as a virtuoso conceit of unbroken spiral line, originating at the tip of the nose. This technique has a precedent in 17th-century calligraphic and engraved decoration (Figure 5-69). Despite the spiral construction the head is perceived as if it were constructed of cross-section contours. Such technical tricks play upon the limits of human visual perception.

A deceptively similar mode of drawing utilizes the spiral: closely spaced spiral contours tend to be perceived as a series of cross sections. This phenomenon is seen in the fanciful calligraphic coils of certain seventeenth-century decorative figures (Figure 5-69) as well as in the more monumental white-spiral drawings (Figure 5-70) of the surrealist Pavel Tchelitchew (1898–1959). Tchelitchew deliberately exceeds the limits of human visual perception, causing one to perceive what is not there, cross-section contours. The apparent cross-section contours of the head in Tchelitchew's drawing appear to be formed on planes that lie parallel to the drawing surface, as do the contours of a relief map. It is remarkable that this mode of figural representation, used for many years in map making, has so rarely been adopted by artists. Scientific contour maps of the body drawn by cartographers reveal graphic possibilities of the map contour that merit the attention of artists concerned with representing sculptural form (Figures 5-71, 5-72, and 5-73). Such maps present a virtually complete description of volumes without concessions to color or shadow factors.

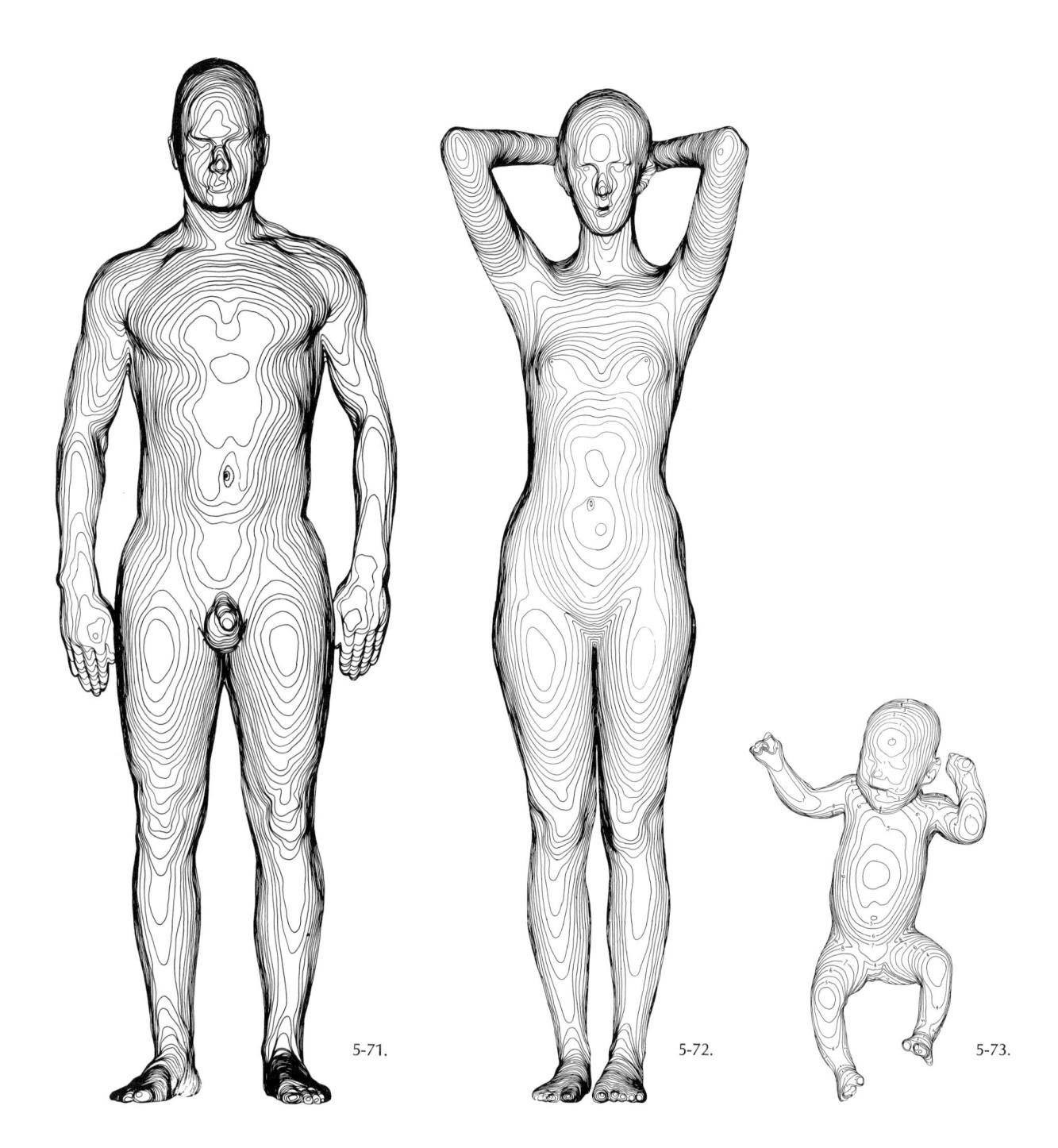

5-71, 5-72, and 5-73. Dr. R. E. Herron, *Photogrammetric maps of a man, a woman, and a baby*. Houston, Squibb Company and Biostereometrics Laboratory, Baylor College of Medicine. With stereo photographs of the human body as a reference, technicians can "plot coordinates of the surface of the photographed subject, much as if they were making a contour map of mountains and valleys. They use a stereo plotter of the same basic type utilized in aerial surveying and mapping" ("Exploring the Third Dimension with Camera and Computer," *Kodak Studio Light*, no. 1 [1975], p. 206).

Seen from a short distance, the individual lines in a contour body map seem to melt into an overall effect of tonal modeling-darkening as surfaces turn, lightening on the flatter frontal surfaces. The contours' varying intervals also produce a sharply denser textural effect on turned surfaces, even sharper than might be expected in a naturally occurring density gradient (discussed earlier in this chapter in the section on perception of form). The reason for this difference of effect is explained by comparing the "natural" gradient of texture density with that of the "map" contour on a simple object such as a cylinder (Figures 5-74 and 5-75). The naturally occurring gradient results from a regular pattern of texture on a surface. The regularly spaced vertical lines seen in Figure 5-74 are analogous to such a gradient. These lines were drawn parallel and spaced equally on a sheet of paper, which was subsequently wrapped around a cardboard cylinder. Viewed on the cylinder, the lines appear to be separated by an interval of space that shortens as the surface turns from the viewer, thereby producing a "denser" textural effect on the sides than in the vertical center. The vertical lines in Figure 5-75 are drawn differently than their counterparts in Figure 5-74. They represent the intersections of the cylinder by equally spaced planes at right angles to the line of sight—in short, they are map contours. Significantly, the apparent variation of interval between the lines, which is much more pronounced than that seen in the "natural" density gradient, creates a correspondingly stronger sense of relief. The effect observed in map contours is in a sense an exaggerated gradient of texture density, one that is well suited to the purpose of representing three-dimensional forms on a flat surface. Such an exaggerated gradient seems to compensate visually for the two-dimensionality of the drawing surface while remaining true (i.e., parallel) to the plane of the surface, a unique quality of map-contour modeling.

5-74. Cylinder with equally spaced vertical lines on its surface. The regular spacing between the lines is comparable to a regularly repeating texture or pattern on the surface of an object. Such patterns in nature produce a gradient of texture density that serves as a visual cue in form perception.

5-75. Cylinder with vertical lines representing intersections of equally spaced planes. A comparison of the intervals between these lines with those in Figure 5-78 suggests that the former may represent an exaggeration of naturally occurring gradients of texture density.

The contours of relief maps are essentially the same as the cross-section contours considered earlier. Geometric in origin, they are readily generated on the modern computer. The "drawing" process of the computer, though completely mathematical, can be compared in a general way with the traditional drawing process of the artist. For example, the action of the plotter, the machine that actually makes ink lines on paper, is basically that of mechanical energy governed by fairly simple signals (causing the pen to move to the left or right, up or down) and is thus comparable to the motor skills of the artist. The signals are deduced from data that is coordinated by means of an ingenious mathematical plan called the computer program. In computer drawing this program usually incorporates a concept of space similar to that of the artist. The program for Figure 5-76 utilized a concept based on traditional perspective and is called perspective transformation. Data for this program is coordinated by means of three axes corresponding to the three dimensions of space, not unlike the artist's visual estimates and measurements. Before the computer operator commands the plotter to begin drawing, it is possible to view a projected image of the form on a cathode screen. The operator can also command the computer to generate other images of the same form as it might appear from different points of view and from different distances in space. Like the artist, the computer operator can choose from a practically limitless number of possible images, a problem of creative selection quite similar to the problem that commonly confronts the artist in the studio: "The artist," as Degas once wrote, "does not draw what he sees, but what he must make others see."24 Unlike the computer artist, who selects the completed image before the plotter begins to draw, the draftsman exercises selectivity during the drawing process. Yet the contour concept evident in computer drawing applies to several manual drawing methods, in particular to hatch modeling.

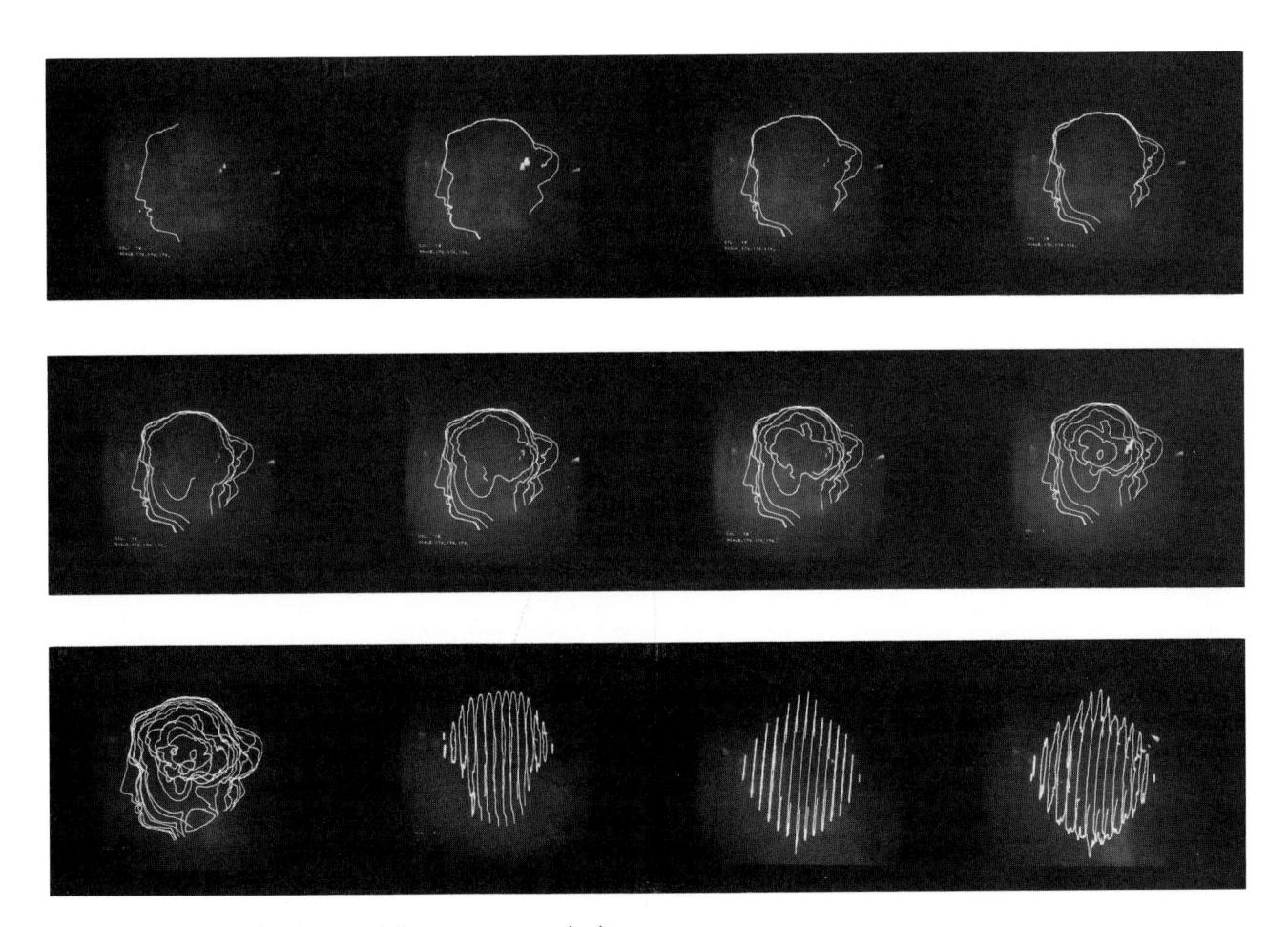

5-76. William Berry and Robert Tyndall, computer console displays. This series of photographs of the cathode display was taken at intervals as the computer image was generated and, in the lower three frames, "rotated" in "space." Upon the command of the operator the computer later directed a plotting machine to draw the image at lower left. The numerical data necessary for drawing the head was derived from photographs of a cast of the head of the Aphrodite of Melos similar to that in Figure 5-54.

STUDY 23. CONTOUR HATCH MODELING

Materials: 36"-×-24" newsprint drawing pad

easel or straight-back chair Masonite or plywood board and

clamps

drawing crayon

Reference: model **Suggested time:** 30 minutes

To begin your first study in hatch modeling from life, prepare a contour drawing of the figure, developing it only as far as is necessary to provide a frame of reference—10 minutes is sufficient for this phase of the study. Draw cross-section contours as in study 21 but do not complete them (Figure 5-77). In drawing the incomplete contours, or hatch marks, follow the turning form of the body. If a passage of your drawing appears to need more development in order to be clear in terms of form, it is likely to be a useful area for hatch modeling. This is often the case with parts of the figure representing surfaces that turn or recede sharply. It is important to work slowly,

giving each hatch mark the same attention and sensitivity that you applied to the complete contours of study 21. It is also important to space the hatch marks evenly, allowing a fairly wide interval between them. Beginners tend to crowd the marks, creating dark patches that prevent further development.

If a portion of the figure includes a general shift in surface direction, it is advisable to change the direction of the hatch. This can be accomplished by imagining an intersection at a different angle and drawing the hatches to correspond to the new surface direction (Figure 5-78). In some areas of the figure you may wish to define modulations of forms that lie within a previously modeled form. You can add a second series of hatch marks, based on a different intersection, across those drawn earlier (Figure 5-79). This technique is called *cross-hatching*.

With practice you will learn to draw hatches deftly without concentrating on each stroke. The hatching motion can become so accelerated that it resembles that of an automobile windshield wiper (Figure 5-80).

5-77. Modeling the figure with hatching over a preliminary contour drawing.

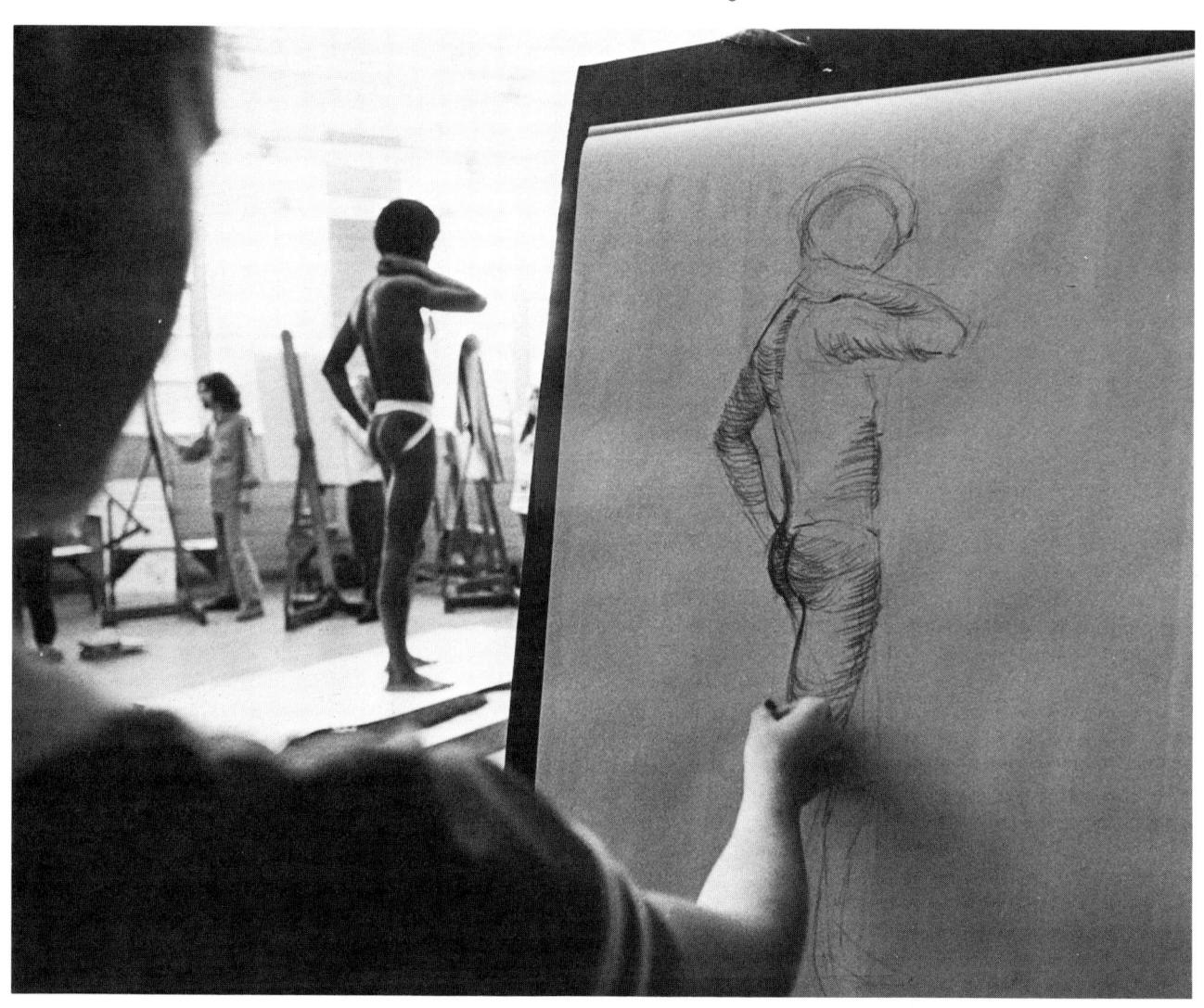

5-78. Cylinder. Cross-hatching is executed by changing the angle of the imaginary plane on which the hatch contours are based. In this example, drawn mechanically, the cross-hatching is based on two different planes.

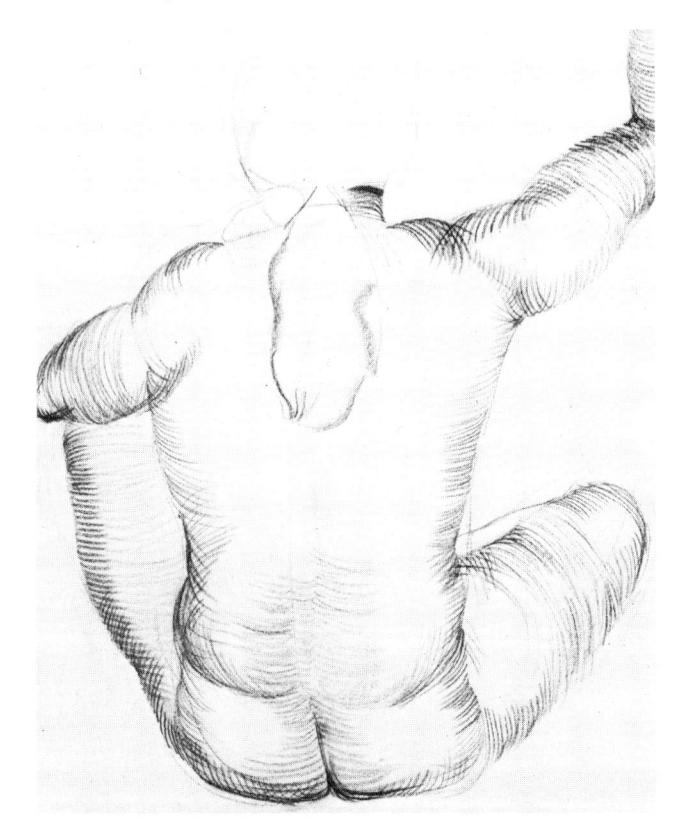

5-79. Student drawing, modeling with incomplete cross-section contours. Crayon on newsprint paper. 36" × 24". In this first attempt at hatch modeling the student varied the angle of the cross section in places, producing occasional cross-hatching effects, as in the lower-left portion of the figure.

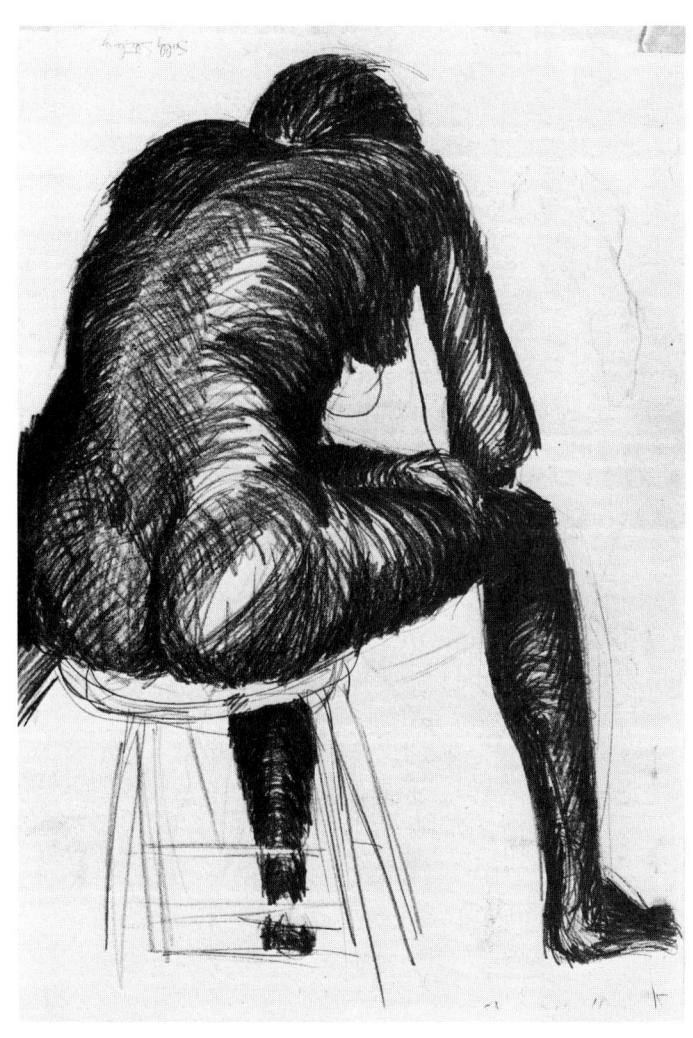

5-80. Student drawing, figure modeled with hatching. Crayon on newsprint paper. $36'' \times 24''$. With contour hatch marks drawn more rapidly than those in Figure 5-79, the modeling describes generalized large forms of the body.

With large, swinging hatch marks you can create forms of strongly modeled volumes, saving the shorter strokes for correspondingly small forms (Figure 5-81). It is sometimes possible to integrate hatch marks with lines indicating natural linear features of the body, such as hair (Figure 5-82), but hatching is generally an abstract construct of figurative representation. In a skillful drawing the hatch marks acquire a kind of luminous transparency as they model the form. The transparent quality makes the individual hatching strokes appear almost invisible, whereas in less skilled works hatch marks are obvious and heavy. To avoid such heaviness, it is important that each hatch mark be drawn carefully in relation to the form that it is intended to describe, for the correlation between the marks and the form makes them appear transparent and effective.

CONTOUR HATCHING

The term "hatching" contains a surprising metaphor, for it is derived from hâchure, a French word meaning "axing" or "chopping." Contour hatching is literally composed of graphic chop marks, a brutal yet unforgettable way of visualizing the intersection of a body form with a plane!

Effects similar to contour hatching can be found in sculpture, as, for example, in a terra-cotta sketch (Figure 5-83) by a pupil of the Italian artist Gian Lorenzo Bernini (1598–1680). In this work the teeth of a modeling instrument create scratches on the surface that heighten the effect of texture and volume in a way not unlike hatch marks in drawing. Some stone sculptures of Michelangelo reveal chisel marks, addentellati, similar to hatching on their surfaces. It is natural that

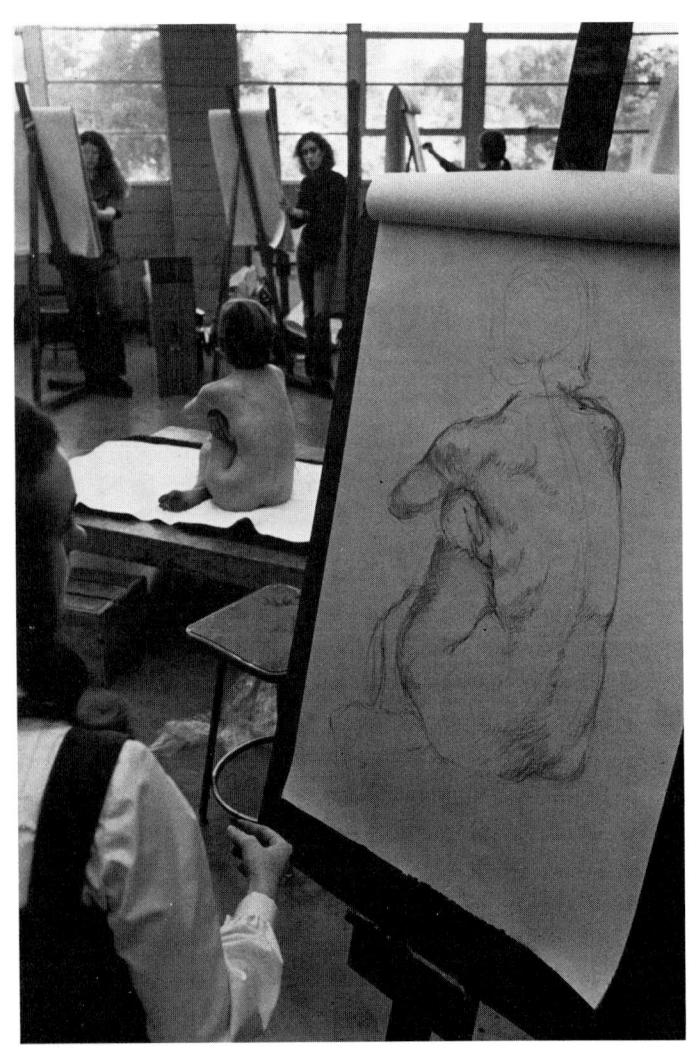

5-81. Drawing from life with hatch modeling. Rather than modeling the entire surface of the figure, the student is employing hatching to model surfaces that appear to need articulation for structural clarity. The preliminary contour line representing the spine of the figure is helpful in constructing the figure.

5-82. Student drawing, life-size study of the head. Crayon on newsprint paper. $36'' \times 24''$.

Michelangelo would turn to hatching as a drawing method, since it combines a sense of sculptural form with textures resembling the chiseled surfaces of his statues (Figure 5-84). The French artist Eugène Delacroix (1798–1863) demonstrated the special sculptural character of contour hatch modeling in drawings from photographs (Figures 5-85 and 5-86). His translation of photographs into drawings imparts a sense of rounded volumes only faintly discernible in the source. The artist's memory of the models as he posed them for the photographer is no doubt partly responsible for the greater volumetric aspect of the drawing. Some credit, however, is due to his mastery of contour and the human form.

5-83. Pupil of Giovanni Lorenzo Bernini (1598–1680), *Triton Bearing a Draped Woman on his Shoulder*. Terra-cotta sketch (bozzetto). 19 1/2" high. The effect of the actual volumes of these sculptured figures is given added emphasis by the hatchlike surface texture. Compare with Figure 5-84.

5-84. Michelangelo Buonarroti, $Nude\ study$, c. 1504. Ink. 37.5 \times 19.5 cm. Paris, the Louvre.

5-85. Eugène Delacroix, Studies, 1855. Pencil. 7 $_{1/4}'' \times 8$ $_{3/8}''$. Amherst, Massachusetts, private collection.

.5-86. Eugène Durieu, *Nude man* and *Nude man and woman,* c. 1854. Pair of photographs. Paris, Bibliothèque Nationale.

Hatch marks alone do not suffice to convey an impression of volume in a drawing. In order for hatching to impact a sense of three-dimensionality, the lines must be organized in terms of a unifying concept of volumetric form. The importance of the conceptual factor in hatch modeling can be seen by comparing a police drawing (Figure 5-87), which apparently lacks such a unifying concept, with a Self-portrait by Dürer (Figure 5-88). The police drawing consists of separate elements, assembled on the basis of the remembered appearance of individual facial features. One senses immediately the disconcerting lack of spatial (i.e., volumetric) coherence. The features appear to float as separate, positive constructs on a white ground; they are not sufficiently integrated to form a pattern of simple frontal symmetry. The nose, for example, has drifted oddly to one side of the other facial features. The drawing appears to be little more than an accumulation of isolated individual parts. There is no hatch modeling at the bridge of the nose, a construction that plays an important role in articulating the forms represented in Dürer's Self-portrait. The lack of such structural articulation is evident throughout the police drawing. In fairness, however, it should be pointed out that the police drawing is a composite by necessity and serves its intended purpose of visual identification surprisingly well.

Department. A \$1,000 reward awaits the think anything else

and Texas Ranger Ed Gooding have found nothing to make us Hugh A. Smith has posted

DO YOU KNOW SUSPECTED SLAYER?

e may have killed Boa Dieger No

park on May 1 a identification p

in cash was in a p A friend sai night about 10 p told officers 'just to walk a

Officers wond park at night. and other incid occurring at Da during two week fatal stroll. The widely publicized media.

Over 100 peo arrested duri disturbances, in Hood scldiers

Nobody park, as Kelly d night. Mrs. Nev daylight hours Mrs. Newberr Neches woman

5-87. Newspaper reproduction of a composite drawing used in police investigation. Pieced together with the aid of evewitnesses, the drawing lacks coherent spatial and structural organization; the individual parts remain isolated. Interesting for its naïveté of concept, the police drawing is the graphic opposite of the Dürer Self-portrait (Figure 5-88).

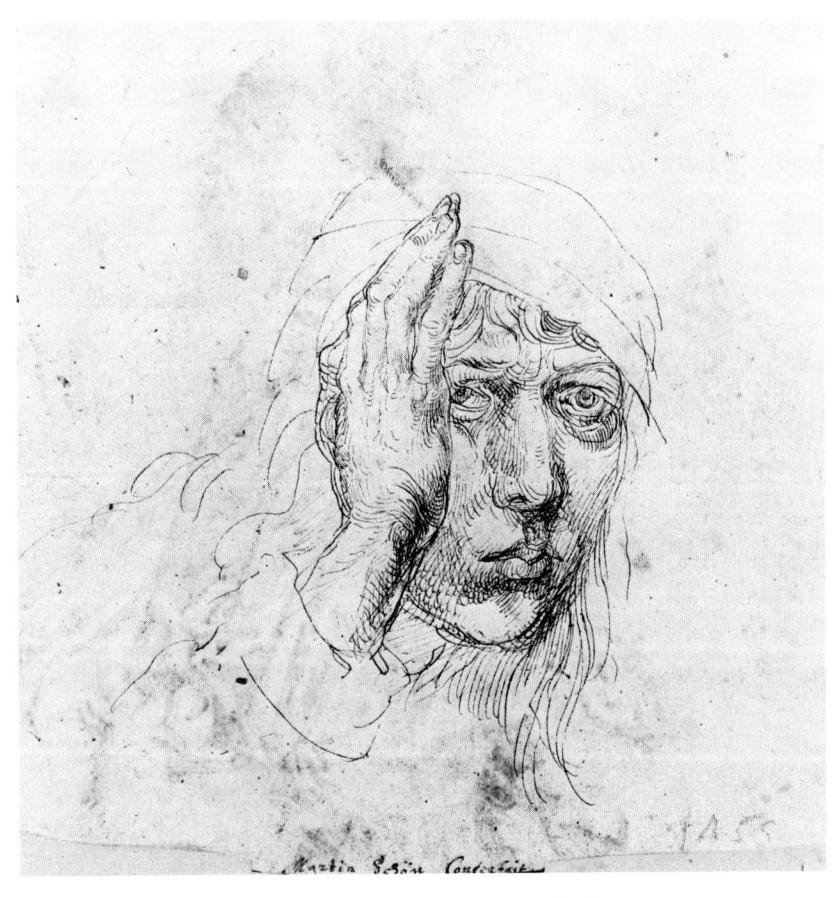

5-88. Albrecht Dürer, Self-portrait, c. 1492-1493. Pen-and-ink. 5.86" × 5.55". Erlangen, Universitätsbibliothek.

5-89. Dr. R. E. Herron, Computer drawing (plot) of the head in cross-section contours. Pen-and-ink. Houston, Biostereometrics Laboratory, Baylor College of Medicine.

5-90. Otto Dix, Head of a Woman, 1932. Black and white chalk on brown-ground paper. 22 5/8" × 18 1/2". Cambridge, Busch-Reisinger Museum, Harvard University. With the brown paper serving as a middle value in the drawing, the artist used white chalk to model frontal surfaces of the figure with contour hatching, a technique also found in German Renaissance drawings.

A completely consistent graphic representation of volumes, while generally desirable in drawing, is nevertheless not in itself a guarantee of quality. The computer rendering of an individual's head (Figure 5-89) is an utterly consistent spatial construction. Though it is not without visual interest, this particular computer drawing lacks the selective sensibility of the trained artist, a sensibility strongly felt in a hatch drawing by Otto Dix (Figure 5-90), a twentieth-century German artist. He used hatch modeling only in areas that needed structural explanation for purposes of expression. A more highly selective description of form with hatch modeling appears in a drawing of the nude figure (Figure 5-91) by the French painter Suzanne Valadon (1867–1938). In this work hatch modeling, though kept to a minimum, is used to articulate sharply turning passages of form at key junctures of the figure. The otherwise starkly linear construction is thereby given a vivid sense of volume.

The selective sensibility of the artist finds expression in modeling not only through omission, as in the Valadon work, but also by "overdrawing" a form until parts of the drawing appear to melt into a near-solid dark. A notable example of this approach is seen in the consummately modeled Reclining Nude of Rembrandt (Figure 5-92). Hatch modeling is so dense in parts of the figure that its descriptive function gives way to the near-black tonality of the ground. Despite the deep values created by the many layers of hatching, the figure itself does not appear dark but rather glowing in darkness. This luminous effect results in part from a near-microscopic ground reversal that occurs as the hatching ceases to appear as positive black lines and becomes instead black ground with minute white spots of positive form. In such areas the white spots take over the function of the hatch in communicating volume.

The special capacity of contour hatching to describe cylindrical and spherical volumes was not overlooked by Picasso, who used this technique in his drawing *Sleeping Peasants* (Figure 5-93) to construct forms with rounded convexities reminiscent of pre-Columbian ceramic forms. Though drawn in color, this work is almost aggressively sculptural in character. The virtual absence of straight forms or planes creates a curious unity of effect. A similar formal consistency can be created by drawing forms strictly in terms of planes.

5-91. Suzanne Valadon (1867–1938), Nude Girl Resting. Black chalk. $12\,{}_{1/4}''\times 10''$. Ottawa, National Gallery of Canada.

5-93. Pablo Picasso, *Sleeping Peasants*, 1919. Tempera, watercolor, and pencil. 121/4"×19". New York, Museum of Modern Art. Abby Aldrich Rockefeller Fund.

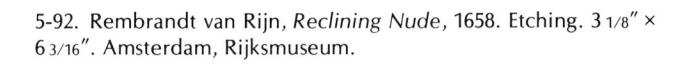

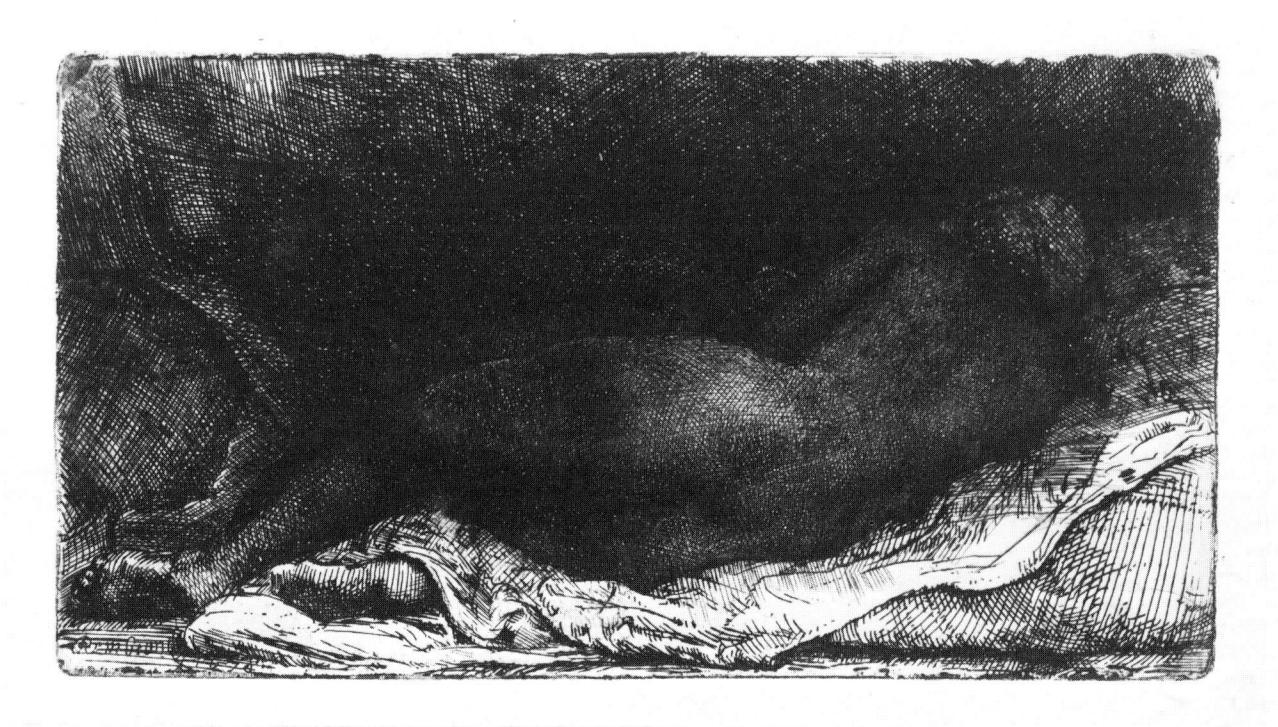

PLANE HATCHING

Plane hatching will seem familiar if you have practiced the angular-line techniques discussed in study 9 in chapter 3, for it is based on the same principle, the reduction of rounded surfaces to imaginary flat planes. There is an important difference, however: while in study 9 lines represent only the intersections of planes, plane hatch modeling can represent the planes themselves (Figure 5-94). The direction of the hatches is suggested by the orientation of the planes as you perceive them on the model rather than by the imaginary intersection of a plane, as in contour hatch modeling.

An effect that is present in other types of modeling but is especially noticeable in plane hatching is *virtual line*, a contour that appears to be formed by the tip ends of hatch marks (Figure 5-95). Such lines are visible both at the edges of hatched planes terminating in white space and at the intersections of hatched planes. A device of great subtlety, the virtual line (or implied contour) can be used to suggest linear elements such as shadow contours as well as edges of planes.

5-94. Plane hatching. The angular intersection of body forms can be interpreted as simple linear angles (a) or as the intersections of planes (b). In the latter case straight hatch marks can effectively describe such planes (c).

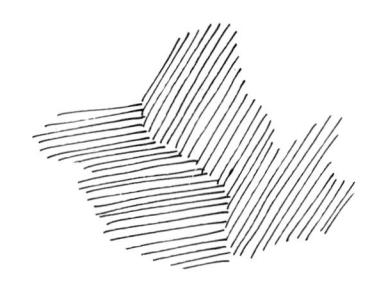

5-95. Virtual lines. Linear effect produced by the tips of hatch marks both at the intersection of the two planes and at the opposite sides of the planes. Such effects are referred to as implied contours or virtual lines.

STUDY 24. PLANE HATCH MODELING

Materials: 36"-x-24" newsprint drawing pad

easel or straight-back chair Masonite or plywood board

and clamps drawing crayon

Reference: model **Suggested time:** 30 minutes

Plane hatching may be used either for shadow modeling (study 19) or for relief modeling (study 16). Whichever mode you choose, it is advisable to begin by drawing the figure in terms of angular intersections, as outlined in study 9. This method assists you in visualizing prominent angular features of the figure, particularly those that occur at discontinuities of the body surfaces (Figure 5-96). Such discontinuities can be interpreted as projecting or as concave intersections of planes on the figure. Both types of intersections can be used to initiate plane hatch modeling and will assist you in choosing a direction for the hatch marks (Figures 5-97 and 5-98). As in other methods of modeling, it is best to treat the larger features—in this case the larger planes—first.

A bold use of plane hatch modeling can be seen in Jacques Villon's engraving Jeune Fille (Figure 5-99). Few edges of form are defined by line borders (enclosures): instead the artist has modeled the head in broad almost architectural planes by means of hatch marks that, though limited in direction, create effects of surprising subtlety. A slight thickening of the hatches, for example, appears to define areas such as the mouth without a change of hatching direction. The severe, angular construction of the head by means of hatch planes reveals Villon's interest in cubism, an art movement that, in the words of Villon, "represents the object on every surface." 26 Given the importance of surfaces in cubist art, modeling, in particular plane hatch modeling, was a logical instrument for Villon. Yet his graphic works are highly personal, as was his interest in cubism: "...I have not been a Cubist because of doctrine," he once observed, "but because it suited me."27 His work confirms the value of remaining faithful to one's artistic sensibility.

An equally personal use of plane hatching is seen in a Self-portrait by Cézanne, the late-nineteenth-century French painter (Figure 5-100). Cézanne modeled this drawing with plane hatches consisting of groups of short pencil marks that resemble brush-strokes. He apparently drew in contour before selecting planes for modeling. Cézanne employed hatching to describe key passages of form by taking advantage of shadow contours of surface planes. Since such planes frequently appear in life as areas with different colors and values, Cézanne's modeling has a characteristic "painterly" quality.

5-96. Beginning a life study. A student develops a contour drawing to be used as a framework for hatch modeling. The medium is crayon.

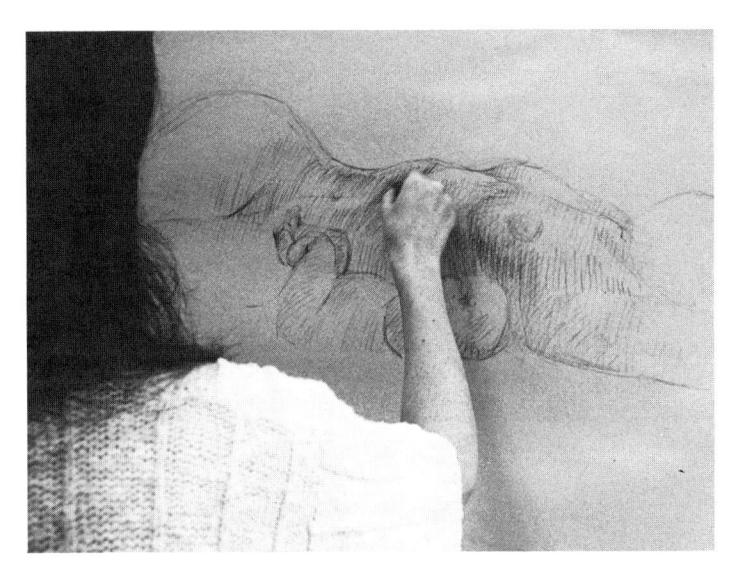

5-97. Developing a life study. Modeling with plane hatching describes the figure structure implied in the preliminary contour drawing.

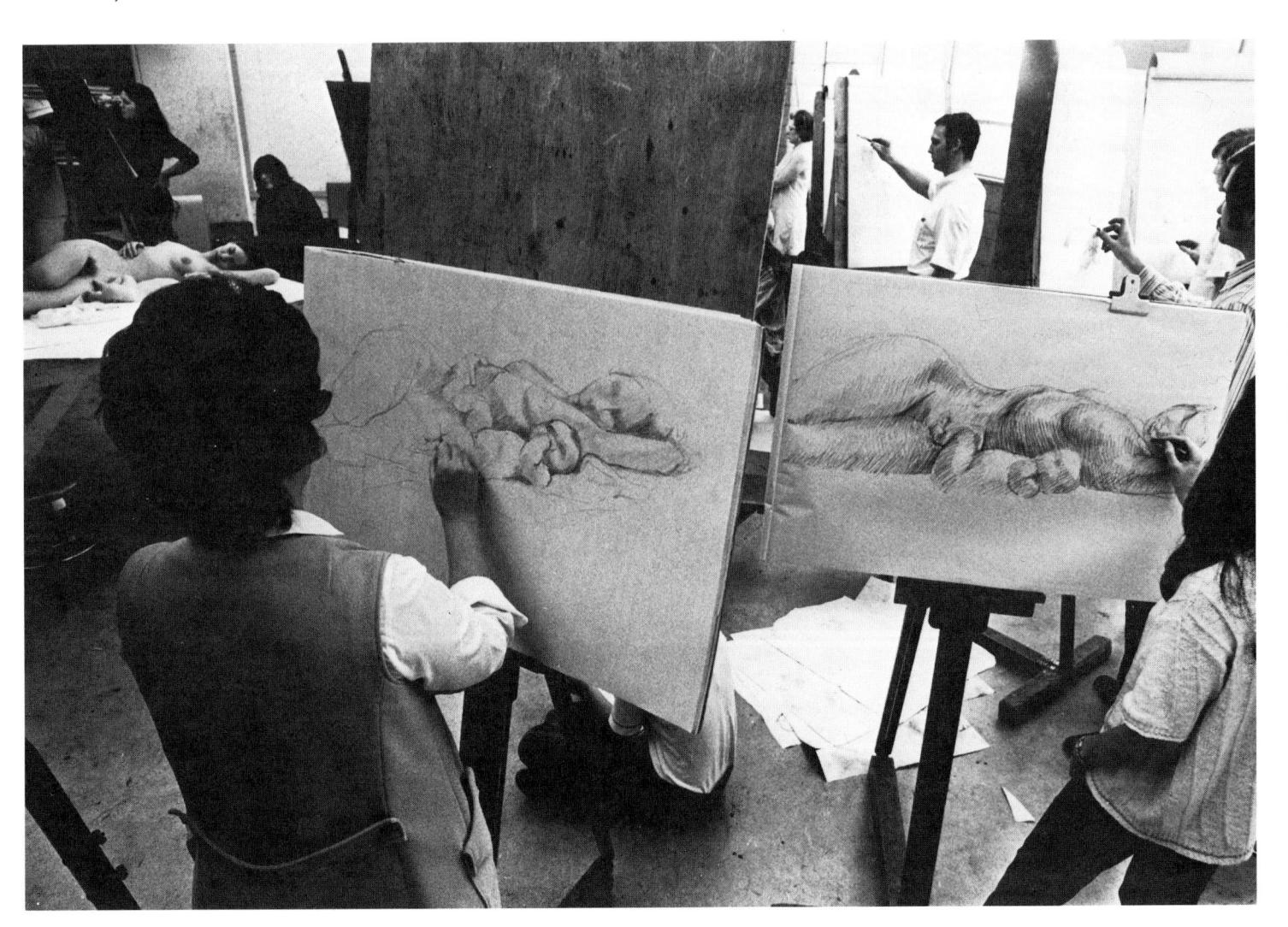

5-98. Drawing from life. The student on the left is using plane hatching to model the effects of light on the model, while the student on the right is using plane hatching to describe form in a more arbitrary way. The earlier stages of the latter drawing are shown in Figures 5-96 and 5-97.

Plane hatching, however, is not the exclusive province of draftsman-painters: its effectiveness in modeling sculptural form is ably demonstrated by the contemporary Italian sculptor Emilio Greco, whose drawings not only create a rich sense of the volume and mass of the figure but also evoke the chisel marks of stone sculpture. In his drawing Dorso (Figure 5-101) the artist modeled almost exclusively in plane hatching. The figure's back, the subject of the drawing, is a powerful statement in plane hatch modeling in the relief mode: receding forms grow dark with hatching. Though the artist's method is straightforward, the drawing is far from an academic study. On the contrary, it is remarkably personal, with curious departures from the traditional method. The modeling of the hand, for example, is inexplicably heavy, as though the hatch were meant to cover up a passage of form that did not please the artist. Similarly, the head is modeled in an oddly wider stroke than the rest of the drawing, causing a slightly inconsistent quality in that portion.

5-99. Jacques Villon, *Jeune Fille*, 1942. Engraving, artist's proof. 11 3/8" × 8 3/36". Boston Public Library, Print Department.

5-100. Paul Cézanne (1839–1906), Self-portrait (on a sheet with Portrait of Cézanne's son). Pencil on white sketchbook paper. 8.5" × 4.9". Art Institute of Chicago. The initial stage of the drawing is evident in the delicate contour lines that appear to flow around the features. The contours serve not only to define the edges of the outer limits of form but also to mark the borders of shadowed planes, as in the contour across the area of the forehead. Cézanne applied plane hatching to the contour structure in a way that suggests differences of both form and shadow.

5-101. Emilio Greco, *Dorso* , 1954. Pen-and-ink. 19.4" \times 13.4". Bath, Adams and Dart Publishers.

It is instructive to compare *Dorso* with Rembrandt's etching, Reclining Nude (Figure 5-92). Not only do the two works offer a similar view of the figure but the graphic methods that produced them, though not identical, have much in common. Both artists modeled the figure in terms of relief, though some concessions were made for the effect of light. More significantly, both artists "overmodeled" the form, resulting in the near-microscopic ground reversals described previously. One technical difference between the two works is in the choice of hatching: Rembrandt modeled in contour hatching; Greco, in plane hatching. Chiseled effects of planes are dominant in the Greco work instead of the more subtly rounded volumes seen in the Rembrandt etching.

The prints of Goya show a use of hatching that is as texturally rich as that of Rembrandt but functions in quite a different way than the contour hatch modeling considered thus far. The figures in *Disparate General* (Figure 5-102) appear to be con-

ceived, like Goya's idea of nature, as "lighted forms and forms which are in shadow, planes which project and planes which recede,"28 yet the hatching does more than model volumes and shadow. Crossing over contour boundaries of figural elements. the hatch sweeps over the forms, evoking a sense of movement and at the same time weaving the figures together in a strange textural fabric. Edges of forms are marked by shifts in value or by changes in hatch direction, creating a strong suggestion of color change. The areas of hatch, which for the most part represent positive forms, are oddly set in a ground of granular texture (aquatint), creating a traumatically dense, atmospheric effect in keeping with the subject of madness. The luminosity of Gova's hatching, like that of Rembrandt, is partially due to the ground reversal within areas in which the hatch marks are sufficiently wide to appear as ground instead of positive form. These and other pictorial qualities of hatching can be explored in the following study.

5-102. Francisco Goya (1746–1828), Disparate General. Etching and aquatint. $9.7'' \times 13.8''$. Madrid, Museo del Prado.

STUDY 25. HATCHING AND THE FIGURE-GROUND RELATIONSHIP

Materials: 36"-×-24" drawing pad

easel or straight-back chair Masonite or plywood board

and clamps

drawing crayon

Reference: model **Suggested time:** 20 minutes

Without observing the model first draw enough hatch marks to cover the drawing page. Straight hatch marks of approximately the same length are suitable for this purpose (Figure 5-103). They can be drawn either in random directions or in a few specific directions (i.e., vertical, horizontal, and diagonal). After you have developed an even, light texture of hatch marks on the paper, you are ready to begin drawing the figure. Instead of the positive form of the figure draw the ground surrounding it, continuing with the same type of hatch marks but making a darker tone. You do not have to press harder with the crayon in order to achieve the dark tone: it will occur naturally as a result of the accumulation of hatching strokes. Drawn in this way, the ground will effectively shape and eventually model the figure (Figure 5-104). The figure, instead of being conceived as an isolated, positive form surrounded by empty (i.e., negative) space, will exist in a pictorial environment, which can itself be further modeled.

In Whistler's drawing Study for Weary (Figure 5-105) this form of hatching is carried further in a pictorial direction. Bold, slashing strokes drawn around the higher forms define the face and the hand of the figure. The delicate modeling of the face seems almost out of keeping with the starker drawing of the hand, an inconsistency that borders on sentimentality in the eye of the contemporary viewer. Within the dark areas, however, Whistler subtly varied the tonal values so that the sparkling effects of the white spaces between the hatching. such as those seen around the head and shoulders of the figure, define the dark dress and the face of the figure as integrated elements in an overall compositional environment not unlike that of his painting.

5-103. Drawing tone with random hatch marks.

5-104. Figure and ground. Hatch marks in this study are limited to three directions: vertical, horizontal, and diagonal. The tonal ground defines the form of the figure and integrates it pictorially.

5-106. Pablo Picasso, *Sculptor and Model*, 1933. Etching. 14 $_{1/2}$ " × 11 $_{3/4}$ ". New York, Museum of Modern Art. Purchase.

SUMMARY

The studies and master drawings shown in this chapter are arranged to focus clearly on specific modalities of modeling. Due to the complexity of the subject the functions of line as contour and as outline are considered separately in chapters 2 and 3, but it must be kept in mind that all drawing methods are part of an artistic continuum that has no such clear distinctions. Artists are sometimes able to fuse diverse techniques creatively into a single work. An example of such a fusion occurs in Picasso's etching Sculptor and Model (Figure 5-106), in which he combines classic line with hatch modeling. Although the two techniques have existed side by side for centuries, Picasso is one of the few artists to combine them successfully in a finished work of art. He did so by adding a darkly glowing passage of hatch modeling to line figures conceived in the classical mode. The contrast between the high-key effect of the line drawing and the dramatic emphasis of the modeled head has a freshness characteristic of highly original art. This work serves as a reminder of the creative uses of modeling that remain to be explored.

^{5-105.} James Abbott McNeill Whistler (1834–1903), Study for Weary. Black chalk. $95/8'' \times 67/8''$. Williamstown, Sterling and Francine Clark Art Institute.

6. THE SKELETON:

The Structural Framework of Body Forms

Now since the important thing in these arts is to draw a nude man and a nude woman well, and to remember them securely, one must go to the foundation of such nudes, which is their bones, so that when you will have memorized a skeleton you can never make a mistake when drawing a figure, either nude, or clothed; and this is saying a lot.—Benyenuto Cellini

Direct observation of external form has been the basis of the previous drawing exercises. The artist's sense of structure, however, can be enhanced by studying the natural internal structure of the body, for the human body, unlike that of some other animals, depends on an interior bony framework—the skeleton—for its general external form.¹ If one were to remove the thighbone, as Stephen Peck, the anatomist, points out, "a thigh would have little more shape than a puddle of water." Skeletal structure also affects the appearance of the body by governing movement and gesture: the bone formation at the knee joint, for example, largely determines the hingelike action of the leg and thigh (Figure 6-41).

Despite its key role in determining the form of the body, skeletal structure is not readily discernible in life (Figure 6-1). In order to perceive the skeleton in the model, it is necessary to have some prior knowledge of it. Psychologists remind us that "visual perception is as much concerned with remembering what we have seen as with the act of seeing itself." Committing skeletal form to memory, as suggested by Cellini, is therefore a worthy project for the serious draftsman, for it enables him to transcend the limitations imposed on visual perception by previous experiences and to see the form and structure of the human body more clearly.

REFERENCE SOURCES

The best reference for studying the skeleton is the the skeleton itself, ideally an articulated skeleton mounted on a stand (Figure 6-2). A skeleton mounted in a fixed position is much less helpful, as it cannot simulate body movement. If an articulated skeleton is not available to you, you may be able to draw from one in a natural-history museum or from a miniature plastic model, available in many stores.

Anatomical illustrations are another useful reference. Although no flat picture has the immediate three-dimensional clarity of a mounted skeleton, it can provide some visual information that the skeleton cannot: for instance, an anatomical illustration is especially helpful in showing the relative position of the bones inside the body and their relationship to the muscles.⁴ Anatomical plates are included in this volume to assist you in studying skeletal and muscular structures. The appropriate illustrations are listed at the beginning of each study.

Another source of information that should not be overlooked is the living human body. Several key points of the skeleton lie just beneath the surface and can be easily detected by touching them. Others are apparent in the visible bumps that they produce on the surface. In each study suggestions are provided for using anatomical clues of this sort.

6-1. Radiograph of the female body. (Courtesy of Eastman Kodak Company.) In an x-ray photograph the skeleton appears as a distinct pattern of white and gray, while the body tissues are seen as filmy tones ranging from near-black to gray.

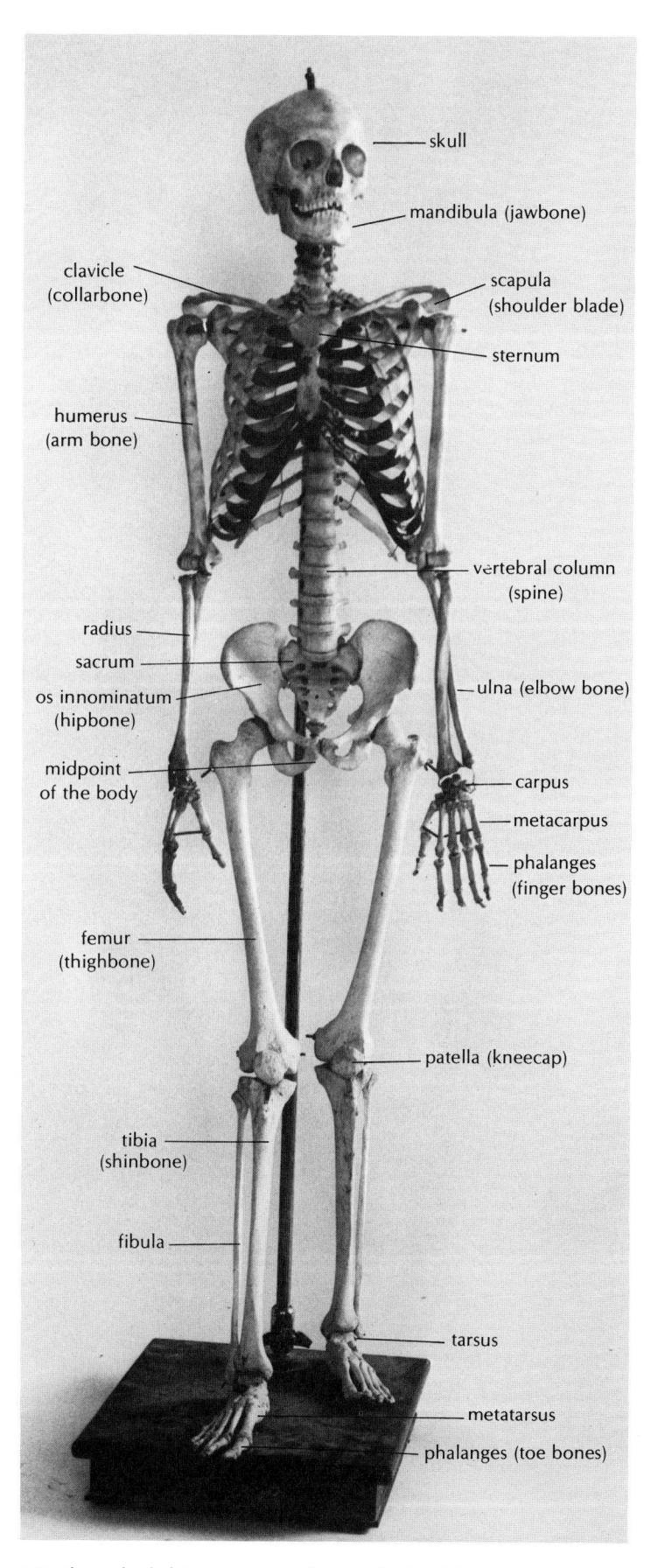

6-2. The male skeleton. A mounted and articulated skeleton is an excellent reference for studying skeletal forms. The dark parts of the rib cage represent softer cartilage, which does not retain its form when dry. Joints articulated with springs and bolts permit a variety of postures.

6-3. The male skeleton, rear view. (Dr. J. Fau, *The Anatomy of the External Forms of Man* [London: Hippolyte Bailliere, 1849]. Courtesy of Countway Library, Harvard University.) Though lacking the three-dimensional clarity of a mounted skeleton, the anatomical illustration has the advantage of showing both the skeleton and its relationship to superficial forms of the body.

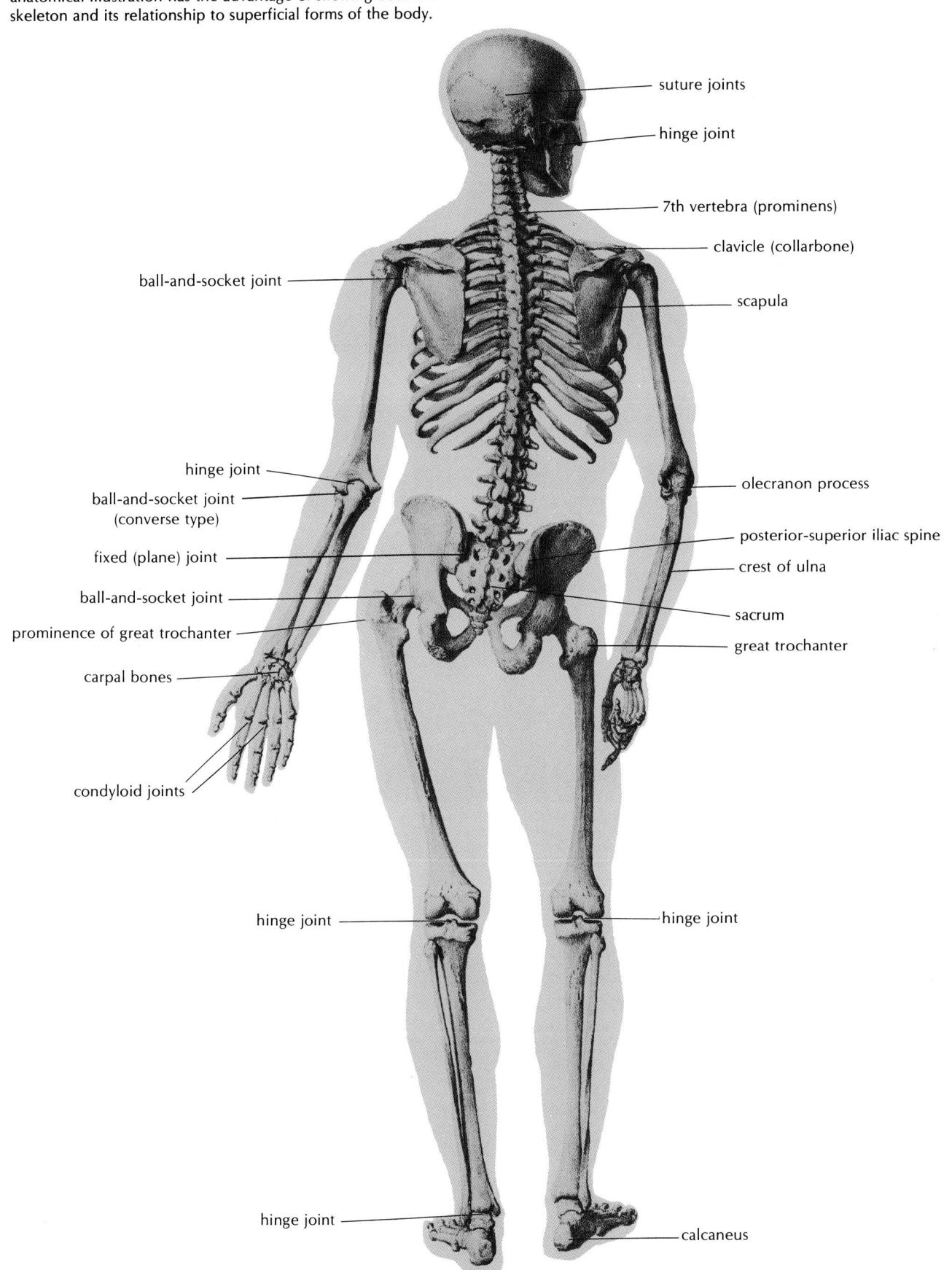

6-4. The male skeleton and the external forms of the body, side view. (Dr. J. Fau, *The Anatomy of the External Forms of Man* [London: Hippolyte Bailliere, 1849]. Courtesy of Countway Library, Harvard University.)

STUDY 26. INTRODUCTION TO THE SKELETON

Materials: 11"-x-14" bound sketchbook or

bond paper held by a clipboard drawing pen (0.5 mm point) and

india ink

compressed charcoal pencil

(optional)

Reference: Figures 6-1, 6-2, 6-3, 6-4, and 6-5 **Suggested time:** 10–15 minutes for each drawing

A general introduction to skeletal forms can be gained by drawing directly from anatomical illustrations. Using the figures listed above or a suitable anatomy book, make several 10- to 15-minute studies of the skeleton, then try to repeat the same drawing from memory. After you have finished, you may make corrections by comparing your drawing with the illustration. In this exercise a rapid general rendering is preferable as a means of grasping the essential forms. Laborious copying of detailed anatomical illustrations may prevent you from concentrating on the more important larger forms, such as those of the rib cage, the skull, and the pelvis. Your first efforts may not satisfy your desire for accuracy or completeness, but these qualities will come later with more experience in drawing the skeleton. Through this exercise, however, you will learn much of the basic structure, which can then be applied to studies relating the skeleton to the figure as a whole.

6-5. Three-quarter rear view of the mounted skeleton. The skull is almost perfectly balanced on top of the vertebral column.

STUDY 27. THE MODEL AND THE SKELETON

Materials: 24"-x-26" newsprint drawing pad

easel or straight-back chair Masonite or plywood board and

clamps

one dark brown or black and one sanguine or Venetian red drawing crayon (Nupastel or

Conté brand)

Reference: model and mounted skeleton or Figures 6-1, 6-2, 6-3, 6-4,

or Figures 6-1, 6-2, 6-3, 6-4

and 6-5

Suggested time: 40 minutes

Drawing from an actual skeleton in conjunction with the live model is perhaps the most direct way of comprehending the integration of the bone structure with the exterior forms of the body. It is important that the model hold a pose that can be simulated with the mounted skeleton. Place the laboratory skeleton on the model stand in such a way that the model and the skeleton are in approximately the same pose (Figure 6-6). Allow yourself 20 minutes to make a contour drawing of the figure from the model, using a black

or dark brown crayon. When the life drawing is completed, draw the skeleton inside the figure, using a sanguine or Venetian red crayon to distinguish the two drawings. While you are drawing the model, glance at the skeleton to see if you can locate features that are visible in the model. Collarbones, ribs, and cheekbones are a few skeletal parts that may be immediately apparent in the model, and closer comparison will reveal many others. Of special importance are any visible clues of the hipbones (pelvis) and the rib cage. For the purposes of this study Latin names of bones are irrelevant. Visual comparison is vital: if such an arrangement of skeleton and model is not available, you may wish to take your drawings of the model to a museum or laboratory in which a skeleton is on display and complete the study there. If no skeleton is available, anatomical illustrations are a good substitute.

Certain skeletal forms are so crucial that they warrant separate study, especially those that are not readily apparent in life. The vertebral column—the structural axis of the trunk and the entire axial skeleton, a larger structural assemblage that includes the pelvis, the rib cage, the shoulder girdle, and the skull—is such a form.

6-6. Drawing the skeleton within a life study. The mounted skeleton affords a means of visualizing the skeleton in the body. The student is interpreting the skeleton of the model by comparing the mounted skeleton with suggestions of the bony structure in the body.

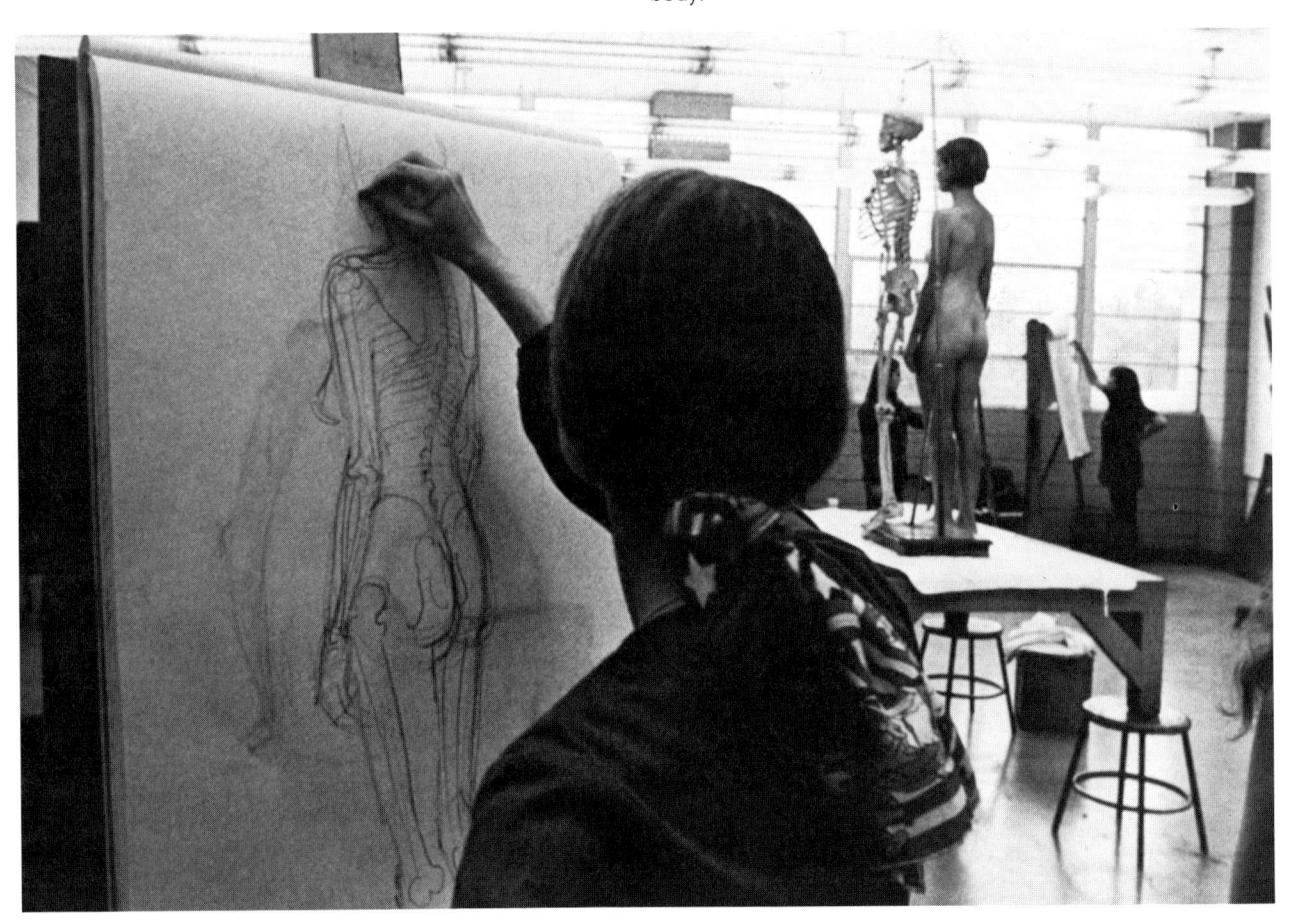

STUDY 28. THE VERTEBRAL COLUMN

Materials: 24"-x-26" newsprint pad

easel or straight-back chair Masonite or plywood board and

clamps

drawing crayon

Reference: model and mounted skeleton or

Figures 6-1, 6-2, 6-3, 6-4, 6-5, 6-7,

and 6-8

Suggested time: 15 minutes

6-7. The axial skeleton in the figure. (Dr. J. Fau, *The Anatomy of the External Forms of Man* [London: Hippolyte Bailliere, 1849]. Courtesy of Countway Library, Harvard University.)

Because this study focuses on the position and shape of the spine in the body, it is advisable to begin with a 10-minute contour study of the figure seen from the back or from the side. In drawing from life take care to indicate any visible suggestions of the vertebral column, such as the vertical groove of the back or bumps therein. Purely frontal views of the figure are best avoided in this study, as they do not permit observation of the spinal curves. After you have completed the life drawing of the back, indicate on it the general curves and position of the vertebral column (Figure 6-9), using anatomical illustrations or the mounted skeleton as a guide.

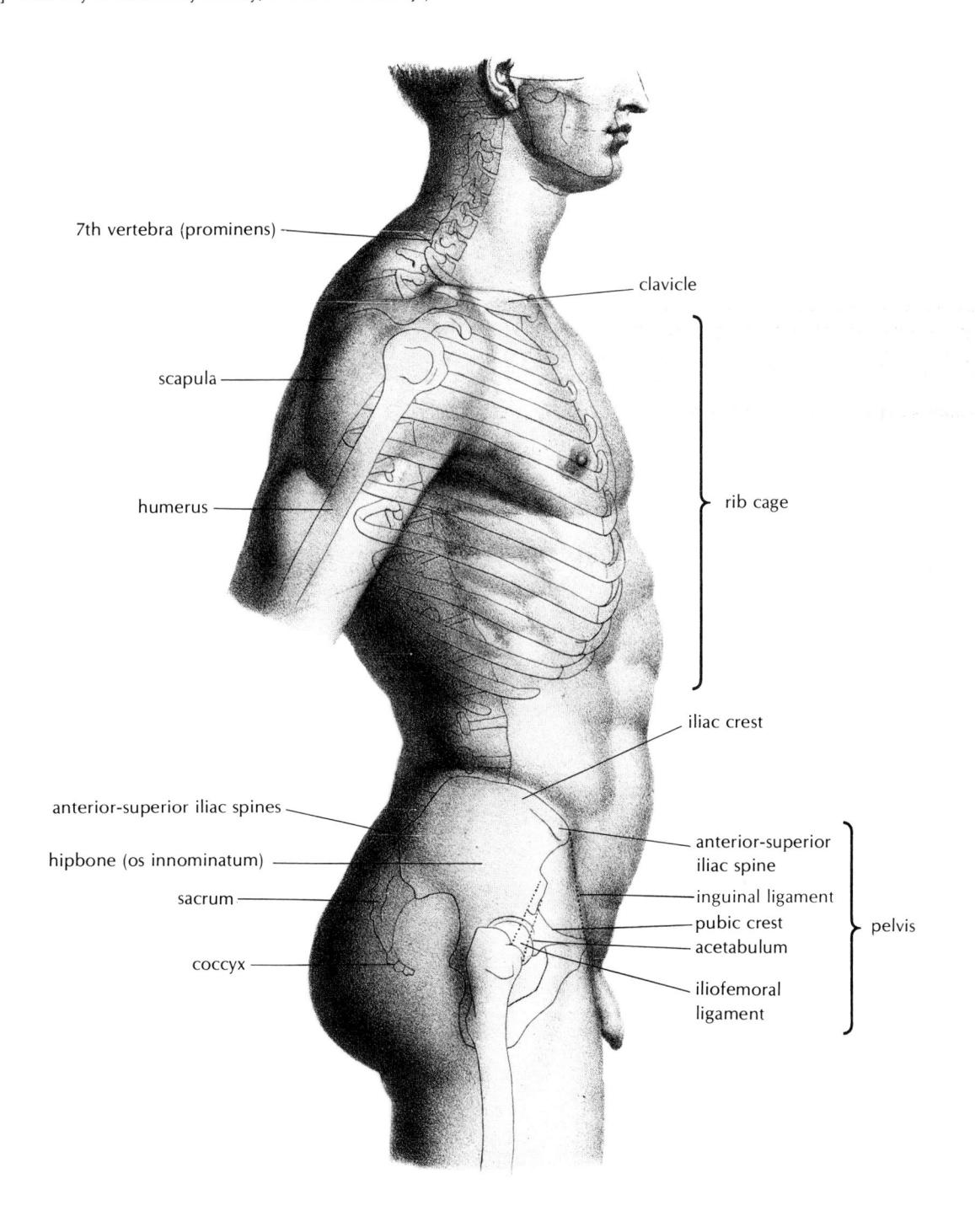

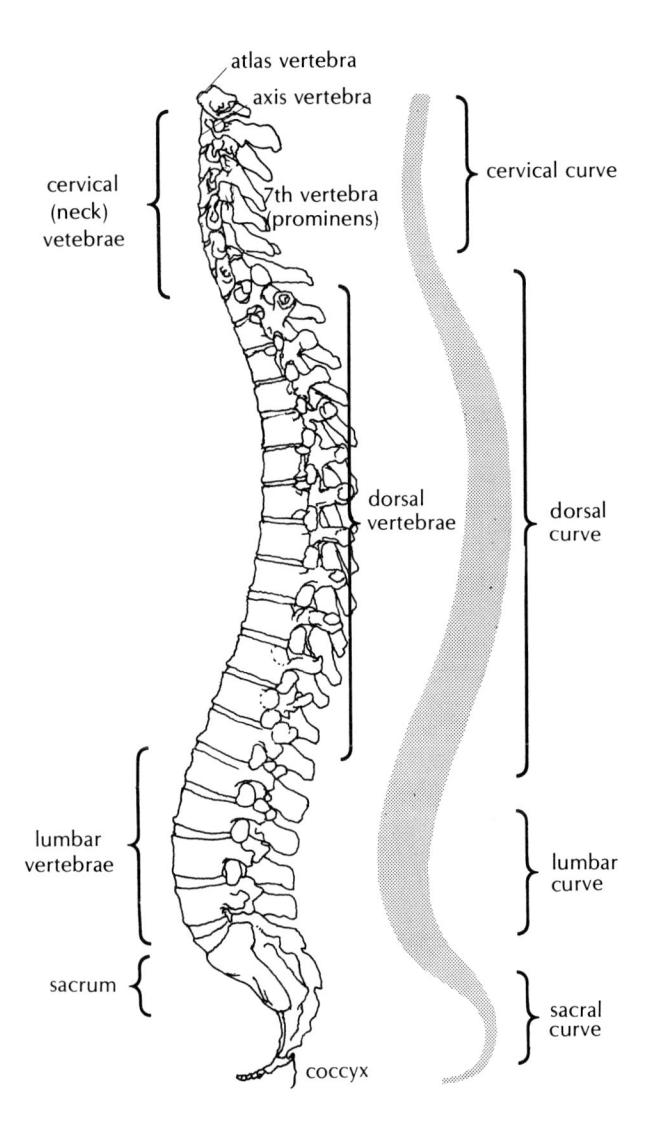

6-8. Left. Line drawing of the vertebral column (after Gray's Anatomy). Right. Silhouette representing the spinal curves.

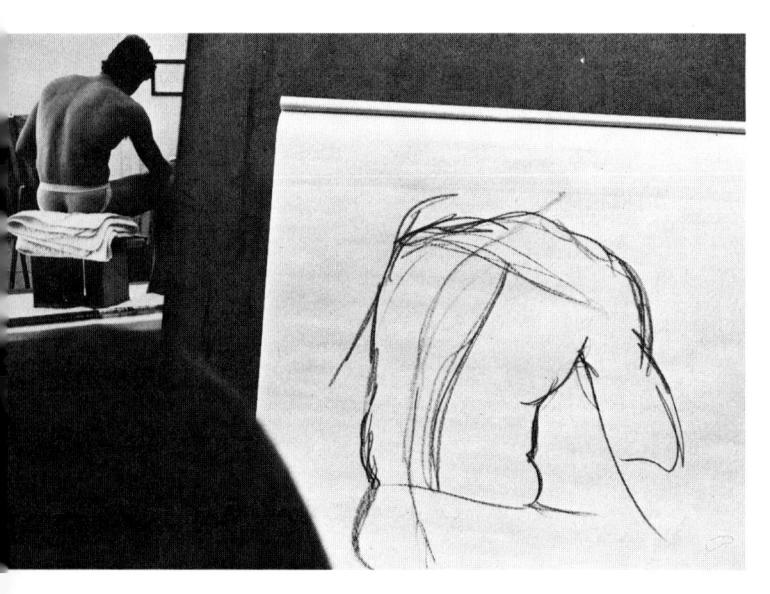

6-9. Drawing the curves of the vertebral column. This hastily drawn figure reveals two attempts at locating the spine. The first is represented by the darker line, which divides the figure equally. Just left of it is a second and more accurate line, which corresponds more closely with the groove of the model's back.

THE STRUCTURE OF THE SPINE

As your study demonstrates, the spinal column rises in a double-S curve that begins with its two lowest parts, the sacrum and coccyx (Figure 6-8).⁵ Above the sacrum the lumbar region of the spine is bowed forward.⁶ The lumbar curve, which develops just before a child learns to walk, is in fact a by-product of man's upright posture and is not generally found in animals that walk on all fours.⁷ The lumbar curve is a peculiarly human characteristic that gives the figure its special grace and poise in the standing position.

Above the lumbar curve the spine continues its backward thrust until the less obvious dorsal curve appears, causing the upper spine to bend toward the front of the body. The dorsal curve accounts for the visible forward thrust of the neck. The top seven cervical vertebrae, however, which make up the neck itself, curve backward again before terminating at the base of the skull. The lowest cervical vertebra is usually apparent as a prominent bump on the back of the neck. On top of the curving form of the spine the skull rests in a state of near-perfect balance,⁸ for the atlas vertebra, which supports the skull, joins it quite close to the head's center of gravity.

The curving character of the spinal column, though apparent in anatomical illustrations of the skeleton, is seldom clearly visible in life, a fact that can mislead the uninformed draftsman. The reason for this is to be found in two features of human anatomy: (1) the spines of the vertebrae (Figure 6-10) project outward to form a surface contour, sometimes punctuated with bumps, that is less pronounced than that of the drums of the vertebral column; (2) two powerful sets of muscles (sacrospinalis), one on each side of the spinal column, tend to mask the lumbar curve, giving the back a straighter appearance in the lumbar region (Figure 7-24).

The construction of the spine can by understood by examining the individual component bones, the vertebrae. Although there is considerable variation in size and shape among vertebrae, ranging from the generally smaller, lighter neck (cervical) bones to the large, thick bones of the lower-back (lumbar) region, certain features are common to almost all of them: the vertebral body, the arch, and the spinous process. The vertebral body is the solid, round, cylindrical part of the bone situated on the front (anterior) side of the spine. Like the drums of an architectural column, "the bodies of the vertebrae are piled one upon the other, forming a strong pillar for the support of the cranium and trunk" (Figure 6-10). 10 Sandwiched between the vertebral bodies are padlike disks of cartilage that are flexible enough to permit a certain degree of movement. Although the movement of the individual vertebra is very slight, together they

add up to a remarkable range of turning and bending (Figure 6-11).¹¹

Located behind the body of the vertebrae is the arch, which forms a round opening for the spinal cord. Projecting from the arch are a number of processes, the most visible (and the most useful in drawing) of which is the spinous process, a knobby blade of bone extending backward and downward from the arch. In life it is familiar as a row of bumps along the vertical groove of the back, most visible when the body bends forward. The most noticeable of these is that of the seventh (cervical) vertebra, mentioned earlier, known as the vertebra prominens. You can easily locate it by touching the back at the base of the neck. As a site for muscle and ligament attachments the spinous process provides leverage that facilitates movement of the vertebral bodies.

A vertebra generally has six other processes (projections) in addition to the spinous process. Four articular processes, located on the arch, connect other vertebrae with joints. The remaining two, called transverse processes, are winglike projections on the sides of the arch, which, like the spinous process, provide extra leverage for the muscles and ligaments attached to them. The formal complexities of the vertebrae make it advisable to examine the spine in a mounted skeleton in order to gain a clear idea of the function of the interfacing articular processes. Variations of these general features are noticeable in different regions of the spine.

The special construction of the uppermost vertebra, the atlas, and the axis vertebra immediately beneath it makes possible the freedom of movement associated with the head. The axis vertebra features a vertical projection that acts as a pivot for the atlas vertebra above it, enabling the head to turn easily to the side. Further down the spine the dorsal vertebrae feature articular surfaces for ribs in the form of facets or half-facets (which accept rib heads). Such surfaces are entirely lacking in the lumbar vertebrae of the abdominal region.

The lowest region of the spine appears so different from the rest that at first there seem to be no similarities. This is due to the fact that the vertebrae of this section fuse together early in life to form two connecting bones, the sacrum and the coccyx, which have their own distinctive shapes. The wide, triangular sacrum fits between the hipbones, to which it is fixed by nonmovable joints. Beneath the sacrum is the coccyx, a small segmented bone that forms the vestigial tail of the spine. The sacrum and coccyx together form a hooklike curve that turns inward at the lower end. In a standing figure the sacrum transfers most of the upper-body weight to the pelvis (and thence to the leg bones). The sacrum's relationship to the pelvis can be better studied as a part of the axial skeleton proper.

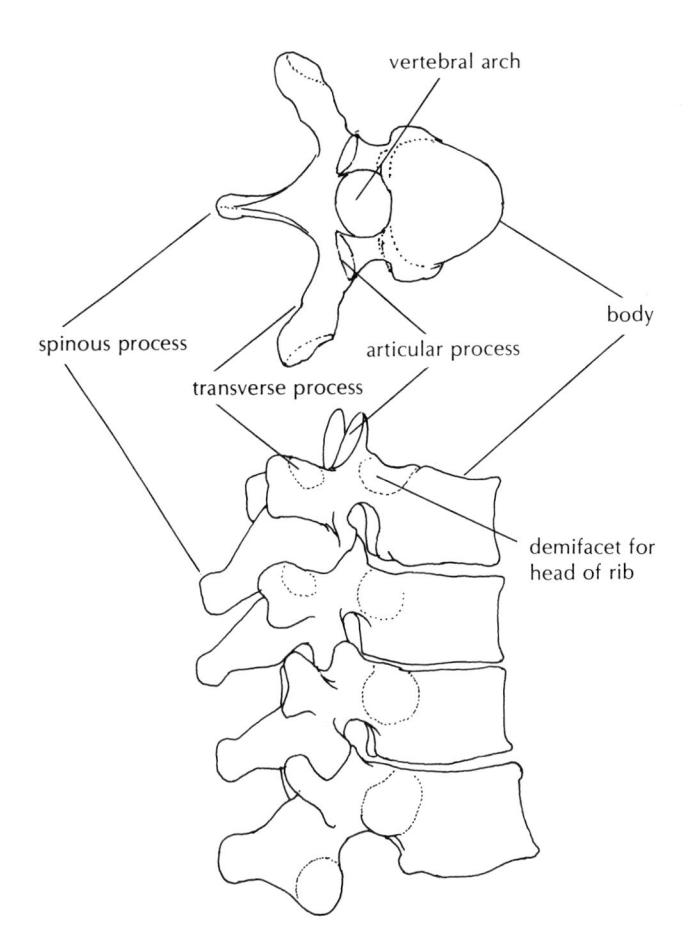

6-10. Dorsal vertebrae (after Gray's Anatomy).

6-11. Movements of the vertebral column. *Left*. Extension. *Center*. Rotation. *Right*. Flexion. The zigzag lines represent tensed muscles. (Jean Galbert Savage, *Anatomie du Gladiator Combattant*. Courtesy of Countway Library, Harvard University.)

STUDY 29. DRAWING THE AXIAL SKELETON

Materials: 11"-x-14" sketchbook

drawing pen (0.5 mm point

recommended)

india ink

11"-x-14" pad of tracing paper

HB drawing pencil

eraser

transparent (Scotch) tape

model and Figures 6-5, 6-7, 6-12, 6-13, and 6-14 or mounted

skeleton

Suggested time: 15 minutes for each drawing of the model (part 1) and maximum

Reference:

the model (part 1) and maximum 30 minutes for each drawing of

the skeleton (part 2)

6-12. Frontal (anterior) view of the mounted axial skeleton.

As the first part of your study of the axial skeleton it is useful to execute a series of twelve pen-and-ink drawings of the nude model (Figure 6-15). The rapidcontour technique (described in chapter 3) can be used, as the drawings need not be highly developed. In preparing them, however, reverse the procedure of the previous exercises: that is, indicate the position and curvature of the spine first, then use this indication as the basis for visual measurements while you draw other features of the figure. In drawing the shoulder form, for example, compare it as you draw not only with neighboring forms but also with the position of the spine, determining approximately how far it lies to the right or left, above or below the spine. This can be done more easily if you can see the back of the model, but it can also be accomplished from the front by using your ability to visualize the skeletal structure. In this way you can begin to see the body in terms of its internal structure as an integral whole.

The vertebral column makes an almost ideal line of reference on which to base a drawing of the figure, for it is of central importance to the attitude and gesture of the body. The idea of using an imaginary internal line as the basis for setting up a drawing is applicable to almost any subject 12 and is also very useful in developing your skills as a draftsman. Certain other skeletal features of the figure can be drawn from life and are especially useful in drawing the skeleton later. Such features include bony protrusions just under the skin that reveal the position of skeletal structures deeper inside the body. For example, the slight depression at the base of the neck, known as the pit of the neck (Figure 6-13), is usually visible in life. The bottom (or floor) of the pit marks the upper (superior) surface of the breastbone (sternum) as well as the inner (medial) attachments of the collarbones (clavicles). An indication of the pit of the neck in your life drawing, if your view of the model permits, greatly facilitates drawing the rib cage and the shoulder girdle of the same figure later. The pit of the neck is not only helpful in making anatomical studies but also provides a surface indication of the body's line of lateral symmetry. The most prominent visual clues in the pelvic region are two bony projections that you can easily feel on each side of your body just below the waist. Called the anterior-superior iliac spines, they describe the front, upper projection of the ilium bone. In addition to revealing the position of the pelvis the two projections define a line known as the pelvic axis, which is useful in articulating the form of the trunk with that of the legs (Figure 6-13).

6-13. The axial skeleton and its relation to exterior form. (Dr. J. Fau, *The Anatomy of the External Forms of Man* [London: Hippolyte Bailliere, 1849]. Courtesy of Countway Library, Harvard University.)

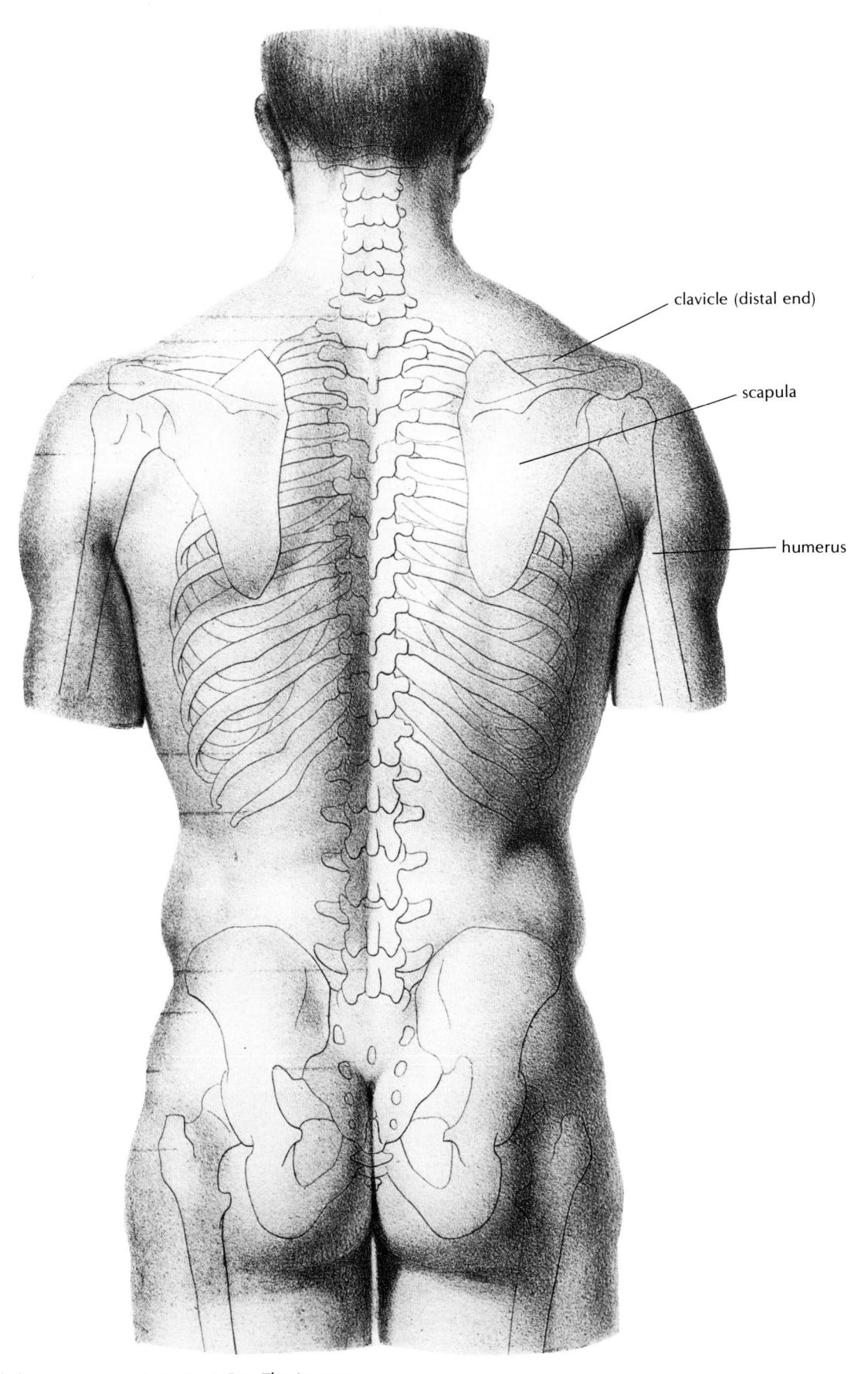

6-14. The axial skeleton, posterior view. (Dr. J. Fau, *The Anatomy of the External Forms of Man* [London: Hippolyte Bailliere, 1849]. Courtesy of Countway Library, Harvard University.) The visual relationship between the groove of the back and the spinal column is apparent. Note also the correspondence of the sacrum with surface features of the lower back.

6-15. Sketchbook drawing with pen-and-ink. To ensure an uninterrupted flow of ink in the drawing pen, the sketchbook should be held at an angle rather than perpendicular to the floor.

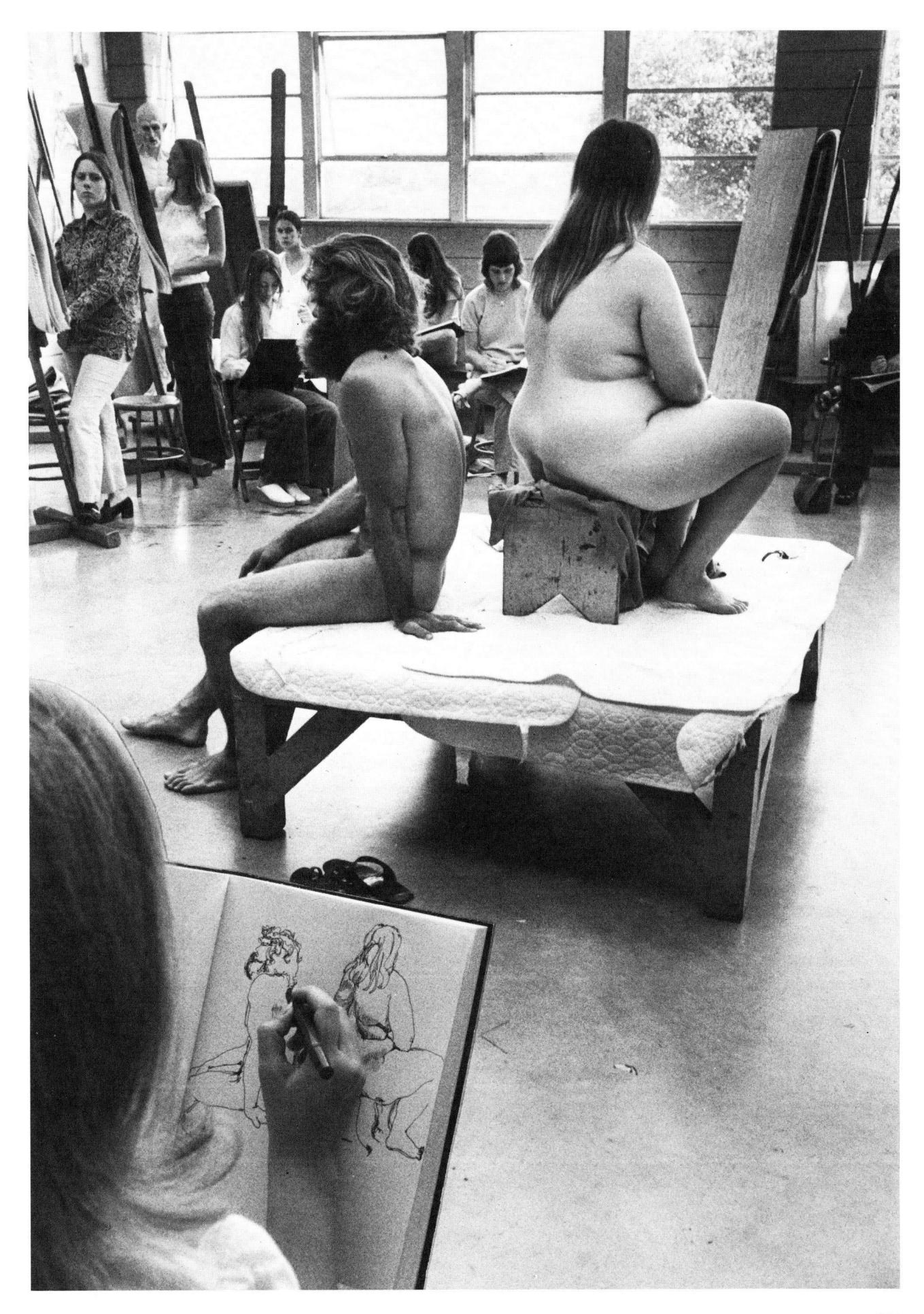

Pen-and-ink is recommended as the drawing medium because it is the most clearly visible through translucent tracing paper, the material used in part 2 of this study. It also discourages any tendency to overwork the drawings. From your series of drawings select six that you like best, then cut rectangular pieces of tracing paper slightly smaller than the size of the sketchbook page (Figure 6-16). Place the tracing paper over the drawing and tape one edge of the former to the sketchbook page. The tracing paper is held in one position over the drawing but can be lifted if you wish to examine the original drawing underneath. The remaining five drawings should also be prepared with tracing-paper overlays. By rendering your study of the skeleton on the tracing paper you can make use of your life drawings without spoiling their value as independent works, for even if you decide to erase and start over, the original drawing remains untouched. After selecting one drawing for your first study scan the anatomical illustrations in this book until you find a view of the skeleton that approximates that of your figure. You may need to refer to more than one illustration to obtain the visual information necessary to render the axial skeleton in the attitude dictated by your original drawing. In short, you must visualize the skeleton as it might appear in the model.

Once you have roughly indicated the position of the spine in your drawings, you will have no difficulty in developing a more complete rendering of the vertebral column on the tracing-paper overlay. When this is done, the spine will suggest the position of the skeletal forms to which it attaches—namely, the skull, the pelvis, and the rib cage. Work toward accuracy of placement and position rather than detail, using the eraser to clear away confusing mistakes.

Certain abstract forms may assist you in making the generalized drawing of the skeleton. If the cranium of the skull were seen without the complex facial bones in front, it would resemble an enormous egg, poised

on top of the spinal column with the larger end in the back. 13 The rib cage also suggests an egg shape but one in which the large end is cut off. Attached to the spine at its back, the rib cage projects forward from it, creating a hollow enclosure (Figure 6-17). There is no need to be concerned with such details as the shape of individual ribs in this study: draw only the large, general shapes. When the general skeletal forms are accurately rendered, the smaller units of form, such as ribs and individual vertebrae, fit easily into the larger pattern. You may find it helpful, however, to indicate the position of the collarbones (clavicles) and shoulder blades (scapulae), which are connected to the rib cage. It is also advisable to include the femur bones, which join the pelvis at. the hip, and the humerus bones of the arms, which join the shoulders (Figure 6-18), for they can assist in visualizing the exact position of the axial skeleton. In drawing the pelvis try not to lose sight of its essential three-dimensional character, which is that of a ringlike formation enclosing a round void—the pelvic cavity. The front center of the ring corresponds with the vertical center of the pubic area. The back of the ring joins the vertebral column by means of the sacrum, a joint that is suggested in life by the triangular plane between the hips in the lowest region of the back. Seen from the side, the ring shape of the pelvis appears to sag downward in the front somewhat as the ribs do in relation to the spine (Figure 6-19). From the front and back of a standing figure, however, the pelvis appears to be aligned horizontally with the vertical of the spine. Even when the spine bends, the pelvis maintains a relatively fixed angular relationship with the lower spine, for the joint of the sacrum and the pelvis does not permit movement.

Some components of the axial skeleton that are treated broadly in this study—the skull, the rib cage, and the pelvis—are such important determinants of body form that they merit separate examination.

6-16. The sketchbook overlay. Tracing paper can be cut and taped over a figure drawing for a study of the skeleton.

6-17. Theodore Gericault, Study for The Raft of Medusa, 1818. Charcoal on white paper. 289×205 mm. Besançon, Musée des Beaux Arts. The lower edge of the rib cage and pelvic prominences are apparent in this superbly modeled life study.

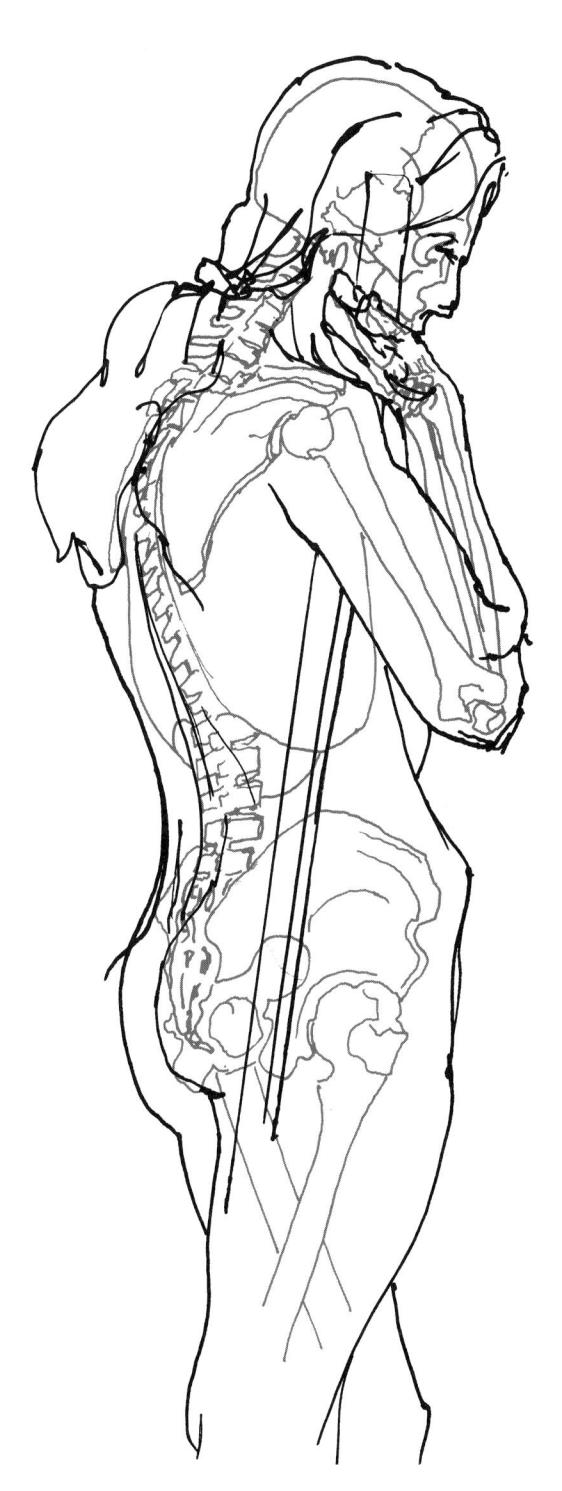

6-18. Student drawing, the figure as seen with a tracing-paper overlay showing an interpretation of the skeleton. Pen-and-ink on sketchbook paper.

6-19. The oval void of the pelvis can serve as a basis for positioning a drawing of the pelvis.

STUDY 30. SELF-PORTRAIT WITH THE SKULL

Materials: 11"-x-14" tracing paper

drawing pen (0.5 mm) or compressed-charcoal pencil

HB drawing pencil

large dressing mirror and smaller

mirror (optional)

Reference: Figures 6-5, 6-12, 6-20, 6-21, and

6-22 or mounted skeleton no more than 1 hour for the life

study and 1 hour for the skull

study

Suggested time:

Because the skull and the form of the head are closely related, the self-portrait is a convenient vehicle for studying this part of the skeleton; it is also economical, as it eliminates the expense of a model! All that is required is a good mirror, preferably of plate glass, adequate illumination, and one or two hours of uninterrupted time. With two mirrors at your disposal it is possible to form an arrangement similar to that in a clothing store, in which you can see yourself from the side and in an unreversed image. The unfamiliarity of such an image can be a decided advantage in drawing the self-portrait. The mirror is also useful as a means of inspecting the drawing itself, for a reversed image can sometimes provide an insight into your own work.¹⁴

If this is your first self-portrait, a few suggestions may be in order. Above all, draw yourself as you would draw a model, observing and drawing in terms of form and shape. It is advisable to set aside temporarily considerations of color changes, particularly if they involve facial features, for they can tempt the beginner to draw fussy details that are irrelevant to the formal unity of the drawing (Figure 6-23). If this approach is carried further, however, it can sustain details within the context of the larger forms (Figures 6-24 and 6-25). In drawing the form of the eyes, for instance, it is helpful to concentrate on the form of the eyeball rather than on the color areas of the iris or eyebrow. Though only a small portion of the eyeball itself is normally exposed in life (Figure 6-21), its spherical form is often suggested by the eyelids, which usually follow the form of the eyeball both above and below the exposed portion (Figure 6-26). Other structural features that should be emphasized in this study are the planes of the cheekbones (Figure 6-25), which are considered later in connection with the skull, and the form of the forehead and temple region. These large formal characteristics are very important in creating a convincing drawing of the head.

The completed self-portrait serves as the basis for drawing the skull. With a sheet of tracing paper taped over your self-portrait, try visualizing and then drawing a curving line that follows the vertical division of the head's symmetry (Figure 6-26). Check your original drawing against this line. Are the facial features consistently spaced in relation to the line? If not, is the apparent asymmetry in your drawing intentional? Such questions may help you to reevaluate and change your drawing. The central curving line, also known as the medial arc, provides a visual reference for gauging the relative position of basic facial elements in a rounded spatial drawing of the head. It is comparable in an abstract way to the Greenwich Meridian that divides the globe in half along the North-South axis. Once this arc is drawn, it is possible to visualize the basic features of the head, such as the eyes and the mouth, as lying on arcs similar to those that mark latitude on the globe. The projecting form of the nose, however, rises above the medial arc and can confuse the beginning draftsman. For this reason it is advisable to pay special attention to the construction of the lower portion of the nose, which lies on the medial arc. Like the eyes, the mouth, unless it is distorted momentarily by expression, can also be conceived as lying along a horizontal arc intersecting the medial arc.

6-20. Frontal view of the skull. (Jean Galbert Savage, Anatomie du Gladiator Combattant. Courtesy of Countway Library, Harvard University.) Vertical and horizontal lines represent useful axes for drawing the head. The vertical axis conforms to the bilateral symmetry of the skull and is crossed by the medial axis of the eyes and the lower axis of the mouth. The medial axis touches the eye, as shown in the left socket.

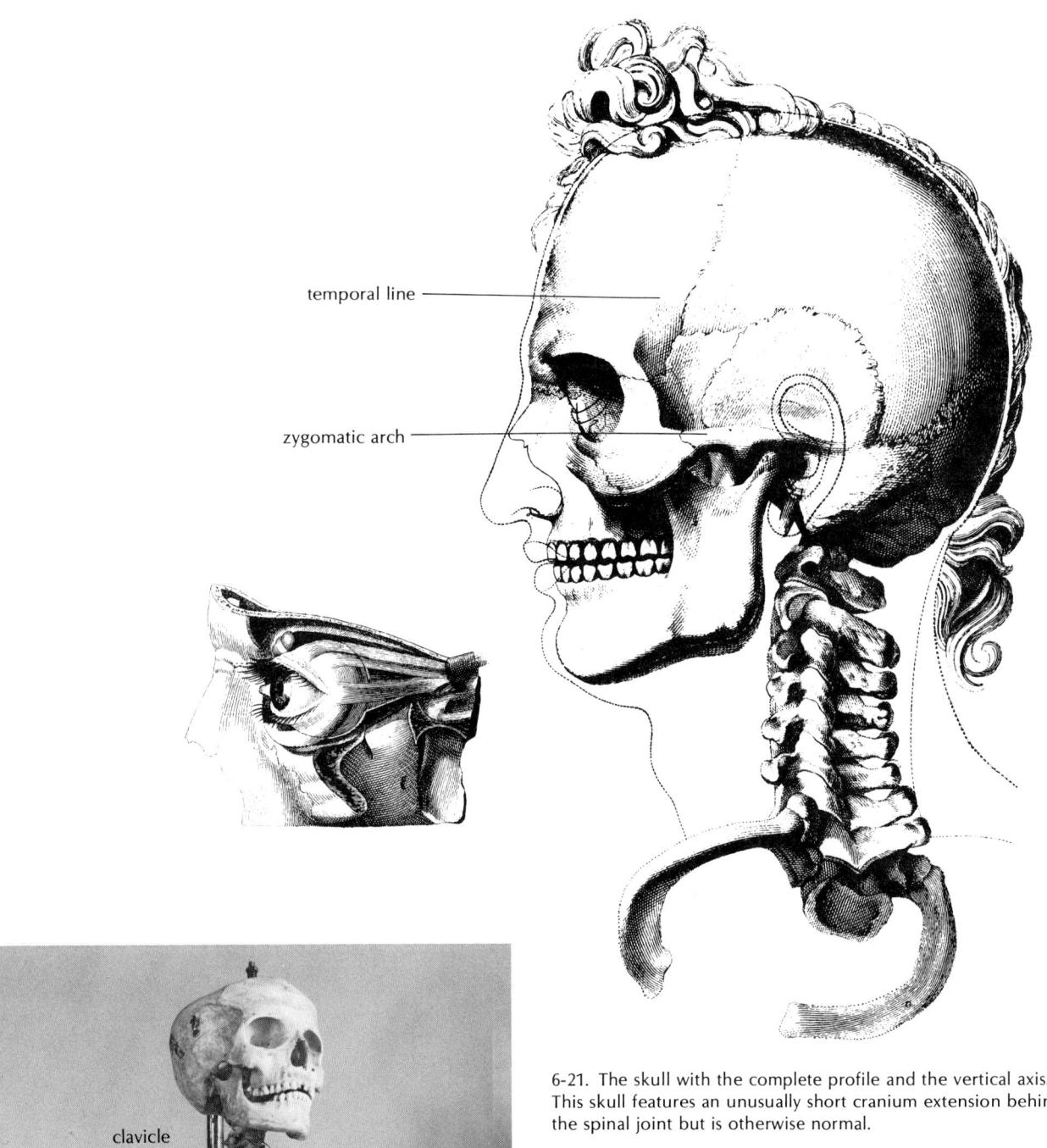

hyoid bone

sternum

xiphoid process

6-21. The skull with the complete profile and the vertical axis. This skull features an unusually short cranium extension behind the spinal joint but is otherwise normal.

 $\,$ 6-22. Mounted skeleton, upper portion. In the mounted skeleton the general rounded form of the rib cage is apparent.

6-23. Student drawing, self-portrait. Nupastel crayon. $14'' \times 11''$. The student chose to represent the more general forms of the head, yet a portrait quality is apparent. The more characteristic forms of the individual are often seen in larger shapes rather than in details.

6-24. Student drawing, self-portrait. Compressed charcoal pencil on bond sketchbook paper. $11'' \times 8 \, 1/2''$. Beginning with a free contour-line drawing, the student carefully modeled with tone to show light and shadow. Despite a slight problem in aligning the mouth the basic construction retains a sense of the bilateral symmetry that underlies variations in facial form.

6-25. Julio Gonzalez (1876–1942), Self-portrait, 1940. Wash and pencil. 9 $1/2'' \times 6 \, 1/4''$. Otterloo, Kröller-Müller National Museum. The Spanish sculptor adopted relief modeling in this self-portrait as a means of defining the form of the head in terms of broad planes suggestive of the underlying skull structure.

6-26. Filippino Lippi (attributed to), *Life study of a man's head*, 1470–1480. Düsseldorf Kunstmuseum, Grafische Sammlung, Inv. Nr. FP9 verso. Metalpoint and white on lilac-gray paper. 246 × 188 mm. This freely drawn study exhibits the use of arcs based on an ovoid concept of the head. Both the vertical medial arc and the arc connecting the eyes are apparent. The contours of the eyelids suggest the spherical form of the eyeball.

Draftsmen have used arcs as a means of construcing the form of the head since their initial formulation in the Renaissance. Arc constructs appear to have played a part in the visual thinking of many artists, even when they do not actually appear in their drawings. ¹⁵ In some drawings, however, particularly those with an informal quality, the arcs are clearly visible. The medial arc, for example, is apparent in a drawing of the head by the Italian artist Filippino Lippi (c. 1457–1504), as is the general ovoid form on which the arc is based (Figure 6-26). The horizontal-arc construction appears in a drawing by Piero della

Francesca (1420–1492) in which the head is represented as an ovoid, with the planes of each cross section tilted isometrically with respect to the surface of the drawing (Figure 5-64). Leonardo da Vinci used a similar formula to study the form of the skull by making both a vertical section of the entire skull and a horizontal section of the cranium (Figure 6-27). A modern example of a drawing constructed with arcs is a skull (Figure 6-28) by the contemporary Swiss artist Alberto Giacometti (1901–1966). Though the medial arc is not present as a line in the Giacometti drawing, it is implied (Figure 6-29).

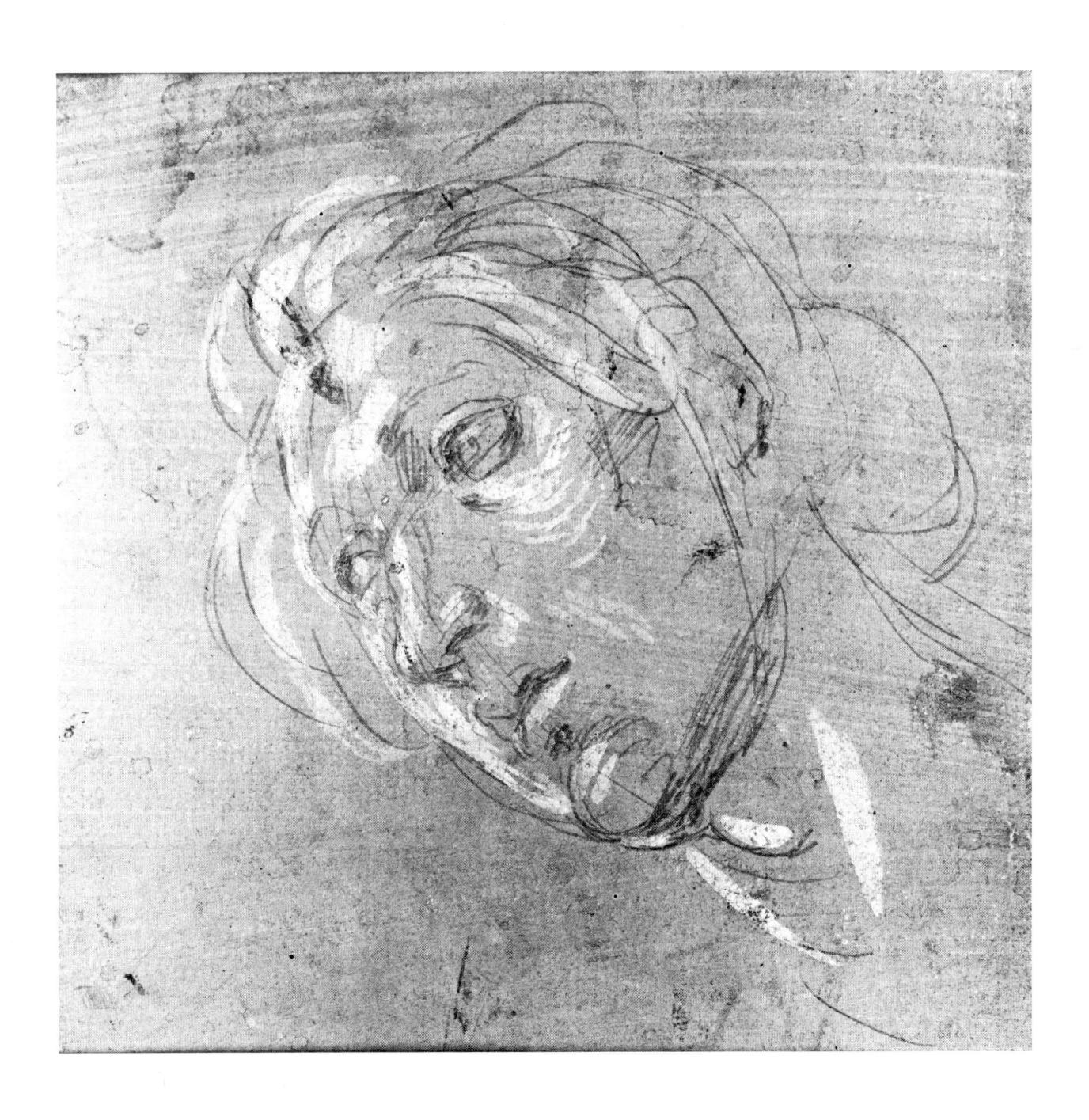

The medial arc that you have drawn on the tracing paper over your self-portrait can be useful in drawing the skull. Using anatomical illustrations as a reference, try drawing the ovoid shape of the cranium within the outer lines of the self-portrait so that the medial arc appears to lie in a centered position upon the ovoid. At this stage in the drawing it is vital that you estimate the size of the cranium carefully. Though the human cranium does vary in size and shape, a common error of beginning draftsmen is to draw the back portion too small with respect to the rest of the head. By drawing the cranium accurately on the overlay any discrepancy in this part of the drawing will become apparent. The reason for the recurrence of this problem may be due in part to the fact that this region of the head is usually concealed

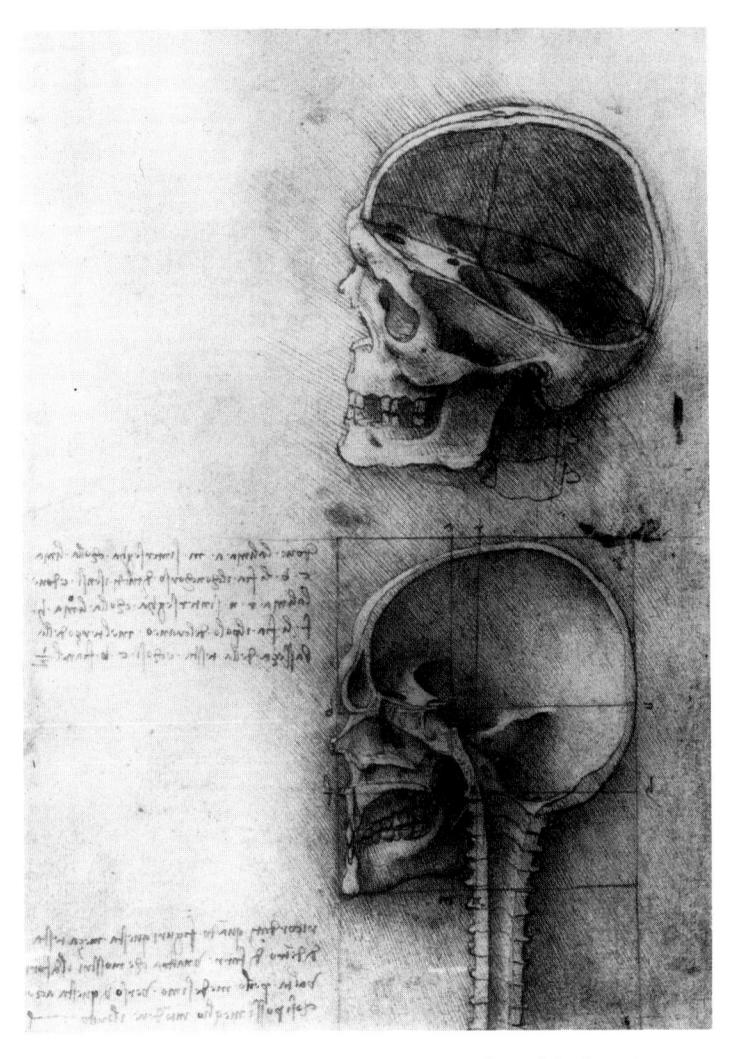

6-27. Leonardo da Vinci, Anatomical studies of skulls, 1489. Silverpoint. 18.1 × 12.9 cm. Windsor Castle, Royal Library. Leonardo's interest in the structure of the skull is evidenced by his careful proportional studies of its form. The vertical section of the bottom skull corresponds with the vertical axis of Figure 6-20.

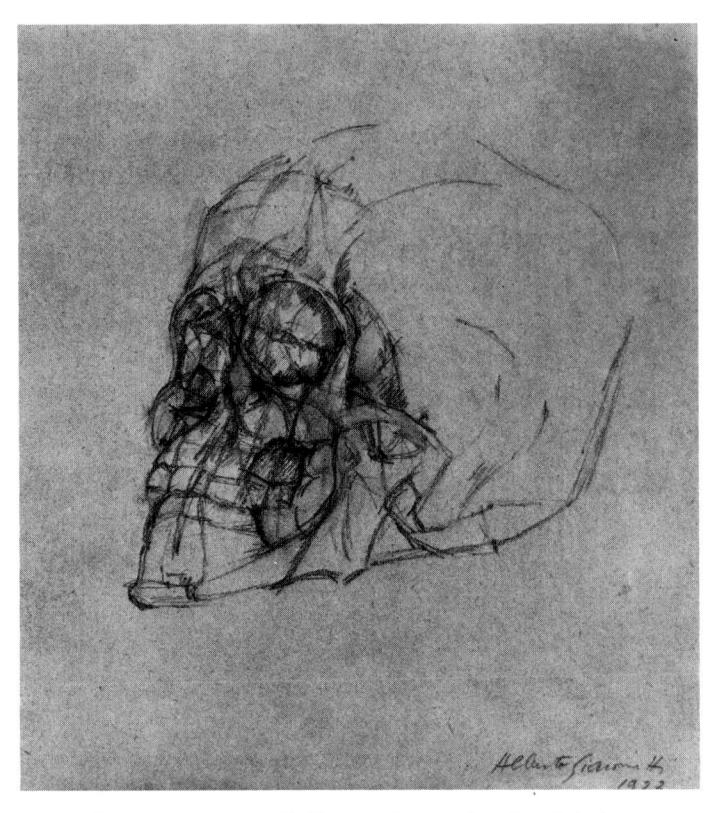

6-28. Alberto Giacometti, *Skull*, 1923. Crayon. London, Sainsbury Collection.

6-29. Linear reduction of Figure 6-28, indicating vertical and horizontal axes.

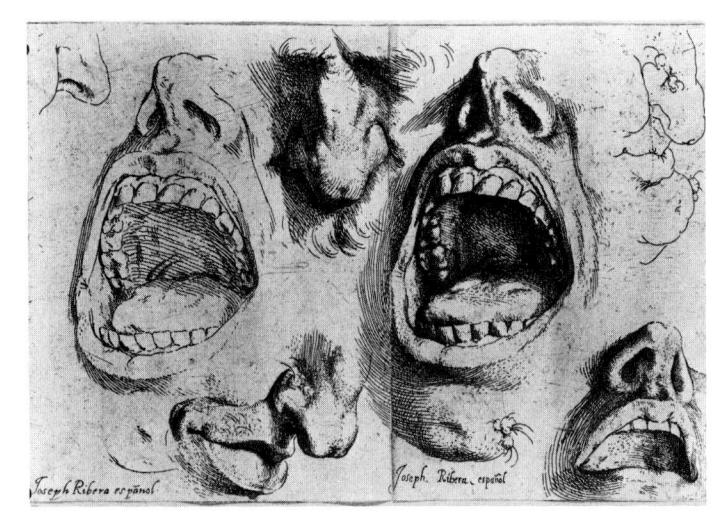

6-30. Jusepe de Ribera (1591-1652), Studies of the mouth and nose. Engraving. Copenhagen, Royal Museum of Fine Arts.

by masses of hair, making it difficult to visualize the form of the head except in the facial region. A bald head, however, gives a clear idea of the influence of the cranium on the outer form of the head (Figure 7-29). The platelike bones of the skull, 22 in all, are held together by nonmoving suture joints, which are visible as narrow cracks in the skull's surface. The unique construction of the skull is dictated by its special function of protecting the delicate brain and sense organs, a task that is accomplished by means of forms and structures that ensure maximum strength and a minimum of bone.

The eve sockets can also be spaced by means of the medial arc. They form a symmetrical pattern, crossing the medial line at a height roughly equal to the vertical middle of the head (Figures 6-20 and 6-29). A horizontal axis at this height can be helpful in locating their positions, for they are not aligned as on a flat plane but, like the horizontal axis, are part of the curving form of the skull. The eye sockets are thus turned slightly away from each other, a difference of alignment that is more pronounced in the skulls of lower animals. The eve sockets of the skull, also known as orbits, are round, bony concavities housing the eyeballs and the surrounding muscles that move them. In life the outline of the orbits is often suggested by a slightly bluish coloration in that region, caused by the eye muscles and their associated blood vessels. The oval shape of the orbits resembles the lenses of aviator-style sunglasses, a resemblance that is heightened by the linear joint at the bridge of the nose (Figure 6-21). After drawing the orbits of the eyes, compare them with the self-portrait underneath to see whether they conform to the symmetry dictated by the medial line. The orbits also provide a way of checking your drawing for accuracy, for they can serve as a frame of reference for visible portions of the eyeball.

On the outer side of the orbit of each eyeball is the cheekbone (zygomatic bone). Viewed from the side, it contributes to an irregular parabola that continues along the side of the forehead and echoes the oval of the cranium (Figure 6-21). This curve originates near the ear and terminates on the upper side of the cranium. A portion of it, known as the temporal line, is apparent at the temples. The lower edge of the zygomatic bone, a determinant of the planes of the cheek, is frequently visible in the face (Figure 6-25). Viewed from above, the bone appears as part of an open bony arch. A slender band of muscle connects the outer surface near the arch with the side (angle) of the mouth. Called the zygomaticus major, it cre-

ates the characteristic plane of the jaw (Figure 6-20).

The cartilage structure that gives the nose its projecting form is almost never preserved in the skull, which shows only the bridge between the eyes and the nasal cavity. One advantage of this presentation, however, is that the medial arc is easier to visualize in the skull than it is in life, for it is not interrupted by the projection of the nose. Moreover, you can observe in the skull a fine suture joint above and below the nasal cavity that corresponds to the position of the medial arc. The same joint appears to divide the upper teeth into two symmetrical groups.

The teeth are the only part of the skeleton exposed to view in life, and they play a significant role in shaping the lower part of the head, a fact made sadly plain in people who are toothless. Though they are seldom exposed in portraits, the teeth make a fascinating study, as is demonstrated in *Studies of the mouth and nose* (Figure 6-30) by the Spanish artist Jusepe de Ribera (1591–1652). In this startling rendering of a gaping mouth both upper and lower teeth are shown. The teeth made visible in a smile, however, are usually the upper ones, as they tend to overlap the lower set, which rise from the jaw.

The jawbone (mandibula) can be drawn with its center along the same medial arc as the rest of the skull, for, despite its well-known mobility, it generally remains aligned with the arc. The angle at the back of the jawbone, like the projection at the chin, affects the appearance of the head in a way that is useful in drawing from life as well as from the skull.

After completing several skull studies with the head, you will be able to visualize the skull clearly in the model, for the bones lie very near the surface and directly determine the exterior shape of the head. You may wish to test your knowledge of the skull by making a rapid overlay study from memory over a self-portrait. Visualizing the exterior structure of the skull can be of particular value in portraiture, as it provides a coherent framework of rendering the expressive features of the face. If the skull is an unfamiliar form to you, its novelty can be turned to advantage by using it as a new way of seeing and drawing the head. Apart from its use in drawing the head, the skull, unlike other parts of the human skeleton, has a history as a subject in its own right. It is, of course, the traditional symbol of human mortality and as such appears in much medieval and Renaissance art. Some drawings of the skull are ranked very highly as independent works of art (Figures 6-27 and 6-28).16

THE PELVIS

In contrast to the skull, the pelvis has little direct influence on the body's exterior form due to the abundance of tissues covering it. Indirectly, however, it determines not only the form of the lower trunk but also the gestures of the entire lower body. Pelvic structure is therefore especially important in any serious study of the skeleton for drawing purposes.

The pelvis consists of two large, bladelike bones that connect the spine with the thighbones, or femurs (Figure 6-31). The odd shape of the pelvic bone is suggested by its anatomical name, os innominatum (the nameless bone), which refers to the fact that it does not resemble any familiar object. In the pelvis, however, each bone forms half of the ring described earlier: both are connected to the sacrum on the posterior side and the pubis joint (symphysis pubis) on the anterior side. The uppermost portion of the os innominatum is a curving blade of bone (the *ilium*), the upper edge of which forms a crest that terminates in the front with a projection just below the waist. This projection, mentioned previously, is the anterior-superior iliac spine. The same crest continues on the posterior of the ilium to form a projection just above the joint with the sacrum—the posterior-superior iliac spine. In life this projection, with its companion on the other side, is suggested by two dimples that appear just above the hips on each side of their separation. If the dimples are visible, they are useful in locating the position of the sacrum, for they form a triangle with the coccyx that, like the sacrum, appears as a wedge between the hips (Figure 6-32).

The lower portion of the pelvis is the hipbone the ilium and curves forward as a tuberosity to join with the branch of bone above it, the pubis. The pubis and the ischial tuberosity together form the hole visible on each side of the lower pelvis. This structure supports the body's weight in the sitting position. The upper portion of the ischium and the lower part of the ilium form a cusp on the outer side in which the round head of the thighbone (femur) joins with the pelvis. The pubis and the ilium form an irregular, jagged contour on the frontal surface, which is concealed in life by a powerful ligament connecting the anterior-superior iliac spine with the pubis. The smooth, curving line of this inguinal ligament creates the rounded contour along the lower abdominal region, a feature familiar in classical sculpture. This rounded contour, also known as the groove of the groin, is less steep in the female, since the female pelvis is generally shorter and slightly wider than that of the male (Figure 6-33). This skeletal sex difference is related to the childbearing function, which requires a larger pelvic cavity.

As the structural unit connecting the legs with the trunk, the pelvis exercises a special influence on the gestures of the body, an influence that is determined in part by the differing types of pelvic joints. The pelvic joint with the spine is nonmoving. In terms of a specific gesture this means that if the pelvis tilts to the right, for example, the lower portion of the vertebral column would also bend in that direction. The thigh, however, is free to assume a relatively independent direction due to the ball-and-socket type of joint formed on each side by the head of the femur and the socket (acetabulum) of the pelvis (Figure 6-34).¹⁷

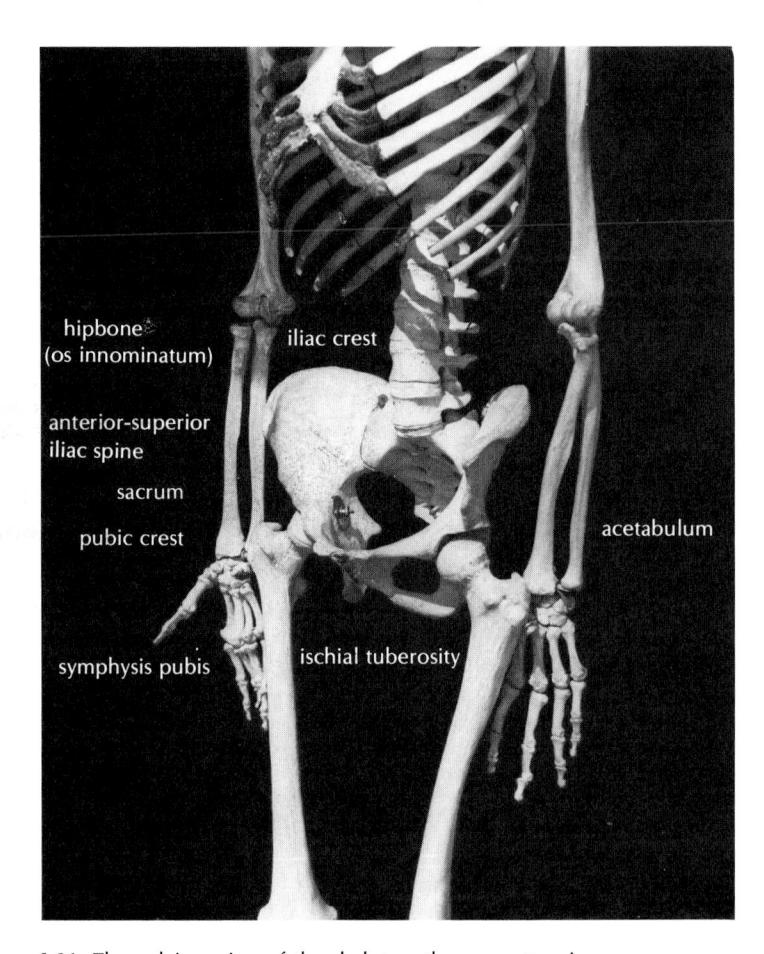

6-31. The pelvic region of the skeleton, three-quarter view.

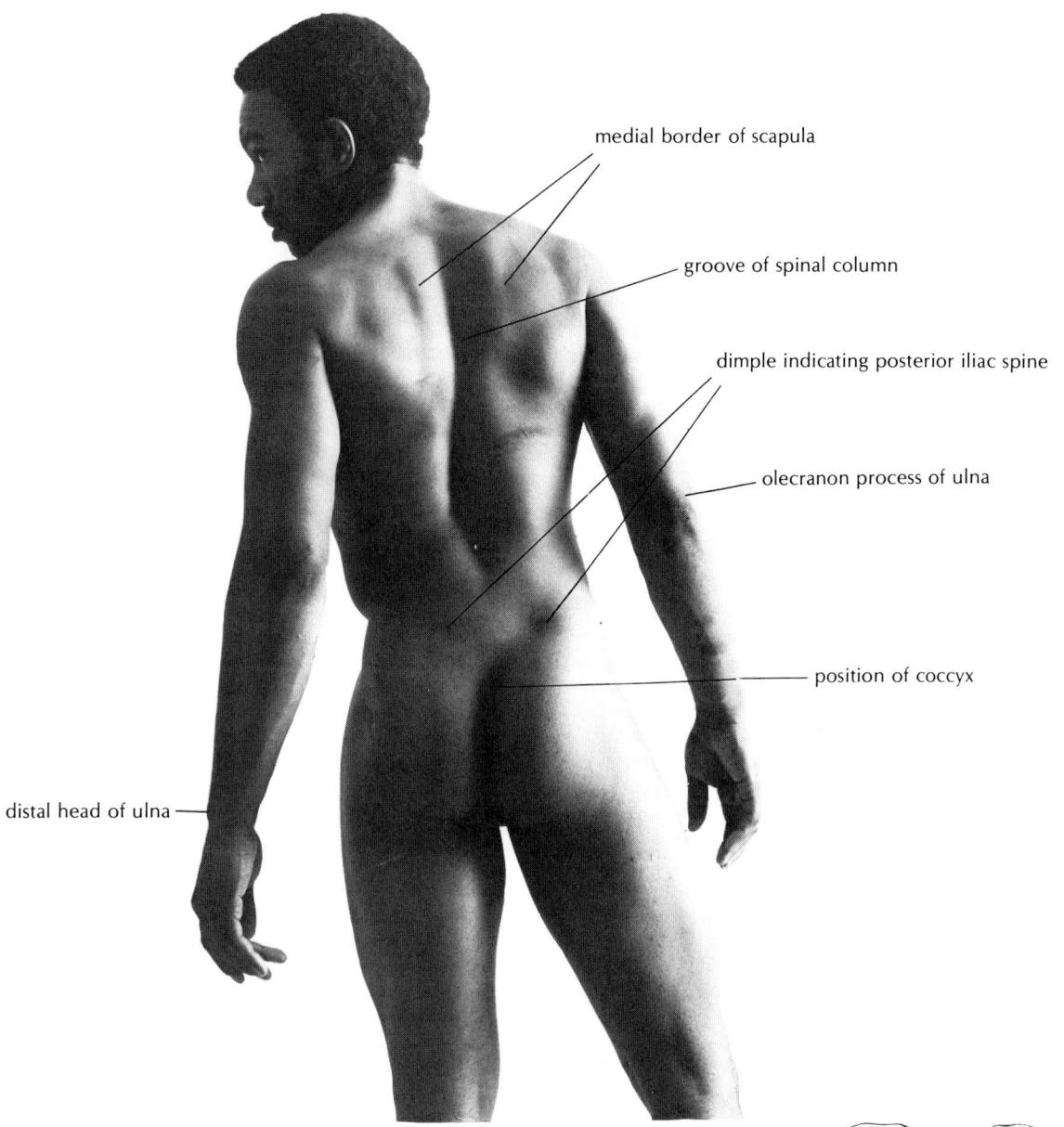

6-32. The back. The two dimples above the hips are helpful in gauging the attitude of the pelvis, for they correspond with the underlying posterior-superior iliac spines. Other skeletal features apparent in this figure include the groove of the back and the inner edge of the scapulae.

6-33. Composite of the female and male pelvis. The female pelvis (gray silhouette) is proportionately wider and shorter than the male pelvis (line).

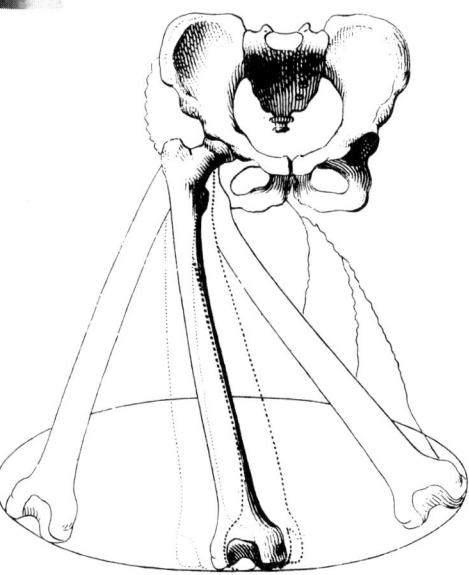

6-34. The action of the ball-and-socket joint of the hip. (Jean Galbert Savage, *Anatomie du Gladiator Combattant*. Courtesy of Countway Library, Harvard University.)

STUDY 31. DRAWING THE PELVIS

Materials: 11"-x-14" sketchbook

drawing pen (0.5 mm point

recommended) HB drawing pencil tracing paper

transparent (Scotch) tape

Reference: model and Figures 6-1, 6-2, 6-3, 6-4, 6-5, 6-7, 6-12, 6-13, 6-35, and

6-36 or mounted skeleton

Suggested time: 30 minutes

Using a drawing from the model as the basis for your study, attach a tracing-paper overlay, as in study 30. Make a general indication of the axial skeleton, taking care to place the form of the pelvis as it might appear within the figure. Due to the sculptural quality of the pelvis, you may wish to model its shape; for the same reason it is best to draw from a skeleton if one is available. If you must draw from anatomical illustrations, however, use several illustrations of the pelvis as a reference. A single illustration is unlikely to show the particular view required by your life drawing. A variety of viewpoints will enable you to visualize the appearance of the pelvis quite accurately in the drawn figure (Figure 6-37).

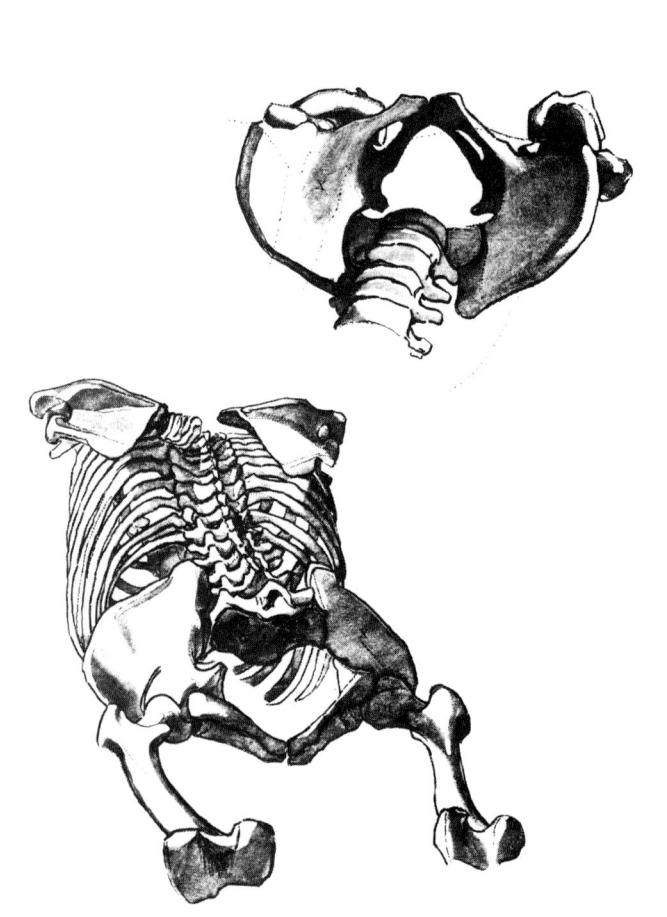

6-35. Back side of the female pelvis, seen from below. (Flaxman's Anatomical Studies, engraving by Henry Landseer. Courtesy of Countway Library, Harvard University.)

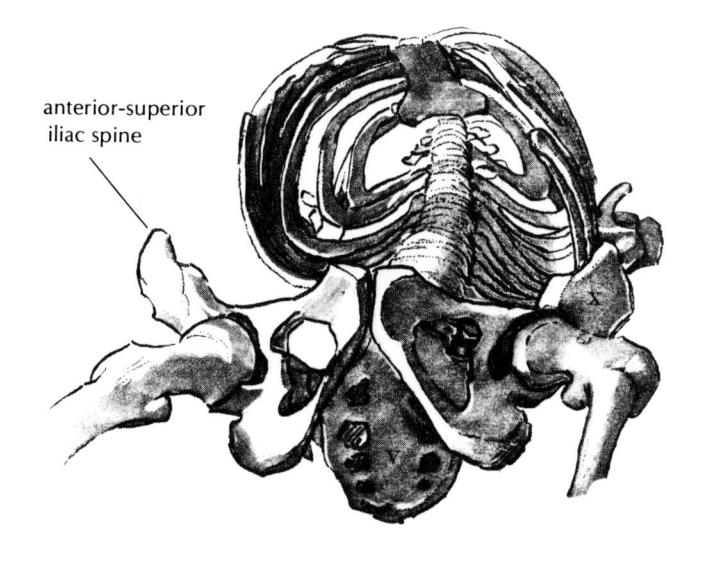

6-36. Axial skeleton, seen from below. (Flaxman's Anatomical Studies, engraving by Henry Landseer. Courtesy of Countway Library, Harvard University.)

6-37. Student drawing, life study with overlay study of the skeleton. Pen-and-ink on sketchbook paper. 14" × 11".

THE RIB CAGE AND THE SHOULDER GIRDLE

The general eggshell form of the rib cage is suggestive of its role in protecting vital organs, such as the heart and lungs. It also provides attachment and support for the shoulder girdle, the bony structure that articulates with the arm bone (humerus). The unique construction of the rib cage allows it to change shape slightly, an action necessary for breathing. Such varied functions account for its relatively complex structure. Common sense suggests that the ribs should appear as a series of rings located at right angles to the spine, which is how they frequently appear in beginners' drawings. The ribs are actually blades of bone that curve downwards from the spine, to which they are attached in the back (Figure 6-22). Some also curve upward in the front before joining the breastbone (sternum) by means of flexible cartilage. A segmented bone resembling a necktie both in shape and position, the sternum is detected in the body by touching the slight depression called the pit of the neck, which reveals the bone's upper limit. The lower limit of the sternum (the xiphoid process), however, is visible only when the chest is expanded and the stomach drawn in. Then it appears at the top of the pointed arch of lower ribs, the thoracic arch. The xiphoid process corresponds with the position of the pit of the stomach in life (Figure 6-22).

The shoulder girdle (Figure 6-38), consisting of the collarbone (clavicle) and the shoulder blade (scapula), is the only skeletal connection between the rib cage and the arm bone (humerus). Surprisingly, the shoulder girdle joins the rib cage only at the sternum. This juncture can be located by touch. If you feel the pit of your neck, you will notice slight elevations to the right and to the left. These bumps represent the joints of the proximal ends of the clavicles with the sternum. The *clavicle* is a relatively thin bone, and in general the shoulder girdle is a weak structure compared with the pelvic girdle, but it compensates for its lack of strength with greater mobility.

Although the individual joints of the shoulder girdle permit only limited movement, together they account for the broad range of movement associated with the shoulder. One consequence of the loose construction of the skeletal shoulder is that the shoulder girdle depends heavily on muscle attachments to hold it in place. This is especially evident in the shoulder blade (scapula), a thin, triangular bone that forms the major part of the joint with the humerus and glides freely over the back of the rib cage but is held in check by muscles attaching it firmly to the axial skeleton. An important feature of the scapula is its spine, the elevated ridge on its outer surface, which rises near the shoulder to form a knobby projection called the acromium process. This, together with the socket-type head of the scapula and its associated coracoid process, receives the head of the humerus at the shoulder.18

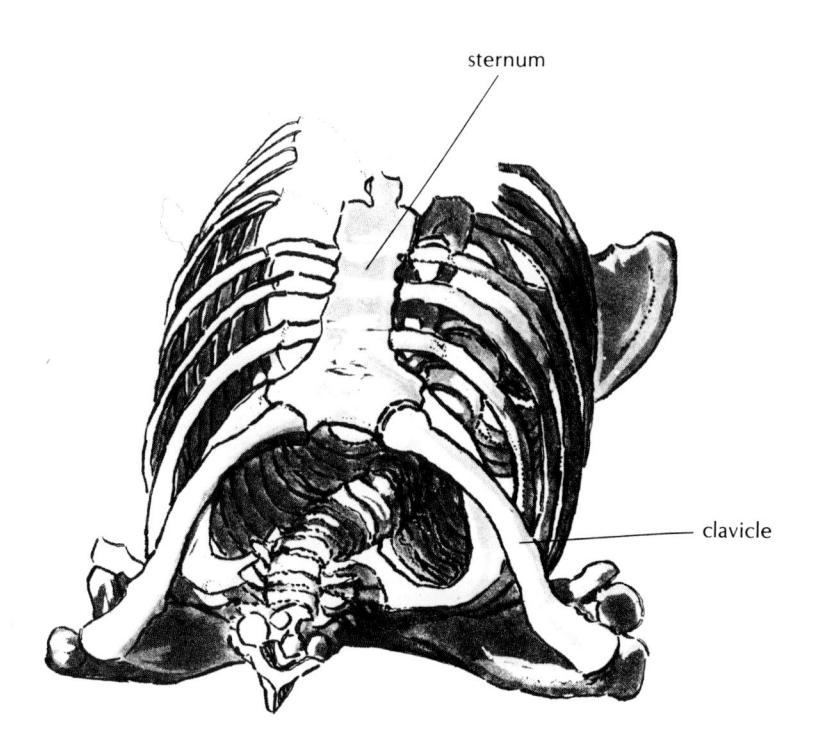

6-38. View of the rib cage, showing the bowlike construction of the clavicles and sternum. (Flaxman's Anatomical Studies, engraving by Henry Landseer. Courtesy of Countway Library, Harvard University.) Note the rounded space separating the sternum from the spinal column.

6-39. Student drawing, life study of the model. Pen-and-ink on sketchbook paper. $10'' \times 8\,1/2''$. The drawing includes indications of visible landmarks of the scapula and the spine.

6-40. Student drawing (Figure 6-39), with overlay study of the rib cage and the shoulder girdle. Graphite pencil. This study illustrates the displacement of the scapula when the arm is raised.

STUDY 32. DRAWING THE RIB CAGE AND THE SHOULDER GIRDLE

Materials: 11"-x-14" sketchbook

drawing pen (0.5 mm point

recommended) india ink

HB drawing pencil tracing paper

transparent (Scotch) tape

Reference: model and Figures 6-1, 6-2, 6-3,

6-4, 6-5, 6-7, 6-12, 6-13, 6-35, and

6-36

Suggested time: 15 minutes for the life study and

45 minutes for the skeletal study

Due to special problems associated with drawing this part of the skeleton it is advisable to make several life drawings that afford different views of the upper half of the figure. In drawing from the model be sure to indicate the pit of the neck, the pit of the stomach (if visible), and as much of the clavicles and scapulas as you can discern. Such indications simplify the skeletal study of this region, which is exceptionally changeable in appearance (Figures 6-39 and 6-40).

With a tracing sheet taped over your life study, begin the skeletal study by penciling in the curving form of the spinal column (as in study 28). It is important to render its position accurately, for it supports the rib cage and is thus an important determinant of the chest's appearance. If the pit of the neck is indicated in your drawing from life, you can easily render the sternum in its proper position and develop the general ovoid shape of the rib cage. The individual ribs can then be delineated as forms curving and sagging around the large shape (Figure 6-41). Remember that

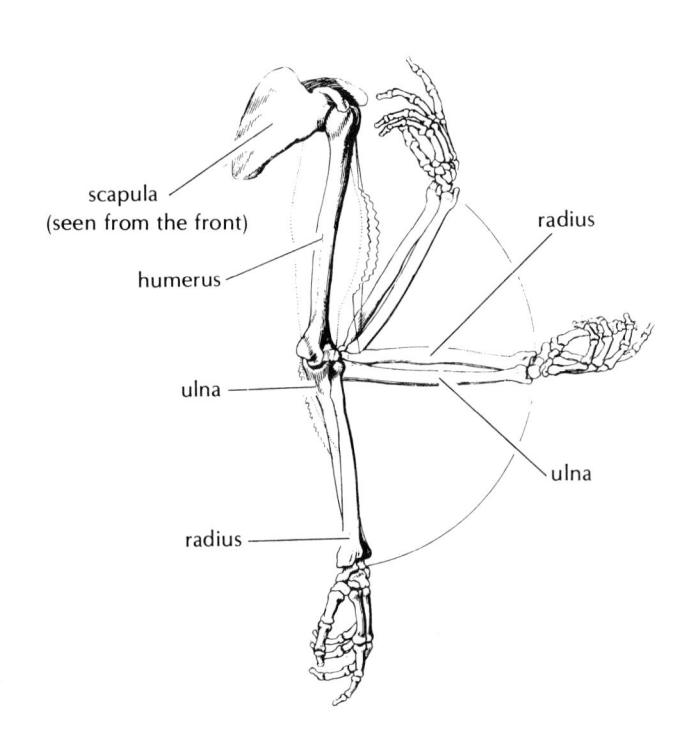

the sternum appears to be aligned with the spinal column only if the body is seen directly from the front.

THE APPENDICULAR SKELETON

The bones of the limbs, the appendicular skeleton, have several features in common. Both the arm and the leg are joined to the axial skeleton by single bones with rounded heads: the femur of the thigh and the humerus of the arm. Both bones are relatively long; the femur is "the longest, largest, and strongest bone in the skeleton, and almost perfectly cylindrical in the greater part of its extent (in a man six feet high it may measure eighteen inches-onefourth of the whole body)."19 The lower (distal) ends of the femur and humerus flare out and form knobs called condyles that articulate the joints with the outer limbs. Both the (lower) leg and the forearm have two bones: in the arm they are the ulna and the radius: in the leg, the tibia and the fibula (Figure 6-10). There is also a similarity of proportions: both the (upper) arm and the thigh are proportionately longer than the lower members.

The differences in structure between the legs and the arms are related to differences in function. The assumption of upright posture has resulted in more specialized roles for the limbs.²⁰ The lower limb has evolved into a strong but less flexible structure, while the arm, no longer needed to support the body, has evolved into a lighter structure with a great range of movement. Illustrating this difference is the fact that one can easily rotate the forearm and the wrist about 180 degrees without moving the (upper) arm; the ankle, however, cannot be rotated without turning the upper leg as well. The reason for this contrast is revealed in the skeletal structure.

The two bones of the (lower) leg, the fibula and the tibia, form a nonmoving joint just below the knee. Although the knee joint of the femur and tibia is the largest in the body, it permits only a hingelike movement (Figures 6-42 and 6-43). The forearm construction is guite different: the two bones are formed so that one, the radius, can rotate around the other, the ulna (Figure 6-44). The proximal end of the radius features a rounded cusp that joins with a round knob (condyle)21 on the outer side of the humerus at the elbow. As the structure suggests, this joint per-

mits rotation of the forearm. The distal end of the radius articulates with the wrist (carpal) bones: when the radius rotates, the wrist and hand also turn. Movements of the ulna, however, are more like those of the tibia in that they are governed by a hinge-type joint at the elbow so that the ulna, unlike the radius, does not rotate when the hand turns. This fact may seem difficult to comprehend but is easily demonstrated in the skeleton (Figure 6-44). If the skeletal hand is lying palm up (supine), the radius and ulna do not cross but lie parallel; but if the hand is rotated

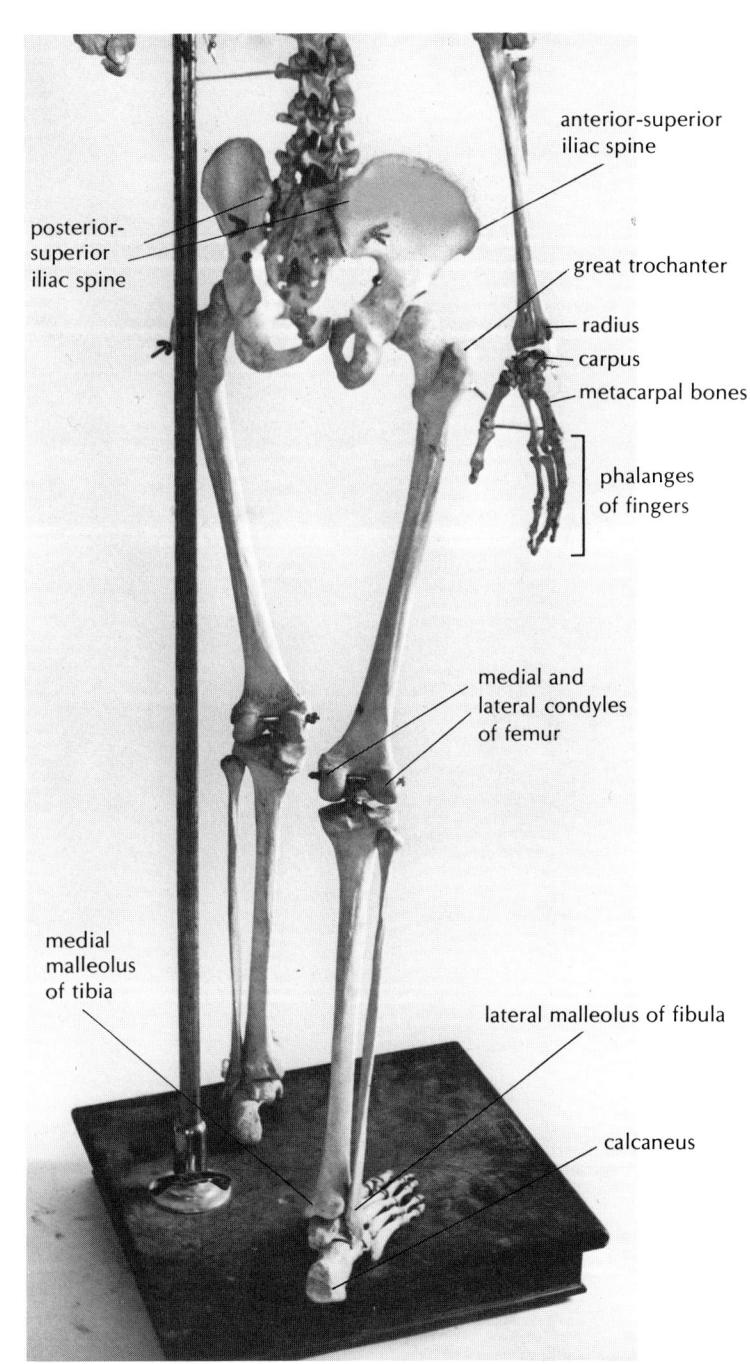

6-42. The lower limbs of the mounted skeleton. The femurs form a characteristic angle with the tibia and the fibula in the standing position.

^{6-41.} Movements of the arm, forearm, and hand. (Jean Galbert Savage, Anatomie du Gladiator Combattant. Courtesy of Countway Library, Harvard University.) The forearm swings along an arc dictated by the hinge joint of the ulna and the humerus. At the same time the wrist rotates from the supine position, seen at the top and middle, to the prone position, at bottom. The prone position requires that the radius cross the ulna, a movement made possible by the converse ball-and-socket joint of the radius and the humerus.

so that it is palm down (*prone*), the arm appears straight, but the radius crosses over the ulna. This movement, which so fascinated Michelangelo (Figure 7-39), naturally affects the position of the muscles that lie over these bones and hence alters the appearance of the entire forearm. The hinge joint of the humerus and the ulna governs only the extension, or unbending, of the arm. The familiar tip of the elbow, visible

when the arm is bent, is actually a projection of the ulna called the *olecranon process* (Figure 6-3). The condyle of this process glides in a groove of the humerus.²² As the forearm extends, the olecranon process glides backwards until it catches in a notch on the back of the humerus, thereby terminating the extension of the forearm at an angle of about 180 degrees with the (upper) arm.

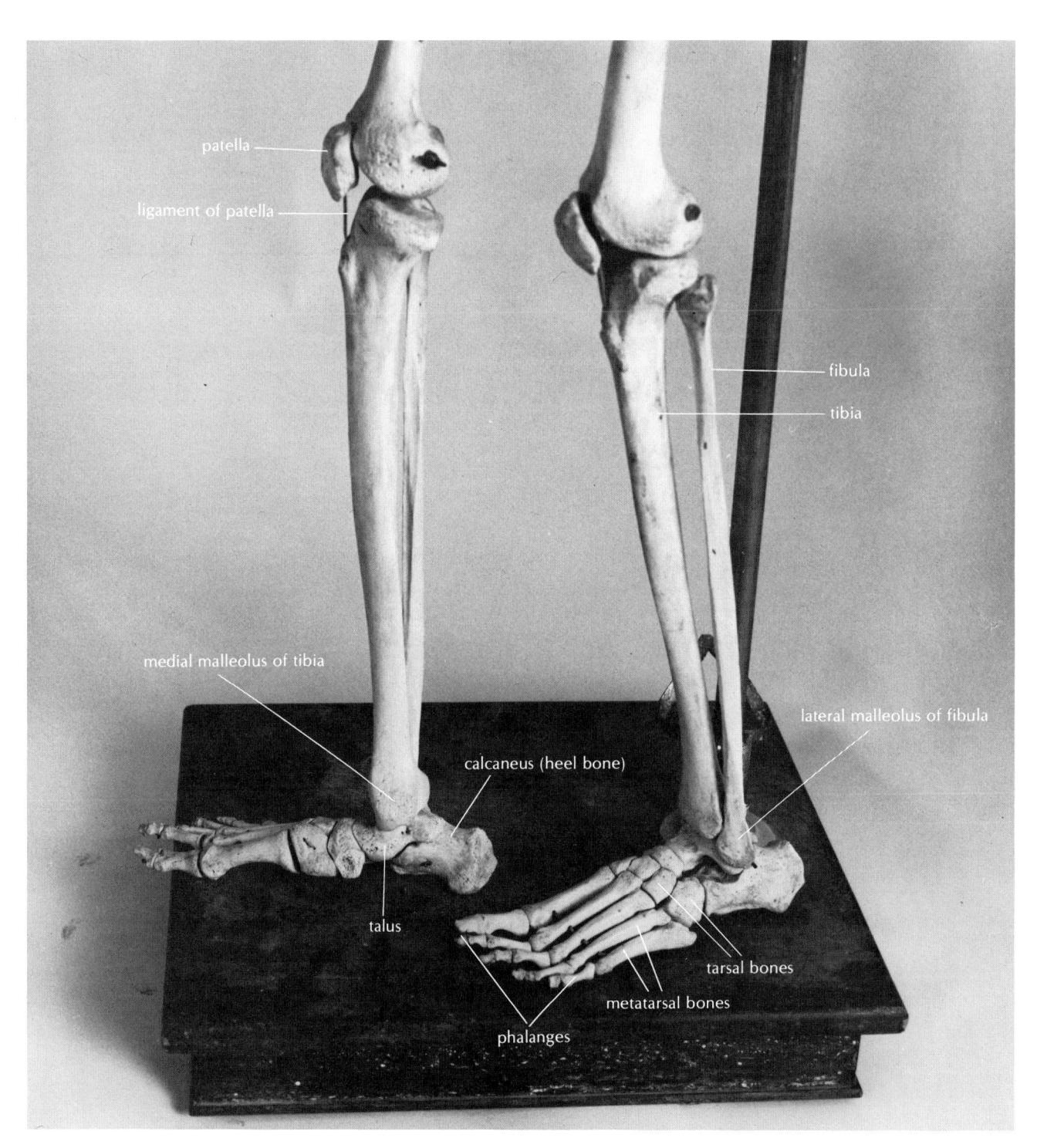

6-43. The skeletal legs and feet. The structural difference between the distal ends of the tibia and the fibula causes the superficial ankles to appear noticeably higher on the medial (inner) side of the foot.

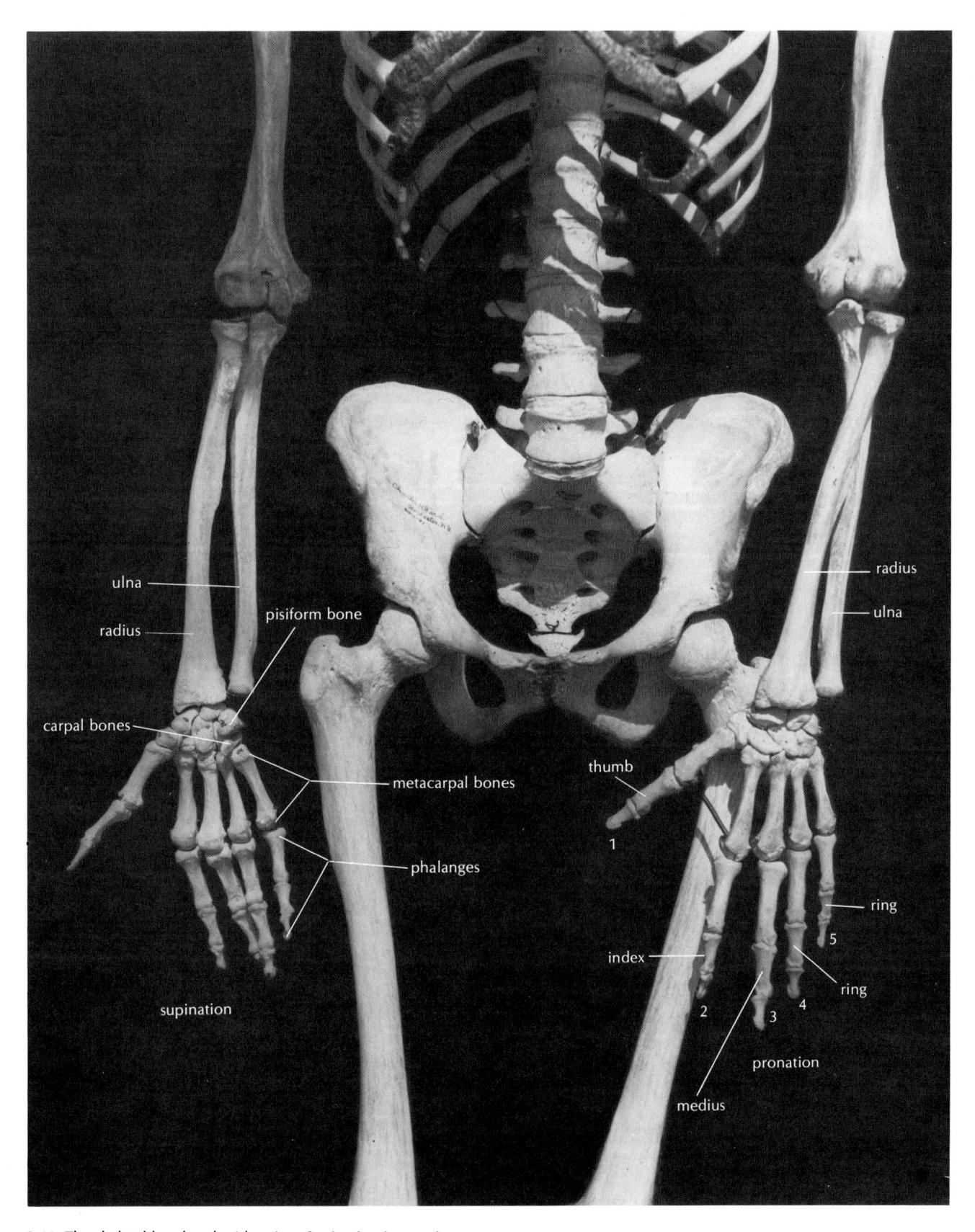

6-44. The skeletal hand and midsection. Supination is seen in the right hand, and pronation in the left hand of this mounted skeleton. The ulnar joint retains the same relative position with the femur in both cases.

STUDY 33. THE SKELETAL ARM

Reference:

Materials: 11"-x-14" sketchbook

drawing pen (0.5 mm point

recommended)
HB drawing pencil
tracing paper

transparent (Scotch) tape

model and Figures 6-3, 6-4, 6-5,

6-12, 6-41, 6-44, and 6-45

Suggested time: 15 minutes for the life study and 45 minutes for the skeletal

drawing

Because the mobility of the arm bones causes the surface forms of the arm to change, it is advisable to prepare a series of at least four drawings from life, with the model posed so as to display various gestures of the arm. It is particularly helpful to include poses that show the supine and prone attitudes of the hands. The drawings are most useful if they indicate certain skeletal features usually visible in the arm. The distal end of the humerus, for example, can be recognized by the knobby bumps (epicondyles)²³ on both sides of the elbow; the wrist in the prone position reveals the position of the distal end of the ulna. Including such features in the life drawing will facilitate the skeletal study to be drawn later on the tracing-paper overlay.

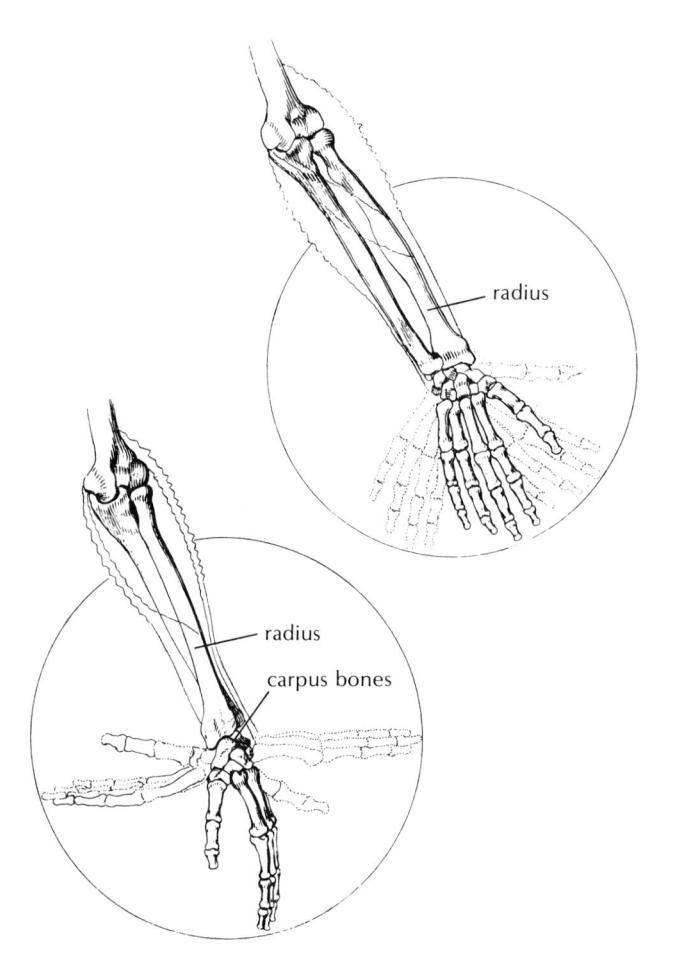

STUDY 34. THE LOWER LIMB

Materials: 11"-×-14" sketchbook

drawing pen (0.5 mm point

recommended) HB drawing pencil tracing paper

transparent (Scotch) tape

Reference: model and Figures 6-1, 6-2, 6-3,

6-4, 6-42, 6-43, 6-46, and 6-47 or

mounted skeleton

Suggested time: 15 minutes for the life study

and 45 minutes for the skeletal

drawing

Beginning draftsmen are sometimes troubled by the proportional relationship between the legs and the rest of the body.²⁴ As a basis for a study of the skeletal lower limb (the anatomical term for leg) it is helpful to draw the full figure of the model so that the limb can be seen as an integral part of the body.

In preparing the life studies it is advisable to include any visible clues of the skeletal lower limb. One such clue is the prominence of the great trochanter on the side of the hip (Figure 6-3). The kneecap (patella) is another part of the skeleton often visible in this limb (Figure 6-43). In the leg the shinbone (tibia) is often apparent in life as a curving ridge originating just below the kneecap and terminating with the shape of the inner ankle. The fibula, however, is suggested only by the bumps caused by the knobby ends, or projections, visible on the side of the leg just below the knee. The lower end of the fibula features a projection (process) called the lateral malleolus that is clearly visible in the form of the outer ankle. The inner ankle, or medial malleolus, is shaped by the end of the tibia and is slightly higher than the outer ankle. The prominence of the great trochanter will reveal the position of the upper femur, which, with its stem and ball, somewhat resembles a pistol handle. The patella, though sometimes disguised by fatty tissue, may assist in locating the condyles of the femur as well as those of the upper tibia, to which the patella is attached from below by a strong ligament. With such forms as these included in the life drawing, you will have little difficulty in rendering the detailed skeletal study on an overlay of tracing paper.

6-45. Movements of the wrist (carpus). (Jean Galbert Savage, Anatomie du Gladiator Combattant. Courtesy of Countway Library, Harvard University.) The carpus joins the radius in a balland-socket-type joint in which the ball is oblong and does not permit the vertical rotation observed in the humerus at the shoulder. Zigzag patterns indicate the muscles that cause the movement illustrated.

In the skeleton the tibia and fibula bones have the appearance of an enormous safety pin (Figure 6-43).²⁵ Structurally, however, the fibula serves as a reinforcing buttress for the tibia. In the standing figure seen from the front the femur does not continue the vertical line of the tibia in the leg but rather inclines outward from the knee joint at a slight angle.²⁶ If the leg in the standing figure is viewed from the side, the tibia and femur are not in exact alignment but may form a slight angle along the front of the leg at the knee, an angle that varies from person to person. The degree of this angle (of extension) is determined by the ligaments of the knee joint rather than by skeletal structure in the strict sense.²⁷

Although a detailed study of ligaments lies beyond the scope of this book, the structure of the leg is such that certain ligaments, which attach bone to bone, merit consideration. Among these is the ligament joining the kneecap to the frontal tubercle of the tibia (Figure 6-43). Since the patella has no joint with the rest of the skeleton, the patellar ligament should be rendered as part of your study of the lower limb. The iliofemoral ligament (Figure 6-7) is also of special interest. It joins the great trochanter and the neck of the femur with the pelvis (at the anterior-inferior iliac spine). This ligament joins no muscle tissues and thus neither causes nor initiates movement, but it does check the backward movement of the femur, effectively locking the joint when the femur lines up with the trunk. In this way it enables the body to stand erect with relatively little effort.²⁸

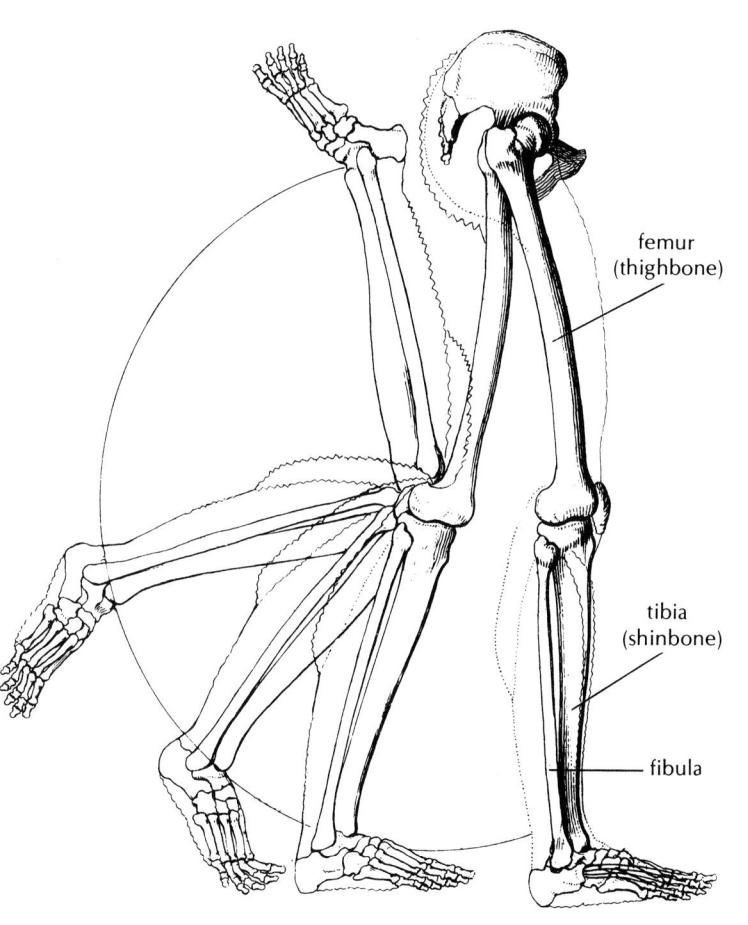

6-46. Movements of the lower limb. (Jean Galbert Savage, Anatomie du Gladiator Combattant. Courtesy of Countway Library, Harvard University.) The hinge joint of the knee permits the leg to swing backward behind the thigh but not forward, since its movement is checked by ligaments that lock the joint in place. This feature enables the body to stand with little muscular effort of the leg. (Arthur Thompson, A Handbook of Anatomy for Art Students [New York: Dover Publications, Inc., 1964], p. 291).

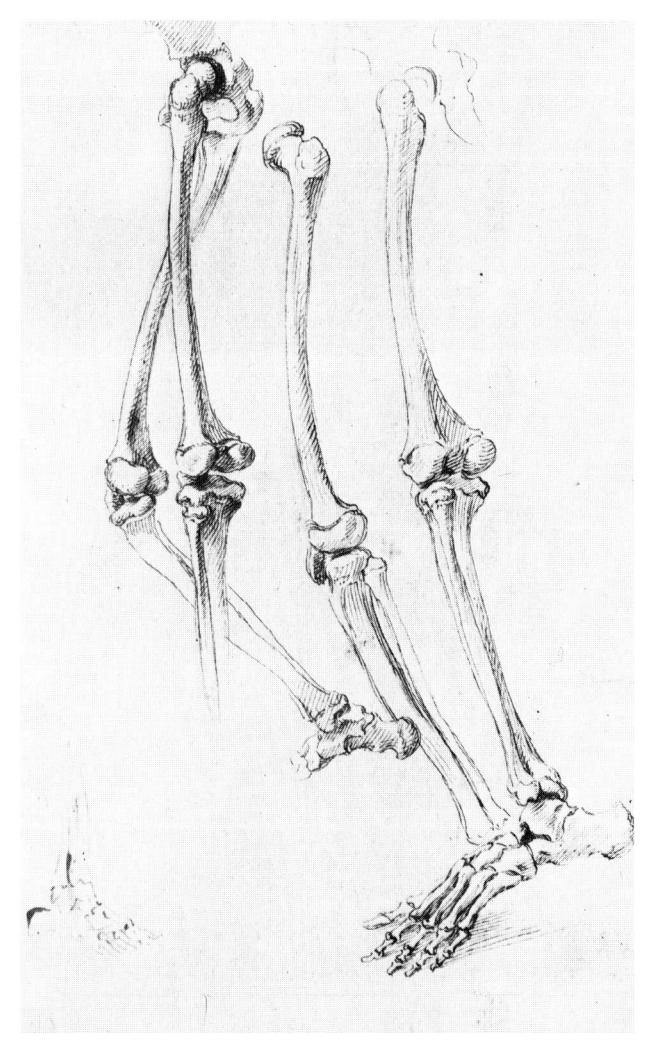

6-47. Peter Paul Rubens (1577–1640), Leg Skeletons. Pen-and-ink. 257×184 mm. Budapest, Museum of Fine Arts. Rubens' interest in forms of movement included that of the skeleton, as exemplified in this study of the lower limbs.

THE EXTREMITIES

The affinities of structure observed in the lower limb and the arm are paralleled by the structure of the extremities. Even a superficial inspection of them reveals a surprising similarity of construction—surprising chiefly because it is so well disguised in life by tissue (compare the skeletal hand and foot in Figure 6-42). These structural parallels make it convenient to study the hand and the foot together.

Although the toes are much shorter than the fingers, the number of bones comprising each is the same—three. Moreover, the toe and finger bones diminish proportionately in length so that the tips are the shortest. As if to underscore this similarity, the toe and finger bones have the same anatomical name—phalanges.²⁹ The shorter length of the toes renders them practically useless for grasping objects, but it enhances the action of the powerful muscles that pull the toe bones downward. This downward resistance of the toes is useful in running, for it effectively lengthens the leg and provides a spring of step well known to track athletes (Figures 3-44, 6-46, and 6-47).

6-48. Movements of the ankle and foot. (Jean Galbert Savage, Anatomie du Gladiator Combattant. Courtesy of Countway Library, Harvard University.) The distal ends of the tibia and the fibula, together with the talus (anklebone), form the ankle joint. The ankle joint is superficially apparent in the protuberances of the lateral and medial malleoli. Activated by muscles of the calf, the foot points downward; the muscles in front cause the foot to point upward.

One does not ordinarily think of the big toe as related to the thumb, but the skeleton clearly demonstrates their common structure (compare Figures 6-45 and 6-48). Their different appearance in life is due primarily to the fact that the *metacarpal* bone of the thumb is physically separate from the other metacarpal bones of the hand, endowing the hand with its most important function, grasping. The corresponding *metatarsal* bone of the big toe is wedded by tissue to the rest of the metatarsal bones, assuring a stronger platform to support the body.³⁰

All of the metacarpal bones of the hand reveal a general affinity to the metatarsal bones of the foot. This is not the case, however, with adjoining *carpal* bones in the hand and *tarsal* bones in the foot (Figures 6-43 and 6-44). The eight carpal bones of the wrist and the seven tarsal bones of the foot have a similar masonrylike construction, but their differences are striking:³¹ "The outstanding deviation of a foot is the enlargement and backward projection of its bones to form a heel."³² This is the heel bone, or *calcaneus*. In addition to forming one end of the arch it provides the leverage necessary for the flexion of the foot (Figure 6-48). This action enables dancers to stand on their toes as prescribed by the gestures of classical ballet.

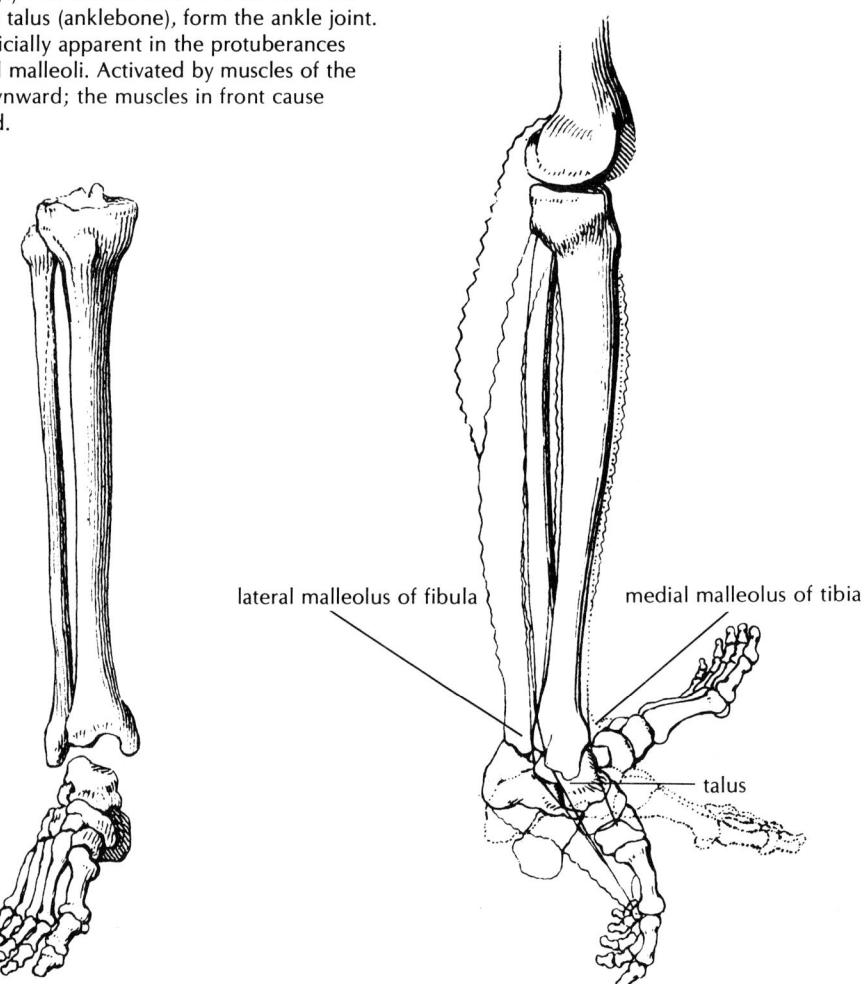

STUDY 35. THE HAND AND THE FOOT

Materials: 11"-x-14" sketchbook

drawing pen (0.5 mm point

recommended)

india ink

HB drawing pencil tracing paper

transparent (Scotch) tape

mirror (optional)

Reference: Figures 6-3, 6-4, 6-5, 6-12, 6-41,

6-42, 6-43, 6-44, 6-45, 6-46, and

6-48 or mounted skeleton

Suggested time: 1 hour for each set of studies

and 30 minutes for each skeletal

study

In drawing the extremities, as in the self-portrait (Study 30), no model other than yourself is necessary, for a mirror enables you to observe the hand and foot from a variety of viewpoints and to draw them on the same page. Given the complexity of form in the hand and foot, it is best to make life-size studies (Figures 6-49 and 6-50). Drawing to scale, in this case to life-size scale, requires careful observation, for the extremities are larger than you might suppose. The foot measures about one head length from the heel to the tip of the big toe; the hand, when spread, covers an area about the size of the face. These are relative measurements, but they may help you to establish the size of your drawing. By drawing life-size you can make any necessary corrections of scale by simply comparing the drawing with the actual subject. As in the other studies it is useful to include clues of skeletal structure. An indication of the knuckles can be useful later in the skeletal study; the prominences of the heels and ankles should be noted, if they are visible, for the same purpose (Figure 6-51).

6-49. Student drawing, study of the left hand. Compressed-charcoal pencil on sketchbook paper. $11'' \times 8 \, \text{1/2}''$.

6-50. Student drawing, studies of the artist's foot. Compressed-charcoal pencil on sketchbook paper. 11" \times 8 1/2". Sensitive though somewhat inconsistent tonal modeling was added to a preliminary contour drawing.

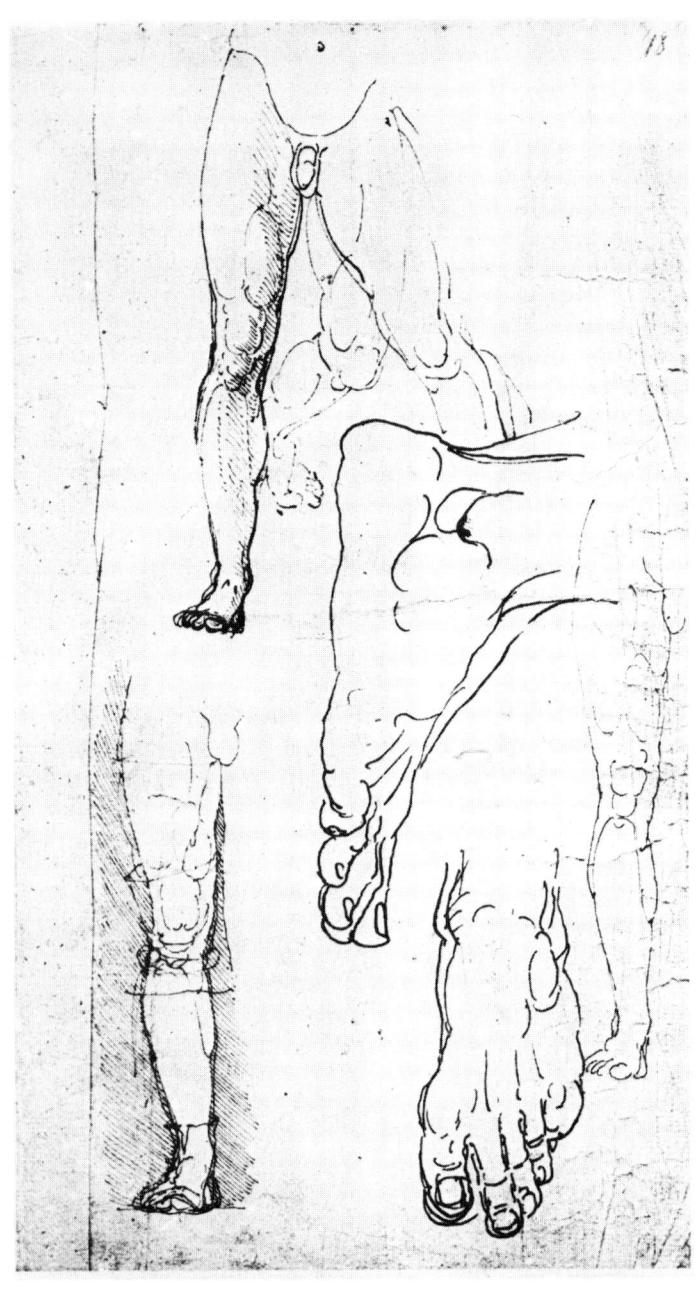

6-51. Albrecht Dürer, Study of the feet and legs, c. 1500. Page from The Dresden Sketchbook. Pen-and-ink, 294 × 206 mm. Dresden, Sächsische Landesbibliothek. Though simply drawn in contour, Dürer's studies of the foot describe prominences at such places as the heel and ankle that clearly suggest the underlying skeletal structure.

The special challenge of the hand is suggested by the number and quality of drawings of this subject by important artists of the past (Figures 6-52 and 6-53). It is a challenge that derives partly from the complexity of the forms but perhaps even more from the hand's significant role in visual experience. Like the face, it is usually exposed in daily life, and familiarity makes one keenly aware of its form. Moreover, the hand is used as a means of visual communication through gesture. Waving good-bye is a common instance of such visual signals, which in some countries amount to a veritable language. In the dance and visual art of India, for example, the gestures of the hand communicate a rich "vocabulary" of specific meanings. In Italy, as in other Mediterranean countries, the hand is an important adjunct of speech, a fact that may account in part for the subtlety of gesture seen in Leonardo's studies of the hand.

From your drawings of the hand select two for a study of the skeletal structure. Using tracing paper and pencil, make a rough indication of the radiating pattern of the phalanges and metacarpal bones as a practical way to begin your study. With this framework established, you can start to develop the form of individual bones. The lengths of the outer two phalanges can be estimated from the creases under the last segments of the fingers. In each finger the largest phalanx extends inside the outer pad of the palm, joining with the metacarpal bone to form the knuckle. This phalanx is therefore somewhat longer than the exterior suggests. As noted earlier, the phalanges diminish in size in about the same proportion for all fingers. You can use the indications of the knuckles in the original life study to estimate the position of the metacarpals. These bones converge from the knuckles to the carpals, the compact group of small bones that form the wrist. Little of the carpal and metacarpal structure is normally visible in the hand.

It should be pointed out that the radiating pattern of the metacarpal bones is not to be confused with a similar but separate radiating pattern caused by the tendons attached to the tops of the knuckles (discussed in chapter 7). The carpal bones need not be drawn in detail; individually they have little effect on the outer form of the hand. It is important, however, to render the joint of the carpus at the wrist, where the carpal bones form a rounded (ellipsoidal) surface articulating exclusively with the radius.

^{6-52.} Leonardo da Vinci, *Study of a woman's hands*, c. 1474. Silverpoint on a prepared pink ground. 21.5×15 cm. Windsor Castle, Royal Library.

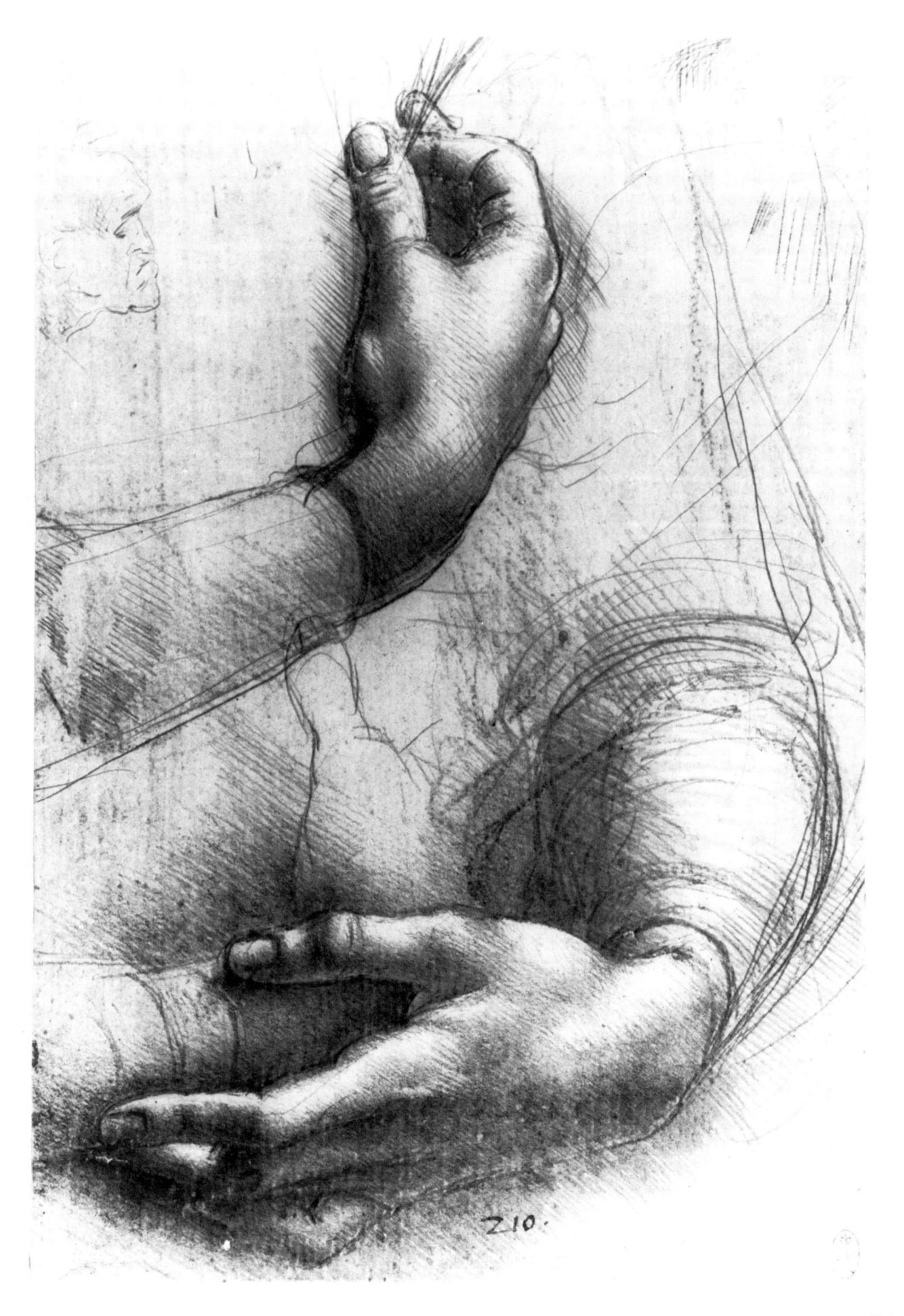

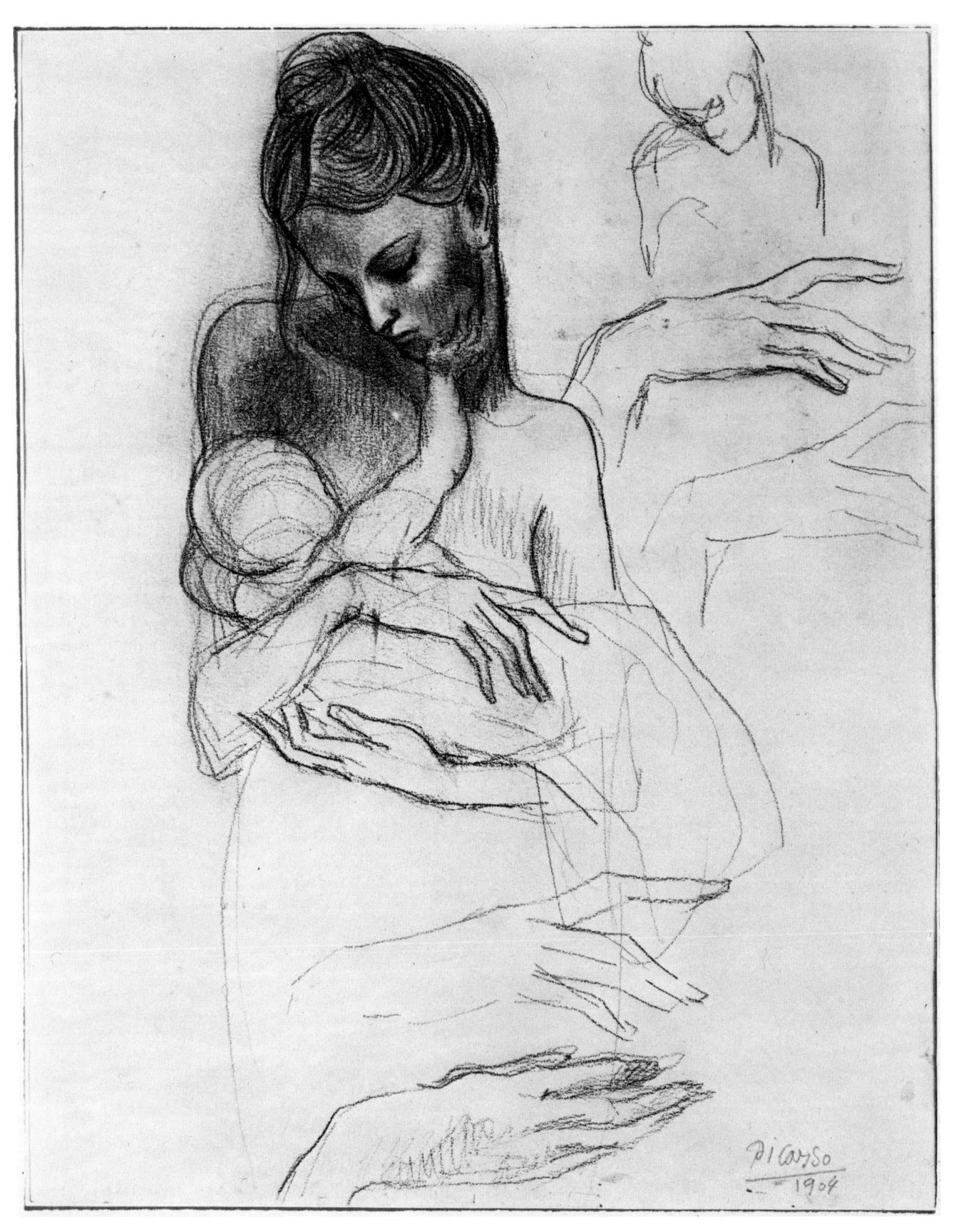

6-53. Pablo Picasso, *A mother holding a child and four studies of her right hand*, 1904. Black crayon. 13 1/2" × 10 1/2". Cambridge, Fogg Museum, Harvard University. Bequest of Meta and Paul J. Sachs.

Although the skeletal foot presents a fairly complex arrangement of bones, you should bear in mind that its general form is quite simple, resembling a wedge with a low arch on its underside (Figure 6-54). Before rendering the bones in detail draw the general form, as in the study of the hand. A free interpretation from an anatomical illustration is sufficient. Check the position of the top of the arch, however, for appearances are especially deceptive in this region.³³ The rear portion of the arch terminates in a single large bone, the calcaneus, the round end of which contrasts with the wedgelike tapering of the bones at the other end of the foot. The forward portion of the arch fans out with the metatarsal bones, the distal ends of which distribute the body weight over the front pad of the foot. The top of the arch features the talus, a large bone that provides a spool-shaped articular surface for the joint with the leg bone (tibia).

The ankle joint, which transmits the body's weight to the foot, merits close attention. The bump of the inner ankle (medial malleolus) is caused by the distal end of the tibia, which articulates with the spoolshaped articular surface of the talus. The fibula rests on the outer side of the talus, creating the form of the outer ankle (lateral malleolus). The tibia and fibula are structured to hold the spool of the talus on the sides in a pincer grip, which prevents the joint from slipping to the sides and yet permits the characteristic hinge movement of the foot (Figure 6-48). Situated beneath the talus is the calcaneus in the rear and the other tarsal bones in the front. The joint of the tarsals with the metatarsals, about midway on the top of the foot, may be visible as a slight bump. The phalanges of the toes continue the radiating pattern that originates in the metatarsals, but those in the big toe bend slightly in the direction of the other toes, giving the foot its characteristic sole shape.

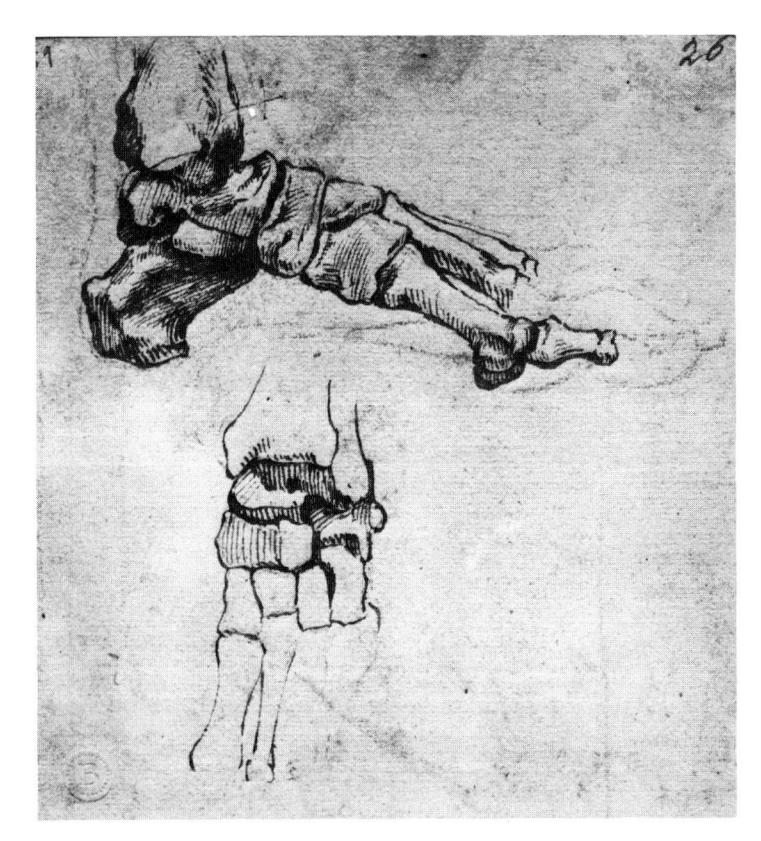

6-54. Michelangelo Buonarroti, Studies of the skeletal foot. Crayon, pen-and-ink. Florence, Casa Buonarroti. (Photo courtesy of Alinari.) A faint crayon drawing of the foot encloses the larger study in ink.

STUDY 36. COMPARATIVE STUDIES

Materials: 11"-x-14" sketchbook

drawing pen (0.5 mm point rec-

ommended)

india ink **Reference:** mounted

mounted skeleton of an animal and anatomical illustrations of

the human body

Suggested time: 30 minutes for each study

Studies of animal skeletons are not only of assistance in drawing animals but also help reinforce your awareness of the unique characteristics of the human skeleton and, ultimately, of the human form. Though they are not found in art schools or art museums, displays of animal skeletons are available in most natural-history museums and frequently in zoology departments of colleges and universities. Once you have located such a display as a model, take your sketchbook there and draw from it. One method is to leave the page opposite the drawing blank and, with the aid of an anatomy book (or a mounted skeleton), to render the human skeleton in a comparable position and scale later. Skeletons of other primates (apes, monkeys, chimpanzees) offer intriguing subjects owing to their subtle differences from the human frame (Figures 6-55 and 6-56).

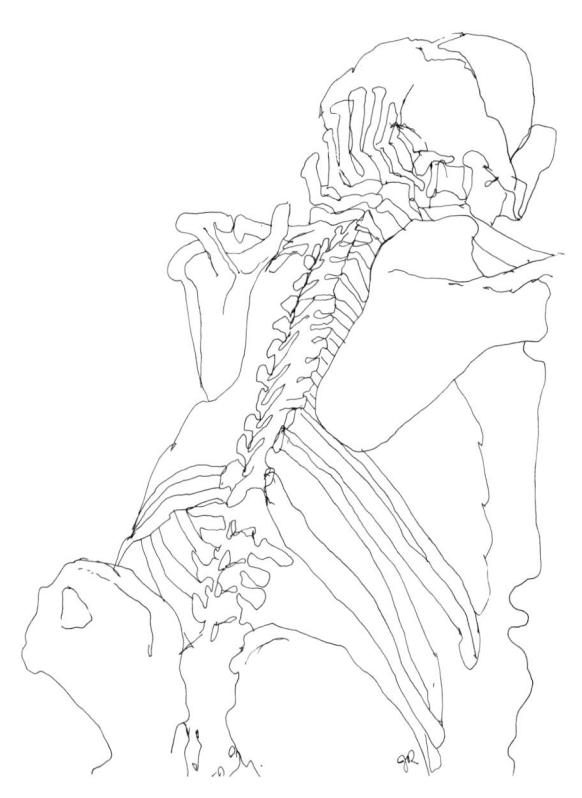

6-55. Student drawing, comparative study of the ape skeleton. Pen-and-ink on sketchbook paper. $14'' \times 11''$. The special affinity between ape and human skeletons makes them an interesting subject for comparison. The lowered skull and projecting spinous processes of the ape are reminders of its four-footed posture.

STUDY 37. DRAWING THE SKELETON FROM MEMORY

Materials: 36"-x-24" newsprint drawing pad

Easel or straight-back chair Masonite or plywood panel and

clamps

Sanguine and black or brown

drawing crayons

11"-x-14" sketchbook (optional) drawing pen (0.5 mm point) and

india ink (optional)

Reference: model and appropriate anatom-

ical illustration

Suggested time: 40 minutes

After completing several of the preceding studies you are ready to visualize the skeleton in the human figure without the assistance of a mounted skeleton or an anatomy book. Develop a drawing of the figure from the model—a 20-minute session should be sufficient. Observe the model carefully for skeletal landmarks, such as the sternum, clavicles, anterior iliac spines of the pelvis, groove of the spinal column. You may be surprised at the number of skeletal features that you can identify through clues of surface anatomy. You may even be able to visualize the entire rib cage in the model. If you have learned the

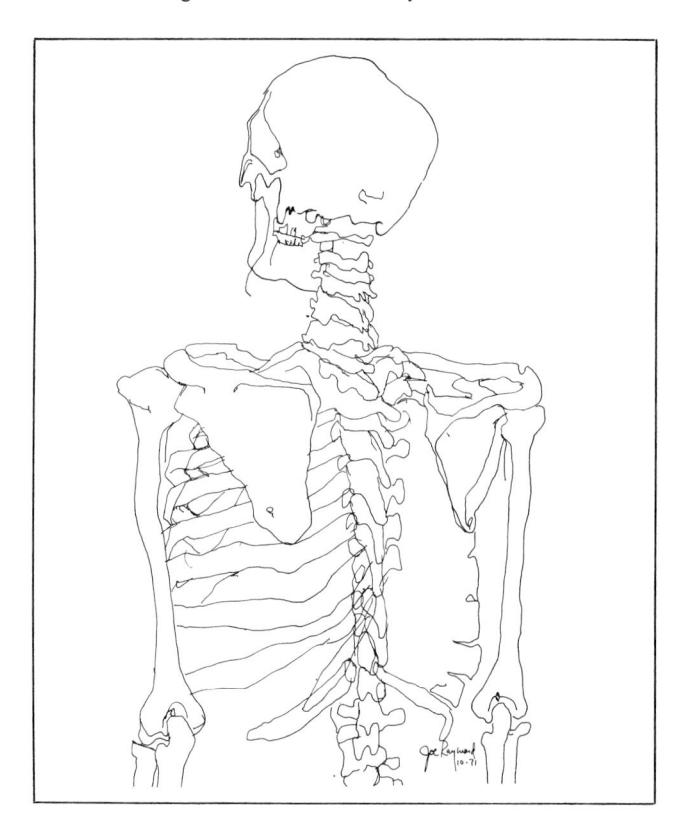

6-56. Student drawing, comparative study of the human skeleton. Pen-and-ink on sketchbook paper. 14" × 11". After completing the study of the ape skeleton (Figure 6-55) the student drew this similar view of the human frame, thereby inviting close comparison.

skeleton well, you may experience, as have other draftsmen, an almost shocking recognition of the entire skeleton.

Referring back to the model as you work, draw the skeletal form within the drawing of the figure. You may wish to use a different-colored crayon in order to distinguish the skeletal drawing from that of the figure. As in the sketchbook studies, it is helpful to generalize the most complex forms at first. This is particularly true of the rib cage. Smaller forms, such as the ribs, can be drawn later within the general forms (Figure 6-57). No more than 20 minutes should be allotted to drawing the skeleton, for more time would invite the temptation to embellish with unnecessary and possibly inaccurate detail.

When the study is complete, compare your analysis with the skeleton (or anatomical illustration). Correct the drawing on the spot in order to resolve problems while they are still fresh in your mind and while the model is in front of you. You may find that your drawing of the skeleton does not fit within the life drawing of the figure. If this occurs, check your drawing carefully against the model, for the error may reside in the drawing of the figure rather than in that of the skeleton if the latter is rendered accurately. Repeat this exercise at least once a week until you develop a clear mental image of the skeleton applicable to the figure in many positions.

Drawing the skeleton from memory reveals both the strengths and the weaknesses of your understanding of skeletal form, and it may do the same for your drawing of the figure, suggesting areas that need further study. This is perhaps the most important of the anatomical studies, for your newly acquired ability to see skeletal structure in the body will almost certainly be reflected in a greater sense of interior structure in your drawings of the figure.

SUMMARY

The chief purpose of skeletal studies is to give the artist an insight into the solid framework of the body as an artistic structure for visualizing and drawing the figure. The skeletal structure alone, however, represents only one aspect of the human form, for it operates as part of a system that utilizes the energy of muscles for its motivation. This system, more than the skeleton or the muscles considered separately, determines the appearance of the body and is interesting in its own right, for "... the notion of the body as a complex of thrusts and tensions, whose reconciliation is one of the chief aims of the figure arts, remains eternally true.³⁴

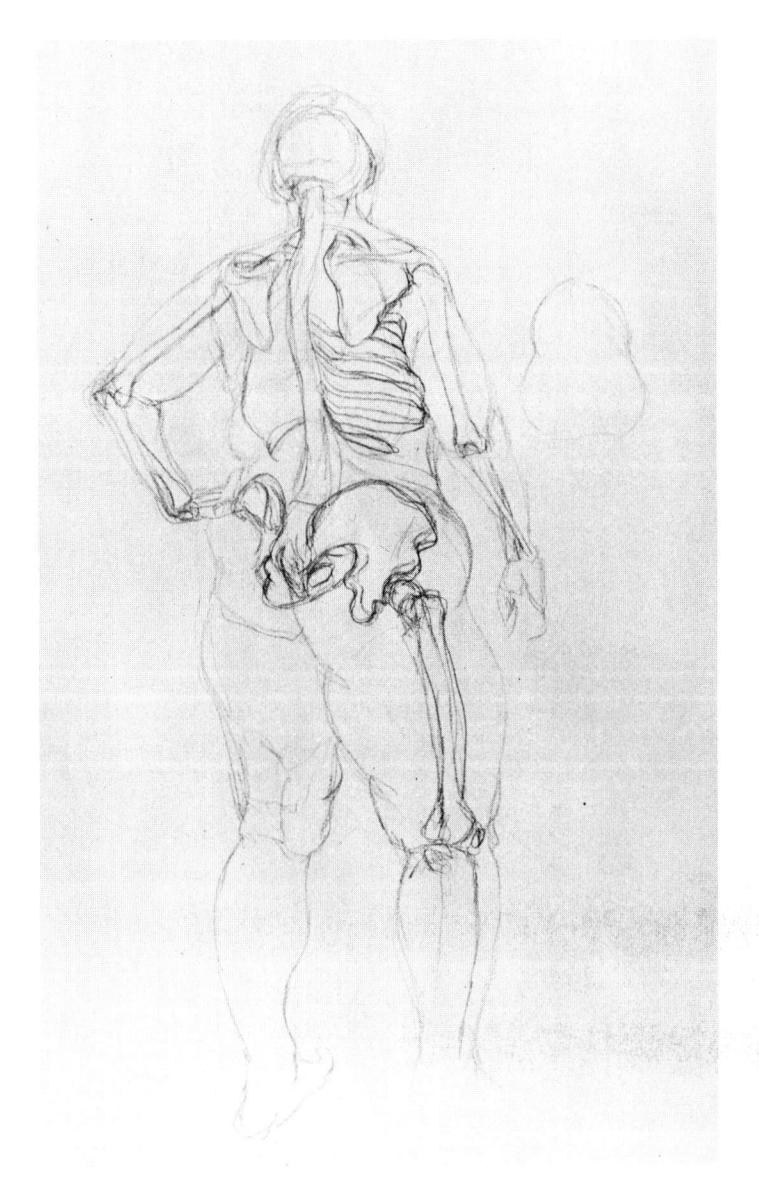

6-57. Student drawing, life study with skeletal structure drawn from memory. Crayon on newsprint paper. $24'' \times 18''$. Smaller forms, such as the ribs, were drawn after the larger form of the rib cage was constructed.

7. THE MUSCLES:

The Dynamics of the Human Form

To draw the human figure it is necessary to know as much as possible about it, about its structure and its movements, its bones and muscles, how they are made, and how they act. . . . —Thomas Eakins

It would be possible to imitate body movement by attaching strings to a skeleton and operating it as if it were a puppet, with each string producing a leverlike movement of the bone to which it is fastened. In life the bones of the skeleton also move like a series of levers by means of a pulling action. The pulling action in the body, however, is caused internally by means of muscle tissues that consist of elongated fibrous cells that can suddenly change length.1 When the muscle cells are at their longest, they are said to be relaxed; when tensed, some muscle fibers contract to as little as one-half their original length.2 The pull resulting from this contraction is transmitted by means of tendons, which consist of tough, elastic material that forms at the ends of muscle fibers and is attached to bone or to other tissues, enabling many muscle fibers to combine and perform a common function. Such a unit of muscle fibers and tendons constitutes the muscle proper and gives the "typical" muscle a spindle (fusiform) shape (Figure 7-1). The word itself suggests a more vivid image, for it is derived from the Latin musculus, which literally means "little mouse" 3 and refers not only to the form of the muscle, with its thick body and taillike tendons, but also to the crawling motion that it can produce as it contracts.

The locations of the muscle's attachments with the skeleton determine the muscle's action. If the attachments are with two bones that have a common movable joint, the muscle can produce a lever-type action comparable to the movement of a screen door pulled shut by a common door spring. The brachialis, an arm muscle, offers an example of this type of action (Figure 7-2). When the brachialis contracts, the arm bends forward (flexes). With such flexion the forearm usually moves more than the upper arm, for the latter is anchored at the shoulder by the weight of the body. For this reason

anatomists distinguish between the attachments of muscles, calling those that tend to move less *origins* and those that are more mobile *insertions*. As a rule the classification of two attachments of a muscle can be determined by considering which is nearer the greater mass of the body.

Not all muscles produce a direct action of the kind generated by the brachialis, for many are attached to bones that are separated by intervening bones. The biceps muscle of the arm (Figure 7-3), for example, originates in the bones of the shoulder girdle and inserts with bones of the forearm, skipping the intervening humerus bone entirely. This arrangement results in an indirect action, whereby contraction can cause not only flexion of the forearm, as does the brachialis, but also effect the raising of the entire arm. Antagonistic muscles, on the opposite side of the arm, operate by the same principle, though they serve to bend back (extend) and lower the forearm. Such direct and indirect muscle actions are common throughout the skeletomuscular system and account not only for flexion and extension of the limbs but for rotation as well. Rotation, however, differs from the other skeletal movements in that it requires a special ball-and-socket type of joint, such as that seen in the shoulder, while flexion is possible within the limitations of a hinge-type joint, as seen in the knee. Another requirement for rotation is that the tendon of the muscle involved must attach to the far side of at least one of the bones to which it is joined. When the muscle contracts, a twisting action results that is similar to the torque produced by the string that spins a toy top. Perhaps the clearest examples of such rotation occur in the shoulder and elbow joints.

The relaxation of muscles also plays a vital role in producing motion.⁴ As the muscles on one side of a limb contract, those on the other side must relax if the limb is to move. Equal tension on both sides results in no motion at all, as the pull of the muscles on one side opposes and neutralizes that of the other. Such *isometric* tension is most visible in the strained but static poses of musclemen, yet the same
kind of tension, though perhaps less marked, enables the artist's model to hold a pose. The fact that the model tires quickly from holding a standing pose attests to the muscular activity involved. While holding a fixed standing position the skeleton and muscles work in a way analogous to structures such as radio-transmission towers (Figure 7-4). The tower girders, like the bones of the skeleton, are incapable of standing erect by themselves. With the help of the tension created by the surrounding cables, however, the girders are held upright, reaching heights far beyond their independent capabilities. In a similar way the tension of the muscles, aided by ligaments of the joints, maintain firm posture.⁵

The tensions and thrusts of the body that have excited the imagination of many artists thus have a physical basis in the skeletomuscular system. For this reason the integral system merits study as a way of deepening one's understanding and appreciation of these forces and their influence on the form and appearance of the body. Though the muscles are partially visible on the body surface, their interaction with the skeleton is not readily apparent in most cases. A systematic method of anatomical study similar to that employed in chapter 6 for the skeleton is recommended.

7-1. Muscle components. The fusiform muscle consists of a fleshy body (A), which contracts and relaxes, and tendons (B), which lead to attachments with bones. This muscle has two upper tendons and one lower.

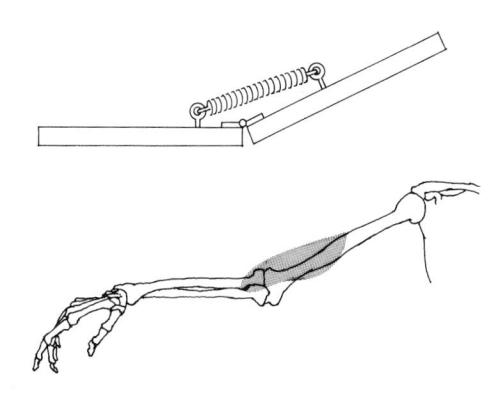

7-2. Direct action of muscles. The action of a spring pulling a door shut is similar to the direct action of muscles pulling against bones that are connected with a hinge-type joint, such as the elbow joint of the humerus and the ulna. The brachialis muscle (in gray) causes the arm to flex.

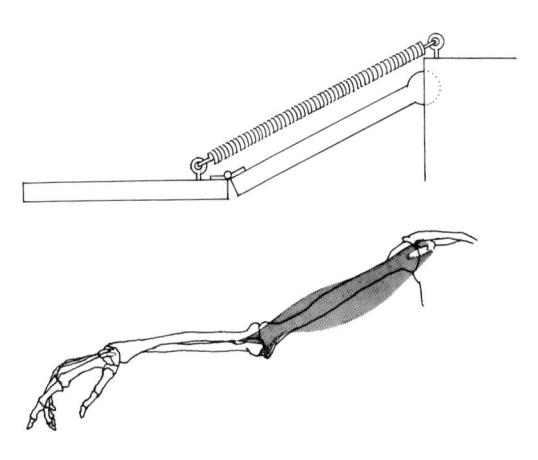

7-3. Indirect action of muscles. Although the biceps muscle lies over the ulna, it does not attach to it. The biceps attaches instead to the adjoining bones, an arrangement that enables it to flex and raise the arm—indirect actions. When the biceps flexes the arm, the humerus is held steady by *synergist* muscles. In addition *fixation* muscles act to hold the scapula steady as a base for the humerus.

7-4. Radio tower. A typical broadcast tower depends upon the tension between cables and rigid beams for support. This tension is comparable to that between antagonistic muscles, which plays an important role in maintaining body posture and position.

METHODS, MATERIALS, AND REFERENCES

A practical way of studying the skeletomuscular system is to draw the figure from life, using pen-and-ink and a sketchbook, and then to draw a skeletal analysis of the life drawing on an overlay in pencil, as described in the previous chapter. The final step, which is unique to this exercise, is to draw an interpretation of the muscles on a second tracing-paper overlay (Figure 7-5). A sanguine pencil is an excellent medium for studying the muscles, for it produces a rusty-red color suggestive of muscle tissues and is not easily confused with the tones of the drawings underneath.

The illustrations in this chapter are adequate for the suggested studies. In addition to anatomical illustrations an écorché (Figure 7-6),6 a plaster cast of the muscles, can be helpful. This cast provides a three-dimensional representation of muscle structure and is particularly useful if it can be compared with the live model, for it represents the figure without the superficial tissues that tend to disguise the muscle forms in life.

Much can be learned about the muscles by direct observation of the human body itself, however, for specific gestures can bring specific muscles into play. When the arm, for example, is raised from the side of the body to a horizontal position, the shoulder muscle (deltoid) tenses, thus revealing its function. By raising your arm you can feel how the deltoid changes from a soft mass to a hard, tense form, as suggested in a drawing by Michelangelo (Figure 7-7). The muscles underneath the arm, which can oppose such an action, remain relaxed, a fact that can be verified by feeling the lower side of the raised arm. Quite the contrary occurs when the arm is pulled downward and meets the resistance, say, of a tabletop: the deltoid muscle relaxes and the underarm muscles become tense.

7-7. Michelangelo Buonarroti, *Anatomical studies*, 1504–06 (?). Ink and black chalk. 28.4 × 21 cm. Florence, Galleria degli Uffizi. In these studies of the shoulder Michelangelo accurately conveys the muscular tension that is created when the arm is raised.

7-5. Sketchbook with overlay sheets. A life drawing (1) in a sketchbook can serve as the subject of anatomical studies executed on tracing paper (2, 3) taped over the original drawing.

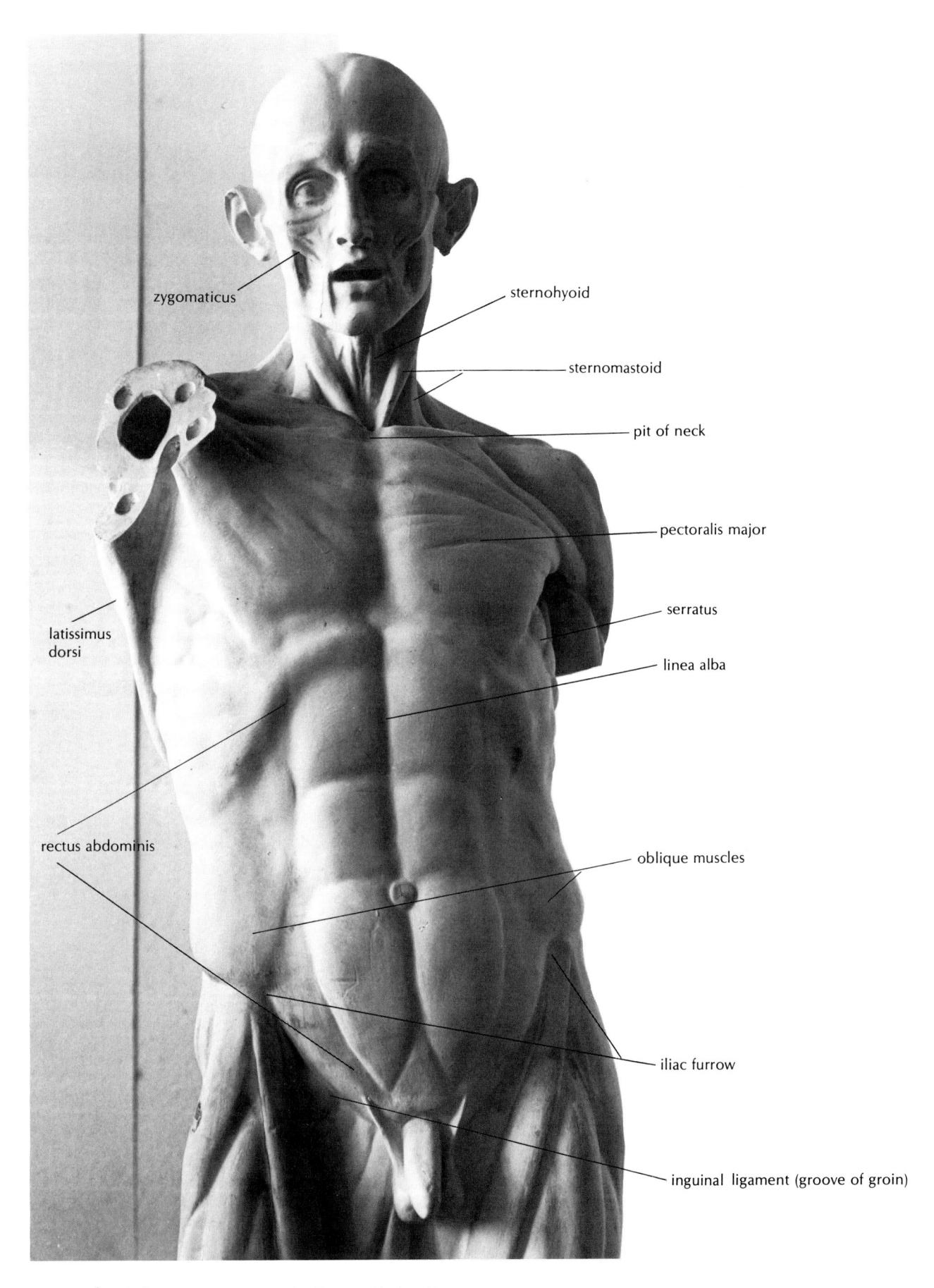

7-6. The écorche. A cast representing the figure with the skin removed, the écorche displays the superficial muscle structure more clearly than is possible in life.

When a muscle is tensed, it generally reveals its form on the surface of the body more clearly than it does in a relaxed state (Figure 7-8). A gesture or action of the body is expressed externally by clear muscle forms in the region(s) of the body involved in the action. An artist familiar with muscle anatomy can afford to be selective, emphasizing only those muscles that express the action, for, as Leonardo pointed out, there is no point in drawing "... all the muscles of the figure unless they are exerting great force. Do not try to make all the muscles of your figures apparent because even if they are in the right places, they do not show very clearly unless the parts in which they are located are exerting great force or are greatly strained; the muscles of those parts which are unexercised should not show. If you do otherwise, you will make something that looks more like a bag of nuts than a human figure."7

If a specific set of muscles is the subject of a study, however, you may prefer to obtain a clearer view by having the model tense them, whether or not they are involved in the gesture of the pose. This can be particularly helpful in studying parts of the body with relatively complex muscle forms, such as the limbs. The arm muscles in a life study by Degas

(Figure 7-9) are so well defined that it is probable that the model tensed them in order to better display their structure. Generally, however, it is advisable to follow Leonardo's suggestion and to draw only those muscle forms that are discernible as an active element of a gesture. Muscle forms that are not apparent in the model can later be drawn on the overlay study by referring to anatomical illustrations.

Whether or not a muscle is tensed, its tendons remain the same length. The proportion of tendon to muscle body, however, varies with the individual and accounts for differences of build that are not due to athletic training or the lack of it. In some people ". . . the muscular fibers are long and the tendinous portions are relatively short . . . in others the fleshy belly of the muscle is short and the tendons long."8 Observed differences of muscle build between the sexes are surprisingly slight, however: the chief differences are due to the protective fatty tissues that usually characterize the female body (Figures 7-10 and 7-11): "This augmented investment amply fills the hollows and crevices of deeper structures and accounts for the smoothness and the flowing line of surface form."9

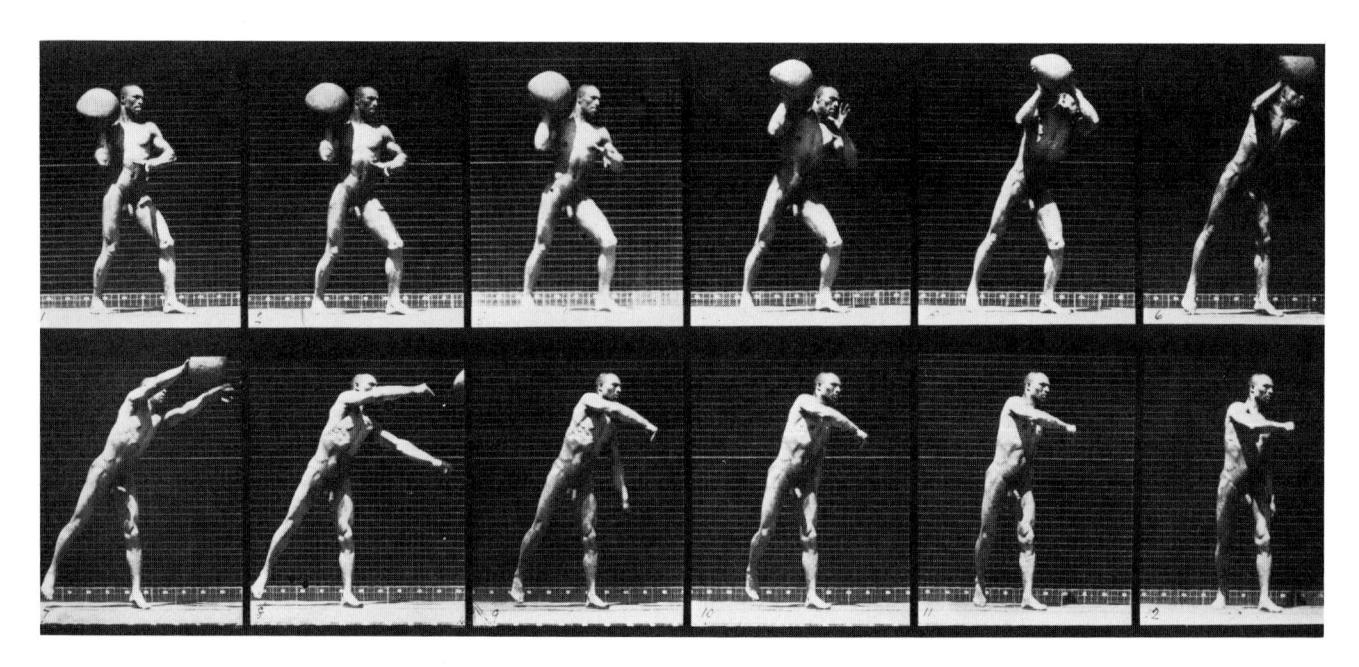

7-8. Eadweard Muybridge, Man heaving a 75-pound boulder, 1884-85. Serial photograph. Washington, D.C., Smithsonian Institution. The muscle forms of the leg and abdomen become clear as they are tensed for throwing; afterwards they become less conspicuous, as seen in the lower-right frame.

7-9. Edgar Degas, Academic study of a nude man, 1856–58. Charcoal on pale gray paper. 24" × 18 3/8". Boston, Museum of Fine Arts. Gift of W. G. Russell Allen. This study was executed roughly ten years before Degas began working in the mature impressionist style for which he is best known. The skill and knowledge necessary to produce the later drawings were gained in part through studies such as this one, in which the artist pays special attention to the model's right arm. Compare Figure 7-37.

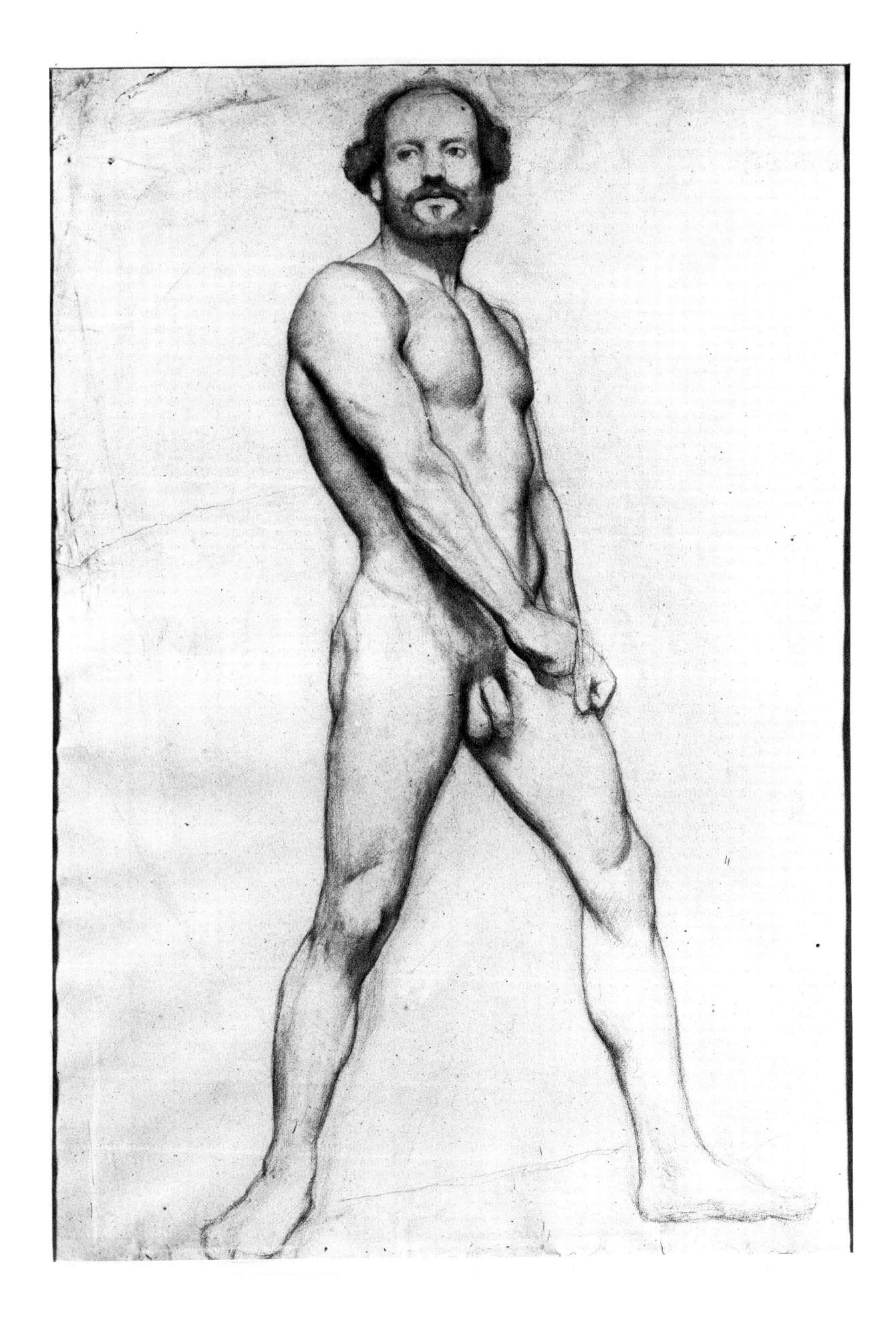

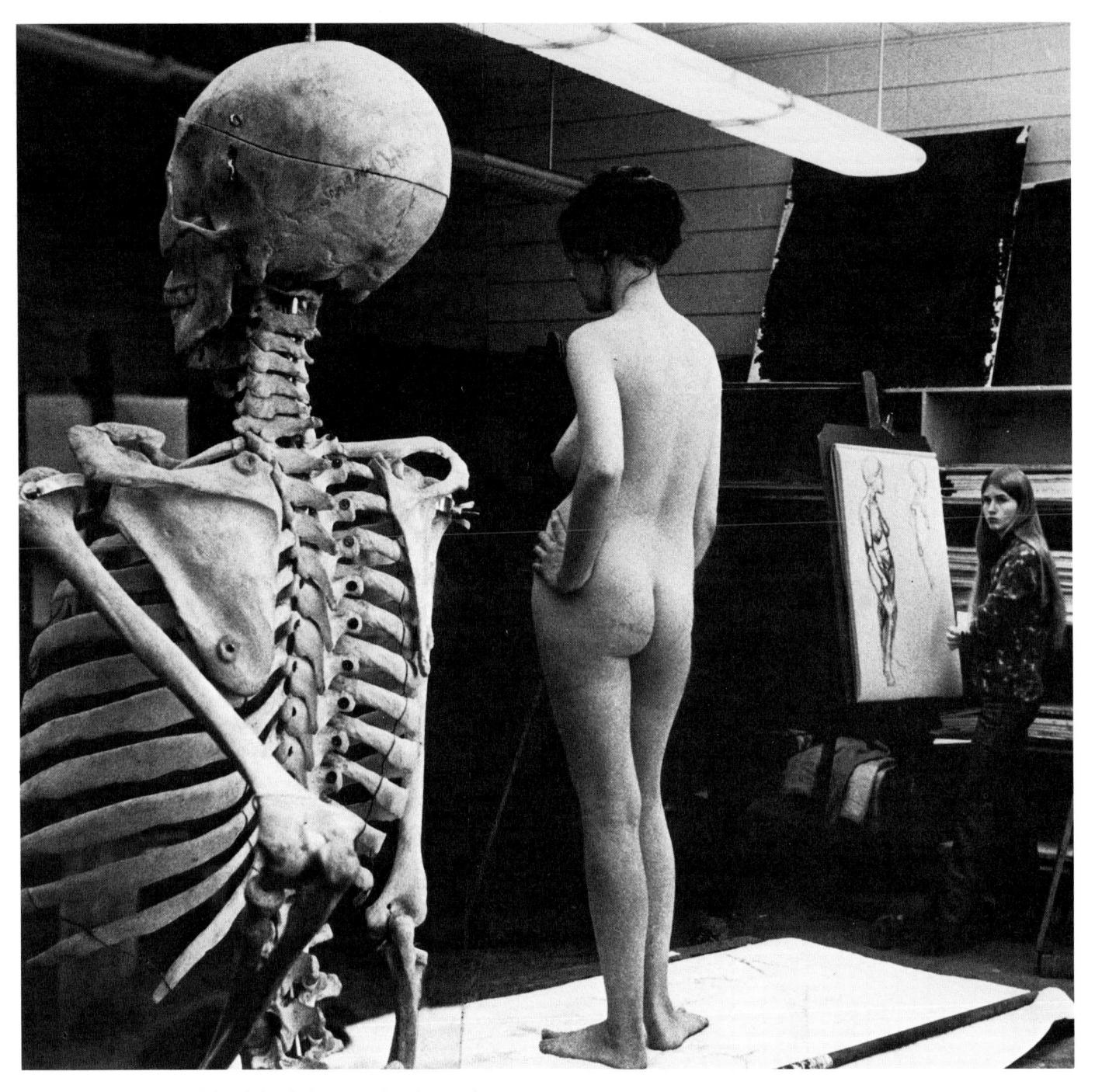

7-10. The female model and the skeleton. Surface forms of the female figure, though generally displaying subtler transitions than those of the male, nevertheless contain common skeletal and muscular features. The skeleton and the model are being compared by the student.

7-11. Thomas Eakins, Academic Study, 1866–69. Charcoal on French paper. Cambridge, Fogg Museum, Harvard University. (Courtesy of Seiden and de Cuevas, Inc.) This study, drawn while Eakins was a student in Paris, was cut apart in order to pass through American customs, which in the 19th century censored drawings of the nude. The piece representing the figure below the knee is apparently lost.

Despite differences of build the bilateral symmetry earlier noted in the skeleton is also reflected in muscle structure. A muscle on the right side of the chest is matched by a similar one on the left. The line of symmetry dividing the trunk is generally marked by a slight furrow running vertically from the pit of the neck to the pubis. In the cadaver it is visible as a band of tendinous tissues, the whitish color of which gives it the name *linea alba* (Figures 7-6 and 7-12). A similar line of symmetry is apparent in the groove of the spine on the back of the trunk (Figure 7-13). The muscles appear as a symmetrical pattern only if the body is viewed

directly from the front or back (Figures 7-13 and 7-14). The *structural* symmetry of the muscles, however, does not change when the view of the body changes, for the muscle origins and insertions retain their bilateral structure in relation to the skeleton. The muscle attachments are therefore important in the artist's study of anatomy and are emphasized in this chapter as a key to understanding and interpreting the appearance of the muscles as a part of the unchanging three-dimensional, symmetrical structure of the body. The symmetry of muscle structure is most apparent in the trunk, the subject of the following study.

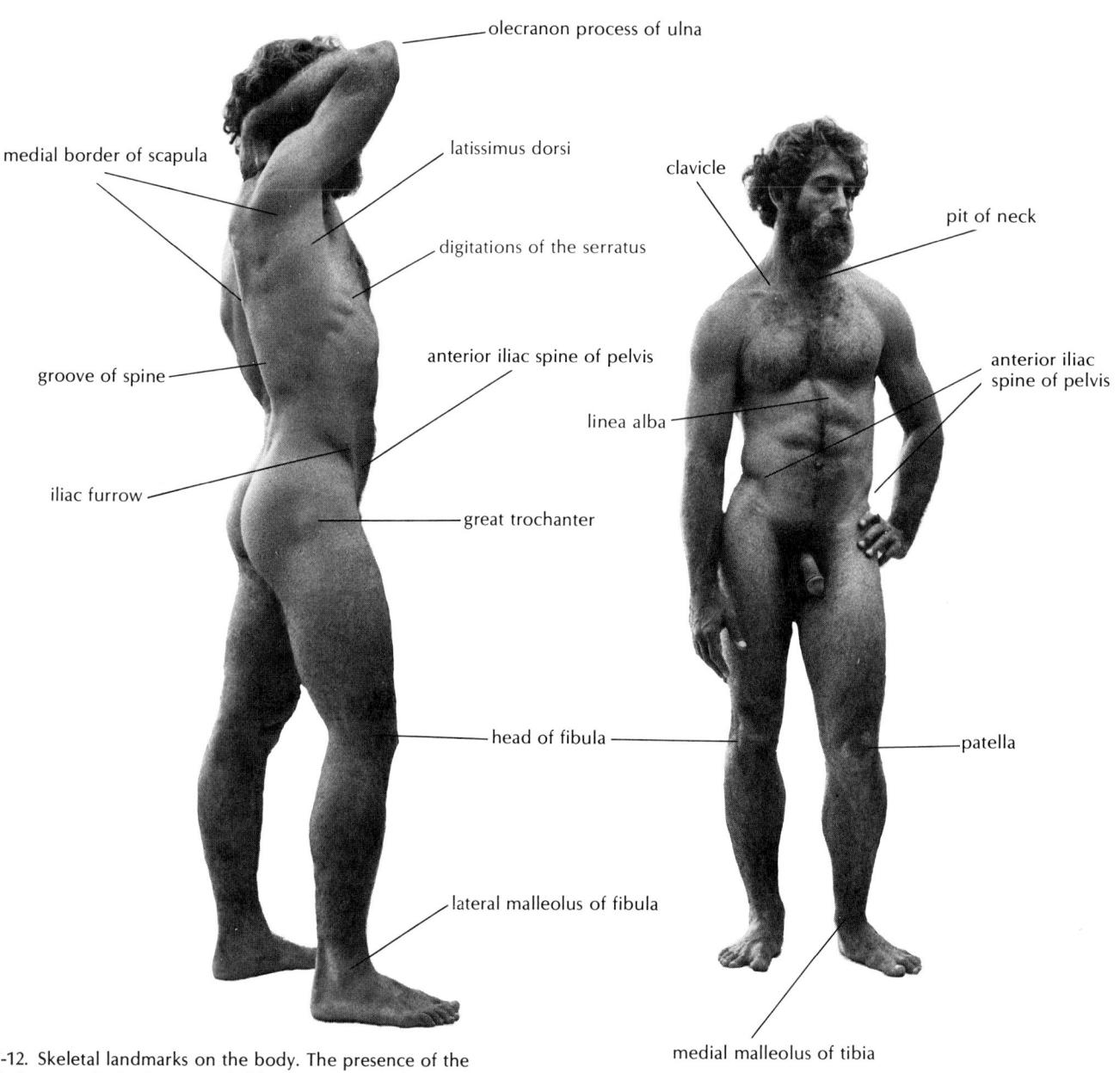

7-12. Skeletal landmarks on the body. The presence of the skeleton in the body is revealed by prominences (bumps) and other surface discontinuities that lie over bones just beneath the skin. Such skeletal landmarks of the body are also important in visualizing muscle origins and insertions. In addition to the landmarks the upraised arm displays the latissimus dorsi and the serratus.

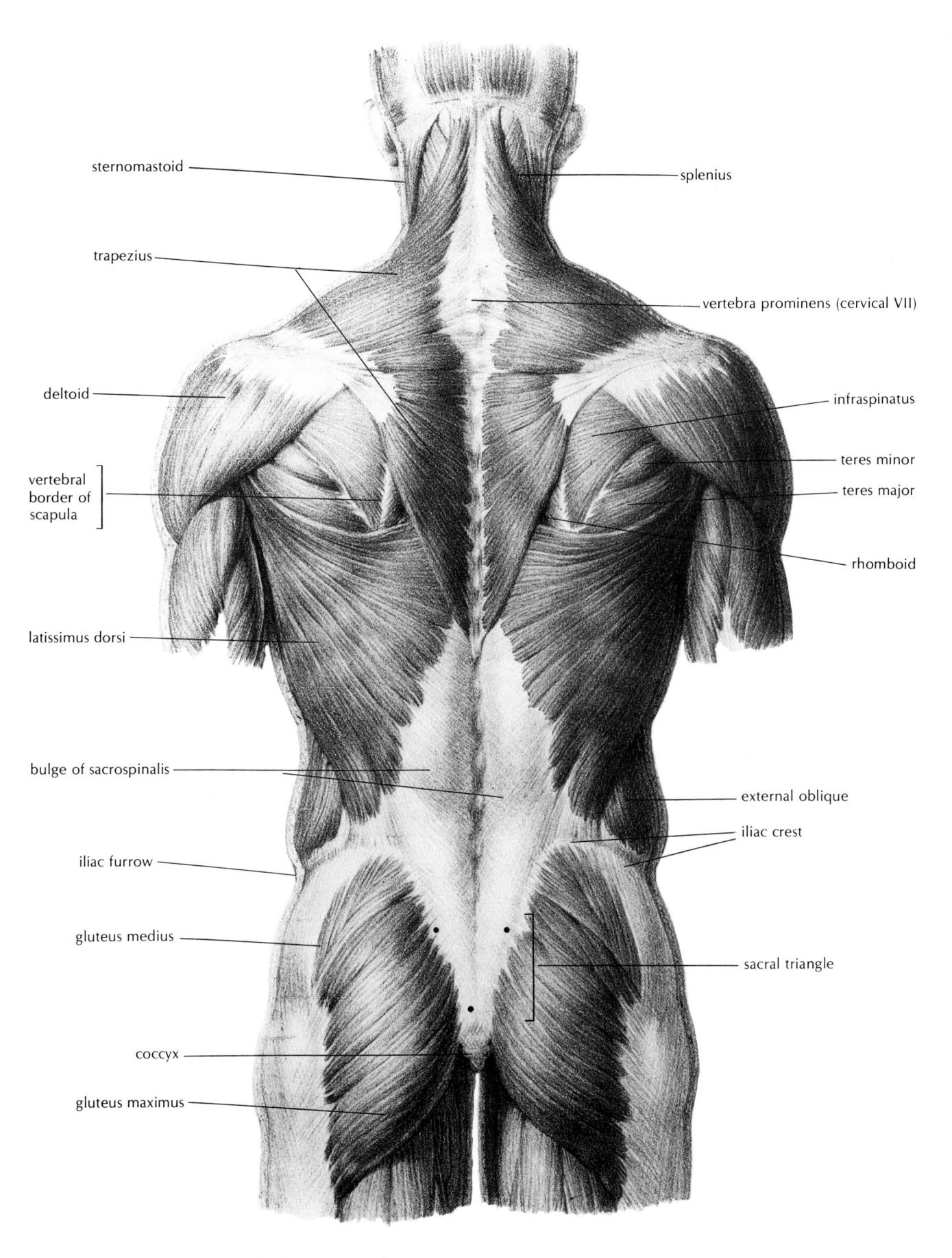

7-13. Muscles and tendons of the back. (Dr. J. Fau, *The Anatomy of the External Forms of Man* [London: Hippolyte Bailliere, 1849], plate II. Courtesy of Countway Library, Harvard University.)

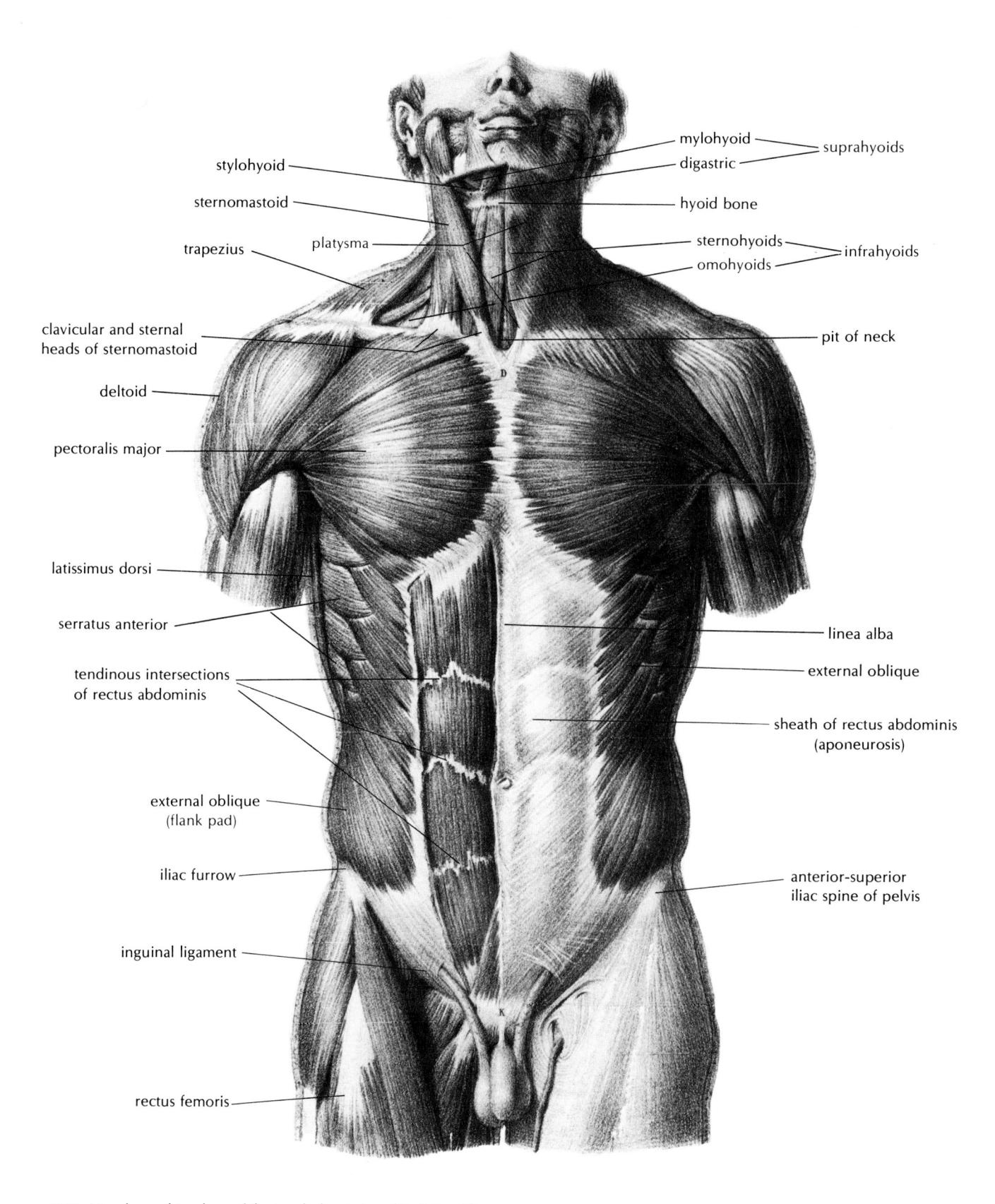

7-14. Muscles and tendons of the trunk, front view. (Dr. J. Fau, *The Anatomy of the External Forms of Man* [London: Hippolyte Bailliere, 1849], plate 10. Courtesy of Countway Library, Harvard University.) Tendinous tissues are represented in white as they appear in life. The sheath of tendinous tissue (aponeurosis) that clothes the abdominal muscles is removed on the figure's right side.

7-15. Muscles and tendons of the trunk, side view. (Dr. J. Fau, *The Anatomy of the External Forms of Man* [London: Hippolyte Bailliere, 1849], plate 12. Courtesy of Countway Library, Harvard University.)

STUDY 38. THE MUSCLES OF THE TRUNK: FRONT VIEW

Materials: 11"-×-14" sketchbook

drawing pen (0.5 mm point)

india ink

HB drawing pencil sanguine pencil

11"-x-14" tracing paper

Reference: model and Figures 7-6, 7-12,

7-13, 7-14, and 7-15 or écorché

of the muscles

Suggested time: 15–20 minutes for each life

study, 30 minutes for the overlay drawings of the skeleton, and 30 minutes for the overlay drawings of the muscles A figure study drawn previously can serve as the basis for this study, or you may prefer to start afresh by making three or more studies that show the front side of the trunk. It is helpful to indicate the bony landmarks of the body accurately in preparing the life study (Figure 7-12). They are useful not only in structuring the skeletal study on the first overlay drawing but also in visualizing sites of muscle attachments (Figures 7-16 and 7-17). The pit of the neck, for example, suggests the origins of chest and neck muscles as well as the location of the sternum. The linea alba, which lies over the sternum, can also be traced down the trunk as a means of locating muscles in the abdominal region (Figure 7-18).

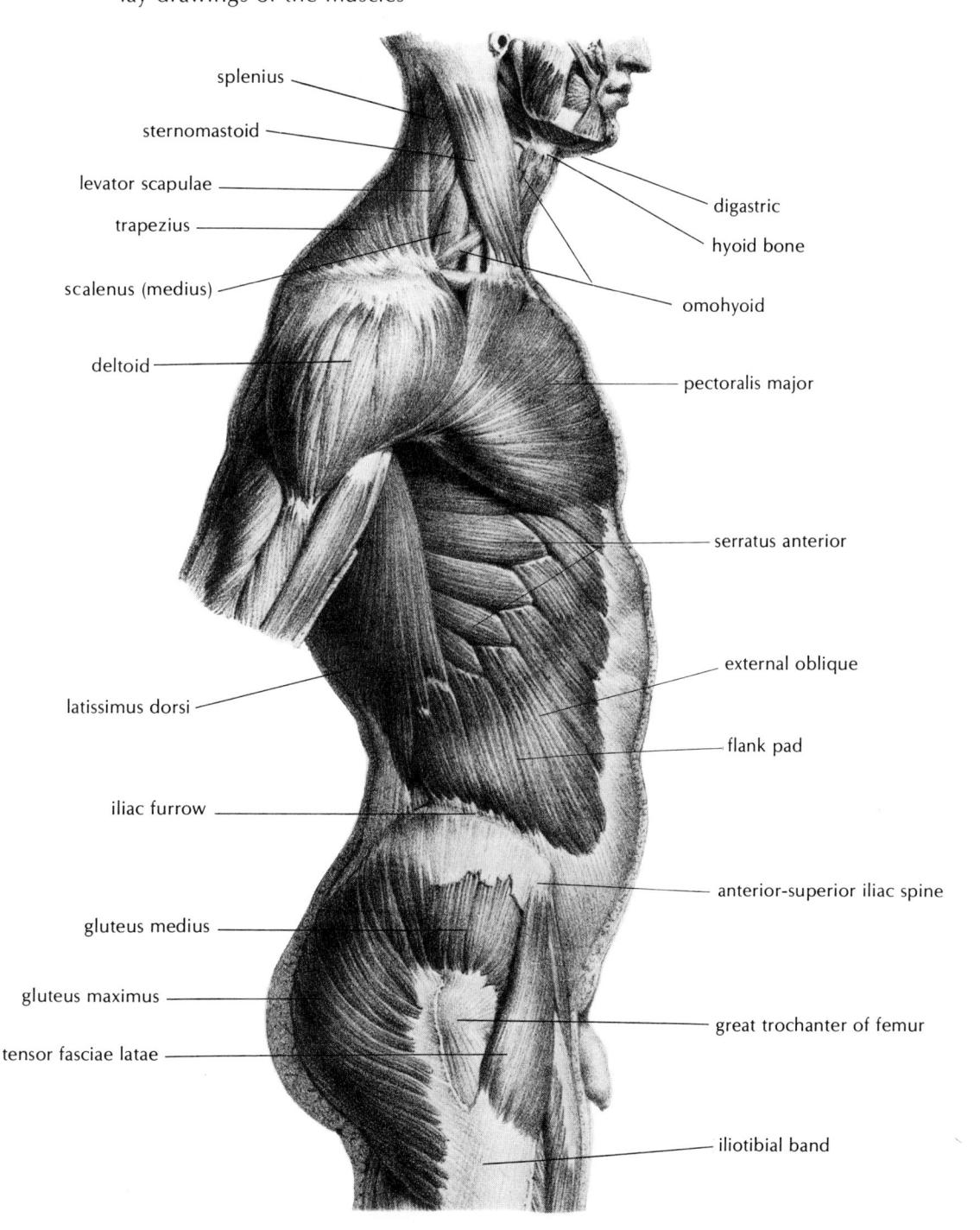

7-16. Student drawing, life sketch and skeletal study. Ink and graphite pencil on sketchbook bond paper. $11'' \times 8\,1/2''$.

7-17. Student drawing, arm and trunk muscles. An overlay taped on the study shown in Figure 7-16 provides the surface for an additional study, drawn in sanguine pencil.

TRUNK MUSCLES: FRONT SIDE

In the upper part of the trunk the linea alba separates the two sets of pectoral muscles, the pectoralis major. The largest and most visible of these originates from the sternum and the clavicle (Figure 7-14). The fibers of the pectoralis major are drawn together near the shoulder, where they disappear from view under the deltoid to insert with a ridge on the front side of the arm bone (humerus) near the upper end. When this muscle contracts, it pulls the arm forward toward the trunk. The pectoralis

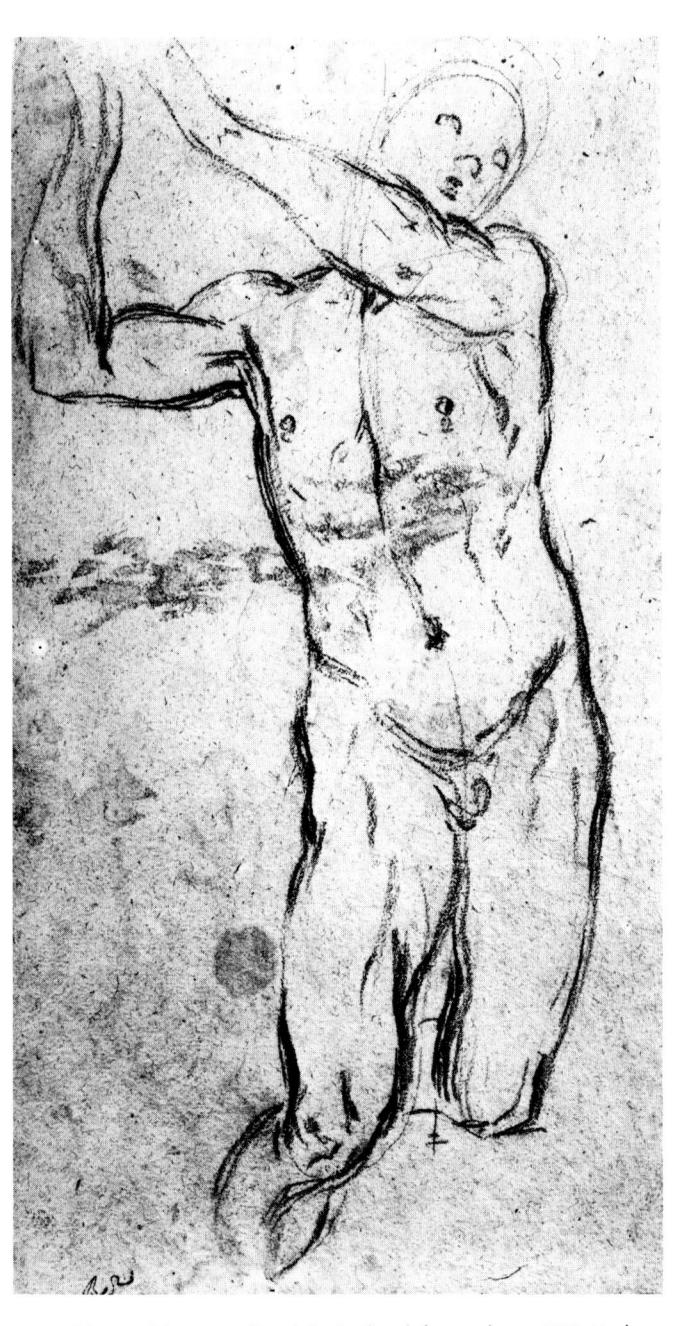

7-18. Giovanni Lorenzo Bernini, Study of the nude, c. 1655. Red crayon on gray paper. 386 × 212 mm. Leipzig, Museum der Bildenden Künste. The light, preliminary lines in this drawing, a study for a figure of Daniel, include a rendering of the linea alba

major also assists in rotating the arm (inward) and in pulling the arm down after it has been raised.

The lower border of the pectoralis major terminates in the abdominal sheath, a blanket of tendinous fascia¹¹ that encases a group of muscles directly below it called the *rectus abdominis*. Inserted with the cartilage of the fifth through the eighth rib (counting from the top), the sheath extends all the way down to the pubis. Inside the sheath are the padlike divisions of the rectus-abdominis muscles, which join each other by means of the tendinous intersections. The reason for the small divisions instead of long stretches of muscles is that smaller fibers are stronger.¹² Since the rectus abdominis must provide great strength, it evolved in a segmented form that permits the muscles to be short but also to cover a relatively great length.

A common function of the rectus abdominis is easily demonstrated by lying on your back and raising your legs. In this position you can feel that the rectus-abdominis muscles immediately contract, even though they play no direct part in raising the legs. The muscles directly responsible for raising the legs—the *prime movers*, as they are termed by anatomists—are the powerful muscles in front of the thigh, which also contract in this action. The rectus abdominis holds the pelvis steady, while the leg muscles, which originate with the pelvis, lift the leg. By stabilizing the origin of the prime mover the rectus abdominis functions as a *fixation* muscle.

The lower reaches of the abdominal sheath extend from the iliac crest to the pubis, forming the inguinal ligament that is visible in life as the groove of the groin (Figure 7-6). The lateral edges of the abdominal sheath serve as an insertion for the external oblique muscles, or the flank pads (Figures 7-14 and 7-15), which also insert with the iliac crest of the pelvis. In the latter insertion the externaloblique muscle slightly overlaps the iliac crest. In the male figure this feature, known as the iliac furrow, is apparent as a contour that marks a division between the lower abdomen and the thigh (Figure 7-12).14 The external-oblique muscles reach upward diagonally from the abdominal sheath to their origins with the fifth through the twelfth rib. 15 In order to attach to individual ribs, the external-oblique muscles separate into fingerlike bunches of muscle fibers, called digitations.

7-19. Jacopo da Pontormo (1494–1556), Study for St. John, Dublin Pietà, c. 1518. Natural red chalk. 392 × 262 mm. Florence, Galleria degli Uffizi. The muscle structure of the shoulder and the trunk is especially clear in this study, suggesting the interweaving digitations of the serratus and the external-oblique muscles on the side of the chest as well as the iliac furrow at the juncture of the lower abdomen and the upper thigh. Compare Figure 7-15.

The top four digitations slip between similar digitations of a neighboring muscle, the *serratus*, forming a characteristic row of bumps along the sides of the chest (Figures 7-12 and 7-19). The remainder of the fan-shaped serratus disappears under the latissimus dorsi, slipping between the scapula and the rib cage to its hidden insertion along the medial edge of the scapula, an arrangement that enables this muscle to draw the scapula forward around the rib cage.

The deltoid, an important muscle of the shoulder, also attaches with the scapula. Its attachment, however, is an origin, located on the projecting spine and acromium process of the scapula. The deltoid also originates with the outer (lateral) end of the clavicle. The muscle rises in a rounded triangular shape, which inspired early antagonists to name it after the Greek letter delta. This muscle inserts at only one place, a raised surface on the outer side of the humerus known as the deltoid tuberosity.

The deltoid shares the scapular spine and the clavicle's lateral end with another muscle, the *trapezius*, which has insertions in both places. In a frontal view of the trunk (Figure 7-14) the upper portion of the trapezius reaches from the shoulder diagonally to the neck and its highest origin, the occipital protuberance, a bump in the lower back of the skull. The upper trapezius governs the attitude of the head, drawing it backward and rotating it.

Another major back muscle is often partially visible from the front just below the armpit—the *latissimus dorsi*. This muscle, which literally means "broadest muscle of the back," merits a separate study, not merely because of its unusual size but also because of its concealed insertion in the shoulder.

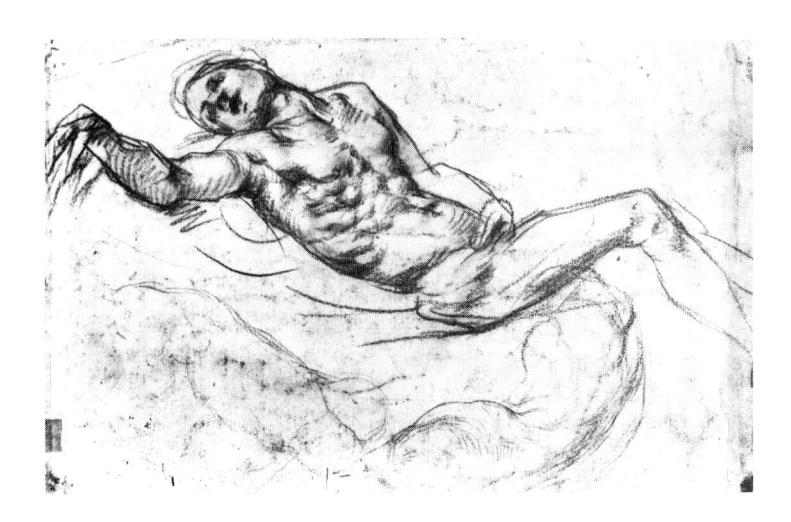

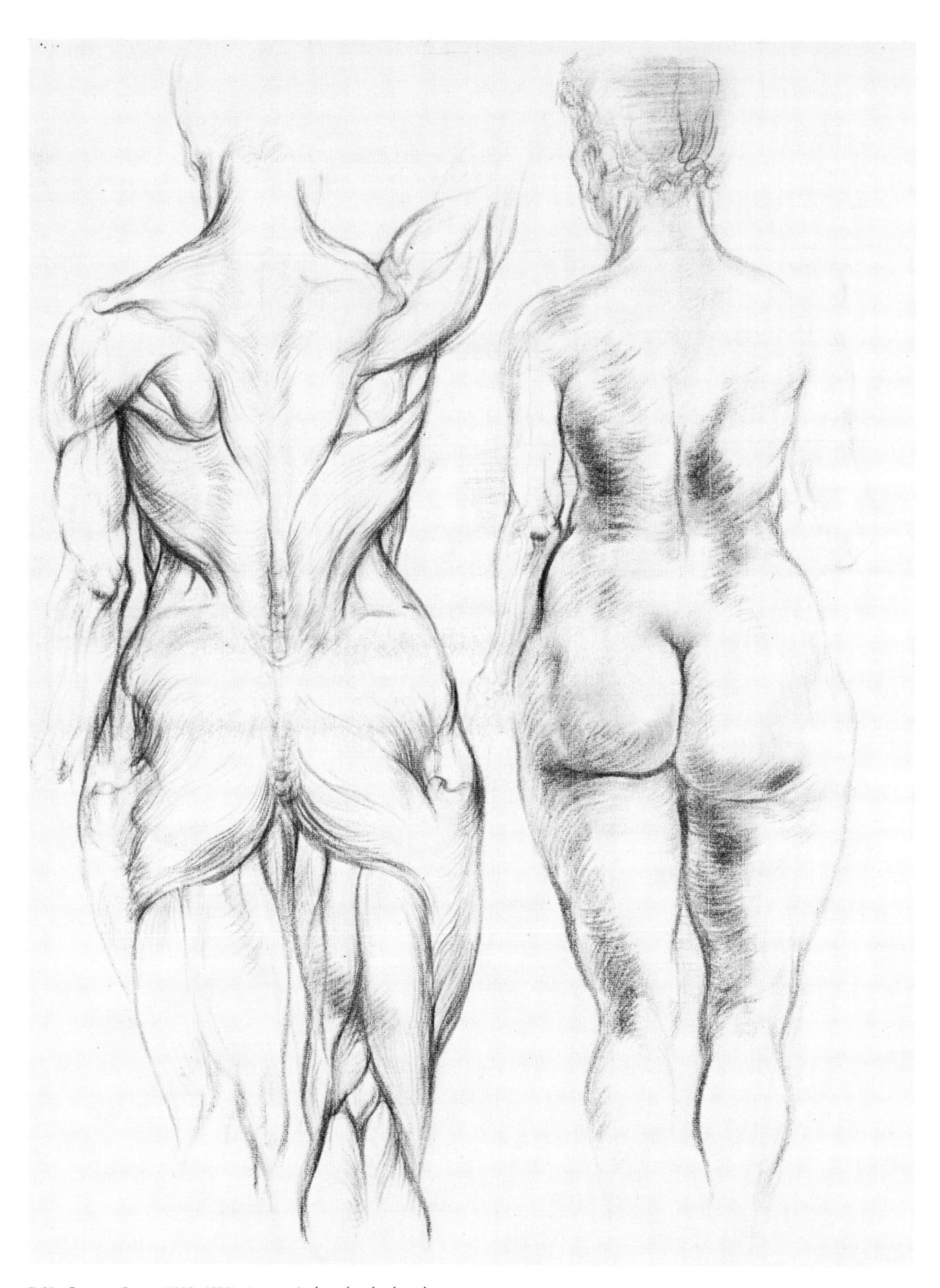

7-20. George Grosz (1893–1959), Anatomical study of a female nude. Crayon. Peter Grosz collection.

STUDY 39. THE LATISSIMUS DORSI

Materials:

11"-×-14" sketchbook

drawing pen (0.5 mm)

india ink

HB drawing pencil sanguine pencil

11"-x-14" tracing paper

Reference:

model, figures 7-13, 7-15, and

7-20, and/or écorché

Suggested time:

15–20 minutes for the life study, 30 minutes for the overlay drawing of the skeleton, and 20

minutes for the overlay drawing

of the muscle

For this study it is advisable to draw the model from the side, preferably with the arm raised, a pose that fully displays the muscle. The study of the skeleton can be drawn in pencil on a tracing-paper overlay (Figure 7-21). In addition to the axial skeleton the study should include the humerus of the arm, on which the insertion of the latissimus dorsi is located. The second overlay study (Figure 7-22) is devoted entirely to the latissimus dorsi itself and can be estimated from the anatomical illustrations listed above (Figures 7-13 and 7-15). The life study may suggest the muscle's position, for its lateral border is often visible as a ridgelike discontinuity just beneath the armpit (Figure 7-12).

The origins of the latissimus dorsi are invisible on the body surface, as the muscle forms a broad, flat, tendinous sheath (aponeurosis) on the back before attaching to the spines of the vertebral column from the sacrum up to the middle of the rib cage. Moreover, the upper portion of the muscle is partially covered by the trapezius muscle (Figure 7-13). From these origins the latissimus dorsi sweeps laterally to the sides of the rib cage, covering the lower part of the scapula and holding it in place against the rib cage. Continuing around the rib cage, the muscle overlaps the serratus, inserting with the front side of the humerus near its head.

If you imagine its insertion free of overlapping muscles, the function of the latissimus dorsi is not difficult to comprehend. As the muscle contracts, it pulls the arm backward and toward the trunk. The forward insertion on the humerus enables it to twist the arm, causing the limb to rotate inward. The form of the latissimus dorsi is visually important for the draftsman, as it helps articulate the arm with the trunk (Figures 8-8 and 8-14).

Studies of an individual muscle, such as the latissimus dorsi, are advisable if its function is obscured by overlapping muscles or other tissues, but it is usually most helpful to study muscles together as they appear in life. The remaining muscles of the back are considered in a single study.

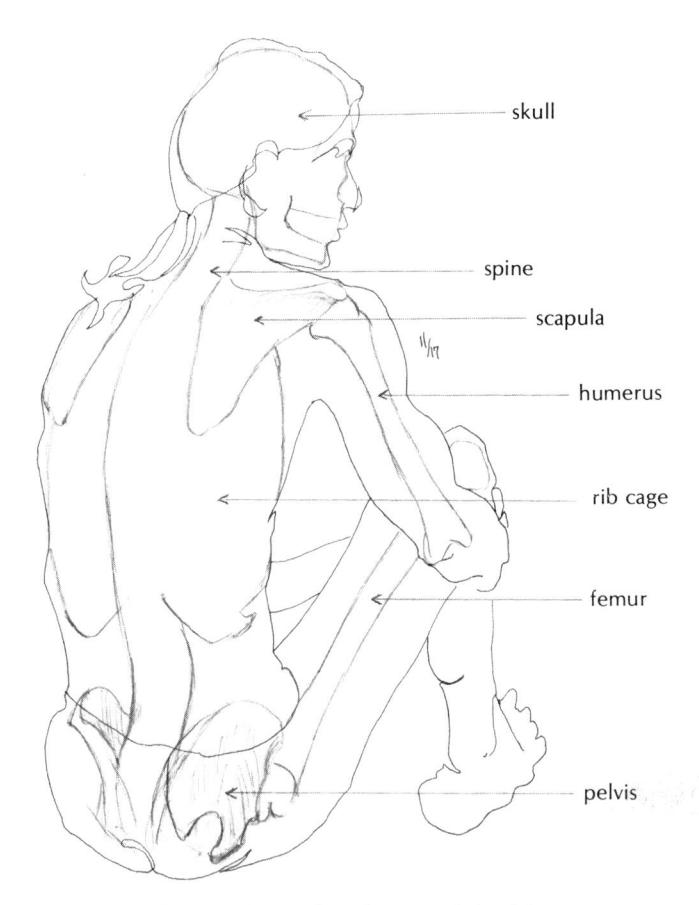

7-21. Student drawing, life study with major skeletal forms. Pen-and-ink and pencil on sketchbook bond paper. $11''\times 8~1/2''$.

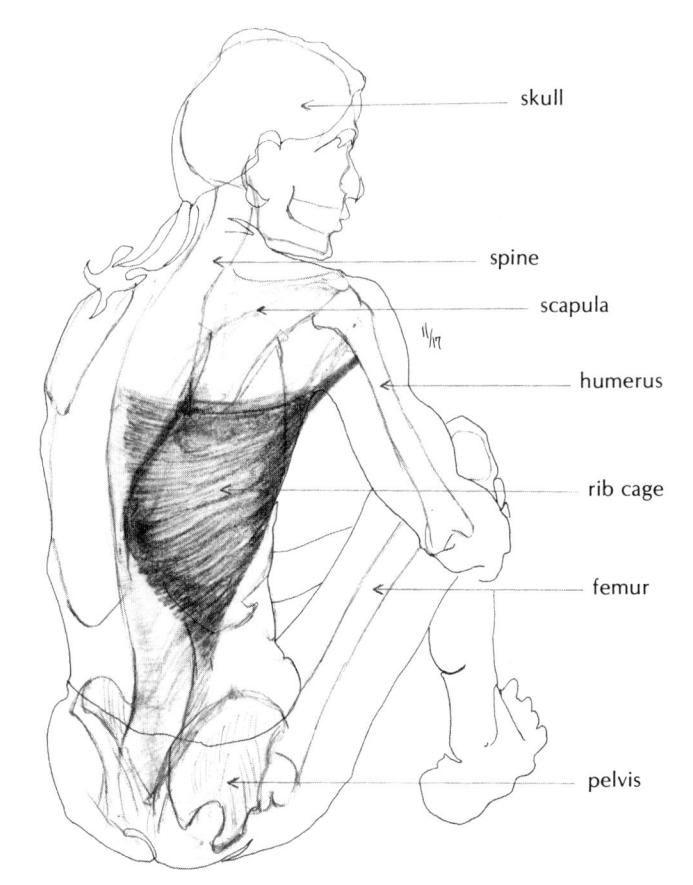

7-22. Student drawing, overlay study (over Figure 7-21) of the latissimus dorsi. Sanguine pencil.

STUDY 40. THE MUSCLES OF THE TRUNK: BACK VIEW

Materials: 11"-x-14" sketchbook

drawing pen (0.5 mm point)

india ink

HB drawing pencil sanguine pencil

11"-x-14" tracing paper

transparent tape

Reference: model, Figures 7-13 and 7-15,

and/or écorché

Suggested time: 15–20 minutes for each life

study, 30 minutes for the overlay drawing of the skeleton, and 30 minutes for the overlay study of

the muscles

If you do not already have a suitable pen-and-ink drawing of the back of the figure in your sketchbook, you may wish to prepare several contour drawings from life. Allow no more than 20 minutes for each

drawing. Select one of these for your study (Figure 7-23). After attaching an overlay sheet of tracing paper to the drawing render the skeleton on the overlay in pencil as before so that it corresponds to the gesture of the figure in the life drawing. After attaching a second overlay you are ready to begin a study in sanguine pencil of the muscles of the back (Figure 7-24).

The latissimus dorsi is a convenient place in the figure to begin drawing the back muscles, as it may be suggested by contours in the pen-and-ink study from life. The lower region of the latissimus dorsi may reveal the rounded forms of the deeper sacrospinalis muscles on either side of the vetebral column. These powerful muscles are apparent in a life study of the back by Michelangelo (Figure 7-25), in which they seem tensed between the pelvis and the rib cage. When the figure is bent forward slightly, the groove separating these muscles may feature a row of bumps caused by the underlying vertebral spines (Figure 7-26).

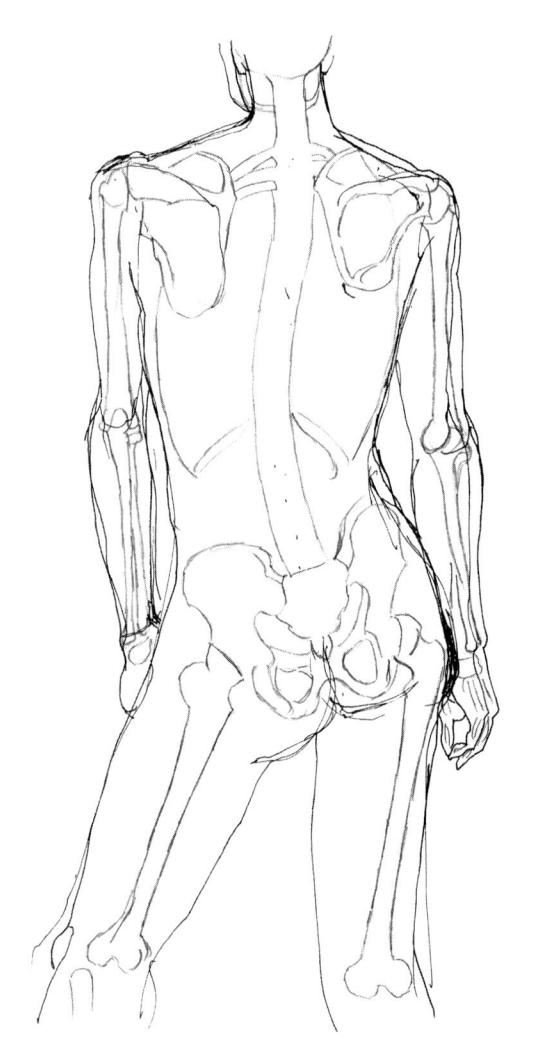

7-23. Student drawing, life study with skeletal forms. Pen-and-ink and pencil on sketchbook bond paper. $11'' \times 81/2''$.

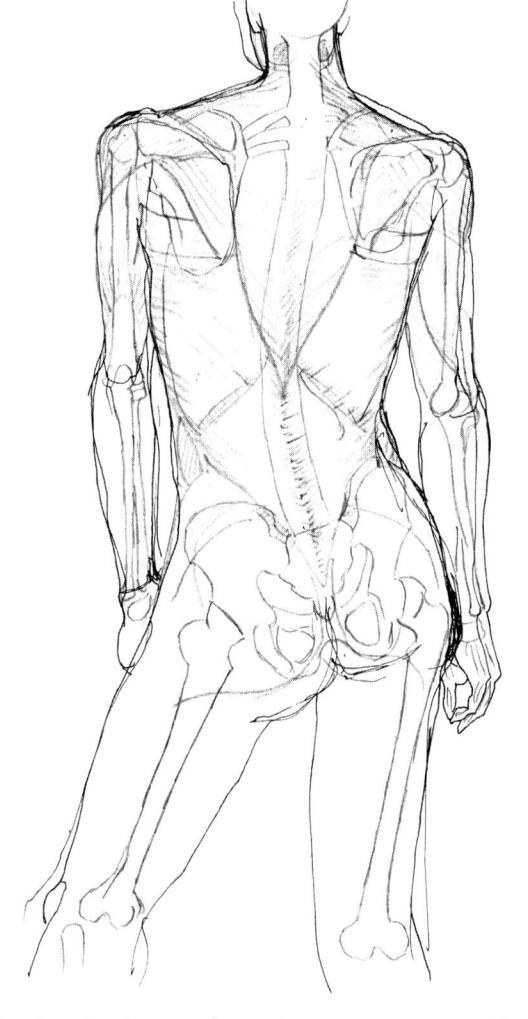

7-24. Student drawing, overlay study (over Figure 7-23) of back muscles. Sanguine pencil.

TRUNK MUSCLES: BACK SIDE

As the name suggests, the sacrospinalis muscles extend from the sacrum and the pelvic region up the length of the spine, attaching to vertebral spines and to ribs. The upper reaches of these muscles insert with neck vertebrae, though they are not visible in this region due to overlapping muscles. The sacrospinalis is also known as the *erector spinae*, for it holds the spine erect by pulling it backwards in opposition to the rectus-abdominis muscles. The sacrospinalis performs another interesting function, which you can feel in your lower back while walking. The muscle tenses on the side of the raised foot, fixing the position of the pelvis and permitting the opposite foot to be raised.¹⁸

The upper-central portion of the latissimus dorsi is covered by the lower portion of the trapezius muscle, mentioned earlier in connection with the neck (Figure 7-13). Named after the trapezium, a geometric diamond shape, the form of this muscle is

7-25. Michelangelo Buonarroti, Study for The Last Judgment, 1534–41. Black chalk. 25.8 × 15.7 cm. Florence, Casa Buonarroti. The action of the sacrospinalis and gluteus muscles is important in the gesture of this figure.

elegantly subtle, changing according to the body's gesture. As the trapezius is seldom completely visible on the surface, its form is best visualized by reviewing its attachments, all of which are uncovered. The trapezius originates in the part with the occipital protruberance at the base of the skull and along much of the spinal column, including the nuchal ligament at the nape of the neck, the vertebra prominens, and all the thoracic vertebrae of the rib cage. 19 As noted previously the trapezius finds insertion on the shoulder with the lateral end of the scapula, the scapular spine, and the acromium process (Figure 7-27). The trapezius muscle can thus be visualized as consisting of two opposing parts, for the upper portion can pull the scapula toward the spine or upward, while the lower portion can draw it downward. When both portions are tensed, however, the trapezius serves as a fixation muscle for the scapula.

Originating on the same scapular spine with which the trapezius inserts is the back portion of the deltoid. Though considered earlier as an arm muscle, it should be included in a study of back muscles due to its common attachment with the trapezius on the scapula.

7-26. Student drawing, study of the back. Crayon on newsprint paper. $24'' \times 18''$. Skeletal forms of the rib cage, scapula, iliac crest, and prominences of the vertebral spines are integrated with muscle forms in this study.

7-27. Abraham Bloemaert (1564–1651), Studies of heads, arms and a leg, and the head and shoulders of a recumbent man. Red and white chalk, slightly touched with pen, on coarse buff paper. 270×330 mm. Oxford, Christ Church. The unusual view of the shoulders and back in the recumbent figure reveals the contours

of the upper region of the trapezius muscle and its relation to the clavicle and to the vertebra prominens. Studies of the arms and leg also display an accurate integration of skeletal and muscular forms.

In addition to the trapezius and the deltoid there are three other muscles that operate the scapula: the infraspinatus, the teres minor, and the teres maior (Figure 7-13).²⁰ As they appear close together and are only partially exposed, they can be studied as a group. The infraspinatus, as its name suggests, originates just below the raised spine of the scapula.²¹ Viewed without the deltoid that covers its outer reaches, the infraspinatus extends around the back of the humerus, inserting on the outer side of the bone near its head (at the major tubercle). This insertion enables the infraspinatus to rotate the arm backward when the muscle contracts. The teres minor, although slightly lower than the infraspinatus, shares its attachments and function. The straplike teres major, located just below the teres minor, has a different insertion and a different function. Originating with the lower end of the scapula, the teres major follows the same route as the latissimus dorsi: it turns in between the humerus and the rib cage before inserting on the front of the humerus just below and behind²² the insertion of the latissimus dorsi. When the teres major contracts, it can rotate the arm inward and pull it downward, a similar function to the latissimus dorsi.

If you wish to make a more complete study of the back muscles, omit the trapezius muscle on one side of the sanguine drawing in order to render the series of muscles situated beneath it (Figure 7-28). Among these are the major and minor rhomboids and the levator scapulae, which contract to pull the scapula upward and toward the middle of the back, causing the acromium process to rotate downward. This action is assisted by the pectoralis-minor muscles, which attach to the other side of the scapula at the coracoid process. Other hidden muscles are considered in connection with the neck region.

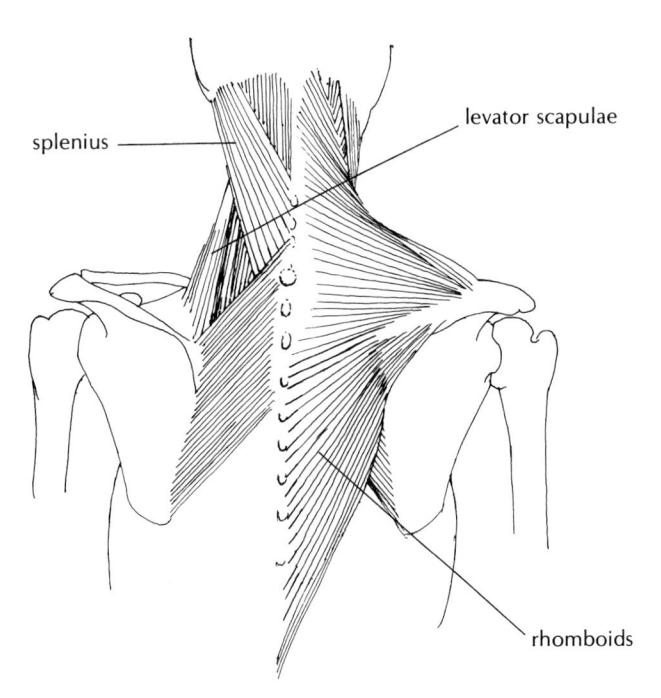

7-28. Deep muscles of the neck.

STUDY 41. MUSCLES OF THE NECK

11"-x-14" sketchbook **Materials:**

drawing pen (0.5 mm point)

india ink HB pencil sanguine pencil

11"-x-14" tracing paper

model (optional) and Figures Reference:

7-6, 7-13, 7-14, 7-15, and 7-28

15-20 minutes for each life study Suggested time:

and 30 minutes for each overlay

study of the neck

The neck region can be studied either by preparing new life drawings limited to the upper region of the body or by simply adding to the overlay studies already made in connection with the trunk (studies 38, 39, and 40 and Figures 7-17 and 7-21). If you opt for the latter approach, you can begin by adding one bone, the hyoid (Figure 7-29), to the overlay drawing of the skeleton. This U-shaped bone is held in place above the Adam's apple by muscles and tendons, somewhat as the patella is held in the knee; it has no joints with other bones.²³ You may also wish to add to the skeletal study the Adam's apple, an angular structure of cartilage that is plainly visible as a bump in the neck below the chin. Also known as the thyroid cartilage, the Adam's apple is generally larger in the male than in the female.24 Below the Adam's apple is a smaller bump caused by the thyroid gland proper.

The neck muscles can be drawn with a sanguine pencil on a second sheet of tracing paper attached to the sketchbook page over the skeletal analysis. With a life drawing representing a frontal or three-quarter view of the neck (Figure 7-16), you can begin by rendering the sternomastoid muscles. Using the top of the sternum²⁵ in your skeletal drawing as a guide, draw the V-shaped juncture of the sternomastoids' origins with the sternum. Check the position of the insertions with the skull, the mastoid processes, which can be felt as bumps just behind the ears (Figure 7-29). The sternomastoid muscle has a secondary origin with the clavicle (Figure 7-15). The small space between the two origins creates a triangular "window" that is often visible in life, especially when the head is turned. With the sanguine pencil you can easily trace the diagonal sweep of the sternomastoid muscles from the sternum to the mastoid processes. Once rendered, this muscle can serve as a frame of reference for the remaining muscles of the neck.

THE NECK MUSCLES

The sternomastoid muscles work together to turn the head to the side. When the head turns toward the left side, for example, the sternomastoid muscle on that side relaxes while the muscle on the right contracts, pulling the left side of the head forward and rotating it in the direction of the left shoulder. With the head turned to one side, the tense sternomastoid in front appears to rise almost vertically from the sternum, an indication of how much the contraction shortens the muscle. Its secondary origin on the clavicle is also clearly visible. A more subtle function of the sternomastoid muscles is to raise the head

while the body lies in a prone position.²⁶ The muscles are highly visible and tense in performing this action, a clear indication of their involvement.

A life drawing of the side or back of the neck usually takes into account the upper portion of the trapezius muscle (Figures 7-17, 7-30, and 7-31). This large, flat muscle accounts for the almost unbroken contour of the neck and the back. The upper cervical vertebrae have short spines and do not affect the trapezius' outer surface. The seventh vertebra of the neck (vertebra prominens), however, has a very long spine, which appears as a bump on the back of the neck (Figure 7-27), the only place at which the vertebral column is apparent on the neck's surface.

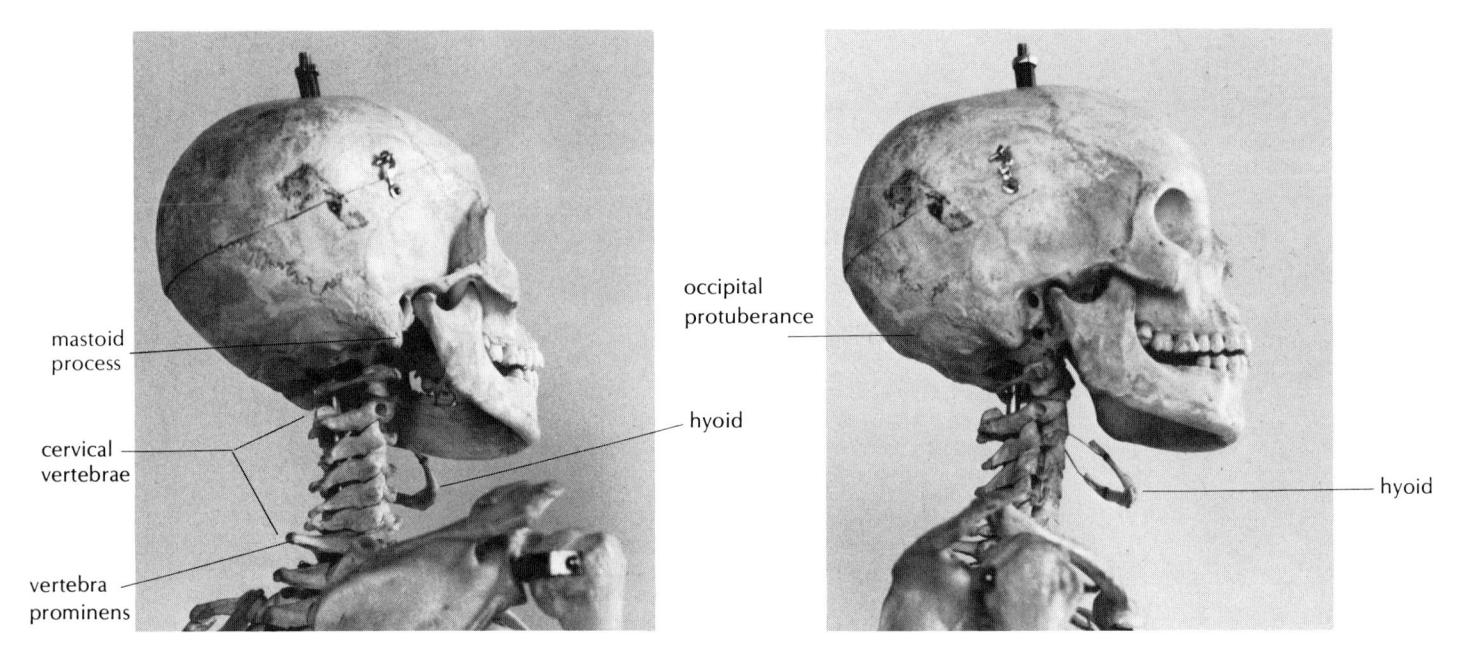

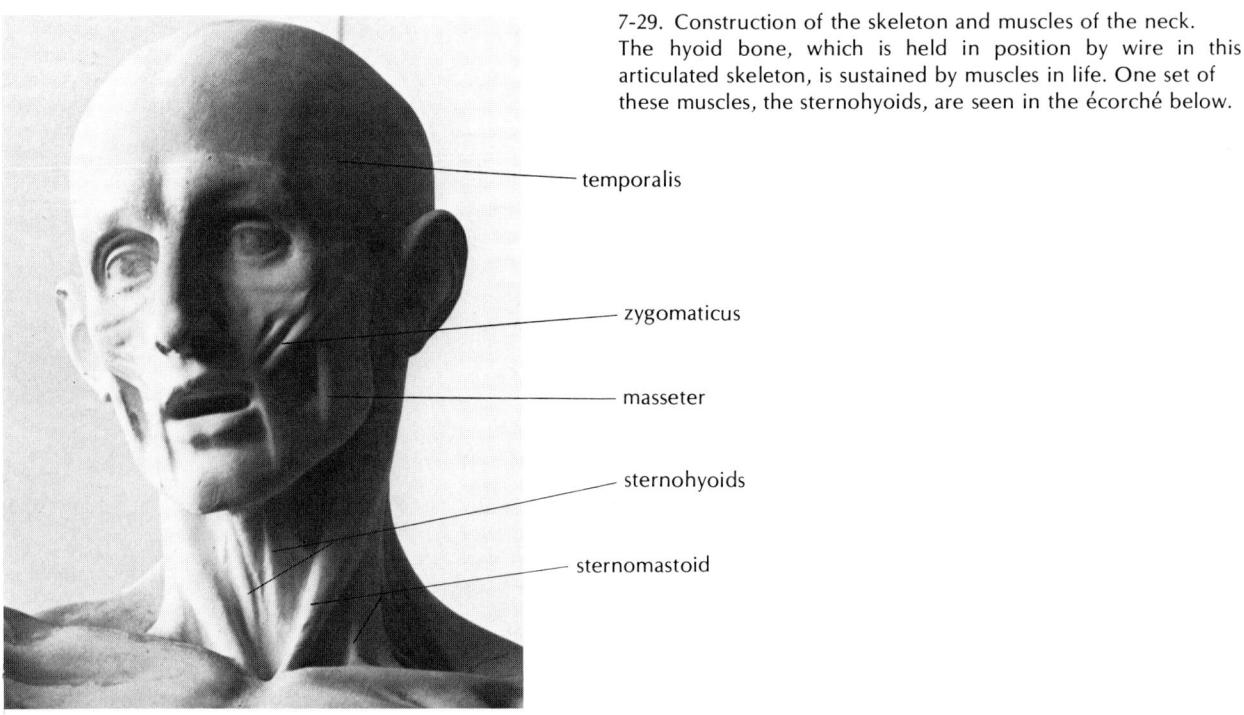

Although the sets of sternomastoid and trapezius muscles dominate the exterior of the neck, intervening spaces make it possible to glimpse portions of other muscles that play a role in the structure and movement of the neck. Two such muscles are partially exposed between the sternomastoid and the trapezius, the scalenus medius and the splenius (Figure 7-15). The scalenus, which originates with the cervical vertebrae and inserts with the two uppermost ribs, pulls the neck sideways towards the rib cage. When both the left and right scalenus muscles contract, however, the neck bends forward. The splenius rises diagonally from its origin with vertebrae of the neck and chest to its insertion with the occipital bone of the skull, a site shared with the sternomastoid, its opposing muscle (Figure 7-28).

Between the two sternomastoid muscles are two groups of muscles that control the hyoid bone (Figure 7-14). Their names reveal their location: those above the bone are known as the *suprahyoid* muscles; those below, the *infrahyoid* muscles. When the neck muscles are tensed as you swallow, it is possible to feel the two sets of infrahyoids: the *sternohyoids* and the *omohyoids*. Both of these muscles insert with the

hyoid bone, though they have different origins (Figure 7-29). The sternohyoid originates with the inner and upper end of the sternum, while the omohyoid, reaching under the sternomastoid on the side, inserts with the scapula.²⁷ The omohyoid is also partly visible between the sternomastoid and the trapezius (Figure 7-15). Among the suprahyoids the most prominent externally is the *digastric* muscle, the anterior belly of which connects with the hyoid by means of a fibrous loop and extends to the inner side of the jawbone at the chin (symphysis of the mandible).

Last and in some ways least of the neck muscles is the *platysma*, a thin sheath that usually covers the entire front of the neck. It is generally visible only intimes of physical duress, but in older persons it may always be apparent (Figure 7-31). Originating from a covering tissue (fascia) of the pectoralis, deltoid, and trapezius muscles, the platysma inserts with the lower jaw (mandibula) from the chin to the angle below the ear. This peculiar and seldom used muscle need not be included in your study, for its form is derived from the thicker, more active muscles situated beneath it.²⁸

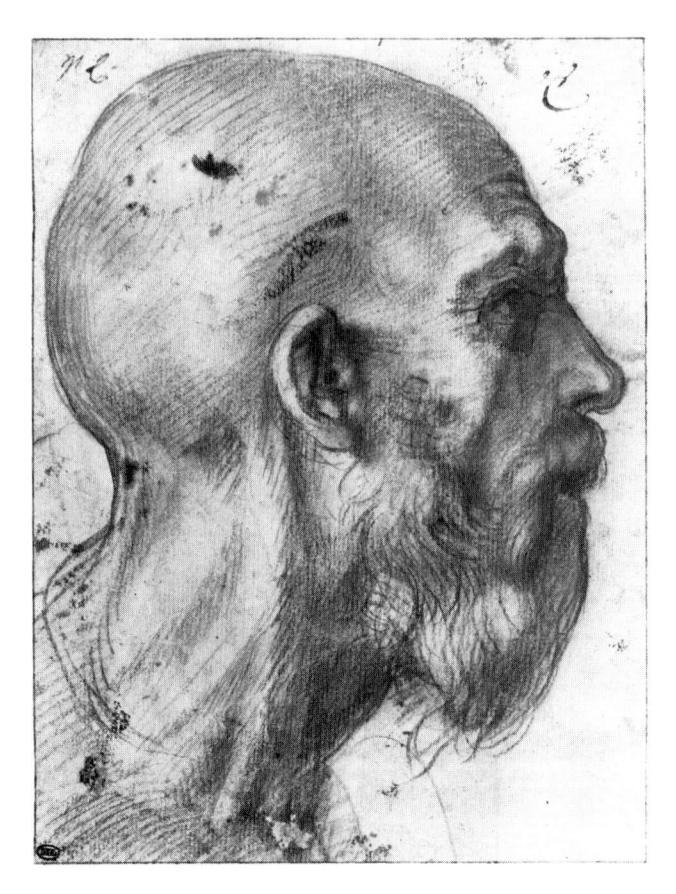

7-30. Andrea del Sarto (1486–1530), Study of the head. Natural red chalk. 19.5 × 15 cm. Paris, the Louvre. This powerfully modeled drawing reveals surface forms of neck muscles, particularly the sternomastoid, with its insertion behind the ear, and the trapezius, visible on the posterior side of the neck. Between the two muscles the diagonal forms of the scalenus and splenius muscles are apparent.

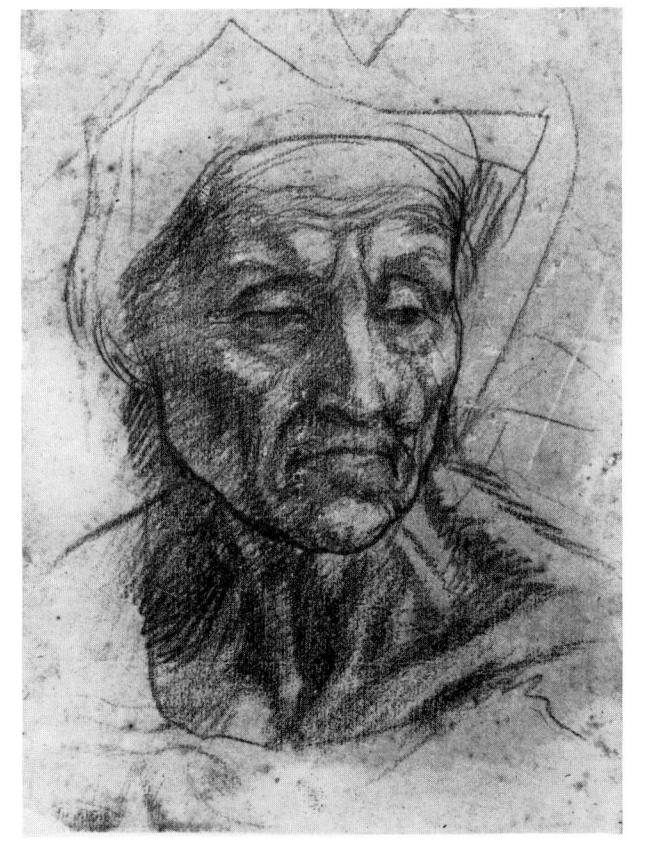

7-31. Andrea del Sarto, Study for the head of St. Elizabeth in the painting Madonna with St. Elizabeth and the Infant St. John, c. 1528 (?). Natural red chalk. 250×186 mm. Oxford, Ashmolean Museum. Modeling of the neck region reveals rich muscle structure in this study.

THE MUSCLES OF THE LIMBS

Psychologists have found that "there is a general tendency to perceive any shape with the maximum degree of simplicity, regularity, and symmetry." This tendency is expressed all too often in life drawings, in which the individual limbs may resemble forms turned on lathes. In life the limbs, though sharing in the bilateral symmetry of the body, are not individually symmetrical. The apparent asymmetry of the limbs can be understood by studying their muscular and skeletal structure.

STUDY 42. THE ARM MUSCLES

Materals: 11"-x-14" sketchbook

drawing pen (0.5 mm point)

india ink

11"-x-14" tracing paper

HB pencil sanguine pencil

Reference: transparent tape

model and Figures 7-32, 7-33, 7-34, 7-35, 7-36, 7-37, 7-38, 7-39,

and 7-40

Suggested time: 15–20 minutes for each life study,

20 minutes for each overlay study of the skeletal arm, and 30 minutes for each overlay study of

the muscles

In view of the complexity of the muscle structure in the upper limb it is advisable to make six or more life drawings, showing the arm, forearm, and shoulder as large as is conveniently possible on the sketchbook page. For a complete study of the arm muscles you need drawings of both sides of the arm and at least one view with the palm downward, or turned toward the back (in pronation), and another with the palm up, or turned forward (in supination). These drawings enable you to study the different appearance of the arm in those two positions, a difference due to the skeletal and muscular structure of the forearm.

When the life drawings are completed, tape an overlay of tracing paper in place over the drawing selected for anatomical study. By making a skeletal study of the arm, forearm, and shoulder you can visualize the framework that provides the attachments for the muscles. The forearm bones should be drawn carefully to reflect the gesture. With the hand in pronation, the radius crosses over the ulna, but in supination the two bones are parallel (Figure 6-44). Other skeletal aspects that warrant attention are the knobs on the lower end of the humerus, known as the medial (inner) and lateral (outer) epicondyles (Figures 7-33 and 7-35). In the forearm the wrenchlike head of the ulna displays two processes (projections), the olecranon at the tip of the elbow and the coronoid process on the opposite

side (Figure 7-35), which are sites of muscle attachments. Other key sites of attachment are two bumpy projections at the far end of the forearm bones: the styloid process of the radius (Figure 7-32), a bump that you can feel on the wrist near the thumb, and the styloid process of the ulna (Figure 7-35), a spur that projects on the same side of the wrist as the little finger. Although it need not be included in your overlay rendering, you may wish to make a mental note of another feature of the ulna, the ridge or crest that appears on its lower side and is usually visible in life (Figures 7-32 and 7-37). Tape a second tracing-paper overlay on the skeletal study in preparation for a sanguine-pencil study of the muscles, based on the anatomical illustrations in this chapter. As a prelude to your study it is helpful to review the muscles of the arm and forearm and their attachments with the skeleton.

THE ARM MUSCLES

Consider first the frontal view of the upper arm as it appears with the palm turned outward in supination (Figure 7-33). The fleshy mass of the frontal region just below the deltoid is the biceps (literally, "two heads") muscle, which appears as a single semicylindrical form running almost parallel with the humerus. When the shoulder muscles that cover the upper fibers and tendons are removed (Figure 7-33, upper right), it is possible to see the two heads of the biceps, which find their origins with two places on the scapula. One head shares its attachment on the coracoid process with the pectoralis minor: the other tendon extends over the head of the humerus to reach a bump (tuberosity) on the scapula above the cusp joint (glenoid fossa) with the humerus. It is notable that the biceps has no attachment with the bone that it covers, the humerus (Figure 7-3).30 The biceps inserts with the radius and a ribbon of tendon called the bicipital fascia (Figure 7-33). The latter remains on the surface and wraps around the forearm muscles just below the inner condyle of the humerus. The attachment of the biceps with the radius gives this muscle the dual function of flexing the arm and turning the lower arm to a supine position, a task assisted by lower arm muscles.

Immediately behind the biceps are the visible portions of a thicker, flatter muscle, the *brachialis*. With its origin on the front side of the lower half of the humerus and its insertion on the upper, anterior end of the ulna,³¹ the brachialis assists the biceps in flexing the forearm (Figure 7-2). On the other side of the upper arm is the *triceps* muscle, which performs the opposing action of extending the arm. When the flexor and extensor muscles of the arm are tensed, they are separated by a vertical ridge below the deltoid. The long, straplike tendon of the triceps, which inserts with the olecranon process of the ulna, stretches along the almost flat surface of the arm's

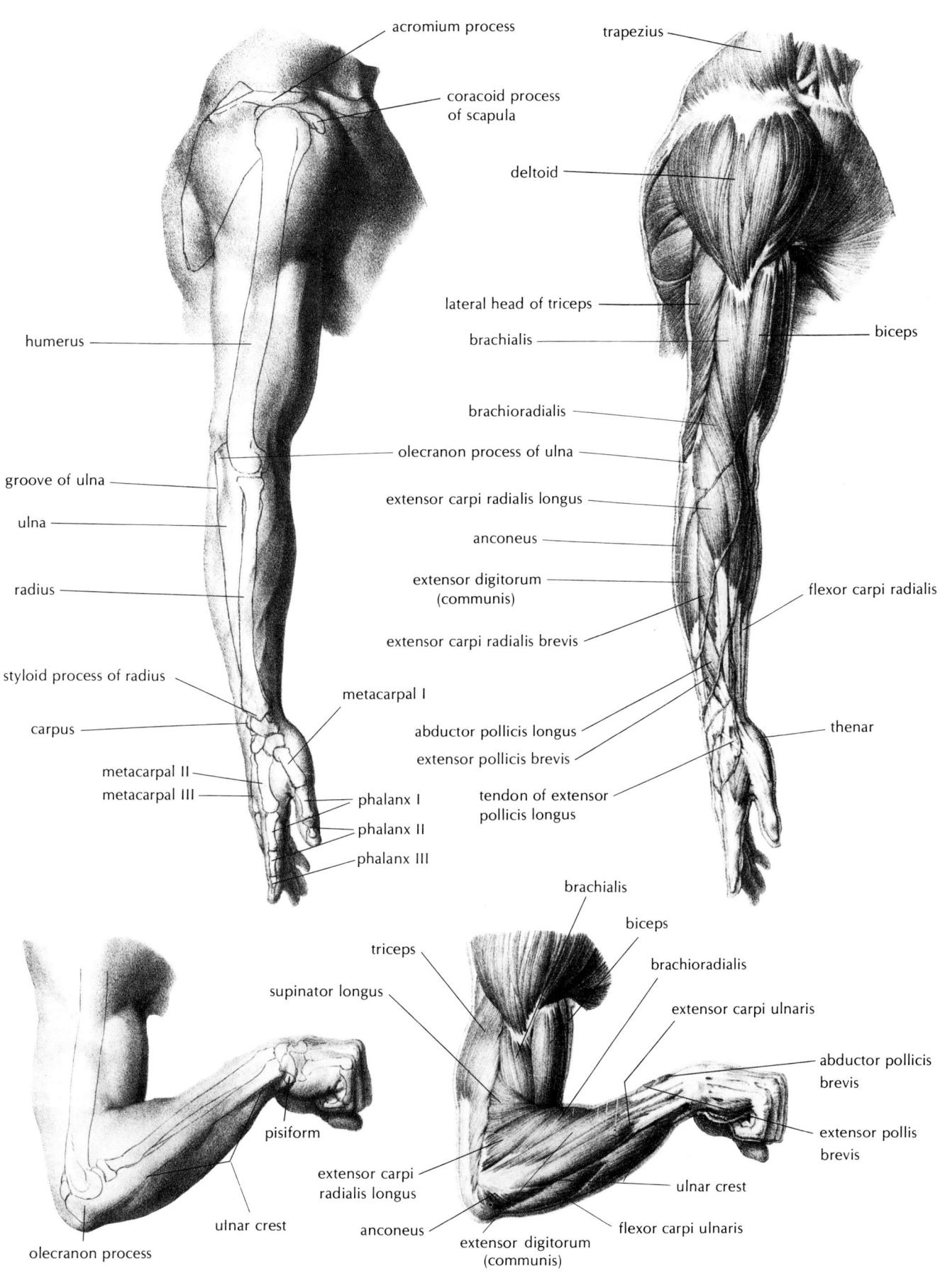

7-32. Muscular and skeletal structure of the arm extended and supinated (above), flexed and pronated (below), viewed from the side. (Dr. J. Fau, The Anatomy of the External Forms of Man

[London: Hippolyte Bailliere, 1849], plate 15. Courtesy of Countway Library, Harvard University.)

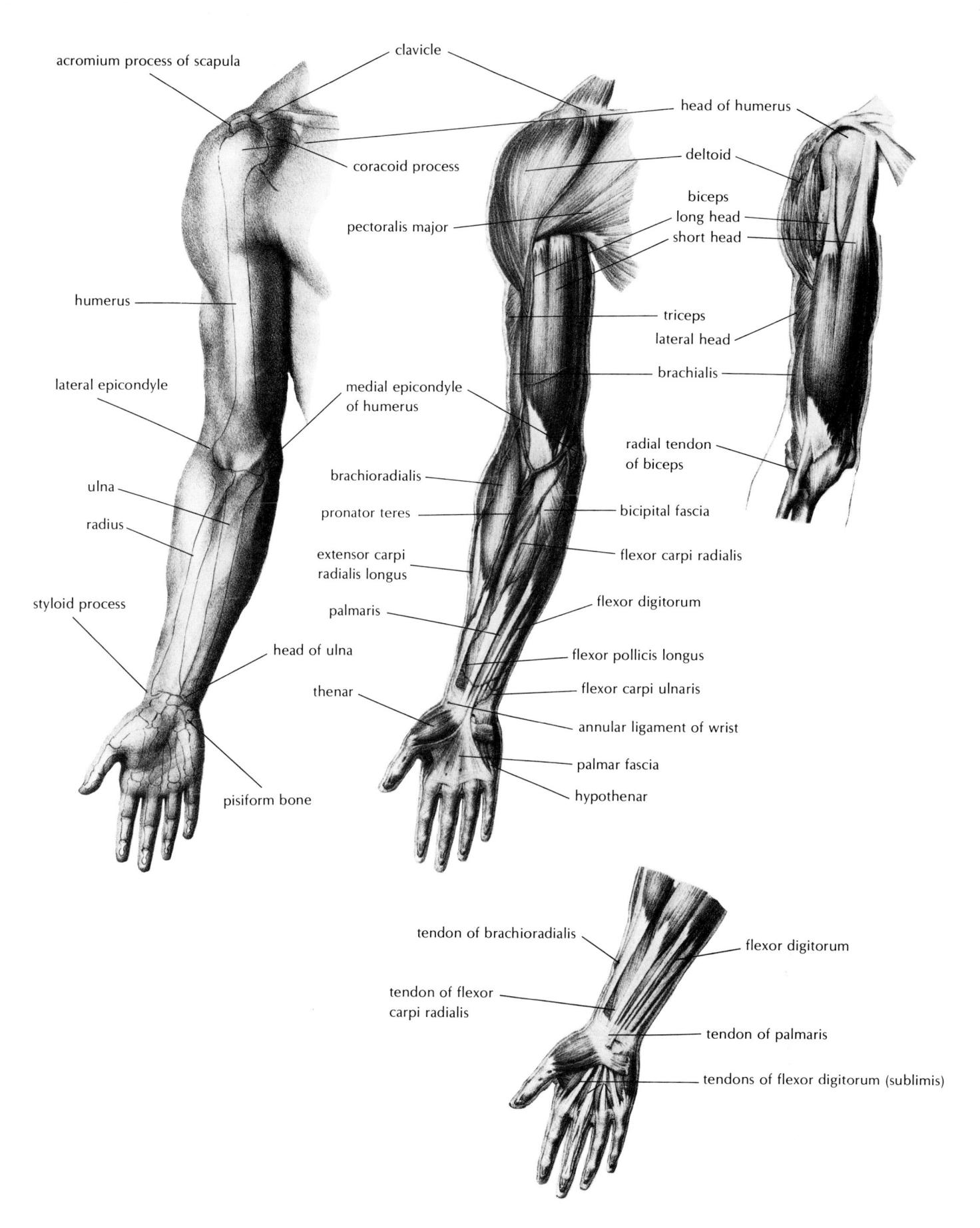

7-33. Muscular and skeletal structure of the extended and supinated arm, seen from the front. (Dr. J. Fau, *The Anatomy of the External Forms of Man* [London: Hippolyte Bailliere, 1849], plate 13. Courtesy of Countway Library, Harvard University.)

backside to the fleshy body of the triceps, with its characteristic swell, which appears halfway up the arm. As the name suggests, the triceps is divided into three heads: the *lateral* head, visible under the deltoid on the side; the *long* head, on the backside; and the *medial* head, on the inner side of the arm. The lateral and long heads are often visible in life when stressed and form an inverted V-shape with their common flat tendon. Both have origins on the posterior side of the upper humerus (Figure 7-36). The long head of the triceps originates with the scapula just below the hollow of the scapular joint with the humerus.

The raised arm (Figure 7-40) reveals not only the medial head of the triceps but also the *coracobrachialis*, a muscle wedged between the biceps and the triceps near the armpit. Named after its origin with the coracoid process of the scapula, a site of attachment that it shares with the pectoral minor muscle,³² the coracobrachialis inserts with the inner side of the humerus at about the same height as the inser-

7-34. Albrecht Dürer, *Arm studies for Adam* (for the engraving of 1504). Pen-and-ink. $8\,1/2^{\prime\prime} \times 10\,7/8^{\prime\prime}$. London, British Museum. With the palm turned upward, the forearm assumes the position of supination.

tion of the deltoid on the other side. These attachments combine to enable the coracobrachialis to pull the arm toward the center and front of the body.

A special muscular arrangement accounts for the characteristic tapering form of the forearm. The relatively thin tendons occupy most of the distal half of the forearm, while the bulkier muscle bodies lie nearer the elbow joint. Arthur Thomson³³ points out that this arrangement frees the hand from the bulk of the large muscles. It also places less weight at the end of the arm, creating a more efficient lever mechanism. The forearm appears to be a particularly clear instance of anatomical form following function. An examination of the forearm's structure reveals two muscle groups with opposing functions: (1) the extensor and supinator muscles and (2) the pronator and flexor muscles. The ulnar crest makes a convenient landmark for studying the forearm muscles, for it marks the separation of the two groups of antagonist muscles. Seen from the side, the extensor-supinator muscles appear on the top (dorsal) side above the ulnar crest, while the pronator-flexors lie below the ulnar crest on the inner (medial) side of the forearm (Figure 7-32, lower right).

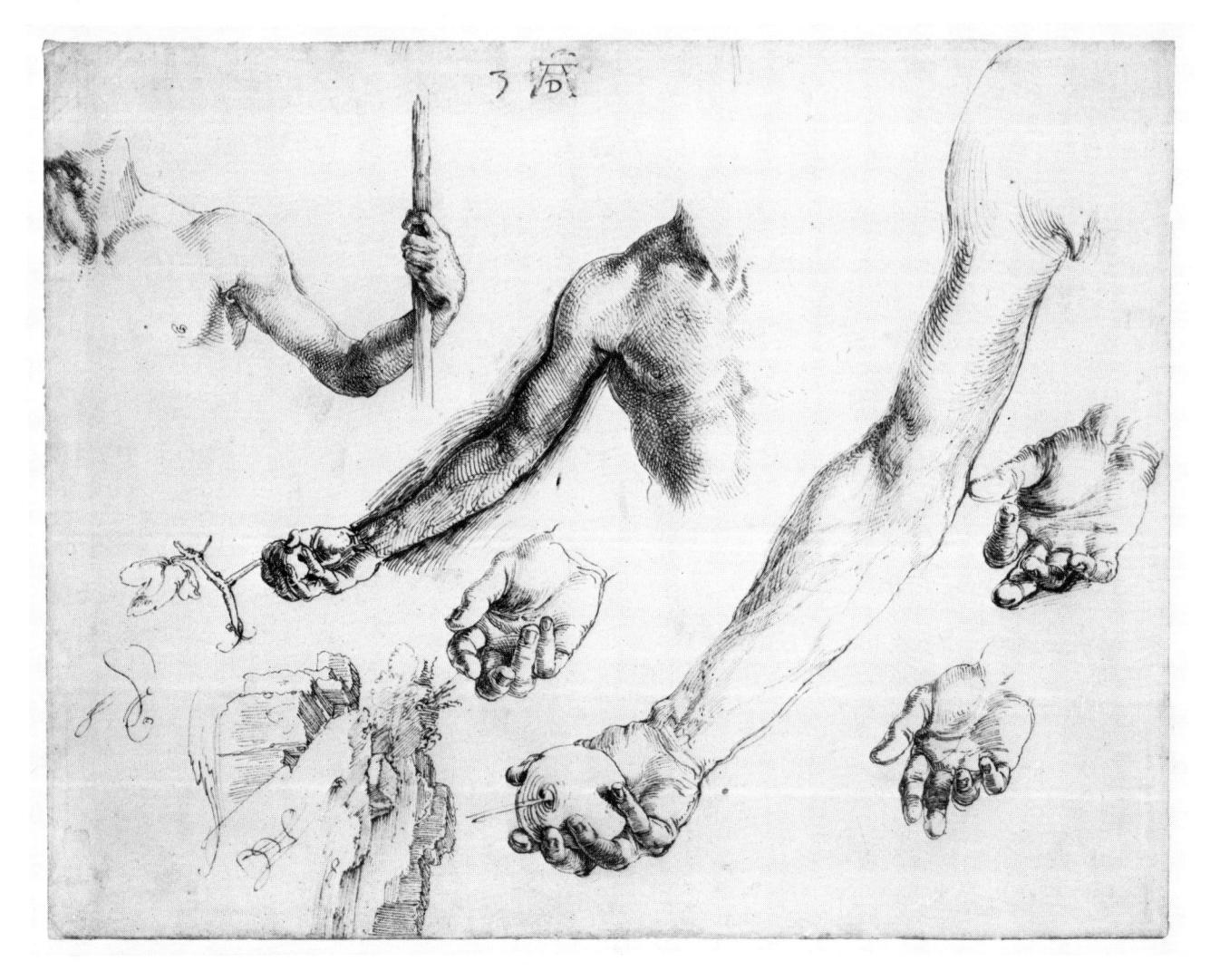

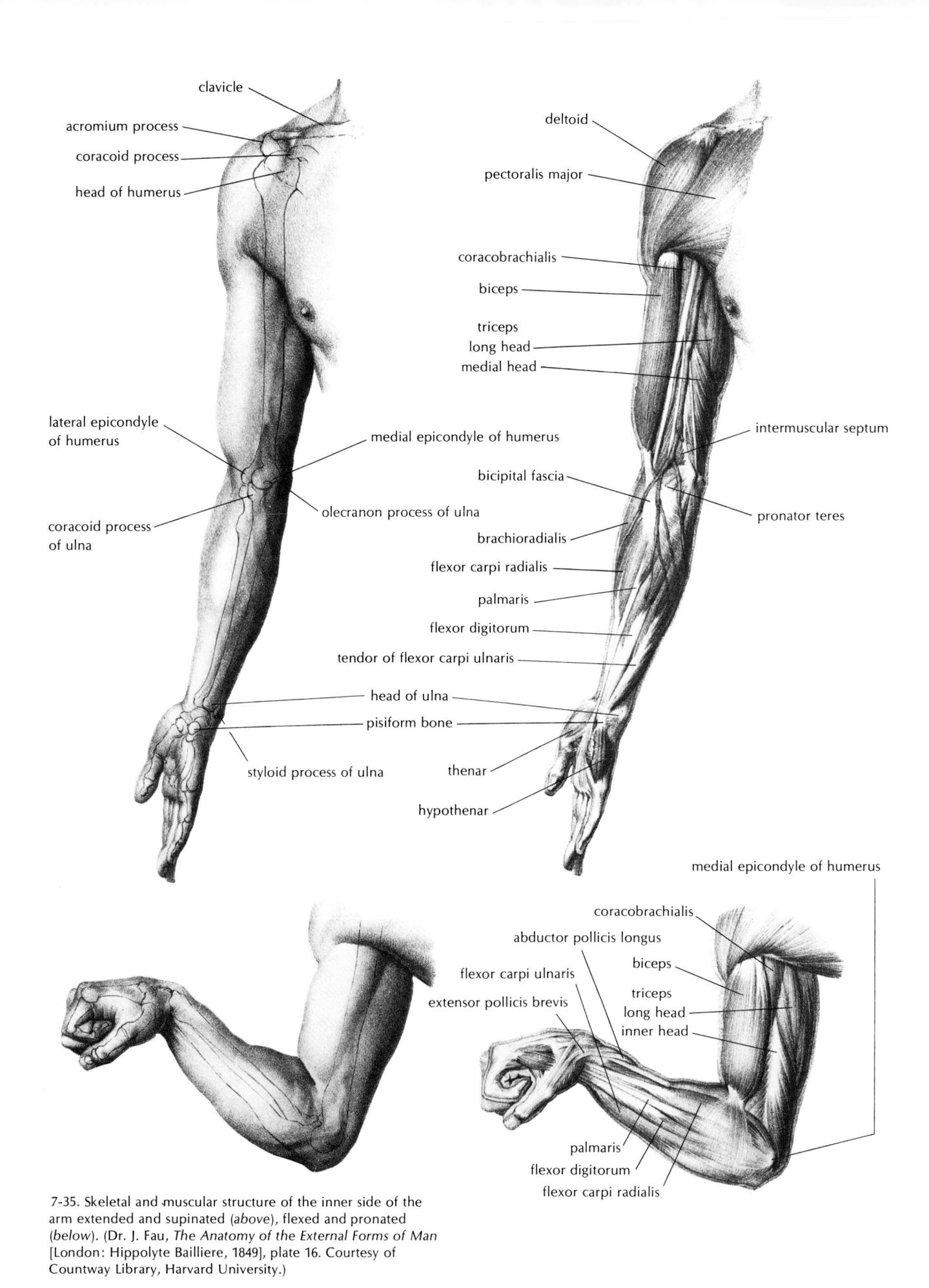

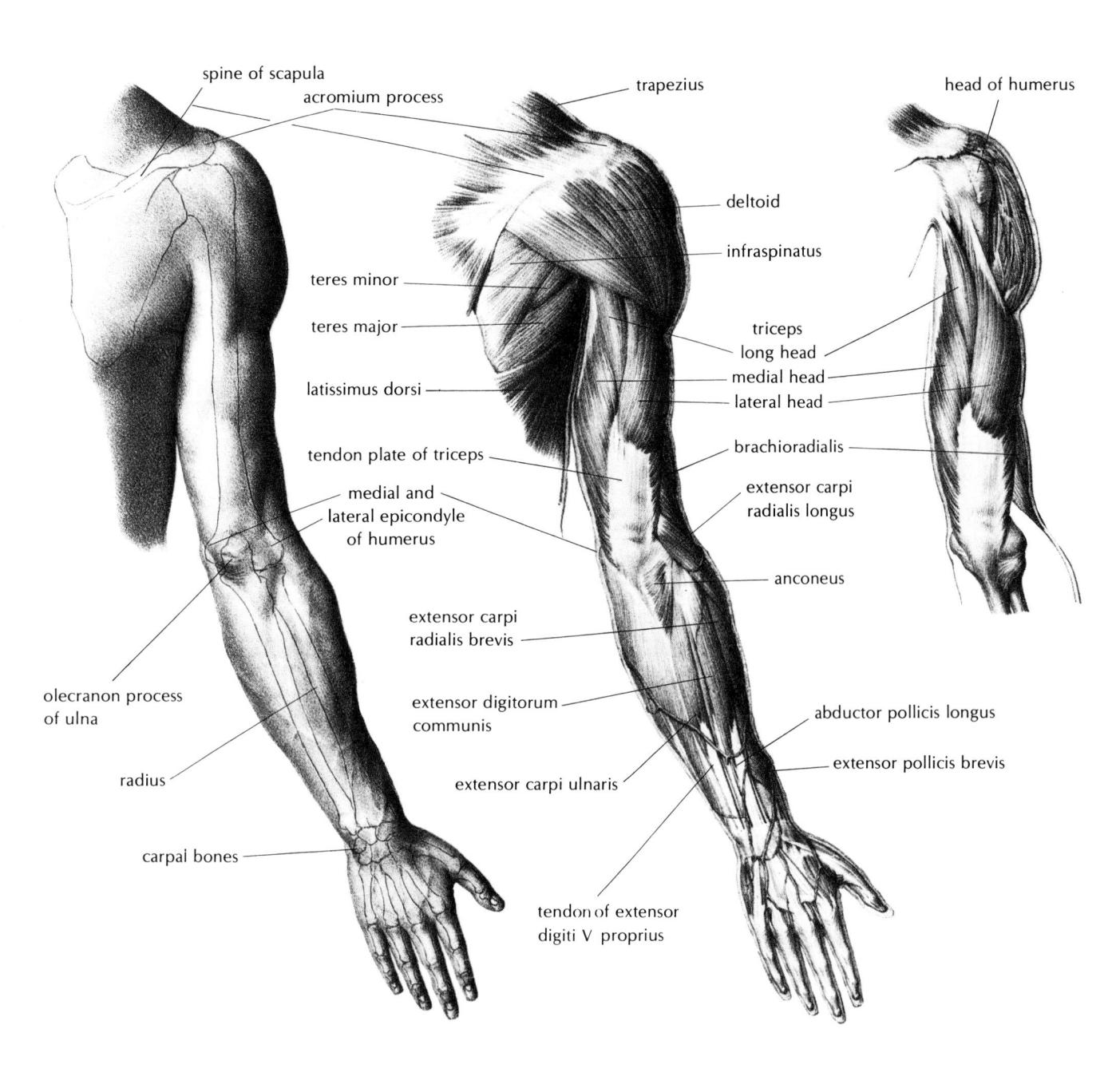

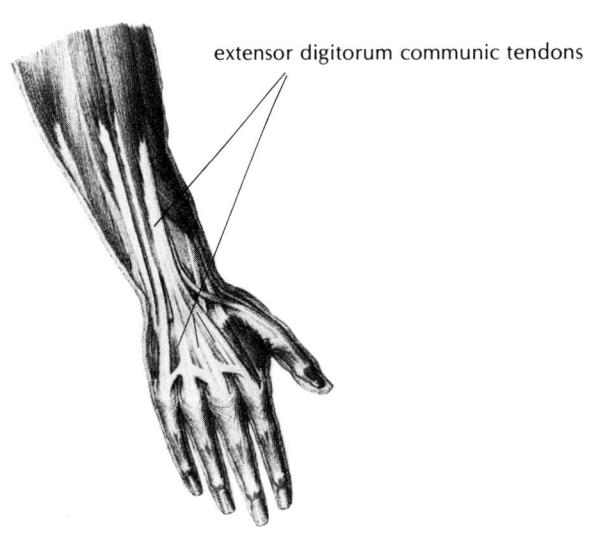

7-36. Skeletal and muscular structure of the supinated arm, as seen from behind. (Dr. J. Fau, *The Anatomy of the External Forms of Man* [London: Hippolyte Bailliere, 1849], plate 14. Courtesy of Countway Library, Harvard University.)

Muscles that supinate or pronate the forearm attach either directly or indirectly to the radius, for it is the only forearm bone capable of true rotation. The mechanical leverage required for such rotation is provided by the epicondyles of the humerus, which project on both inner and outer sides of the elbow, with the inner being more prominent. A muscle originating on the outer (lateral) epicondyle and inserting with the radius on the side of the thumb can thus cause the distal end of the radius to turn over to the outer side of the ulna. This action in turn causes the hand to rotate to a supine position, for the wrist bones join exclusively with the radius. An extensor muscle of the same group bends back (extends) the hand.

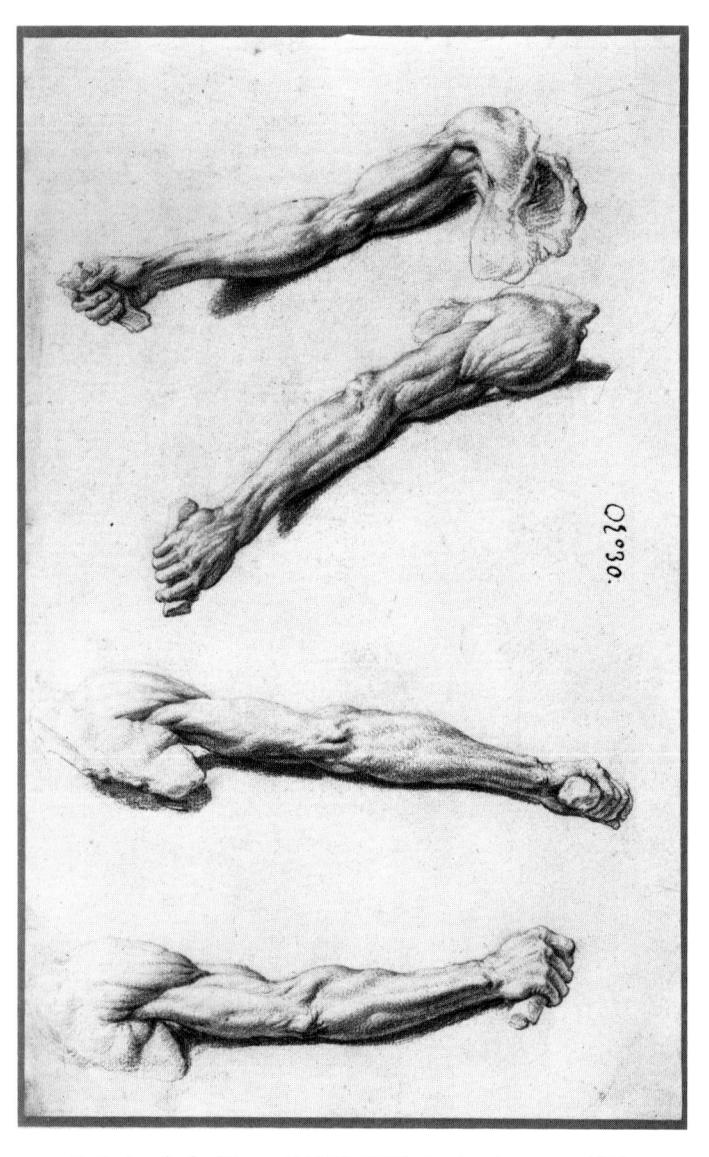

7-37. Jacob de Gheyn II (1562–1629), *Study of arms*, c. 1600. Black chalk. 360 × 231 mm. Amsterdam, Rijksmuseum, Print Room. This series of drawings appears to be based on a cadaver, so clear is the exposition of the muscles. The lowest drawing provides a useful description of the forearm in pronation. Compare the ulnar crest in Figure 7-31.

The most superficial muscle of the extensor-supinator group is the *brachioradialis*, which extends from its origin along the lower third of the humerus (on the lateral ridge) to the far end of the radius, where it inserts with the styloid process at the wrist (Figures 7-32 and 7-33). The relatively high origin of this muscle results in a singular contour on that side of the forearm. The diagonal twist of the brachioradialis, especially noticeable when the forearm is prone, indicates that this muscle can supinate the hand; older anatomy texts refer to it as the supinator longus. The primary function of the brachioradialis, however, is to flex the forearm.

The brachioradialis is closely related to its companion supinator muscle, the extensor carpi radialis longus, which originates with the lateral ridge of the lower humerus and inserts with metacarpal bone II on the radius side of the wrist (i.e., the side of the thumb). As the name suggests, this muscle extends the hand. Like the brachioradialis, it also supinates and flexes the forearm. Adjacent to the extensor carpi radialis longus, is the extensor carpi radialis brevis. Although it originates with the lateral epicondyle of the humerus and appears to run somewhat diagonally across the arm, this muscle inserts with the base of the metacarpal bone of the middle finger, providing little or no mechanical leverage to rotate the hand, and consequently its chief function is to assist the extensor carpi radialis longus in extending the hand.

Situated just below the extensor carpi radialis brevis are two forearm muscles known as the abductor pollicis longus and the extensor pollicis brevis.34 Their twisting configuration correctly indicates that they assist in supinating the forearm. Both originate with the back of the radius, though the abductor pollicis has an additional origin with the back surface of the ulna. The two muscles insert with the thumb bones, the abductor pollicis longus with the base of metacarpal bone I and the extensor pollicis brevis with phalanx I of the thumb (Figure 7-32). Both muscles abduct the thumb (that is, pull it away from the midline) and pull it up towards the back of the hand. The extensor pollicis brevis is attached to the base of the first thumb phalanx and also extends the thumb.35 The tendons of these muscles are indistinguishable in the metacarpal area, but there is a more visible tendon close by, which stands out when the thumb is raised. This tendon belongs to the extensor pollicis longus, which is covered by the other extensors of the wrist (Figure 7-32). Arising from its origin with the shaft of the ulna, this muscle inserts with the thumb's second (distal) phalanx. The chief action of this muscle is to abduct the thumb.

The radiating tendons conspicuous on the back (dorsal) of the hand belong to a set of muscles called extensor digitorum communis (Figure 7-36). Its origin with the lateral epicondyle of the humerus is concealed by the brachioradialis and the extensor

carpi radialis longus. Inserting with the phalanges of all fingers except those of the thumb, the extensor digitorum is a powerful extensor of the hand and fingers. The extension of the little finger is assisted by a separate but closely related muscle that parallels the extensor digitorum in its upper reaches, the extensor digiti V proprius (Figure 7-36). Differing only in its insertion, this muscle is essentially a part of the extensor digitorum, which separates above the wrist to form the distinct tendon of the little finger. Close to the extensor digitorum is the extensor carpi ulnaris, an extensor muscle that also pulls the hand toward the ulnar side of the arm. Leverage for these functions is provided by its origins

with the lateral epicondyle of the humerus and the dorsal surface of the ulna. It inserts with metacarpal V of the little finger. Near the proximal end of the extensor carpi ulnaris is the *anconeus*, a small muscle that slips diagonally from its origin with the lateral epicondyle of the humerus to its insertion with the dorsal surface of the ulna at the proximal end. At this point it appears as a continuation of the ulnar crest noted earlier. The anconeus is an extensor only of the forearm.

All of the superficial flexor-pronator muscles of the forearm have prime origins with the medial epicondyle of the humerus, a knob that projects further than the lateral epicondyle on the other side of the

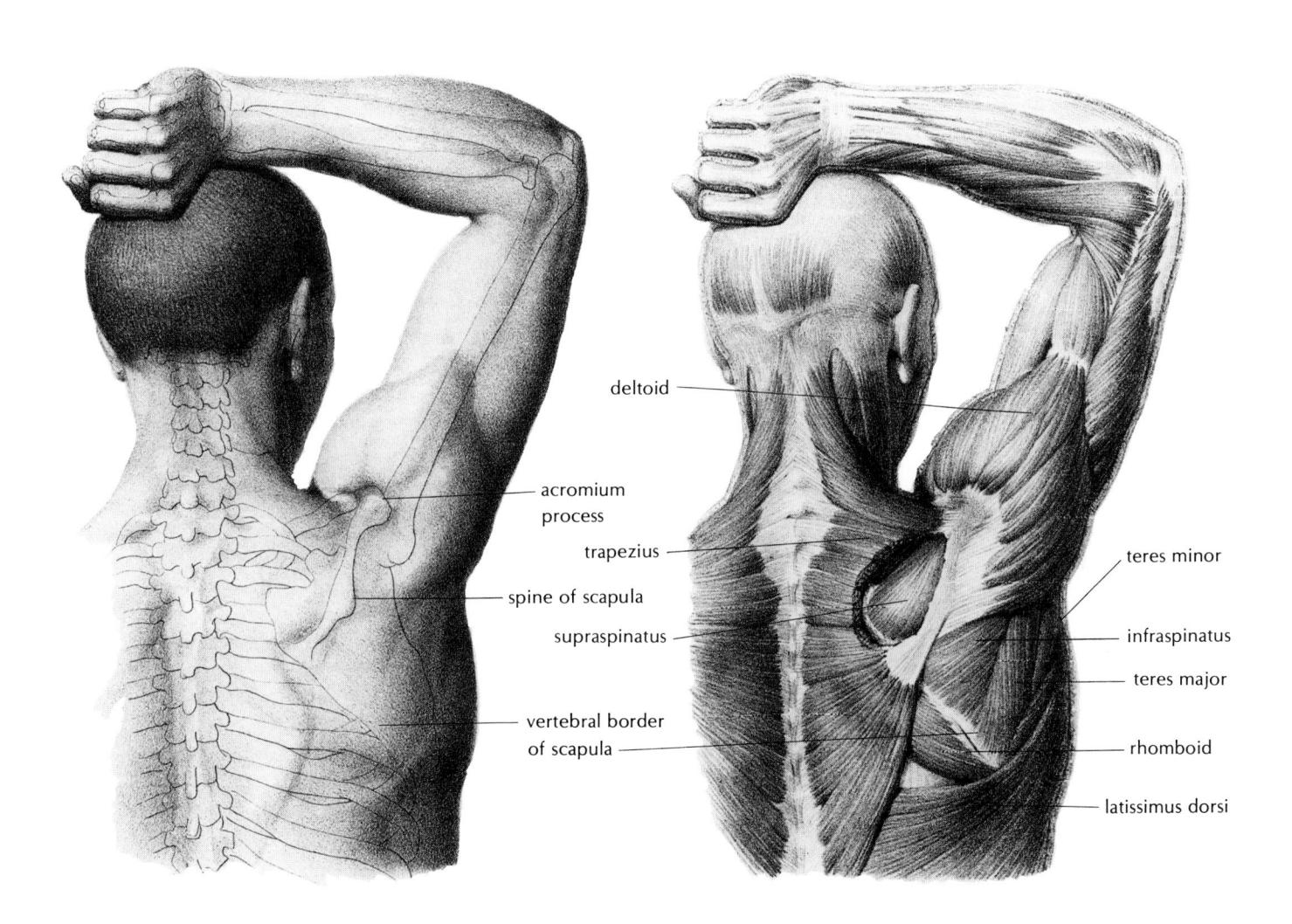

7-38. Skeletal and muscular structure of the flexed and raised arm and shoulder, as seen from behind. (Dr. J. Fau, *The Anatomy of the External Forms of Man* [London: Hippolyte Bailliere, 1849], plate 17. Courtesy of Countway Library, Harvard University.)

humerus. The additional projection provides the flexor-pronator muscles with the mechanical advantage that is apparent in the grasp (or flexion) of the human hand. The weaker action of extension is thought to be a consequence of the relatively poor leverage of the shorter lateral condyle.³⁶ The flexor-pronator muscles are situated largely on the medial side of the forearm beyond the ulnar crest; when the hand lies in the prone position, they form the underbelly of the forearm (Figure 7-32, lower right).

The muscle immediately below the ulnar crest in the pronated forearm is the *flexor carpi ulnaris*, the lateral border of which runs along the ulnar crest just opposite the extensor carpi ulnaris. The muscle arises from two heads, one attaching with the medial condyle of the humerus and the other with the inner margin of the olecranon. By means of a tendinous fascia it also originates with the upper portion of the posterior border of the ulna. The

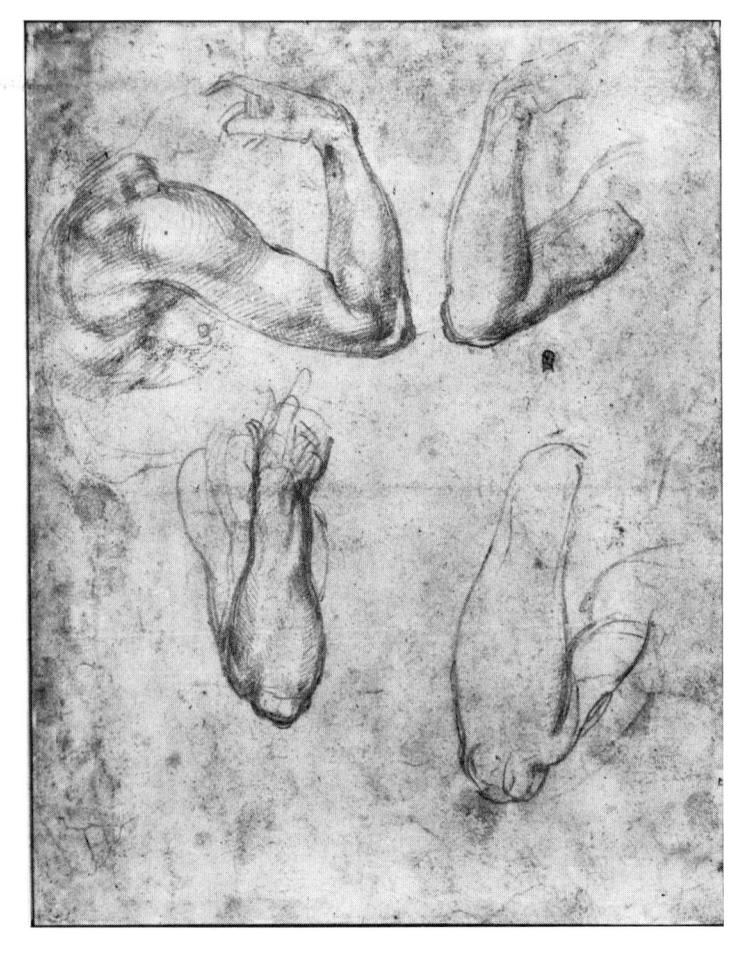

7-39. Michelangelo Buonarroti, *Study of arms* (1524–27). Natural red chalk with touches of black. 258 × 332 mm. Oxford, Ashmolean Museum. Believed to be drawn from life, these studies were probably preparations for the allegorical sculptures of *Night* and *Day* on the sarcophagus of Giuliano de Medici in Florence. The projecting forms at the elbow and wrist provide a skeletal basis for the modeled contours of the muscles. The olecranon process of the ulna and the epicondyles of the humerus are apparent in this study.

lower half of the muscle consists of a tendon that inserts with the pisiform bone of the wrist (Figure 7-32), enabling the muscle to flex the wrist.³⁷ The action of the flexor carpi ulnaris is apparent when the little finger presses downward against a surface while the hand is prone. The resulting tensed muscle raises the tendon on the side of the wrist beneath the ulna.

When the hand is flexed against resistance, another tendon may be visible near the center of the wrist on the palm side. This belongs to a long muscle called the *palmaris*, which inserts with the aponeurosis of the palm (thus its name). Like other pronating and flexing muscles, the palmaris originates with the medial epicondyle of the humerus.³⁸

Beside the palmaris is another pronator-flexor muscle with the same origin, the *flexor carpi radialis* (Figure 7-35). It runs the entire length of the forearm and forms a groove with the brachioradialis. The long tendon of this muscle disappears from view at the wrist beneath the annular ligament to reach its insertion with the base of metacarpals II and III. The muscle's name derives from its function as a flexor of the radial side of the wrist; it is clearly visible at this point when tensed.

Situated between the flexor carpi radialis and the brachioradialis is the *pronator teres*, a muscle that runs diagonally from its origins at the medial epicondyle and the coronoid process of the ulna to its insertion as a flat tendon with the middle of the outer surface of the radius. True to its name, the pronator teres rotates the radius over the ulna, causing pronation, and, when the radius is fixed, assists in flexing the forearm.

Three other muscles of the inner forearm that function primarily as flexors are the flexor carpi ulnaris, the flexor digitorum (sublimis), and the flexor pollicis longus. All three contribute to shaping the contour of the inner side of the forearm, a contour that is smooth and regular in comparison with that of the dorsal side. These contrasting contours are counterpointed in a study by Dürer (Figure 7-33). The strongest of the three muscles is the flexor digitorum. Situated between the palmaris and the flexor carpi ulnaris, this broad muscle originates with the medial epicondyle of the humerus, the ulnar tuberosity, and the anterior surface of the radius (Figure 7-33). In its lower reaches it splits into four separate bands of muscle, which join with tendons. These tendons, tightly gathered at the wrist, pass under the carpal bones to their insertions in the middle phalanges of the fingers (but not the thumb). Despite the breadth of the flexor digitorum it is more important for its effect on the total shape of the inner forearm than for its superficial aspect, for very little of it is not covered by other muscles. The flexor pollicis longus, which assists in flexing the hand and raising the thumb, is also largely covered by other muscles and likewise contributes to the form of the muscles that lie over it (Figure 7-33).

The individual muscles of the hand are of doubtful importance for drawing purposes. Many are either very small or covered by tendons, as is the case with the back of the hand. Two muscle groups of the palm, however, do merit the draftsman's attention: the *thenar* muscles of the thumb and the *hypothenar* muscles on the ulnar side of the palm (Figure 7-33). These two groups, which consist of seven smaller muscles, form the padlike bodies on the outer and inner sides of the palm. Both groups origi-

nate in the carpal ligament (the front portion of the annular ligament that encircles the wrist). The thenar group inserts with the thumb at metacarpal I and at the first phalanx; the hypothenar group, with the little finger at the base of its first phalanx and with metacarpal V of the little finger. With these attachments the thenar and hypothenar muscle groups are well situated to draw the thumb and the little finger, respectively, toward the center of the hand. This movement, called *adduction*, is important in grasping, a hand function that produces some of the superficial folds of the palm (Figure 7-34).

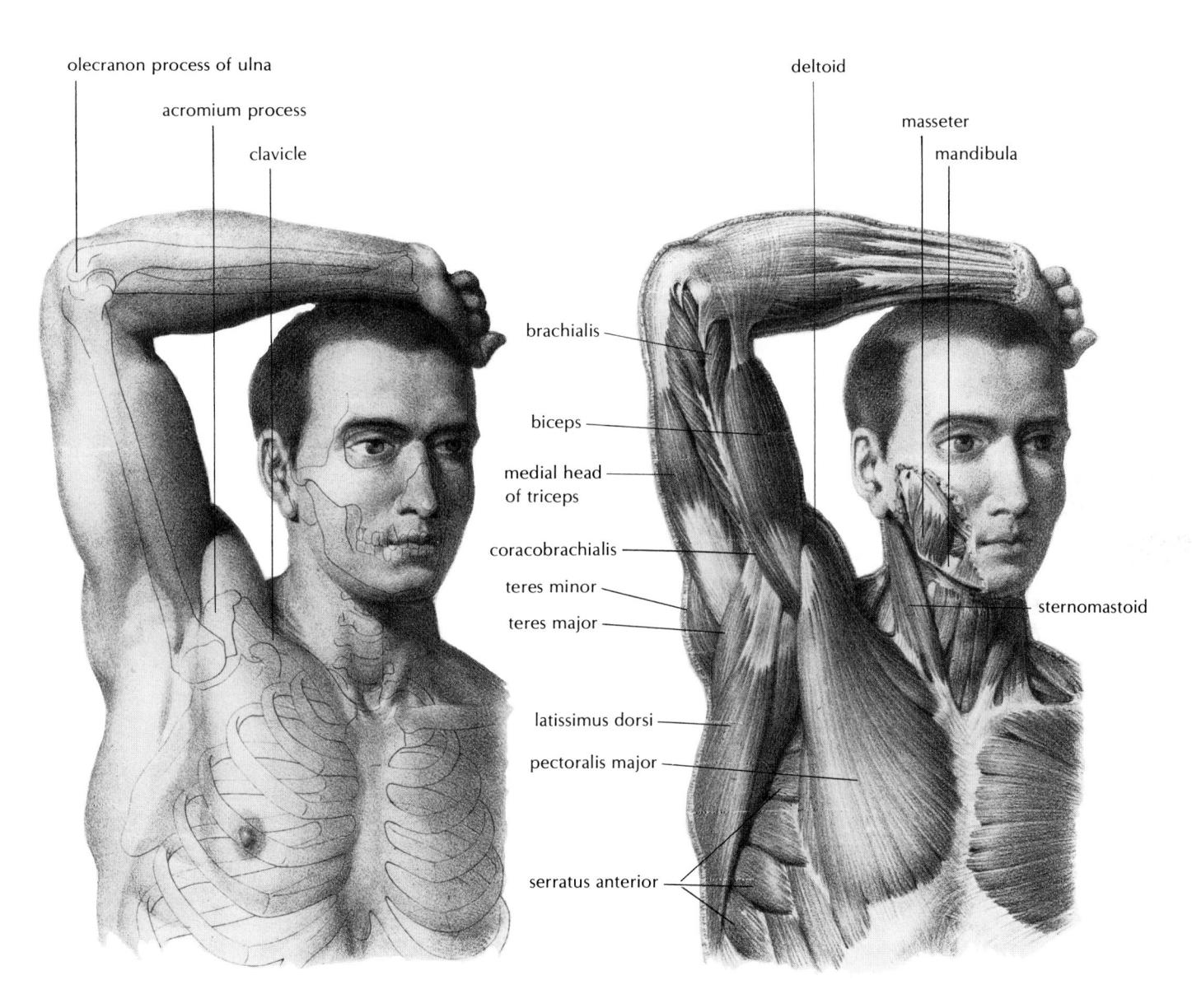

7-40. Skeletal and muscular structure of the arm and shoulder, front view. Compare with Figure 7-38. (Dr. J. Fau, *The Anatomy of the External Forms of Man* [London: Hippolyte Bailliere, 1849], plate 17. Courtesy of Countway Library, Harvard University.)

THE LOWER LIMB MUSCLES

The lower limb generally presents a stronger but less mobile structure of bone and muscle than that observed in the arm. Despite similarities of skeletal structure in the two limbs there are significant differences, particularly in the joints of the bones, which account for the visible distinctiveness of the limbs. The sturdy hip joint of the femur and the pelvis does not permit the free-ranging movement observed in the shoulder joint with the humerus and the scapula. The leg's fibula also lacks the cusp-type joint that enables its counterpart in the arm, the radius, to rotate around the ulna. The consequences of these skeletal differences will become clearer as you examine the nature and functions of lower-limb musculature.³⁹

STUDY 43. THE MUSCLES OF THE LOWER LIMB

Materials: 11"-x-14" sketchbook

drawing pen (0.5 mm point)

india ink HB pencil

sanguine pencil

11"-x-14" tracing paper

transparent tape

Reference: model and Figures 7-41, 7-42,

7-43, 7-44, 7-45, 7-46, 7-47, and

7-48

Suggested time: 15–20 minutes for each life study,

20 minutes for each overlay study of the skeletal leg, and 30 minutes for each overlay

study of the muscles

In order to gain a clear idea of the leg's muscle structure, it is helpful to prepare a series of life studies in which the lower limb is seen from several points of view. Although these need not be highly developed drawings, they should include views of the back, the front, and the sides of the leg. In drawing from life try to observe and draw any superficial landmarks that reveal skeletal structure in the lower portion of the body (Figure 7-12). For example, the points of the pelvis (the anterior-superior iliac spines), if drawn, can be used later as references not only in the skeletal study but also in the muscle study, for they are sites of important muscle attachments in the lower limbs. The same is true for the prominences of the great trochanters on the sides of the hips. Further down the limb are other skeletal landmarks, among them the kneecap, the head of the fibula, the heel bone (calcaneus), and the ankles (lateral and medial malleoli). Your previous experience in drawing the skeleton can assist you in perceiving such bony landmarks and, more important, the skeletal structure that they imply.

From this series of drawings select three that best illustrate different views of the lower limb. Tape a sheet of tracing paper over each of the selected drawings. The tracing-paper overlay serves as the surface for a pencil rendering of the bones of the lower limb as they would appear in the original life study. In addition to drawing the bones of the limb proper it is important to render the pelvis and a general suggestion of the bones of the foot. Special attention should be paid to the bony formation of the joints, where the raised surfaces of epicondyles and tuberosities form important sites of muscle attachments. After completing the overlay drawings of the lower skeleton do studies of the leg muscles, based on the original life drawing, on a second tracing-paper overlay, using sanguine pencil. For this purpose the anatomical illustrations of the lower limb in this chapter are especially helpful, as they show the skeletal and muscle structure as well as an external view of the same figure.

The study of the lower-limb muscles is simplified by a natural division into distinct groups with special functions. Viewed from the front, the thigh reveals two basic muscle groups: the extensors, located on the front (anterior) side; and the adductors, on the inner (medial) side (Figure 7-41).

The four extensor muscles of the thigh share a common insertion with the kneecap (patella) and can be visualized as one muscle with four heads (quadriceps). Together they pull the kneecap upward. The force of this movement is transmitted by the patellar ligament to the front of the tibia, resulting in a forward swing of the leg, used, for example, in kicking.

Foremost in the extensor group is the *rectus* femoris, an elongated muscle rising from a band of tendon that attaches to the patella and indirectly with the tuberosity of the tibia (Figure 7-41). It joins the pelvis near the acetabulum at the anterior-inferior iliac spine, a site shared with the iliofemoral ligament. The pelvic attachment, unique in this extensor group, endows the rectus femoris with the special function of flexing and abducting the thigh (i.e., raising and drawing outward the femur, hence the muscle's name) as well as that of extending the knee. The rounded bulk of the muscle is largely superficial and contributes directly to the profile contour of the front of the thigh.

The rectus femoris lies over the three adjoining vastus muscles, two of which are visible on each side of the former: the *vastus medialis* on the inner side of the thigh and the *vastus lateralis* on the outer. Like their companion muscle, the *vastus intermedius*, which lies hidden beneath the rectus femoris, they originate in the upper portion of the femur. Seen as a group, the vastus muscles and the rectus femoris have a characteristic teardrop form (Figure 7-41, center).

Between the extensor group and the adductor group is a muscle that belongs to neither category, the *sartorius*. This straplike muscle, clearly seen in a drawing by Michelangelo (Figure 7-42), is the longest muscle of the body.⁴⁰ Originating with the anterior-superior iliac spine of the pelvis, it reaches down around the inner side of the thigh before inserting on the upper medial surface of the tibia. This curious arrangement enables the sartorius to rotate the thigh as well as to flex and abduct it, thus assisting in crossing the legs.⁴¹

Beyond the sartorius on the inner side of the leg next to the crotch is a group of muscles responsible for the adduction of the thigh (that is, pulling the thigh inward toward the midline of the body). As a group the adductors extend from the inner side of the femur to parts of the pelvis near the midline of the body (i.e., the pubic ramus and the tuberosity of the ischium).42 Individual muscles of this group are seldom apparent in life, but together they make a continuous rounded form on the inner side of the thigh above the sartorius (Figure 7-41). The innermost of the adductor group is the gracilis, a muscle that descends from its origin with the lower surfaces of the pubis and the ischium to its insertion with the tibia immediately behind the tendon of the sartorius. Other muscles of the group are the adductor magnus, the adductor longus, and the pectineus. These muscles fan out from the front of the pelvis on either side of the symphysis pubis in the direction of their respective insertions with the femur.⁴³

Certain muscles of the thigh are more fully displayed when the lower limb is viewed from the outer side (Figures 7-43 and 7-44). Among these is the tensor fasciae latae, a short, thick muscle that branches upward diagonally from the top of a wide strap of fascia called the iliotibial band.44 Rising diagonally from the back portion of the band is the gluteus maximus, a hip muscle that originates with the lower sides of the sacral triangle—the border of the sacrum and coccyx and part of the posterior of the ilium (Figure 7-48). The fascial strap spans most of the side of the thigh down to its insertion with the tibia on the outer tuberosity near the knee joint. The wide band conveys the force of both muscles to the lateral side of the tibia. A visual side effect of the tension of the iliotibial band is the compressing or flattening of the muscles on the side of the thigh, in particular the vastus lateralis. Contraction of the tensor fasciae latae alone can assist in flexing the thigh as well as in abducting and rotating it inward. The gluteus maximus, on the other side of the band, works in opposition to the tensor fasciae latae by extending the thigh backwards, adducting it, and rotating it outward. The gluteus maximus inserts not only with the iliotibial band but also with the femur, where it has extensive attachments on the posterior surface below the great trochanter.

Through these attachments the muscle acts as a powerful extender of the thigh. When one rises from a sitting position, the gluteus maximus helps straighten the thigh, enabling the body to assume an erect posture. Like the sacrospinalis, the gluteus maximus "plays an important part in the act of walking, as it supports the trunk on the limb which is in contact with the ground during the same time that the opposite foot is uplifted."45

In drawing the gluteus maximus on the overlay you may notice that its lower border does not correspond closely with the crease below the buttock observed in life. The crease, or gluteal furrow, tends to be more horizontal in the standing figure, while the border of the muscle is on a diagonal with the thigh (Figure 7-46). This is due to the accumulation of fat that generally pads the lower, inner border of the muscle and to the gluteal band of fascia that supports the fat and causes the crease.

The space between the gluteus maximus and the tensor fasciae latae exposes part of another muscle of the buttock: the gluteus medius. From a tendinous insertion with the great trochanter this muscle spreads in a radiating pattern to its origins along the back of the ilium of the pelvis, extending from a position near the posterior-superior iliac spine in the back of the anterior-superior iliac spine in the front (Figure 7-43).46 The muscle thus lies over most of the back of the hipbone. Because of its insertion with the outer side of the great trochanter the gluteus medius is an abductor of the thigh, capable of drawing the legs apart. While the muscle is in use or tensed, it is visible in the body. In a study by Michelangelo the tensed gluteus medius appears as an elevation above the region of the gluteus maximus (Figure 7-45).

The posterior profile of the thigh is formed by the biceps femoris, one of a group of three flexors in the leg. From a single insertion with the head of the fibula on the outer side of the leg the muscle rises up the back of the thigh. The tendon of insertion is easily detected near the knee when the biceps femoris is tensed. Like the biceps of the arm, the biceps femoris has two heads, each with a different origin. The long head of the biceps femoris, superficial for most of its length, disappears from view under the lower border of the gluteus maximus, beneath which it joins the pelvis at the ischial tuberosity below the acetabulum. The short head, visible only in the lower side of the thigh, tucks under the vastus lateralis before reaching its origin with the back of the femur along a ridge called the linea aspera, or rough line (Figure 7-46). The short head is the smaller muscle of the biceps. With its double origin, the biceps femoris is capable of assisting in a variety of actions: flexion of the leg, adduction of the thigh, extension of the thigh backwards, and, due to its insertion on the outer side of the tibia, rotation of the leg outward.

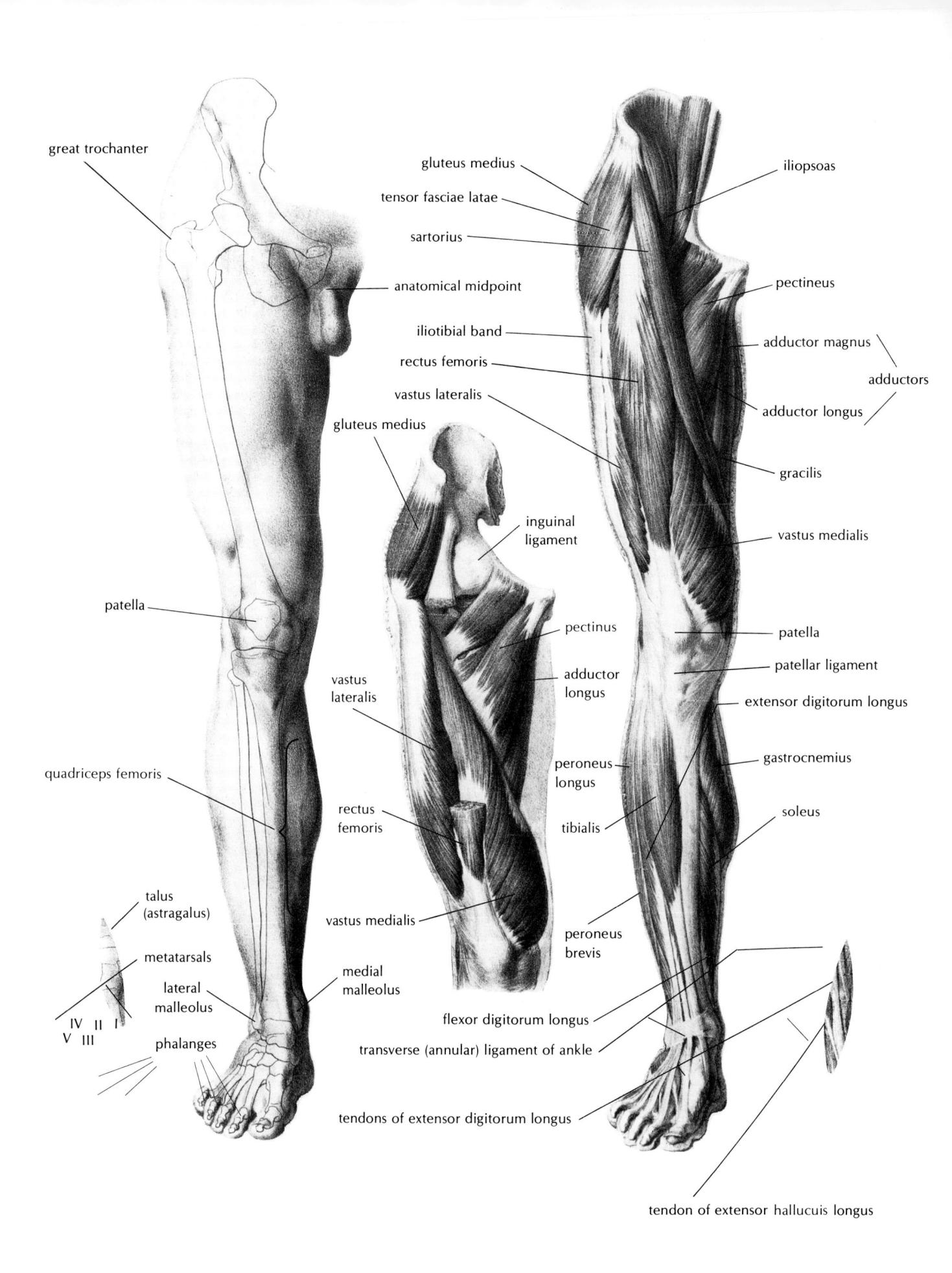

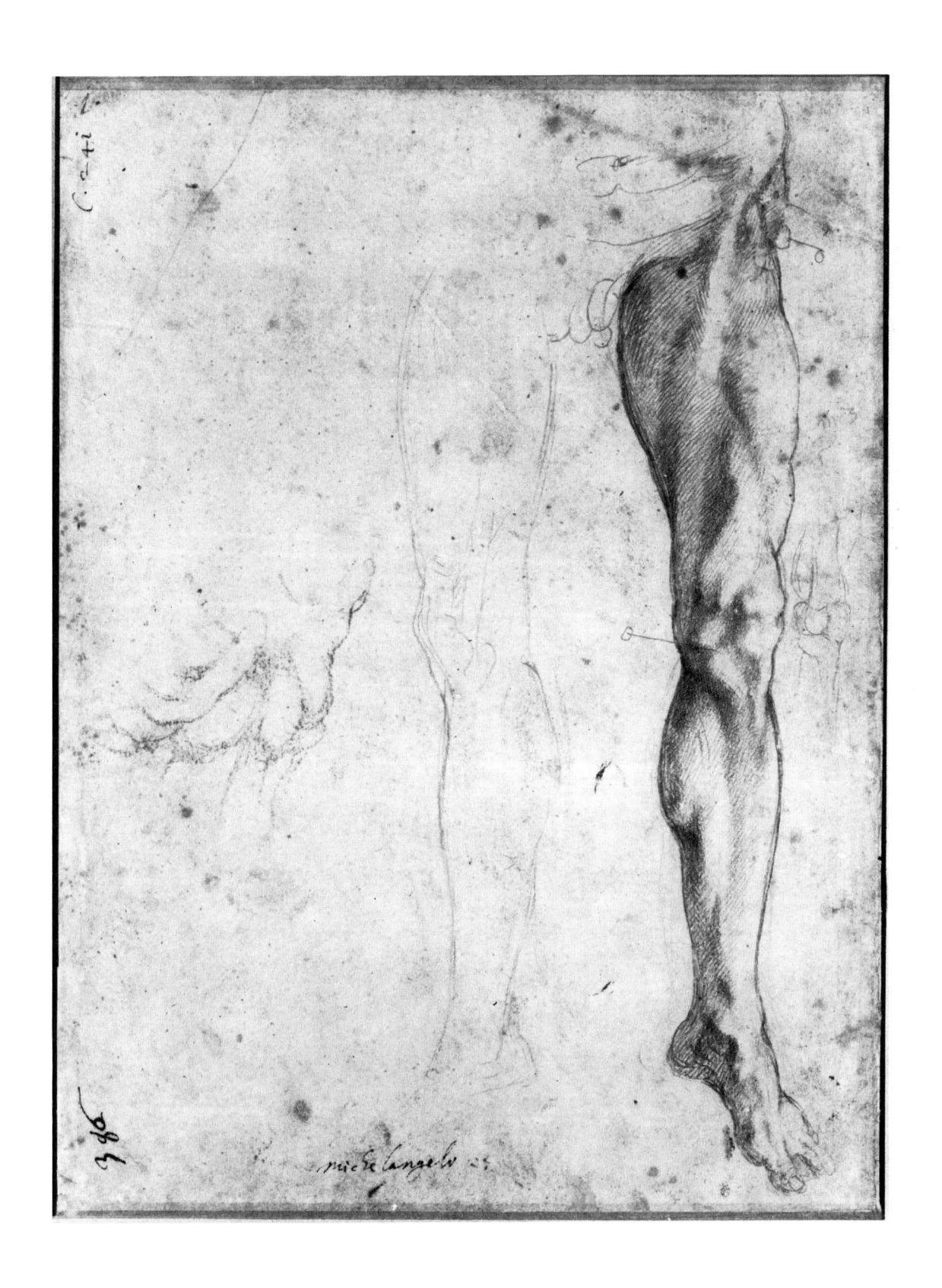

7-41. Skeletal and muscular structure of the lower limb. (Dr. J. Fau, *The Anatomy of the External Forms of Man* [London: Hippolyte Bailliere, 1849], plate 18. Courtesy of Countway Library, Harvard University.) The rectus femoris, sartorius, and gracilis muscles are excised in the central illustration in order to expose the deeper muscle forms, notably the vastus and the adductor muscles. The rendering of the femur (*left*) reveals the remarkably off-center diagonal thrust of this bone, which is reflected in the muscle structure of this region. Compare with Figure 7-42.

7-42. Michelangelo Buonarroti, *Studies of a man's leg*, 1515–20. Natural red chalk. 212 × 283 mm. Oxford, Christ Church. Pinlike marks on this drawing indicate bony protuberances just below the skin, as that indicating the head of the tibia in the modeled study just left of the knee. Another mark on the upper right indicates the protuberance of the great trochanter. The pelvic attachments of the sartorius and the tensor fasciae latae are especially clear in this study. Compare Figure 8-8.

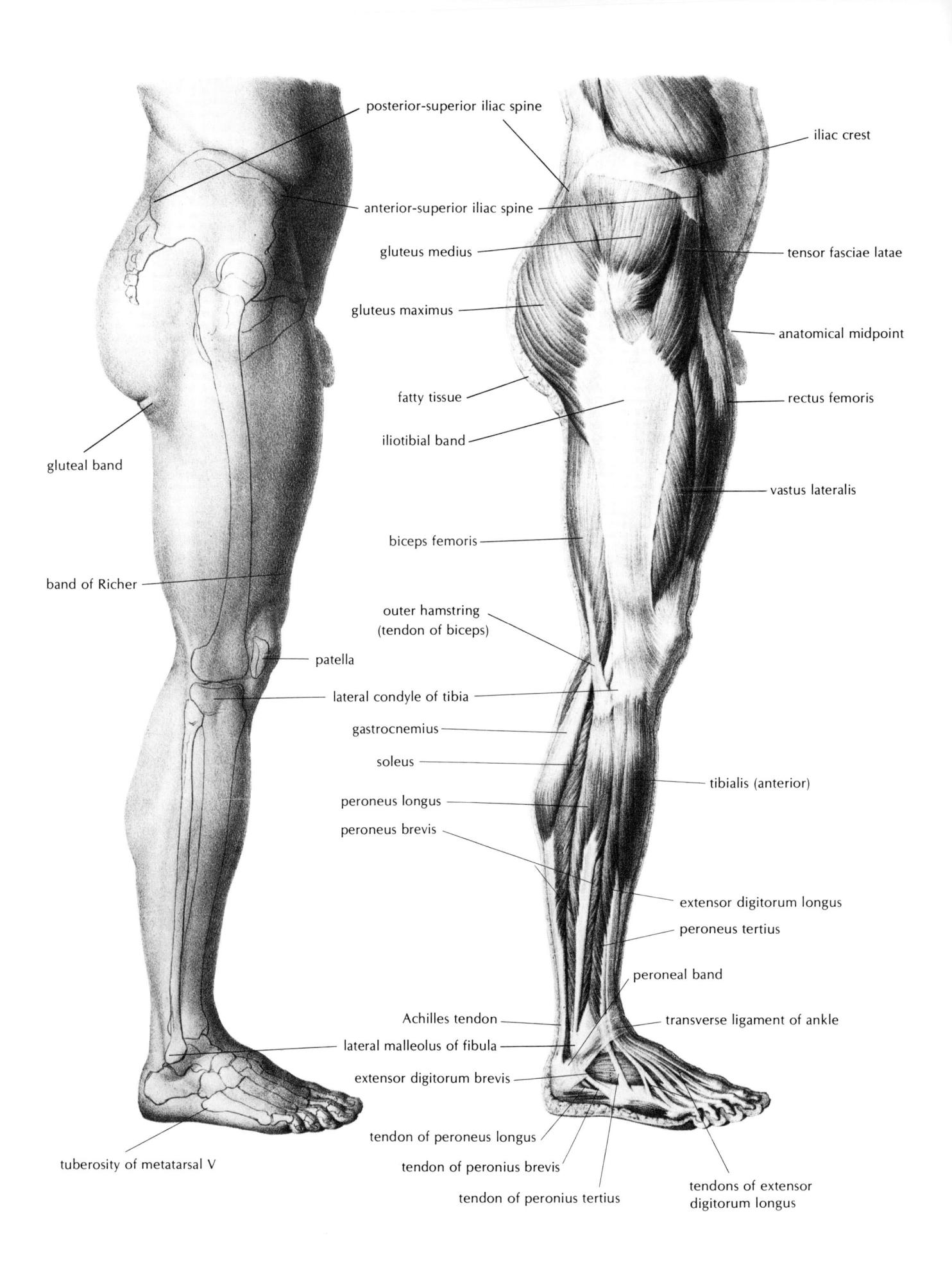
The columnar verticality of the flexor-muscle group contrasts with the convex muscle formation of the front of the thigh. The flexor group appears as a pair of muscles that runs along the length of the posterior thigh but separates above the knee into tendons that reach opposite sides of the leg, where they insert with the tibia and the fibula. The inner flexor is the semitendinosus (so called because its lower half consists of tendon), which inserts with the tibia at the medial inner condyle. The semitendinosus lies directly over another flexor of the leg, the semimembranosus. Narrow portions of the latter, however, are visible on either side of the overlapping semitendinosus (Figure 7-48). The tendon of the semimembranosus reaches downward to its insertion with the inner tuberosity of the tibia, next to the insertions of the sartorius and the gracilis.

The insertion tendons of the flexors are called hamstrings after the ham, the hollow space behind the knee between the tendons.⁴⁷ The hollow becomes evident when the knee is bent. When the knee is straightened, the hollow disappears, replaced by a bump or swelling caused by fatty tissues behind the knee. Wrapping around the back of the knee, a horizontal band of fascia48 somewhat like a natural garter assists in strengthening the knee joint. It corresponds roughly to the crease that crosses the ham, usually visible on the back of the knee. (The slight bump above the fascia is caused by the inner portion of the semimembranosus.) It should be noted that the flexor group flexes the leg, not the thigh. The same muscles, however, do extend the thigh backward. Extension of the thigh is an indirect action on the part of these muscles, 49 which, except for the short head of the biceps femoris, are not attached to the femur. The flexor muscles, even when relaxed, control flexion at the hip joint: a person with tight hamstrings may not be able to touch his toes without bending his knees.50

Unlike the flexor muscles of the thigh, which are usually not pronounced, those of the leg dominate the form of this part of the limb and contrast markedly with the bony anterior surface. The most prominent and superficial of the leg flexors is the *gastrocnemius*, or calf muscle.⁵¹ The two bodies of this muscle give rise to two heads, which disappear under the hamstrings to origins above the posterior surfaces of the condyles of the femur. The lower edges of the two muscle bodies form the straplike *Achilles tendon*, which inserts with the calcaneus (heel bone). Considered the strongest tendon in the body,⁵² the

7-43. Side view of the skeletal and muscular structure of the lower limb. (Dr. J. Fau, *The Anatomy of the External Forms of Man* [London: Hippolyte Bailliere, 1849], plate 21. Courtesy of Countway Library, Harvard University.) The characteristic tapering of the leg is due to the preponderance of muscle bodies in the calf region and the less bulky tendons of these bodies in the lower region. Compare with the similar change of form in Figure 7-33.

Achilles tendon is shared with another flexor, the soleus, a flat muscle that lies under the gastrocnemius and originates with the upper third of the tibia and the fibula. Some texts consider the soleus and the gastrocnemius to be merely different heads of a single muscle.⁵³ Seen from the lateral side in a study by Michelangelo (Figure 7-45), the gastrocnemius appears as a distinct profile contour over the soleus. Viewed from the back (Figure 7-48), the bodies of the gastrocnemius exhibit a characteristic asymmetry, with the prominence of the inner head slightly lower than that of the lateral head. Contraction of the gastrocnemius and the soleus can result in a simple lever action in which the calcaneus pivots on the fulcrum of the ankle, causing the front of the foot to flex downward (plantarward) in an attitude familiar in classical ballet. Because the gastrocnemius originates with the femur, it is also able to flex the leg, an indirect action.

In order to complete a survey of the major leg muscles, the view from the front of the lower limb (Figure 7-41) should be considered. The tibia is an invaluable reference for structuring a drawing of these muscles. The inner front facet of the bone shaft is bare of muscles, and the bone lies just beneath the skin. The outer facet of the tibia, however, is covered with a muscle appropriately named the tibialis. The head of this muscle originates with the upper tibia, the lateral condyle of the tibia, and the fascial membrane between the tibia and the fibula. The tendon of the tibialis, which appears halfway down the leg, extends downward and inward to the inner side of the foot, where it curves under to insert with the inferior surfaces of the foot bones (specifically, cuneiform I and the base of metatarsal I of the big toe). The tibialis is a flexor of the foot. If you raise (flex) the front of your foot upward, you can easily locate it by. touching the frontmost part of your leg. With its insertion on the inner side of the foot, the tibialis also inverts the foot, acting as an antagonist to a set of muscles with tendons that reach around the opposite (outer) side of the foot, the peroneus muscles.

The two main peroneus muscles appear on the outer (lateral) side of the calf next to the soleus (Figure 7-43). When the leg is extended (straight), the tendinous origin of the peroneus longus with the head of the fibula appears to be a linear continuation of the hamstring tendon of the biceps above it. The peroneus longus has a second origin with the upper lateral surface of the tibia; the muscle generally parallels the direction of the tibial shaft. The lower lateral surface of the tibia serves as the origin of the peroneus brevis, a smaller muscle that is almost completely covered by the peroneus longus. The insertion tendons for both peroneus muscles are strung around the back of the lateral malleolus (the outer ankle) and strapped in place by a band of fascia (the peroneal band), one of several annular (ringshaped) ligaments in this region (Figure 7-43). Beyond

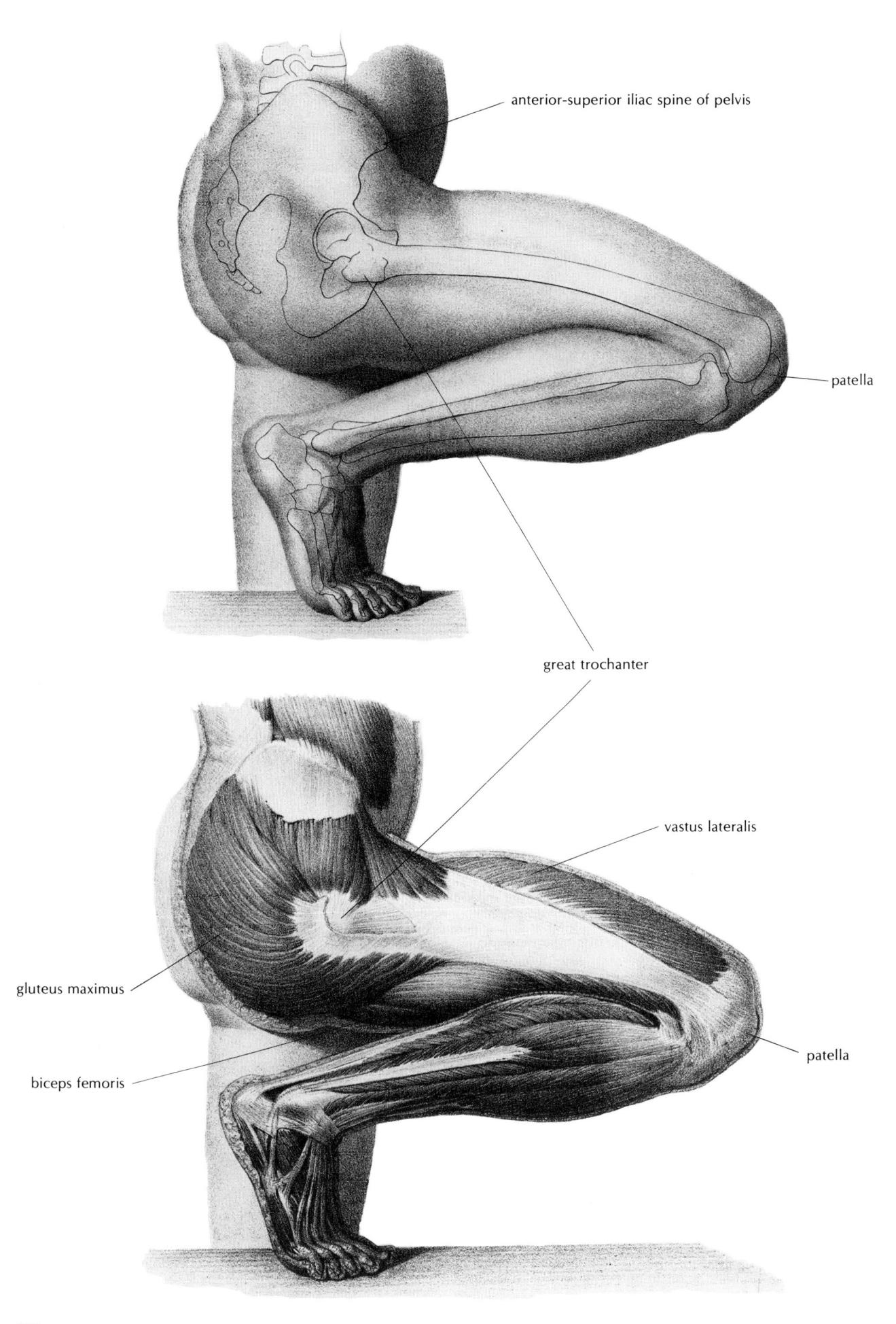

the outer malleolus, however, the tendons turn forward, forming an angle with each other before reaching their separate insertions with the underside of the foot. This arrangement enables the peroneus muscles to assist in flexing the foot (downward). The peroneus longus slips under the foot to reach its insertions with bone surfaces on the sole (plantar) of the foot, specifically with the internal cuneiform and the base of the metatarsal bone of the big toe. The peroneus brevis joins with a tuberosity of metatarsal V of the little toe. These insertions enable the peroneus muscles to lift (evert) the outer side of the foot.54 If you raise the outer side of your foot, you can see that the peroneus muscles are tense and raised on the lateral side of the leg and that the tendons are visible below the outer ankle. This tension opposes that produced by the tibialis, the antagonist of the peroneus. When both the tibialis and the peroneus muscles are tensed, their antagonism helps to support the foot's arch as well as to fix the position of the leg upon the foot, especially if the body rests on only one foot.55

The band of muscle lying between the peroneus and the tibialis is the extensor digitorum longus. Superficial for most of its length, it originates with the outer (lateral) condyle of the tibia, the shaft of the fibula, and the ligament between the bones, or interosseous membrane (Figures 7-41 and 7-43).56 Approximately midway between the knee and the ankle the extensor digitorum longus forms a tendon that passes under the transverse (annular) ligament in front of the ankle, where it divides into the individual toe tendons, except for the big toe (Figure 7-43). These spread in a radiating pattern to reach their insertions with the toes on the upper (dorsal) sides of the phalanges.57 This pattern, not unlike that on the back of the hand, becomes clear when the toes and foot are extended (raised upwards). This movement raises an additional tendon, that of the extensor hallucis longus, the extensor muscle of the big toe (Figures 7-41 and 7-46).58 Originating with the midsection of the fibula and with the interosseous membrane between the bones of the leg, the extensor hallucis longus is covered by the extensors of the toes and by the tibialis muscle. It is superficial, however, as a tendon above and below the transverse ligament of the ankle, where it lies between tendons of the extensor digitorum longus and the tibialis. From the front of the ankle the hallucis-longus tendon extends to the top (dorsal) surface of the big toe, reaching its insertion with the last phalanx of that extremity. Both the extensor digitorum longus and the extensor hallucis extend (straighten and raise) the toes and, when this action is continued, flex the foot upon the leg.⁵⁹ They also abduct and evert the foot because of their position on the lateral (outer) side of the leg.

In opposition to the extensors of the toes is the flexor digitorum longus, a muscle that is superficial in the lower third of the leg on the medial side (Figures 7-41 and 7-46). Originating along the back surface of the tibia, the flexor digitorum longus is largely concealed by the soleus and gastrocnemius muscles, though it is partially superficial in the lower third of the leg above and behind the inner malleolus, where it fills some of the space between the Achilles tendon and the shaft of the tibia. Its tendon bends around the inner side of the calcaneus along a special groove before turning forward to pass under the sole of the foot, where it divides into four tendons that insert with the bases of the last phalanges of the four smaller toes. 60 The medial location of the flexor digitorum longus also enables this muscle to invert and abduct the foot. As is the case with the extensors of the toes, the big toe has a separate flexor muscle, the flexor hallucis longus, which arises from the back of the tibia and has a tendon that follows those of the other toe flexors in the groove of the calcaneus. The insertion of this tendon, with the underside of the final phalanx of the big toe, assists in flexing the foot (downward).

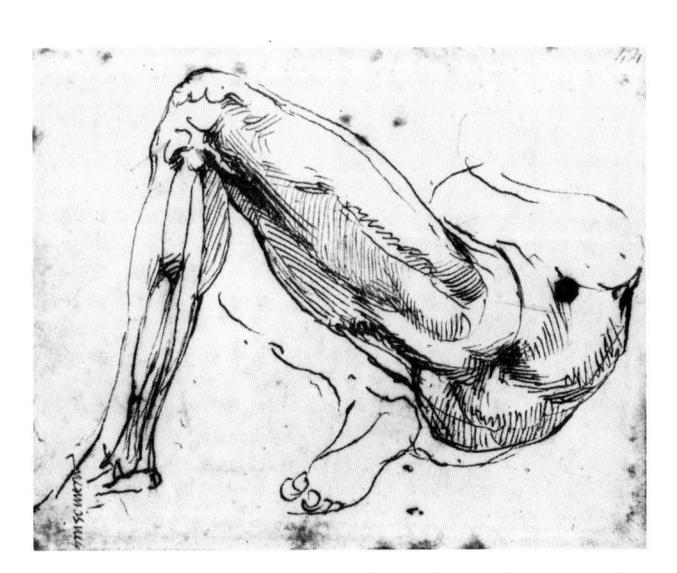

7-45. Michelangelo Buonarroti, *Study* (probably of a river god), c. 1525–30. Pen-and-ink. 14.5 × 19.3 cm. Florence, Casa Buonarroti.

^{7-44.} Skeletal and muscular structure of the flexed leg and thigh. (Dr. J. Fau, *The Anatomy of the External Forms of Man* [London: Hippolyte Bailliere, 1849], plate 22. Courtesy of Countway Library, Harvard University.) Compare with Figure 7-45.

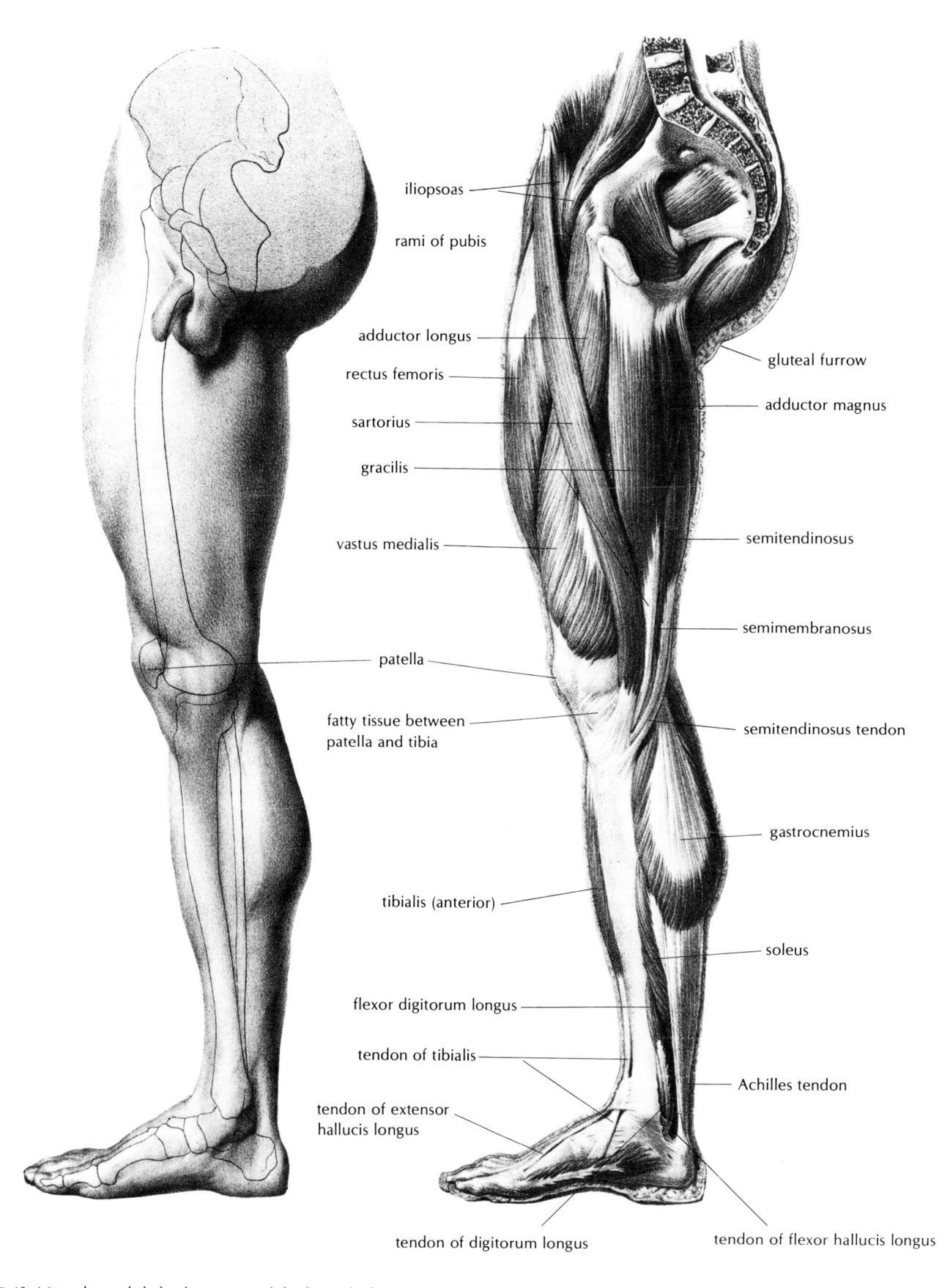

7-46. Muscular and skeletal structure of the lower limb, inner profile. (Dr. J. Fau, *The Anatomy of the External Forms of Man* [London: Hippolyte Bailliere, 1849], plate 20. Courtesy of Countway Library, Harvard University.)

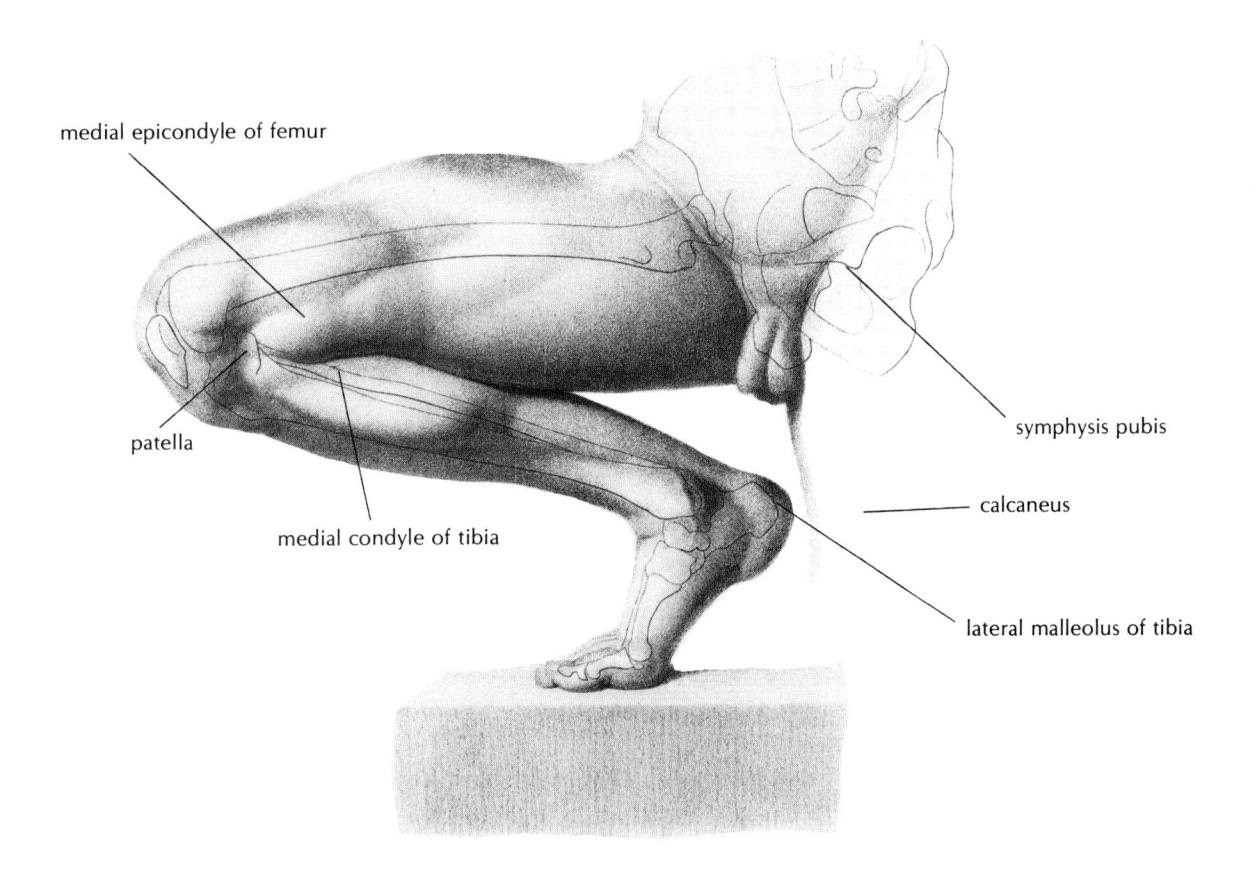

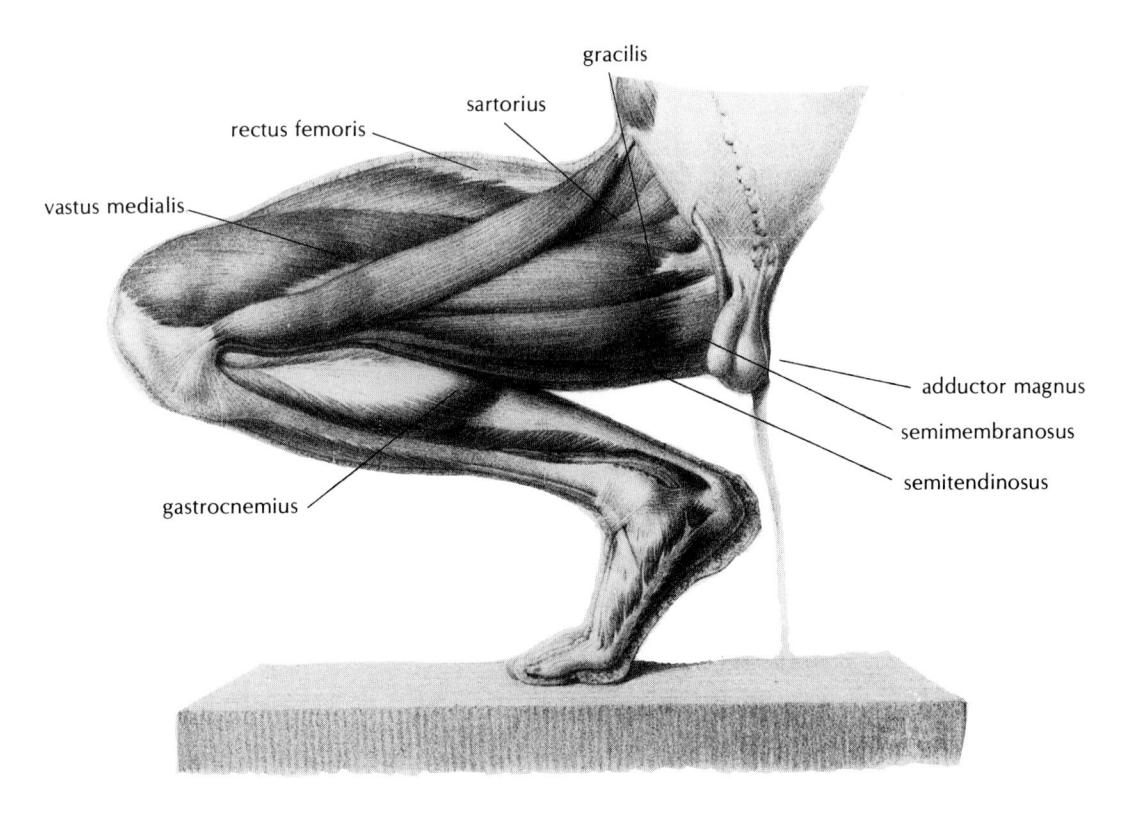

7-47. Inside view of the flexed lower limb. Compare with Figure 7-37. (Dr. J. Fau, *The Anatomy of the External Forms of Man* [London: Hippolyte Bailliere, 1849], plate 19. Courtesy of Countway Library, Harvard University.)

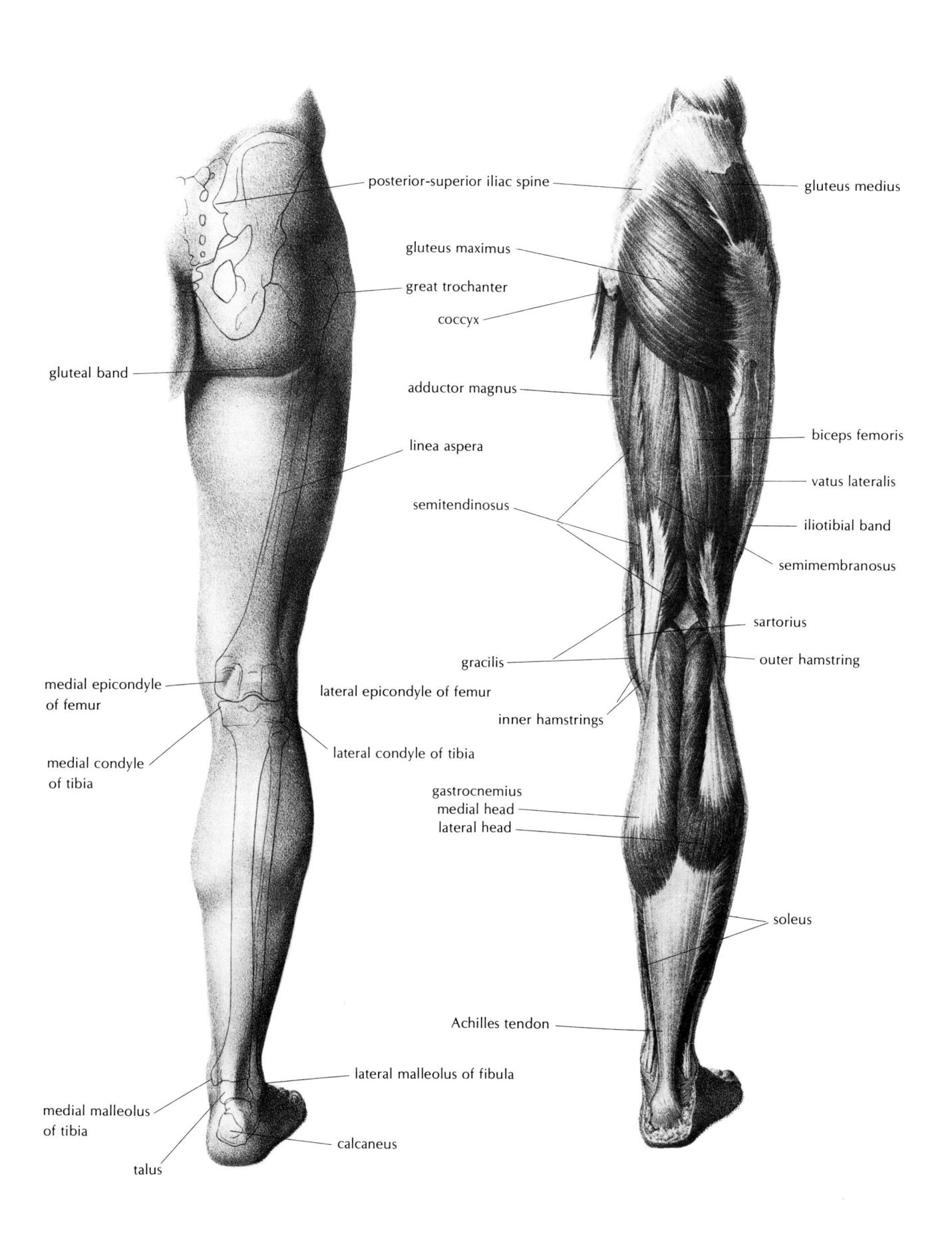

SUMMARY

Upon learning about the anatomical complexities of the leg and the foot a character in an Italian novel once became temporarily lame.⁶¹ There is little reason to fear that a study of anatomy, properly undertaken, may similarly cripple the artist, but a sense of mental reservation is inescapable, for, as Eakins once pointed out, anatomy as such is of no importance to the artist.⁶² Moreover, anatomical study has seldom directly influenced the direction of art; the notable exception is the Renaissance, a period in which the interests of art and science were especially close.⁶³

Such reservations suggest that anatomy be studied in a way that focuses on aspects more related to problems of contemporary art by stressing structural dynamics. The body's thrusts and tensions are similar if not directly related to those found in some abstract sculpture. An affinity to body construction is apparent, for example, in the work of the contemporary American artist Kenneth Snelson, whose sculpture, like the human body, depends on tension and thrust for support (Figure 7-49).

Despite the occasional application of anatomical principles to nonfigurative art the most direct application of anatomical study is in the figurative arts, in which the human form continues to be explored as a theme, as it has been throughout most of the history of art. The drawn figure is a poignant reminder that art is above all a human activity destined to be appreciated by fellow humans. As the British scientist Sir Julian Huxley once remarked: "... man alone can draw, or make unto himself a likeness. This then is the great distinction of humanity, and it follows that the most preeminently human of creatures are those who possess this distinction in the highest level." 64

7-48. Skeletal and muscular structure of the lower limb, seen from behind. (Dr. J. Fau, *The Anatomy of the External Forms of Man* [London: Hippolyte Bailliere, 1849], plate 19. Courtesy of Countway Library, Harvard University.)

7-49. Kenneth Snelson, Free Ride Home, 1974. Stainless steel and aluminum. New York. (Photo courtesy of the New York Times.) Though completely abstract in concept, this work depends on thrusts and tensions analogous to those of the skeletomuscular system for support. Without such tension, provided here by cables, the sculpture would collapse.

8. DRAWING AS PREPARATION:

The Development of Visual Concepts

... the true goal to attain is to discover amongst the mass of works produced in a given period those which contain principles of expression capable of furnishing men with the means of expressing and understanding themselves.—Pierre Francastel

Although drawing is now considered as a distinct form of visual expression embodying characteristic principles and methods, it can be misleading to study it as an isolated discipline. The historical role of drawing before the modern period was to assist in the creation of works in more permanent media. Few drawings, even in Renaissance times, were intended for public viewing: the overwhelming majority were thought of as personal artifacts, by-products

8-1. Anonymous Egyptian artist, *Drawing and unfinished relief of a princess*, c. 1365 B.C. Amarna, North Palace, late Eighteenth Dynasty. Limestone with drawing lines in black pigment. 23.5 cm high. Cairo Museum.

of the creative process. This attitude may account for the extraordinarily free, uninhibited quality of many master drawings and for their undisguised revisions and changes, made as the visual idea developed. Like working drafts of poems, with rewritten phrases and deleted mistakes, preparatory drawings can provide insights into creative processes that are sometimes masked in a finished work of art. Moreover, a comparison of preparatory drawings with their respective finished works may offer some insight into the nature of drawing itself. Such comparisons should ideally be made with original art instead of with reproductions, but this is often difficult if not impossible, because in some cases the original drawings have been separated geographically from the finished works. In other cases, however, the reasons for this situation are themselves related to the traditional use of drawing as a means of preparation.

Before paper became readily available, drawings were generally made directly on the surfaces to be painted or carved.² Preparatory drawings from ancient times are rare, as they were usually destroyed or obliterated by the finished work.3 A portion of an ancient drawing has been preserved on an unfinished stone relief from Amarna (Figure 8-1), which provides a tantalizing glimpse of figure drawing as it was practiced by an unknown Egyptian artist of the Eighteenth Dynasty. The seated female figure consists of a linear construction, drawn in large, swinging arcs deftly executed with calligraphic thickand-thin stress. This technique is especially apparent in the raised forearm of the figure, in which an arc continues beyond the form of the elbow into the surrounding negative space, suggesting a free, sophisticated drawing method. The function of the Amarna drawing may be inferred by examining the way in which the artist translated its painted lines into stone relief carving. The elegant calligraphic swells and thins of the brushstrokes reappear as linear shadows in the carved lower portion of the figure, the result of the Egyptian technique of sunken-relief carving. In the carved portion of this work the ground surrounding the

figure remains raised and uncarved, while the silhouette of the figure is deeply incised, capable of creating cast shadow around the edges. Within the silhouette of the figure, however, the contour lines form the basis for a delicate low-relief carving, the subtle shadows of which, as in the abdominal area, suggest tonal modeling. It is not known why the sculptor left this work unfinished, nor is it known whether its unfinished aspect had any special aesthetic value to the ancient Egyptians. There is evidence, however, that certain unfinished paintings by important Greek masters were admired more highly than the finished works. (See Pliny's comment on the special quality of unfinished works of art in study 6, chapter 3).

Like the ancient sculptor, the ancient painter usually destroyed the preparatory drawing in the course of completing the finished work of art. In medieval times the painter of panels and walls followed much the same procedure, covering the preparatory drawing as the work progressed.4 Thanks to recent advances in conservation techniques some preliminary drawings (sinopie) done by medieval and Renaissance painters as preparation for wall paintings in fresco are available to modern students (Figures 8-2 and 8-3). For the medieval and early Renaissance artist, however, such drawings were generally seen only during the creative process, a fact that must have been a serious impediment to the study of drawing. At that time, of course, drawing had no special value as an independent art form. Only when drawings became physically separate entities, divorced from the finished product, could they be considered as a distinct artistic discipline. This separation was possible in medieval times—some draftsmen used parchment and vellum made from animal skins to preserve their drawings (Figure 1-3)—but the prohibitive cost severely restricted their use.

Not until paper became relatively inexpensive in the fifteenth century was it possible for many western artists to work out their ideas freely on a separate surface, thereby preserving their drawings. The liberation of drawing from the final artwork tended to give artists more opportunities to experiment with different ideas before deciding upon which one to execute in the more expensive materials. Paper thus gave drawing an experimental, intellectual character that it has retained to the present day.⁵

If a finished painting is seen side by side with a preparatory drawing (or drawings), as in the case of Jan Van Eyck's study and painting *Portrait of Cardinal Nicoló Albergati* (Figures 8-4 and 8-5), the drawing may sometimes seem more appealing to modern sensibilities. Compared with the drawing, the painting, though far more "finished," may appear relatively dull. Art historians believe that the drawing only was done from life. The cardinal was

apparently unable to sit for the painting, for the drawing contains detailed notations on the colors to be used in the painted version. With the painting, consequently, "... we feel the strain of working from a drawing without an opportunity to refer back to the living model.... The result, meant to recapture a reality no longer accessible to the artist, lacks the complete integration of details to which we are accustomed in the works of Jan Van Eyck...."6 The painting, though more developed in its smaller forms, lacks the fully rounded effect of shadow modeling that is so vivid in the silverpoint drawing.

Van Eyck's use of modeling in a silverpoint drawing can be compared with that of another master, Leonardo da Vinci (Figure 8-6). Although Van Eyck's study for the Portrait of Cardinal Nicoló Albergati and Leonardo's Study of the head of a young girl both utilize shadow modeling, the direction and thus the function of the hatched line are quite different. Van Eyck's hatch lines, though somewhat smoothed out, seem to follow the surfaces of the volumes observed, while in Leonardo's study the orientation of the hatching is unrelated to the form of the head. The direction of the hatch marks is instead parallel to that of the light that appears to stream over the surface of the head from the left, modeling it in shadow patterns. The extraordinary luminosity of the drawing is due in part to a microground reversal that occurs in areas where the thick silverpoint lines are seen as "ground" transversed by white "lines" that are actually unmarked spaces. This purely graphic effect, a visual metaphor for light rays, enhances the volumes implied in the contour framework of the drawing and at the same time subtly shifts the focus of the drawing from the observed form to the effect of light striking the form, a shift that prophesies the future direction of European painting.

Van Eyck and Leonardo were both concerned with directional light, yet Leonardo's drawing seems less pictorial in quality. Van Eyck integrated the tones on both sides of the head with the ground, thus defining the illuminated side of the form by its contrast with the drawn tone of the ground. Likewise he carefully modeled the dark side of the head so that it merges with the values of the ground, transferring the emphasis from the linear edge to the modeled volume of the form. Leonardo, on the other hand, effectively limited his modeling to the dark side of the head, permitting contour line to define the entire illuminated side. The resulting effect is almost musical: the contour construction of the illuminated side functions as a melodic line against the tonal harmony of shadow modeling. Near the definitive contours on the left are two fainter, more tentative lines that were almost certainly drawn very early, as Leonardo developed the general form of the head in line.

8-2. Anonymous Pistoiese master, *Crucifixion*, mid-13th century. Sinopia. 315 × 452 cm. Pistoia, Church of San Domenico. (Photo courtesy of Gabinetto Fotografico–Soprintendenza alle Gallerie, Firenze.)

8-3. Anonymous Pistoiese master, *Crucifixion*, mid-13th century. Fresco. 315×452 cm. Pistoia, Church of San Domenico. (Photo courtesy of Gabinetto Fotografico–Soprintenea alle Gallerie, Firenze.)

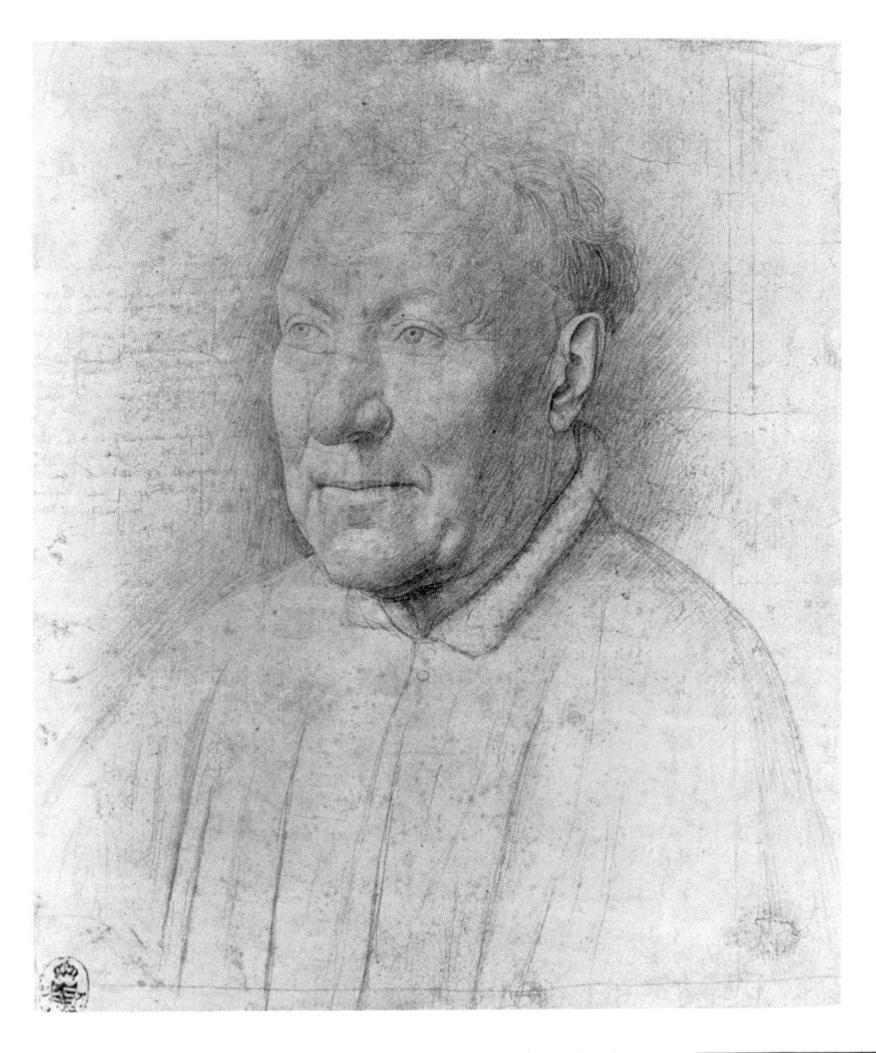

8-4. Jan Van Eyck (c. 1390–1441), *Study for* Portrait of Cardinal Nicoló Albergati. Silverpoint on grayish-white ground. 250 × 180 mm. Dresden, Staaliche Kunstammlungen. Faintly visible on the left side of the drawing are the artist's color notes for the painting (Figure 8-5): "Geelachitig und witte blauwachtig [yellowish- and bluish-white]; *rotte purpurachtig* [red-purple]; *die lippen seer wittachtig* [the lips very whitish]; *die nase sanguy nachtig* [the nose suffused with blood]" (Philip Rawson, *Drawing* [London: Oxford University Press, 1969]; p. 113).

8-5. Jan Van Eyck, *Portrait of Cardinal Nicoló Albergati*. Panel painting. 13 3/8" × 10 3/4". Vienna, Kunsthistorisches Museum.

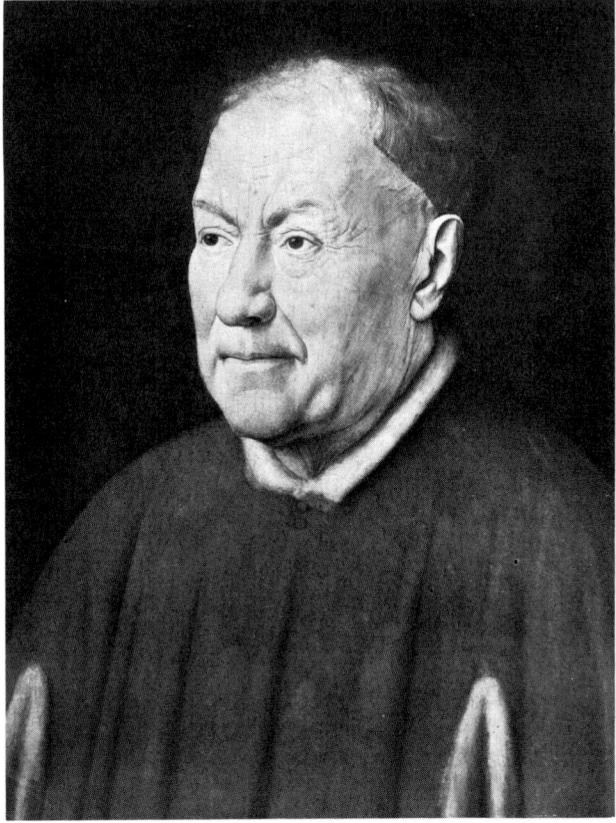

The purpose of Leonardo's study was to create a type of head suitable for the angel figure in the painting The Virgin of the Rocks (Figure 8-7). Kenneth Clark comments: "The drawing-one of the most beautiful . . . in the world—aims at the fullest plastic statement. The painting is sweeter, lighter, more unearthly. This is still idealization in the Gothic sense." Such a critical assessment suggests that the painting is more conservative in treatment and more in accordance with the taste and standards of Leonardo's time than is the drawing. Leonardo, perhaps assuming that the preparatory drawing would not be exhibited, drew with greater personal freedom of approach than he dared to apply in the commissioned work, subject as it was to the approval of a patron.8

The delicate but firm line quality seen in the Leonardo and Van Eyck drawings is characteristic of *silverpoint*, a popular drawing medium in the Renaissance. If you wish to try silverpoint, the materials, though less frequently used by modern artists, are still available in art-supply stores. You need to purchase the silver wire, which produces the mark, and a stylus to hold the wire firm. Silverpoint requires a specially treated surface, which can be prepared at home or purchased in the form of clay-coated papers. A thin coat of artist's gesso (either zinc or titanium white) over a smooth-surfaced paper or fiberboard panel is sufficient. In the Renaissance ground animal bones were sometimes used for this purpose. The mark that silverpoint leaves on the

8-6. Leonardo da Vinci (1452–1519), Study of the head of a young girl, c. 1480. Silverpoint on a ground prepared with bister (brown pigment). 18.2×15.9 cm. Turin, Biblioteca Reale.

ground may seem disappointingly faint at first, but with time it grows dark, as it chemically combines with sulfur in the air to become silver sulfide, a substance that has the dark color commonly seen on unpolished silverware.¹¹

Some Renaissance drawing media are the historical predecessors of modern manufactured media. Silverpoint, for example, is the ancestor of the graphite pencil, a metal medium that became more popular than silver partly because it requires no special ground.12 Similarly, the predecessors of today's drawing crayons were sticks cut from natural chalk alone without the addition of any binding material. Different minerals were mined for different colors of chalk: carbonaceous shale for black, calcite for white. and hematite for red. Natural chalk is not generally commercially available today, nor is it popular because of its inconsistent, unpredictable quality. In the nineteenth century manufacturers such as Conté in France produced crayons that in many ways surpassed natural chalk as a drawing medium. Natural

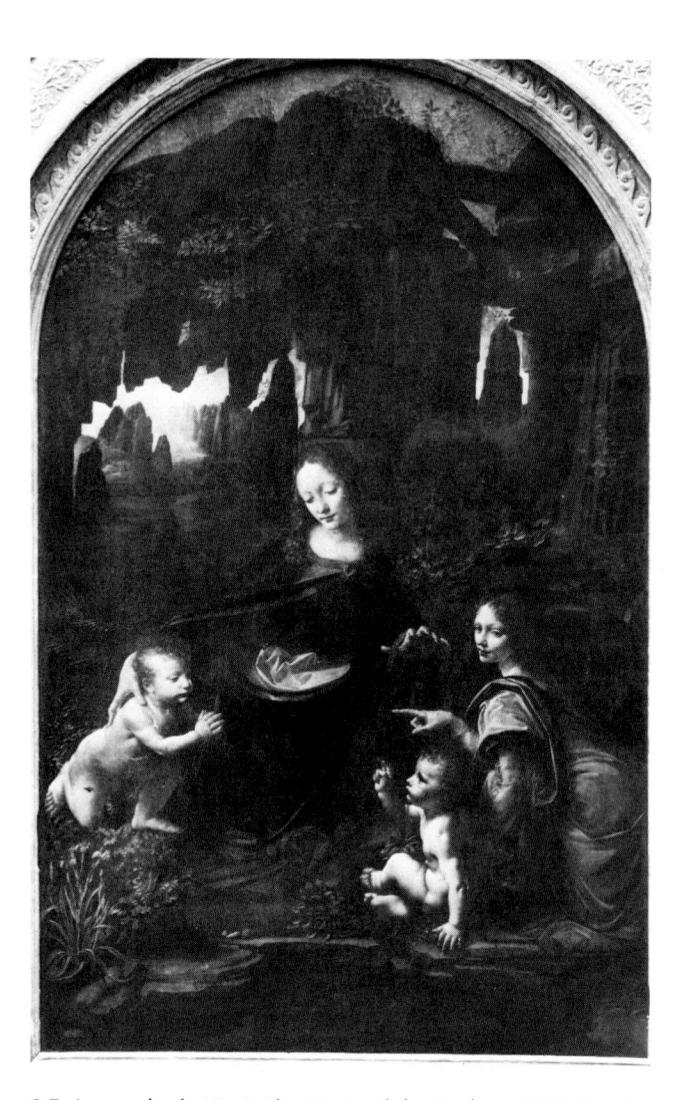

8-7. Leonardo da Vinci, *The Virgin of the Rocks*, c. 1485. Panel painting (later transferred to canvas). $75'' \times 43 \, 1/2''$. Paris, the Louvre.

chalk tends to be rather hard and is therefore not suited to large-scale drawings. Michelangelo, as Watrous points out, seems to have been aware of this limitation, for his *Studies for* The Libyan Sibyl (Figure 8-8) measures only 8 3/8 by 11 3/8 inches, despite the monumental size of the fresco for which it was intended (Figure 8-9).

The Michelangelo study for the Sistine ceiling is in fact not one but several drawings of the same subject on the same sheet.¹³ The various drawings appear to be placed somewhat randomly: no attempt was made to organize them into a unified pictorial composition. The drawings were realized in a variety of techniques. In the combination of relief and shadow modeling used for the principal male figure as well as in the contour drawing of the torso and shoulder of the secondary figure Michelangelo reveals his profound knowledge of anatomical form.¹⁴ Form in this drawing is characteristically sculptural in quality. Like a statue, the figure is conceived as positive form surrounded by empty space. Notably lacking is any attempt to relate the figure tonally with the ground, as in the more pictorial study for the Portrait of Cardinal Nicoló Albergati (Figure 8-4) by Van Eyck. The sculptural aspect of the Michelangelo drawing is not surprising in view of the fact that the artist considered himself a sculptor rather than a painter. Moreover, the fact that the finished painted figure, for which this drawing was a preparation, was intended to be set in a painted architectural framework, creating the illusion of a three-dimensional niche commonly used to hold sculpture, accounts for the sculptural appearance of the drawing.

Although both the drawing and the finished painting share sculptural qualities, a number of transformations take place between the two, the most notable of which is the change of sex: the male model in the drawing becomes a female prophetess in the painting. This change, partly explained by a difficulty in obtaining female models, was effectuated by concealing much of the figure in voluminous draperies and by generalizing or softening the undraped anatomical forms. Another change in the fresco figure as compared to the drawing is thought to lie in its greater degree of diagonal thrust. This difference, however, may be more apparent than real: if the drawing is tilted slightly to the left, the figure appears to be inclined at the same angle as the fresco figure. A more significant change between drawing and painting is found in the gesture of the left arm: greater foreshortening occurs in the forearm of the painted figure. The difficult foreshortened drawing of the hand, deftly realized in the studies, appears somewhat awkward in the fresco, while the drawn foot, developed in several studies, was more closely followed in the fresco.

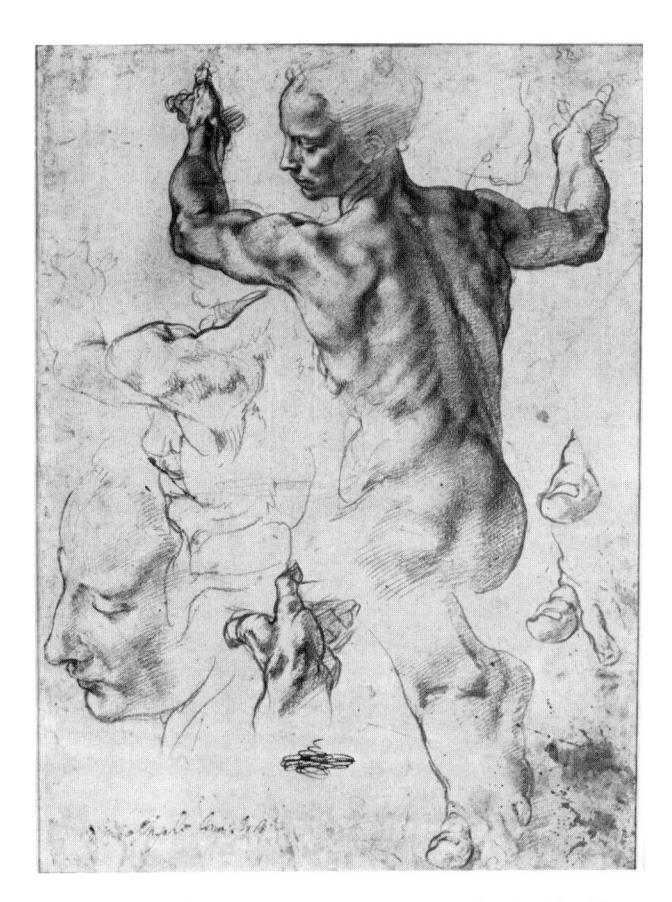

8-8. Michelangelo Buonarroti (1475–1564), *Studies for* The Libyan Sibyl (paper restored on the right side), c. 1511. Natural red chalk. 8 3/8" × 11 3/8". New York, Metropolitan Museum of Art. Pulitzer Bequest.

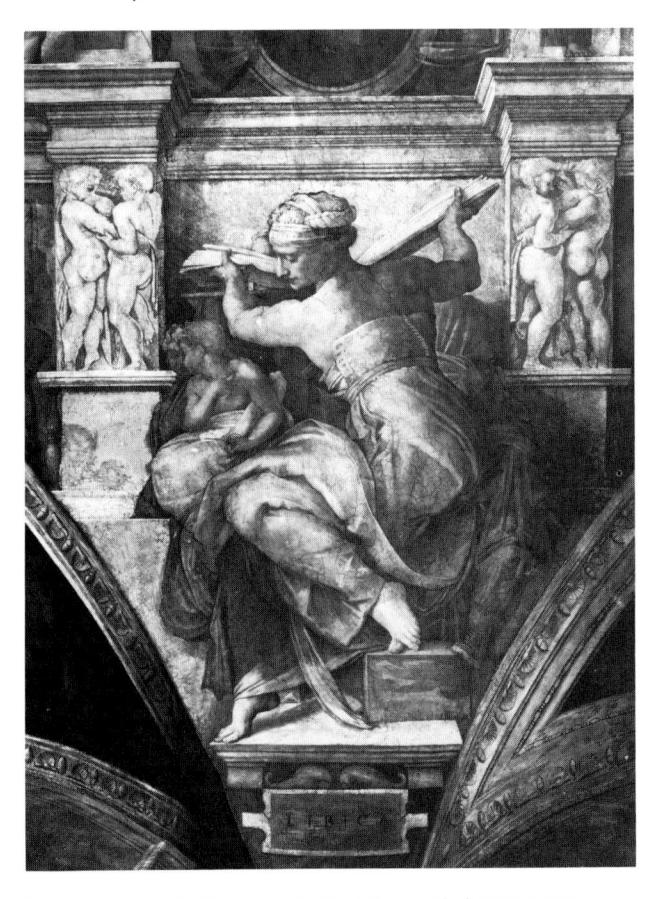

8-9. Michelangelo Buonarroti, *The Libyan Sibyl*, 1511–1512. Fresco. Rome, Sistine Chapel ceiling.

The art of Michelangelo exercised an almost irresistible influence on younger artists of the time, particularly on Roman and Florentine painters who worked between 1520 and 1600. Prominent among those younger artists was Jacopo da Pontormo (1494– 1556), a painter who was active in Florence. Like Michelangelo who inspired him, Pontormo was a brilliant draftsman who used drawing not only to visualize a compositional idea, as in his studies for the Santa Felicitá Altarpiece (Figures 8-10 and 8-11), but also to render forms from life as a means of fleshing out an abstract concept. The subject of the altarpiece (Figure 8-10), long thought to represent the deposition from the cross, is now believed to be a scene of mourning derived from Michelangelo's celebrated Pietà in the Vatican. 15 If this analysis is correct, as seems likely, Pontormo's altar-

8-10. Jacopo de Pontormo (1494–1556), Study for the Santa Felicitá Altarpiece, 1525–1528. Black chalk, heightened with white and touches of bister wash, squared in red chalk, top two figures redone in pen. 445×276 mm. Oxford, Christ Church.

8-12. Jacopo da Pontormo, Santa Felicitá Altarpiece (detail), 1525–1528. Panel painting. 123 $_{3/8}'' \times 75$ $_{5/8}''$. Florence, Santa Felicitá, Capponi Chapel.

8-11. Jacopo da Pontormo, *Study for the* Santa Felicitá Altarpiece, 1525–1528. Natural red chalk. 287 × 201 mm. Florence, Galleria degli Uffizi.

piece and associated studies provide an interesting example of a work of sculpture by one artist inspiring a painting on a similar theme by another. Adapting a three-dimensional (i.e., sculptural) idiom to a two-dimensional work is itself a difficult problem, and Pontormo's drawings; as compared to the painting, reveal his search for a solution. The smaller life study for the altarpiece (Figure 8-11) records the artist's search for a body gesture that would be compatible with his composition as seen in the larger study. Pontormo apparently discovered in the sagging gesture of the model the large, rhythmic arc formed by the back, a motif that he further developed in the painting by means of the more overtly abstract, swooping forms of drapery. The graceful arcs of the cloth, so vital to the painting's complex composition, are strongly reminiscent of drapery conventions in Roman art. 16

The composition of Pontormo's Oxford study (Figure 8-10) generally corresponds with that of the finished painting (Figure 8-12), although a few passages, such as the supporting figure on the left, are far more developed in the latter. The fact that the large study is inscribed with a grid pattern in red chalk suggests that it immediately preceded the execution of the painting, as the squaring technique was often used by Renaissance artists to simplify the task of enlarging a small drawing to fit a large surface. (In order to double the size of a drawn composition, for example, it can be copied on a grid pattern twice as large with very little distortion.) In both the drawings and the painting linear constructs dominate. The purest contour technique is found in the sketch of the pelvic region of the figure located in the upper portion of the Uffizi study (Figure 8-11). Below it are drawings that exhibit degrees of shadow modeling, culminating in the highly developed study of the head at lower right. Even here, however, considerations of line override those of modeling: the drawn line remains clear even in the darkest passages. Likewise, the modeling of light and dark, chiaroscuro, never entirely obscures the essentially linear construction of the painting.

There is an appreciable difference between the drawing of the head (Figure 8-11) and the painted version. In the drawing the head lacks a consistent sense of symmetry: the base of the nose shifts too far to the right to conform to the symmetrical placement of the eyes. It is likely that Pontormo was aware of the discrepancy, for in the Oxford study (Figure 8-10) he made the changes necessary to realize the flawlessly structured version of the head seen in the altarpiece—changes, however, that further remove the painting from the realism of the life drawing. The shift from realistic draftsmanship in the drawing to the more abstract structure of the painting reflects the overriding concern with stylistic refinement that is so characteristic of mannerism.

Using certain features of Michelangelo's art as a creative point of departure—in particular his predilection for small-headed figures and tightly packed figural groupings in relieflike compositions—Pontormo's style moved in the direction of greater elegance and elongation of form.

The art of Peter Paul Rubens (1577-1640), the Flemish painter, exhibits a creative extension of other aspects of Michelangelo's art, such as its dynamic movement and virtuosity of draftsmanship. A study by the young Rubens of Michelangelo's The Libyan Sibyl (Figure 8-13), though it follows the original closely, reveals characteristics distinctive of Rubens' later work, notably a skillful use of convex-contour construction of form combined with angular measurement and a painterly tonal relationship between figure and ground. Both traits can be seen in the superb Study for the figure of Christ on the cross (Figure 8-14). Like his countryman Van Eyck, Rubens established a logical though understated figureground relationship by applying tone outside the figure. Such a passage is noticeable on the dark side of the figure, where suggestions of very dark tone distinguish the figure from the ground and at the same time contribute to the effect of heroic scale. The British Museum study (Figure 8-14) apparently preceded a second drawing of the same subject (Figure 8-15) that is now in the Fogg Museum. In the latter drawing Rubens modified his idea of the Christ figure in ways that he later incorporated in the painting (Figure 8-16). The most important difference in the second drawing lies in its use of shadow modeling to suggest light shining from the right side. The second study also appears to resolve the gesture of the figure, changing it from the bolt-upright pose of the original version to the bent torso with upraised arms, a gesture that in the painting seems to be caused by the pull of gravity.

The date of both drawings coincides with the period during which the artist employed several assistants in his studio to facilitate the completion of many projects at the same time. It is believed that studies such as these were intended in part as guides for his assistants, who did much of the actual painting of The Elevation of Christ on the Cross.¹⁷ The drawings may thus reflect Rubens' role as the head of a large studio, which was in effect a school for many artists. The media chosen for the two studies-natural black and white chalks-are softer than the natural red chalk used by Michelangelo for his studies for The Libyan Sybil. Rubens may have preferred them for this very quality, which allows a more fluid effect comparable to that seen in his painting. The softness of the white chalk is most apparent in the British Museum drawing (Figure 8-14), in which its free application in highlighted areas enlivens the more cautiously constructed black-chalk drawing.

229

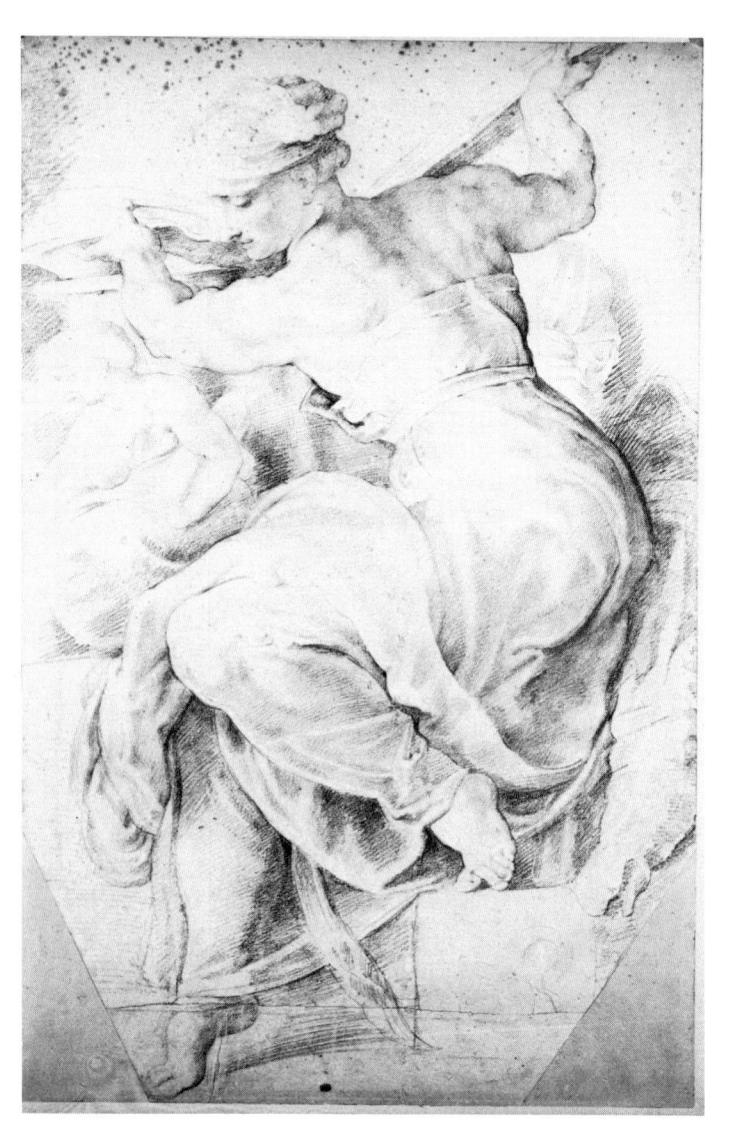

8-13. Peter Paul Rubens (1577–1640), *Study after* The Libyan Sibyl of *Michelangelo*, c. 1601. Natural red crayon. Paris, the Louvre.

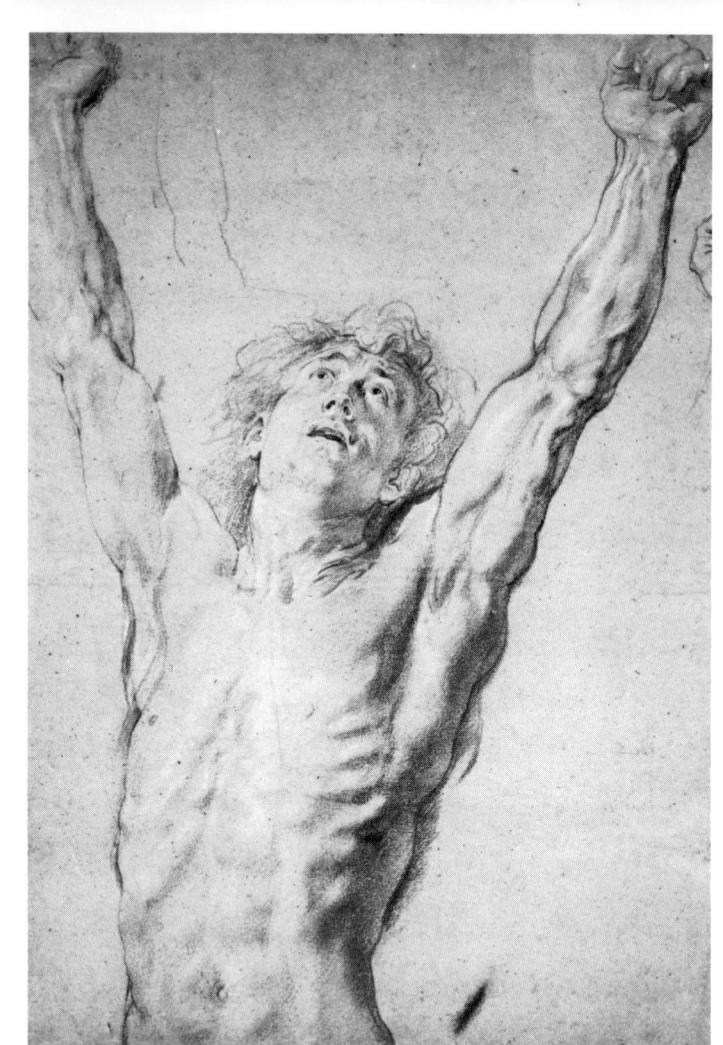

8-14. Peter Paul Rubens, Study for the figure of Christ, c. 1610. Black and white chalk, touched with pale brown wash, on coarse gray paper. 528×370 mm. London, the British Museum.

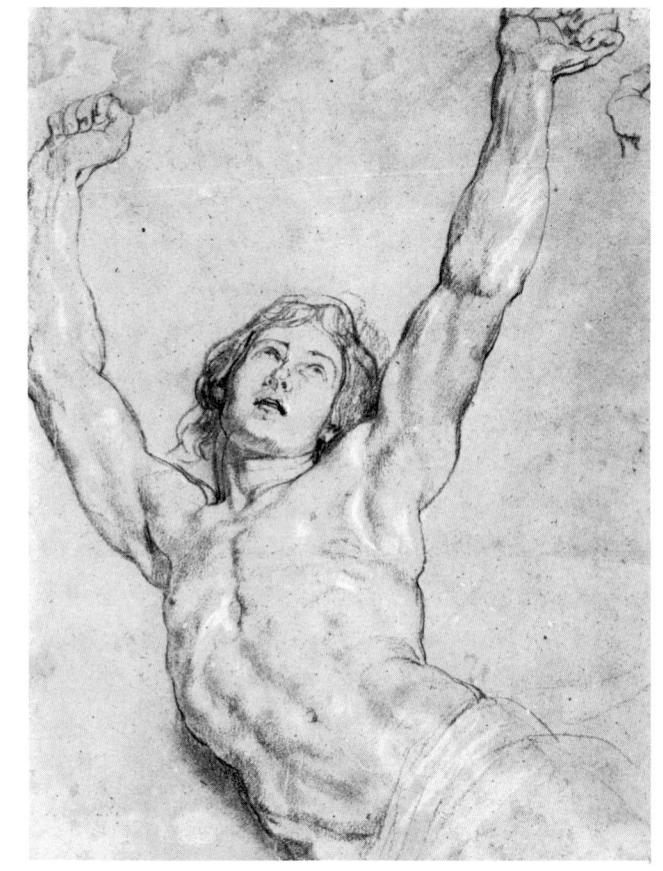

8-15. Peter Paul Rubens, Study for the figure of Christ, 1609–1610. Black chalk with outlining in charcoal, heightened with white, on buff paper. 15 $_{3/4}{}''\times$ 11 $_{3/4}{}''.$ Cambridge, Fogg Museum, Harvard University.

A preference for softer, more fluid media and effects was not limited to Rubens but reflected a growing tendency that paralleled the stylistic movement in post-Renaissance art away from linearity and toward the more broadly painted effects of light and mass associated with the baroque and rococco styles of the seventeenth and eighteenth centuries. The drawings of Gova clearly exemplify this general tendency. Significantly, one of the few Goya drawings known to be related to a painting is done in a liquid medium, sepia wash and brush (Figure 8-17). Created near the end of his long and distinguished career, the drawing Three Men Digging (Figure 8-17) and the painting entitled The Forge (Figure 8-18) reflect a singular harmony of concept and technique. In The Forge undisguised brushstrokes, bold use of black and white, and an unerring sense of gesture result in a graphic quality more commonly found in drawing than in painting. Likewise, the free use of brush and liquid in the drawing gives it the character of an underpainting.

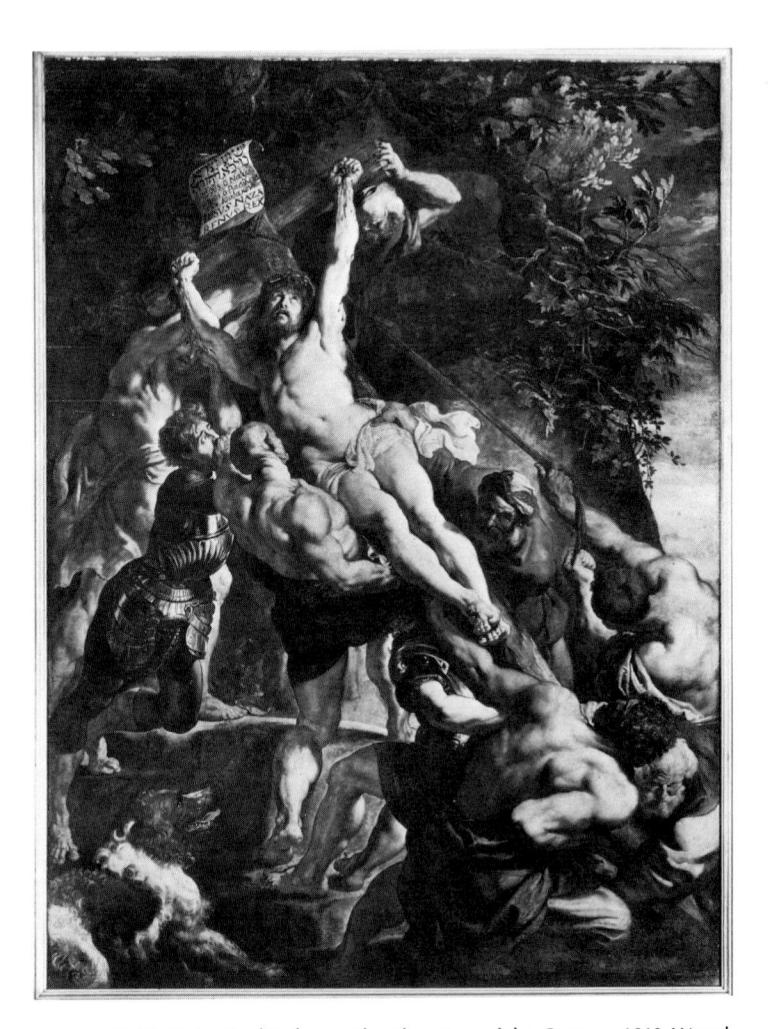

8-16. Peter Paul Rubens, The Elevation of the Cross, c. 1610. Woodpanel painting. $182'' \times 134''$. Antwerp Cathedral.

Although the painting and the drawing represent different subjects—the painting is set in a blacksmith's shop, the drawing in the open fields there is remarkably little difference in composition. Both feature gestures abounding in strongly diagonal forms. Figural elements tend to be realized as color masses separated by general changes of tone. Note the lack of tonal modulation in black areas—a feature as prominent in the painting as in the drawing. If one assumes that the painting was done after the drawing, the most important single change was the decision to darken the tone of the trousers of the principal figure (holding the hammer in the painting, the hoe in the drawing). This darkened tone, dictated to a certain extent by the darkened ground of the painting, binds the three figures together more tightly than in the drawing, in which the high tonal value of the principal figure visually divides the composition. The darker value of the trousers in the painting also permits a contrast with the red of the hot iron, resulting in a luminous effect that would have been more difficult if the figure's clothing had remained light in tone. By painting the principal figure's shirt white, as in the drawing, Goya focuses attention on his back, dramatizing the region essential to the powerful gesture of the blacksmith.

The precise relationship between Goya's drawing and his painting is a subject of speculation. Some authorities believe that the drawing is "an independent composition on a similar theme," even though "directly related" to the painting. It is not unusual for an artist to transpose compositional inventions from one work to another; thus the question is one of sequence. For purposes of discussion I have assumed that the drawing came first, but it is possible that it did not. If the latter is the case, the painting then unexpectedly becomes the preparatory work for the drawing, and, given the importance of graphic work in Goya's career, he may have seen it in just that way.

The art of Goya and that of the Japanese print were destined to become primary sources of ideas and inspiration for European, particularly French, artists of the late nineteenth century. You have already witnessed one instance of the influence of the Japanese print in Lautrec's poster *May Milton* (Figure 3-34). Goya was himself a contemporary of one of the most important exponents of the Japanese print—Katsushika Hokusai (1760–1849). Like Goya, Hokusai was a painter who was also known for his prints.

8-17. Francisco de Goya y Lucientes (1746–1828), *Three Men Digging*, c. 1812–1823. Illustration from Album F. 51 (1472). Sepia wash. 20.6×14.3 cm. New York, Metropolitan Museum of Art.

8-18. Francisco de Goya y Lucientes, *The Forge*, c. 1812–1816. Oil painting. 181.6×125 cm. New York, Frick Collection.

Since it was not customary for the Japanese artist to cut his own blocks. Hokusai prepared a special drawing, like that for the Suikoden Book of 1829 (Figure 8-19), representing the image that he wished to appear in the final print. Artisans then cut the woodblocks to realize the desired effect. A separate block was usually cut for each color. The extraordinary accuracy of the cutting can be judged by comparing the drawing (Figure 8-19) with the resulting print (Figure 8-20). Those familiar with modern photomechanical printing will recognize a similarity with the Japanese technique. Like many modern illustrators, Hokusai made the drawing larger than the format of the print in order to give the latter a greater sense of scale. The highly developed finish of the drawing was necessary to provide sufficient clarity to facilitate cutting the blocks; vet light wash lines such as those below the right foot of the female figure show that changes were made even at this stage. Such changes, or ghosts, in drawings and paintings are generally referred to as pentimenti. Other differences can be seen in the dress patterns. In order to avoid drawing repetitious patterns, Hokusai merely indicated the areas in which

they were to occur and provided the woodblock cutter with a separate pattern.

The flat linearity of the Japanese print, which was destined to receive an enthusiastic acceptance by European artists in the late nineteenth century, was in some ways presaged by a French contemporary of Hokusai—Jean Auguste Dominique Ingres (1780-1867). In addition to his acknowledged classical inspiration (discussed in chapter 3), ". . . the sinuous line and the absence of shadow in Ingres' best work," as Kenneth Clark observes, "has something oriental about it." A critic even accused Ingres of being a "Chinese painter astray in the ruins of Athens."19 Regardless of one's opinion concerning his stylistic sources, Ingres is recognized today as one of the finest draftsmen in art history.²⁰ Since his portraits rank among his best works, it is of special interest to consider how he utilized drawing in the course of completing a portrait commission such as that of Madame d'Haussonville (Figures 8-21, 8-22, and 8-23). A slow, methodical worker, Ingres required four years and many drawings to complete his Portrait of Madame d'Haussonville (Figure 8-23). Almost two dozen related drawings

8-19. Hokusai (1760–1849), Preparatory drawing for a wood engraving for the Suikoden book of 1829. Brush and ink. 25.3×17 cm. London, British Museum.

8-20. Hokusai, *Page from the* Suikoden *book of 1829*. Wood engraving. 18.5×12.5 cm. London, British Museum.

survive. Two such drawings (Figures 8-21 and 8-22), now in the Fogg Museum, suffice to give an impression of the artist's method.

Ingres' choice of the newly developed graphite pencil as his drawing instrument was in a sense a return to the metal points of an earlier era. The pencil, like silverpoint, permitted the clarity of line and delicacy of tone essential to his classical approach. In his squared study (Figure 8-21) he primarily employed a linear technique except in the area of the head, where he subtly introduced tonal modeling. The restriction of modeling to the portrait figure's head, a common technical convention of his pencil portraits, was later taken up by Picasso (Figure 5-106), who admired Ingres' drawings. In another study for the portrait of Madame d'Haussonville (Figure 8-22) Ingres more boldly modeled the folds of the dress in charcoal. The subtle conflict between the linear and tonal modes in Ingres' work, a conflict often left unresolved in his drawings, results in a conceptual compromise in many of his paintings. In the Portrait of Madame d'Haussonville the sitter appears illuminated from near the front, an arrangement that allowed Ingres to model the form in shadow and at the same time to preserve the linear quality of the composition.²¹

The two studies focus on different though related problems associated with the finished painting. In the squared study (Figure 8-21) Ingres experimented

8-21. Jean Auguste Dominique Ingres (1780–1867), Study for Portrait of Madame d'Haussonville, c. 1842–1845. Graphite pencil on thin white woven paper, squared for transfer. 9 $_3/16^{\prime\prime}\times7$ $_3/4^{\prime\prime}$. Cambridge, Fogg Museum, Harvard University.

with the compositional relationship between the sitter and the mirror. The mirror contains a reflection of almost half the figure. He abandoned this arrangement in the painting in favor of a more classically frontal orientation, in which the mirror reflects only the head and shoulders—a solution that permitted subtle color gradations between the reflection and the figure that partially overlaps it.²² In the same squared study Ingres experimented with the attitude and proportions of the figure. The head is drawn proportionally large and in a more upraised position than was finally adopted in the painting. The unstudied gesture in the drawn figure, evident in the more frontal direction of the head and in the straight-pointed finger under the chin, presents a less graceful but more realistic aspect of the sitter than Ingres chose to paint in the elegantly classical Portrait. This apparent shift from

8-22. Jean Auguste Dominique Ingres, Study for Portrait of Madame d'Haussonville, c. 1842–1845. Charcoal over graphite pencil on thin white woven paper. 14 $_{1/8}'' \times 8$ $_{1/16}''$. Cambridge, Fogg Museum, Harvard University.

realism in drawing to stylization in the finished work parallels that noted earlier in connection with the angel figure in Leonardo's *The Virgin of the Rocks* (Figures 8-6 and 8-7).

In the pencil-and-charcoal study (Figure 8-22) Ingres develops the pose used later in the painting, a pensive attitude that appears in some female figures of classical art.23 On the figure's right he wrote, "plus de movement" (more movement), indicating an additional contour of the figure's back. This contour, perhaps more than any other feature of the drawing, reveals Ingres' use of line to solve abstract problems of form in the painting, for the painted contour of the back exhibits a graceful continuation of the curve of the neck much like that seen in the additional contour of the drawing. Another notation on the drawing—"grand foyer de lumiere plus" (large center of light . . .)24seems to refer to a scarf, a garment discarded in the painting. The folds of the figure's dress evolve from the irregular and somewhat rumpled forms suggested by the pencil pattern in the squared drawing. Acting visually as gradients of texture, the fold patterns in the skirt endow the figure with the rounded monumentality of a fluted column—a visual analogy previously expressed by a French clas-

8-23. Jean Auguste Dominique Ingres, *Portrait of Madame d'Haussonville*, 1846. Oil on canvas. 131.8×92 cm. New York, Frick Collection.

sical painter of another era, Nicolas Poussin (1593–1665).²⁵

Although the pencil-and-charcoal study (Figure 8-22) appears to be primarily a study of costume, the broader linear treatment of the exposed parts of the figure is nevertheless significant, for Ingres believed that: "The simpler your lines and forms, the more beauty and strength they will possess. Whenever you divide your forms, you enfeeble them."26 Ingres' desire to simplify the complexities of form observed in life is consistent with his interest in classical art. which often features large, rhythmic, linear constructs. Underlying the simplified form of Ingres' drawing, however, is a remarkable sense of draftsmanship, which vitalizes what might otherwise seem to be merely a classical manner. The undercurrent of realism in his art became the avowed aim of some younger artists who rejected neoclassicism, which since the time of Ingres' great teacher, Jacques Louis David, had been virtually the official style in France. Prominent among the artists of this radical persuasion was the French painter Jean François Millet (1814-1875).

The son of a peasant, Millet's background and personal sentiment apparently attracted him to subjects very different from the elegant new aristocrats of Ingres' portraits: "Peasants," he wrote, "suit my temperament best; for I must confess, even if you think me a socialist, that the human side of art is what touches me most."27 Millet used drawing concurrently with painting, often working and reworking a single theme over a long period of time. His drawing The Fagot Carriers (Figure 8-24) was preceded by an earlier painting of the same subject and followed several years later by the final painting (Figure 8-25). His choice of a soft manufactured crayon (Conté) ensured a broad quality of stroke in harmony with the brushstrokes evident on the surface of his paintings. Although the ostensible subject of the drawing and the painting is the same peasants carrying heavy bundles of sticks—the drawing graphically realizes another theme favored by Millet, the close identity of the peasant with the field. In the drawing he modeled the figures with the same long crayon strokes used to symbolize the sticks, achieving not only a satisfying textural unity appealing to the modern sensibility but also a blurring of the distinction between the figures and the growth of the field—his way of emphasizing their poetic oneness. This strong thematic unity seems to spring directly from Millet's artistic convictions: "I try not to have things look as if chance had brought them together, but as if they had a necessary bond between them."28 In this respect the drawing is perhaps more successful than the painting, with its clearer division of figure and background. Like Goya's Three Men Digging (Figure 8-17), Millet's drawing is more than a preliminary study: it stands as an independent work of art.

Despite the growing tendency toward a more realistic and coloristic form of painting in the nineteenth century, as exemplified by the art of Millet, the neoclassical tradition of David and Ingres continued to prevail in many European art academies, including the provincial Art Academy of La Coruña where the youthful Picasso studied drawing in the 1890s. Although he worked in a variety of styles in his lifetime, some of his finest works recall the classical tradition in which he was trained. Precociously skilled as a draftsman, Picasso grew less interested in recording the immediate perception of things (i.e., sensation)—a primary concern of many realist and impressionist artists who preceded him. He expressed instead the desire to "... paint things, not as I perceive them, but as I conceive them."29 This artistic philosophy, which underlies nearly all his mature work, is the formal basis of Picasso's so-called classical Greek period (1905-1906), during which he drew and painted The Two Brothers (Figures 8-26 and 8-27). Reflecting the artist's involvement with conception as opposed to perception of form, both the preparatory drawing and the painting were probably done without models.³⁰ Yet in working from memory Picasso did not simply set down a composition already fixed in his mind's eye. The pen-and-ink study (Figure 8-26), in which a similar gesture occurs, is

8-24. Jean François Millet (1814–1875), The Fagot Carriers, 1852–1854. Conté crayon. 11 3/8" × 18 3/8". Boston, Museum of Fine Arts. Gift of Martin Brimmer.

one of a series of variations on this theme. Other preparatory sketches show a single nude figure with arms upraised. Picasso apparently decided to add a second figure of a small child to the arms of the primary figure, giving new meaning to the upraised gesture. Another study, similar to the one reproduced but showing both figures from the back, reveals that Picasso's concept of form was fully three-dimensional, a quality that one senses in the assertive modeling

8-25. Jean François Millet, *The Fagot Carriers*, 1875. Painting. Cardiff, National Museum of Wales.

of the painting as well as in the distinctly sculptural figure-ground relationship. In addition to the preparatory drawings Picasso made at least two gouache studies of the same theme on cardboard. It seems reasonable to assume that these were also preparatory for the large oil.

The classical constructs of outline and contour noted earlier in Picasso's drawings (Figure 4-10) also prevail in Study for The Two Brothers (Figure 8-26), though the redrawn lines suggest a more informal approach. The same classical construction underlies the painting, which is enhanced considerably by two departures from the drawing: in the upper region of the figure the embrace and grasp of the child create a visual link that bonds the two figures in a compact, plastic unit; a second change is seen under the principal figure's left arm. In the drawing the line of the baby's leg, redrawn several times, appears to define and diminish the back of the principal figure, creating an ambivalent effect. In the painted version Picasso resolved this problem by carefully modeling the plane above and to the left of the baby's protruding leg, establishing the volumetric continuity of the torso form in the principal figure. Other aspects of the painting are almost directly transposed from the drawing: for example, the emphatic hatch modeling of the head, a convention noted earlier in another work by

?casso

8-26. Pablo Picasso (1881–1973), Study for The Two Brothers, 1905. Pen and black ink. $12\,1/8''\times 9\,3/8''$. Baltimore Museum of Art. Cone Collection.

Picasso (Figure 5-106), is repeated in the painting and developed in other parts of the figure as well.

Although the positive forms in Picasso's painting appear rounded as a result of modeling, the figure as a whole is parallel with the surface of the canvas. As in a relief sculpture, few figural elements seem to project very far in space. Such an orientation of form does not disturb: it is in part responsible for the sense of calm for which classical art is noted. This very sense, however, limits classical conventions in the eyes of some artists, who strive for a more dynamic modality of expression. The forceful art of the Mexican mural painter José Clemente Orozco (1883–1949) provides an interesting contrast with Picasso's classical style.

The primal gesture of the human figure taking a step is represented in both *The Two Brothers* and Orozco's *Study of legs* (Figure 8-28), yet the two artists saw and used the gesture in strikingly different ways and for different purposes. Drawing from life, Orozco apparently assumed a point of view beneath the model. Consequently, the foreshort-

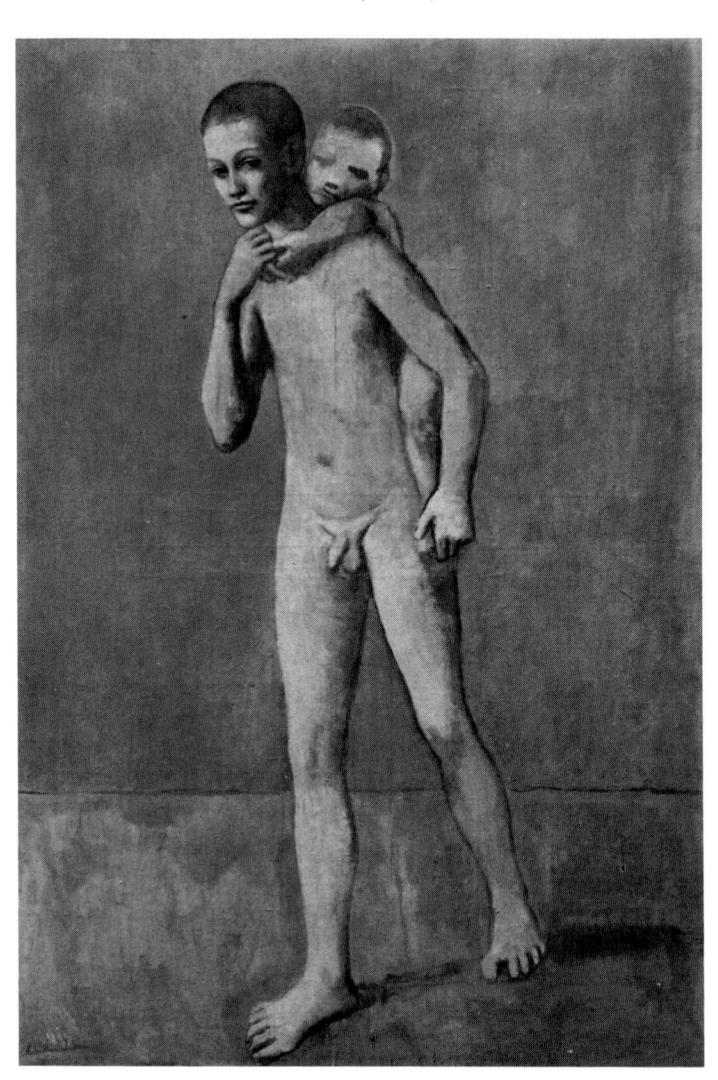

8-27. Pablo Picasso, *The Two Brothers*, 1905. Oil painting. 142×97 cm. Rodolphe Staechelin Foundation Collection, on loan to the Kunstmuseum, Basel.

8-28. José Clemente Orozco (1883–1949), Study of legs, 1938–1939. Charcoal on light gray paper. $25\,7/8'' \times 19\,5/8''$. New York, Museum of Modern Art. Inter-American fund.

8-29. José Clemente Orozco, El Hombre, 1938-1939. Fresco painting in a cupola. Guadalajara, El Hospicio Cabañas.

ened figure seems almost to threaten the viewer with its aggressively projecting foot and leg, an illusion that is heightened by bold contour hatching. The reason for the unusual foreshortening of the figure is apparent in the mural painting El Hombre (Figure 8-29), for which the drawing was a study. Painted on the curving ceiling under a dome (cupola), the fresco is normally seen from below—a direction that corresponds with the point of view represented by the foreshortened figure in the drawing. The effect of receding space conveyed by the foreshortening is further enhanced by the placement of the flaming figure painted inside the dome. The figure's feet as well as the larger encircling figures are positioned so as to be physically nearer the spectator on the ground. This arrangement is also encountered in certain Renaissance frescoed domes, which may have been the artist's source of inspiration.

Orozco made use of yet another convention of European art-the allegorical figure. The flaming figure is an allegorical personification of fire, and the other three elements—earth, sea, and air—are represented by the figures that ring the dome.31 The unusual color tonalities in the painting, such as the blue used to model the head of the sea figure, seem to justify this interpretation. Color thus takes on a symbolic rather than representational function in order to clarify and dramatize the intended allegory of the painting. Orozco's art, though highly personal, is thus a complex synthesis of artistic concepts from the past. "It is unnecessary," he once wrote, "to speak about Tradition. Certainly we have to fall in line and learn our lesson from the Masters."32

Yet Orozco's art is far from traditional in style. He made use of dramatic distortions of form and intensified color contrasts in a way that is reminiscent of certain twentieth-century German expressionists (i.e., Nolde and Kirchner). Orozco did not use such devices as formal ends in themselves but rather as a means of heightening the drama of the thematic content. Broadly speaking, Orozco's themes encompass the historical and political struggle of the Mexican people, whom he frequently represented them in a way that is didactic in its clarity. His direct, unequivocal approach to a theme or subject is in extreme contrast to that of his Belgian contemporary René Magritte (1898-1967), who was concerned instead with the poetic ambiguities of imagery. A surrealist in the true sense of the word, Magritte based his art on a careful examination of objective reality: "If one looks at a thing with the intentions of trying to discover what it means," he once wrote, "one ends up no longer seeing the thing itself, but thinking of the question that has been raised."33 Magritte's approach transforms a real object into the surreal.34

One may only speculate as to the nature of the thing that Magritte utilized as the creative point of departure for his painting Delusions of Grandeur (Figure 8-30). A related drawing (Figure 8-31) shows a truncated figure that resembles a classical Venus without limbs and head, suggesting that such a figure may have been the object that Magritte originally contemplated. The artist's transformation of the Venus figure is achieved by a device borrowed from architecture—step construction—which produces a systematic though unnaturalistic change of scale within the figure at discrete intervals, resulting in a towering ziggurat effect. Ironically, Magritte adopted a form of academic naturalism, disarmingly simple in technique, to realize this unnatural construction. In the painting (Figure 8-30) he developed the figure as a rounded form by means of shadow modeling and applied the same technique to the sky area, which is treated as though it consisted of solid cubes, giving the air the same sense of volume that is apparent in the figure. At the same time the hollowness suggested in the figure causes it to appear lighter in weight than the surrounding atmosphere.

The painted version of Delusions of Grandeur (Figure 8-30) preceded the drawings (Figures 8-31, 8-32, and 8-33) and the sculptured version (Figure 8-34) by five years: "The idea of making sculptures which would be based on a three-dimensional realization of images from Magritte's paintings was born out of a conversation with his dealer Alexandre Iolas."35 Delusions of Grandeur was one of eight paintings that Magritte chose to translate into sculpture in January 1967: "He made working drawings for each one ... deciding the scale and measurements himself, which he seemed to have no difficulty in visualizing or transposing."36 The sculptural quality of the painting may have prompted Magritte to select it for a project in cast bronze. Magritte's drawings thus served a purpose quite unlike that of most preparatory drawings, as they were intended to assist in translating an earlier pictorial work into another artistic medium. His schematic study (Figure 8-31) shows the underlying construction of the sculpture. Dimensions are indicated to help the foundrymen assemble the work. By contrast, the two additional studies (Figures 8-32 and 8-33) present straightforward realistic views of the back and side elevations of the completed work. Freely modeled with hatch, the drawings show the telescoping sections, with rounded cross sections at the top of each. "Unfortunately, Magritte died without ever seeing the sculptures completed. He did see the [full-scale] wax models, however, when he visited the foundry in June 1967, just two months before he died. At that time he made several modifications and adjustments . . . in Delusions of Grandeur, he altered the angles of the torso and arranged for the arms to be hollowed out."37 That no major changes were made indicates the effectiveness of

8-30. René Magritte (1898–1967), *Delusions of Grandeur*, 1962. Oil on canvas. 39 1/2" × 32". Private collection.

8-31. René Magritte, Study for the sculpture Delusions of Grandeur, 1967. Ballpoint pen. Paris, Galerie Iolas.

8-32. René Magritte, *Study for the sculpture* Delusions of Grandeur, 1967. Ballpoint pen. Paris, Galerie Iolas.

8-33. René Magritte, *Study for the sculpture* Delusions of Grandeur, 1967. Ballpoint pen. Paris, Galerie Iolas.

the drawings as a means of conveying his ideas for the sculpture to the foundry.

It is not easy to relate the title Delusions of Grandeur to either the painted or the sculptured version. This is no doubt intentional: "The titles of paintings," he once wrote, "were chosen in such a way as to inspire in the spectator an appropriate mistrust of any mediocre tendency to facile selfassurance."38 The hollow though monumental appearance of the figure set against a seemingly solid sky suggests a possible rationale of Magritte's concept. Other explanations, however, are equally plausible, though none seems conclusive. One must eventually look upon the work in the way that Magritte himself looked upon things in nature to see the philosophical questions that underlie appearances. In Delusions of Grandeur Magritte frames questions that challenge our common sense assumptions about the substance and solidity not only of the world in which we live but of the human body as well.

8-34. René Magritte, *Delusions of Grandeur*, 1967. Bronze sculpture. 51" high. Paris, Galerie Iolas.

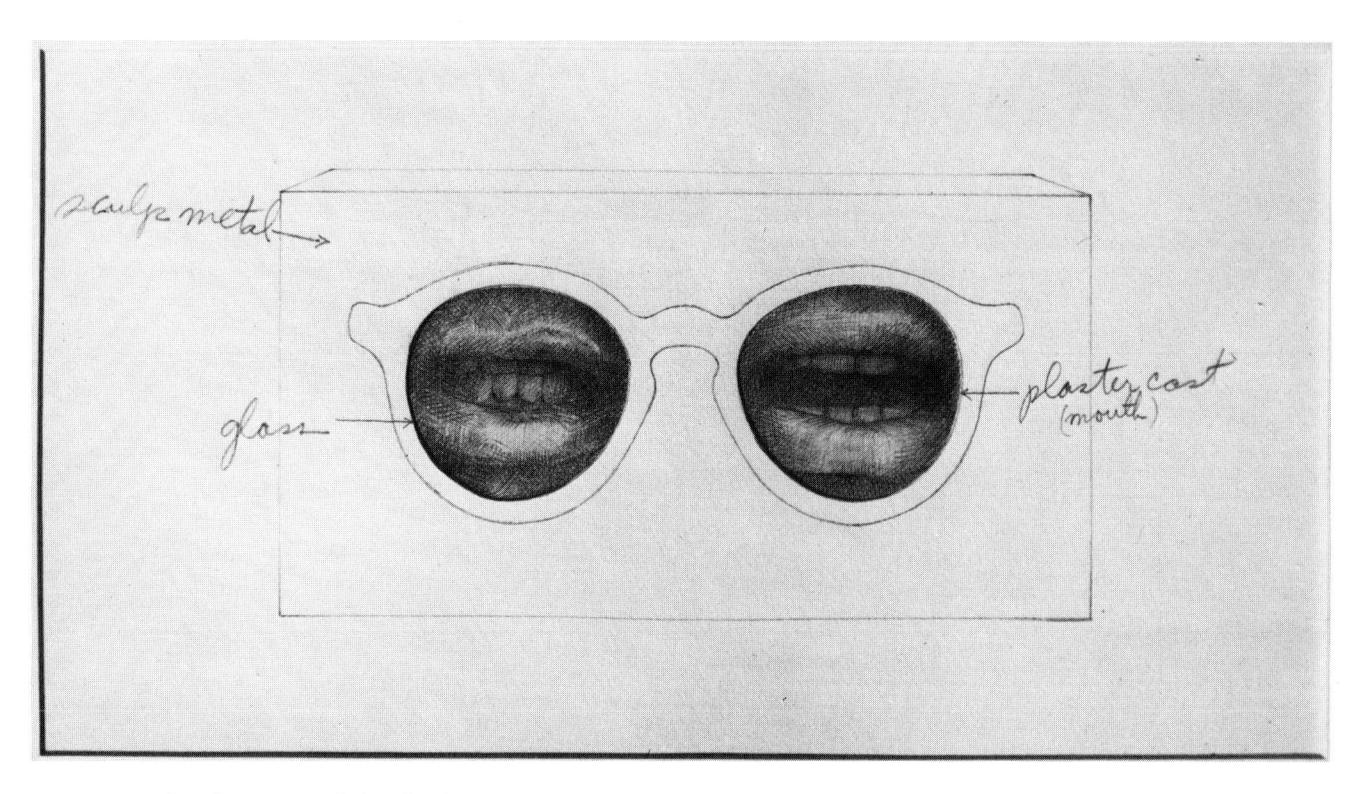

8-35. Jasper Johns (b. 1930), Study for The Critic Sees, 1961. Graphite pencil on paper. $6\,1/4''\times12''$. Collection of Mr. and Mrs. Leo Castelli.

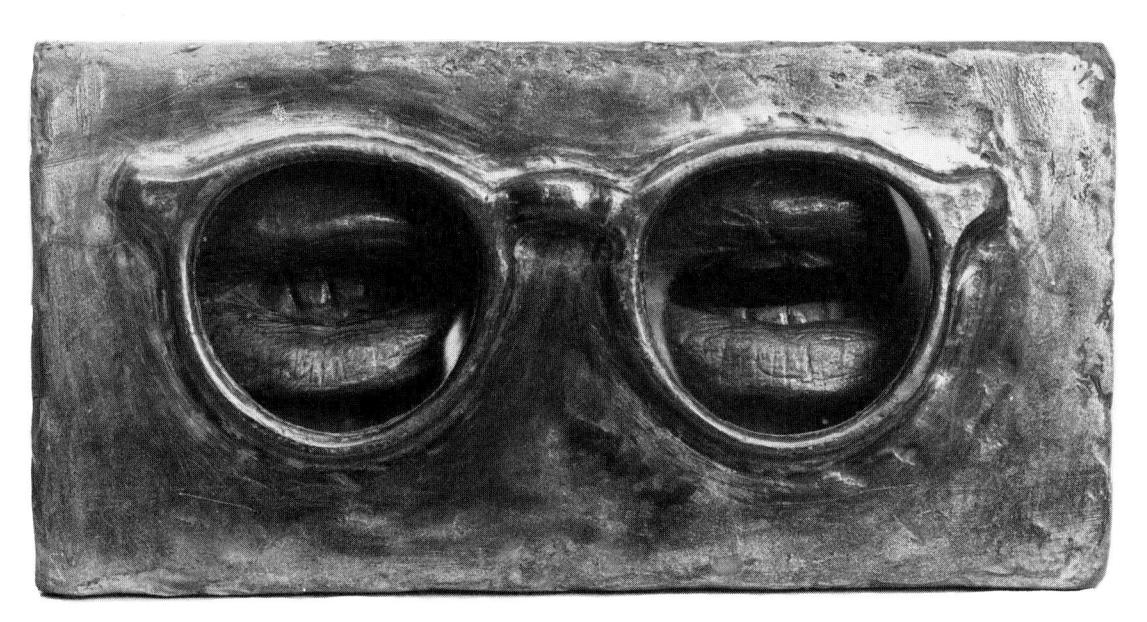

8-36. Jasper Johns, *The Critic Sees*, 1961. Sculpmetal, plaster, and glass. $3\,1/4''\times6\,1/4''\times2\,1/8''$. New York, Leo Castelli Gallery.

In some of his works Magritte exploits formal similarities in common objects for surrealistic purposes: "There is a secret affinity," he once wrote, "between certain images; it is equally valid for the objects which those images represent."39 Such a concept was developed earlier by Arcimboldo, who substituted forms of pots and pans for similar formal constructs of the head (Figure 3-19). Magritte, however, applied the idea in such novel ways that it seems practically to have been invented by him. The same concept has served as the source of inspiration for certain younger artists as well. It appears, for example, to underlie a sculpture by the contemporary American artist Jasper Johns (b. 1930). Entitled The Critic Sees (Figures 8-35 and 8-36), this work consists of a rectangular solid with a pair of glasses on one side, behind which are life casts of human mouths. The rectangular format of the sculpture brings to mind opticians' signs of the past. The use of such a visual cliché—like Magritte's use of the familiar object—is an integral part of the artist's method. The "mouth casts" set behind the glasses reveal a "secret affinity" with the form of the human eye. The ambiguity of the image, which deliberately confounds the verbal with the visual sense, raises questions in the viewer's mind. The title provides a partial answer in the form of a sculptural comment on the role of the art critic. The artistic coherence of the comment was assured by working out the compact integration of formal elements in advance in a pencil drawing (Figure 8-35).

In making his preparatory drawing Johns did not find it necessary to resort to a new medium or method, as he did in the final sculpture, despite the avant-garde nature of his concept.40 On the contrary, the hatch modeling and written notations recall the technique of Van Eyck over 500 years earlier (Figure 8-4). Traditional drawing methods and materials are capable of encompassing an almost limitless range of ideas for works in other media, both old and new. This universality of application underscores the unique historical continuity that sets drawing apart from other art forms in the West. In view of the influential role that drawing continues to play in shaping works of art in all media the advice that Cennino Cennini gave to artists 600 years ago continues to be valid: "Do not fail, as you go on, to draw something every day, for no matter how little it is it will be well worth while, and it will do you a world of good."41

Footnotes

PREFACE

- Leonardo da Vinci, The Notebooks of Leonardo da Vinci, ed. Jean Paul Richter (New York: Dover Publications, Inc., 1970), vol. 1, p. 249.
- 2. Kenneth Cark, The Nude: A Study in Ideal Form (Garden City, N.Y.: Doubleday & Co., 1959), p. 447.
- 3. Robert Goldwater and Marco Treves, Artists on Art (New York: Pantheon Books, 1945), p. 70.

CHAPTER 1

- Describing the procedure of an Assyrian sculpture, Isaiah recorded (44:13) that "... he marketh it out with a line; he fitteth it with planes and he marketh it out with the compass, and maketh it after the figure of a man according to the beauty of a man."
- 2. Giorgio Vasari, Lives of the Artists, ed. and trans. E. L. Seeley (New York: Noonday Press, 1957), p. 8. Vasari's stories have become professional myths and have a value unrelated to their historical accuracy. As Roger Shattuck commented in The Banquet Years (New York: Vintage, Random House, 1968): "As vividly as any museum, real or imaginary, these stories set the Renaissance still living before us. We need such mythologies in order to understand the past." Vasari's apocryphal account of Giotto accurately reflects a real concern of many Renaissance artists, geometry. Viewed as the intellectual aspect of art, geometry was a means of distinguishing fine art from craft. It also led to one of the most important discoveries of the Renaissance, perspective, the first systematic method for representing solid forms on a flat surface.
- 3. Works by such present-day artists as Ellsworth Kelly and Donald Judd have much in common with Giotto's drawing in that their paintings and sculptures often feature single, irreducible shapes such as circles or stripes. Called minimal art by critics, these works effectively eliminate any reference to a reality beyond that of the shapes themselves.

 Los Angeles: University of California Press, 1954), p. 167. An interesting discussion of how children create drawing constructs is found on pp. 155–212.
- M. D. Vernon, The Psychology of Perception (Harmondsworth, Middlesex, England: Penguin Books, Ltd., 1962), pp. 52–53.

CHAPTER 2

- 1. Lorenz Eitner, Neoclassicism and Romanticism (Englewood Cliffs, N.J.: Prentice-Hall, 1970), vol. II, p. 137.
- Paul Klee, Inward Vision: Watercolors, Drawings and Writings (New York: Abrams, 1959), pp. 5–10.

- 1. M. D. Vernon, *The Psychology of Perception* (Harmondsworth, Middlesex, England: Penguin Books, Ltd., 1962), p. 40.
- David Noton and Lawrence Stark, "Eye Movements and Visual Perception," Scientific American, vol. 224, no. 6 (June 1971), p. 35.
- 3. The fovea is "the small central area of the retina that has the highest concentration of photoreceptors" (ibid.).
- It is clear that the eye does not normally function like a still camera, a common misconception that has "dominated philosophy and psychology for many years." Ulric Neisser, "The Processes of Vision," Scientific American, vol. 219 (Sept. 1968), p. 206.

- 5. Pliny, Natural History, Book XXXV, 65-68, trans. H. Rackham (Cambridge, Mass.: Harvard University Press, 1968), p. 367. Though not an artist himself, the Roman author Pliny recorded much of what is known about ancient Greek and Roman art. His brilliant insight into the nature of contour line is contained in a paragraph praising the Greek artist Parrhasius, whose works were prized for their linear quality—a quality Pliny considers to be "the high-water mark of refinement." Pliny clearly favored the line techniques of classical art over the use of modeling for effects of mass and volume: "... to paint bulk and the surface within the outlines, though no doubt a great achievement, is one in which many have won distinction, but to give the contour of the figures, and make a satisfactory boundary where the painting within finishes, is rarely attained in successful artistry.... This is the distinction conceded to Parrhasius. . . ." It is one of the sad ironies of history that Pliny's writings on ancient Greek painting have survived the centuries, but the subject of his writings, the paintings themselves, have almost completely disappeared.
- An outstanding example of the box construction of the figure is found in George B. Bridgman's Constructive Anatomy (New York: Dover Publications, Inc., 1960).
- 7. Ulric Neisser, op. cit., p. 214.
- 8. "At the Petite Ecole—now known as the Ecole Nationale Supérieure des Arts Decoratifs [Paris]—the painter Horace Lecoq de Boisbaudran was teaching a revolutionary method of drawing from memory, and a whole generation of artists was influenced by him, among them Dalou, Fantin-Latour, and Legros.... Rodin wrote in 1913, 'Most of what he taught me then, still remains with me.'" Robert Descharnes and Jean-Francois Chabrun, Rodin (New York: Viking Press, 1967), p. 15.
- Elizabeth Gilmore Holt, From the Classicists to the Impressionists (Garden City, N.Y.: Anchor Books, Doubleday and Co., 1966), p. 401.
- In the French Art Academy of the 19th century the art student "centred his sketch with horizontal and vertical guide lines formed with a plumb line." Albert Boime, The Academy and French Painting in the Nineteenth Century (London: Phaidon, 1971), p. 32.
- Artists in the past sometimes used the thumb instead of the crayon to estimate parallelism—hence the stereotyped gesture of the artist with arm extended.
- 12. An inexperienced draftsman might reason that it would be simpler and more accurate to take measurements not by eye but by a measuring instrument, such as the carpenter's calipers. This type of method ignores the discrepancy between appearance and objective reality, a discrepancy that visual measurement takes into account. Nevertheless, some artists have utilized actual measuring instruments. The naiveté of this approach is suggested by Apollinaire's account of the "primitive" artist Henri Rousseau, who began a portrait by measuring his model and inscribing on the canvas reduced measurements in proper proportion. Charming though they are, Rousseau's portraits offer mute testimony to the accuracy of draftsmanship derived from physical measurements of the model.
- 13. Guillaume Apollinaire, "The Young Picasso, Painter," La Plume, May 15, 1905, p. 477.
- Amedée Ozenfant, The Foundations of Modern Art (New York: Dover Publications, Inc., 1952), p. 323.
- 15. Studies in perception show that the human brain may be especially equipped to detect angles and sharp curves in visual patterns. David H. Hubel and Torsten N. Wiesel of the Harvard Medical School have found angle-detecting cells in the visual cortex of cats and monkeys, "and recordings obtained from the human visual cortex by Elwin Marg of the University of California at Berkeley give preliminary indications that these results can be extended to man." David Noton and Lawrence Stark, op. cit., p. 37.

- 16. Until recently scientists believed that our "sense of position and movement of the joints" depended on a "mysterious muscle sense" deriving in some way from the relative length of the muscles. Research by J. E. Rose and V. B. Mountcastle, however, disclosed that nerve receptors in the joints of the limbs serve as pickups informing the brain of the angular attitude of the limbs. James J. Gibson, *The Senses Considered as Perceptual Systems* (Boston: Houghton Mifflin Co., 1966), pp. 110–111.
- flin Co., 1966), pp. 110–111.

 17. "Color" refers specifically to local color—the basic color of an object without the hue changes that often accompany shadows.
- 18. Leonardo preferred to drop the vertical line from the hollow of the model's throat. Leonardo da Vinci, op. cit., p. 131.
- 19. Julius Held, in Rubens Selected Drawings (London: Phaidon Press, 1959), mentions the London drawing as a work sheet for the same painter's Kermesse in the Louvre. He omits reference to Peasant Dance, though the two paintings are listed by Reginald H. Wilenski in Flemish Painters (London: Faber & Faber Limited, 1960) as probably dating from the same period and including similar dancing figures.
- 20. Italo Svevo, quoted in Udo Kultermann, New Realism (Greenwich, Conn.: New York Graphic Society, 1972), p. 24.
- 21. Leonardo da Vinci, *Trattato della Pittura* §169, quoted in Kenneth Clark, *Leonardo da Vinci* (Harmondsworth, Middlesex, England: Penguin Books Ltd., 1959), p. 79.
- 22. Quoted originally in Charles H. Caffin, *Camera Work*, no. 2, 1903, pp. 22–23; reprinted in Albert E. Elsen, *Rodin* (New York: The Museum of Modern Art, 1963), p. 163.
- 23. Ulric Neisser, op. cit., p. 206. In an article on visual perception of motion, Gunnar Johansson writes: "The eye has evolved to function essentially as a motion-detecting system. The concept of a motionless animal in a totally static environment has hardly any biological significance; the perception of physical motion is of decisive importance. In many lower animals the efficient perception of moving objects seems to be the most essential visual function. A frog or a chameleon, for example, can perceive and catch its prey only if the prey is moving." Gunnar Johansson, "Visual Motion Perception," Scientific American, vol. 232, no. 6 (June 1975), p. 76.
- 24. Eugène Delacroix, the French painter of the 19th century, made one of the most direct applications of the principle of movement (and of memory) in order to clarify form. He sometimes asked his model to walk around the studio while he observed. Only after the model left the room did he begin to draw.
- Picasso, quoted in Pierre Daix and George Boudaille, Picasso: The Blue and Rose Periods, A Catalogue Raisonné of the Paintings, 1900–1906 (Greenwich, Conn.: New York Graphic Society, 1966), p. 67.

- Classical drawings and mirror engravings share a technical as well as a conceptual similarity with Picasso's drawings of the Rose Period: they utilize a line that has a constant width. This form of line, called *monoline*, is also characteristic of ancient Greek writing styles, which lack the swells and thins of later Roman letters.
- Vitruvius, On Architecture, trans. Frank Granger (Cambridge, Mass.: Harvard University Press, 1970), book III, c. 1. p. 159.
- The system of classical proportions permitted the artist to compensate for effects of foreshortening by means of deliberate distortion. In this respect it was a freer concept of form than that exhibited in earlier art.
- 4. Vitruvius, op. cit., p. 68.
- In 1525 Venetian writer Francesco Giorgi attempted to demonstrate a relationship between the intervals of bodily forms and musical intervals of tones (Francisci Giorgii Veneti

- de harmonia mundi totius cantica tria, cited in Erwin Panofsky, Meaning in the Visual Arts [New York: Doubleday & Co., 1955], p. 91).
- Leonardo da Vinci, The Treatise on Painting, trans. A. Philip McMahon (Princeton, N.J.: Princeton University Press, 1956), vol. I, p. 119.
- 7. The golden section is the division of a line or the proportion of a rectangle in which the smaller dimension is to the greater as the greater is to the whole: "The golden section has for centuries been regarded as . . . a key to the mysteries of art" (Herbert Read, as quoted in Webster's Third New International Dictionary [Springfield, Mass.: G. and C. Merriam Co., 1971]).
- 8. For a fascinating example of a Renaissance study of body proportions the reader is referred to *The Human Figure by Albrecht Dürer, The Complete Dresden Sketchbook* (New York: Dover Publications, Inc., 1972).
- 9. The consensus of opinion on proportional norms (and on art in general) in ancient times may have been achieved partly at the expense of restrictive practices limiting drawing instruction to persons of a certain class: "Drawing . . . has always consistently had the honour of being practiced by people of free birth, and later on by persons of station, it having always been forbidden that slaves should be instructed in it. Hence it is that neither in painting nor in the art of statuary are there any famous works that were executed by any person who was a slave" (Pliny, Natural History, books XXXV and XXXVI, 77–80 [Cambridge, Mass.: Harvard University Press, 1967]).
- 10. M. D. Vernon, op. cit., p. 51.
- 11. In some respects the bilateral symmetry of the brain is not matched by a symmetry of function. Dr. Doreen Kimura reports ("The Asymmetry of the Human Brain," Scientific American, vol. 228, no. 3 [March 1973], pp. 72-76): "... evidence that the right hemisphere is ... primary for some very fundamental visual processes.... In the simplest kind of spatial task—the location of a single point in a twodimensional area—the right hemisphere is dominant.... It has been known for some time that injury to the right posterior part of the brain (the parieto-occipital region) results in the impairment of complex abilities such as drawing, finding one's way from place to place and building models from a plan or picture." Both spheres of the brain, however, seem to be equally capable of perceiving shape, a function that, according to Dr. Kimura, apparently involves neural systems "relatively independent" of those that analyze information about the location of objects in
- Symmetria, literally "measuring together," is translated from ancient Greek as "proportion, the commensurability of all the parts of the statue" (J. J. Pollitt, The Art of Greece 1400–31 B.C., Sources and Documents [Englewood Cliffs, N.J.: Prentice Hall, Inc., 1965], p. 57).

- 1. Ulric Neisser, "The Processes of Vision," Scientific American, vol. 219, no. 3 (September 1968), p. 205.
- Leonardo da Vinci, Treatise on Painting, trans. A. Philip McMahon (Princeton, N.J.: Princeton University Press, 1956), vol. I, p. 285.
- In theory black is not a color but the absence of color. Since all pigments reflect some light, however, there are actually different blacks. Felt-tip pens are available in both warm and cool blacks.
- Norma Brouse, "New Light on Seurat's 'Dot': Its Relation to Photo-Mechanical Color Printing in France in the 1800's," The Art Bulletin, LVI (December 1974), p. 584.
- 5. Ibid., p. 581.
- 6. Ibid., p. 586.

- Jeanne L. Wasserman, assisted by Joan M. Lukach and Arthur Beale, Daumier Sculpture, A Critical and Comparative Study (Cambridge, Mass.: Fogg Art Museum, Harvard University, 1969), p. 89.
- 8. The association of drawing with design is not superficial. Drawing almost always involves design in the modern sense, whether it be two- or three-dimensional. Although a distinction is made in the English language, in French and Italian the same word signifies both (i.e., dessin, disegno).
- 9. James J. Gibson, The Senses Considered as Perceptual Systems (Boston: Houghton Mifflin Co., 1966), pp. 198-9.
- 10. Ibid., p. 191.
- 11. Renaissance artists of 15th-century Italy invented perspective, a geometrical system for representing the apparent diminution of size associated with distance. In traditional linear-perspective renderings apparent size changes are projected along lines that radiate from imaginary vanishing points on a horizontal line. As a drawing method linear perspective is a practical means of representing solid objects with geometrical surfaces such as architectural constructions but is not necessary for drawing the figure. Distance and the resulting apparent diminution of size generally play a lesser role in determining the appearance of the body than do the factors discussed in chapter 5, such as surface orientation. For this reason perspective is not treated as a drawing method in this book.
- 12. Neisser, op. cit., p. 208.
- 13. Neisser, op. cit., p. 204.
- Ingres, "Note for 'L'Age d'Or," cited by Kenneth Clark in The Nude (Garden City, N.Y.: Doubleday & Co., 1959), p. 219.
- 15. Leonardo da Vinci, *The Notebooks*, ed. Jean Paul Richter (New York: Dover Publications, Inc., 1970), vol. I, p. 281.
- Julian E. Hochberg, Perception (Englewood Cliffs, N.J.: Prentice-Hall, Inc., 1964), p. 51. For an interesting discussion of the related phenomenon of color constancy see Jacob Beck, "The Perception of Surface Color," Scientific American, vol. 233, no. 2 (August 1975), pp. 62–75.
- 17. Leonardo da Vinci, op. cit., p. 278.
- 18. The political nature of Käthe Kollwitz's art was not overlooked by the Nazis, who dismissed her in 1933 from her teaching post in the Berlin Academy, where she had taught master classes in graphic art since 1928. In 1936 they forbade an exhibition of her art. Earlier she had been the first woman ever elected to the Berlin Academy (Louis Kronenberger, Atlantic Brief Lives [Boston: Little, Brown and Company, 1971], p. 436).
- 19. It is a sad commentary on the Victorian attitudes of 19th-century America that Eakins found it necessary to cut his drawings of the nude into small pieces in order to hide them from customs officials when he reentered the United States. Such drawings were routinely confiscated and destroyed during inspection. The lower portion of the original drawing shown in Figure 5-47 was lost; the remainder consists of two reassembled pieces.
- 20. Surprisingly, drawing from casts was not practiced in the Ecole des Beaux-Arts during the 19th century. Instruction was limited to drawing from the live model, since cast studies were completed before admission to the Ecole (Albert Boime, *The Academy and French Painting in the Nineteenth Century* [London: Phaidon Press, Ltd., 1971], pp. 24–5).
- 21. A specially prepared 35mm slide is one means of demonstrating surface contours. The slide can be made from a small piece of kitchen aluminum foil cut nearly in half with a razor. Guiding the razor with a straightedge, cut two straight edges of foil. The edges should be separated very slightly to form a crack of about a hair's width or less. The two separated pieces can be held in position by an ordinary glass slide mount. If it is placed in a projector, such a slide creates a thin curtain of light, which behaves in the same way that

- a plane does when it intersects a solid object, producing a vivid effect of surface contour. It can be projected on a plaster cast as well as on a model.
- 22. "Exploring the Third Dimension with Camera and Computer," Kodak Studio Light, issue no. 1 (1975), p. 206.
- 23. "Surrealism" literally means "more than realism." As a 20th-century school of art it attempts to recreate the fantastic dream imagery of the subconscious.
- 24. Degas, quoted in Robert Goldwater and Marco Treves, *Artists on Art* (New York: Pantheon Books, Inc., 1945), p. 308.
- 25. Van Deren Coke, The Painter and the Photograph (Albuquerque: University of New Mexico Press, 1972), p. 9.
- Statement from the weekly Paris review Arts, April 26-May 2, 1961, quoted in Peter A. Wick, Jacques Villon, Master of Graphic Art (New York: October House, Inc., 1964), p. 24.
- 27. Ibid
- 28. Helen Gardner, Art Through the Ages (New York: Harcourt, Brace and World, Inc., 1959), p. 442.

- Certain classes of creatures, such as insects and crustacea, possess external exoskeletons. The key to their structure for drawing purposes is the superficial appearance of their forms rather than the internal structure, as is the case with the human body.
- 2. Stephen Rogers Peck, Atlas of Human Anatomy for the Artist (New York: Oxford University Press, 1951), p. 2.
- 3. Ralph Norman Haber, "How We Remember What We See," *Scientific American*, vol. 222 (May 1970), p. 104.
- 4. For a list of recommended anatomy books for artists see the bibliography.
- Coccyx means "cuckoo" in Greek, and the coccyx of the spinal column is so named because of its supposed similarity to the cuckoo's beak (Henry Gray, Anatomy, Descriptive and Physical [Philadelphia: Running Press, 1974], p. 50).
- 6. "Lumbar" refers to the region of the body between the hipbone and the lowest ribs (i.e., the loins).
- 7. Arthur Thomson, A Handbook of Anatomy for Art Students (New York: Dover Publications, Inc., 1964), p. 3.
- 8. The atlas vertebra, which supports the globelike cranium of the skull, derives its name from the mythical Atlas, who supported another globe—the earth—on his back (Gray, op. cit., p. 36).
- The balance is not quite perfect. If a person falls asleep sitting up, the head tends to fall forward.
- 10. Gray, op. cit., pp. 34-5.
- 11. The term "vertebra" is derived from the Latin vertere, "to turn" (Henry Gray, op. cit., p. 34).
- 12. "When you draw take care to set up a principal line which you must observe all throughout the object you are drawing; everything should bear relation to the direction of this principal line" (Leonardo da Vinci, *The Notebooks*, ed. Jean Paul Richter [New York: Dover Publications, Inc., 1970], vol. I, p. 260).
- 13. Certain artists have found the visual analogy between the head and the egg to be useful imagery in their work. Among these is the surrealist Giorgio de Chirico (b. 1888), who depicts the head of a figure as an egglike form in several of his compositions.
- 4. The use of the mirror by artists was noted in Renaissance times by Leonardo da Vinci, whose *Treatise on Painting* advised, "When you wish to see whether the general effect of your picture corresponds with that of the object presented by nature, take a mirror and set it so that it reflects the actual thing, and then compare the reflection with your picture and consider carefully whether the subject of the two images is in conformity with both, studying especially the mirror." Alberti also recommended its use. (Quoted in Robert Goldwater and Marco Treves, *Artists on Art* [New York: Pantheon Books, 1945], p. 54).

- 15. Anthropologists prefer to view this arc as an angle for purposes of measurement. The facial angle, as it is called, is "made by the intersection of the [vertical] axis of the face with the [central] axis of the skull" (Webster's New Collegiate Dictionary [Springfield, Mass.: G. and C. Merriam Co., 1951].
- In the view of Kenneth Clark, a noted authority on Leonardo, the artist "never surpassed the rendering of light passing curved surfaces in the studies of skulls dated 1489 [Figure 6-27]" (Kenneth Clark, Leonardo [Baltimore: Penguin Books, 1959], p. 77).
- 17. The ball-and-socket joint is capable of rotation in addition to the hinge movements of other free-moving joints. Movement at joints is facilitated by *synovia*, an oily fluid produced by a membrane lining the inner surface of the joint's ligaments (Thomson, op. cit., p. 28).
- 18. The bony bump that you can feel on the top of your shoulder is not the acromium process of the scapula but the prominence of the outer end of the clavicle. The acromium process of the scapula extends beyond the prominence of the clavicle to the tip of the shoulder.
- 19. Gray, op. cit., p. 183.
- 20. Anthropoid apes have thumbs on both hands and feet, reflecting the unspecialized use of these members.
- 21. "Condyle" is defined as "an articular prominence on a bone," often appearing in pairs (i.e., on the distal end of the humerus and femur). The word also refers to any smooth surface of a joint (Webster's Third New International Dictionary [Springfield, Mass.: G. and C. Merriam Co., 1971]).
- 22. The term "funny bone" may be a pun on the word "humerus." It is defined, however, as "the place at the back of the elbow where the ulnar nerve rests against a prominence of the elbow joint in the bone of the upper arm" (Webster's New Collegiate Dictionary [Springfield, Mass.: G. and C. Merriam Co., 1951].
- 23. "Epicondyle" literally means "beside the condyles" and refers to a knobby swelling of the bone on the lateral side of the condyles.
- Measured from the great trochanter, the lower limb is approximately half the body height (Thompson, op. cit., p. 428).
- 25. The word "fibula," in fact, originally denoted the ancient equivalent of a safety pin.
- The angle of inclination in the femur is usually greater in the female skeleton due to the greater width of the female pelvis (Gray, op. cit., p. 183).
- 27. Thomson, op. cit., p. 291.
- 28. Ibid., p. 259.
- 29. "Phalanx" is derived from the Greek *phalanx*, meaning "line of soldiers."
- 30. "Carpal" is derived from *karpos*, Greek for "wrist." Likewise *tarsus* is Greek for "flat of the foot," and *meta* means "after"; hence "metatarsal" is literally "after the tarsal," which corresponds to its relative position in the skeleton.
- 31. The difference in the number of bones in the tarsus and in the carpus is believed to be due to the fusion of two bones in the former, causing it to have one bone less than the latter (Thomson, op. cit., p. 15).
- 32. Peck, op. cit., p. 78.
- The Achilles tendon of the heel conceals the length of the calcaneus in life.
- 34. Kenneth Clark, *The Nude* (Garden City, N.Y.: Doubleday and Co., Inc., 1956), p. 453.

- The importance of this special ability is illustrated by the human heart, an organ composed largely of muscles that contract in regular beats.
- Stephen Rogers Peck, Atlas of Human Anatomy for the Artist (New York: Oxford University Press, 1973), p. 89.

- 3. Webster's Unabridged Dictionary (Springfield, Mass.: G. and C. Merriam Co., 1951).
- 4. In his book *Living Anatomy* (London: Faber and Faber Limited, 1963), p. 7, Dr. R. D. Lockhart suggests that the word "relaxation" be replaced by "decontraction," as the latter more accurately describes how muscles "relax": "When the arm is being gradually lowered," he states, "the deltoid (shoulder muscle) can still be felt firm—it is still working hard in controlling the gravitational descent of the arm, but getting longer as it pays out, like a crane lowering a weight."
- In a relaxed standing position, however, the body requires little muscular activity, as "Ligaments may take the strain before muscles are necessary" in the hip and knee joints (R. D. Lockhart et al., Anatomy of the Human Body [Philadelphia: J. B. Lippincott Co., 1974], p. 146).
- 6. Ecorché means "skinned" in French.
- Leonardo da Vinci, The Treatise on Painting, trans. A. Philip McMahon (Princeton, N.J.: Princeton University Press, 1956), vol. I, p. 125.
- B. Arthur Thomson, A Handbook of Anatomy for Art Students (New York: Dover Publications, 1964), p. 171.
- 9. Peck. op. cit., p. 150.
- 10. Linea alba is Latin for "white line."
- 11. A fascia is a sheet or layer of tough connective tissue that covers and binds together muscle structures of the body. If a fascia (instead of a tendon) forms the end of a muscle, the condition is called aponeurosis. Fascia is called intermuscular septa if it lies embedded between groupings of muscles.
- 12. Peck, op. cit., p. 89.
- 13. R. D. Lockhart, M.D., *Living Anatomy* (London: Faber and Faber Limited, 1963), p. 6.
- 14. Arthur Thomson, whose 19th-century work on artistic anatomy remains a useful text, provides an amusing insight into the neoclassic taste of his day: "The student should be warned against the ungainly forms which are dependent on the undue accumulation of fat in the region overlying the iliac crest. This is particularly liable to occur in the female models past their prime, and imparts a grossness of form at variance with the delicacy and refinement displayed in earlier life" (Thompson, op. cit., p. 271).
- 15. Peck, op. cit., p. 102.
- 16. The upper origins of the latissimus dorsi are from the seventh vertebra of the rib cage on downward (Peck, op. cit., p. 102).
- 17. Jenö Barcsay, Anatomy for the Artist (London: Spring Books, 1958), p. 206.
- 18. Lockhart, op. cit., p. 49.
- Including the lowest vertebra of the rib cage, the twelfth (Henry Gray, Anatomy [Philadelphia: Running Press, 1974], p. 337).
- 20. Deeper muscles associated with the scapula include the rhomboids and the supraspinatus. According to Arthur Thomson, the rhomboids have a "considerable influence on the surface contours, [forming] . . . a somewhat broad and oblique elevation which accentuates the relief of the trapezius muscles which overlie them" (Thomson, op. cit., p. 108). This muscle can be rendered by drawing the trapezius on one side only of your study of the back, and the rhomboids and supraspinatus on the other side.
- 21. Infra means "below": hence, infraspinatus means "below the spine" (of the scapula).
- 22. Peck, op. cit., p. 102.
- Connected with the base of the tongue, the hyoid bone is associated with swallowing movements. You can locate it by feeling your neck above the Adam's apple as you swallow.
- A secondary sex characteristic, the Adam's apple becomes larger in the male about the time that the voice deepens during adolescence (Thomson, op. cit., p. 365).

- 25. The top segment of the sternum is called the *manibrium*, after the handle of an ancient sword that the sternum as a whole resembles (Gray, op. cit., p. 124).
- "Concerning the combined action of the two [sternomastoid] muscles, there is disagreement in the various textbooks: Some assert that the muscles bend forward the head and neck, whilst others state that the muscles act as extensors of the head; the truth appears to lie between two statements. Their united action seems to be the bending forward of the neck on the thorax [chest] combined with the extension of the head upon the bent neck" (Thomson, op. cit., p. 373). Peck seems to agree, saying that the sternomastoids 'together lift the face and tip the head backward" (Peck, op. cit., p. 95). Jenö Barcsay, however, asserts that the sternomastoid "flexes the head" forward, adding that the "forward flexation of the head cannot take place before the face has been lowered [so that] . . . the insertion of the muscle lies in front of the [spinal] joint [with the skull]" (Barcsay, op. cit., p. 238).
- 27. Barcsay, op. cit., p. 236.
- 28. The platysma muscle "is a survival in man of a muscle which commonly occurs in many animals. Anyone who has watched a fly settle on a horse's neck has seen that the latter has the power of rippling or wrinkling its skin in a remarkable manner. [The platysma] belongs to the same class" (Thomson, op. cit., p. 374).
- Vernon, M. D., The Psychology of Perception (Harmondsworth, Middlesex, England: Penguin Books Ltd., 1968), p. 51.
- The action of the biceps on the humerus is therefore indirect.
- 31. The ulnar tuberosity, a bump on the front side of the ulna near the coronoid process (see Figure 7-33).
- 32. It is also shared with the bicep.
- 33. Thomson, op. cit., p. 192.
- 34. Polex is Latin for "thumb"; pollicis, "of the thumb."
- 35. Anatomical texts differ on the exact function of these muscles. Barcsay states (Barcsay, op. cit., p. 72) that the extensor pollicis brevis extends the distal phalanx of the thumb (even though he also states that it attaches only to the proximal or first phalanx). Peck more accurately asserts (Peck, op. cit., p. 112) that it "extends the first phalanx."
- Pronation is also a weaker movement that supination. For that reason "Screws are usually made to be driven home by supination of the right forearm" (R. D. Lockhart et al., Anatomy of the Human Body [Philadelphia: J. B. Lippincott Co., 1974], p. 214).
- 37. The pisiform (pea-shaped) bone does not join with the radius, but its projection adds depth to the inner arch of the carpals, through which many tendons of the flexor muscles pass.
- 38. Thomson, op. cit., p. 197. According to Thomson this muscle is absent in 10 percent of the population, so you need not be surprised if you cannot locate it in your wrist.
- 39. The term "lower limb" is used in place of the word "leg." In common usage their meaning is identical, but in anatomical writing "leg" applies only to the part of the lower limb between the knee joint and the foot. The word "thigh" denotes the section above the knee.
- 40. Thomson, op. cit., p. 297.
- 41. Sartor is Latin for "tailor." In times past tailors often sat cross-legged to facilitate sewing.
- 42. The iliopsoas, a deep muscle that attaches to the ilium, the lower vertebrae, and the femur, is sometimes included in this group, but it is omitted here because it does not act as an adductor. The muscle extends from the lower vertebrae and the inner wall of the ilium beneath the inguinal ligament to the femur, inserting with the small inner trochanter. It is largely internal, appearing superficially only in one small area between the inner angle of the sartorius and the inguinal ligament. Its function is to flex the thigh.

- 43. Gray warns of the danger to the adductor longus posed by horseback riding—a vivid reminder of the location of the muscle (Gray, op. cit., p. 426).
- 44. Other fascial bands in addition to the iliotibial affect the form of the lower limb: the band of Richer, which girds the front of the thigh above the knee, causing a noticeable bulge in the vastus medialis (Figure 7-35); another that reaches under the hip muscles to form the crease below the hip (the gluteal furrow); a band lower on the limb at the knee that binds the back knee muscles in a manner similar to a garter (Figure 7-39); and the transverse ligament of the ankle, which is comparable to the annular ligament of the wrist (Figure 7-33). Not usually visible themselves, these bands of fascia help hold the muscles and tendons in place and tend to alter their appearance, especially under stress.
- 45. Thomson, op. cit., p. 276.
- 46. The gluteus medius covers a smaller, deeper muscle, the gluteus minimus, also an adductor of the thigh.
- 47. Ibid., p. 304. The ham is referred to as the popliteal fossa in Peck, op. cit., p. 132.
- 48. The popliteal band of fascia (see footnote 47).
- 49. The indirect action of the leg flexors on the femur recalls the indirect action of the arm biceps on the humerus (Figure 7-3).
- 50. The hamstring muscles not only flex the leg but also restrict or limit the flexion of the hip joint. People with short or tight hamstring muscles are unable to touch their toes by bending at the hip. By bending the knees the distance between the insertions and the origins is shortened, facilitating the task. For an illustration of this function see Lockhart, op. cit., p. 61.
- Gastrocnemius literally means "belly of the leg" in Greek (Peck, op. cit., p. 131).
- 52. Gray, op. cit., p. 437.
- 53. The single name for both muscles is *triceps surae* (Barcsay, op. cit., p. 151).
- 54. A much smaller muscle, unimportant for the draftsman, arises from the lower fourth of the tibia and is visible as a tendon on the lateral side of the foot (Figure 7-43). This muscle, known as the peroneus tertius, is actually part of another muscle, the extensor digitorum longus. It inserts with the upper surface of the base of the little toe's metatarsal (Gray, op. cit., p. 435).
- 55. Gray, op. cit., p. 441.
- 56. The front muscles of the leg are separated from those of back by the interosseous membrane, a thin layer of ligament that spans the gap between the inner sides of the tibia and the fibula (Gray, op. cit., p. 202).
- 57. The tendons insert with the second and third phalanges of the four smaller toes (Gray, op. cit., p. 435).
- 58. Hallucis is Latin for "of the big toe."
- 59. Gray, op. cit., p. 436.
- 60. Ibid., p. 439.
- 61. Italo Svevo, Confessions of Zeno (New York: Random House and Alfred A. Knopf, Inc., 1958), pp. 94–95.
- 62. John W. McCoubrey, American Art 1700–1960 (Englewood Cliffs, N.J.: Prentice-Hall, Inc., 1965), p. 153.
- For an interesting discussion of the relationship between scientific anatomy and the history of art see Eugenio Battisti, "Visualization and Representation of the Figure," Encyclopaedia of World Art (New York: McGraw-Hill Book Company, Inc., 1963), vol. VII, p. 666.
- 54. Sir Julian Huxley, July 1871, quoted in "Fifty and 100 Years Ago," Scientific American, vol. 225 (July 1971), p. 10. Huxley's assessment of the humanism of drawing, though apparently serious, was made in the context of a humorous speech comparing professional disciplines with attributes of animals, part of a mock-scientific search for the distinction between animals and humans. The speech, which was given at a dinner for the Royal Academy of the Arts, was in all likelihood well received.

- The examples selected are not all-inclusive due to limitations of space. It is hoped that the omission of significant time periods from this chapter of the book are balanced by inclusion elsewhere. My selection was motivated by didactic considerations and the intention of providing examples most useful to the modern student of drawing.
- The invention of paper is traditionally credited to Ts ai Lun, an officer of the Chinese Imperial guard (105 A.D.), though it did not come into general use until after 220 A.D. Brought to the West by Arabs in the 8th century, paper was not generally available in Europe before 1300.
- The rare sketches made by ancient Egyptian artists on small, irregular stone slabs are an exception. The purpose of such sketches is poorly understood at present.
- 4. "Sinopia" is a term used to designate a preparatory drawing made directly on the plaster wall surface before beginning a fresco painting. The reddish pigment used for the wash drawing is derived from the ancient Asian town of Sinope, from whence it was presumably exported in early times. For an interesting account of traditional sinopia and fresco techniques see Cennino Cennini's The Book of Art.
- Ironically, the fragile, combustible nature of paper has contributed to the destruction of many drawings, leaving many works of art for which no preparatory drawings exist.
- Erwin Panofsky, Early Netherlandish Painting (Cambridge, Mass.: Harvard University Press, 1958), vol. 1, p. 200.
- Kenneth Clark, Leonardo da Vinci (Baltimore: Penguin Books, 1963), p. 51.
- 8. Ibid. The patron in this instance was the Confraternity of the Immaculate Conception.
- For a complete discussion of the preparation of silverpoint ground see James Watrous, The Craft of Old-Master Drawings (Madison: The University of Wisconsin Press, 1967), pp. 3–33.
- 10. Ibid., p. 13.
- 11. One of the dubious benefits of air pollution is that it speeds up the darkening of silverpoint. You can test the quality of metal as a drawing medium by marking a painted surface with a dime or a penny (ibid., p. 22).
- 12. Graphite was mined in its natural form for use in art as early as 1560 in England, though it did not come into general use until the 17th century. In 1795 Nicolas Jacques Conté patented a process for preparing graphite-pencil rods similar to those still used today. Made from compressed graphite powder and clay, the Conté pencil rods, later known in English as leads, became very popular in the 19th century. Most graphite used in pencils today, however, is a synthetic form of the metal (ibid., pp. 138-44).
- 13. Although scholars agree that the main figure was drawn by Michelangelo, not all agree on the authorship of the smaller studies on the sheet. If the contour drawing of the shoulder and chest to the left of the principal figure and the drawing of the large profile are, as de Tolnay believes, the work of a pupil, the secondary studies represent a valuable example of the instructional use of drawing in art training. Berenson, however, concluded that the entire sheet is the work of Michelangelo. If this is so, it seems likely that the contour construction of the shoulder and chest, in which the pectoral muscle is more pronounced, was an experiment in adapting the male figure to forms more in accordance with female anatomy.
- 14. Amid the brilliant anatomical modeling of this drawing can be noted two pinlike indications of the tips of the shoulder clavicle bones, bones that can be used to set the important horizontal axis of the torso. For similar markings in another drawing by Michelangelo see Figure 7-42.
- 15. Leo Steinberg, "Pontormo's Capponi Chapel," The Art Bulletin, vol. LVI, no. 3 (September 1974), p. 387.
- 16. See the Roman frescoes of the Villa of the Mysteries, Pom-

- peii in Amedeo Maiuri, Roman Painting (Geneva: Editions Albert Skira, 1953), p. 59.
- Julius S. Held, Rubens Drawings (London: Phaidon Press, 1959), vol. 1, p. 72.
- Pierre Gassier and Juliet Wilson, Francisco Goya (New York: Reynal and Company in association with William Morrow & Co., Inc., 1971), p. 244.
- 19. Kenneth Clark, *The Romantic Rebellion* (New York: Harper and Row Publishers, 1973), pp. 97–8.
- 20. The later French artist Odilon Redon (1840–1916) objected to Ingres on the grounds of his traditionalism: "Ingres is an honest and useful disciple of the masters of another age. . . In those false temples, with their great false gods, Ingres, the disciple who follows, is always raised on high. . . . Ingres did not belong to his age; his mind is sterile, the sight of his work, far from increasing our moral force, lets us placidly continue on our bourgeois way of life, in no way affected or changed. His works are not true art; for the value of art lies in its power to increase our moral force or establish its heightening influence. . . . " (quoted in Robert Goldwater and Marco Treves, Artists on Art [New York: Pantheon Books, 1945], p. 359).
- 21. This technically subtle form of shadow modeling, also seen in portraits by Raphael, a painter whom Ingres greatly admired, is later encountered in paintings by the impressionist Edouard Manet (1832–1883). Such modeling creates an effect similar to that of relief modeling, as described in chapter 5.
- 22. The prominence given by Ingres to the mirror and its reflection in this portrait recalls Leonardo's belief that mirrored images were among the effects impossible to create in sculpture that prove the superiority of painting as an expressive art form (*The Notebooks of Leonardo* [New York: Dover Publications, Inc., 1970], vol. I, p. 329).
- For a classical example of this pose, which Ingres may have seen, see the Graeco-Roman relief carving of Medea and the Peliades in the Lateran Museum, Rome, reproduced in Rodenwaldt's Kunst der Antike (Berlin: Im Propläen-Verlag, 1927), p. 369.
- 24. In the catalog for the Memorial Exhibition of Works of Art from the Collection of Paul J. Sachs (Fogg Museum, Harvard University, 1965), p. 46, Ingres' writing is deciphered as "grand foyer de Carmin." In the catalog for the Ingres Centennial Exhibition (Fogg Museum, Harvard University, 1967), p. 85, the same writing is transcribed as "grand foyer de lumiere plus" (crossed out). The latter reading seems more accurate to this author.
- 25. Poussin, in a letter to his friend Chantelou in 1642, commented: "The beautiful girls whom you will have seen in Nimes will not, I am sure, have delighted your spirit any less than the beautiful columns of Maison Carrée; for the one is not more than an old copy of the other." Poussin may have been referring to the Roman author Vitruvius' account in which columns were designed according to human proportions. Kenneth Clark, The Nude (New York: Doubleday, Anchor Books, 1956), p. 45.
- Lorenz Eitner, Neoclassicism and Romanticism (Englewood Cliffs, N.J.: Prentice-Hall, 1970), p. 137.
- 27. Kenneth Clark, *The Romantic Rebellion* (New York: Harper and Row Publishers, 1973), pp. 292–3.
- 28. Robert Goldwater and Marco Treves, op. cit., pp. 292-3.
- 29. As quoted in *Picasso's Private Drawings* (New York: Simon and Schuster, 1969), p. 11.
- 30. Pierre Daix and Georges Boudaille, *Picasso, The Blue and Rose Periods* (Greenwich, Conn.: New York Graphic Society, Ltd., 1967), p. 294.
- 31. MacKinley Helm, *Modern Mexican Painters* (New York: Dover Publications, Inc., 1941), p. 83.
- 32. Justino Fernandez, José Clemente Crozco, Forma y Idea (Mexico City: Libreria de Porrua Hnos. y Cia., 1942), p. 31.

- 33. Magritte, as quoted by Suzi Gabelik, "A Conversation with René Magritte," *Studio International* (London), vol. 173, no. 887 (March 1967), p. 128.
- 34. The purposes of surrealist art were described by the French poet and critic André Breton: "... the strongest surrealist image is the one that pursues the highest degree of the arbitrary, the one that takes the longest to translate into practical language, whether it contains an enormous amount of apparent contradiction; whether promising to be sensational, it seems to come to a weak conclusion; whether it draws from itself a derisory formal justification; whether it is of a hallucinatory nature; whether it lends very naturally the mask of the concrete to abstraction or vice versa; whether it implies the negation of some elementary physical quality; or whether it provokes laughter" (quoted by Eddie Wolfram in Magritte [New York: Ballantine Books, 1972], p. 4). On the basis of this statement Magritte's painting and sculp-
- ture *Delusions of Grandeur* qualify as surrealist imagery on several counts.
- Suzi Gabelik, Magritte (Greenwich, Conn.: New York Graphic Society, Ltd., 1973), p. 181.
- 36. Ibid
- 37. Ibid.
- 38. Ibid., p. 183.
- 39. Magritte, as quoted in Louis Scutenaire, René Magritte (Brussels: Librairie Selection, 1947), p. 38.
- 40. Sculpmetal, used to create the textured surface of this work, is the trade name for a metal solution that turns to solid metal as it dries. It can be applied to almost any surface by means of a brush or a palette knife.
- 41. Cennino Cennini, *The Book of the Art*, as translated in Goldwater and Treves, op. cit., p. 23.

Bibliography

The following selection is offered primarily as a basic working bibliography to assist the reader who wishes to pursue the subject further. Representing but a fraction of the works consulted in preparing this book, the list omits monographs on individual artists and references to articles in periodicals: the former, because such titles are easily found in the card catalog of any library; the latter, because they are too specific to warrant inclusion here. Since nothing is so valuable for the student of drawing as looking at original master drawings, the preponderance of works listed in the general-reference category were selected to provide the next best thing—reproductions of a variety of master drawings—with the hope of stimulating both the appreciation and the production of drawings.

GENERAL REFERENCES

Bean, Jacob and Stampfle, Felice. *Drawings from New York Collections: The Italian Renaissance*. New York: The Metropolitan Museum of Art and the Pierpont Morgan Library, 1965.

——. The 17th Century in Italy (Drawings from New York Collections III). Catalog. New York: Metropolitan Museum of Art and the Pierpont Morgan Library, 1971.

Berenson, Bernard. The Drawings of the Florentine Painters. Chicago: University of Chicago, 1938.

Bertram, A. 1000 Years of Drawing. New York: Dutton, 1966.

Borden Publishing Company. Master Draughtsman Series. 28 inexpensive volumes reproducing drawings of individual artists from the Renaissance to the present day. Alhambra, Calif.: Borden Publishing Company.

British Museum. Italian Drawings in the Department of Prints and Drawings in the British Museum, 4 vols. Vol. 1: Popham, Arthur E. and Pouncey, Philip. The 14th and 15th Centuries, 2 vols. London: British Museum, 1950. Vol. II: Wilde, Johannes. Michelangelo and His Studio. London: British Museum, 1953. Vol. III: Pouncey, Philip, and Gere, John A. Raphael and His Circle, 2 vols. London: British Museum, 1967. Vol. IV: Popham, Arthur E. Artists Working in Parma in the 16th Century, 2 vols. London: British Museum, 1967.

Coke, Van Deren. The Painter and the Photograph. Albuquerque: University of New Mexico Press, 1972.

Haverkamp-Begemann, Egbert; Lawder, Standish, D. D.; and Talbot, Charles. *Drawings from the Clark Art Institute*. 2 vols. New Haven, Conn.: Yale University Press, 1964.

Hofmann, Werner. Caricature from Leonardo to Picasso. Translated by M. L. H. New York: Crown Publishers, 1957.

Kenin, Richard. The Art of Drawing. London: Paddington Press Ltd., 1974.

Levy, Mervyn. The Artist and the Nude. London: Barrie and Rockliff, 1965.

Liberman, William S., ed. Seurat to Matisse: Drawing in France. New York: The Museum of Modern Art, 1974.

Lindemann, Gottfried. *Prints and Drawings: A Pictorial History*. Translated by Gerald Onn. New York: Praeger, 1970.

Marks, Claude. From the Sketchbooks of the Great Artists. New York: Thomas Y. Crowell Company, 1972.

Metropolitan Museum of Art. European Drawings. 2 vols. New York: The Metropolitan Museum of Art, 1943.

Mongan, Agnes and Sachs, Paul J. Drawings in the Fogg Museum of Art. 3 vols. Cambridge, Mass.: Harvard University Press, 1946.

Mongan, Agnes. Memorial Exhibition Works of Art from the Collection of Paul J. Sachs. Catalog. Cambridge, Mass.: Fogg Art Museum, 1965.

— . One Hundred Master Drawings. Cambridge, Mass.: Harvard University Press, 1949.

Moskowitz, Ira, ed. *Great Drawings of All Time*. New York: Shorewood Publishers, Inc., 1962.

Museum of Modern Art. Modern Drawings. Edited by Monroe Wheeler. New York: New York Museum of Modern Art, 1944.

Popham, Arthur E. The Italian Drawings of the XV and XVI Centuries in the Collection of His Majesty the King at Windsor Castle. London: Phaidon, 1949.

Ragghianti, Carlo L. Firenze 1470-1480 Disegni dal Modello. Pisa: Instituto di Storia dell'Arte dell'Universita' di Pisa, 1975.

Rosenberg, Jakob. Great Draftsmen from Pisanello to Picasso. Cambridge, Mass.: Harvard University Press, 1959.

Sachs, Paul J. Modern Prints & Drawings. New York: Alfred A. Knopf, 1954.

Scholz, Janos. *Italian Master Drawings 1350–1800*. New York: Dover Publications, Inc., 1976.

Shorewood Publishers, Inc. Drawings of the Masters. 12 inexpensive volumes treating drawing by country and period: French Impressionists; Italian Drawings from the 15th to the 19th Century; Flemish and Dutch Drawings from the 15th to the 18th Century; 20th Century Drawings, 1900–1940; 20th Century 1940 to Present; German Drawings from the 16th Century to the Expressionists; French Drawings from the 15th Century through Gericault; American Drawings; Spanish Drawings from the 10th to the 19th Century; Persian Drawings from the 14th through the 19th Century; From Cave to Renaissance. New York: Shorewood Publishers, Inc., 1963. Boston: Little, Brown & Co., 1976 (paperback edition).

Tietze, Hans and Tietze-Conrat, Erica. The Drawings of the Vene-

- tian Painters in the 15th and 16th Centuries. New York: Augustin, 1944.
- van Gelder, J. G. Dutch Drawings and Prints. New York: Harry N. Abrams, Inc., 1959.
- Vayer, Lajos, ed. Master Drawings from the Collection of the Budapest Museum of Fine Arts 14th–18th Centuries. New York: Harry N. Abrams, Inc.
- Welch, Stuart Cary. *Indian Drawings and Painted Sketches*. Catalog. New York: The Asia House Gallery, 1976.

DRAWING METHODS, MATERIALS, AND TECHNIQUES

- Chaet, Bernard. The Art of Drawing. New York: Holt, Rinehart & Winston, 1970.
- de Tolnay, Charles. History and Technique of Old Master Drawings. New York: Bittner, 1943.
- Goldstein, Nathan. The Art of Responsive Drawing. Englewood Cliffs, N.J.: Prentice-Hall, Inc., 1973.
- Hale, Robert Beverly. *Drawing Lessons from the Great Masters*. New York: Watson-Guptill Publications, 1964.
- Hutter, H. Drawing: History and Technique. New York: McGraw-Hill, 1968.
- Kaupelis, R. Learning to Draw. New York: Watson-Guptill Publications, 1968.
- Kay, Reed. The Painter's Guide to Studio Methods & Materials. Garden City, N.Y.: Doubleday & Co., Inc., 1972.
- Klee, Paul. Inward Vision: Watercolors, Drawings, and Writings. New York: Abrams, 1959.
- Mayer, Ralph W. The Artist's Handbook of Materials & Techniques. Revised edition. New York: The Viking Press, Inc., 1970.
- Mendelowitz, Daniel M. *Drawing*. New York: Holt, Rinehart & Winston, 1967.
- Nicolaides, Kimon. *The Natural Way to Draw*. Boston: Houghton Mifflin Company, 1941.
- Rawson, Philip. *Drawing*. London: Oxford University Press, 1969. Watrous, James. *The Craft of Old Master Drawings*. Madison: University of Wisconsin Press, 1959.

HISTORY AND PHILOSOPHY

- Boime, Albert. The Academy and French Painting in the Nineteenth Century. London: Phaidon, 1971.
- Clark, Kenneth. The Nude: A Study in Ideal Form. Garden City, N.Y.: Doubleday & Co., 1959.
- da Vinci, Leonardo. *The Treatise on Painting*. Translated by A. Philip McMahon. Princeton, N.J.: Princeton University Press, 1956
- Goldwater, Robert and Treves, Marco. *Artists on Art.* New York: Pantheon Books, 1945.
- Ozenfant, Amedee. The Foundations of Modern Art. New York: Dover Publications, Inc., 1952.
- Panofsky, Erwin. Meaning in the Visual Arts. New York: Doubleday & Co., 1955.
- Vasari, Giorgio. Lives of the Artists. Translated by E. L. Seeley. New York: Noonday Press, Farrar, Straus & Giroux, 1957.

VISUAL PERCEPTION

- Arnheim, Rudolf. Art and Visual Perception. Berkeley and Los Angeles: University of California Press, 1954.
- Buswell, Guy Thomas. How People Look at Pictures: A Study of the Psychology of Perception. Chicago: University of Chicago Press, 1935.
- Gibson, James J. The Senses Considered as Perceptual Systems. Boston: Houghton Mifflin Co., 1966.
- Gregory, R. L. Eye and Brain: the Psychology of Seeing. New York: McGraw-Hill, 1966.
- Hochberg, Julian E. *Perception*. Englewood Cliffs, N.J.: Prentice-Hall, Inc., 1964.
- Scientific American. New York: Scientific American, Inc. A periodical of special interest for its many articles on visual perception.
- Vernon, M. D. A Further Study of Visual Perception. London: Cambridge University Press, 1952.
- . The Psychology of Perception. Harmondsworth, Middlesex, England: Penguin Books Ltd., 1962.
- Wittgenstein, Ludwig. The Blue and Brown Books. New York: Harper and Row, 1965.

ANATOMY

- Barcsay, Jenö. Anatomy for the Artist. London: Spring Books, 1955.
- Fau, Dr. J. The Anatomy of the External Forms of Man. London: Hippolyte Bailliere, 1849.
- Gray, Henry. Anatomy, Descriptive and Surgical. 1901. Reprint. Philadelphia, Running Press, 1974.
- Kramer, Jack. *Human Anatomy and Figure Drawing*. New York: Van Nostrand Reinhold Company, 1972.
- Lockhart, Dr. R. D. et al. *Anatomy of the Human Body*. Philadelphia: J. B. Lippincott Co., 1974.
- Lockhart, Dr. R. D. *Living Anatomy*. London: Faber and Faber Limited, 1963.
- Muybridge, Eadweard. The Human Figure in Motion. New York: Dover Publications, Inc., 1955.
- Peck, Stephen Rogers. Atlas of Human Anatomy for the Artist. New York: Oxford University Press, 1951.
- Saunders, J. B. de C. and O'Malley, Charles D., trans. and annot. The Illustrations from the Works of Andreas Vesalius of Brussels. New York: Dover Publications, Inc., 1973.
- Thomson, Arthur. A Handbook of Anatomy for Art Students. New York: Dover Publications, Inc., 1964.

Index

Boldface numbers refer to illustrations.

abdominal sheath, 191 abductor pollicis muscles: brevis, 201; longus, 201, 204, 205, 206 Abstract Construction (Villon), 119 Acadamic study (Eakins), 105, 106, 185 Academic study of a nude man (Degas), 183 académies d'après nature, 104 acetabulum (pelvis socket), 145, 160, 160, 210, 211 Achilles painter, 66 Achilles tendon, 214, 215, 127, 218, 220 Acrobats (Calder), 62 acromium process, 149, 163, 191, 195, 197, 201, 202, 204, 205, 207, 209 Adam's apple, 197 addentellati (chisel hatching), 126 adduction, 209 adductor muscles, 210-211, 212; longus, 211, 212, 218; magnus, 211, 212, 218-220 African art, 58, 59, 72 Ajanta paintings, India, 66 Allegorical drawing of the plan of Saint Peter's Square (Bernini), 70 Allegorical Figure of a Cook (Arcimboldo), 35 allegory, 239 Amarna drawing, 222, 222 Anatomical studies (Michelangelo), 180 Anatomical studies of skulls (da Vinci), 158 Anatomical study: cross-sectional rendering of a man's right leg (da Vinci), 114 Anatomical study of a female nude (Grosz), Anatomie du Gladiator Combattant (Savage), 147, 154, 161, 164, 168-170 Anatomy (Gray), 146, 147 Anatomy of the External Forms of Man, The (Fau), 142, 143, 145, 149, 150, 187-189, 201, 202, 204, 205, 207, 209, 212, 214, 216, 218-220 anconeus muscle, 201, 205, 207 angles, visual measurement of (study 9), 38-42, 38-41 Angry Kaiser Wilhelm, The (Klee), 118 animal skeletons, 176, 176 ankle bones, 168, 170, 175; 210; see also malleolus, talus annular (transverse ankle) ligament, 202, 208, 209, 212, 214, 215, 217 Annunciation, The (Boscoli), 98 antagonistic muscles, 178, 203, 215, 217 Apelles, 30 ape skeleton, 176, 176 Aphrodite and Pan Playing at Dice (Greek), Aphrodite of Melos, 110 aponeurosis (tendinous sheath), 188, 193, 208 appendicular skeleton, 165-166 aquatint, 81, 136 arch, of foot, 175; vertebral, 147 architecture, 70, 240 Arcimboldo, Guiseppe, 34-35, 35, 243 Aristides, 30 arm, skeletal (study 33), 168 arm muscles (study 42), 200 arms: bones, 141, 163, 201, 202, 204, 205, see also humerus, radius, ulna; muscles, 190,

200-209, 201-209, see also biceps, brachialis Arm studies for Adam (Dürer), 203 articular processes, vertebral, 147 artworks, studying, 54-58 Ascension of St. John the Evangelist (Giotto), 55 astragalus, 212 Atelier of David, The (Cochereau), 4 atlas (1st vertebra), 146, 146, 147 axes, body, 72; imaginary, 18-19; see also medial, pelvis axial skeleton, 144, 145, 146-147, 146, 148-150, 162, 193; drawing (study 29), 148-152. axis (2nd vertebra), 146, 147 back: bones, see vertebral column; muscles, **187,** 194–197, **194, 195** ball-and-socket joints, 142, 160, 161, 168; converse, 142, 164 Beardsley, Aubrey, 44, 45, 46 Bernini, Giovanni Lorenzo, 70, 70, 126, 190; school of, 127 Berry, William, 123 biceps (arm muscle), 178, 179, 200, 201, 202, 204, 209; femoris (leg muscle), 211, 214, 216, 220 bicipital fascia, 200, 202, 204 Bloemaert, Abraham, 196 body, living, skeleton in, 140, 141 Boisbaudran, Lecoq de, 36 Boscoli, Andrea, 98 Bourgeois Society, (Gross), 72, 74 box constructs, 34 brachialis (arm muscle), 178, 179, 200, 201, 202, 209 brachioradialis muscle, 201, 202, 204, 205, breastbone, 141, 148, 163; see also sternum brush, drawing with, 30, 104 buttocks, 211 calcaneus (heel bone), 142, 165, 166, 170, 175, 210, 215, 217, 219, 220 Calder, Alexander, 62, 62 calf muscles, 214, 215; see also gastrocnemius calligraphy, 30, 32, 120 Cambiaso, Lucas, 34, 54, 55 camera, 101 carpal (wrist) bones, 142, 165, 165, 167, 168, 170, 172, 201, 205 carpal ligaments, 209 carpi radialis muscles, 201, 202, 204, 208; brevis, 201, 205, 206-207; longus, 201, 202, 205, 206-207 carpi ulnaris muscles, 202, 204, 205, 207, 208 cartilage, 146, 159, 191, 197 Caryatid with African Sculpture (Modigliani), casts, plaster, 106, 108, 109, 110, 180, 181 Catherine (Dürer), 7, 7 Cellini, Benvenuto, 140 Cennini, Cennino, 243 center, of body, 69, 72, 212, 214; of gravity, 50 cervical curve, 146 cervical vertebrae (neck bones), 146, 146, 164, 198, 198, 199

Cézanne, Paul, 40, 41, 42, 132, 134

chalks, 106, 226-227 chamois skin, 104 charcoal, 104, 235 cheekbones, 154, 159; see also zygomatic chest muscles. 188, 189, 189, 191. chiaroscuro, 229 children's drawings, 8, 8, 94 chimpanzee skeleton, 176 chromotypogravure, 83 Chu Yun-ming, 32 cinematic motion, 51-52 circle, in art, 8, 8, 9; (study I), 10-13, 10, 11 Clark, Kenneth, 6, 226, 234 classic drawing, 66-67 clavicles (collarbones), 141, 142, 145, 148, 150, 152, **155,** 163, **163,** 164, **164,** 186, 190, 191, **196,** 197, 198, 202, 204, 209 clay modeling, 86 closure, 10, 40 coccyx (tail bone), 145, 146, 147, 160, 161, 187, 211, 220 Cochereau, Mathieu, 4 collage, 34-35 Collage (Marca-Relli), 35 collarbones, 141, 142, 148, 152, 163; see also color, 95; and shape, 44; values, 106-109 columns, perception of, 90, 90, 91 comparative anatomy (study 36), 176, 176 compasses, 8 computer drawings, 36, 37, 71, 115, 117, 121, 123, **123,** 130, **130** condyles (knobs), 165, 165, 166, 200, 208, 214, 217, 219, 220 condyloid (knob) joints, 142, 165 Congolese art, 59 constructs, 34-36; see also geometry Conté crayons, 226, 236 contour drawing, 22, 47, 60, 60, 65, 124; (study 4), 24, 25, 27; rapid (study 6), 30, 31 contour hatching, 124-130 contours, 22-23, 23; as angles, 37, 37, 38-42; and outline, 22, 63 63; cross-section, 110, 114-123, **114-121**; of fabric patterns (study 21), 110–111, 111–113 contour, study, rapid, 27, 28, 48; technique, 229 contrapposto position, 50 convext-contour construction, 229 Copy after two figures from The Ascension of St. John the Evangelist by Giotto (Michelangelo), 55 coracobrachialis muscle, 203, 204, 209 coracoid process, 149, 163, 197, 200, 201, 202, 203, 204 coronoid process, 200, 208 cranium (skull), 152, 155, 158-159 crayons, 84, 104, 106, 226, 236 Creation of Adam, The (Querica), 106, 107 Critic Sees, The (Johns), 242, 243 cross-hatching, 124, 125 cross-section contours, 110, 114-123, 114-121; of human form (study 22), 115-123, 115-121 crotch, 211 Crouching Nude (Renoir), 95 Crucifixion (Pistoiese master), 224 cubism, 48, 132 cuneiform (foot) bones, 215 cusp joint, 200

Dance Movement (Rodin), 62 Dancing Figure (Rodin), 61 Dancing Nudes (Pollaiuolo), 67 Dancing Peasants (Rubens), 52, 53 Daughter of Butades Drawing the Shadow of her Lover (Suvée), 14 Daumier, Honoré, 86, 86 David, Jacques Louis, 236, 237 Degas, Edgar, 36, 50, 105, 123, 182, 183 Delacroix, Eugène, 127, 128 deltoids (shoulder muscles), 180, 187-189, 190, 191, 195, 197, 200, 201, 204, 205, 207, Delusions of Grandeur (Magritte), 240-241, 240, 241 Departing for the Underworld (Greek), 64 digastric muscle, 188, 189, 199 digitations, 191 digiti V proprius muscle, 205, 207 digitorum, muscles, 202, 204, 207; brevis, 214; communis, 201, 205, 206; longus, 212, 214, 217, 218; sublimis, 202, 208 dimples, back, 160, 161 disks, cartilage, 146 Disney, Walt, 36 Disparate General (Goya), 136, 136 distortions, drawing, 15 Dix, Otto, 130, 130 dorsal curve, 146, 146 dorsal vertebrae (back bones), 146, 147, 147 Dorso (El Greco), 134, 135, 136 draftmanship, 42 drybrush drawing, 104 Duchamp, Marcel, 21, 51 Duchamp Villon, Raymond, 117 Dürer, Albrecht, 7, 7, 8, 9, 10, 34, 68, 68, 72, 115, 116, 129, 129, 172, 203, 208 Durieu, Eugène, 128

Eakins, Thomas, 51–52, **52**, 104–106, **105**, **185**, 221
easel, 15
écorché (muscle cast), 41, 180, **181**Egyptian art, 48, 51, 67, 222–223, **222**elbow, **141**, 166, 168; see also olecranon process
Elevation of Christ on the Cross, The (Rubens), 229
Elevation of the Cross, The (Rubens), **231**El Greco, see Greco, El
El Hombre (Orozoco), 239, **239**epicondyles (knobs), 168, **202**, **204**, 205, 206, 207–208, **208**, 210, **219**, **220**equilibrium, body, 50
erector-spinae muscle, 195

extensor muscles, 200, **201, 202, 204, 205,** 206–207, 210–211, **212, 214,** 217 extremities, 170

extremities, 170 eyeballs, 154

Euclid, 65

eyes, form, 154; function, 92, **92,** 94, 101; movement, 24; see *also* visual perception eye sockets, 159

fabric contours, 110–111, **111–113**Fagot Carriers, The (Millet), 236, **237**fascia, **189**, 199, 200, **202**, **204**, 211, 215, **220**;

tendinous, 191, 208 fatty tissues, 182, 211, **214, 218**

Fau, J., 142, 143, 145, 149, 150, 187–189, 201, 202, 204, 205, 207, 209, 212, 214, 216, 218–220

feet, 172, 175; feet, bones, 166, 170, 170; see also calcaneus, metatarsal, tarsal, talus; study 35, 171–175, 171
female body, 160, 161, 162, 182, 184, 197
Female Nude Seen from the Back (Maillol), 77
femurs (thigh bones), 141, 152, 160, 165, 165, 168, 169, 169, 183, 210, 211, 212, 219, 220

168–169, **169**, **193**, 210–211, **212**, **219**, **220** fibulas (leg bones), **141**, 165, **165**, 168–170, **169**, **186**, 210, 215, 217, **220** figure, as construct of smaller units (study 7),

figure, as construct of smaller units (study 7), 34–35; -ground relationship, 13, 137, 137; reversal, 13, 21, 44

Figure from a calligraphic scroll (Pisani), 120 fingerpainting, 78–80, 79, 80

fingers, **167**; bones, **165**, 170; see also phalanges

fixation (eye rest), 24; muscles, **179**, 191, 195 fixed joints, **142**

flank pad, **189**

Flaxman's Anatomical Studies, **162**, **163** flexor muscles, 200, **201**, 203, **204**, 207–208, **212**, 215, 217, **218**

Forge, The (Goya), 231, 233

form: concepts, 7–13; and shape, 44; and visual measurement, 37–46

forms, body, 34–36; nonsequential, modeling, 88–89, **88, 89**

fovea (eye), 24

Francesca, Piero della, 115, 116, 157 Free Ride Home (Snelson), 221

French Academy, 70

frontal bone (forehead), 155

Fuseli, Henry, 100, 100

Galen, 67

Gan...L. D. (Daumier), 86 Ganneron (Daumier), 86, 86 Garçons de Café (Beardsley), 45 gastrocnemius (calf muscle), 212, 214, 215, 217, 218–220

Gateway, heads, animals, and heraldic eagle (Honnecourt), **9**

Gauguin, Paul, 83

geometry, in art, 8–13, **9,** 65; see also constructs

Géricault, Théodore, 99, **99, 153**

gesso, 226

gesture, 48; drawing, 65

Gheyn, Jacob de II, 206

Giacometti, Alberto, 42, 43, 157, 158

Gibson, James J., 89

Giotto, 8, 10, 55, **55**

Girl combing her hair (Utamaro), 44, 44

glenoid fossa, 200

gluteal band, 214, 220

gluteal furrow, 211, 218

gluteus muscles, **195**; maximus, **187**, **189**, 211, **214**, 216, **220**; medius, **187**, **189**, 211, **212**, **214**, **220**

golden section, 70

Gonzalez, Julio, **156**

Goya y Lucientes, Francisco de, 76, 81, 136, 136, 231, 232, 233, 236

gracilis (leg muscle), 211, **212**, 215, **218–220** graphite pencils, 226, 235

gravity, center, of, 50

Greco, El, 134, 135, 136

Greek art, 36, 51, **52,** 58, **64,** 66–67, **66, 67,** 75, **75.** 223

75, 223

groin, grove of the, 160, **181,** 191 Grosz, George, 72–74, **74, 192** hallucis longus muscle, **212**, 217, **218** hamstrings, **214**, 215, **220** hands, **173**, **174**; bones, 170; see also carpals,

metacarpals, phalanges; function, 172; grasping, 209, turning, 165–166; study 35, 171–175, **171**

hatching, 223; contour, 124–130; and figureground relationship (study 25), 137, 137; plane, 132–136, 132–135; random, 137 hatch marks, 124

hatch modeling, 238; and line, 139, **139**; contour (study 23), 124–126, **124–126**; plane (study 24), 132–136, **133–135**

Head (Tchelitchew), **120** Head of a Woman (Dix), **130**

heelbone, 170, 210, 215; see also calcaneus

Herculanean wall paintings, 58
Hercules and Telephus (Roman), 58
Hermes Waiting for a Woman (Greek), 64

Herron, Dr. R. E., **71, 117, 121, 130** hinge joints, **142, 164,** 165, 169, **169, 175**

hip bones, **145**, 147, 168; see also ilium; os innominatum, pelvis

hip joints, 160, 161

210

Italy, 172

Ivory Coast art, 59

Hokusai, Katsushika, **12, 30, 32,** 231–234, **234** homunculus, **75**

Honnecourt, Villard de, 8, 9 Horned dance mask (Baoule art), 59 How to hold a brush (Hokusai), 30

humerus (upper arm bone), **141, 145, 150,** 152, 163, **164,** 165–166, 168, 190, 193, **193,** 197, 200, **201, 202, 204, 205,** 206–208, **208,**

Huxley, Sir Julian, 221 hyoid bone, **155**, **188**, **189**, 197, **198**, 199 hypothenar muscles, **202**, **204**, 209

ideal figures, 70, 71 ideal proportions, 67; violation of, 72–74 iliac crest, 145, 160, 160, 187, 191, 195, 214 iliac furrow, 181, 186–189, 191 iliac spines: anterior-inferior, 169, 210; anterior-superior, 145, 148, 149, 160, 160, 165, 186, 188, 189, 210, 211, 214, 216; posterior-superior, 142, 160, 161, 165, 211, 214, 220

iliofemoral ligament, 145, 169, 210

iliopsoas, muscle, 212, 218 iliotibial band, 189, 211, 214, 220 ilium (hip bone), 148, 160, 211 index finger, 167 Indian art, 48, 51, 66, 172 infrahyoid muscles, 199 infraspinatus (back muscle), 187, 197, 205, 207 Ingres, Jean Auguste Dominique, 56–58, 58, 66, 234–236, 235, 236, 237 inguinal ligament, 160, 181, 188, 191, 212 lolas, Alexandre, 240 ischium (pelvic bone), 160, 160, 211 isometric tension, 178–179 Isotta da Rimini (Pasti), 78

Japanese prints, 44, 44, 46, 66, 231–234, 234 jawbone, 141, 159, 199; see also mandibula Jeune Fille (Villon), 132, 134 Johns, Jasper, 77, 77, 242, 243 joints, 142; see also ball-and-socket, cusp, hinge, suture

Kermesse (Rubens), 54 Kirchner, Ernst Ludwig, 239 Klee, Paul, 21, 46, 118 Koffka, Kurt, 13 Kollwitz, Käthe, 101-103, 102, 106 kneecap, 168, 210; see also patella knuckles, 171, 172 Landseer, Henry, 162, 163 latissimus dorsi (back muscle), 181, 186-189, 191, 193, 194, 195, 197, 205, 207, 209; study 39, 193, **193** Le Corbusier, 70, 70 legs, 168-169, 172; bones, 141, 147, 166, see also femurs, fibulas, tibias; muscles, 210-217, 212-214, 216, 218-220; see also limbs Leg Skeletons (Rubens), 169 Leonardo da Vinci, 6, 10, 58, 68, 69, 72, 90, 100, 101, 103, 114, **114,** 115, 157, **158,** 172, **173,** 182, 223-226, 226, 236 levator scapulaee, 189, 197 Libyan Sibyl, The (Michelangelo), 227, 229 Lieberman, Max, 14 life-size drawings, 87, 87, 171 Life study of a man's head (Lippi), 157 ligaments, 145, 160, 166, 168, 169, 181, 188, 191, 195, **202,** 208–210, **212, 214,** 217 lighting, studio, 4; and shadow modeling, 96, 100, 101-104 lightness constancy, 101 limb, lower, study 34, 168-169; muscles, 210-217, 212-214, 216, 218-220; study 43, 210 line: contour, 23, 30, 47, 48, 60, 60, 61; geometric, 65; and hatching, 139, 139; implied, 10; and modeling, 110; and motion, 54, 65; and shape, 44; variations, 60-62; virtual, 10, 132, 132 linea alba, 181, 186, 188, 189, 190 linea aspera, 211, 220 Lippi, Filippino, 157, 158 lithographs, 45, 72, 86, 86, 101, 102, 103, 103 Little Girl Playing Ball (Picasso), 72, 73 lumbar curve, 146, 146 lumbar vertebrae (back bones), 146 Magritte, René, 239-243, 240, 241 Maillol, Aristide, 77-78, 77, 94-95 male body, 160, 161, 197 malleolus (ankle bone): lateral (outer), 165, 166, 168, 170, 175, 186, 210, 212, 214, 215-217, 219; medial (inner), 165, 166, 168, 170, 175, **186,** 210, **212,** 217 mandibula (jaw bone), 141, 159, 199, 209 Man heaving a 75-pound boulder (Muybridge), 182 Man's head (Picasso), 75 maps, contour, of body, 120-123, 121 Marca-Relli, Conrad, 34-35, 35 Marey wheel photographs of Jesse Godley Running (Eakins), 52 Mary and Saint John (Netherlandish), 113 mass, 79 masseter, 198, 209 masterwork, movement in (study 13), 54-58, 55-58 mastoid processes, 197 Matisse, Henri, 23 Mayan art, 66 May Milton (Toulouse-Lautrec), 44, 45, 231 media, drawing, 30, 104, 106, 226-227 medial arc, skull, 154, 157-159

medial axis, skull, 154, 154 medieval art, 68, 223 medius, 167 memory, drawing model from (study 8), 36; drawing skeleton from (study 37), 176-177, 177; studies, 36, 176-177 metacarpals (palm bones), 165, 167, 170, 172, 201, 206-209 metatarsals (foot bones), 166, 170, 175, 212, 214, 215, 217 Mexican art, 66 Michelangelo Buonarroti, 6, 46, 50, 55, 55, 65, 126-127, 127, 166, 175, 180, 180, 194, 195, 208, 211, **213,** 215, **217,** 227-229, **227** Millet, Jean François, 236, 237, 237 mimesis (mimicry of nature), 67 Mirror Polisher, The (Hokusai), 32 model, platform for, 15; rotating (study 10), 47-48, 47; and skeleton (study 27), 144; walking (study 12), 51-52, 51, 52 modeling, 76-139; and line, 110; see also hatch, relief, shadow Model Nizzavona, The (Toulouse-Lautrec), 97 Modigliani, Amedeo, 58, 59, 72 Modulor, 70, 70 monkey skeleton, 176 mother holding a child and four studies for her right hand, A (Picasso), 174 mouth, 154, 154, 158, 159 movement, 48-58, 65; in a masterwork (study 13), 54-58; simple: a double pose (study 11), 48-50, **49** muscles, 178-221; 159, components, 179 Muybridge, Eadweard, 51, 182 mylohyoid muscle, 188 National Aeronautics and Space Administration, 70, 71 naturalism, 101, 104 neck: bones, see cervical vertebrae, hyoid; muscles, 189, 197-199; 198-199; nape, 195; pit of, 148, 149, 164, 181, 188, 189; study 41. 197-199 Neisser, Ulric, 93 Netherlandish art, 110, 113, 114 Nolde, Emil, 103, 103, 104, 239 nose, 154, 158, 159 nuchal ligament, 195 Nude Descending a Staircase (Duchamp), 51 Nude, Face Partly Showing (Mattise), 23 Nude Girl Resting (Valadon), 131 Nude Male Figure in Violent Action (Tintoretto), 12 Nude man (Durieu), 128 Nude man and woman (Durieu), 128 Nude study (Michelangelo), 127 Nude woman (Dürer), 9 Nude woman with staff (Dürer), 68 oblique muscles, 181, 187-189, 191 occipital bone, 199 occipital protuberance, 191, 198 octagon shapes, 80, 90 oil paints, 106 olecranon process (elbow), 142, 161, 166, 186, 200, 201, 204, 205, 208, 208, 209 omohyoid muscles, 189, 199 orbits (eye sockets), 159 Orozoco, José Clemente, 238-239, 239 os innominatum (pelvic bone), 141, 145, 160,

outline, 14-21, 22, 23; and contour, 22, 63, 63; and silhouette, 14; study 2, 16-17, 16-17; superimposed, 17 oval constructs, 34, 34, 63, 63 overlapping forms, 11, 11, 12, 106 overlays, tracing-paper, 152, 152, 153, 180 ovoid forms, 34, 152, 157, 157, 158 Page from a sketchbook (Picasso), 59 Painted figures of athletes (Greek), 52 palmar fascia, 202 palmaris muscle, 202, 204, 208 papers, toned drawing, 106 parallelism, 42 Pasti, Matteo de', 78 patella (kneecap), 166, 168, 186, 210, 212, 214, 216, 218, 219 patellar ligament, 166, 168, 169, 210, 212 Peasant Dance (Rubens), 52, 52, 54 Peck, Stephen, 140 pectineus (leg muscle), 211, 212 pectoralis muscles: major, 181, 188, 189, 190, 191, 202, 209; minor, 197, 203 pelvic axis, 72, 148, 149 pelvis, 145, 147, 152, 153, 160, 160-162, 169, 186, 193, 194, 210, 211, 213, 216; drawing (study 31), 162, 162 pencils, colored, 106; drawing, 226, 235 pentimenti, 234 peroneal band, 214, 215 peroneus muscles, 215-217; brevis, 212, 214, 215-217; longus, 214, 215; tertius, 214 perspective, single-point, 46 phalanges (toe-finger bones), 165-167, 170, 172, 175, **201,** 206, 208, 209, **212,** 217 photography, 51, 52, 94, 101, 127 Picasso, Pablo, 6, 42, 42, 48, 48, 59, 65, 67, 72, **73, 75,** 94, **95,** 106, 108, **109,** 130, **131,** 139, 139, 174, 235, 237-238, 238 Pietà (Michelangelo), 228 Pisani, Geobattista, 120 pisiform, bone, 167, 202, 204; extensor, 201 Pistoiese master, 224 plane joints, 142 plane modeling, 132-136, 132-135 planimetric drawing, 37 plantar (sole of foot), 215, 217 platysma muscle, 199 Pliny, 22, 30 pointillism 83, 83 point of view, artist's, 101-103 police drawings, 15, 129, 129 Pollaiuolo, Antonio, 66, 67 pollicis muscles: brevis, 201, 205, 206; longus, 201, 202, 208 Polyclitus, 67 Pontormo, Jacopo da, 191, 228-229, 228 Portrait of Baldassare Castiglione (Raphael), 56, **56** Portrait of Cardinal Nicolo Albergati (Van Eyck), 223, 225 Portrait of Madame d'Haussonville (Ingres), 234, 235, 236 Poseuse de dos, La (Seurat), 83 Poster for the German Homecrafts Exhibition (Kollwitz), 102 Poussin, Nicolas, 106, 107, 108 "primitive" art, 74, 94 printing methods, 44, 46 "Processes of Vision, The" (Neisser), 93 profiles, 15

prominens (7th vertebra), 142, 145, 146, 147, 187, 196, 198, 198 pronation (palm down), 166, 167, 168, 200 pronator muscles, 203, 207-208; teres, 204, 208 Proportional system based on a schematic figure, le Modulor (Le Corbusier), 70 proportions: classical, 67-72, 68, 69; and symmetry, 72-75 pubic crest, 145, 160 pubic ramus, 211, 218 pubis, 149, 160, 191, 211, 219 Pythagoras, 68 quadriceps muscle, 210 Querica, Jacopo della, 106, 107 radius (forearm bone), 41, 164, 165-166, 165, 167, 168, 200, 201, 202, 205, 206, 210 random hatching, 137 Raphael Santi, 56, 56 realism, 236 Reclining Nude (Rembrandt), 130, 131, 136 rectangle constructs, 34 rectus-abdominis muscle, 181, 188, 191, 195 rectus-femoris muscle, 188, 210, 212, 214, 218, 219 relief carving, 222-223 relief effect, enhanced, 122, 122 relief modeling, 78-95, 156, 227; with continuous tone (study 16), 84-86, 84, 85; with printing ink (study 14), 78-80, 79; with stippling (study 15), 81-83, 81, 82; theory of, 89-85 relief sculpture, 78, 78, 106, 107, 108 Rembrandt van Rijn, 33, 56, 56, 57, 130, 131, 136; school of, 5 Rembrandt with His Students in the Workshop Drawing from the Live Model, 5 Renaissance art, 46, 66, 67, 68, 103, 115, 223, 229 Renoir, Pierre August, 95, 95 retinal image, 92, 92, 93, 94 rhomboids (back muscles), 187, 197, 207 rhythm, 52, 52 rib cage, 141, 145, 149, 152, 153, 155, 163-164, **163-164,** 191, 193, **193,** 194, **195,** 199; drawing (study 32), 164-165 Ribera, Jusepe de, 158, 159 Richer, band of, 214 ring finger, 167 Robusti, Jacopo, 12, 29 Rodin, August, 36, 60-62, 61, 62 Roman art, 58, 58, 68 rotation (study 10), 47-48, 47 roundness, 95 rubber eraser, 104 Rubens, Peter Paul, 52, 52, 53, 54, 169, 229-231, 230, 231 rulers, 8 saccade (eye movement), 24 sacral curve, 146 sacral triangle, 187, 211 sacrospinalis (back) muscles, 146, 187, 194, 195, **195** sacrum (backbone), 141, 145, 146, 146, 147, **150,** 152, 160, **160,** 211 San Giovannino (Tintoretto), 29 Santa Felicitá Altarpiece (Pontormo), 228

Sarto, Andrea del, 199

sartorius muscle, 211, 212, 213, 215, 218-220

Savage, Jean Galbert, 147, 154, 161, 164, 168scale modeling, one-to-one (study 17), 87, 87 scalenus medius, 189, 199, 199 scapulae (shoulder blades), 141, 142, 145, 149, **150,** 152, 161, 163, 164, **164, 186, 187,** 191, 193, 193, 195, 195, 197, 200, 201, 202, 203, 205, 207, 210 Sculptor and Model (Picasso), 139, 139 sculpture, 60-62, 62, 75, 78, 78, 80, 86, 86, 95, 106, 107, 108, 126; see also casts, relief Seated Nude (Picasso), 48 Seated Woman (Seurat), 20 Self-portrait (Cézanne), 132, 134 Self-portrait (Dürer), 129, 129 Self-portrait (Fuseli), 100, 100 Self-portrait (Gonzalez), 156 Self-portrait (Klee), 46 Self-portrait (Nolde), 103, 103, 104 Self-portrait (Picasso), 94, 95 Self-portrait (Rembrandt), 57 Self-portrait in Profile (Duchamp), 21 self-portrait with skull (study 30), 154-159, 156 semimembranosus (leg muscle), 215, 218-220 semitendinosus (leg muscle), 215, 218-220 sepia wash, 231 septum, intermuscular, 204 serratus muscles, 181, 186, 191; anterior, 189, 209; interior, 188 Seurat, Georges, 20, 83, 83, 94 shadow: 89; cast, effects, 96, 101, 101; on body, 97, 100, 100; contours, 24, 97; modeling, 96-105, 98, 223, 227, 229; blackand-white (study 20), 104; study 19, 96-100 shape: and color, 44; and form, 44; and line, shinbone, 141, 168, 169; see also tibia shoulder, axis, 72; girdle, drawing (study 32), 164-165 shoulders: blades, 141, 152, 163, see also scapulae; girdle, 163, 164, 195; muscles, 207, 209, see also deltoids silhouette, 60, 61; and outline, 14; study 3, 18-21, **18, 19, 21** silverpoint, 232, 225, 226, 226 simultaneity, 47 simultaneous drawing, 47-48, 47 sinopie (preliminary drawings), 223 skeleton, 140-177, 142, 143; articular mounted, 140, 141, 143, 144, 155; introduction to (study 26), 143; in living body, 140, Sketch after Raphael's Baldassare Castiglione (Rembrandt), 56, 56 sketchbook, artist's, 58 Sketchbook study of the écorché (Cézanne), skin: creases, 24, 172, 211; surface, 77; wrinkles, 24 skull, 141, 146, 152, 154-159, 154, 155, 158, 199 Skull (Giacometti), 158 Sleeping Peasants (Picasso), 130, 131 Snelson, Kenneth, 221, 221 Soldier Holding a Lance (Géricault), 99 soleus muscle, 212, 214, 215, 218, 220 space, negative, 13, 13, 40 spinal column, 146, 146, 164; groove of, 150,

161, 186

spine, 141, 193; see also vertebral column spines, vertebral, 146 spinous process, vertebral, 147 splenius (neck muscle), 187, 189, 199, 199 squaring technique, 229 step construction, 240 stereometric drawing, 37 Stereometric elaboration of various animals (Hokusai), 12 Stereometric man: thirteen cross sections of the body (Dürer), 116 sternohyoid muscles, 181, 188, 198, 199 sternomastoid (neck muscle), 181, 187-189, 197-199, 198, 199, 209 sternum (breastbone), 141, 148, 149, 155, 163, 163, 189, 190, 198 stippling, 80-83, 81, 82 stomach, pit of the 163, 164 Studies (Delacroix), 128 Studies of The Libyan Sibyl (Michelangelo), 227, 227 Studies of a man's leg (Michelangelo), 213 Studies of a woman adjusting her hair (Hokusai), 32 Studies of heads, arms and a leg, and the head and shoulders of a recumbent man (Bloemaert), 196 Studies of the mouth and nose (Ribera), 158, 159 Studies of the skeletal foot (Michelangelo), Study (Michelangelo), 217 Study (Picasso), 42 Study after the Libyan Sibyl of Michelangelo (Rubens), 230 Study after The Triumph of Titus (Poussin), Study for a Resurrection (Michelangelo), 50 Study for Portrait of Cardinal Nicolo Albergati (Van Eyck), 225, 227 Study for Portrait of Madame d'Haussonville (Ingres), 235 Study for St. John (Pontormo), 191 Study for Skin I (Johns), 77 Study for The Critic Sees (Johns), 242 Study for the figure of Christ (Rubens), 229, 230 Study for the head of St. Elizabeth (Sarto), Study for The Last Judgment (Michelangelo), 195 Study for the Portrait of Madame Moitessior (Ingres), 58 Study for The Raft of Medusa (Géricault), 153 Study for the Santa Felicitá altarpiece (Pontormo), 228, 228 Study for the sculpture Delusions of Grandeur (Magritte), 240, 241 Study for The Two Brothers (Picasso), 238, 238 Study for Weary (Whistler), 137, 138 Study of a profile (Picasso), 42 Study of arms (Gheyn), 206 Study of arms (Michelangelo), 208 Study of a torso after a plaster cast (Picasso), Study of a woman's hands (da Vinci), 173 Study of legs (Orozoco), 238, 239 study of proportions after Vitruvius, A (da Vinci), 69 Study of the feet and legs (Dürer), 172

Study of the head (Sarto), 199 Trois Femmes Nues (Giacometti), 43 Study of the head of a young girl (da Vinci), 223, **226** Study of the nude (Bernini), 190 Study of the proportions of the head (Francesca), 116 stump, 104 stylohyoid muscle, 188 styloid process, 200, 201, 202, 204, 206 Suikoden Book (Hokusai), 234, 234 supination (palm up), 165, 167, 168, 200 supinator muscles, 203, 206; longus, 201 suprahyoid muscles, 199 supraspinatus muscle, 207 surrealism, 35, 117, 120, 238, 243 suture joints, 142, 159 Suvée, Joseph Benoit, 14 Svevo, Italo, 54 symmetry: of body, 186, 200; and proportion, 72-75 symphysis, of mandible, 199; pubis (pubis joint), 160, 160, 211, 219 synergist muscles, 179 talus (anklebone), 166, 170, 175, 212 tarsal bones (feet), 166, 170, 175 Tchelitchew, Pavel, 120, 120 teeth, 159 tempera paints, 106 temporalis, 198 temporal line, 155, 159 tendons, 172, 178, 188, 189, 191, 193, 201, 202, 205, 206, 208, 211, 212, 214, 215-217, 218 tension, muscle, 178-179, 182 tensor fasciae latae muscle, 189, 211, 212-214 teres-major muscle, 187, 197, 205, 207, 209 teres-minor muscle, 187, 197, 205, 207, 209 texture, 89-90, 91, 94; density, gradient of, 92, 93, 94, 122, 122 thenar muscles, 201, 202, 204, 209 thighbones, 141, 160, 169; see also femurs thighs, 211 Thomson, Arthur, 203 thoracic arch, 163 Three Men Digging (Goya), 231, 232, 236 thumb, 167, 170, 206, 208, 209 thyroid, cartilage, 197; gland, 197 tibia (shinbone), 141, 165, 165, 166, 168, 169, 170, 186, 210, 211, 214, 215, 217, 218-220 tibialis muscle, 212, 214, 215, 217, 218 Tintoretto, il, 12, 29 toes, 170, 175, 217; bones, see phalanges tonal modeling, 84, 235 tonal values; restricted, 96-100; subtle, 104tone, 89-90, 91; continuous, 84-86 Toulouse-Lautrec, Henri de, 42, 44, 45, 97, 231 transparency, 101 transverse processes, vertebral, 147 trapezius (back muscle), 187-189, 191, 193, 195, 196, 197-199, 199, 201, 205, 207 Treatise on Painting (da Vinci), 90 triceps (back) muscle, 200-203, 201-205, 209 Triumph of Galatea, The (Poussin), 106, 108 Triumph of Titus, The, 106, 107 Triton Bearing a Draped Woman on his Shoulder (Bernini, school of), 127 trochanter, great (femur top), 142, 165, 168, 169, 186, 189, 210, 211, 212, 213, 216, 220

trunk muscles, 188, 189, 190-191, 190, 195-197; back view (study 40), 194-197, 194, 195; front view (study 38), 189-191 tubercles, 169, 197 tuberosities, 160, 160, 191, 200, 210, 211, 214, 215, 217 Two Brothers, The (Picasso), 237-238, 238 Two studies of a begging woman with two children (Rembrandt), 33 Tyndall, Robert, 123 ulnae (elbow bones), 141, 161, 164, 165-166, 167, 168, 186, 200, 201, 202, 204, 205, 206, 207, 208, 209, 210 ulnar crest, 142, 201, 203, 207, 208 ulnar groove, 201 Utamaro, 44, 44 Vaillant, Wallerant, 109 Valadon, Suzanne, 130, 131 value constancy, 101, 101 values, formal, 106-109 Van Der Rohe, Miës, 65 Van Eyck, Jan, 223, 225, 226, 227, 243 Vasari, Giorgio, 8 vastus muscles: intermedius, 210; lateralis, 210, 212, 214, 216, 220; medialis, 210, 212, 219 vertebrae, 146-147, 146, 147 vertebral column (spine), 141, 144-146, 145, 146, 148, 198 Villon, Jacques, 117, 119, 132, 134 Vinci, Leonardo da, see Leonardo da Vinci Virgin of the Rocks, The (da Vinci), 226, 226, visual measurement and form, 37-46 visual perception, 10, 14, 76, 76, 89-95, 90-93, 101, 101 Vitruvian Man (da Vinci), 69, 72 Vitruvius, 67-68, 70 volume, 95 wash modeling, 99, 99 watercolors, 106 Watrous, Harry Wilson, 227 Watteau, Jean-Antoine, 110, 112, 114 Whistler, James Abbott McNeill, 137, 138 Woman Holding a Warrior's Helmet, A (Achilles painter), 66 Woman Seated on the Ground, Seen from the Back (Watteau), 112 woodcuts, 30, 44, 46, 46, 234, 234 wrist, 165, 168, 172, 206, 208; see also carpal bones xiphoid process, 155, 163 x-ray photographs, 141 Young Artist Drawing from a Cast (Vaillant), zygomatic arch, 155 zygomatic (cheek) bones, 159 zygomaticus muscles, 181, 198; major, 159